The Enemy

The Enemy

A Biography of Wyndham Lewis

JEFFREY MEYERS

Routledge & Kegan Paul

LONDON AND HENLEY

First published in 1980
by Routledge & Kegan Paul Ltd

39 Store Street,
London WC1E 7DD and

Broadway House,
Newtown Road,
Henley-on-Thames
Oxon RG9 1EN

Set in 11/12 Monotype Imprint 101
and printed in Great Britain by
Ebenezer Baylis and Son Ltd
The Trinity Press, Worcester, and London

British Library Cataloguing in Publication Data
Meyers, Jeffrey
The enemy.
1. Lewis, Wyndham, b. 1882 - Biography
2. Authors, English - 20th century - Biography
3. Painters - England - Biography
4. Art critics - England - Biography
I. Title
828'.9'1209 PR6023.E97Z/

ISBN 0 7100 0514 8

m.r.

Jacket credits

(Front) Wyndham Lewis and The Laughing Woman, *c. 1912*
(courtesy of Barratt's Photo Press)
(Back) Alcibiades *from* Timon of Athens, *1912*
(courtesy of the Victoria and Albert Museum)

For William Calder

Contents

Plates

Acknowledgments

The editor of Lewis' *Letters*, W. K. Rose, observed that "The scholar concerned with the data of Lewis' life has found himself lost in a fog of rumour and half-proved fact, of conflicting statements and pure fantasy." I am pleased to acknowledge the generous assistance I have received from a great many people who have helped me penetrate the fog, evaluate the facts and understand the life of Wyndham Lewis. Donald Eddy and Joan Winterkorn of the Rare Books Library at Cornell University allowed me complete access to the superb collection of Lewis letters and manuscripts and guided me through the complex task of reading them. C. J. Fox and Hugh Gordon Porteus gave me the benefit of their extensive knowledge of Lewis. A Guggenheim Fellowship and a University of Colorado Faculty Fellowship enabled me to spend a year in London writing the book.

For personal interviews and letters I would like to thank: Walter Allen, Joseph Alsop, Pamela Askew, Elizabeth Ayrton, Robin Barry, Dr. Antony Branfoot, D. G. Bridson, Cleanth Brooks, Mary Campbell, Peter Caracciolo, Betty Chapman, Sybil Lady Cholmondeley, William Cookson, Dr. Sheldon Cooperman, Richard Cork, Robert Cowan, John Cullis, Teresa Campbell Custódio, Anthony D'Offay, David Drey, Richard Ellmann, Jane Farrington, Reverend Willis Feast, Desmond Flower, Margaret Flower, David Garnett, William Gaunt, Frederick Gore, Geoffrey Grigson, Melville Hardiment, Michael Holroyd, Dr. Peter Isaacson, Yvonne Kapp, Hugh Kenner, Pierre Kerroux, Russell Kirk, Phillip Knightley, Anne Wyndham Lewis, Paul and Eleanor Martin, Ellsworth Mason, Marshall and Corinne McLuhan, Dr. Ian McPherson, Dr. Swithen Meadows, Walter Michel, Naomi Mitchison, Henry Moore, Riette Sturge Moore, Bradford Morrow, Father J. Stanley Murphy, Stella Newton, Helen Peppin, Omar Pound, William Pritchard, Mary de Rachewiltz, Gillian Raffles, John Reid, Keidrych Rhys, Edgell Rickword, Sarah Roberts, M. L. Rosenthal, Tom Rosenthal, Sir John Rothenstein, John Slocum, Rowland Smith, Stephen Spender, Julian Symons, Tambimuttu, E. W. F. Tomlin, Dr. Patrick Trevor-Roper, William Wees, Rebecca West, Katherine Wheat, J. Alan White, Josephine Whitehorn and Desmond Zwemmer.

For letters about Lewis I am grateful to: Mary Adams, Miriam Allott, Hugh Anson-Cartwright, Helen Arbuthnot, Anthony Aylmer, Elliott Baker, Margaret Barr, Jane Beckett, Lord Bernstein, Burgon Bickersteth, T. J. Binyon, Florence Blood, Anthony Blunt, Pauline Bondy, James Brophy, Ashley Brown, Lord David Cecil, Mary Chamot, Edward Chaney, Robert Chapman, Leslie Chisholm, Lord Clark, Alistair Cooke, Lady Diana Cooper, Robertson Davies, Lord Drogheda, Ronald Duncan, Michael Durman, Valerie Eliot, C. J. Eustace, Barker Fairley, Hugh Ford, Northrop Frye, Donald Gallup, Martha Gellhorn, Margaret Giovanelli, Robert Gordon, Nicolete Gray, Michael Greenwood, Lord Harmsworth, Sir Rupert Hart-Davis, George Homans, Lady Huxley, Sam Hynes, The Earl of Inchcape, Admiral Sir Caspar John, Romilly John, James Laughlin, Sylvia Legge, Harry Levin, Rt. Hon. Malcolm MacDonald, Archibald MacLeish, Timothy Materer, William McCann, James McKinley, Henry Miller, Terence Millin, Ivor Montagu, Jennifer Montagu, Michael Moorcock, Daniel Sturge Moore, Frank Morley, Konrad Morsey, Sir Oswald Mosley, Alan Munton, Charles Nagel, P. H. Newby, Michael Parkin, Sir Roland Penrose, Myfanwy Piper, Anthony Powell, Sir Victor Pritchett, Eleanor Pyron, Peter Quennell, Kathleen Raine, Henry Regnery, I. A. Richards, Edgar Richardson, Michael Richter, Laura Riding, Anne Ridler, Lynette Roberts, Edward Rogers, Kenneth Saltmarche, Richard Shone, Sir Sacheverell Sitwell, A. J. M. Smith, Thomas Smith, Antony Stone, Dora Stone, Frank Swinnerton, Allen Tate, Diana Trilling, Geoffrey Wagner and Sir William Walton.

I also received useful information from: Black Sparrow Press; Boston Public Library; BBC Written Archives; British Legal Association; Bucks County Historical Society; State University of New York at Buffalo; Canadian Broadcasting Corporation; Carcanet Press; Cassell; Chatto & Windus; Ferens Art Gallery; Films Incorporated; Henry Ford Museum; Greater London Council; Harvard University Archives; A. M. Heath; Reimar Hobbing Verlag; University of Leeds; Lefevre Gallery; London Library; McCord Museum, Montreal; Methuen; National Archives, Washington, D.C.; National Library of Canada; Town Clerk, Nundā, New York; Pennsylvania Department of Health; Philadelphia Department of Records; Public Records Office, London; Redfern Gallery; Registrar General, Nova Scotia; Registrar General, Toronto; Routledge & Kegan Paul; Royal Commission on Historical Manuscripts; Rugby School; Ryerson Press; Santa Barbara Museum of Art; Slade School of Fine Art; University of Sussex; United States Military Academy; Voltaire Foundation; University of Windsor, Ontario; Wyndham Lewis Society; York University, Toronto.

Many libraries and museums allowed me to read Lewis' unpublished papers and to study paintings and drawings that were not on

exhibition: the British Library; Columbia University Library; Library of Congress; Imperial War Museum; London University Library; Pierpont Morgan Library; National Library of Scotland; New York Public Library; Queen's University Library, Kingston, Ontario; Tate Archives and Library; University of Texas; Vassar College Library; University of Victoria, B.C.; University of Virginia Library; Washington and Lee University Library; Yale University Library; and the Ashmolean Museum; Assumption College, Windsor; British Museum; Eliot House, Harvard University; Johnson Museum of Art, Cornell University; Magdalene College, Cambridge; Manchester City Art Galleries; Mayor Gallery, London; Munson, Williams, Proctor Museum, Utica, New York; Museum of Modern Art; New College, Oxford; Tate Gallery; Victoria and Albert Museum.

The British Institute of Recorded Sound and the BBC enabled me to hear recordings by Lewis and broadcasts of *The Human Age*; and the Arts Council of Britain showed me a film on *Blast*. For arranging my lectures on Lewis I would like to thank Roger Sharrock of King's College, University of London; John Whitley of the University of Sussex; and Dr. Roy Weller and the pathologists of Southampton University Medical School, who also provided expert medical advice.

The author and publisher would like to thank the Executors and Trustees of the Estate of the late Mrs. Gladys Anne Wyndham Lewis for permission to reprint extracts from published and unpublished works and letters of Wyndham Lewis, and to reproduce paintings by him, © Mrs. G. A. Wyndham Lewis, by permission of the Executors and Trustees of the Estate of Mrs. G. A. Wyndham Lewis. Lines from *Letters from Iceland* by W. H. Auden and Louis MacNeice (Faber, 1937) are reprinted by permission of Curtis Brown Ltd. Lines from *The Georgiad* are reprinted by permission of The Bodley Head from Roy Campbell's *Collected Poems*; and those from *Flowering Rifle* are used by permission of Curtis Brown Ltd. on behalf of the Estate of Roy Campbell. The quotation from Part 25 of "Transitional Poem" is reprinted from *Collected Poems 1954* by C. Day Lewis by permission of the Executors of the Estate of C. Day Lewis, Jonathan Cape Ltd., and the Hogarth Press. Lines from *Fisbo* by Robert Nichols are reprinted by permission of William Heinemann Ltd. Lines from "The Encounter" are reprinted by permission of The Bodley Head from *Collected Poems* by Edgell Rickword. The extract from Dorothy L. Sayers' translation of Dante's *Inferno* is reprinted by permission of David Higham Associates Ltd. Extracts from the following poems are reprinted by permission of Faber and Faber Ltd.: "A Happy New Year" from *The English Auden* by W. H. Auden; "Preludes" from *Collected Poems 1909–1962* by T. S. Eliot; "Plotinus" from *Collected Early Poems of Ezra Pound*, and material from *The Cantos* of Ezra Pound.

O the mind has mountains; cliffs of fall
Frightful, sheer, no-man-fathomed. Hold them cheap
May he who ne'er hung there.

> G. M. Hopkins, Sonnet 41

I see a fiery mist wherever I direct my eyes.
But the fire is not outside me, the fire is in
my brain.

> Wyndham Lewis, *Self Condemned*

CHAPTER ONE

Childhood, Rugby
and the Slade, 1882–1901

Outside I am freer.
Enemy 1

I

Percy Wyndham Lewis' terse account of his early years emphasized
the romantic associations of the sea, the distinct phases of his life in
three countries and the cosmopolitan background: "My cradle was a
ship, moored to the side of a wharf. At around the age of 6 I arrived in
England, a small American, and left it for France about 11 years later
a young Englishman. I returned to England a European. . . . It should
also be remembered that at 6 years old I frisked and frolicked with other
little American boys on the New England coast—*not* with little Britons
on the English coast. The American beginnings are irrelevant, except
that I could not help imbibing from my very American father much
Stimmung [mood], a certain sentiment, and a lot about the Civil War.
And my mother was more American than Irish, and her memories are
mine. I have masses of my uncle's letters, who was an American coal
magnate. It adds up to nothing very solid, but must be reckoned in."[1]
Lewis' parents moved from America to England in 1888; and when
they separated five years later, he was completely cut off from his
American origins. His education at Rugby and the Slade turned him
into a young Englishman; and seven years of bohemian life on the
Continent endowed him with a European rather than an insular out-
look. The American, English and European elements all contributed to
Lewis' character, but they were never fully integrated and made him
feel an outsider in all three places.

Lewis' great-grandfather, Ansel, was born and married in Boston.
His grandfather, Shebuel, was a Quaker, born in Portland, Maine in
1803. Shebuel worked in the lumber trade in Pennsylvania and married
Caroline Romaine, whose wealthy French-Canadian family lived in the
lakeshore town of Oakville, Ontario, and owned a business in Montreal
and a substantial building in Toronto. Shebuel and Caroline had seven

sons and one daughter; and after he had retired in 1859, they moved
to Nundā, a village in the Genessee Valley of western New York. They
lived on a large farm called Cedar Place, just south of the village at the
foot of Stone Quarry Hill, and Shebuel indulged his inordinate weak-
ness for horseflesh. In 1873 the Lewis family left Nundā and moved to
Canada, where Caroline died in 1884.

Lewis' father, Charles Edward Lewis, was probably born in New
York City in 1843, and grew up in Nundā where he learned to shoot
and ride. A tall, handsome, square-jawed young man, with brown hair
parted in the middle and intense brown eyes, he entered the United
States Military Academy at West Point in 1861 but resigned after four
months because of failing vision. Charles returned to Nundā and in
August 1862 enlisted in the Union Army, was made a sergeant and
then promoted to 2nd Lieutenant in October. He had a dashing career
in the Civil War, despite poor eyesight; and recorded his adventures in
a pamphlet, privately printed in London and "Dedicated to comrades
of the Grand Army, wishing them joy of their 1897 campfire." Charles'
older brother and close friend, William, was a major in the Civil War;
and his brother Julian, who was too young to fight, followed Charles
to West Point.

Charles described, in his ornate and digressive style, his participation
in the charge of General Sheridan's cavalry at Manassas in October
1863. Charles led fifteen men of the 1st New York Dragoons to capture
a vital hill and claimed that his rash attempts to seize a second promon-
tory, when he was wounded in the hip, precipitated the battle. He was
captured during the Battle of Wilderness, at Todds Tavern, Virginia,
on May 7, 1864, and fled from a Confederate military stockade on
November 4. He described his "Escape from a Rebel Prison" in a
2,000-word article in the *Nundā News* of February 18, 1865.

After six months' confinement in Richmond, Virginia, and Macon,
Georgia, Charles escaped without difficulty from a prison in Columbia,
South Carolina. There was no fenced enclosure and he only had to wait
for a dark night. The guards pursued him, but he hid in a thick wood.
He then met two other escaped officers and decided to travel about four
hundred miles northwest to Tennessee. He had been treated inhumanly
in prison: starved, abused and insulted. With only a thin Rebel uniform,
ragged shoes and no rations he was not prepared to endure hardship.

Charles was chased by a pack of bloodhounds and eluded them by
crossing a swift-flowing river on a raft. Negroes often helped him by
providing food and showing him the right direction. He had to cross
the Smoky Mountains through six inches of snow and at one point,
while being pursued by Indians, had nothing to eat for four days. After
an exhausting month, he finally reached the lines of the Union Army and
reported to the Provost Marshal in Knoxville on December 5. He spent

that month recovering in hospital, was on leave in January 1865, and returned to his regiment in February, when he was promoted to 1st Lieutenant. In October 1868, three years after the War, he was made brevet Captain for "gallant and meritorious services." Charles always wore his Grand Army button, loved to tell stories about the war, considered himself a member of the military aristocracy and regarded his active service as the happiest time of his life.[2]

Charles Lewis practiced law for a few years after his fighting days were over, but he was a confirmed romantic who despised American materialism, never had a proper career and followed what his son called the "do-nothing mode of life." He played the flute and violin, was a great horseman and mariner, loved fox-hunting and sailed his own brig across the Atlantic. He seemed built on the grand scale: experienced, rash, humorsome—a spendthrift, a sportsman and a hard rider. Charles, who scarcely earned a cent in his life, was able to enjoy the ease of a "professional idler" and "essay-writing bum" because his prosperous family owned mining and railroad companies in upstate New York and Canada. Apart from his father's wealth, his brother Harry owned a business in Wisconsin; his brother Albert, who had been educated at Heidelberg, had a law firm in Toronto; and his older brother George was the director of several banks and utility companies, and president of the Bell, Lewis and Yates Coal Company of Buffalo, which produced more than a million tons a year.

On February 23, 1876, in St. Stephen's Church, Camberwell, Charles married the sixteen-year-old Anne Stuart Prickett, who had family in Oakville. She was a lively and attractive English girl of Scotch-Irish descent, with gentle features, a full sensitive mouth and a good figure. Anne had been brought up as a Catholic, though she no longer practiced her religion, and was sixteen years younger than her husband. For a few years after his marriage Charles worked in his uncle William's wine business in Montreal, travelling around the Maritime Provinces and New England, and sending his wife many dull but tender letters which complain of sluggish trade, boredom and loneliness. Anne spent most of this period in Canada, but also visited her mother in England. In September 1877 their first child died just after birth.

The following year, though business was still slow, Charles spent "a pile of money" on a yacht, the *Wanda*. On November 18, 1882, Percy Wyndham Lewis was born aboard that yacht, tied to a dock at Amherst, Nova Scotia. He was born in the same year as James Joyce and Virginia Woolf, three years before Pound and six years before Eliot. Lewis was christened in Montreal, and kept Canadian nationality for the rest of his life. He served as a Canadian War Artist in the Great War and lived in Canada, where he looked up his family, during World War Two.

Lewis spent his first six years on the coast of Maine and Chesapeake

Bay. His father, who had abandoned the tedium of commerce, hired a nurse, two servants and a cook, and indulged his passion for sailing. The earliest photograph of Lewis portrays him in a sailor's cap and jacket, holding a fishing net and standing beside a lobster pot. Lewis later traced his artistic origins and recalled: "My mother and father's principal way of spending their time at the period of my birth was the same as mine now: my mother painting pictures of the farm house in which we lived, my father writing books inside it."[3] Fifty years later he still had drawings of beautiful American birds by his mother, who had been to art school in Bloomsbury Square before her marriage, and sketches of his horse, dog and boat by his father. His mother would make fair copies of his father's "Reveries" and journal of voyages to England, which he would then rewrite.

In 1888 the family moved to that Victorian pleasure-garden, the Isle of Wight. Anne had wanted to return home and be closer to her aging mother; and there Charles could more easily pursue the life of a dilettante gentleman, and enjoy fox-hunting, and yachting on the grey expanse of the Solent and of Southampton Water.

Though life was still pleasant, Charles was bored and easily distracted; and Lewis recorded: "My mother affirmed that he was scarcely responsible for his actions, some of which departed so far from the norm as to be alarming."[4] In 1893, when Lewis was eleven, Charles, who had a reputation for lechery and whom Lewis called "the Old Rip," ran off with one of the housemaids—whose red hair seemed to make things even worse. He later confessed to his wife: "I have without realizing it soon enough, got myself entangled in a way that makes my extraction next to impossible. I would be all right as I am but for you and Percy. . . . I am awfully sorry too for the miserably unnecessary pain I have caused your good mother." Charles' family was outraged and immediately sided with his wife. His sister, Tillie, who had married George Chisholm of Oakville, wrote: "About Charles, the less said the better perhaps. I cannot bear to think of his despicable conduct, and hope I may never see him again. Rest assured you have our sympathy." And his brother George exclaimed: "He seems to have become lost to all sense of duty and loyalty. . . . He has forfeited my love and respect and I have no desire for intercourse with him."[5] Though George disapproved of Charles' immorality and idleness, he continued to send him money and also supported Anne and their son. In 1894 George lent Anne $4,500 and invested it for her in Buffalo real estate to provide her with an income.

Anne, with her son and mother, moved to a succession of London suburbs: Highgate, Hampstead, Beckenham and Ealing. Charles soon left his mistress and bought a cottage at Tarporley in Cheshire, where he consoled himself with his horse, and bemoaned his lonely fate and

the loss of his child. In a letter to his son of July 1894, filled with guilt and self-pity, he apologized for the pain he had caused and accepted all responsibility. But he also blamed Anne for excessive attachment to her mother: "When my thoughts revert *to those two lone* figures, a great love and tenderness, an anxious yearning for at least one of these oppress my soul beyond the power of mere utterance, and then I feel I would readily give all I possess, and more if I had it, to cancel my transgression, and to look out for my boy and call him back again. I feel sorry, too, for Annie—pained, shocked, indignant with myself. Indeed it is only scant justice to her for me to admit *I was all to blame.* She did her best always and did well, but she made the mistake of cleaving to her mother rather than to me."[6]

Anne, wounded and embittered by his infidelity, refused to consider a reconciliation. George Lewis sent £100 a year to Anne; but she had financial difficulties and tried a number of small business ventures, including dress-making and a laundry. She refused to divorce her husband—perhaps for religious reasons—and to arrange a definite settlement, though he stopped sending her money when his remorse turned to bitterness and she was warned that she would get nothing if Charles died. When George suddenly died in 1897, a year after selling his business, Charles inherited about $40,000. But the will had been made before their separation, and Anne received nothing. Tillie, who had cut herself off from Charles, was still commiserating with Anne as late as 1904 when she said it was shameful that her wealthy brother forced his wife, who had been accustomed to comfort and leisure, to struggle for money. Anne lived precariously in genteel poverty, like one of Orwell's lower-upper-middle-class characters, with her mother and a loyal relative, Frances Prickett, who was called "Tomkins." She still had the family silver and china, and tried to maintain a standard above her means. Though she complained of poverty in letters to her son, she invariably responded to his rather relentless demands with sacrificial generosity.

Lewis attended the County School in Bedford and then the Castle School in Ealing from September 1894 to December 1896. In his last term he seemed to be well-behaved but not particularly studious. He was rated only fair to good in English, French, Latin, Bible, History and Mathematics; but his conduct was considered "Very good on the whole." He also wrote, illustrated and stitched together "Good Times," a thirty-page adventure story of shipwrecks and battles with savages. His father was well pleased with his drawings, and praised his son's remarkable talent and original designs.

Though Lewis was glad to receive compliments from his father, his relationship with his mother, "a very grand character," was far more important. They liked to go to Buzzards on Oxford Street for tea and

ice-cream; and spent a few weeks of every year in Paris, always visiting the Louvre and the Luxembourg. (While in France he kept a diary about the peasants, on a roll of toilet paper, and planned to make a book out of it.) Lewis ignored the paternal influence in his portrayal of the autobiographical hero of *Tarr*, published in 1918, and stated that he inherited all his characteristics "from his mother, except his height. That he seemed to have caused himself. . . . An enervating childhood of mollycoddling . . . has its advantages. He was an only child of a selfish vigorous little mother. The long foundation of delicate trustfulness and irresponsibility makes for a store of illusion to prolong youth and health beyond the usual term."[7] He replaced his father in his mother's emotional life; and he confided in her, respected her and relied on her. She concentrated all her love on him, after the loss of her first child and her husband, and they always remained extremely close. Lewis' arrogant self-confidence suggests that he exemplified Freud's belief: "A man who has been the indisputable favourite of his mother keeps for life the feeling of a conqueror."

Lewis scarcely ever saw his father after 1900, when Charles left England for Toronto and Portland, Maine. But Charles wanted Lewis to follow in his gentlemanly tradition and paid his school fees at Rugby —the last substantial sum he ever gave to his family. Lewis admired but resented his absent father, was angered by his mother's sudden hardship and was forced to make a permanent adjustment to poverty. Though "the swaggering he-man" could not obtain a divorce, he contracted a bigamous marriage and had a son and daughter before 1911. Charles' will of that year left Lewis the lease of a house on Curzon Road in Southport. In his last years he became a silent, solitary, lonely and unhappy man, "eccentric almost to the point of madness." Lewis' father provided an example of reckless adventures with women that he would often imitate and easily surpass.[8] Lewis began to live with his future wife, who was called Anne and was also nearly twenty years younger than he, just after his mother died; and she was as loyal and devoted to him as his mother had been.

2

In *Self Condemned*, written more than fifty years after Lewis entered Rugby, he described the Library Tower, the line of pseudo-Gothic school buildings which had more solidity than grace, and the headmaster's quarters which once housed the stern Dr. Arnold. He then offered a rather gloomy portrait of the place: "Rugby is a dull town, with none of the distinction that might be expected as a background for the ancient school. In the days of Tom Brown, yes: the approaches

to the gaping gate, leading into the School House quadrangle, would still have possessed some style. But long ago the industrialism of the Midlands had converted everything into a drab uniformity."[9] He also criticized the social snobbery (the bane of the Arnold system) which must have wounded the poor, *déclassé* adolescent.

The headmaster in Lewis' time was H. A. James, an uninspiring teacher and preacher; and one of the tutors was the father of Rupert Brooke, who entered the school four years after Lewis, in 1901. The emphasis was on sport, especially Rugby football, which had been invented at the school after a freakish breach of traditional rules, and on winning scholarships to Oxford and Cambridge—neither of which interested Lewis.[10] The day began at 5:45 with a cold bath and a short lesson before a breakfast of vile porridge, bad tea and hunks of buttered bread with dried haddock. Supper was made up of stale crusts, cold meat and miserable tea. Two-thirds of the six hundred boys were on the Classical Side and worked eleven hours a day. Lewis' contemporaries included R. H. Tawney, William Temple (the future Archbishop of Canterbury) and Arthur Ransome, who was a particular friend of Lewis and later became a well-known author and illustrator of children's books.

Lewis entered Stallard House (newly founded in 1893 and now called Tudor House) in January 1897 and left two years later in December 1898. The house was a large red-brick Victorian building, with housemaster's lodgings, dorms, commons and tiny studies for the boys. Lewis began in the 2nd Lower Middle Form and progressed to the Middle School, where he was placed on the Modern Side. He did not stand out in house or school games (he once invited his mother to watch him lose the hundred yard dash), nor participate in the Debating Society or the newspaper: he was distinguished by his invisibility.[11] The only significant event he ever recorded was a lecture by the Norwegian explorer Nansen about his recent expedition to the North Pole.

Later in life Lewis sometimes talked about his grotesque adventures at Rugby. He disapproved of the house tart and the boy expelled for stealing; disliked the numerous regulations to delineate seniority of students and the practice of fagging. When a prefect would shout for a fag, all the little boys would rush to answer the call and the last to arrive would be assigned a trivial task. Lewis satirized this servile system in the sycophantic relationship of Pulley and Satters in *The Childermass*. In a letter to his mother Lewis mentioned that one unfortunate boy got a rare "sixth licking"—stripes from every sixth-former in the house. And he proudly told Marshall McLuhan that he was the first Rugby man to receive six beatings by a prefect in one day. When he had received his fifth licking and was close to breaking the

record, he bashed a tennis ball against the prefect's door until he was accorded the distinction of a sixth lashing.

Lewis' academic performance, like that of so many brilliant men, gave no indication of his later intellectual distinction: he finished at the very bottom of the class of twenty-six. His two determined attempts to transfer to the army class were repulsed, and though he claimed to have been "turned out of school" for remaining in the same form for four successive terms, he was in fact promoted to the Middle School. But his evaluation for the Michaelmas term of 1898 was, as the headmaster angrily noted, "as bad a report as can be imagined." He was generally lazy and very unpunctual, not really at his best in English, weak and idle in Latin and French, poor in Mathematics, sluggish in Physics and very slow in Chemistry. His tutor, Mr. Waterfield, euphemistically remarked that he was "very variable in preparation; sometimes works well, but often falls short of being really industrious"; his housemaster more bluntly asserted that he was thoroughly idle (underlined twice); and the headmaster threatened that "he must work or go." He went. His lethargic school report was a striking contrast to the demonic energy of his maturity.

In *Tarr*, Lewis wrote that "all english training is a system of *deadening feeling*, a stoic prescription."[12] And in his unpublished vita of 1949 he took the abysmal teaching and cruel whippings of Rugby rather philosophically: "I am unable to say I had a disagreeable time. . . . Scarcely did I learn how to spell, certainly. Masters noticing this, and pretending it was my fault, took advantage of the fact to beat me unmercifully. They gave me a note to hand to my Housemaster. When he read it he beat me too. But I understood it was their fun, and being quite healthy didn't mind." Though this insight and feeling of persecution were characteristic of Lewis, the passive acceptance of his unhappy fate was unusual. It would seem that Lewis, with neither money, sporting ability nor academic motivation, rejected the conventional education at Rugby, deliberately decided to become a conspicuous failure and was extremist right from the start. He could not succeed in the traditional fashion, for his teachers took scant interest in his artistic talent, so he chose the "do-nothing mode." He acquired an upper-class accent and was proud to have been at a famous public school, which certified (in lieu of a university) his proper social and educational background. But Rugby influenced Lewis only in a negative way by giving him a set of values to rebel against: philistinism, conformity, snobbery, academic ambition and the conventional goals of Oxford and Cambridge.

Lewis' future direction was determined by a single talent well employed. "Nobody bothered me," he told a friend. "Most of the day I stayed in my study painting." When he set up an easel and copied the

head of a large dog, an older boy called him a frightful artist; but his housemaster arranged for drawing lessons with an old Scot and properly concluded that he belonged in an art school. Toward the end of his life, when Lewis had achieved fame as a painter, a fellow student re-membered "how odd he thought it was that Lewis was leaving Rugby to go to a place called the Slade, which he had never heard of."

3

The school was named after Felix Slade, a wealthy patron of the arts, who died in 1868 and left money to create professorships of art at the University of London, Oxford and Cambridge. The Slade School in London became part of the University College quadrangle, near Gower Street, and taught a succession of brilliant students, many of whom were later associated with Lewis: Harold Gilman, Spencer Gore, Edward Wadsworth, Christopher Nevinson, David Bomberg, Paul Nash and William Roberts. Lewis entered the Slade in 1898 and left in 1901. In 1899 he earned a Certificate in Figure Drawing (his earliest works, two confident drawings of male nudes, are still owned by the Slade) and the following year was awarded a Slade Scholarship, which had been won previously by Augustus John and William Orpen, and paid £35 per annum for two years.

The teaching staff at the time included Frederick Brown, who had succeeded Alphonse Legros as Professor of Fine Art in 1892, Henry Tonks and Wilson Steer. Brown was a rather grim, grey-haired figure with a jutting jaw, who always wore a black frock coat. Brown's assistant, Henry Tonks, a tall gaunt man, had abandoned medicine for art and possessed an expert knowledge of anatomy. His natural goodness was hidden under a forbidding mask, and his fierce expression and sharp tongue sometimes reduced the female students to tears. Lewis liked to tell amusing stories about Tonks, who had a resonant name that sounded comic, who inspired no respect and who was blasted in *Blast*. Yet in *Blast 2* Lewis credited Tonks with directing his pupils to the inspiring art of the High Renaissance: "A peculiar enthusiastic and school-boy like individual of the name of Tonks told his students at the Slade School to go to the British Museum to copy Michael Angelo and Andrea. They all did. In their youthful conclaves they all became figures of the Renaissance: they read Vasari; they used immense quantities of red Italian chalk in pastiching the Italian masters of the Cinque Cento." Though the large and lethargic Wilson Steer was considered by the art establishment to be the successor to Turner and the best living English painter, Lewis categorized him as a tardy English impressionist with a tendency to imitate Constable. Lewis admitted that Steer knew more

than the others, but dismissed him as a strangely somnolent and ineffective teacher.

The Slade was limited by old-fashioned and austere art school traditions (it ruled that all shading had to be done at 45 degrees) and provided what Lewis considered to be uncraftsmanlike training in academic impressionism. The students began in the Antique Room, furnished with plaster casts of Classical and Renaissance sculpture, and were set to draw with a stick of charcoal. Men and women were separated when they moved into the life drawing class, and students were forbidden to speak to the models.

Hubert Wellington, a friend and fellow student, remembered Lewis being "surprisingly ignorant about art when he first appeared at the Slade; his favourite painter was a Victorian Academician who specialised in highland landscapes full of sheep grazing in the heather."[13] But this seems most unlikely in view of his mother's intelligent influence, his annual visits to the Paris museums and his temperamental iconoclasm which revolted against the sentimental and grandiose traditionalism inculcated at the Slade. Lewis told McLuhan (with some exaggeration) that he avoided the studios as much as possible and spent his time down in the boiler room on the pretext of drying his canvasses. When he was sent to the Print Room of the British Museum to study the *cinquecento* drawings of Raphael and Michelangelo, he was intensely attracted to the glass cases filled with more savage symbols from Easter Island, the South Pacific and Africa. He wanted to discover how to incorporate the energy of archaic sculpture into his own work and to fuse the creative achievement of primitive and European art—as Picasso was doing in Paris.

Augustus John was already a legend at the Slade—for his drinking, womanizing and quest for the gypsy way of life—and his works on the walls commemorated his powers and bore witness to the triumphs of this young "Michelangelo." "One day the door of the life-class opened and a tall bearded figure, with an enormous black Paris hat, large gold ear-rings decorating his ears, with a carriage of the utmost arrogance, strode in and the whisper 'John' went round the class."[14] It was the beginning of a lifelong rivalry and friendship in which Lewis proved to have the greater talent and John the greater success. The flamboyant John had a significant influence on Lewis during his early years in bohemia.

Lewis, known as the best draughtsman at the Slade since Augustus John, was enthusiastically admired by his fellow students. One of them correctly predicted: "Lewis will one day burst on the world like a cataclysm." While at the Slade Lewis came into conflict with the establishment. As Gore told Wellington: "So bitterly do the authorities at the Slade dislike Lewis that anyone going in for a prize or Scholarship

is apparently first questioned and his former life examined to find out 'whether he is a friend of Lewis'. . . . They must have a very high opinion of him to consider him dangerous."[15] At both Rugby and the Slade, Lewis disliked the authorities, felt the teaching was poor and the traditions stifling. But he was passionately interested in art; and the discipline, direction and insistence on the importance of drawing had a beneficial influence. The students, if not the staff, were lively and stimulating, and respected his poems and his paintings. In contrast to his apathetic performance at Rugby, Lewis matured and began to reveal his genius at the Slade.

While at the Slade Lewis, who had a studio on Charlotte Street in Fitzrovia, began to write pessimistic Shakespearean sonnets and was introduced to Will Rothenstein, who admired the poems. In his memoirs Rothenstein, who did two pencil portraits of Lewis, recalled Lewis' striking looks and already formidable personality as well as his characteristic secrecy: "The imaginative and romantic side of his nature he put into his poems and into his daily life. He liked to shroud himself in mystery. After hiding for weeks he would suddenly reappear, having been, he would declare, in Sweden, or in some remote country; and he would hint at a conquest. . . . I was never sure whether, indeed, he had ever left England."[16]

Lewis later wrote that there was no sign of Rothenstein's great wit and flashing intelligence in his sincere and rather fumbling paintings. But he praised Rothenstein as a born teacher and eager mentor: "To have his brains picked was what most delighted him. . . . He was one of the last people in England able to distinguish between what is authentic, and what is not, in the field of art. . . . He has proved an inspiring teacher—small and alert, he has moved among the young almost as one of them and has been able to impart to them all his tremendous knowledge."[17] Rothenstein, whose son John later became a friend of Lewis and organized the retrospective exhibition at the Tate, gave Lewis the sense that there was no barrier and no limit to what one can embark upon—a more important lesson than he ever learned at the Slade.

When Lewis left the Slade his father, who had gone back to America, volunteered to pay for his education at Cornell University and strongly urged him to return to his roots in New York. Though this offer guaranteed financial security for four years, it would have meant leaving his mother. Lewis also felt that America, whose promising painters were all studying on the Continent, had nothing to teach him about art. In 1901 he rejected this opportunity and made the crucial decision to be a European. He chose instead to proceed to the vaster alma maters of Madrid, Munich and Paris, which was then the cultural center of the world.

Bohemia and Augustus John,
1902–1908

> Everything suggests that he was not able to enter life
> in a normal and natural way, but was obliged to do so
> indirectly. This gives him a certain intensity, and may
> have been his principal asset.
>
> Lewis on George Meredith

Lewis' seven years of bohemian adventures on the Continent—a sharp break from his life in England—were a prolonged and leisurely self-development, a sustained imitation of his father's "do-nothing mode" during which the public school boy was polished by the sophisticated life of Europe. "Gradually the bad effects of English education wore off, or were deliberately discarded," Lewis later recalled. "Being with 'foreigners' all the time who never 'played the game,' I rapidly came to see that there was, in fact, no game at all."[1] In Europe he searched out kindred spirits, lived among unconventional artists and found a freer and less restrictive environment. He was never able to recapture this freedom and independence, this milieu that encouraged and respected the arts. Life in Europe made him see England in a new and more critical perspective. He never learned to play the game as the English understood it, and always remained an outsider in England. He could be brash and contentious, egotistical and arrogant. He was uneasy and abrasive with wealthy patrons and with the art establishment. He frequently borrowed money that he was unable to repay. He eagerly sought publicity and deliberately did things that were "not done."

His life of garrets and mistresses centered on Paris; and his half-dozen addresses there were all in Montparnasse, within walking distance of the junction of the boulevards Raspail and Montparnasse. But he also travelled a great deal, lived in Spain, Holland and Germany, and spent summers in Normandy and Brittany. There is no consistent record of Lewis' activities during these years before he became a notorious figure, and we see only brief glimpses of his shadowy trail.

Lewis, who felt he had been taught very little at the Slade and who

disliked German art, learned about painting mainly in Paris, Haarlem and Madrid. In the autumn of 1902 he went to Spain with Spencer Gore, a close friend at the Slade, who was four years older than Lewis. Gore had also gone to a good public school (Harrow), and had a wealthy father who abandoned his family and left them in straitened circumstances. Gore later provided a *poste restante* address to which Lewis' money could be sent; and his pet tortoise once ate Lewis' boot-laces when he and Gore became absorbed in a discussion of art. Gore was associated with Lewis in several artistic ventures. He helped to decorate Frida Strindberg's nightclub, the Cave of the Golden Calf, was a member of the Camden Town Group and joined Lewis in his quarrel with Roger Fry's Omega Workshops. Gore had established his reputation before he died of pneumonia, after a three-day illness in 1914. "Had he lived," Lewis wrote in an affectionate memoir in *Blast*, "his dogged almost romantic industry, his passion for the delicate objects set in the London atmosphere around him, his grey [pessimistic] conception of the artist's life, his gentleness and fineness, would have matured into an abundant personal art."[2]

The two young men went to Spain—rather than to Italy, the traditional pilgrimage of art students—to copy Goya, El Greco and Velázquez in the Prado. Lewis was attracted to the savagely satirical vision of Goya, who was not fashionable at that time, from the very beginning of his career. In the Foreword to his postwar exhibition, *Guns*, Lewis praised "Goya's *Desastres de la Guerra*, a series of etchings done in his old age, an alternately sneering, blazing, always furious satire directed against Fate, against the French, against every folly that culminates in this jagged horror."[3] Velázquez's *Surrender at Breda* inspired one of Lewis' greatest paintings, *The Surrender of Barcelona* (1936).

The two friends lived with a Mrs. Briggs at 92 Calle Mayor Tercero, rented a studio for about nine shillings a week, tried to warm it with a coke stove and carpet, and found a few willing models. But it was grey, rainy and bitterly cold during the winter on the high plateau of the capital. They did virtually no work, and distracted themselves by watching funerals pass by under their windows. They were intrigued when some priests at the pension discoursed learnedly about the local brothels and, without being asked, recommended their favorite *bordel* as the cleanest.

In 1903 Lewis moved to the house of Madame Picnot at 41 rue Denfert Rochereau in Paris and later lived at 90 rue d'Assas. To the young Lewis Paris seemed expansive and civilized, temperate in climate, beautiful and free. It was the city that inspired Symbolism, Art Nouveau, the Fauves, the Cubists and the Surrealists: of Rodin, Henri Rousseau, Matisse, Picasso, Braque and Derain, of Debussy, Diaghilev and Sarah Bernhardt, of D'Annunzio, Gide, Proust and Gertrude Stein, and of

hundreds of young artists who gathered in the lively and hospitable cafés: the Dôme, Select and Rotonde. Lewis portrayed the substratum of this stimulating *belle époque* world in his first novel, *Tarr*.

The eponymous hero of *Tarr* (a near anagram of "art" and "rat") is an English painter. Like Lewis he is tall and thin, with "dark skin and a steady, unamiable, impatient expression. He was clean-shaven with a shallow square jaw and straight thick mouth. His hands were square and usually hot," and he wore a defensive "grimacing tumultuous mask for the face he had to cover." Augustus John's early portraits of the young Lewis, with his intense expression, fine features and shock of black hair, reveal his transformation from a rather correct Englishman to an exotic bohemian. John's etching of 1903 depicted Lewis in a jacket, waistcoat and tie, with full lips and a clean-shaven, rather heavy-set face. John's oil painting of 1905—when Lewis had fully absorbed the influence of Spain and become the *caballero* with the cape and Cordoba hat—portrayed him with wide shoulders and large hands clasped in front of him, sternly seated and tilted slightly forward. His eyes are wide-spaced and deep-socketed, his jaw firmly set, and his pale face crossed by a drooping moustache and surrounded by long black hair that falls toward his somber black coat. In contrast to the gentle, pensive look of the youth in the etching, the strikingly handsome subject of the painting—who resembles his father and has the same defiant glance—is tense and taut, and stares out with a self-assured and decidedly arrogant expression.

Despite Lewis' remark about being with foreigners, most of his friends were English expatriates. He had met Kathleen Bruce, who later married the explorer Robert Scott, before she had gone to Paris to study sculpture; and in 1903 she found him a studio next to her own. He also met an American Fauvist painter Anne Estelle Rice, who helped him financially in the early 1920s; and he saw a good deal of Augustus John and his talented sister, Gwen. Lewis studied at the Académie Julian, which had been founded in 1860 by Rodolphe Julian, a former prizefighter and model, who knew nothing about painting. Like the Slade, it was segregated. It had a section for men, with nude models, in the Latin Quarter; and another for women, without nude models, just off the Champs Elysées. Will Rothenstein described the Académie as "a congeries of studios crowded with students, the walls thick with palette scrapings, hot, airless and extremely noisy."[4] Lewis installed himself in his studio and began a series of paintings and drawings of the Creation of the World. In 1904 he exhibited his first picture, *Study of a Girl's Head*, at the New English Art Club, which had been founded to oppose English academic painting but was now hostile to Post-Impressionism. Lewis did a great many drawings during his years in Europe, but lost or destroyed almost all of this work.

Lewis' movements can be traced through his unusually frank letters to his mother—who was lonely in England without him—about his three lifelong preoccupations: pursuit of sex, delicate health (including the state of his bowels) and lack of money. He sometimes wrote in French and signed off with a pun as "your devoted piccaninnie, Pierce-Eye the Lewis." This correspondence, extraordinary in the Edwardian era, reveals that Lewis maintained his close relationship with his mother. He addressed her as a contemporary and friend (and made the same sexual boasts to Augustus John, who responded with mockery); he bragged of his conquests and expected her to be proud of him. By telling his mother everything about his private life, he reassured her that his girlfriends were no serious threat to their own relationship. When the time came to break off his first serious liaison, his mother dealt the final blow.

Lewis portrayed his poverty in Tarr's penniless friend, Otto Kreisler, whose relations with his father are also formal and financial. Lewis lamented that one could do nothing in Paris without paying in advance; and gave Spencer Gore a hyperbolic account of his abysmal financial status: "Now for the whole length of the Avenue d'Orleans I am a disreputable byword, as one hardened in the subtlest forms of deception. . . . Each sweep of my barber's razor grates with a grim reproach,— I feel sure he uses an old razor, employed upon no other chin, desecrate to me. When I order my modest luncheon, the mournful tones of the garçon's voice echoed dismally in a gloomy kitchen beyond, sounds as though the food were paid for with bad money in advance, as though at least the waiter's tip, and this being at my mercy, were never worth the lifting from its place. I'm sure that my photograph is in every police register in Paris, with some epithet for fallen folks beneath."[5] One of the stories he told his mother, about an American friend, crippled by rheumatic fever, foreshadowed the nihilistic "Russian" extremism of *Tarr*: "I was going out to tea the other day, when I found him in the court of the hotel, flourishing a revolver and saying that if a certain individual so much as showed his nose again, he'd shoot him. I did all I could to pacify him, and even stayed with him an hour to this end, but all to no purpose.—The man arrived, was shot, and I was arrested."[6]

Lewis truly claimed that Paris was his university, and his wife later provided a résumé of his intellectual background: "During nearly ten years of his 'travels' he was studying at Julian's in Paris, at the Heymann Academy in Munich, visiting the Bauhaus on various occasions, studying in Museums in Spain, Germany, France and Holland; was in very close touch with the Apollinaire Group and their Associates, knew Modigliani, Derain, Gertrude Stein and friends, and many other artists as well as poets and writers, even Prince Kropotkin; attended Bergson's lectures at the Collège de France as well as other lectures."[7]

Lewis knew a bit of Russian and refers to Kropotkin in *Rude Assignment*. But he must have met Kropotkin in London—perhaps through Ford Madox Ford, who had connections with the Anarchists—for the prince lived in exile in England from 1886 until he returned to Russia in 1917. Lewis found Bergson an excellent lecturer in philosophy, dry and impersonal with a high collar and frock coat, though he attacked Bergson's theories in *Time and Western Man*. He also met Charles Maurras and members of the ultra-Right Action Française at the Closerie des Lilas; and was familiar with the work of contemporary French thinkers: Georges Sorel, Julien Benda, Charles Péguy and Remy de Gourmont.

The influence of Nietzsche and the Russian novelists was paramount during these early years in Paris and lasted until after the War. *The Joyful Wisdom* was one of Lewis' favorite books, and in his brief but extremely important Nietzschean manifesto, "The Code of a Herdsman" (1917), he asserted: "Above all this sad commerce with the herd, let something veritably remain 'un peu sur la montagne'. . . . The terrible processions beneath are not of our making, and are without our pity. Our sacred hill is a volcanic heaven. But the result of its violence is peace."

Paris was full of Russian students, anarchists and revolutionaries, who walked about together, stern and self-absorbed. Lewis went to Russian dances; immersed himself in the world of Dostoyevsky's *Poor Folk*; read Gogol, Turgenev, Tolstoy and Chekhov in French translations; and was pleased when Rebecca West noticed that Tarr had been influenced by the psychology of Stavrogin, the hero of Dostoyevsky's *The Possessed*. In February 1905 Lewis attended a conference where Anatole France was pleading for the release of Gorki from prison; and he adopted the fierce polemical style of the Russian intellectuals.

Though Lewis lived mainly in Paris, he also spent considerable time in other European cities to learn what he could about art, languages and women. He was briefly in London and in Hamburg in 1904; and in October he lived for a month in Haarlem, copying paintings in the Frans Hals Museum, which contains the great *Banquet of the Officers*, the portraits of the Civic Regents and of Nicolaes van der Meer and his wife. Lewis stayed with a Belgian family and learned more colloquial French than he did in Paris, by trifling with the daughter of the household. He told his mother, with his usual candor, that he had kissed the girl and fondled her breasts; and that his dalliance had led to con-spiratorial discussions of marriage within the family ("of course the furniture would go to her dear little Lesbie"). All this led to his hasty departure. A year later, in September 1905, he returned to Noordwijk, on the rough coast of Holland, and installed himself in the Villa Cato, a tall, oblong house that had a studio, bedroom and dining-room with

a magnificent view of the surging sea and the white bathing machines.

In February 1906 Lewis moved to Munich, which was then a charming and easy-going town, with a great musical tradition. Its gay squares and white-columned buildings, neo-classical monuments and Baroque churches, palaces and parks, were all surrounded by the snowy peaks of the Bavarian Alps. The young artists, who sat in cafés reading *Simplicissimus* or strolled about in flowing cravats, paid for their lodgings with color-sketches and filled the pit of the Kaimsaal and Schauspielhaus in the evenings. It was the city of Thomas Mann, Kandinsky and Richard Strauss. There were philosophy lectures to attend and books to study at the university, and paintings to see at the Pinakothek and the Academy. Lewis stayed for six months at the Pension Bellevue at Theresienstrasse 30 and rented a studio from a Turk at Amalienstrasse 85, both quite near the Englischer Garten. He was delighted to discover that Ibsen had inhabited a neighboring room for six weeks in the late 1880s. Lewis took German lessons from a young lady, and enrolled in an evening class at the Akademie Heymann, a private art school where his friend Edward Wadsworth also studied. Moritz Heymann, a Jewish artist who was born in Breslau and had come to Munich in 1902, offered classes in drawing and lithography. Lewis also celebrated the Carnival, a great event which lasted for weeks, at several fancy-dress balls. He assured Augustus John that if he came to Munich for Carnival, he would be able to dance with the crown princess.

Lewis had seen John's theatrical entrance at the Slade when John came down from teaching at Liverpool, and had been introduced to him by William Rothenstein in 1902. But their friendship really began on the coast of France and in Paris in 1906, when Lewis moved from 19 rue Mouton-Duvernet and took over Kathleen Bruce's studio near the Dingo bar at 22 rue Delambre. Lewis admired the princely John for both his amorous and artistic achievements. He was surrounded by his imposingly beautiful wife and mistresses, and a brood of squalid, cheeky children who called Lewis a "smutty booby." One of the children, Caspar (who later became an admiral), said the painters had an uneasy and volatile relationship, and recalled the confused "feeling of how a child should behave to a man who at one moment was a friend of his father and the next an object of distaste."[8] In a witty but rather envious letter to his mother in 1907, Lewis reported: "John is taking a studio in Montmartre, where he thinks of installing two women he has found in England: and I think John will end by building a city and being worshipped as sole man therein,—the deity of Masculinity. . . . Beneath John's roof is the highest average of procreation in France."[9]

By contrast, the successful and self-assured John, four years older but far more experienced than Lewis, was openly amused by his friend's "uncontrollable erections" and by his ineffectual attempts at seduction.

John, noting Lewis' attachment to his mother, condescendingly told Alick Schepeler, a typist friend at the *Illustrated London News*, who later became Lewis' mistress: "Lewis announced last night that he was *loved*! At last! It seems he had observed a demoiselle in a restaurant who whenever he regarded her sucked her cheeks in slightly and looked embarrassed. The glorious fact was patent then—l'amour! He means to follow this up like a bloodhound. In the meanwhile however he has gone to Rouen for a week to see his mother, which in my opinion is not good generalship."

When the friends moved in August 1906 to Ste. Honorine des Perthes, near Bayeux on the Normandy coast, John continued to ridicule—and also to exaggerate—Lewis' voyeurism, ludicrous costume and clumsy attempts to satisfy his lusty appetite. Though John's wife, Ida, thought Lewis a beautiful and nice young man who grew a beard, let off fireworks and made everyone cry with laughter, John reported: "He came back full of the beauties of sea-bathing—that is to say: he had been viewing the girls frolicking in the water from a prominent position on the beach. He assures me there were at least 10 exquisite young creatures with fat legs, and insists on my accompanying him tomorrow."[10] Lewis' memoir merely noted that Ste. Honorine was a depressing and unhealthy place where he wrote verse and slept in the sun.

The rivalry between the two men was intellectual and artistic as well as sexual. Though Lewis favored lemonade when he first met John, who was always a heavy drinker, they would tour the nightclubs together and drink at a café in the rue Dareau, whose sauerkraut had been highly recommended by Walter Sickert. John found Lewis' first-rate mind immensely stimulating and "absolutely indispensable" when he wanted to engage in conversation "about Shelley or somebody." But John, who was critical of Lewis' scurrilous sarcasm, gave a fascinating account of his malignity, quarrelsomeness, suspicion, his struggle for recognition and quest for power. "In the cosmopolitan world of Montparnasse," John later recalled in *Chiaroscuro*, "P. Wyndham Lewis played the part of an incarnate Loki, bearing the news and sowing discord with it. He conceived the world as an arena, where various insurrectionary forces struggled to outwit each other in the game of artistic power politics. Impatient of quietude, star-gazing or woolgathering, our new Machiavelli sought to ginger up his friends, or patients as they might be called, by a whisper here, a dark suggestion there."[11]

John had another disconcerting habit of suddenly turning against his friends, which provoked a long and strangely formal letter from the wounded Lewis. He warned that John's irritable moods and sharp tongue threatened their intimacy, and claimed that his former self, the

imaginary object of John's abuse, had now disappeared: "Latterly, although for the most part [you showed] a perfect friendliness towards me, I became extremely irritated by a certain manner you assumed from time to time. You permitted yourself often a license of temper that was not compatible with the sentiment which is at least natural to me in any close and friendly relationship that I may have with another man. . . . Your abuse cried after me is doubtless the prompting of that pitiful and delusive self that I have left behind: I leave you willingly this shadow as a bondman: may he die as soon as possible and be forgotten, in the ignominy that such deserve. He needs no epitaph."

John's frankness was a strong contrast to Lewis' instinctive secrecy; and in a typically rhetorical letter of June 1907, John answered Lewis' letter, complained that his honesty and openness had not been reciprocated, and maintained that Lewis did not really esteem him or value his intimate friendship:

I called you poltroon for not daring to let me know before in what contempt you held me—when I had admitted you—fondly—almost to my most secret places, for not honouring me so far as to be frank in this. I called you mesquin for jesting at my discomfiture, for playing with words over the stricken corpse of our friendship, ever sickly and now treacherously murdered at a blow from you, poor thing! And I called you bête for so estimating me as to treat me thus—cavalierly—for though my value as a friend has not proved great, it is neither nil nor negligible. And I say this from the very abysm of humility. Nor am I one to be dismissed with a comic wave of the hand. . . .

I am as little inquisitive by habit as secretive by nature. I have never wished to, I have never committed the indecency of trespassing on the privacy of your consciousness, of which you are rightly jealous. But in a *friendly* relationship I expect . . . an honest traffic—within its limits—a plainness of dealing, which is the politeness of friends. *That* we have never practised—you have never—it seems to me—given the [idea] of friendship a chance.[12]

John's criticism was valid, for Lewis found it very difficult to be on intimate terms with anyone. He saw his friends separately, rarely revealed anything about his past or personal life, kept his marriage secret for many years and liked to appear as a man of mystery. Lifelong friends like T. S. Eliot claimed they never really knew him. Since John had seen his youthful weaknesses and failures, Lewis was anxious to keep him at a distance, especially after he had equalled and then surpassed his friend's achievement.

But in 1907 Lewis admired John's patriarchal way of life and unconventional personality; copied John's large black Paris hat, adopted his romantic swagger and imitated his recklessness with women. But he was also extremely critical of John's indiscriminate lechery, his drunkenness, his boring cult of the gypsy, his squandered talent, his

crude desire for material and social success, and his intolerably patroniz-ing attitude—which must have sharpened his hostility to John and increased his desire to surpass him as an artist. Many of these criticisms were focussed in a letter to his mother of March 1907, in which he described John's rather callous reaction to the tragic and probably unnecessary death of his young wife, Ida, who had loved Lewis "as a brother": "Mrs. John died about 4 or 5 days ago, and on Saturday I was at her funeral; she was cremated, and buried at Père la Chaise, in Montmartre. John has been drunk for the last three days, so I can't tell you if he's glad or sorry: I think he's sorry, though. Miss McNeil has taken up her position in the vacant chair, in the vacant bed: the queen is dead, live the queen! Mrs. John had a baby and six days afterwards was dead,—of peritonitis and a heap of other things."[13]

Lewis intensely disliked Dorelia McNeill who inspired a numbre of fine paintings, and felt that "sickening bitch" had muzzled John's genius. Lewis believed that John was endowed with the highest creative gifts and "could have stood beside Rubens as an equal" if he had lived in the seventeenth century. He was so overwhelmed by the strength of John's naturally and fully-developed artistic personality that he was unable to paint in the summer of 1906 while living with John in Normandy. Yet only three years later he told Yeats that he now mourned for John, whose work was patently deteriorating and who was painting portraits for money (as Lewis himself was later forced to do). John returned the compliment in 1912 when he told Lewis he was unable to discover any merit in his recent abstract drawings. When John visited Lewis' rented country cottage and crudely molested the parson's young daughter who had come to the house on an errand, Lewis was furious and felt John's behavior revealed his radical decline.[14]

Though they judged each other harshly and stopped meeting regularly before the War (just as Lewis was establishing his reputation as the leader of the avant-garde in England), they were also enormously fond of each other and able to see the justice of their mutual criticism. With John, as with Pound and Eliot, Lewis' friendship survived numerous quarrels and recriminations, and lasted until the end of his life. When he returned to London in 1909 Lewis told John: "The consciousness of difficulties in the way of a continued relationship with you made me mortally nervous. I probably in little things supposed your opinions of me to be worse than they were, & by a well known perversity, may have been compelled to justify them, at least superficially. Whenever I have the pleasure of seeing you in future, when I feel myself going shy, I will spit & scowl." Lewis' irrational "Russian" behavior and the con-voluted expression of his letters suggest he was extremely uncomfortable with his overpowering rival. For Lewis, who felt he also had genius but had not yet been able to use it, was forced into an unnaturally inferior

position which made him anxious, touchy and aggressive. Yet he also admitted the salutary influence of John's strictures: "My weaknesses and vices are quite patent to me, and I live with them with alternate irritation and bonhomie. . . . I believe with a Calvinistic uncompromisingness that one cannot be too hard on the stupidities of one's neighbors; and I thank you quite unaffectedly for having knocked a good deal of nonsense out of [me], and am only sorry that I was not able (owing to my tender years and extravagant susceptibilities) to have rendered you a similar service."

Though Lewis did not realize it at the time, he could render a similar service. In *Blast 2* (1915), Lewis called John a great artist but found him lacking control and prematurely exhausted—"an institution—like Madame Tussaud's." He criticized John for becoming "a public lion practically on the spot" and for borrowing a Borrovian cult of stage-gypsies that shipwrecked his talents on a romantic reef; but he also paid homage to his considerable ability. This harsh but just evaluation provoked a violent response from John when they met in person, followed almost immediately by a decently contrite letter: "I must apologise for being so stupid yesterday. I must have been positively drunk to assume so ridiculously truculent an attitude upon such slender grounds. . . . Your thrusts at me in 'Blast' were salutary and well-deserved—as to the question of their exact justice—any stick will do to rouse a lazy horse or whore."[15]

The most significant event of these years was Lewis' first serious relationship with a woman—which also had its torturous Dostoyevskian elements, its syndrome of the insulted and injured, and which can be more clearly understood in the context of his friendship and sexual competition with John. In *Tarr* Lewis satirized his attractive and indulgent German mistress, Ida, as Tarr's official fiancée Bertha Lunken, whose name suggests birth as well as Big Bertha, the Kaiser's *Super-Kanon* that had fired on Lewis during the War. Bertha, who is raped by Tarr's friend Kreisler, is scornfully described in the novel as an attractive Teutonic animal: "a high-grade aryan bitch, in good condition, superbly made; the succulent, obedient, clear peasant. . . . Bertha's was the intellectually-fostered hellenic type of german handsomeness. . . . Bertha had been a heavy blond westphalian baby: her body now, a self-indulgent athlete's, was strung to heavy motherhood."[16] Though Tarr sleeps with the dull-witted, sensuous and slavish Bertha, he adores the Russian girl, Anastasya Vasek, "bespangled and accoutred like a Princess of the household of Peter the Great," who embodies his passionate attaction to Russia.

The affair with Ida lasted for about four years and seems to have been happy only at the beginning. In 1905 the proud but detached Lewis told his mother that he had been seduced by the uninhibited girl: "I

am engaged in a very extraordinary love affair; the German lady . . . to my unquenchable amazement asked me to kiss her, and threw herself into my arms and kissed me with unabated vigour for three hours." "Die Kleine" posed for him regularly; he was pleased by her practical assistance and artistic inspiration, and delighted that a sensual and attractive woman was willing to give herself to him. A mistress was the *sine qua non* of bohemian life and certainly enhanced his prestige with John.

But by February 1906 Lewis foresaw that their separation would be painful and hoped he would be able to forget the strongest and most unfortunate attachment he was ever likely to experience. John mentioned to a friend that Ida was with them in Normandy and insisted on visiting the gypsies when Lewis tried to leave her behind. During the following year Lewis restricted his visits to short and always disagreeable half-hours. "I suppose she's so nervous that she doesn't know what to do with herself," he explained to his attentive mother, "and that 'scenes,' quarrels, are the only means of letting off steam—nice for me, isn't it ?"[17]

In November 1908 Lewis' mother sent five guineas to Ida, who was expecting Lewis' baby the following month. When the infant was born, Lewis disowned it, left Ida and returned to England, establishing a pattern he would repeat with his later illegitimate children. He once told Kate Lechmere that he had accidentally dropped and killed Ida's baby;[18] and though this was probably not true, it did reflect his attitude toward the nameless child who, with its mother, soon disappeared without a trace. At the end of *Tarr* the hero marries Bertha to legitimize the child of his dead friend Kreisler; in actual life Lewis refused to marry Ida, though the child was his own.

Lewis' mother visited Ida in June 1909 and wrote him a long letter listing the various reasons why he should finally break with her: their constant fights, Ida's lack of tact, their difference of nationality and their lack of money. Though she adopted an unusually didactic tone, she remembered her own desertion by Charles Lewis. She was torn by loyalty to the girl who bore her son's child and by a strong desire to extricate him from a disastrous entanglement:

[Ida] also said she was very unhappy so I gathered that you had had an *extra violent* disagreement. I always thought that the association was unwise, even in the beginning, for you both. Personally I like Ida, and apart from you, shall always think her a good generous-minded girl; it is her misfortune to be very tactless, and as I have told you always it is very rare to find people of two nationalities able to live together amicably. National characteristics, however cosmopolitan one may feel oneself, are apt to assert themselves unpleasantly under the strain of daily and intimate companionship. I think had you or Ida had sufficient money to be very independent you would probably have continued on much better terms. As it is you have wasted

each other's time, strained your affection to its utmost limits, & have now parted, I am sure, in a very unbefitting manner. When I was eager for you to come to England last autumn, & stay here, I felt you & Ida were bound to part sooner or later, but you could not drag yourself away from her, as you know; you ought then to have had sufficient resolution to stay away. Although you feel weary of her now, very likely indeed by the autumn you will be wanting to follow her to Germany, if she does go there. Would it not, under all circumstances, have been much nicer and more politic to have said good bye amiably & have left her for your summer excursion leaving it vague & indefinite as to *when* and *where* to meet again.[19]

Lewis' older friend Sturge Moore put things more bluntly and reinforced his friend's fears. He warned Lewis not to sacrifice his talent for domestic discomfort and urged him to be more circumspect with any woman who used the "slop of sex" to trap him: "If [a man] puts his genius between her legs she will cover it with any petticoat that takes her fancy, and no one will see it again."[20]

Lewis left Paris during the summer months to travel and to get away from Ida. He was in Dieppe at the Hôtel Rocher during the summer of 1907; and in Spain, for the second time, from May to July 1908. He crossed the frontier at San Sebastian and felt Spain's "overflow of sombreness" as he travelled west through the cathedral city of León to Vigo, a great fishing port on the coast of Galicia, north of Portugal. The city's houses were tinted green and rose like a faded bouquet and its bay stretched between hills for many miles to the ocean. He lodged in Vigo on the Calle Real, in the pension of a landlady who looked like a dwarf by Velázquez. In one of his earliest essays, "A Spanish Household," published in the *Tramp* in June 1910, he described the servant, Flora, "a tall, lithe and handsome fisher-girl. Her eyebrows always raised in weary, affected fatalism, her mouth hanging in affected brutal listlessness, she was very fond of notice and had one of the best of hearts."[21] Lewis was attracted to Flora's leaden intensity of expression and she may have given him the first of several doses of venereal disease. When he wrote to John about his misadventure, his friend replied with a mixture of ironic amusement and paternal concern about the young lady's deception of Lewis: "I am distressed to hear of your persistent illness. . . . Fly and linger not if that young woman can really represent the manners of the Spanish fair sex. Effrontery indeed! Is this Spanish frankness?"[22]

On the way back to Paris Lewis met his mother and her friend Mrs. Castells, at Quimperlé, on the south coast of Brittany, which he had previously visited with the painter Henry Lamb. His encounter with a primitive society and "barbaric" environment inspired several important paintings and stories. "These fishermen went up to Iceland in quite small boats," he recalled, "they were much at home in the huge

and heaving Atlantic . . . their speech was still Celtic and they were highly distrustful of the stranger. They brawled about money over their fiery apple-juice: when somebody was stabbed, which was a not infrequent occurrence, they would not call in a doctor, but come to the small inn where I stayed, for a piece of ice."[23]

Lewis' first real paintings, like *Port de Mer*, were of fishermen and fishwives in the Norman and Breton ports. He experimented with expressionist and cubist styles and then attempted to develop "a visual language as abstract as music." Art and literature had a complementary and harmonious co-existence in Lewis, who distilled the pictorial and literary essence into two distinct and efficient modes of creation. He gave an interesting account of his original inspiration and impetus in his essay, "Beginnings": "It was the sun, a Breton instead of a British, that brought forth my first short story—*The Ankou*. . . . I was painting a blind Armorican beggar. The 'short story' was the crystallization *of what I had to keep out of my consciousness while painting*. Otherwise the painting would have been a bad painting. That is how I began to write in earnest. A lot of discarded matter collected there, as I was painting or drawing, in the back of my mind—in the back of my consciousness. As I squeezed out *everything* that smacked of literature from my vision of the beggar, it collected at the back of my mind. It imposed itself upon me as a complementary creation. . . . There has been no mixing of the *genres*. The waste product of every painting, when it is a painter's painting, makes the most highly selective and ideal material for the pure writer."[24]

Lewis was powerfully attracted to the violent energy of these people, and in "Les Saltimbanques" likened them to "corrosive lavas that illuminate before they destroy the object in their path." This description of a circus troupe in Quimperlé, who symbolize the neglected artist, was probably influenced by Picasso's "blue period" paintings of elongated acrobats on a deserted beach. His sketch appeared in the *English Review* in 1909 in the distinguished company of De La Mare, Norman Douglas and Henry James. A more important work, "Some Innkeepers and Bestre," was also published in the *English Review* with works by Conrad, Tomlinson and Pound; and like "Les Saltimbanques," it was later revised and collected in *The Wild Body* (1927). This story illuminates the character of provincial innkeepers through the example of the highly contentious Bestre of Karmanec, who clearly expresses the hostility and aggression which would later make Lewis feared in the art world of England: "Bestre's great principle, however, is that of provocation: to irritate his enemy. . . . As to the *raison d'être* of these campaigns at all, of his pugnacity, I think this is merely his degeneracy—the inevitable caricature of a warlike original"[25]—his Spanish ancestor.

Lewis' own warlike original, Charles Lewis, gave no sign of returning

to England and every indication that he would stop sending infrequent remittances to his ne'er-do-well twenty-six-year-old son. When his "Parent over the Water" failed to respond to his endless requests for funds, Lewis realized his student days were over. In December 1908, the month his first child was born, he made plans to return to London with three peculiar companions and told Sturge Moore: "I am bringing some spaniards over with me; one to buy six suits of clothes,—another to have his pimples cured,—and a third is coming because he dare not let the man with the pimples out of his sight, as he is his only means of support."26

At the very end of his life Lewis began a novel about a young artist, "Twentieth Century Palette," which combined autobiography and wish-fulfillment—his real and ideal life. The hero, Evelyn Purchass, a student at Marlborough (Rugby), shows a talent for painting and is sent to a London art school (the Slade) where he completes his education. He is "a man who [never] did anything very much, except sleep with his models, and squeeze pigment out of fat tubes," but he develops into the kind of artist Lewis would have liked to be—free from financial worries: "he is able economically to develop his talent without the usual money obstructions."27 But Lewis, unlike his fortunate hero, was plagued by money problems throughout his entire career.

Despite his apparent idleness, the bohemian years had a profound influence on Lewis. They taught him to be independent and to live in poverty; stimulated his taste for good food and wine; established the pattern of frequent travel and change of address; enabled him to learn French, Spanish and German; allowed leisure time for extensive reading in philosophy and literature; encouraged a Continental rather than an insular outlook; provided serious training in art schools, studios and museums; put him in close touch with Cubism and other movements of modern art; strengthened his nourishing friendship with Augustus John; led to his first ecstatic but threatening relationship with Ida, and a number of other "art tarts," which created his lifelong conflict between attraction and hostility to women; and inspired his first Breton paintings and idiosyncratic stories. He returned to London thoroughly prepared to release the torrent of creative work that would transform the art and literature of England.

CHAPTER THREE

Ford and Pound,
1909–1912

I

Though Lewis could be aloof, defensive and hostile—as John had suggested—he possessed a rare talent for friendship and could also be warm, responsive and charming. He was an immensely attractive man to both men and women, and when he returned to London he inspired the friendship of older writers like Thomas Sturge Moore and Ford Madox Ford (then called Hueffer), contemporaries like Ezra Pound and younger women like Rebecca West.

Lewis had first met the golden-bearded Sturge Moore, the poet, artist and elder brother of the Cambridge philosopher G. E. Moore, at the Vienna Café near the British Museum in about 1902, and had corresponded with him while living abroad. But their friendship really developed when Lewis came back to England in December 1908; they felt an instinctive sympathy with each other and seemed to hit it off immediately. Moore's son recalls that he went with his father to visit Lewis' flat in 1910 and "was struck by a vividly-coloured wall painting above the door. It was in a futuristic style."[1] Moore and his lively French wife, Marie, who also liked Lewis and felt rather motherly toward him, often invited him to dine at their home (Constable's old house) at 40 Well Walk, Hampstead; they also lent him money and offered to pay for the typing of *Tarr*. In 1911 Moore dedicated *A Sicilian Idyll and Judith* "Affectionately to P. Wyndham Lewis"; and Lewis sent Moore most of his books, beginning with *Tarr* in 1918. Lewis' presentation copies of *Time and Western Man* and *The Lion and the Fox*, with respectful inscriptions to Moore, were received with great enthusiasm. In *One-Way Song* (1933), which he inscribed "To Sturge Moore, from his great friend and great admirer, Wyndham Lewis," he punned on Moore's name, alluded to his poems on classical and biblical themes, and praised:

> Moore, the sturgeon of the Hampstead Hill,
> Nations of Greeks and Hebrews drives at will
> Across a gothic landscape.

26

Moore read Lewis' early works in manuscript and praised his poetry, for at the start of his career Lewis wrote a five-act play in blank verse, "Grignolles," a description of a Breton village, and about forty sonnets, including "The Birth of Sound," an apostrophe to Doubt, and a poem in praise of self-trust and daring enterprise:

> Some in the van of Enterprise have placed
> The quaking legions of their doubts and fears,
> Lest they, too rash, in their best hope disgraced,
> Should lend example to their panic-rears.
>
> And seldom in man's battailous front is seen
> The person of commanding Faith to tower,—
> The provocation of assured mien
> Was ever yet the careless front of power.
>
> And base men face their fate with many foils,
> And dark unseason'd hopes never declare,
> To untried faiths they mete imagin'd spoils,
> More rich in fancy than in fact they dare:
>
> Such men ne'er trust,—seeing they live this lie
> To plume themselves on faiths they dare not fly.[2]

Moore, a close friend of Yeats, responded to this Shakespearean pastiche with an exaggerated generosity that reflected his admiration for Lewis' personality and intelligence: "Of all the poetry which I have read by my contemporaries, those who are alive now, it is these sonnets which gave me the most sense of a new possibility, a new creation, and consequently there is no writer alive whom I desire to accompany and communicate with [more than you]."[3]

Lewis was very fond of Moore, trusted his taste and appreciated his serious interest in *Tarr*; and he was grateful for his friendship, encouragement, criticism and conversation. In one of his last letters to Moore, three years before his friend's death in 1944, Lewis remembered the tea-shop he had visited with his mother and the first, tranquil meetings before their stable world had been destroyed: "How calm those days were before the epoch of wars and social revolution when you used to sit on one side of your work-table and I on the other, and we would talk . . . and you used to grunt with a philosophical despondence I greatly enjoyed. It was the last days of the Victorian world of artificial peacefulness—of the R.S.P.C.A. and London Bobbies, of 'slumming' and Buzzards cakes."[4]

Ford Madox Ford, a tall thin man with fair hair, gaping mouth and ragged lemon moustache, transformed his first encounter with Lewis, during these balmy prewar days, into the dramatic discovery of a genius who resembled a Russian anarchist. Though his story is apocryphal, it is certainly amusing: "Lewis, tall, swarthy and with romantically disordered hair, wearing a long black coat buttoned up to his chin, arrived

at Number 84 [Holland Park Avenue] with the MS of a character sketch called 'The Pole.' " He entered the side door, walked up two dark flights of steps above a fishmonger's shop, knocked on the door, entered the bathroom and found Ford, like a pink egg, soaping himself in the tub. "Disregarding any unconventionality in his surroundings, the 'Enemy' at once proceeded to business. After announcing in the most matter-of-fact way that he was a man of genius and that he had a manuscript for publication, he asked if he might read it. 'Go ahead,' Ford murmured, continuing to use his sponge. Lewis then unbuttoned his coat, produced 'The Pole' and read it through. At the end Ford observed, 'Well, that's all right. If you'll leave it behind, we'll certainly print it.' " Goldring, who records this story, heard it from Ford that same night. Lewis, who was not quite so brash, said that he did climb the stairs but quietly left the packet of stories: "Some weeks later when I went to enquire about the manuscript they gave me a copy of the proofs of the first story, which they had corrected and returned to the printer, as they did not know where I lived."[5]

"The Pole," Lewis' first work, was appropriately published by Ford, Conrad's friend and collaborator, in the May 1909 issue of the *English Review*. It appeared with reminiscences by Conrad, a story by Norman Douglas, a tale by W. H. Hudson and a poem by Sturge Moore—who had probably sent Lewis to Ford. Lewis' sketch, based on his previous summer in Brittany, concerns a type of impoverished foreign artist who lives in seaside boarding houses on his landlady's charity. Lewis was well-paid and received five guineas for each of his three stories in the *English Review*; but when one check was delayed Lewis, who had a short fuse and often resented people who helped him, called Ford "a shit of the most dreary and uninteresting type."

The vitality of "The Pole" made a strong impression on Lytton Strachey, who was distressed by its lack of sensibility and refinement. His mannered criticism, with its unwarranted inference about Lewis' character, foreshadowed the inevitable confrontation between Bloomsbury's refined taste and Lewis' violent mode of expression. Though Strachey recognized his strengths, he was horrified by them and mocked Lewis: "It was cleverly done. I could no more have written it than flown—fiendish observation and very original ideas. Yet the whole thing was most disagreeable, the subtlety was curiously crude, and the tone all through more mesquin than can be described. . . . Ugh! the total effect was affreux. Living in the company of such a person would certainly have a deleterious influence on one's moral being. All the same I should like to see more of his work—though not his paintings."[6]

While Lewis was publishing his *Wild Body* stories in the *English Review*, in Douglas Goldring's short-lived travel magazine, the *Tramp*, and in Orage's *New Age* in 1909–1910, he lived first at 4 High Street,

Ealing, with his mother—who gave him an allowance until the beginning of the War—and then on his own at 14B Whiteheads Grove, Chelsea, before moving to more familiar haunts on Fitzroy Street and Percy Street, near the British Museum. During this time Lewis completed a pot-boiler, *Khan and Company*, which was supposed to provide money to live on while he was working on *Tarr*. The novel was read and revised by his mother and submttied to J. B. Pinker; but when the literary agent was unable to place the book, Lewis realized the futility of trying to write a popular success. The work was not published until 1978, when it appeared as *Mrs. Dukes' Million*.

Ford and his companion, Violet Hunt, also commissioned Lewis to do an abstract panel for the study of South Lodge, a squarish Victorian mansion on the top of Notting Hill at 80 Campden Hill Road, which was imbued with the spirit of the Pre-Raphaelites. Rebecca West described the strident red painting, completed in November 1914, as "a huge abstract work over the fireplace, very violent and explosive, and I remember Ford saying in his quizzical way that he 'found it extremely restful.' "[7]

Ford lectured, in a tailcoat, at Lewis' Rebel Art Centre (established in opposition to Roger Fry) in the spring of 1914 and published the opening section of *The Good Soldier* in the first number of *Blast*. Lewis designed the cover of Ford's war poem *Antwerp* (1915) and dragged Ford around to conspiracies, nightclubs and lectures, where Marinetti made noises like a machine-gun. But he considered Ford's technical experimenst, literary Impressionism and Jamesian self-effacement hopelessly *passé* in the more egoistic, theatrical and hedonistic age of Cubism, Futurism and Vorticism. Ford, who was intrigued by Lewis' megalomania, listened good-humoredly to his vitriolic attack on the concept of the artist as passive observer and had to concede he was perfectly right. The iconoclastic *Blast* had toppled the old literary idols and he told Ford: "You and Mr. Conrad and Mr. James and all those old fellows are done. . . . Exploded! . . . *Fichus!* . . . *Vieux jeu!* . . . No good! . . . Finished! . . . Verisimilitude—that's what you want to get with all your wheezy efforts. . . . But that isn't what people want. They don't want vicarious experience; they don't want to be educated. They want to be amused. . . . By brilliant fellows like me. Letting off brilliant fireworks. Performing like dogs on tight ropes. Something to give them the idea they're at a performance. You fellows try to efface yourselves; to make people think there isn't any author and that they're living in the affairs you . . . adumbrate, isn't that your word? . . . What balls! What rot! . . . What's the good of being an author if you don't get any fun out of it; . . . Efface yourself! . . . Bilge!"[8] When Ford died in 1939, Lewis (who never appreciated the greatness of *Parade's End*) told Pound he was not a "Fordie-fan" and had never been able to read more than a few lines of his fiction.

Lewis (who had studied at the Heymann Academy of Art in Munich) appears as George Heimann in Ford's first postwar novel, *The Marsden Case* (1923), which deals with London bohemians and aristocrats just before and during the Great War. This minor novel begins in July 1914, the month after *Blast* was first published, as Heimann, a handsome young man with a romantic appearance and violent temper, has a bitter dispute with the unscrupulous publisher, Mr. Podd, about payment for his translation of a German poem: *The Titanic: An Epic*. Podd's insinuations about Heimann's obscure origins (he is actually the secret son of an earl) recall Lewis' image—when he first met Ford—as a mystery man without a past. And Ford's description of Heimann reflects the Spanish *persona* (later perfected by Robert Graves) that Lewis adopted when he returned to London after seven years on the Continent: "[He was] a young man with a face, by contrast, alabaster white and aquiline; intent under a slouch hat. . . . [His] accent was faultless, his voice a noticeable, deep organ. I gathered that the foreignness of his aspect, his high-crowned hat, his coat, black and buttoned-up round his neck, like a uniform—always a startling effect, his immense black Inverness cloak, his young beard and his long black hair drooping over his ears, all these things were the products of a sojourn in Bohemia, not of foreign birth."

The lecture that the narrator, Ernest Jessop, gives at the Ladies' Club in chapter 5 recalls the ludicrous *dénouement* of the lecture Ford gave at Lewis' Rebel Art Centre in 1914. Lewis' patron and colleague, Kate Lechmere, described how "The event nearly ended in disaster, for this dignified literary figure had his efforts rewarded half-way through the talk by a sharp blow from one of Lewis' largest paintings: it had been hanging on the wall behind Ford and suddenly pitched forward on top of him. Luckily, however, no harm was done . . . since the frame broke loose from the picture and crashed to the floor, leaving the canvas perched harmlessly on Ford's head."[9]

The Night Club in the novel is clearly based on Frida Strindberg's Cave of the Golden Calf, which Osbert Sitwell said was "hideously but relevantly frescoed" by Lewis in his prewar Vorticist style. "I just dimly had a vision of the lighted stage of the Night Club," Ford writes in the novel, alluding to Heimann's translation of *The Titanic*, "in a cavern, at an immense distance, with the negro-coon orchestra and, on the boards, a representation of a liner sinking. . . . The walls were decorated with paintings of menlike objects that had the faces of enlarged ants and blue, reticulated limbs like rolled paper cylinders. . . . On the walls the slate-green men with the cylindrical dirty blue limbs ministered to each other in scarlet landscapes."[10]

Though Heimann's appearance, milieu and paintings resemble Lewis', the complex but static plot has no real concern with his life.

Heimann's character is actually an aspect of Ford's, and the events of *The Marsden Case* are based on Ford's laceration by women, escape to German spas, military experience and shell-shock—which were rendered much more successfully in *Parade's End*.

During dinner with Ford and Violet Hunt at South Lodge in 1912, Lewis first met Rebecca West, a dark young maenad who burst into the dining-room like a thunderbolt. She admired Lewis and found him a charming man, extremely good-looking and well-mannered. When she suggested Lewis become a bishop because he would look well in clerical black, he alluded to the king-maker in *Barchester Towers* and wittily replied: "Then you must be my Mrs. Proudie." She introduced him to H. G. Wells and he took her out to dinner several times, but she never got to know him because he never conversed with her on these occasions. She did not understand the reason for his mysterious silence—which Ford thought was a positive rather than a negative quality in Lewis—but naturally felt awkward with the magnificent loner and began to refuse his invitations.

Lewis admired West's articles in the *New Freewoman* and invited her to contribute to the first number of *Blast*. She wrote unusually perceptive critiques of *Tarr* and *Paleface*, and Lewis called her the best reviewer in contemporary England. In 1932 she sat for Lewis in his studio on Percy Street, opposite the Tour Eiffel Restaurant; and her striking portrait, with distorted features and strained expression, revealed a troubled intelligence. West seems to have imposed a silence on Lewis, who never spoke while drawing her. He also portrayed her in *The Roaring Queen* (1936) as Stella Salt, an attractive, aggressive, fire-eating feminist who attacks the pompous Samuel Shodbutt (Arnold Bennett): "Stella was a big old girl, very determined looking, with an easy platform-manner and a beefy swing of the arm. She was a somewhat greying golden blonde, with an amusing feline face, who in her time had hungerstruck with the best and trumpeted the slogans of democratic revolt and red feminine revolution. Born not so very far away from where Shodbutt had seen the light, her blood possessed the same black-country aggressiveness and grim grit. The thick amber rims of her spectacles enclosed two darkling eyes, and her mouth now took on a flower-like curl for the discharging of a taunt."[11]

Lewis' most important and (after John) his most enduring friendship was with Ezra Pound, who had come to London in 1908 and had already brought out several volumes of poetry. Lewis said he became acquainted with Pound through Ford, who had discovered and published both of them in the *English Review*. The two men first met in the Vienna Café, on the second floor above the corner of New Oxford Street and Bloomsbury Street, which was furnished in the Danubian mode with red plush chairs and seats. It was a favourite rendezvous for European *émigrés* and

for writers associated with the British Museum: Sturge Moore, R. A.
Streatfield and Laurence Binyon, who had met Lewis in the Print
Room, where he was Assistant Keeper. Binyon took Pound to the Vienna
and introduced him to Lewis, who was with Sturge Moore. In Canto 80
Pound fondly recalled his first meeting with Lewis and noted that when
the Austrian owner, Josef, was forced to close the Vienna after the War
broke out and the waiters were interned, the Café was transformed into
a bank:

> Mr Lewis had been to Spain
> Mr Binyon's young prodigies
> pronounced the word: Penthesilea
> There were mysterious figures
> that emerged from recondite recesses
> and ate at the WIENER CAFÉ
> which died into banking, Josefff may have followed
> his emperor. . . .
> So it is to Mr Binyon that I owe, initially,
> Mr Lewis, Mr P. Wyndham Lewis. His bull-dog, me
> as it were against old Sturge M's bull-dog.

According to Lewis, Pound approached the group of Englishmen as
one might a panther—"tense and wary, without speaking or smiling:
showing one is not afraid of it, inwardly awaiting hostile action."
Pound was "an uncomfortably tensed, nervously straining, jerky,
reddish-brown young American"[12]—rather like what Lewis might have
become had he remained in the United States. Pound brought all the
rawness of the Midwest into that sophisticated and learned turn-of-the-
century literary society, which considered him a "bogus personage" with
encyclopedic pretensions and polyglot propensities. Lewis, who always
regarded him as extraordinarily eccentric, later imitated Pound's
strong American accent and mocked his virile posturings. Pound, who
tried to be a portable substitute for the British Museum, aggressively
attempted to prove his superiority as a poet and intellectual. He also
affected a mode of bombastic behavior and outrageous dress, with
velvet coat and turquoise earring, based on the *fin-de-siècle* model of
Whistler. Goldring wrote that both Lewis and Pound, "in clothes,
hairdressing and manner, made no secret of their calling. Pound
contrived to look 'every inch a poet,' while I have never seen anybody
so obviously a 'genius' as Wyndham Lewis when, after a return from a
sojourn abroad, he first appeared at Ford's parties."[13]

Lewis and Pound, both only sons, rather spoiled and used to getting
their own way, and both hypersensitive and irascible, were immediately
cautious and suspicious of each other. Lewis remained passive and did
not even talk to Pound the first two times they met, though Pound
spoke to him on the second occasion. But when someone asked about

a prostitute, Pound, who had heard Lewis was an unconventional rebel, stared at him and said: "This young man could probably tell you!" His mischievous remark finally broke the ice, for even Lewis could not successfully quarrel with the generous-hearted Pound.

Both men were ambitious, self-confident, talented and energetic. They were eager to fight the philistines, to challenge the prevailing contempt for artists and to destroy the smug Edwardian insularity. Both were passionately devoted to art and soon established a dynamic creative sympathy. Pound respected Lewis' intelligence, admired his ability and did everything possible to help him in the early stages of his career. Pound was a kind of minister of culture without portfolio, who acted as midwife for unknown literary talent. He had a compulsive managerial streak, a genius for simultaneous action and was never satisfied until everything was organized. He introduced Lewis to Eliot, Gaudier, Aldington, H. D. and many other artists. He contributed to and collaborated on *Blast*, where he was described as a "Demon pantechnicon driver, busy with removal of old world into new quarters." He convinced Margaret Anderson and Harriet Weaver that Lewis' work was vitally important, arranged for the publication of *The Ideal Giant* and *Tarr* by the *Little Review* and the *Egoist* in 1917–1918, and sent the manuscript of the novel to Alfred Knopf for publication in America.

When Epstein told Pound that Lewis' drawings had the quality of sculpture, he also became enthusiastic about Lewis' art. When Lewis was in the Army, Pound took control of his affairs and sold a great many works to the American collector John Quinn. He knew how to arouse the patron's appetite about the little-known and undervalued Lewis, and wrote with great excitement: "Lewis has just sent in the first dozen drawings. They are all over the room, and the thing is stupendous. The vitality, the fullness of the man! Nobody knows it. My God, the stuff lies in a pile of dirt on the man's floor. Nobody has seen it. Nobody has *any* conception of the volume and energy and variety."[14] Pound planned to do a study of Lewis to match the one he had done on Gaudier in 1916. He was unable to find a publisher for this project, but praised Lewis' work in more than twenty books and essays.

Though Lewis and Pound sometimes quarrelled, their criticism was frank and open, and they always remained friends. Pound said he was not interested in the vices of his friends, but in their minds. He admitted that though Lewis could be irritating, he was often right. He perceptively observed of Lewis: "A man with his kind of intelligence is bound to be always crashing and opposing and breaking. You cannot be as intelligent, in that sort of way, without being prey to the furies. . . . A volcanic and disordered mind like Wyndham Lewis' is of great value, especially in a dead, and for the most part rotted, milieu."[15]

Lewis appeared in Pound's *Cantos* in an aesthetic rather than a political guise. In the first version of Canto 1 (*Poetry*, June 1917), Pound praised Lewis as an innovator in the arts: "Barred lights, great flares, new form; Picasso or Lewis." In Canto 78 he spoke of Lewis as one of the three prophetic voices in modern art. Though Gaudier and Hulme were killed in the War, their art and aesthetic ideas (like Lewis') survived and became influential:

> Gaudier's word not blacked out
> nor old Hulme's, nor Wyndham's.

In Canto 96 Pound alluded to Lewis' note in *Blast 2* and stated that Lewis recognized the aesthetic importance of the capital of the Eastern Empire, which plays such a significant role in Yeats' poetry:

> "Constantinople" said Wyndham "our star"
> Mr Yeats called it Byzantium.

All of Pound's allusions emphasize Lewis' force of mind and powerful originality.

<div align="center">2</div>

Lewis' work as a painter kept pace with his active social and literary life. He had a burst of creative activity before the outbreak of the War—which virtually extinguished artistic life in England—and had frequent exhibitions and commissions between 1911 and 1914. He appeared with the Camden Town Group in June and December 1911, with the Allied Artists' Association in July 1912 and July 1913, and at the Second Post-Impressionist exhibition in October 1912, and decorated the Cave of the Golden Calf in the spring of 1912. He continued to move around London during these years, and lived briefly in Camden Town, Primrose Hill and Greek Street, Soho. He spent the summers from 1909 to 1913 on the coast of France, at Dieppe and Dunkirk, painting with Walter Sickert and Frederick Etchells; and began to write *Tarr* as early as 1911.

The Camden Town Group was led by Harold Gilman (who had been at the Slade and was the subject of Lewis' book of 1919) whose own paintings and those of his friends were being rejected by the New English Art Club. The group was named as a tribute to Walter Sickert, whose followers frequently painted that working-class district of north London. In his review of the Camden Town retrospective in 1950, Lewis criticized its pervading dinginess and drabness, and its notable lack of interest in form. There was some opposition to Lewis joining

the group in 1911, for he was not enthusiastic about their work and was beginning to paint in the cubist style. But he was eager to exhibit his paintings, was strongly supported by Gilman and Gore, and showed six of his works in the three shows at the Carfax Gallery.

Lewis' painting first received serious attention when he showed *Kermesse* at the massive Allied Artists' Association exhibition at the Albert Hall in July 1912. The Association was founded in 1908 by the advanced art critic Frank Rutter, and modelled on the Parisian Société des Artistes Indépendants. The artists paid an annual fee and could then show their works without first submitting them to a jury. The huge *Kermesse*, nine feet square, was described by Rutter as "a whirling design of slightly cubist forms expressed in terms of cool but strong colour contrasts."[16] This seminal work was the first English painting to show the influence of Cubism and won high praise from Sickert (who called it "magnificent"), from Augustus John and from Roger Fry. John wrote to Lewis, in an unusual tribute: "I was greatly impressed by your picture and the impression increases as I think of it. . . . I recognise the energy and grandeur of the conception and am positively moved by it." And Fry's criticism, though characteristically dry and pedantic, was enthusiastic and showed that he would have been a valuable ally if Lewis had remained on good terms with him: "One artist, and one only, Mr. Wyndham Lewis, has risen to the occasion presented. His design of a Kermesse, originally intended for the Cave of the Calf, the new Cabaret Theatre, is the only thing that survives the ordeal of being placed in such ample surroundings. . . . [He] has built up a design which is tense and compact. . . . The rhythm is not merely agreeable and harmonious, but definitively evocative of a Dionysiac mood."[17]

Fry's first Post-Impressionist exhibition in December 1910 had introduced Gauguin and Van Gogh to a reluctant English public and caused the art critic of the *Morning Post* to insist that all the paintings be consigned to the flames. Fry continued his salutary education of public taste in the second exhibition of October 1912, where Lewis showed his hard, energetic, geometrical designs for Shakespeare's *Timon of Athens*. This satirical tragedy was a superb subject for Lewis to illustrate, and his identification with the angry and bitter hero gave him the first public opportunity to present his hostile "Enemy" *persona*. Timon, a victim of ingratitude, has been betrayed by his friends and reacted violently against them. He rejects the disgusting temptations of the flesh, is driven into the wilderness by a materialistic society and becomes a secluded misanthrope—a harsh, extreme, abusive individualist who can go no further in negation. When Timon screams:

> All's obloquy;
> There's nothing level in our cursèd natures
> But direct villainy,

Apemantus justly comments: "The middle of humanity thou never knowest, but the extremity of both ends."

The highly emotional theme of *Timon*, what Pound called "the fury of intelligence baffled and shut in by circumjacent stupidity," was expressed in Lewis' violent yet perfectly controlled masterpiece, *Alcibiades*, which clearly foreshadowed his own public image. Lewis' illustrations were intended to accompany the play and to be published by Max Goschen, but the text was mistakenly printed without the blocks being fitted into the places designed for them. Lewis expressed a Timon-like fury about the fiasco, and in December 1913 he privately printed the drawings as a portfolio, under the imprint of the Cube Press.

In the spring of 1912 Lewis, with Spencer Gore, Charles Ginner and Jacob Epstein, received his first important commission from Frida Strindberg, the playwright's second wife, to decorate her new night-club: the Cave of the Golden Calf (or Cabaret Theatre Club). Frida, who had recently inherited a large sum of money, was an attractive and volatile Viennese, with pale face, dark hair and blazing eyes. Even Augustus John, who called her a "Walking hell-bitch," was unnerved by her sexual appetite and frequent attempts to commit suicide.

Her expensive Cave, London's first ultra-modern, arty nightclub, was located in a low-ceilinged basement at 9 Heddon Street, off Regent Street. Its Viennese cook, smart corps of Austrian waiters and lively orchestra led by a frenzied gypsy fiddler, attracted the intelligentsia of prewar London. The guests, who wore evening dress, were subjected to odd experiments in amateur theatre and shadow plays, and tried all the latest dances. Young, attractive girls were introduced to wealthy worshippers of Mammon, who bought them good food and wine, served in a civilized fashion. Rebecca West recalls that in 1913 she saw Katherine Mansfield perform, "when she was *commère* at a cabaret show in a nightclub in Regent St., run by one of Strindberg's wives. She did not do it very well, but looked very pretty in a Chinese costume. She was very attractive, with her beautiful dark hair."[18] In the small hours of the morning the Cave appeared to Osbert Sitwell "to be a super-heated Vorticist garden of gesticulating figures, dancing and talking, while the rhythm of primitive forms of ragtime throbbed through the wide room."[19]

Frida contracted to pay Lewis £60 for his brilliantly colored "abstract hieroglyphics" on two paintings, two screens and the walls, and agreed to pay another £10 to exhibit *Kermesse* for three months. One of his designs, like the *Timon* drawings, moved toward total abstraction. It was an oblong painting in rust, blue and green, with four dancers—one wearing a Grecian skirt in the style of Isadora Duncan— swirling in a vertiginous curve.[20] When the nightclub opened, after

considerable publicity, Lewis' huge, freshly-painted drop-curtain, the color of raw meat, was still damp and stuck to the stage. Frida soon quarrelled with Lewis and told Gore he "is as ferociously jealous as a watch-dog and half as faithful." Ford attempted to smooth things over and urged Lewis to try to bear with her. But he also exposed Frida's spurious *mélange* of bohemianism and high-life: "She is trying to build up a palace of all the Arts with three oyster shells and stale patchouli and sawdust and creme de menthe and champagne corks, the buttons off waiters' waistcoats and vers libre."[21] But Lewis soon became anxious about payment. One Sunday, when Frida was away, he guarded the till, accumulated £60, took what was owed him and departed forever. Frida wrote him a furious letter and then, despite her legal contracts, vanished to America in 1914 with all his paintings.

Richard Aldington and David Bomberg both described Lewis' artistic activities in 1912, soon after his sudden and powerful impact on the tranquil world of English painting. In the first part of *Death of a Hero* (1929), a typically ill-tempered and exaggerated satire of artistic and literary life in prewar London, Aldington portrayed Lewis' Picasso-like propensity for changing styles, launching new movements and painting theoretically rather than naturally. His weak irony (also directed at Ford, D. H. Lawrence and T. S. Eliot) revealed that even among modernist writers there was considerable hostility to Lewis' achievement. Aldington, who was jealous of Lewis' success, used his friend as the model for Frank Upjohn, who is extremely vain, highly nervous and always prepared to give subtle erotic advice:

Mr. Upjohn was a very great man. He was a Painter. Since he was destitute of any intrinsic and spontaneous originality, he strove much to be original and invented a new school of painting every season. . . . One season he painted in gorgeous Pointillisme blobs, the next in monotone Fauviste smears, then in calamitous Futuriste accidents of form and colour. At this moment he was just about to launch the Suprematist movement in painting. . . .

Mr. Upjohn produced two pictures in illustration (the word is perhaps inaccurate) of his theories. One was a beautiful scarlet whorl on a background of the purest flake white. The other at first sight appeared to be a brood of bulbous yellow chickens, with thick elongated necks, aimlessly scattered over a grey-green meadow; but on closer inspection the chickens turned out to be conventionalised phalluses. The first was called Decomposition-Cosmos, and the second, Op. 49, Piano.[22]

But his fellow-painter David Bomberg gave a lively account of Lewis' unexpected midnight appearance in his East End flat at Christmas-time: "To Lewis' knock I responded 'this is an inconvenient hour to tramp through the snow and mount three flights of stairs with the gas-jets off—anyhow, how did you know I lived up here?'—'Nothing is impossible for Wyndham Lewis—Bomberg! I have come to see what

you are doing'. . . . We had talked ourselves silly when he left—dawn, the next morning. I recognised in the conversation, a Slade man honouring the same pledge to which I was staking my life—namely, a Partizan."[23] Lewis' spontaneity and passionate commitment had also attracted Ford and Pound, who gave him vital encouragement at the beginning of his artistic career. His violent controversy with Roger Fry and break with the Omega Workshops freed him from the bonds of traditional art, and led directly to the Rebel Art Centre and to the mature works that first made him famous: the Vorticist paintings and *Blast*.

Omega Workshops and
Rebel Art Centre, 1913–1914

I

Lewis' bitter quarrel with Roger Fry was a critical turning-point in his career. The controversy began his lifelong conflict with Bloomsbury and permanently damaged his ability to earn his living as an artist. It established his distrust and dislike of art impresarios—from Fry and Clive Bell to Herbert Read and Kenneth Clark. It stigmatized Lewis in the eyes of the art world as an instigator of rude public combats and gave him the reputation of an Enemy, which he adopted as his public *persona*. This complex episode is worth discussing in some detail, for it reveals both the deficiencies of Bloomsbury morality and the reasons for the anger that Lewis stored up and discharged in *The Apes of God*.

To Lewis, Roger Fry's dishonesty emphasized the shoddiness of his artistic theory and practice, exposed an adversary within the cultured world who was far more dangerous than the ordinary philistine, heightened Lewis' suspicion of and alienation from the art establishment, and encouraged his defensive isolation. Despite his bluster and menacing reputation, Lewis was neither cunning nor unscrupulous enough to defeat Fry's maneuvers, and his public outbursts were, in an important sense, an expression of despair.

Lewis' relations with Bloomsbury were at first very cordial. He met Duncan Grant in Paris in 1907; he stayed in France with Virginia Woolf's brother, Adrian Stephen; he exhibited his *Timon of Athens* drawings in Fry's Second Post-Impressionist show in 1912; he visited Gertrude Stein with Fry in the spring of 1913 and saw her rich collection of modern art. In 1912 Clive Bell bought a large painting, possibly *The Laughing Woman*, from Lewis for £50; and Fry praised *Kermesse* in the Allied Artists' show that year.

The visit to Gertrude Stein, the American patron and panjandrum of the Paris art world, shows that Lewis' behavior could easily be misinterpreted—even by a careful observer. She wrote: "It was about this time that Roger Fry had many young disciples. Among them was Wyndham Lewis, Wyndham Lewis, tall and thin, looked rather like a young frenchman on the rise, perhaps because his feet were very french,

or at least his shoes. He used to come and sit and measure pictures. I can not say that he actually measured with a measuring-rod but he gave all the effect of being in the act of taking very careful measurement of the canvas, the lines within the canvas and everything that might be of use. Gertrude Stein rather liked him. She particularly liked him one day when he came and told all about his quarrel with Roger Fry. Roger Fry had come in not many days before and had already told all about it. They told exactly the same story only it was different, very different."[1] This account, written after Lewis' attack on "Trudy" Stein in *Time and Western Man* (1927), is more satirical than sympathetic. For Lewis, certainly not a pedantic or mechanical painter, was merely studying the pictures very carefully. Helen Rowe, who was his model before the Great War, explains that "Lewis tried 'to do everything with great deliberation.' He subjected the most commonplace actions to thorough scrutiny, and then chose a particular way to speak, laugh, gesture, sit, walk, eat."[2]

Though Fry admired Lewis' work, their taste and style were radically different. Lewis disliked Bloomsbury's pretentious self-applause and the adoration of Fry by his supercilious, cohesive clique. Bloomsbury expressed the end of the traditional and refined mode of expression, while Lewis represented the beginning of the harsh and violent style that was influenced by modern machines and contemporary art. Fry advocated Post-Impressionism and "invented" Duncan Grant (whom Lewis called "a weak and lady-like coal-heaver"),[3] while Lewis went beyond Cubism to total abstraction. Though somewhat advanced in his theories, Fry was an extremely conventional painter. Even his friend Kenneth Clark admitted: "His hand was heavy and lifeless and his awkwardness was not confined to the actual touch, but extended, strangely enough, to the whole construction."[4] After his break with Fry, Lewis called the Omega Workshops an arty-crafty *fin-de-siècle* survival, and in *Blast 2* he stated: "The most abject and anemic—the most *amateurish*—manifestation of this Matisse 'decorativeness' . . . [is] Mr. Fry's curtain and pincushion factory in Fitzroy Square." The Omega Workshops were amateur in that they lacked the technical expertise to execute their commissions. "Naturally the chairs we sold stuck to the seats of people's trousers," Lewis wittily recalled. "When they took up an Omega candlestick they could not put it down again, they held it in an involuntary vice-like grip. It was glued to them and they to it."[5]

Though the Omega tone and tradition were not likely to appeal to the brash master of *Timon* and *Kermesse*, Lewis, who was still unknown and poor, and did not earn enough before the War to pay for haircuts and cigarettes, accepted Fry's offer to join the Workshops when they opened in July 1913 at 33 Fitzroy Square.[6] Fry supplied most of the original capital of £1,500, and Vanessa Bell and Duncan Grant were chosen as co-directors. Lewis painted a few screens and candle-shades;

and the first, inevitable sign of hostility and dissension appeared almost immediately. When Fry somehow "forgot to ask" if Lewis had anything to send to the Grafton exhibition in Liverpool, Lewis told Fry, with conspicuous irritation: "To continue in the atmosphere of special criticism and ill-will, if such exist, would have manifest disadvantages, as well as being distasteful, to me."[7]

Lewis and Spencer Gore had received considerable acclaim for their striking decorations of Frida Strindberg's nightclub, the Cave of the Golden Calf; and P. G. Konody, the Austrian-born art critic of the *Daily Mail*, which sponsored a modernist room in the Ideal Home exhibition, proposed to his paper that Gore should do similar decorations for this room. But Gore, who was busy working in Somerset and setting up a new home in London with his pregnant wife, suggested to Konody that Lewis should decorate the room and that Fry should provide the furniture from the Omega. Gore then went round to the Omega to tell the good news, for the Ideal Home was an important commission and would be seen by large crowds. Since Lewis and Fry were not there, he left the message with Duncan Grant. Grant later recalled that Gore did leave a message and that he "may have forgotten" to give it to Lewis. Fry certainly received the message asking him to communicate with the Ideal Home agent.

A less reliable variant of the story, which Lewis later told John Rothenstein and which Frederick Etchells confirmed, was that Konody (not Gore) delivered the message to the Omega and that Fry (not Grant) received it. In any case, these facts are not disputed by either side: that the Cave of the Golden Calf inspired the commission for Lewis and Gore, that a message was left at the Omega for Lewis, that Fry got the message and that Lewis did not. Gore thought he had handed the matter over to Lewis and forgot about it.[8]

In a caustic "Round Robin" letter, written in October 1913 and sent to the Omega shareholders and to the press, Lewis stated that in July, when "it came to apportioning the work, Mr. Lewis was told by Mr. Roger Fry that no decorations of any sort were to be placed on the walls, and was asked if he would carve a mantelpiece. Shortly after this, Mr. Lewis went away on his holidays, and on his return in [late] September, found large mural decorations, destined for the Olympia Exhibition, around the walls of the workroom."[9]

When Lewis met Gore a few days later, shortly before the opening of the exhibition, and told him of the decorations, he discovered that the commission had originally been given to him. (According to Rothenstein's variant, where Konody again replaces Gore, Lewis learned about the commission from Konody.) Lewis returned to the Omega in a fury, had a stormy scene with Fry and left the Omega with all the important non-Bloomsbury artists: Frederick Etchells, C. J. Hamilton, Edward

Wadsworth, Gaudier-Brzeska and William Roberts, who were soon to become part of the Vorticist group.

On October 5, 1913, Fry wrote to Gore giving his version of the story and ignoring the fact that he had injured Gore as well as Lewis. At this point the factual disagreement begins. Fry wrote: "Lewis tells me that you said you left a letter [i.e. a verbal message] here from the Ideal Home Exhibition people asking Lewis to do decorations and asking the Omega to do the furniture. I told him that the *Daily Mail* people had approached me directly and that they had never mentioned his name. He thereupon doubted my word and said that I accused you of telling a lie." This sharp rebuttal was characteristic of Lewis.

When Gore asked for an explanation, Fry said he could explain it better in person than in writing, and did not attempt to give one. He offered, by way of diversion, a totally irrelevant discussion of Lewis' carving: "Lewis wanted to do the carving for it. It was his own suggestion and I considered it the most interesting and important job in the whole work. However, he never carried it out in spite of constantly repeated assurances that he would." Here Fry adopts the injured tone of a school captain let down by his team, falsely states that the carving was the most important job and pretends to be puzzled about why Lewis never finished it. Fry knew perfectly well that Lewis was a painter, not a sculptor, and that Lewis had asked for the carving only after he had been told there would be no decorations.

In the midst of this serious controversy, which burst upon the Omega shortly after it had opened, Fry left for a holiday in Avignon—before Gore could see him. In response to a second letter from Gore, Fry changed his story slightly, saying that he had indeed received Gore's message but "I never got it with sufficient clearness to make me consider it as compared with what I thought the quite authoritative full statement of the *Daily Mail*." In other words, the message that the commission was intended for Lewis was very faint, in contrast to the loud and clear statement that the job was meant only for Fry. He also asked, rather disingenuously, "what the Devil have I to gain by it?"[10] The answer clearly was: the Ideal Home commission.

At this point Lewis, Etchells, Hamilton and Wadsworth issued their "Round Robin" letter and charged: "The Direction of the Omega Workshops secured the decoration of the 'Post-Impressionist' room at the Ideal Home Exhibition by a shabby trick, and at the expense of one of their members—Mr. Wyndham Lewis, and an outside artist—Mr. Spencer Gore." As Lewis explained to Konody: Fry "does *not deny that he got Gore's message*, but says, with much specious rigmarole, that somehow or other when he got in touch with the Ideal Home people, the commission became exclusively his. That is exactly what we say." They told exactly the same story, only it was very different.

The four defectors also made a second charge: that when Frank Rutter, who was organizing an exhibition at the Doré Galleries, asked for Etchells' address, he was told by Fry that Etchells had no pictures ready: "This statement of Mr. Fry's was not only unauthorised but untrue. It is curious that a letter from Mr. Rutter to Mr. Lewis on the same subject, and addressed to the Omega Workshops, should never have reached him." Ten days later this letter finally got to Lewis. It had been opened by Fry, who explained that he had read it before noticing it was meant for Lewis. If Rutter had not sent a second letter to Lewis' studio (at 142 Brecknock Road, Islington), he, like Etchells, would have missed the Doré show.

Lewis concluded the "Round Robin" with an attack on the Omega's lack of taste and Fry's lack of morality. The Omega's "Idol is still Prettiness, with its mid-Victorian languish of the neck, and its skin is 'greenery-yallery,' despite the Post-What-Not fashionableness of its draperies." As for Fry himself, he was "the Pecksniff-shark, a timid but voracious journalistic monster, unscrupulous, smooth-tongued and, owing chiefly to its weakness, mischievous." Lewis unburdened himself even more forcefully to Clive Bell, from whom he naively expected sympathy: "You will hardly expect me to be amused at these tricks and contrivances, or wish to remain longer in the vicinity of a bad shit."[11] Lewis' excessive vituperation hurt his cause and allowed Bloomsbury to malign *his* character. They gradually shifted the grounds of the dispute from the facts to the personal integrity of the contestants, an integrity based on manners, not actions.

Since Fry was in France, Vanessa and Clive Bell and Duncan Grant had no direct knowledge of the facts. But they never admitted the possibility that Fry could be wrong. As Clive Bell plainly asserted: "The whole thing's a matter of character. . . . Everyone who knows what's what will draw his own conclusions from the style of the circular."[12] Bloomsbury was extremely snobbish and hostile to anything that was not in their style, to any talk not in their language. Lewis' truculent behavior was the antithesis of Bloomsbury gentility, and his furiously rude and uncompromising language was sufficient to prove to them that Fry had acted properly. As Grant wrote to Strachey, as early as 1907, foreshadowing Strachey's satirical letter to Ottoline Morrell about Lewis' stories: "My gorge simply rises whenever I see him. . . . I simply descend into the depths of gloom . . . and I cannot decide whether my feelings are absurd and silly, but I certainly think all his hopelessly mesquine and putrid. . . . It's very odd that anyone should have the power of making one go into such 'hysterics.' "[13] Lewis clearly gave a ferocious jolt to Bloomsbury's sensitive nerve-endings: he made Grant sick, depressed, confused—even hysterical.

Though Vanessa Bell, who had been left in charge of the Omega,

wrote to Fry for clarification and instructions, she had to handle the affair and acted vigorously on Fry's behalf. She attacked the moral character of the dissident painters, who "had behaved monstrously in writing this letter without first accusing you to your face," without realizing that they had confronted Fry directly and received no explanation of his conduct. She had an unsuccessful interview with Etchells. She was alarmed that one of the charges might be valid: "I hope you *didn't* say that Etchells had no paintings! Apparently he had several." She raised the possibility of a libel action. And she tried to obtain information from the *Daily Mail* about who was supposed to receive the commission.

Since everyone agreed that Gore's integrity could not be questioned, Bloomsbury decided to attack Lewis—though Gore was convinced that Lewis was right and firmly supported him against Fry. Fry maintained: "Lewis' vanity touches on insanity" and cited Gaudier's sympathetic support: "The Lewis gang do nothing else even now but abuse me. Brzeska, who sees them, says he's never seen such a display of vindictive jealousy."[14] Yet Gaudier-Brzeska complained bitterly to a friend that the Omega had "sucked his brains" and "swindled him."[15]

Grant loyally agreed with Fry, though he had no evidence for his opinion: "I'm perfectly sure the whole thing was engineered by Lewis simply to advertise himself." Clive Bell also maintained this argument, and attempted to persuade Lewis that Fry was a high-minded, decent sort of chap, incapable of such underhanded behavior. He argued didactically and, as Bloomsbury usually did, on the grounds of snobbery: "There may be plenty that's irritating, or at any rate vexatious in Roger Fry but he's not that sort: you're wrong. And anyway, whatever you think of him and his doing you ought not to bombard the town with pages of suburban rhetoric. The vulgarity of the thing. And the provincialism. That's what I mind. You don't belong to the suburbs, so what the devil are you doing there?"[16]

Quentin Bell and Stephen Chaplin, writing in 1964, followed Clive Bell's line of argument by contrasting the characters of Lewis and Fry, and by making assertions in a crude and anachronistic manner. He referred to Lewis as a brutal Fascist before the Fascists existed, and transposed his rather different postwar character to 1913: Lewis was "one of nature's *fascisti*. . . . Caustic, truculent and at times brutal, he was also, one may suppose, a very vulnerable character, easily wounded and naturally suspicious." Fry, on the other hand, "valued integrity, intelligence and humility" (implying that Lewis did not) and had the "maddeningly angelic quality of the Quakers" (as if all Quakers, though irritating, were morally superior).[17]

In view of Bell and Chaplin's *ex cathedra* pronouncements, it is essential to examine Fry's character as seen, not by his enemies, but by

himself and two of his closest friends: Clive Bell and Leonard Woolf. In
1911 Fry engaged in a quarrel with William Rothenstein (the Blooms-
bury–Rothenstein conflict has lasted for two generations) about the
control of the Post-Impressionist exhibition at the Grafton Gallery.
Fry admitted to Virginia Woolf: "I used to be jealous of Prof. Rothen-
stein, who came along about four years after me and at once got a great
reputation"; and he adopted the same disingenuous tone with Rothen-
stein as he did with Gore and Lewis: "I gather you are very much
annoyed with me, but I simply can't disentangle the reason. No doubt
it is all quite clear in your mind, but I haven't a clue."[18] Clive Bell gave
a good explanation of this side of Fry's "angelic" character: "He was
open-minded, but he was not fair-minded. . . . He had a way of being
sure that while all his own strong feelings were principles, those of
others, when they happened to cross his, were unworthy prejudices. . . .
Suspicious he was, and in his fits of suspicion unjust. He could be as
censorious as an ill-conditioned judge. . . . [He] believed that those who
differed from him must be actuated by the foulest motives."[19]

Leonard Woolf, who was Fry's secretary at the Grafton exhibition in
1912, was even more severe about the "humble" Fry's financial swindles
(Fry himself said the Quakers were sharp about money), and throws
some interesting light on the origin of his quarrel with Lewis: "I was
more than once surprised by his ruthlessness and what seemed to me
almost unscrupulousness in business. . . . [After the exhibition], when
the time came to pay the artists their share of the purchase amounts of
pictures sold, Roger insisted upon deducting a higher commission with-
out any explanation or apology to the painters. Most of them meekly
accepted what they were given, but Wyndham Lewis, at the best of
times a bilious and cantankerous man, protested violently. Roger was
adamant in ignoring him and his demands; Lewis never forgave
Roger."[20] While Bell and Chaplin, apparently presenting the facts of
the case, pronounce Fry humble and angelic, with great integrity and
"transparent honesty," Clive Bell and Woolf, who were favourably
disposed to Fry, found him unfair, prejudiced, suspicious, censorious,
narrow-minded, ruthless and unscrupulous.

Vanessa Bell had a long interview with Frederick Etchells, who had
been a close friend of Fry, Clive Bell and Grant before the dispute, but
he remained convinced that Lewis was right. Later on, he emphasized
that the high-handed manner of the wealthy Fry toward his im-
poverished artistic workmen was partly responsible for the break: "Fry
bossed the show there. It was his money and his enterprise, but as far
as Lewis was concerned there could only be one real boss. He persuaded
me to walk out: I didn't care very much, but it was true that Fry paid
very little. He came from a rich family and we were all broke—his
complacency wasn't always very palatable to an impecunious artist."[21]

With Fry's dubious character clearly in mind, it would be useful to examine the truth of Lewis' charges against him. Four of the five charges were not challenged or disputed by Fry and may be taken as valid: that Fry "forgot to ask" if Lewis had any paintings for the Liverpool exhibition; that Fry said there would be no decorations and gave Lewis a carving to do, when in fact there were decorations; that Fry told Rutter that Etchells had no pictures ready for the Doré exhibition when Etchells did have paintings he wished to show; that Fry opened Rutter's letter to Lewis and delayed sending it for ten days (Fry apologized for this).

The fifth and most important charge, that Fry stole the Ideal Home commission intended for Lewis and Gore, is the core of the dispute. The main evidence produced by Bell and Chaplin in defense of Fry is a letter of October 22, 1913 to Vanessa Bell from F. G. Bussy, secretary of the Olympia exhibition: "The commission to furnish and decorate a room at Olympia was given by the *Daily Mail* to Mr. Roger Fry without any conditions as to the artists he would employ. . . . The names of Mr. Spencer Gore and Mr. Wyndham Lewis were not mentioned by our representative to Mr. Fry so far as he can remember, neither do we recollect having any interview with either of the latter gentlemen."[22]

Bell and Chaplin's conclusion, which attempts to resolve the conflict between Gore's story and Fry's, is that Konody "may perhaps have been guilty of some initial confusion, of setting two officials to work who acted independently," that one official approached the Omega and another approached Gore, and that this duplication of effort caused the confusion and the quarrel.[23]

Though Bell and Chaplin note the conflict in the stories of Gore and Rothenstein (as heard from Lewis) about the origin of the commission, they do not recognize the contradiction in their own explanation. The commission could have originated in two different places: in Carmelite House, the offices of the *Daily Mail*, on the Victoria Embankment, where Gore first said he saw the agent of that newspaper, or in the offices of the Ideal Home exhibition on Fleet Street, where Gore said, in a later version, that he saw the agent of the exhibition.

Vanessa Bell told Fry she was going to see a Mr. Craston of the *Daily Mail* at the Olympia, and then produced a letter from Mr. Bussy, the secretary of the Olympia Hall in Kensington, where the exhibition took place. Mr. Bussy said the names of Gore and Lewis were not mentioned "so far as he [our representative] can remember." The qualification is important, since it expresses some doubt. And since Bussy was not employed by either the *Daily Mail* or the Ideal Home exhibition, and did not himself see Fry, his statement does not offer conclusive proof that the commission was given to Fry.

Bussy's letter merely confirmed that Fry got the commission. Bell and Chaplin write: "With this letter in his hands, Fry could almost certainly have brought an action against the signatories of the 'Round Robin' and have won it." But they also quote Vanessa Bell's statement to Fry, without apparently realizing its implications: "What they really would like would be an action for libel. It seems quite clear now that the best thing is to do nothing."[24] Virginia Woolf stated, in her biography of Fry, that when the "Round Robin" was sent to Fry: "He was not, apparently, greatly surprised; once more he remained 'strangely calm.' . . . Some of his friends urged Roger Fry to bring an action for libel. The Omega might be damaged, they pointed out, if such charges were left unanswered. But Roger Fry refused to take any steps."[25] Virginia Woolf implied that Fry maintained equanimity while others became unduly heated, that he remained above the fray like a gentleman while others rudely squabbled. The real explanation is that Lewis tried to provoke and welcomed a libel suit because he was right, and Fry did not go to court because he was guilty of the charges stated in the letter: the "libel" was true.

Bell and Chaplin never explain the crucial question of how the commission to do the decorating which was definitely given to Lewis and Gore, was ultimately executed by Fry. Even if the commission was given to Fry as well as to Lewis and Gore, it seems clear that Fry got the job for himself by keeping the message from Lewis. The weaknesses in Bell and Chaplin's defense of Fry are numerous: the decorations done by Lewis and Gore in the Cave of the Golden Calf inspired the commission, and Fry had nothing to do with the Cave; Grant gave Gore's message to Fry instead of to Lewis, who never received it; Fry noticed no conflict about who was to receive the commission; Fry pretended there was nothing to gain by taking the important job for himself; Lewis' other charges are true, and Fry even apologized for one of them; Fry did not answer Gore's charges directly, gave no explanation and spoke instead about Lewis' carving; Fry got Gore's letter before October 5 and went on holiday—to escape rather than face the row—in mid-October; Fry and his followers based their argument on assertions about Lewis' lack of character though Fry's own character, according to the testimony of his closest friends, was seriously flawed; Gore, Wadsworth, Etchells and Hamilton believed Lewis was right; the letter confirming Fry's commission came from the Olympia exhibition hall in Kensington, not from the offices of the Daily Mail or the Ideal Home exhibition; Fry did not bring a libel suit to defend himself and his newly-founded firm against "false" attacks.

Bell and Chaplin conclude: "The gravest charge that can be made against Fry is that he may have misunderstood a message."[26] But all the evidence shows that Fry heard of the commission from Grant, who

gave him Gore's message to contact the Ideal Home people; that Fry knew his employees, Lewis and Etchells, were going on their summer holiday to Dieppe; and that when he got in touch with the Ideal Home agent he appropriated the commission for himself, kept the details about the decorations from Lewis and gave him the carving to do.

Since Gore, a man of unquestioned integrity, had no interest in the commission, his evidence is more persuasive than that of Fry, who wanted the job and who had every reason to be jealous of Lewis, as he had been of William Rothenstein in 1911. For the vital and energetic paintings of Lewis, the rising star of the English art world, made Fry's lifeless and awkward pictures seem very weak indeed. Lewis' suspicion of Fry was well-justified: even paranoids have real enemies.

Though Lewis was the injured party, Bloomsbury gossip and propaganda cast him in the role of villain. Lewis carried on intermittent warfare against Bloomsbury until 1930, when he blasted them with the time-bomb, *The Apes of God*. Lewis' attack on false artists who imitate real creators must be read not only as a *roman à clef* but also in the context of the Omega quarrel, which provided the direct, though delayed, inspiration for one of the most devastating satires of the twentieth century.

2

A second, closely related and much disputed question is whether Fry and his Bloomsbury colleagues used their influence to hurt Lewis' artistic career. Lewis, his wife and his friends certainly thought so. David Garnett, who expressed the Bloomsbury viewpoint and denied any malign retaliation, said Fry may have felt resentment about the Omega quarrel, but there was no feud or vendetta on his part.[27] There is no doubt, however, that Fry had the power to harm Lewis if he wished to do so; and though Lewis suffered most in the Omega conflict, Fry must have felt aggrieved about the public charges in Lewis' letter. Douglas Cooper stated that Fry, who was the editor of the *Burlington Magazine* and extraordinarily influential with buyers and museums, "was able to impress his interpretation and his taste . . . for many years on a scandalized, submissive and ever-widening public of collectors and art-lovers." Paul Nash, no friend of Lewis, asserted: "Roger Fry was without doubt *the* high-priest of art of the day and could and did make artistic reputations overnight." And Lewis' old teacher, Henry Tonks, "had the courage of his bad taste to say, at the time of Fry's death [in 1934], that from the point of view of British painting he felt as though Hitler and Mussolini had passed away."[28]

Julian Symons believes that Fry's malign influence prevented Lewis

from getting his customary commissions from wealthy patrons when he returned from the War. Hugh Kenner, noting that painters' prices depend partly on effective publicity and the prospect of a future reputation, thinks there was a Bloomsbury art conspiracy, for they sponsored profitable movements like Post-Impressionism, influenced public taste and commanded the reputation market. Mrs. Lewis felt that Fry gave Lewis trivial and unsuitable jobs at the Omega, established a boycott in the twenties, tried to prevent Lewis from selling his paintings and forced him to turn to writing in order to exist.[29] Lewis always believed that Fry and his Bloomsbury friends had conducted a silent vendetta against him, and prevented him from getting the commissions, exhibitions, reviews and sales that he deserved. He expressed his views on this matter in a letter of 1937 to Oliver Brown of the Leicester Gallery: "The great influence of Roger Fry in the past militated against my pictures being bought institutionally. On account of his dual rôle of critic and dealer he exercised a great deal of power, and as you know he did not care for me, on personal grounds."[30]

Though there is no concrete evidence that Fry actively conspired against Lewis, he had the character, the motive and the power as art-impresario to do so. Before their quarrel Fry requested Lewis' work for his exhibition and praised Lewis in reviews; after the quarrel he was publicly silent about Lewis. Though Lewis could scarcely expect Fry to extol his work after their conflict, he could claim that he had been hurt by the withdrawal of Fry's support. Fry could have done considerable harm to Lewis merely by ignoring him.

Fry remained silent, but Clive Bell was openly critical of Lewis. Bell's great themes—as expressed, for example, in his Introduction to the Second Post-Impressionist exhibition catalogue—were the inferiority and indebtedness of English to French painters, and the importance of Fry's concept of "significant form." Since Bell, following Fry, did not admire linearity and technical experiment, Lewis' strongest qualities, he was limited by personal as well as theoretical prejudice from recognizing Lewis' genius.

In a review of "Contemporary Art in England," published in the *Burlington Magazine* in July 1917, Bell made an absurd attempt to stigmatize Lewis, who brought abstract art to England, as "provincial" —just as he had done in his snobbish letter to Lewis of October 1913: "It is particularly to be regretted that Mr. Lewis should have lent his great powers to the canalising . . . of the new spirit in a little backwater called English vorticism, which already gives signs of becoming as insipid as any other puddle of provincialism."[31] And in the *Athenaeum* of March 1920 Bell attacked the exhibition of War paintings, especially those done by the more advanced artists.

Lewis retaliated with his incisive satirical portrait in *Tarr* of Alan

Hobson, a melodramatic Cambridge-cut villain who ambles along in a slouch. Lewis revealed that Bell's essential superficiality was disguised by the protective coloring of his group, the perverse fellow-travellers of art: "His full-blooded blackguard's countenance attempted to portray delicacies of common sense and gossamer-like backslidings into the inane. . . . You could not say he was an individual, he was in fact a set. He sat there, a cultivated audience, with the aplomb and absence of self-consciousness of numbers, of the herd—of those who know they are not alone. . . . The Cambridge set that [he] represents is, as observed in an average specimen, a hybrid of the Quaker, the homosexual and the Chelsea artist."[32] But Bell's derivative triviality, and the worthlessness of his aesthetic pronouncements, were condemned far more severely by Fry than by Lewis. For Fry clearly exposed his disciple's weaknesses in a letter of December 1921: "I do not exactly find him spiteful. He hasn't much personal judgment and he's a terrible snob . . . it is not by personal antipathy that he castigates a painter but rather by his over-preoccupation to show himself in the forefront of the trend. . . . He does not make a serious effort to understand [art] but collects hearsay and remarks from other artists."[33]

Lewis frequently discussed the Omega quarrel with his sympathetic friend John Rothenstein, and the subject reappears as a lugubrious motif in the latter's autobiography. In 1939 Lewis felt he could effect a catharsis by publishing a severe critique of Fry; in 1951, when he was overwhelmed by blindness, he regretted the quarrel and its painful repercussions; and in 1956, just before his death, the conflict still rankled in his memory:

The most effective means of ridding my own system of a quantity of putrescent matter would be to write a book on Roger Fry: he personifies as much as anybody what I dislike most about the art world, and I've always disliked the man himself. And if I ever make enough money to be able to afford to disregard the uproar it would raise, I'll write it. . . .
[Rothenstein writes:] He ironically blamed himself for his defiance of Fry over the Omega quarrel, saying that he should have submitted without a word, as all the persecution of him stemmed from his alienation of Fry, and that Kenneth Clark, "on whom Fry's mantle is supposed to have fallen," pursued him relentlessly. . . . Shortly before his death, he told me that Roger Fry and his "Bloomsbury" circle had ruined his life and that had he known how much he would have suffered, in his own words, "by a sneer of hatred, or by a sly Bloomsbury sniff," he would never have attacked Roger Fry.[34]

Though Lewis was right and Fry wrong, Lewis' fatal impulse to attack influential friends made him suffer much more than his adversary in the Omega quarrel.

3

The break with Omega hurt Lewis' later career, but it also liberated him from the ties of tradition, set him on an independent course and led to the Rebel Art Centre and the Vorticist group. Between leaving the Omega in October 1913 and founding the Centre the following spring, Lewis appeared in two art shows. He showed six paintings (including *Creation*, priced at £25) in the "Cubist Room" exhibition at Brighton in December 1913; and in March 1914 showed *Eistedfodd* and *Christopher Columbus* in the London Group show at the Goupil Gallery. He announced his credo in the Foreword to the Brighton catalogue: "All revolutionary painting today has in common the rigid reflections of steel and stone in the spirit of the artist."

In March 1914 Walter Sickert, who had inspired the Camden Town Group and given an unenthusiastic speech at the opening of the Brighton exhibition, attacked the English cubists in the *New Age* and claimed their art was pornographic: "While the faces of persons suggested are frequently nil, non-representation is forgotten when it comes to the sexual organs. Witness Mr. Wyndham Lewis' 'Creation,' exhibited at Brighton, Mr. Gaudier-Brzeska's drawing in last week's *New Age*, and several of Mr. Epstein's later drawings." Lewis defended himself and his colleagues the following week and portrayed Sickert, whose "bedroom realism" was once "the scandal of the neighborhood," as a jaded and jealous has-been who covertly practiced precisely what he condemned in other artists: "But now he has survived his sins, and has sunk into the bandit's mellow and peaceful maturity. He sits at his open front door and invents little squibs and contrivances to discomfort the young brigands he hears tales of, and of whose exploits he is rather jealous. . . . As for Phallic aesthetics, I have no quarrel with them, only I don't happen to participate myself, that is all: though much preferring the naked and clean thing to the boudoir suggestiveness and Yellow Book Gallicisms."[35]

Lewis also completed his second major commission: the decorations for Lady Drogheda's dining-room at 40 Wilton Crescent, off Belgrave Square. At the end of November the fashionable countess insisted: "*Do* please come and see me. I should so love you to do a frieze for me"; and in less than three months Lewis had finished a set of painted panels over the fireplace, a large painting above the door, and a narrow frieze below the cornice and around the room. The walls were lined with black velvet draperies and alabaster lamps threw light on to the ceilings and the frieze. The countess, by no means a lover of modern art, was proud of the panels and pleased with the way the black walls showed off her bare shoulders at dinner parties. On February 26 she invited Augustus John, Jacob Epstein and a group of her friends to see the work, which was

illustrated in the *Sketch* in March. After the house was sold in 1920, all trace of Lewis' work disappeared.

In March 1914 Lewis and Kate Lechmere opened the Rebel Art Centre, an antagonistic splinter from the Omega, at 38 Great Ormond Street, near Queen Square. Kate Lechmere, educated at Clifton College in Bristol, had been an art student in Paris and had studied under Sickert at the Westminster School of Art. In 1912, while at the Westminster, she met Lewis at a party given by Robert Bevan of the Camden Town Group. In her lively unpublished memoir, "Wyndham Lewis from 1912," Lechmere writes that she was attracted to Lewis and that she (like Rebecca West) suffered through a silent meal before she became friends with him and suggested she finance an art centre:

I was at once impressed by this striking-looking artist, looking much like Augustus John's early portrait of him. A few days later Lewis invited me to dinner and much to my embarrassment not a word was spoken through the meal, but afterwards, on our arrival at the Café Royal, [he spoke about Dostoyevsky and about himself.] I felt instinctively that here was a man of genius, a powerful but complex character. . . .

My relation with Wyndham Lewis was most amicable and he was a most amusing and entertaining friend. I wrote from France about January 1914 suggesting that we start a modern art Studio in London, run on much the same lines as those in Paris, but the Rebel Art Centre became a much smarter set up. We found a charming old house and we took the first floor and I had a flat on the top floor back. The rooms had to be enlarged and I paid for walls to be taken down and reinstalled. The studio walls were painted pale lemon yellow and the doors Chinese red. We had an office and an extra room for Lewis and prospective pupils to paint in. . . .

Lewis and I decided that I should pay for a new suit to be tailored for him. He arrived one day violently flapping the coat of his suit before me and I asked what he was doing and he replied "Women are so unobservant"—I then remembered this was THE suit. . . . Velvet jackets and floppy ties were not encouraged by Lewis and we were to be anti-aesthetic.

Lechmere thought Lewis was exciting, witty and responsive; he found her extremely attractive and wrote: "I have as many kisses as the envelope will hold. The rest I keep in my mouth for you."

The Centre started rather tamely with Helen Saunders and Jessica Dismorr making fans and screens in tepid competition with the Omega, and Lechmere pouring tea and handing out cakes at the Saturday afternoon gatherings. Lewis kept an empty room to represent the impending arrival of the latest art movement, and he planned to give classes and exhibitions with his friends Pound, Gaudier, Etchells, Wadsworth and Nevinson. Lectures were announced by Pound on Imagism and by Schoenberg and Scriabin on music; and talks were actually given by Marinetti (in May 1914) and by Ford (when Lewis' painting fell on his head). Lewis gave a speech on "Cubism and

Futurism" at the opening of the Leeds Arts Club exhibition on May 16, and kept his head buried in his notes and was inaudible when he spoke at the Kensington Town Hall. In contrast to Lewis and to T. E. Hulme, who had a crabbed, harsh delivery and an odd north-country pronunciation, Pound could be seen and heard on that occasion, gave an effective talk and read some modern poetry. But Lewis, annoyed at Pound's superior performance, told Lechmere "it was rather like clowning poetry read with a Yankee accent." Lewis was often suspicious and antagonistic. He cautiously locked in a buyer with his pictures when he was called away during a sale; and showed his confidence in Pound by inviting him to see his latest paintings, which were hidden away from imitators in a secret back room.

The dissolution of the Centre was hastened if not precipitated by Lechmere's friendship with the critic and philosopher T. E. Hulme, a powerful and aggressive Yorkshireman with an agile and stimulating mind. Lewis sympathetically described him as "a very large and imposing man, well over six foot, broad-shouldered, and with legs like a racing cyclist. . . . He was a very talkative jolly giant, arrogantly argumentative, but a great laugher. . . . He was very fond of the girls. His conversation mostly bore upon that subject."[36] One day Lewis brought Hulme to the Centre, thinking Lechmere had gone out for lunch. But when she came back, she met Hulme, who was very attractive to women, and eventually became engaged to him. She recalled:

I think for a time Lewis was in love with me and I was extremely fond of him and had complete belief in his talent and genius and so I was saved from many a heart-ache. . . . I did not realise that Lewis had an actual fear that he might be supplanted by another at the Rebel Art Centre. This became quite an obsession with him and nothing could convince him otherwise. . . . Poor dear Lewis quite lost his head and when he accused me of this Hulme attachment I said he had shown little attention to me of late and his remark was that it was not too good for a woman to have too much notice taken of her. . . .

During my friendship with T. E. Hulme Lewis made himself most unpleasant. Some mornings he would arrive in a very excitable state and rapidly pace up and down the Studio calling me a "bloody bitch". This hurt and shocked me at first but as the "bloody bitch" was so often repeated I took it quite calmly which only irritated Lewis the more.

Lewis felt his artistic pre-eminence, his leadership of the Vorticist painters, his emotional relationship with Lechmere and her support of the Rebel Art Centre were all threatened by Hulme, who had criticized the lack of cohesion and unity in Lewis' paintings, passionately praised the work of Epstein and Bomberg, swept away Kate Lechmere, and virtually extinguished her emotional and financial interest in Lewis' life and work.

After a violent quarrel with Lechmere about Hulme, the jealous Lewis threatened to kill him, tracked him down at a house in Frith Street where he was talking to friends and seized him by the throat. But Hulme dragged Lewis downstairs and into Soho Square, and hung him upside down on the tall iron railings. Since Lewis was also over six feet tall this scenario seems improbable, yet Lewis has confirmed the story in *Blasting and Bombardiering*: "I never see the summer house in the centre [of Soho Square] without remembering how I saw it upside down."[37] Hulme thought himself tough—and he was.

Both Lewis and Lechmere were impractical and inexperienced. When he advertized a lecture in *The Times*, he forgot to put in the date and had to pay for a second announcement. Few of the proposed activities took place and most of the time was spent preparing the first number of *Blast*. There was no money, work, studios or important commissions to be had at the high-sounding Centre—apart from Lady Cunard's request for decorated party favors. In June 1914, Lechmere "told Lewis that he and his friends must carry on without me and that I could not pay the next quarter's rent. Some days later I went out in the afternoon and on returning found the Studio in confusion and denuded of most of its contents. So ended the Rebel Art Centre and the Vorticists retired to some garret."[38]

Lewis broke with Lechmere, and the Rebel Art Centre lasted only four months. But it produced *Blast* and inspired the Vorticist group, the most dynamic and innovative movement in modern English painting, who adapted and assimilated Cubism and Futurism, and provided the energetic impetus that forced modernism into a provincial and philistine England.

CHAPTER FIVE

Vorticism and *Blast*, 1914

> Every thing has its
> Own Vortex, and when once a traveller thro' Eternity
> Has pass'd that Vortex, he perceives it roll backward behind
> His path, into a globe itself infolding like a sun,
> Or like a moon, or like a universe of starry majesty,
> While he keeps onwards in his wondrous journey on the earth,
> Or like a human form, a friend with whom he liv'd benevolent.
>
> William Blake, *Milton*

I

Lewis' early background—his American father and Canadian birth, separation of his parents, impoverished gentility, difficulties at Rugby and the Slade, long years of art-student life, artistic quarrels, ardent ambition, passion for painting and polemical skill—all contributed to making him a rebellious outsider and shaping the pugnacious character of his movement. For Lewis, erupting with emotional intensity and intellectual energy, enjoyed notoriety and dramatized himself as an insurgent against the flaccid conventions of Victorian taste and the decorative softness of British Impressionism.

After the publication of *Blast* in June 1914 Lewis suddenly became famous—and notorious. He was the editor of an explosive magazine, the leader of a dynamic group of painters and a social lion who dined with titled ladies and discussed with Prime Minister Asquith, a cultured man with an interest in the arts, the latest developments in modern painting. Asquith, however, was uneasy with Lewis and suspected that his fashionable international "stunt" had revolutionary political objectives. In 1914 Lewis' complex and contradictory character made its first impact, and began that disturbing but salutary influence on English art that would continue for nearly half a century.

On the surface was the combative and strident Byronic *persona*—mad, bad and dangerous to know—portrayed by his fellow-painter William Roberts: "Lewis in his prime [was] alert eyed, with an assurance and

55

provocative swagger in his bearing . . . [a] tall form in heavy overcoat and grey sombrero, with scarf flung flamboyantly over one shoulder, striding along, the broad shoulders tilted slightly, like a boxer advancing to meet an opponent. In a sense, acquaintanceship with Wyndham Lewis was like a contest, in which you came out of your corner fighting —and the best man won."[1] Edward Marsh, patron of the arts and editor of the *Georgian Poetry* series, who went to a ball as a Futurist painting designed by Lewis, thought the "buffalo in wolf's clothing" magnificent to look at, but was suspicious and frightened of him. And the American poet John Gould Fletcher also found Lewis rather dark and saturnine: "a grim-jawed, black-haired and beetle-browed individual . . . disposed to be surly and uncommunicative."

But Lewis, who was essentially histrionic, enjoyed playing a role, was stimulated by defiant gestures and intellectual warfare, and deliberately projected this belligerent image. More perceptive observers noticed there was another, more elusive and sensitive temperament beneath the defensive carapace. As Lewis wrote of his hero Georges Sorel: he is "always enigmatic and reserved, a master of obsessional ideas, and generator of the maximum of tension, always fleeting and unstable. . . . He seems composed of a crowd of warring personalities, sometimes one being in the ascendant, sometimes another, and which in any case he has not been able, or has not cared, to control."[2] Eliot, one of his closest friends, believed Lewis was essentially "a highly strung, nervous man, who was conscious of his own abilities, and sensitive to slight or neglect." Anthony Powell felt "there was a kind of uncertainty, a lack of conviction, masquerading as a swashbuckling self-assurance." And the composer Cecil Gray agreed that he possessed "a deep, uneasy sense of self-doubt, and even humility. . . . Behind the aggressive exterior which he chose to present to the world there lay concealed an infinite variety of complexities and subtleties and contradictions."[3]

The Vorticists were not, like the Futurists, a unified group; they were sensitive and touchy artists, always quarrelling with each other. Lewis later wrote: "It was essential that people believe there was a kind of army beneath the banner of the Vortex. In fact there were only a couple of women [Saunders and Dismorr] and one or two not very reliable men"[4]—Wadsworth, Etchells, Hamilton and Roberts, who had all left the Omega with Lewis. Lewis was the leading painter, theoretician and organizer; and he tried to give the group, which had similar artistic ideas and goals, a definite character and style that would be recognized by the public and by potential buyers. But he thought artists were incredibly ignorant people and was a solitary sort of man, not as close to the painters as he was to Pound.

The Vorticists had an almost schizoid attitude toward Lewis, who could be both a marvellous friend and a dangerous enemy. He was

charming, energetic and brilliant, but he enjoyed intrigue and was very short-tempered. "I liked Lewis enormously," Etchells said, "but he was an uncomfortable man to be with. He was a tremendous bully who wanted to be top dog all the time, and I used to get ratty with him: sometimes I just thought he was all theory."[5] But Helen Rowe, who was Lewis' model before the War and was not an intellectual or artistic rival, saw an entirely different side of his personality: "In his everyday life Lewis liked talking with shop keepers, A.B.C. waitresses, professionals and craftsmen, the men who sold paints and made canvasses and frames. The one friend with whom he could be totally at ease was Captain Guy Baker, an ex-army officer, who was not an artist. Lewis enjoyed the company of people who . . . 'didn't have theories on art.' He liked places that were not fancy, such as the A.B.C.'s, and people who went about work without unnecessary fuss. Probably one of the reasons for 'blessing' prize fighters, music hall entertainers, and aviators in *Blast* was that they were not arty."[6]

Lewis' relations with the terribly proper and wealthy female Vorticists were rather different than with the more threatening men. Helen Saunders and Jessica Dismorr were close friends who adored Lewis and suffered from his indifference. He possessed physical charm and intellectual power; was attractive as a man and as an artistic mentor. He had a strong sexual urge and his art was stimulated by his physical relationships. But he was careless and irresponsible with women, wary of emotional attachments that would interfere with his work, unwilling to expose his own feelings and hypersensitive about his constant poverty.

Saunders' father was a barrister and director of the Great Western Railway. She was brought up by governesses and tutors, and shocked her parents by leaving home in her early twenties to study briefly at the Slade. Her elder sister, Ethel, expressed the family sentiment by saying Lewis' influence on Helen had been disastrous: he had dangerous ideas, represented a chaotic way of life and had led her astray.[7] Etchells said that Saunders, whom Lewis had drawn a number of times, "was completely potty about Lewis. If Lewis had painted Kate Greenaway pictures, Saunders would have done them too: she had a schoolgirl 'pash' on him."[8] Her feelings about Lewis, who corresponded with her while in the Army, remained strong until after the War; and in 1920 he had to call in her brother to free himself from his entanglement with her. A. R. H. Saunders wrote: "My wife has seen Helen today, and the result is that she promised not to see you, or communicate with you in any way, in the future. . . . It is quite evident that she failed altogether to understand the position, probably owing to the fact that we have been a little too anxious not to hurt her feelings by speaking plainly."[9]

A letter of 1914 from Lewis to Jessica Dismorr reveals that the two women were rivals for Lewis' affection and that he had to be very

tactful in order to maintain good relations with both of them: "I enjoy talking to you very much, and admire, as you know, your gifts as an artist. I should therefore be sorry if anything unpleasant occurred to disturb the even tenor of our intercourse. But I also value Helen Saunders very highly, & I would avoid at all costs giving her cause of mortification." Most of his letters to Dismorr discuss her poor health and postpone his appointments with her. After the War, Dismorr did a pencil drawing of Lewis seated on a chair and playing with a small dog; and she exhibited with Group X and contributed to *Tyro 2*. In October 1924, when Lewis was writing his long books and very pressed for money, she invited him to come to Paris for a week: "We would have such a good time—there are lots of people who are dying to meet you & I can pay for drinks & dinners occasionally."

But Lewis' humiliating poverty poisoned this relationship—and many others. In May 1925 Lewis told Dismorr that he was hard up and asked her to buy some of his drawings. Her income had been sharply reduced at that time, and when she replied that she could not afford the drawings Lewis—who was quick to sever relations with friends and patrons who offended him—ended their correspondence with a cruel letter that accounted for all his cancelled appointments: "I would much rather not receive letters from you holding out those tantalizing prospects every few months or weeks. I have meant to suggest to you for some time past that the moment had arrived for our acquaintanceship to terminate, and avail myself of this opportunity for doing so. . . . I find you a dull person, and the fact that I have known you for so long does not release me, in your company, from a sense of oppression. The fact that you are possessed of a fixed idea that everybody, wherever you are, is *after your money*, does not improve matters." Yet Lewis had a powerful hold on her feelings and the break was not final, even after this letter. He was still writing to her in November 1928, when she sent him thirty pounds.

Two years later Dismorr spoke bitterly about Lewis and warned a common acquaintance that he was selfish and exploitive—a charge that would be repeated by others who rarely understood that he was financially desperate: "Don't treat him as a friend or think he'll do anything for you—for he only makes use of people—and he'll throw you over." Yet Quentin Stevenson, in an exhibition catalogue of 1974, praised Lewis' encouragement of Dismorr's art and his patience with a difficult and sensitive woman whose psychological problems and emotional upheavals often exasperated him: "Though it is doubtless true that his interest in her was partly financial, he had genuine regard for her work. The earlier letters are generous in their encouragement, almost fulsome in their praise. They also show surprising patience with a woman whose illnesses, both mental and physical, were an interruption to good work. In later life he spoke warmly of her talent."[10]

Though Lewis was irritated by his quarrels with the Vorticists, the tremendous vitality of artistic life in prewar London put him into stimulating and often inspiring personal contact with men like Pound, Hulme and Gaudier. These artists gathered with their friends at the bohemian Café Royal, at Ford and Violet Hunt's South Lodge, at the Rebel Art Centre, at Hulme's adopted salon in Mrs. Kibblewhite's house on Frith Street and at Stulik's accommodating Tour Eiffel Restaurant—the favourite refuge of the Vorticist group.

Rudolf Stulik,[11] the Viennese proprietor of the Tour Eiffel at 1 Percy Street (next to Lewis' flat), had once been chef to the Emperor Franz Josef, and had the same protruding stomach and bulbous nose. He liked to hint that he had come into the world after a "romantic, if irregular attachment, in which the charms of a famous ballerina had overcome the scruples of an exalted but anonymous personage." He was an intelligent, amusing and generous man, with a great fondness for artists, and used to repeat in his rapid, heavily-accented English: "I vould to anyting for Mr. Levis." Stulik's decor was simple, with little tables and pink-shaded lights, but his food was elaborate and expensive. After hours, when a large blind covered the front window, well-known customers were admitted through a side door to a private dining-room on the second floor. On the top floors was the comfortably cheap hotel, filled with heavy Biedermeyer furniture, where bedrooms were available without embarrassing questions. In January 1916 Lewis, with the assistance of Helen Saunders, finished his third commission: three abstract panels for a Vorticist Room in the Tour Eiffel. On February 23 Stulik sponsored a Vorticist Evening to celebrate the completion of the work. These panels were destroyed when the place was sold in 1938, and it became the fashionable and even more expensive White Tower Restaurant.

William Roberts' stylized, nostalgic painting, *The Vorticists at the Restaurant de la Tour Eiffel: Spring 1915* (1962), captures the solemn festivity of the people and place (though the *Blast* party was actually held at a different restaurant). Lewis, with overcoat, scarf and sombrero, dominates the group at the center of the painting. He is surrounded by Hamilton, Pound, Roberts, Etchells and Wadsworth, who are absorbed in conversation and ignore the late entrance of Saunders and Dismorr through the low rear door. Stulik, with moustache and bulging stomach, offers a Viennese cake. A "Vorticist" painting of a mechanical boxer, rope-jumper and weight-lifter appears on the wall behind Joe, the bald waiter, who serves the ladies champagne to celebrate the publication of the brightly coloured *Blast*. One copy of the "puce monster" lies flat on the table while another, prominently displayed by Etchells, shows the thick black capitals running diagonally across a lucent pink cover.

2

The strongest influence on Vorticism and on *Blast* was Italian Futurism, especially its manifestations in England between December 1910, when F. T. Marinetti first lectured in London, and the spring of 1914, when he gave a bizarre series of *conferenze* at the Doré Galleries. Marinetti was born in Alexandria in 1876 and came from a rich north Italian family with business connections in Egypt. Lewis was fond of saying that Marinetti's lavish funds were profits from his father's chain of high-class Egyptian brothels. He looked like a Milanese merchant and wore spats, tailored suit, wing-collar, bow-tie, turned-up moustache, sleek hair and bowler hat. He was "a flamboyant personage adorned with diamond rings, gold chains and hundreds of flashing white teeth." André Gide, who was bored and irritated by his posturing and shocking lectures, recitals and demonstrations, was more severe: "At two o'clock there came a certain Marinetti, editor of a review of artistic junk called *Poesia*. He is a fool, very rich and very self-satisfied, who has never learned how to keep silent. . . . Marinetti enjoys a lack of talent that permits him to indulge in every form of audacity. . . . He paws the ground and sends up clouds of dust; he curses and swears and massacres. . . . [He is] animated in the Italian fashion, which often takes verbosity for eloquence, ostentation for wealth, agitation for movement, freshness for divine rapture."[12]

Despite his obvious faults, Marinetti was a dynamic and stimulating innovator (though not in Gide's mode) who helped to jolt the phlegmatic English public out of their smug indifference and to focus their attention on the excitement of contemporary art. On November 18, 1913, Lewis and Christopher Nevinson, Marinetti's disciple and the leading English Futurist, organized a dinner at the Florence Restaurant on Rupert Street in Soho to welcome the Italian to London. About thirty of the English intelligentsia, including Harold Munro, Laurence Housman and R. H. Wilenski, paid three shillings each to dine with Marinetti and hear him zoom and boom his crashing onomatopoeic poem "The Siege of Adrianople" while the band downstairs played "You made me love you." Lewis later claimed that hearing Marinetti's effective if thunderous bombardment "battle-trained" him for the heavy gunfire on the Flanders front, which seemed by comparison "all quiet": "Signor Marinetti on the platform was a frenzied Jack-in-the-Box. He sprang about, a torrent of words pouring incessantly from his mouth. They were great percussive words, which smote the eardrum with the impact of the bark of a howitzer. All of them added up to one thing—to force, to speed, to power. This embryonic fascist possessed the personality of a Levantine bagman, but he put on a good act. He had been a war-correspondent in the Balkans and his 'poems' about war

were full of the din of modern battle. Banging and popping, rattling and whistling—the sweat pouring from him—he grimaced and shouted at you from the platform and really made you feel you had been at the heart of a barrage."[13]

Futurism, like Vorticism, took a didactic, declamatory and defiant stance; attracted a great deal of provocative publicity; and provided aesthetic theories, pictorial models and inflammatory manifestos. Boccioni used the term *vortice* in his *Pittura Scultura Futuriste* (1914) and Balla painted eight works entitled *Vortice* during 1913–1914. In *Blast 2* Lewis called Balla and Severini, who had exhibited at the Sackville Gallery in March 1912, "two of the most amusing painters of our time." He praised the invention of new forms, and the structure and clarity of their vertiginous paintings, qualities so notably absent from the work of the French Cubists. The Futurists insisted on the importance of the present, praised the joys of speed and advocated violent action which would destroy the bankrupt artistic culture that still clung to decorative forms and outworn values. Lewis supported the negative aspects of their demolition program, which generated excitement, aroused attention to art and helped him formulate a new aesthetic.

Once the original excitement had died down, the intensely intellectual Lewis was bored by the Italian's strident publicity stunts and (like Gide) thought him something of a buffoon. He became antagonistic to Marinetti, as he had to his earlier artistic mentors and rivals: Augustus John, Walter Sickert and Roger Fry. He disagreed with the violent and emotional theories of Marinetti—who was a propagandist, not a painter —and wanted to purge Futurism of error and purify its doctrine. The opportunity for a complete break with the Futurists came on June 7, 1914, when Marinetti and Nevinson published a Futurist Manifesto in the Sunday *Observer*—using the stationery of the Rebel Art Centre. The Manifesto attacked *passéism*, the academies, sentimentality, mock medievalism, "Maypole Morris dances, Aestheticism, Oscar Wilde, the Pre-Raphaelities, Neo-primitives," sham revolutionaries and the indifference of the State toward the arts. In the last paragraph they portrayed Lewis and the other Vorticists in the subsidiary role of Marinetti's commandos: "the great Futurist painters or pioneers and advance forces of vital English Art."

Five days later, Lewis gathered his disaffected artistic allies and led them into the Doré Galleries on Bond Street to disrupt Marinetti's explosive evening lecture, which was accompanied by Nevinson banging on a drum: "It started in Bond Street. I counter-putsched. I assembled in Greek Street a determined band of miscellaneous anti-futurists. Mr. Epstein was there; Gaudier-Brzeska, T. E. Hulme, Edward Wadsworth and a cousin of his called Wallace, who was very muscular and forcible, according to my eminent colleague, and he rolled up very silent and

grim. There were about ten of us. After a hearty meal we shuffled bellicosely round to the Doré Gallery. Marinetti had entrenched himself upon a high lecture platform, and he put down a tremendous barrage in French as we entered. Gaudier went into action at once. . . . He was sniping him without intermission, standing up in his place in the audience all the while. The remainder of our party maintained a confused uproar."[14]

And on June 14, in the next *Observer*, the Vorticists, who had been unwillingly drafted into Futurism, angrily severed themselves from Marinetti's rival band: "We, the undersigned . . . beg to dissociate ourselves from the 'futurist' manifesto which appeared in the pages of the 'Observer' of Sunday, June 7th. . . . The Direction of the Rebel Art Centre wishes to state that the use of their address by Sig. Marinetti and Mr. Nevinson was unauthorised."[15]

Lewis had to dissociate himself from Futurist influence in order to maintain his independence, to capture their publicity and to emphasize the originality of his own movement. When Marinetti asked him to declare himself a Futurist, Lewis attacked his naive and romantic idealization of technology: "It has its points. But you Wops insist too much on the Machine. You're always on about these driving-belts, you are always exploding about internal combustion. We've had machines here in England for a donkey's years. They're no novelty to *us*." When Marinetti glorified the intoxicating thrill of speed, Lewis emphasized the importance of the still moment, the visual element and the clear line: "I loathe anything that goes too quickly. . . . I cannot see a thing that is going too quickly," and he capped the argument by quoting Baudelaire's *"La Beauté"*: *"Je hais le mouvement qui déplace les lignes."*[16]

In later works, like *Time and Western Man* (1927), Lewis justified his rejection of Marinetti and associated his accelerated Impressionism with Bergsonian flux—the passing rather than the fixed moment: "The italian futurists—with their evangile of *action*, and its concomitants, speed, violence, impressionism and sensation in all things—incessant movement with the impermanence associated with that, as the ideal of a kind of suicidal faith—they were thorough adepts of the Time-philosophy: and Marinetti, their prophet, was a *pur-sang* bergsonian." And in *Anglosaxony* (1941), he retrospectively connected Marinetti with Mussolini: "In the writings of Marinetti . . . you will find the pure fascist doctrine of force, as it first burst forth upon the world in pamphlet after pamphlet, and as it was spouted forth in speech after speech, upon the lecture platform and before English and European café audiences. There is no better guide to fascism, its meaning and its methods, than this great verbal diarrhoea, its original inspiration."[17]

3

Ezra Pound, who first used the Cartesian and Blakean word "vortex" in his poem "Plotinus" (1908) and the name "Vortex" in a letter of December 1913, later wrote that his "First connection with vorticist movement [was] during the blizzard of '87 when I came East, having decided that the position of Hailey [Idaho] was not sufficiently central for my activities."[18] Though this stormy movement ended more than sixty years ago, its aesthetic principles have remained blurred. This is partly because it was defined in various ways by Lewis, Pound and Gaudier, and because its members were either dispersed or destroyed by the Great War before the movement could fully develop. Vorticism tried to synthesize the innovative and iconoclastic aspects of Post-Impressionism, Expressionism, Imagism, Cubism, Futurism and abstract painting; was influenced by the theories of T. E. Hulme, who emphasized the importance of African and Polynesian sculpture and praised hard, angular, geometric art; combined primitivism and technology; was fascinated with machinery, the city, energy and violence; was characterized by dissonance and asymmetry, iron control and underlying explosiveness, classical detachment and strident energy; reflected "steel and stone in the spirit of the artist"; and expressed dynamic emotion in abstract design. The Vorticist stood at the heart of the whirlpool, at once calm and violent, magnetic and incandescent: at the great silent radiant place where energy and ideas are concentrated, where (like a waterfall) form is created and maintained by force. Lewis ventured a rather abstract definition in the Vorticist exhibition catalogue of June 1915, and placed himself in dialectical opposition to Picasso, the Naturalists and the Futurists: "By Vorticism we mean (a) *Activity* as opposed to the tasteful *Passivity* of Picasso; (b) SIGNIFICANCE as opposed to the dull or anecdotal character to which the Naturalist is condemned; (c) ESSENTIAL MOVEMENT and ACTIVITY (such as energy of a mind) as opposed to the imitative cinematography, the fuss and hysterics of the Futurists."[19] The Vorticists emphasized the individual artist's intense reaction against the social calm and fixed order, which seemed to prevail before the War, and anticipated the violence and destruction that would soon extinguish traditional life in Europe.

Though Pound tried to discuss Lewis' early works—*Enemy of the Stars* and *Tarr*—in relation to the art movement, there was no school of Vorticist writers. But one extraordinary passage in *Tarr*, when Kreisler rapes Bertha (in a "whirlpool" and "catastrophic rush") and she visualizes a series of fragmented beings, clearly attempts Vorticist effects. This clear, sharp, jagged prose comes closest to Lewis' detached and dynamic style of geometric painting: "She saw side by side and unconnected the silent figure engaged in drawing her and the other one

full of blindness and violence. Then there were two other figures, one getting up from the chair, yawning, and the present lazy one at the window—four in all, that she could not bring together somehow, each in a complete compartment of time of its own. It would be impossible to make the present idle figure at the window interest itself in these others."[20] The keyed-up, cryptic, hard-edged style makes *Tarr* a novel that conveys not a message about life, but a particular way of seeing life: cynical, intensely self-conscious, and critical of the self as well as of society.

The five cold, steely, mechanical drawings, which Lewis executed in 1913–1914 and reproduced in *Blast*, represent his most extreme phase of abstract art. He later called his Vorticist paintings "a fantastic branch of architecture" and described the disturbing effect of his early style: "I painted a number of 'abstract' figures, which nobody could understand, but which were in fact severely classical. . . . People supposed these incomprehensible oddities to be so revolutionary and satanic that the thought of them kept them awake at night." Though he had deliberately tried to eliminate all reference to the natural world, Lewis later felt that totally abstract art produced a dull and dehumanized vision: "Beyond a certain well-defined line—in the arts as in everything else—beyond that limit there is *nothing*. Nothing, zero, is what logically you reach past a line, of some kind, laid down by nature."[21]

4

In less than a year, between October 1913 and June 1914, Lewis moved from the decoration of Omega fans to the violence of *Blast: The Review of the Great English Vortex*, which had a profound effect on modern typography. The cost of printing the 1,700 copies was paid by Lewis' mother and by £100 from Kate Lechmere, who took several of Lewis' paintings as collateral and ordered fifty copies of the magazine. Nevinson suggested the name, which meant to blow away dead ideas and worn-out notions, and Lewis asked Pound to give him something nasty for *Blast*. John Lane, who had brought out the *Yellow Book* in the 1890s, agreed to publish the magazine, and two full-page advertisements appeared in the *Egoist* on April 1 and 15, 1914. The second notice boldly announced a new quarterly at 2s. 6d., instructed subscribers to send their checks to Lewis' flat at 4 Percy Street, promised a "Discussion of Cubism, Futurism, Imagisme and all Vital Forms of Modern Art," and proclaimed, with Nietzsche, the "END OF THE CHRISTIAN ERA."

Douglas Goldring wrote: "As *Blast* was designed to be totally unlike any previous publication in typography and lay-out, [Lewis] required a

printer humble enough blindly to carry out his instructions. After making inquiries I found him a small jobbing printer [Leveridge & Co., still in business] in the outlying suburb of Harlesden, who seems to have done what he was told to do."[22] All the other printers who had been approached thought *Blast* was too ugly, crazy and difficult to do, and Lewis had to supervise Leveridge very carefully and guide him through all the complicated details. By the time Lewis reached Canada in the 1940s *Blast* had acquired legendary status and Leveridge had become a dramatic alcoholic. Lewis told Marshall McLuhan, who reproduced his typography in *Counterblast* (1954), that after long searching "He finally found a skid-row character who had been a typographer, and he supplied him with all the gin necessary, and the chap did the job for him in thanks for the gin. Lewis himself was very fond of gin. It was his favorite drink."[23]

The innovative typography and imaginative format, pulsating polemics and lavish distribution of "blasts" and "blesses" were deeply indebted to Marinetti's book *Zang Tumb Tuuum* (1914) and to the "*merde à . . . rose à . . .*" of Apollinaire's four-page Futurist proclamation, "*L'Antitradition futuriste,*" which had appeared in Marinetti's Florentine magazine, *Lacerba*, in June 1913. Goldring noted that the spontaneous and witty catalogue of "blasts" and "blesses" was drawn up during an inaugural tea party at Lewis' studio: "Lewis and Ezra Pound presided over it jointly, and the guests were the oddest collection of *rapins* in black hats, girls from the Slade, poets and journalists. We solemnly compiled lists of persons who should be blasted and of others who should be blessed."[24] The former were often, in Lewis' eyes, eminent bores (the Beechams, Bergson, Annie Besant, Marie Corelli, Croce, Elgar, Galsworthy, Tagore and Sidney Webb) while many of the latter turned out to be particular favorites of the compilers and were rewarded for services to the arts (J. M. Barrie, Gilbert Cannan, Cunninghame Graham, Frank Harris, Joyce, Konody, Kate Lechmere, Leveridge the printer, Frank Rutter and Frida Strindberg).

An amusing footnote in chapter 4 of Evelyn Waugh's *Vile Bodies* (1930)—which was influenced by Lewis' theory of comedy and satiric technique (and contains a character called Mrs. Ape)—parodies the catalogue of people and things blasted and blessed by Lewis, shows the social effect of his iconoclasm, and reveals how the fashionable world domesticated and debased his advanced ideas: "Finally there was the sort [of invitation cards] that Johnny Hoop used to adopt from *Blast* and Marinetti's *Futurist Manifesto*. These had two columns of close print: in one was a list of all the things Johnny hated, and in the other all the things he thought he liked. Most of the parties which Miss Mouse financed had invitations written by Johnny Hoop."

Lewis later endorsed *Blast*'s caustic but healthy effects and insisted:

"I am all in favour of a young man behaving rudely to everyone in sight. This may not be good for the young man, but it's good for everyone else."[25] In the first challenging Manifesto, "Long Live the English Vortex," Lewis exclaimed:

To make the rich of the community shed their education skin, to destroy politeness, standardization and academic, that is civilized, vision, is the task we set ourselves. . . .

WE ONLY WANT THE WORLD TO LIVE, and to feel its crude energy flowing through us. . . .

Blast sets out to be an avenue for all those vivid and violent ideas that could reach the Public in no other way. . . .

Blast is created for this timeless, fundamental Artist that exists in everybody. . . .

We will convert the King if possible. A VORTICIST KING! WHY NOT?

There was also considerable seriousness beneath the strident surface. The first *Blast* contained the opening chapter of Ford's *The Good Soldier*, some of Pound's minor poetry, Lewis' obituary of Spencer Gore and his fantastic play, *Enemy of the Stars* (whose title echoed Marinetti's epic, *La Conquête des étoiles*). The play takes place in "Some bleak circus, uncovered, carefully-chosen, vivid night," in which throng "enormous youngsters, bursting everywhere through heavy tight clothes," "laboured in by dull explosive muscles, full of fiery dust and sinewy energetic air." It essentially concerns the artist's conflict between his intellectual and sensual self, and pessimistically argues that "The process and condition of life, without any exception, is a grotesque degradation, and 'souillure' of the original solitude of the soul." Its violent ending—when Hanp stabs Arghol and leaps into a canal—is the prototype for the conclusion of virtually all of Lewis' imaginative works.

Blast also included the young Rebecca West's feminist story "Indissoluble Matrimony," which had been rejected by Austin Harrison, Ford's successor on the *English Review*; Wadsworth's review of Kandinsky's theoretical book, *On the Spiritual in Art*; drawings by Lewis, Gore, Gaudier, Epstein, Wadsworth, Etchells, Hamilton and Roberts; and the Vorticist manifestoes. The lasting significance of all the contributors, after sixty-five years, is a striking tribute to Lewis' editorial genius. He was forced to censor part of "Fratres Minores," a poem by Pound, who "cheered things up a little by a couple of 'fresh' lines: namely 'The twitching of two abdominal muscles, cannot be a lasting Nirvana.' John Lane, the publisher of *Blast*, asked me to come and see him, and I was obliged to allow him to black out these two lines. Happily the black bars laid across them by the printer were transparent. This helped the sales."[26] Lewis had held an inaugural *Blast* party at the Cave of the Golden Calf in the spring; and on July 15 he arranged

a grand dinner for his followers at the Dieudonné Restaurant on Ryder Street, St. James's, to mark the June 20 publication of "the great MAGENTA cover'd opusculus."

The ferocious and witty *Blast* inflicted some necessary flesh wounds and shell-shock on the Heartbreak House England of 1914, which was almost completely cut off from contemporary art movements on the Continent. "What's the use of being an island," Lewis asked Augustus John, "if you're not a *volcanic* island?"[27] Lewis became the chief interpreter of European aesthetic theory, introduced an entirely new way of looking at painting, started the English avant-garde movement before the War and was a potent inspiration to the leading artists and writers. The young Henry Moore, for example, read *Blast* and *Tarr* with the greatest interest and enthusiasm, and felt the salutary effect of their energetic strictures. Moore liked the Vorticist emphasis on will and on the self-created power of the artist as well as Lewis' insistence on direct carving in stone. He found Lewis' intellectual eclecticism a useful antidote to Fry and Bloomsbury, who emphasized only one kind of French art. Lewis was an igniting figure who carried tremendous prestige in the world of art and literature, and was a model for the kind of artist that Moore wanted to become.[28]

Many conventional critics and readers were alienated by the shocking presentation of anarchic ideas, which the *Morning Post* referred to as "irrepressible imbecility," and by the strange combination of inspired jokes and defiant challenges. When Lechmere asked Arthur Symons if he had read *Blast*, the poet replied: "No, I have given it to my children in the nursery to teach them their ABC." But two of the most intelligent contemporary critics saw its value and praised the magazine. Ford (admittedly a contributor) called it "very amusing, very actual, very impressive"; and Orage emphasized its intellectual origins and its most original pieces: "It is, I find, not unintelligible as most of the reviewers will doubtless say—but worth understanding. Blake, it is certain, has gone into the making of it. 'Enemy of the Stars' deserves to be called an extraordinary piece of work."[29]

Despite some appreciative reviews, the sale of *Blast* did not earn enough to pay the printer's bill, which was double the original estimate; and Lewis made nothing to live on while he painted and wrote *Tarr*. When the second *Blast* appeared in July 1915 and Lechmere nagged him to repay the loan, he quarrelled bitterly with her and complained: "You have, as you know, vilified me in every way you could to everybody you know."[30] The Rebel Art Centre and Lechmere's patronage terminated as suddenly and angrily as Strindberg's Cave of the Golden Calf.

But the publication of *Blast* cemented Lewis' friendship with Pound and Gaudier. Pound, casting himself in the role of an oriental sage,

wrote that "Lewis supplied the volcanic force, Brzeska the animal energy, and perhaps I had contributed a certain Confucian calm and reserve. There would have been no movement without Lewis."[31] But in his criticism of Pound as a "revolutionary simpleton" in *Time and Western Man*, Lewis awarded Pound very little credit for the Vorticist achievement, regarded his contributions as "compromisingly *passéiste*" and emphasized the difference between Pound's wild theory and mild practice: "What struck [the Vorticists] principally about Pound was that his fire-eating propagandist utterances were not accompanied by any very experimental efforts in his particular medium. . . . This certain discrepancy between what Pound said—what he supported and held up as an example—and what he did, was striking enough to impress itself on anybody. . . . Pound's antiquarian and romantic tendencies, his velvet jacket and blustering trouvère airs [were outmoded]."[32]

Lewis was more affectionate toward Gaudier, an exceptionally gifted sculptor, with a slender build, an ascetic-looking hawk-like face, thin lips and nose, and long dark hair. He spoke with a heavy French accent and had a tolerant smile, delicately moving hands and an abundance of nervous energy. "Gaudier, though I knew him very little, I always liked," Lewis wrote. "This little sharp-faced, black-eyed stranger . . . lived under a railway arch with a middle-aged Polish sister who was not his sister. . . . He was gentle, unselfish and excitable."[33] Though Gaudier was heroically poor, like most of the male Vorticists (Wadsworth was the exception) he refused to work in a pleasing, saleable style. In March 1914 Gaudier returned Lewis' admiration and praised his work at the Allied Artists' show for its marvellous draughtsmanship and originality: "Wyndham Lewis had made enormous progress in his painting. The two small abstractions 'Night Attack' and 'Signalling' are such very complete individual expressions that no praise is sufficient to adequately point out their qualities. These are designs of wilful, limited shapes contained in a whole in motion—and this acquired with the simplest means—ochres and blacks. Lewis' abstractions are of a decided type and their composition is so successful that *I feel right in seeing in them the start of a new evolution in painting*."[34]

The War that began in August 1914 demolished the vital and promising world of prewar Europe, and the very machinery that had recently been glorified by the Vorticists blasted out of existence the greatest art movement that had ever appeared in modern England. The "Men of 1914"—Lewis, Pound, Eliot and Joyce—belonged to a confident future that failed to materialize. All the Vorticist painters went to war; Gaudier and Hulme never returned. Though Vorticism suffered a sad and sudden demise, its achievement was significant. Richard Cork properly claimed that "They managed to forge an identifiably national art . . . from a radical international context; they created a highly

abstract vocabulary which retained manifold and enriching links with the form-language of the visible world; and they demonstrated in a taut, bracing and often exhilarating manner how . . . to fully take account of even the most terrifying aspects of twentieth-century life."[35] Though Lewis had immensely productive careers as a painter and writer, he never recaptured the successful vitality of Vorticism and never fully recovered from its tragic destruction.

CHAPTER SIX

The Great War,
1914–1918

I

Lewis' sexual life was closely related to his creative impulse, and he needed a stream of women for distraction and inspiration. With artistic allies like Lechmere, Saunders and Dismorr as well as with new mistresses—Beatrice Hastings, Mary Borden Turner and Alick Schepeler —he led an active, if emotionally detached, sexual life. There is no evidence that he fell in love with any of these women—for he seemed to prefer casual rather than serious relationships—but he must have spent a considerable amount of time and energy in conducting these affairs. His attitude toward sex was deliberately offhand and sardonic, if we are to believe one of his anecdotes. He was copulating with his landlady's daughter on the floor of the hallway when, much to his amusement, the post was delivered and a shower of letters fell on his bare behind.

But these sexual adventures were not without real hazards. Just before the outbreak of the War Lewis again contracted a "ridiculous" but troublesome venereal infection which led to septicaemia, kept him immobilized in bed for ten days at a time while he attempted to treat himself and to avoid an operation, and made him an invalid, on and off, for six months. In the days before penicillin, it took a long time to recover from gonorrhea; and this disease also led to very serious and painful complications for Lewis in the 1930s. Lewis refers to this illness in his two autobiographies; and in the synopsis of his last, projected novel, about the life of a young artist, he noted, with some irony: "As to the private life of this brilliantly gifted young man, destined for a career of early success, these pages chronicle a misadventure, when he contracted the most serious of venereal complaints."[1]

Lewis enjoyed manly intellectual *camaraderie* as an antidote to what he felt were degrading yet necessary relations with women, whom he considered less intelligent than men and resented for their power to awaken and exploit his passions. In "The Code of a Herdsman" he asserted: "As to women: wherever you can, substitute the society of men. Treat them kindly, for they suffer from the herd. . . . Women, and the processes for which they exist, are the arch conjuring trick: and they

70

have the cheap mystery and a good deal of the slipperiness, of the conjuror." While suffering illness, depression and boredom he wrote to Etchells: "Leaving cunts on one side, you're the only person in London I really care to see or talk to—just now I'm sick to death of clap and poverty & inactivity."[2] When Lewis got the clap and asked the more experienced Sickert how to deal with it, the painter cavalierly replied: "Treat it like a common cold. I've had it dozens of times."[3]

Richard Aldington found Lewis' disease much more alarming, was shocked by his behavior and felt he was strangely oblivious of responsibilities: "Not long after I was married to H.D. [in 1913] he came one afternoon and asked me to lend him my shaving things. As he completed he remarked that he had been copulating for three days! (I hated his attitude toward women.) Now mark. Some time later I ran into him in a little restaurant in Church St. (W.8) and halfway through dinner he announced he had a clap! Nice for me with a young wife to think he had used my shaving brush a short time before! Nothing happened to us, thank goodness."[4] Lewis, who often boasted about having venereal disease, which he thought was a sign of potency, was probably unaware of the malady when he visited Aldington's flat. In any case, Aldington could not have caught clap from a shaving brush.

During intervals of good health Lewis wrote *Tarr*, which he had started as early as 1909, and completed the novel high up on the fourth floor of 18 Fitzroy Street, where he had moved at the beginning of 1915. He took the bulky but precious manuscript with him whenever he left his flat, and carried it to restaurants and cinemas in a small attaché case. He was prepared for the worst in the War; and finished the book before he enlisted, so he would have at least one major novel to his credit if he were killed.

Lewis also showed *The Crowd* and *Workshop*—the only two of the fifteen prewar paintings that have survived—in the Second London Group exhibition at the Goupil Gallery in March; and wrote an Introduction to the catalogue of the first Vorticist exhibition at the Doré Galleries in June 1915, where he showed four paintings and six drawings. The critics recognized the Vorticists' similarity of purpose and method, but reacted with uniform hostility to their unprecedented degree of abstraction.

Lewis had met the fiery feminist Beatrice Hastings, a married woman who had been A. R. Orage's co-editor and mistress, when he first contributed to the *New Age* in 1910. He had a brief but stormy affair with her between the time she left Orage in 1914 and became the mistress of Modigliani the following year. Hastings, who was born in South Africa in 1879, was an attractive woman with dark skin and brown eyes. She was caustic, vivacious, intelligent and intensely emotional; and was portrayed in Francis Carco's *Les Innocents* (1916), a popular

novel of low life in Montmartre, as a woman who had strangled her lover in order to discover how it felt to be a murderer. In 1914–1915 Hastings sent Lewis a pitiful farewell letter that revealed the depths of feeling he was able to arouse in independent yet vulnerable women:

I cannot see you again for a long time. My love for you is altogether beyond me. You become more adorable every time I see you & when I realise how things are I am near fainting; I am just recovered from one of a hundred bursts of pain and tears. It is always tears now. You will let me tell you this because I like you so much as well as love you & I am sure you like me. . . .

I am afraid of being alone. Now, I scarcely dare think of the late hours of tonight when you will not have come. I am afraid of losing my nerve, & crowds pass these horrible hours away. I don't know whether going away will help me. But it will be mad to stay where I see you & always with more delight, & with grief. I think you have often forgotten that I have the tempera- ment of a poet, but I would sooner blame myself or any thing than you. You see I am quite lost. It will be no use if you behave ever so badly because of this, I should never believe you meant to hurt me now I have told you beyond any doubt of my perfect admiration.[5]

In the spring of 1914—while he was running the Rebel Art Centre, preparing *Blast* and seeing Beatrice Hastings—Lewis met (through Ford or the publisher John Lane) the American heiress, amateur painter and popular writer Mary Borden Turner. May (as she was called) was born in Chicago in 1886, graduated from Vassar, married just after college and then divorced her first husband, travelled around the world and finally settled in England. When Lewis met her she was married to a red-haired Scottish missionary, George Douglas Turner, and had two young daughters and a new infant. She had published two works of fiction under the pseudonym of Bridget McLagen in 1912–1913, and Ford courteously said "the delightfully dainty little blonde lady" was "a novelist of really great gifts and authenticity." Though Lewis also called her attractive, her friend Juliette Huxley wrote: "She was not pretty in the usual meaning of that word, her teeth were blackened by constant smoking, and her American voice resisted all effort at improvement. . . . She was intelligent and quick, witty and a brilliant hostess. She was also very knowledgeable about politics and many international problems, and her parties were always remarkable."[6] She introduced Lewis and Shaw, who went to the opera and found they had nothing to say to each other.

In 1914 Mrs. Turner bought several paintings by Lewis, including *Slow Attack* and *The Crowd*, and in June she commissioned him to decorate her drawing-room at 33 Park Lane, where she lived in grand style. She cancelled the project when the War started, but paid Lewis £50 for his plans and £200 for his pictures. When Lewis fell ill in July, the hospitable Mrs. Turner invited him to join Ford and Violet Hunt,

and recuperate at Charter Hall, the country house she had rented across the Scottish border in Berwickshire. Ford, whose account was characteristically unreliable, called the manor delightful, though in July Mrs. Turner told Lewis that she disliked the location of the dreary grey house, which reminded her of a middle-class Glasgow suburb.

Lewis soon formed a close friendship with Mrs. Turner, and in January 1915 he told Pound about her grandiose and unrealistic plans for a kind of one-man Rebel Art Centre: "The excellent Mrs. Turner is going to take a large studio or hall near Park Lane and there house my squadron of paintings, until after the war a large building is constructed for them in the rear of her own house. She will pay the rent, furnish it, and I suppose supply a page boy or secretary: also a stage for Theatrical Performances, Lectures, etc."[7]

At about this time Mrs. Turner wrote a pleasing and intimate note, arranging to see Lewis when her husband (whom she divorced in 1918) was out of town on religious business: "My Dear. . . . Next week I want Wednesday and Thursday evenings with you. Can I have them; D[ouglas] is going away. . . . You are nicer than anyone else, even when unshaved. . . . Next week I've three clear days. Please make them nice for me." After spending the night with Lewis in his seedy flat, she sent a rather abject love letter that expressed her infatuation with him: "It doesn't matter, does it, whether I understand your technique or not as long as I adore you, not too stupidly? If I'm an artist at all it is in living. . . . You are a genius and you might be cruel to me some day were it not for this. Anyhow—I don't care. . . . I lay awake last night and heard you snoring peacefully in the place that was once a brothel, but I didn't want to cut your throat. . . . I am happy with that delicious 'malaise' that comes when one is obsessed by another personality."

But their relationship soon deteriorated, probably because of her vanity and possessiveness, his callousness and cruelty, and the fatal mixture of sex and patronage which lacked a "primitive" element and suggested slumming and sexual exploitation:

You have made me unhappy. You hurt me. I can't go on like this. You must be considerate and human. You must not tell me to come to John Lane's and then get drunk and go away without seeing me. You've no idea how these little episodes interfere with the current of primitive feeling. I could love you madly and give you pleasure if you'd just take a little trouble, to be courteous. You say I'm not primitive enough and I—good God. Your voice was horrid over the phone. I love you. And you must think for me, sometimes, and of me.[8]

Something ugly, unpleasant, has grown up suddenly out of our intercourse. . . . We get on each other's nerves. We are bored with each other. We offend each other. . . . I feel that I have been tactless, inconsiderate and stupid on several occasions. I am sorry. This is because I am vain and spoiled, but I

am also fine enough to know that you are a great artist. You *are* a great artist—you are also a faulty human being and you have hurt me, many times.

Their affair ended when Lewis quarrelled with her about money, and Mrs. Turner left to equip and direct a mobile military hospital at the front. In France she met Major-General Sir Edward Spears, the chief liaison officer between the English and French armies, became Lady Spears in 1918, resumed her sumptuous style of life and continued her career as a successful novelist.

Lewis seemed to feel much more at ease with Alick Schepeler, who worked as a secretary on the *Illustrated London News*, was interested in the arts and had been the model and mistress of Augustus John in 1906–1907, when he informed her about Lewis' adolescent longing for the ladies of Normandy. Her exotic background must have appealed to Lewis' taste for all things Russian. Alick was born in Russia the same year as Lewis and grew up in Poland, where her mother became a governess after the death of her German father. The moody and highly-strung girl, who was obsessed by clothing, had luxurious brown hair, deep blue eyes and a rich slightly accented voice. She was unpretentious, passionate and (unlike most of her contemporaries) eager for love affairs. John, who was fascinated by Alick for a time and did some very successful portraits of her, called her his *"jeune fille mystérieuse et gaie."*

In mid-1915 Lewis wrote apologetically to Alick: "I cannot describe my resentment against a woman who made me drunk last Saturday afternoon. . . . I was maudlin and very insolent." And in June he wrote a tantalizing letter, describing his fascination with her nightgown, and his temporary escape, which suggests she was also his mistress: "You caused me this morning to almost alter all my arrangements: for the pink nightgown on sunday (though I don't believe you've got one) captured my sense, over-susceptible as you know. But I kept my head, and the result is that I regret to say that I shall *be away* on Sunday next. I am going to the country again . . . & could not, save by extreme dislocation of arrangements, get back in time for the pink nightdress. Perhaps when you can once more *move*, and are no longer wrapt round with the odour of disinfectants [she had been ill], I may yet hope to have a glimpse of that garment?"

Lewis wrote to Alick while he was at the front in 1917; and he continued to see her until 1930 when he apparently suspected her loyalty and quarrelled about malicious gossip that had been attributed to her. In September of that year she reproached him and regretfully said: "I am extremely sorry that our friendship should have come to an end in this fashion. . . . My feelings towards you have not changed. . . . I can only come to the conclusion that someone has made mischief & repeated to you something I have *not* said. I would have thought that

after all these years my loyalty to you would have been above suspicion."[9] The sketchy but suggestive evidence reveals that Lewis remained rather distant and dispassionate, while the women freely expressed their feelings and suffered emotional upheavals because of their involvement with him.

In 1914, while recovering from his illness and conducting affairs with various women, Lewis also formed close friendships with Captain Guy Baker, a wealthy professional soldier, and with T. S. Eliot. Lewis met Baker at the Tour Eiffel, where they both took their meals. He was about eight years older than Lewis, came from Gloucestershire and had also been at Rugby. He was a lively companion who got drunk very easily and dissolved in overpowering laughter. Like Lewis, he hobbled about in poor health. He suffered from a chronic skin disease and rheumatic afflictions, and had been forced to resign his commission. Helen Rowe, an invaluable informant for this period, "remembered his friend Guy Baker, whom he seemed to like as well as any man. He was an ex-Indian Army officer. He was a very sick man and couldn't decide whether to return to the Army. He had quite a lot of money, though nobody knew, and he went slumming in Fitzroy Street. He lived over a French grocer's shop and wore a slouch hat, though there was no artiness about it. That was the sort of thing Lewis liked in him. That was their bond." In *Tarr*, Baker is affectionately portrayed as Guy Butcher: "the sweetest old Kitten, the sham *tough guy* in excelsis. He might have been described as a romantic educating his english school-boyish sense of adventure up to the pitch of drama."[10]

Baker admired Lewis' work, made a fine collection of his early drawings and bequeathed them to the Victoria and Albert Museum. He was also a great collector of limericks, which match the best in Norman Douglas' anthology and deserve to be quoted.[11] Ill health did not impede Baker's love affairs, any more than it did Lewis'. "We got on famously," Lewis said, in an unusual compliment, "it was like having a woman around."[12] Baker served in the War for a short time, and died in the influenza epidemic of 1918.

An impressive concentration of subtle minds took place when Lewis first met Eliot, who became a lifelong friend, in Pound's little triangular sitting-room at 6 Holland Park Chambers in Kensington, early in 1915. Eliot had made the acquaintance of Pound only a few days before, when Pound had proudly shown him Lewis' *Timon of Athens* drawings. The tall sibylline figure, "his features of clerical cut," greeted Lewis, the first artist he had ever encountered, with his characteristically prim manner and fastidious speech. The bombastic Pound, disappointed at the studied reserve of Eliot, who was less confident than his new friends, adopted his hill-billy dialect (perhaps to amuse Lewis and soften Eliot, for all three men had spent their childhood in America) and intimated

to Lewis: "Yor ole uncle Ezz is wise to wot youse thinkin. Waaal Wynd damn I'se telling *yew*, he's a lot better'n he looks!"

Eliot soon discovered that Lewis was a brilliantly amusing talker with a powerful critical intelligence and an astonishing visual imagination. In his review of *Tarr* in the *Egoist* he called Lewis, in a phrase that has become famous: "The most fascinating personality of our time. . . . In the work of Mr. Lewis we recognize the thought of the modern and the energy of the cave-man."[13] In *One-Way Song* (1933) Lewis portrayed Eliot's stern features, pessimistic poetic voice and lugubrious religious inclinations with affectionate irony:

> I seem to note a roman profile bland,
> I hear the drone from out the cactus-land:
> That must be the poet of the Hollow Men:
> The lips seem bursting with a deep Amen.

"Appearing at one's front door, or arriving at a dinner rendezvous," Lewis recalled in his memoir of Eliot, "his face would be haggard, he would seem at his last gasp. (Did he know?) To ask *him* to lie down for a short while at once was what I always felt I ought to do. However, when he had taken his place at a table, given his face a dry wash with his hands, and having had a little refreshment, Mr. Eliot would rapidly shed all resemblance to the harassed and exhausted refugee, in flight from some Scourge of God."[14]

In July 1915 Lewis published in the second (and final) *Blast* Eliot's "Preludes" and "Rhapsody on a Windy Night," which were his first poems to appear in England and contained the suggestive lines that Lewis especially admired:

> I am moved by fancies that are curled
> Around these images, and cling:
> The notion of some infinitely gentle,
> Infinitely suffering thing.

But after the censorship of Pound's poem in *Blast 1*, Lewis refused Eliot's "Bullshit" and "The Ballad for Big Louise." He called them "excellent bits of scholarly ribaldry" but stuck to his "naif determination to have no 'words ending in -Uck, -Unt, and -Ugger.' "[15]

Poems and essays by Lewis, Pound, Ford and Gaudier appeared in *Blast 2*, along with drawings by six Vorticist painters; a photograph of Gaudier's hieratic *Head of Ezra Pound*; works by Pound's wife, Dorothy Shakespear; and drawings by Nevinson and Jacob Kramer, who were not in the Vorticist group. But the second, much thinner "War Number" of *Blast*—with Lewis' *Before Antwerp* on the cover, portraying three stark soldiers with rifles, surrounded by jagged and threatening forms—replaced the earlier wit and exuberance with a grim severity. As D. H. Lawrence wrote, using Pound's term to express the

wartime dissolution: "In the winter of 1915–16, the spirit of old London collapsed. The city, in some way, perished, perished from being the heart of the world, and became a vortex of broken passions, lusts, hopes, fears, and horrors."[16]

Lewis' jab at Augustus John's "stage-gypsies emptying their properties over his severe and often splendid painter's gift" provoked (as we have seen) an angry response from his friend. Pound's weak satire on Rupert Brooke's Georgian poetry, "Our Contemporaries," written before but published after Brooke's death on Skyros in April 1915, evoked considerable hostility. Lewis had said farewell to the excited Gaudier when he took the boat-train to join the French army, and the sculptor's notes from the trenches were followed by a solemn black box: "MORT POUR LA PATRIE. After months of fighting and two promotions for gallantry Henri Gaudier-Brzeska was killed in a charge at Neuville St. Vaast, on June 5th, 1915."

The lists of those "blasted" and "blessed" were shorter, less pungent and more obscure than in Blast 1. The painters Brangwyn, Orpen and Mestrovic, the critic W. L. George (who had been previously "blessed"), Birth Control, the Roman Empire and the Regent Palace Hotel were "blasted," while three Japanese painters,[17] war heroes, war babies (the result of "blasting" birth control), Selfridge, the War Loan and Lewis' favorite A.B.C. tea-shops (though they seemed papered with their own damp leaves) were "blessed." Lewis' most substantial contributions were a "History of the Largest Independent Society in England"—the Allied Artists; "A Review of Contemporary Art"; and "The Crowd-Master," a description of the blind masses roaring for their own destruction when war is declared, which was later revised and included in Blasting and Bombardiering. Lewis' Vorticist painting The Crowd (1915) was the visual portrayal of urban conformity and chaos.

Lewis' opening editorial gallantly defended the value of art in time of war: "Blast finds itself surrounded by a multitude of other Blasts of all sizes and descriptions. This puce-coloured cockleshell will, however, try and brave the waves of blood, for the serious mission it has on the other side of World-War. The art of Pictures, the Theatre, Music, etc., has to spring up again with new questions and beauties when Europe has disposed of its difficulties. And just as there will be a reaction in the Public then to a more ardent gaiety, art should be fresher for the period of restraint." And he added ironically, in "Artists and the War": "The Public should not allow its men of art to die of starvation during the war. . . . But as the English Public lets its artists starve in peacetime, there is really nothing to be said. The war has not changed things in that respect." The seeds of Lewis' lifelong bitterness were sown, at the beginning of his career, in Blast and Tarr.

John Quinn ordered twenty copies of Blast and, inspired by the

infectious excitement of Pound, who had emphasized the orgasmic energy of Lewis' work, began to buy his paintings. "The thing is stupendous," Pound wrote to Quinn, who also collected women, "every kind of geyser from jism bursting up white as ivory, to hate or a storm at sea. Spermatozoon, enough to repopulate the island with active and vigorous animals. Wit, satire, tragedy."[18] When Lewis joined the army and needed money to pay his debts, Quinn immediately sent £30. He bought *Kermesse* for £125 in April 1916, when Lewis planned an American number of *Blast*, and paid another £60 for a group of drawings. Lewis, recognizing a gold mine, kept urging Pound to extract more money from Quinn, and Pound obliged.

In January 1917, at Pound's urging, Quinn organized and paid for a Vorticist exhibition at the Penguin Club on East 15th Street in New York. When the show failed because of the unfamiliar abstract style, the high proportion of loaned paintings, the poor catalogue and the absence of the artists, Quinn, the only purchaser, bought nearly all of Lewis' forty-five works in the show. He made his largest purchase in August 1917 when he paid £375 for thirty-two of Lewis' drawings and watercolors. As Pound told Lewis, Quinn's great and obvious virtue was that he worked like a dog, earned a fortune and paused only to catch his breath and dispatch checks across the ocean.

2

The Great War seemed to come suddenly after the lovely, unreal summer of 1914. At first, men thought it would be like the fight against the Boers, and rushed to enlist so they would not miss the glorious experience of a battle that was expected to end in victory before Christmas. But by March 1916, when Lewis had finished *Tarr*, recovered from his infection, was well enough to enlist and had made several unsuccessful attempts to enter a desirable branch of the service, he could have no illusions about his prospects in Flanders. As he told Mrs. Turner, when asking her help in getting into the Army Service Corps, the Howitzer Brigade or (more suitably) the Secret Service, where his knowledge of French, Spanish and German would be useful: "A 2nd lieut.'s commission in the infantry is a death warrant more or less."

If, as Lewis thought, his right arm was more creative than destructive and he had "as little reason to be shot at at once and *without a hearing* as any artist in Europe,"[19] why did he feel impelled to join the army? He was too individualistic to be seriously affected by the very considerable propaganda and moral pressure to enlist. But he had a deep sympathy with French art and culture, and felt obliged to defend civilization against German barbarism: "The monstrous carnival of this

race's thwarted desires and ambitions." He also thought the intensive test of war would be valuable to a writer, and believed he had a patriotic obligation to help his country and the other fighting men in time of crisis. As Aldington starkly stated: "I thought it was a plain duty to be in the army, and cowardly to be out of it."[20] Lewis was always deeply bitter about Bloomsbury's pacifism.

In March 1916 Lewis volunteered as a gunner in the Royal Artillery and described military life as a "concentration of furious foolishness." Pound observed that his departure reduced the intelligent population of London by one-third and warned him not to irritate his unfortunate "superior" officers more than was absolutely necessary. Lewis spent the first week of service at Fort Burgoyne in Dover with the rough and heavy men recruited by the artillery: Rugby footballers, heavyweight boxers, coal-miners and oversize navvies. In an attempt to escape the ennui, fatigue and hoarse Irish drill-sergeants, he got sopping drunk on the quayside pubs and had to crawl on all fours up the hill to the castle.

Lewis spent the rest of the year in artillery camps in Weymouth, Horsham and Lydd; and soon became a non-commissioned officer, or bombardier. While drilling recruits at Menstham Camp in Dorset, he was startled by an officer who had seen a reproduction of his painting in a newspaper, became interested in the Napoleonic title and demanded: "Bombardier, what is all this Futurism about? Are you serious when you call your picture *Break of Day—Marengo*? Or are you pulling the Public's leg?"[21] Lewis quickly reassured his superior that all was quite in order, just as he had done when the prime minister suspected the political implications of contemporary art.

Lewis was acting sergeant during his first ordnance course in Kent, where he learned to fire the six-inch Howitzer, or "Bull-Gun." He made a great many futile attempts to become an officer, and in June confessed to his mother that it had been a mistake to enlist and that he should have waited for a commission. But toward the end of 1916, when he was finally accepted at the Artillery Cadet School in Exeter, he bought two well-cut uniforms in Savile Row, an overcoat, a swagger stick and a revolver; and nearly killed himself while learning how to ride. Lewis studied trigonometry and ballistics, was commissioned just before Christmas, and spent the next four months training troops in Lydd and Cobham. He did not arrive in Bailleul (near the Belgian border, between Calais and Lille) as a subaltern in his first Siege Battery, until May 24, 1917. If it had not taken so long to become an officer, Lewis, who spent the rest of the year at the front, would have been sent into battle twelve months earlier. Pound was, as always, solicitous for his welfare: "I can not see that the future of the arts demands that you should be covered with military distinctions. It is equally obvious that you should not be allowed to spill your gore in heathen and furrin places."[22]

Lewis, when sent into battle, was most concerned about the future of his two illegitimate children (he seems to have had no further contact with Ida's child, presumably living in Germany). His son Raoul (born in Dieppe in September 1911) and daughter Betty (born in London in November 1913) were the children of Olive Johnson, an acquaintance of Sickert and John. She was a vivacious but moody, bad-tempered and unstable woman whom Lewis had met by chance in a restaurant in 1909 and continued to see until 1918. The children were brought up by Lewis' mother, her companion Frances Prickett and a nurse, Miss Pierpont. During his monthly visits to the household, Lewis seemed to be an affectionate father who brought lavish presents. Lewis told Pound that an officer received no money for his children and that if he were killed he did not want to "put into the hands of my mother any pence that could be scraped together to help with the education of the children." He asked Pound, with Sturge Moore and Guy Baker, his closest friends at that time, to execute his will "for my children, & keep an eye on my boy occasionally."[23]

In the last, extraneous paragraph of *Tarr*, Lewis writes that his hero had three children with the joyless and stodgy Rose Fawcett, who consoled him for the lost splendors of his "perfect woman," Anastasya. And in "The War Baby," a story of 1918, the hero returns from combat and repudiates his grotesque child, who reflects the stupidity of his mistress: "Beresin helped regularly with the rearing of the child, and saw it fairly often. For the first year and a half it was, with its reveries, its dead white face and beauty of minuteness, very affecting. . . . But when Veronica grew big she lost her beauty. The pulpy and stormy little totem became a dull human being, with whom decay set in early."[24] The warm letters to Pound and the icy wartime fiction are Lewis' only surviving references to these "little totems," who were soon forgotten and disappeared from his life after the War.

Lewis coolly wrote to his mother, from "the more than illusory security of a concrete dugout," that he was neither afraid nor excited by the days and nights of gas attacks and heavy fire from the roaring guns that flamed at the mouth and hurled their great projectiles in the air. The compulsory game called war reminded him of school, though the food was slightly better and more casualties occurred. At first he was a supernumerary replacement, with little to do but hang about, smoke cigarettes and read Proudhon, Karl Marx and *La Chartreuse de Parme*. But he soon took up his hard and dangerous duties, observing shell bursts from a forward observation post in no-man's-land and phoning back instructions to make the barrage more accurate.

After a month at the front Lewis caught trench fever, which was spread by lice, in late June. His tongue turned green, his face and neck swelled up in a "mump-like magnification" and he was sent back to a

military hospital at Étaples, near Boulogne, in critical condition. On July 7 he wrote to Pound that his "balls were smaller and less troublesome" and the pain in his eyes had diminished. After recovering in an officers' convalescent home in Dieppe, converted from a grand hotel and run by the wealthy and generous Lady Michelham, he returned to duty in late July.

His second battery was posted at the heart of the fighting, behind Nieuwpoort, near Ostend, in Belgium. In September, while leading his men to a forward observation post, he was spotted by a hovering zeppelin, immobilized and shelled for several hours. But he eventually led his signallers through a heavy barrage and back to safety. He narrated this episode with lively good humor in the "Hunted with Howitzers" chapter of *Blasting and Bombardiering*. On September 28 T. E. Hulme, who in 1915 had been wounded by a bullet that passed through his arm and killed the man behind him, was killed by a direct hit from a big shell. Hulme's battery was less than a mile away from Lewis, who regretted he had not made peace with his old friend before Hulme's death.

In October Lewis met the Irish artist William Orpen, who had been his fellow-student at the Slade and was "blasted" in *Blast 2*, at Cassel, near St. Omer. Orpen had become an official war artist in April 1917 and offered Lewis some fine whiskey from Haig's headquarters. Lewis envied the posh portrait-painter, who was living off the fat of the land, and decided to get into this scheme, if he could. The contrast between Orpen's life and his own was intensified that month when Lewis moved to his third battery in the "romantic ruin" of Ypres and fought in the battle of Passchendaele, one of the greatest disasters of the War. Though two years of experience and the battle of the Somme had proved beyond all doubt that it was impossible to break through the German defenses with the current tactics and weapons, the generals issued their hopeless orders, the men sustained terrible losses, and gained only four miles during this long epic of mud. This ground was recaptured by the Germans in their last major offensive of March 1918.

3

Just after the worst shelling Lewis had ever experienced, a providential telegram arrived in early November announcing that his mother was dangerously ill with her second attack of pneumonia since 1914. Lewis was granted emergency leave, and rushed back to England to find that the oxygen cylinders were still at her bedside but that the danger period was over.

Lewis was about to return to the front when Guy Baker suggested

that he utilize his artistic talent and join the Canadian War Memorials scheme, which had been started in October 1917 by Lord Beaverbrook to portray Canada's part in the War. Lewis' old friend P. G. Konody, who had recommended him for the Ideal Home exhibition in 1913 and now helped Beaverbrook to select the war artists, was able to get Lewis out of the trenches and to secure his appointment. Lewis visited Konody, who gave him an enthusiastic welcome, at the Albany in Piccadilly, and got final approval during an interview with the courteous Beaverbrook.

Through the influence of the American-born Lady Cunard, one of the fashionable hostesses who had lionized Lewis after the publication of *Blast*, he obtained four extensions of leave while awaiting transfer and lived at the Rembrandt Hotel in South Kensington. He spent a great deal of time with Lady Cunard in November and December, in her box at Covent Garden and her house in Grosvenor Square, and gratefully described her as a generous, witty, intelligent patron of music and keen politician. Lewis gained insight about the limitations of political power during one of her grand dinner-parties at Claridge's, when the ambitious Lord Curzon (frustrated, no doubt, by wartime restrictions) denied that he possessed much authority and declared he did not have the power to send an office boy across Whitehall.

One of the many improbable, yet surprisingly true, incidents concerning Lewis occurred at the end of 1917 when Lady Cunard arranged a luncheon party where Lewis met the Prince of Wales. Peter Quennell gave an amusing account of Lewis' bizarre and alarming behavior, which was probably intended to enliven the rather stiff gathering and draw dramatic attention to himself: "Wyndham Lewis accepted the invitation, contrary to his usual practice; but he was taciturn and pensive and self-absorbed, and, as soon as they had sat down to luncheon, produced from his pocket a small pearl-handled revolver, which he placed beside his wine-glasses. Did he mean to assassinate the Prince? Was it his intention to commit suicide? At all events, a crisis threatened; disengaging herself from the guest of honor, [Lady Cunard] turned her attention at the first opportunity to Mr. Wyndham Lewis' 'pretty little pistol,' admiring its workmanship and the elegance of the design, handling it as if it had been a Fabergé Easter Egg or an enameled Georgian snuff-box, at length with an absent-minded smile dropping the weapon into the bag she carried; after which she turned to the Prince and resumed her social duties."[25]

On December 12 Lewis was ordered to return as soon as possible to his battery, report to his commanding officer and be ceremoniously seconded by him—though a postcard would have done just as well. Lewis joined the headquarters of the Canadian Army at Vimy Ridge in northeast France on the last day of the year, lived in a luxurious château

that provided a vivid contrast to the squalid mud of the trenches, and did more than fifty drawings and studies of the war.

Augustus John appeared a few days after Lewis' arrival. He was a major in the Canadian Army and the only British officer, except the king, who wore a beard. John was often mistaken for his monarch by startled soldiers, who would leap to attention when they saw his striking figure. One day John and Lewis lost their bearings, mistakenly commanded their chauffeur to drive up to the front line instead of away from it, and nearly got killed.

In *Blast 2* Lewis wrote of the artist: "If out of the campaign in Flanders any material, like the spears in Uccello's *Battle [of San Romano]* in the National Gallery, forces itself upon the artist's imagination, he will use it." After a month in France, Lewis returned to London on January 26, 1918, and spent most of the next two years completing his two large war paintings: *A Canadian Gun Pit* (National Gallery, Ottawa) and *A Battery Shelled* (Imperial War Museum, London), for which he received £500 when he finally completed the latter in October 1919. Lewis was forced, by the requirements of the War Records project, to return to a conventional style of painting; and in February John asked Alick Schepeler: "Have you seen anything of that tragic hero and consumer of tarts and mutton-chops, Wyndham Lewis? He is I think in London, painting his gun pit and striving to reduce his 'Vorticism' to the level of Canadian intelligibility—a hopeless task I fear."[26] Though Lewis' paintings were among the finest works inspired by the War, he repudiated them and felt that Konody had made him paint two of the "dullest good pictures on earth." One of the muscular Jamaican Negroes, who was attached to Lewis' battery to carry shells (and who may have influenced his ideas about race in *Paleface*) appears in a bright pink shirt in the right foreground of *A Canadian Gun Pit*. His old friend Edward Wadsworth was the model for the moustached figure on the left in *A Battery Shelled*, who contemplates the ravaged landscape in the painting.

Late in 1917, when Lewis was being entertained by Lady Cunard and awaiting transfer to the Canadian War Artists, he met Sybil Hart-Davis and Herbert Read. Lewis was introduced to Sybil by Augustus John. Sybil, who was born in 1886, was the daughter of a successful London surgeon and the elder sister of Alfred Duff Cooper, who married the beautiful Lady Diana Manners and became war minister in 1935. In 1903 Sybil had married Richard Hart-Davis, a handsome but prosaic member of the Stock Exchange, and was the mother of Rupert Hart-Davis, who later became a successful publisher. Lewis remarked on her proficiency in Greek and great taste for learning, but he was probably more attracted by her wealth, social connections and cool, classical beauty—she looked like a female Rupert Brooke, with clear eyes, fine

features and blonde hair—than by her intellectual abilities. For Lewis married women provided the thrill of deception without the fear of entanglement.

Sybil's rather whimsical letter, written during the War to her friend Iris Tree, suggests that she was an attractive, vain, nervous and spoiled woman: "I smoke too much and am all fluttery. My nails are beautifully manicured and my underclothes have improved a bit, lace and billowing pale pink silks, also dozens of new white silk stockings, to say nothing of green and gold brocade shoes. . . . Have you forgotten how short and gold my hair is, how slight my body and great my charm?" Sybil wrote Lewis letters in French and signed them "Your Pet"; and in November 1917, during their love affair which lasted through the following year, she confessed: "I am just extremely happy to go away. Glad to have your drawing. Such agony to let go of your fingers, but realising all the time what an anticlimax had I stayed. . . . (I still cry, having left you)."[27]

Herbert Read, a young army officer with a distinguished war record and Socialist leanings, was planning a new magazine, *Art and Letters*, and asked Lewis to contribute. Lewis sent him two stories, "The War Baby" and "Sigismund," which were published in 1918 and 1920; and the two men met frequently in September and October 1918, when they were both in London. Read, like most people, was impressed by Lewis' character, intelligence and originality; by his art, his pamphlets and his books. Read (like Henry Moore) saw Lewis at that time as an inspiring artistic model; and gave a lively and sympathetic portrait of his friend:

Wyndham Lewis is the ringleader of "les jeunes" and has a personality *and* a BRAIN: that is why he must be read. . . . He is rather brusque, very energetic, quite normal in appearance, and a good talker. His big picture [for the Canadian War records] is quite interesting, but not so fine as some drawings he showed us later. . . . His drawings (descriptive of artillery life at the Front) are great. The best war drawings I've seen yet. Full of power and energy, and true. . . .

Lewis' flat [at 1 Hatfield House, Great Titchfield Street]—lots of stairs to go up, but a view and fresh air at the top and the jolliest suite of rooms: 1 bedroom, 1 sitting-room, 1 bathroom, 1 kitchen sort of place (very small). But all very jolly and dainty. I fancy they cost about £35 a year.

When Read reviewed *Time and Western Man* in 1927 he again praised Lewis as "a great and scandalously ignored painter . . . a brilliant protagonist, by far the ablest pamphleteer of his generation, by far the most active force among us. . . . Mr. Lewis has engaged himself with an originality and a lusty vigour without parallel in contemporary criticism." But in a particularly nasty obituary of Lewis, Read's last blow after many bitter artistic quarrels with his old companion, he ignored Lewis' impressive charm and brilliance, superimposed Lewis' later and less attractive character on to his earlier years, and gave a very

distorted picture of what Lewis was really like at the end of the War: "He exhibited from the first his characteristic cageyness. . . . I have never known anyone with whom it was so difficult to collaborate. Every meeting seemed like an act in some conspiracy. The difficulty began with the rendezvous, for he usually lived in two or three places at the same time, painting in one, writing in another, and presumably living a very undomestic life in a third. He liked good food and wine, but avoided fashionable restaurants. More often than not we met in an A.B.C.— with our backs to the wall. . . . But he came as a powerful stimulus to me at a very impressionable age, and I have always been grateful to him for the corrective he supplied to a native romanticism. . . . 'Take out all those adjectives,' he said, 'and it will be a good poem.' I followed his advice, then and ever afterwards."[28]

Just before his mother's illness and his meeting with Read, in October 1917, the United States Post Office suppressed the *Little Review* because of alleged obscenity in Lewis' story "Cantleman's Spring-Mate." The editor, Margaret Anderson, appealed against the ban and John Quinn defended the case, but Justice Augustus Hand found that Cantleman's relations with Stella were described in excessive detail which did not seem necessary to convey the theme of the story.[29] This was the first of several works by Lewis to be suppressed.

Lewis had better luck with *Tarr*, published in England by Harriet Weaver's Egoist Press (which had brought out Joyce's *A Portrait of the Artist as a Young Man* in 1916) and in America by Knopf in June 1918, while Lewis was working on his war paintings. Lewis had completed *Tarr* in December 1915 and, like Joyce, had difficulty placing his novel. John Lane, who had brought out *Blast*, thought it was "too strong a book" and many other publishers agreed with him. At Pound's urgent insistence, *Tarr* was finally accepted by Miss Weaver, who serialized it between April 1916 and November 1917 and paid £50 for the rights (she still had a £36 deficit in 1924).

Though Lewis' first novel, which had an unconventional style and typography and (like all his books) was difficult to read, had a sale of only 600 copies, it was widely reviewed and well received. The best and most serious notices were by Eliot in the *Egoist* (already quoted), Rebecca West in the *Nation* and Pound in the *Little Review*. West emphasized the Russian influence and saw that Kreisler was the moral center of the novel. She called *Tarr* "A beautiful and serious work of art that reminds one of Dostoievsky only because it is too inquisitive about the soul, and because it contains one figure of vast moral significance which is worthy to stand beside Stavrogin. The great achievement of the book, which gives it both its momentary and its permanent value, is Kreisler, the German artist."[30] Pound saw the book, which was entirely free of clichés, as a cyclonic destruction of useless conventions

and a European novel of ideas: "We have a highly energised mind performing a huge act of scavenging; cleaning up a great lot of rubbish, cultural, Bohemian, romantico-Tennysonish, arty, societish, gutterish. . . . *Tarr* is the most vigorous and volcanic English novel of our time. Lewis is the rarest of phenomena, an Englishman who has achieved the triumph of being also a European. He is the only English writer who can be compared with Dostoievsky."[31] A more recent judgment by Anthony Powell, who acknowledged Lewis' marked influence on his own fiction and called *Tarr* an "astringent force, at once baroque and ascetic, utilitarian and outlandish,"[32] confirmed the contemporary reviews of one of the least read and most underrated novels of the twentieth century.

Lewis was seriously ill at the beginning, in the middle and at the end of the War. Just after the Armistice in November 1918, an influenza epidemic devastated Europe and killed millions of people who had miraculously survived four years of war. Lewis caught influenza, which led to double pneumonia, and spent several months in the Endsleigh Place Hospital for officers, near Euston Road, before being sent to a seaside convalescent home. His mother, with her "poor tragic face," came to see him in hospital and brought books to read. He lost a great deal of hair during this illness, and was nearly always photographed with his hat on after the War. The illness also delayed his demobilization until April, though he moved into his new flat at 1A Gloucester Walk, Kensington, in February 1919.

In February Lewis had his first one-man show at the Goupil Gallery on Regent Street. In his Foreword to the *Guns* catalogue he emphasized the representative treatment and narrative theme of his portrayal of artillery warfare: "I set out to do a series dealing with the Gunner's life from his arrival in the Depôt to his life in the Line. . . . It attempts to give a personal and immediate expression of a tragic event. Experimentation is waived: I have tried to do with the pencil and brush what story-tellers like Tchekov or Stendhal did in their books." Pound wrote an appreciative review in the *Nation*, John Quinn bought seven drawings for the considerable price of £245, of which £146 went to Lewis.

Lewis was the only one of the "Men of 1914"—Pound, Eliot and Joyce—who went to war, and his intellect and emotions were profoundly affected by this hateful yet fascinating experience. He felt the War had destroyed cultural values, settled nothing, demoralized the world, and accustomed people to purposeless and incessant violence. He acquired his political education while sidestepping corpses and dodging missiles: "On the battlefields of France and Flanders I became curious about how and why these bloodbaths occurred—the political mechanics of war. I acquired a knowledge of some of the intricacies of the power-game, and

the usurious economics associated with war-making.''[33] It is essential to remember that Lewis' attempt to prevent a second world war—however wrongheaded and misguided—was the dominating impulse behind his disastrous political books of the 1930s.

Lewis was also personally bitter about the War and felt that four years of the most vital period of his career had been torn from his life. He felt he had the right to give his birth date as 1886, instead of 1882, partly to claim precocity (for he was a late starter) but mainly to compensate for the loss of these crucial years. The War forced Lewis to suppress his residue of tenderness, which appeared obliquely but significantly in his later masterpieces, *The Revenge for Love* (1937) and *Self Condemned* (1954). He adopted a defensive, harsh, cynical, bitter and unsentimental role—which convincingly disguised the inner man—and played it out, at his own cost, to the very end of his life.

Just as the separation from his father had marked the end of his childhood in America, so the death of the impressively idle old man marked the end of his life as a soldier. Twelve days after the Armistice, on November 23, 1918, while his son was in hospital with influenza, Charles Edward Lewis suffered a heart attack and died, as Wyndham Lewis was born, on a yacht, and was buried in Philadelphia. The news of his death reached Lewis two months later, on January 20, 1919, while he was being interviewed by Ben Hecht in Pagani's Restaurant in Great Portland Street. Lewis was cheated of his patrimony and did not inherit the house in Southport, which had been left to him in his father's will of 1911. The severe and degrading poverty that he suffered during his entire adult life accounts in large measure for Lewis' suspicious character and hostile behavior after the War.

Women and Marriage,
1918–1925

And all should cry, Beware! Beware!
His flashing eyes, his floating hair!
Coleridge, "Kubla Khan"

I

Lewis had no serious relations with women until after the Great War. He had the gift of inspiring feminine devotion and had attracted a number of lady patrons—Frida Strindberg, the Countess of Drogheda, Olivia Shakespear and Lady Cunard—as well as a variety of lively and artistic mistresses: Ida, "Rose Fawcett," Olive Johnson, Kate Lechmere, Beatrice Hastings, Mary Borden Turner, Alick Schepeler, Sybil Hart-Davis and possibly Helen Saunders and Jessica Dismorr. He enjoyed luxurious excursions into upper-class society, needed women's money and affection, and rivalled Augustus John in his sexual conquests. But he was interested in women mainly as a physical necessity, felt a faint disdain for them, kept them at a distance, did not live with any of them, and never let them interfere with his emotions or his work. Like Tarr, he felt that "soft, quivering and quick flesh is as far from art as it is possible for an object to be." Lewis, who told John the highest development a woman could achieve was a grace-ful and intelligent surface, was fond of women sexually without caring for them as a sex. Rebecca West and Kate Lechmere endured long, enigmatic silences; and when Lewis spoke to Ford's companion, Stella Bowen, she found him alarming, for his "conversation held so many traps for the unwary that it was just a question of choosing which one you would fall into."[1]

Lewis' fiction provides some insight into his self-protective attitude toward women and his deep-rooted hostility to children. Both were directly related to his Nietzschean concept of the artist ("When you go to consort with the *Weib*, take your whip with you"), and echoed Sturge Moore's earlier warning about the danger to an artist of being trapped by a woman. In *Tarr*, Kreisler "approached a love affair as the Korps-

student engages in a student's duel—no vital part exposed, but . . . at least stoically certain that blood would be drawn"; and Tarr's "intellect had conspired to the effect that his senses should never be awakened, in that crude way. . . . Surrender to a woman was a sort of suicide for an artist"—for it aroused his feeling and confused his intellect.[2] Lewis' natural severity instinctively opposed his "abnormal addiction to sex."

In stories written at the end of his life Lewis reiterated the sentiments first stated in "The War Baby" and expressed an almost Swiftian disgust about bodily functions and newborn infants. For Lewis, sex and birth emphasized the horrifying dichotomy of mind and body, which was the basis of his theory of satiric comedy: "The reproductive act, the swallowing and evacuating process (self-preservation) are degrading, we look fools when we are at it." The hero of "Junior" compares his newborn infant to a foetus and a fish in order to dissociate himself from the emotional realities of paternity. He thinks his inhumanity is merely the result of looking at things with scientific clarity, but admits a jealous rivalry with his own baby for his wife's affections: "He had married Perdita Murdock, an exceedingly attractive girl, simply in order to sleep with her. The last thing he ever thought of was breeding. . . . In his imagination, he reduced the entire company to creatures of this kind. A small dark wriggling monster. Then he knew that there was a piscine phase of the foetus—and he could visualize them all, at that stage of life; collected in a tank. As a little fish, he could see himself glassily eyeing Perdita. The sharp-sighted are apt to be granted this fundamental vision of the human, in the moments immediately succeeding procreation—the female adoration of the just-born abortion, striking a spark." In the final paragraph of his last novel, *The Red Priest* (1956), the posthumous son of Augustine Card, who inherits paternal characteristics—"He would look like his terrible father; he was fated to blast his way across space and time"—is born on the remote African shores of Lake Rudolf and is appropriately named "Zero."[3] Lewis was hostile to women, especially those with intellectual pretensions, except when they were ministering to his wants or satisfying him in bed.

Though Lewis did not change his attitude toward children—he took no responsibility for his pregnant mistresses and refused to have children with his wife—the experience of War matured him and enabled him to sustain serious relationships. He had been through hell and miraculously survived the danger of mutilation and death. He was older, less intellectual and isolated, more human and willing to acknowledge the emotional side of his being. In 1918, at the age of thirty-six, he was more fully prepared to respond to the first important woman in his life—after his mother.

Iris Barry, whose real name was Crump, was born in Birmingham in 1895 and came from a provincial, dreary and impoverished background.

Her family was so poor that they felt honored by a visit from the butler of the neighboring great house. She was the only child of a Sheffield brassfounder who had been divorced by his wife, when Iris was still a baby, because she contracted gonorrhea from him—the first time this was used as grounds for divorce in England. Iris' mother, Annie Symes, looked like a dark, romantic gypsy and, in the guise of Madame Pandora, told fortunes in Bognor Regis and the Isle of Man.

Despite this bizarre background, Iris was attractive, talented, quick-witted and intelligent. Her wealthy grandparents paid for her education in Birmingham and at the Ursuline Convent in Verviers, Belgium, and she passed the Oxford entrance examination in 1911 (though she did not attend the university). She was a slim, tiny woman, with searching and sceptical blue eyes, and black hair cropped very close to her shapely head. Though she had little money, she always wore striking clothes. She had an almost clinical precision of speech and in *Who's Who* listed her recreation as "Talking." She laughed easily, especially at pomposity; and could be very amusing or quite truculent, always long on mockery and short on tact.

Early in 1916 Pound, forever on the lookout for new talent, noticed some of Iris' poems in Harold Munro's *Poetry and Drama*. In April he asked to see more of her work, suggested she might be published in *Poetry*, encouraged her to leave her job ordering telephone poles at the Birmingham post office and urged her to come to London. He first met her on a bench in Hyde Park and soon introduced her to Read, Aldington, Ford, Yeats, Eliot and Lewis. She was inevitably attracted to the most handsome, mysterious and exciting artist, and had the ability to draw out his best qualities. She wrote about "Lewis, back from the Front, ghastly pale under his black hair and after silences that seemed, at least, to denote some suspicion of his fellow-creatures, proving full of inimitable conversation, riotous song, and an unequalled play of humour."

The lives of Lewis and Iris were curiously parallel. Both had obscure origins and disguised their background. Both had considerable wealth in their families and many rich friends, but were poor all their lives. Both were separated from their fathers at an early age and educated partly in Europe. Both possessed a sharp tongue and a quick temper, and had many love affairs. Both spent long periods of their lives in North America. Both were ambitious and confident of their ability, and made their mark on the world of art.

In October 1918, just after Iris became pregnant, Read noted that Lewis had a girl in his Great Titchfield flat " 'to pour out tea'—I did not catch her name, but she is a young poetess who had not yet published [a book]."[4] And in the final sentences, added at the last moment to *Tarr* (which catalogues his love-life from Ida to Iris), Lewis alludes admir-

ingly to Iris, who sat for his mask-like and monumental *Praxitella* in 1921: "Beyond the dim though solid figure of Rose Fawcett, another arises. This one represents the swing back of the pendulum once more to the swagger side [of sex]. The cheerless and stodgy absurdity of Rose Fawcett required as compensation the painted, fine and enquiring face of Prism Dirkes."

Iris lived with Lewis, the only man who never bored her, from about 1918 until 1921, while ordering machine-guns for the Ministry of Munitions and working as a librarian in the School of Oriental Studies. They had two children—through carelessness rather than desire—a boy born in June 1919 (soon after Lewis left the Army) and a girl (his fifth child) in September 1920. Lewis and Iris led a poor, unsettled, erratic existence and neither of them wanted to keep the infants. Iris, who felt that Lewis ought to do the housework, thought the children would be a burden and interfere with her career. She once mentioned the children to Lewis, who said with a calculated coldness: "Oh, was there more than one?" And he told a friend: "I have no children, though some, I believe, are attributed to me. I have work to do."[5] He left Iris with the two children and no money and, like Pound's offspring, they were soon given away.

The daughter was adopted within a year of her birth by a prosperous Lancashire manufacturer who had answered their advertisement. She had a happy childhood and never heard of Iris until she appeared, in a bad mood, and took her away for a few disturbing days. The son had a much harder time of it. He lived with his grandmother, Annie Symes Crump, until he was four, and spent the next six years in a dismal orphanage in Essex. A friend once accompanied Iris to visit the six-year-old child, who called her Auntie and did not know she was his mother. He was a miserable and unhealthy little boy whose appearance hurt Iris and made her feel guilty. Lewis, who had been abandoned by his own father, never saw his children, and they did not know he was their father until they were adults. The daughter, who is more resentful about her background than the son, once owned an oil painting by Lewis but threw it in the dustbin. The siblings did not meet each other until 1940 when the son, stationed in Lancashire during the war, received an offhand note from Iris saying he had a sister living there and might like to meet her. They never really knew Iris until she returned to Europe from America in 1950 and, rather late in life, made embarrassing attempts to be motherly.

Lewis kept his liaison with Iris secret, made her sit in the kitchen when his guests came to the flat and treated her rather badly. She would not have continued to live with him, even if he had been able to support the children and she had been willing to care for them. Though she almost never mentioned him to her friends, she did tell one woman

about a bitter experience. When she returned from the hospital with her baby girl, Lewis was having sex with Nancy Cunard in his studio, and she had to wait outside on the steps, holding the baby, until he was finished. In April 1921 Iris wrote Lewis a disillusioned and bittersweet letter that expressed her uneasiness about abandoning the children and suggested that their relationship was coming to an end: "We never had any peace of mind, ripe, tasty hours together, Lewis, except those stolen from my domestic cupboard, leaving a skeleton there. . . . Write quick & say you miss me & that you are well & your plans thriving."[6]

Lewis' "sprightly mind" had a profound influence on Iris Barry, who was thirteen years younger than he. In 1914 Lewis, who was seriously interested in the earliest Chaplin films, took Helen Rowe to see the flickering comedies in a flea-pit cinema at the bottom of Charlotte Street, where they paid tuppence and sat among the children on school forms; and he criticized Chaplin in *Time and Western Man*. Iris published a long review of *The Gold Rush* (1924) and an imitation of Lewis' *Wild Body* stories in Edgell Rickword's the *Calendar* in 1925, when Lewis' essays on art and politics appeared in that magazine.

Iris was a brave and independent woman who started her distinguished and colorful career as soon as she left Lewis. In 1923 she began to write the first serious film criticism in England, for the *Spectator*; published her first novel, *Splashing into Society*, a take-off of Daisy Ashford's best-seller, *The Young Visiters* (1919); and married the Oxford poet Alan Porter, who became literary editor of the *Spectator*. She later spoke wistfully of him, as of an adorable but helpless child.[7] She was a founder of the Film Society in 1925 and was film editor of the *Daily Mail* from that year until 1930. Lewis evidently shared her bitterness, for when she sent him one of her novels—perhaps *Here is Thy Victory* (1930), about the chaos that results when there is suddenly no more death—and asked for a kind word to be used as publicity, he replied: "Our relationship was an unfortunate disaster. I don't want to have anything more to do with you." In 1930 Iris was sacked from the *Mail* for demanding more money and a business trip to Hollywood; she separated from Porter and left for America, which she thought of as a land of promise.

She had difficulty in finding a job during the Depression. In November 1931, ten years after their separation, when Lewis was visiting America (though she did not know this), Iris sent him a moving letter when she was in truly desperate circumstances, asking for help with a fine mixture of tenderness and pride: "I wonder if after all this time I might ask something of you? I wouldn't unless it were really quite desperate. . . . I wondered whether you could possibly scrape up a few pounds and send them to my mother? . . . Of course I know I've no claim on you at all—but I thought maybe if you happened to be able

to put your hand on £10 you might just this once help me over a rather bad patch. . . . If I make my plea so simply, it is perhaps because I hope that now, at this late date, I may have earned your confidence."[8] We may hope that Lewis helped her mother (who had brought up his son) on that occasion, for he was later forced to apply to Iris for help, when he was in New York in 1940 and their financial positions were reversed.

With the help of the architect Philip Johnson, Iris became a librarian at the Museum of Modern Art in 1932; three years later, with the assistance of a Rockefeller grant, she founded the Film Library and was its pioneering curator until her retirement in 1950. She was reputed to have seen more films over a greater length of time than any other critic. She published Let's Go to the Movies, a book of film criticism, in 1926, translated Bardèche's History of the Film in 1938 and prepared an exhibition catalogue of D. W. Griffith's films in 1965. Alistair Cooke, who knew Iris well in New York, recalled: "She spilled the most knowing gossip about famous movie people and yet never revealed any confidences about herself. . . . She was generous to her close friends, could be bitchy to people she disliked; she liked to think of herself as a wheeler-dealer with the film moguls; she enjoyed her acquaintanceship with the Warner brothers, and clearly revelled in rubbing shoulders with Nelson Rockefeller—who was one of the directors of the Museum." In 1934 she married the young, athletic Wall Street financier John Abbott, who was a vice-president of the Museum of Modern Art and the brother of Charles Abbott, a professor of English at Buffalo University who later invited Lewis to paint Chancellor Capen. She divorced Abbott in the late 1930s.

Iris met Pierre Kerroux at the 1947 Cannes film festival when a journalist friend broke his leg and gave Kerroux a press card to see the films Iris was judging. Kerroux, a handsome man who was twenty years younger than she, was then smuggling olive oil from Corsica to the coast of France in his boat, which he was forced to sell just before it was confiscated by the police. Iris and Kerroux lived together for twenty years in a farmhouse, La Bonne Font, in Fayence, near Grasse in the Maritime Alps, on her tiny pension and the money earned by growing vegetables and roses for perfume. Iris, who had had a cancer operation in New York, died of cancer of the larynx in a Marseilles hospital in 1969 and was buried in Fayence.[9]

2

Lewis first met the wild and beautiful Nancy Cunard, granddaughter of the wealthy shipping magnate, at the home of the Countess of Drogheda before the War; and he had been very friendly with her

mother, Maud, who entertained him when he was on military leave in London in the autumn of 1917. Nancy was then a young debutante, "very American and attractive after the manner of the New World." She had short fair hair, large sapphire eyes, pale ivory skin, taut feline features, high cheekbones and a long, bone-thin, tensile body that resembled a cheetah. She spoke in a gentle musical voice and wore flamboyant clothes.[10]

Nancy was a rebellious, iron-willed woman who had quarrelled publicly with her mother and left her husband after a brief marriage. But she was also a friend of George Moore and Norman Douglas, and later became the publisher of the Hours Press and a fighter on behalf of the Negroes in America and the Loyalists in Spain. She had originated the idea and contributed the title poem of the Sitwells' anthology *Wheels* (1916); was the model for Iris March in Arlen's *The Green Hat* (1924), Margot Metroland in Waugh's *Decline and Fall* (1928), Lucy Tantamount in Huxley's *Point Counter Point* (1928) and the childish Baby Bucktrout, the heroine of Lewis' *The Roaring Queen* (1936), who tries to seduce the gardener with a copy of *Lady Chatterley's Lover*—a book she disliked and refused to publish. She was loved by Louis Aragon and Tristan Tzara, photographed by Cecil Beaton and Man Ray, sculpted by Brancusi, painted by Kokoschka and drawn five times in 1922–1923 by Lewis. His portrait captured her strength and fine features, and suggested her steely elegance through the tall Venetian tower that stands behind her.

We have seen that Lewis began his affair with this exciting and legendary woman while he was still living with Iris Barry in 1920. In the early twenties Nancy (like Jessica Dismorr) invited Lewis to visit France as her guest, for a change or a holiday, and addressed him in a seductive and imperious tone: "I am dining in great weariness and pleasant enough solitude in the last place where we had a scene (of a kind) at [Restaurant] Larivière—my dear darling Lewis. . . . I have found a house, called Les Fresnes, eight miles west of Dieppe. . . . If you would *be* there, I would take it for you, any time till September. . . . I wish I had seen you more; I always do. . . . You once said that I was drunk, when I was sober. Don't do it again!"[11] In November 1921, Lewis told Robert McAlmon that he was planning to spend a week in Paris with Nancy and do portraits of several people there.

A few days before Mussolini's March on Rome, in October 1922, while squads of armed Blackshirts fought in the streets, Lewis was invited to Venice as Nancy's guest and lover. He was pleasantly lodged in her "palace," Casa Maniella in San Barnaba, near the Accademia and on the Grand Canal, with good food and drink, and "every freedom." But he was penniless and patronized, unable to extend his journey to Florence and Rome (which he never saw) and sensitive about his

awkward position. Nancy later remembered that this holiday ended with
an angry quarrel: "Recalling Lewis' vagaries as a lover, she told of their
departure from Venice, where he had been her guest. Two gondolas
were needed to get the luggage, Nancy, Lewis, another friend (male)
[possibly Mondino del Robilan], and a maid to the train. Nancy took
the other friend with her, putting Lewis in the boat with the maid.
Lewis, easily offended, was in such a rage by the time they reached the
station that he didn't speak till they were half-way to Paris."[12] But
Nancy, who was highly emotional and not afraid to show her feelings,
soon sent Lewis a suggestive letter from Paris that patched things up:
"Darling Lewis. . . . I hope you will not forget *me* in any way either,
and I *beg* you to write to me rather often. . . . I wish I could see you
more often, as in Venice or rather as in the train that day. . . . My real
love to you, Lewis."[13]

Both Nancy and Lewis were eccentric, extremist, proud, idealistic,
quick-tempered and vulnerable. She was very fond of Lewis, but
abhorred his Right-wing politics (he was then writing *The Art of Being
Ruled*), hoped to convert him to a more humane and "committed"
point of view, and was disappointed when she failed. Her final judgment,
written a year before her death in 1964, criticized his overbearing
personality and political intransigence, but praised his artistic and
literary ability. (The friend she alludes to was probably Sybil Hart-
Davis.) "He was a very close 'friend' of one of my best woman-friends
at that time. Perceptive she—who was nor writer, nor painter, nor
musician. From what she told me, I consider that he was the sort of
'dominating kind' and (it came to me, later, when I knew him in Venice)
that his kind of 'persecutedness' must have been eternal. . . . Perhaps he
DID have a more difficult time than many another. I don't think so.
What I will tell you now is this: He was DAMN DIFFERENT to us, the
way we feel (I think), towards 'humanity.' I think, on the whole, he was
half a SHIT. But a great painter. And a splendid letter-writer."[14]

The fullest and most influential fictional portrait of Lewis appears in
Huxley's satirical novel *Antic Hay* (1923), which was directly inspired
by the sexual rivalry of Lewis and Huxley, who were then competing
for Nancy's affection. Huxley's biographer writes that he fell madly in
love with Nancy—the model for Myra Viveash in the novel—in the
autumn of 1922 and that his feelings were unrequited: "What she
wanted were men who were more than a match for her, strong men,
brutes. Aldous was simply not her type. He was far too gentle, too un-
excessive and, with her, too hang-dog, too love-sick."[15] Being in bed
with him, Nancy said, was like being crawled over by slugs. Huxley was
no match for the stronger and more "magnificently brutal" Lewis—
who had recently had three successful art exhibitions in 1919-1921—
and was living with Nancy in Venice when Huxley fell in love with her.

Antic Hay, Huxley's second novel, was written in two months in the late spring of 1923, just after his wife, Maria, forced him to leave England for Italy and to break off his anguished relationship with Nancy.

Casimir Lypiatt ranks with Huxley's satiric characterizations of Katherine Mansfield, Middleton Murry, D. H. Lawrence and Frieda Lawrence. Lewis once wrote to a publisher: "I have been painter, sculptor, novelist, poet, philosopher, editor (cf. *Blast, Tyro, Enemy*), soldier, war-artist, traveller, lecturer, journalist";[16] and when Lypiatt, who (like Lewis) writes the prefaces for his own exhibition catalogues, exclaims he is a painter, poet, philosopher and musician, the owner of his gallery warns: "there is a danger of—how shall I put it—dissipating one's energies." In 1923 Huxley told H. L. Mencken that Lewis was "A queer and very able fellow," and Gumbril expresses this condescending ambivalence when he thinks: "Dear old Lypiatt, even, in spite of his fantastic egoism. Such a bad painter, such a bombinating poet, such a loud emotional improviser on the piano! And going on like this, year after year, pegging away at the same old things—always badly! And always without a penny, always living in the most hideous squalor! Magnificent and pathetic old Lypiatt!"[17] Though Lypiatt (like Lewis) is extremely ambitious and idealistic, wants to recapture the greatness of the old masters and believes that artists reveal the moral nature of the universe, he is (unlike Lewis) totally without talent and doomed to the disappointment of unsold pictures and bad reviews.

There are a number of references to Lewis' books and paintings in *Antic Hay*. The eclectic and rather precious critic, Mercaptan, alludes to Lewis' Dostoyevskian novel *Tarr* when he insists: "We needn't *all* be Russians, I hope. These revolting Dostoievskys." But Lypiatt, who has a Russian first name, shouts back: " 'What about Tolstoy?' . . . letting out his impatience with a violent blast." The last word, of course, refers to Lewis' bombastic magazine of 1914, which contained his dramatic fantasy, *Enemy of the Stars*, and his manifesto of Vorticism. Lypiatt alludes to the former when he turns his eyes heavenwards and looks up at the Milky Way: " 'What stars,' he said, 'and what prodigious gaps between the stars!' "; and he defines the latter when he speaks of his work as "enormous, vehement, a great swirling composition." Another of Mercaptan's criticisms specifically condemns the extreme energy and excessive emotion that characterize both Lewis' personality and the deliberately provocative *Blast*: "You protest *too* much. You defeat your own ends; you lose emphasis by trying to be over-emphatic. All this *folie de grandeur*, all this hankering after *terribiltà*."

Lypiatt's abstract paintings resemble Lewis' violent Vorticist drawings of Shakespeare's *Timon of Athens* (1913): "a procession of machine-like forms rushing up diagonally from right to left across the canvas, with as it were a spray of energy." His "violent grimace of mirth"

reflects the savage *Tyro* portraits of 1921. And his picture of Myra Viveash is exactly like the famous portrait of Edith Sitwell (painted in 1923): "He had distorted her in the portrait, had made her longer and thinner than she really was, had turned her arms into sleek tubes and put a bright, metallic polish on the curve of her cheek." Though Lewis, the first abstract painter in England, was artistically though not financially successful, Myra Viveash believes his paintings are bad because "there was no life in them. Plenty of noise there was, and gesticulation and a violent galvanized twitching; but no life, only the theatrical show of it."

There are several biographical details in the novel that match Lypiatt with Lewis. Lypiatt, who is also forty years old, paints Myra Viveash in a dirty studio, down a cul-de-sac in a mews, which resembles the Lee Studio in Adam and Eve Mews, Kensington, that Lewis used between July 1921 and October 1923. Lypiatt's passionate rejection of "aesthetic emotions and purely formal values" refers to the theories that Roger Fry applied to the art of Cézanne; and Lypiatt's angry response to his lack of critical recognition alludes to Lewis' quarrel with Fry, which led to his belief that he was being ignored and persecuted by Fry and Clive Bell: " 'Fighting all the time. God, how I hate people sometimes! Everybody. It's not their malignity I mind; I can give them back as good as they give me. It's their power of silence and indifference, it's their capacity for making themselves deaf."

Lypiatt is scorned by Gumbril, condemned by Mercaptan, rejected and insulted by Myra Viveash. He provides a powerful contrast to the traditional English virtues of modesty and reticence; and is a truculent, turbulent, titanic, exultant and extravagantly boastful man, who has no literary tact and recites his own verses at every possible opportunity (Lewis' first, unpublished works, were sonnets). But Lypiatt is also a serious and dedicated artist, while Gumbril abandons his teaching position and devotes himself to promoting his absurd pneumatic trousers. (When Boldero is sent by Gumbril to ask Lypiatt to draw an advertisement for these trousers, he is kicked down the stairs by the indignant artist.) Though Lypiatt lives in solitary squalor and contemplates suicide, he is much more alive and attractive than any other character in the novel. Huxley, whom Lewis called "a moonstruck and sickly giraffe," compensates for his emotional frustration with Nancy Cunard by linking Lypiatt's failure in art with his failure in love. Despite the satiric portrait of the bruised heart beneath the veil of cynicism, the contrasting temperaments of Lypiatt and Gumbril suggest not only the enormous personal difference between the emotional Lewis and the intellectual Huxley, but Huxley's reluctant recognition of his rival's obvious merits.[18]

3

In about 1920, a few years after Lewis met Iris Barry, Pound also introduced him to Agnes Bedford, a young concert pianist and music teacher. In December of that year Pound published *Five Troubadour Songs* in collaboration with Agnes, who moved into his flat in Kensington when he left for Paris and gave him technical advice when he composed operas. Agnes was an intelligent, charming and amusing woman who admired Lewis and said he had more intellectual power than anyone she had ever met. She was his mistress during the 1920s, and Lewis' friend and patron, Sir Nicholas Waterhouse, encouraged them to marry. But Lewis said of Agnes, who had a large hooked nose and was certainly no beauty: "I can't look at that face every day at breakfast"[19]—and eventually married the beautiful Gladys Anne Hoskyns. Agnes renewed her friendship with Lewis when he became blind in 1951, played an important part in his later life and resumed the sometimes bitter rivalry with his wife that had started thirty years before.

Anne Hoskyns was born in Teddington, southwest of London, on June 29, 1900, in a working-class family. Her father, who had come from Okehampton in Devon, was a florist, nurseryman and landscape gardener. She attended art school in Lewisham, modelled hats at Liberty's, and during the War worked in an aircraft factory in South Kensington. A friend at the factory had been a model, and in 1918 took Anne to a party given by Gerald Brockhurst (who later became a successful portrait-painter and member of the Royal Academy). There she was introduced to Lewis, the first artist she had ever met; he was wearing his military uniform and looked very handsome. He took her out to dinner at Kettner's the next evening; and when she visited his studio she was "terrifically impressed" by his art. It is quite likely that he seduced the eighteen-year-old girl soon after they met. Lewis admired her father but did not get on with her frosty and possessive mother, who disliked him and did not want her daughter to get married.

Lewis, like Tarr with Bertha and Anastasya, was able to see a number of women at the same time and keep them all secret, separate and satisfied. He was involved with Iris from 1918 until 1921, but he did not neglect Anne. When he parted from Iris and rented a flat at 16A Craven Road in Paddington, Anne moved in with him and became his favorite, loveliest model. She was an extremely attractive woman, with strawberry blonde hair, a wide clear brow, soft grey-blue eyes, ivory skin, classic features and an exquisitely modelled head. She disliked sitting at first because Lewis, concentrating hard and easily distracted, was very strict and did not allow her to stir. If she did, he would bark out harshly: "Don't move! Don't move!"

Lewis falsely said that Anne's mother was German (she was, in fact,

English); and Hugh Porteus and E. W. F. Tomlin were both encouraged to believe that Anne came from Schleswig-Holstein or South Africa. Lewis provided an explanation of her unusual way of speaking when he wrote of Margot Stamp in *The Revenge for Love*: "An attractive foreign accent . . . made her speech pleasant and a little 'quaint.' It was not a foreign accent, however. As she had been born poor, she had taught herself English, and so had evolved a composite speech of her own. . . . [It] was extremely pretty, though her voice had gone a little hollow with the constant effort cautiously to shape the words correctly."[20]

Though Anne was eighteen years younger than Lewis, she did not notice their age difference, for she had been the youngest of six children and was used to being with people much older than herself. She was, in fact, the ideal wife for Lewis: beautiful but devoted, tolerant of hardship and infidelity, self-effacing yet lively, intelligent without being intellectual, an adventurous travelling companion, a good housekeeper who always did the minor repairs, a superb cook, inspiring model, efficient secretary, helpful critic, kind nurse. She was a placid woman who prided herself on her ability to endure adversity. She always called him "Lewis," and he called her "Froanna," a humorous variation of "Frau Anna," which was the way a German friend addressed her.

Froanna later emphasized that Lewis was not a difficult or short-tempered man, but (as Helen Rowe and Iris Barry had said) great fun to be with, lively, witty, always interesting: "He was a great conversationalist and loved to talk to all kinds of people, even his London char or the Scotch maid and manageress in the Canadian hotel. He was interested in everything and everybody, had a terrific curiosity, liked to talk to people on trains. Lewis was a very social character who made friends wherever he went."[21] All this more than compensated for his unfaithfulness, his decision not to have children, though she wanted them, and his long years of illness and poverty.

Though Lewis had left Iris to live with Froanna, he usually had a separate studio and continued his affairs with Nancy, Agnes and an "extraordinary" number of unknown models and mistresses. John Beevers, who sat for Lewis in the mid-thirties, recalled: "After he'd drawn me I often went [to his flat] in the daytime—and . . . he introduced me to Mrs. Lewis: an unsettling experience because she was always a different girl &, once introduced, these girls always vanished from the flat to leave us alone."[22] Lewis was "terrified" at the thought of a permanent marriage. And Froanna, like Lewis' mother, worshipped him, believed in his genius and dedicated her life to him. She knew that it would be impossible to confine him to a monogamous existence and did not attempt to limit his sexual freedom. She knew about his women and children, eventually learned to accept them without jealousy and even claimed they did not bother her. She was rather proud that Lewis

was so attractive and successful with rich and clever women, and yet always remained with her.[23] She expressed surprise when someone suggested that Lewis seemed hostile to women and replied: "Was Lewis anti-women? Some cheek, a womanizer like that!"

Lewis had the arrogance to demand her sacrifice and accept absolute freedom for himself, and insisted that his common-law and actual marriage to Froanna remain secret. He wanted to present himself to the world as an artist, not as a husband. He would not share her with anyone, believed that a woman must be kept in her lowly place and, because he was much older than his beautiful wife, felt the jealousy of a Turkish sultan. Though she sometimes complained: "It's not fair, I'm never allowed to see a soul," she did not wish to interfere with his life, had her own circle of lady friends, became resigned to *purdah* and would be heard scuttling into the next room of their tiny flat when a visitor approached.

Roy Campbell's wife, Mary, who knew Lewis for more than thirty years, did not remember meeting or even hearing about Froanna. Naomi Mitchison, who met Lewis in 1930 and soon became a close friend, did not know about his wife until many years later and thought "it was part of his game to hide her." Desmond Flower, his editor at Cassell in the early thirties, knew Lewis was married but never met his wife. Lewis often came to dinner alone at Flower's home, and never invited Flower's wife to dine with them at the Hyde Park Hotel. Julian Symons, another friend of the thirties, recalled that Lewis sometimes mentioned that his wife was in the flat and that he must meet her, but they were not introduced until after Lewis returned from Canada in 1945. Hugh Porteus saw Froanna's disembodied hands appear through the serving hatch for many years before he actually met her. And Geoffrey Grigson knew Lewis for two years before he was permitted to meet Froanna or even learn of her existence—though he heard her walking about in the adjoining room. One day, in the middle of a conversation, Lewis suddenly said: "Stay to dinner. I've a wife downstairs. A simple woman, but a good cook."

Many friends noticed that Lewis was "oppressive" and Froanna "worried," for they endured continuous financial insecurity and a great many domestic, legal and medical problems. Though she had a good deal to put up with, and sometimes seemed nervous and depressed, she was obviously a woman of great strength and inner resources. She sometimes engaged in insulting exchanges with her husband, though he always won these contests. According to Hugh Porteus: "Lewis had a masochistic wish to pin down his most amiable friends as enemies. Is it ironic that he should marry a masochistic doll? They were absolutely devoted to one another, and thoroughly enjoyed their merely verbal duels and duets. Froanna was a placid devotee, and a superb hostess. I

had always supposed that Lewis would be oriental in his intense jealousy if males so much as glanced at Froanna."[24]

In *The Revenge for Love* Lewis expressed Froanna's anxiety and wrote that Margot wore Victor's ring, "but everyone knew it was not a serious ring, and that she was not a proper wife. She had never had the heart to coax him to the Registry Office, against which he had an unaccountable prejudice." Lewis' prejudice, perhaps based on his mother's unhappy marriage, lasted for ten years. But on October 9, 1930, just before they applied for passports for Froanna's first trip abroad to Germany, he attended the only wedding of his life and finally married Froanna. All their friends agreed that they were extremely fond of each other, though we will never know the full extent of Lewis' feelings since his letters to her were intentionally destroyed. But his two most attractive, sympathetic—and doomed—heroines, Margot Stamp in *The Revenge for Love* and Hester Harding in *Self Condemned*, are based on Froanna. Margot, who has the "head of a small wistful seabird, delicately drafted to sail in the eye of the wind, and to skate upon the marbled surface of the waves—with its sleek feathery chevelure, in long matted wisps,"[25] feels that her love adds an unbearable burden of responsibility to her husband's life. Lewis' tenderness and adoration of his wife shine forth gloriously from the many superb portraits he did of her, especially the sombre and mysterious figure in *Red Portrait* and the gentle and deeply moving *The Artist's Wife*, both of 1937.

In a rare revelation of personal feeling, when he was in danger of dying during a serious illness of 1934, Lewis asked Nicholas Waterhouse to look after "my very much loved wife, Gladys Anne." And he gave the fullest description of Froanna in a letter to the wife of John Rothenstein, which revealed that his wife had a more significant role in America than in England, emphasized his desire to protect her from his frequent battles, and praised her pluck and devotion: "Life has been something of a war for me, and the warriors—the Gauls being an exception—have usually kept the field of battle free of females. Man's domestic nature is stressed here in your American matriarchy and I have found myself rather overshadowed by my wife, as a fact, [and she has been forced a little into the fray]. She is a very good sort and I am sure you would like her.—We have no children. She is a blonde, she tends to put on fat, her mother was German, her father a good British farmer and as straight as a gun barrel; she has ridden all over the Atlas on a mule and is a great reader of my books: but you can see she is a wife in a thousand."[26] She was, in the profoundest sense, his muse. The three stable pillars in Lewis' combative and chaotic life were his devotion to his mother, his marriage to Froanna and his dedication to art.[27]

CHAPTER EIGHT

Underground Man,
1919-1925

I

The sudden reputation and notoriety that Lewis achieved in 1914 as the leader of the Vorticists and editor of *Blast* had disappeared when peace broke out in 1919. Though he had done some extraordinary abstract pictures and published *Tarr*, he had to some extent to begin all over again. Lewis possessed a sincere and little suspected mixture of idealism and modesty. He felt that his early success had perhaps been achieved too easily and that there was still a great deal for him to learn about painting and writing. Because (as Froanna said) "he was really mad about art," thought it was "a constant stronghold of the purest human consciousness" and believed that this highest form of human endeavor enriched mankind, he was willing to withdraw into a second and more fundamental period of study and preparation—just as he had done on the Continent between 1902 and 1908—in order to realize his artistic and literary ambitions.

Lewis was always extremely secretive about his family background, past life and personal feelings. He sent up a characteristic smokescreen and deliberately obscured his origins. He liked to arouse interest in himself by appearing as a mysterious figure and thought his books would make a greater impression if they came out suddenly, like a flash of lightning illuminating the darkness. He preferred people to believe that he carried on his genuinely deep and fruitful retirement behind locked doors and in strict obscurity, like a Tibetan lama in the fastness of a mountain monastery. "My existence was so private," he confided, "that only two or three people ever saw what was done in it, or knew in fact how I spent my time. . . . During the 'post-war' I was incubating and was pretty silent. My personal story was an interesting one during those years but it's not my business to talk about that here. 1918–26 is a period marked 'strictly private'. . . . I buried myself [and] disinterred myself in 1926."[1] Froanna confirmed that "Lewis went into hiding to avoid people and get on with his work," and E. W. F. Tomlin warned that Lewis' biographer "will have some difficulty in coping with certain periods, especially that between 1919 and 1923; for during

this time Lewis' life was so isolated as to have been barred from all but one or two intimates."[2]

It is true that Lewis, who acquired and lost several libraries in his lifetime, did immerse himself in serious study, spent long years in the British Museum, read widely in art, literature, philosophy, history, politics, economics, science and mathematics, and was thoroughly familiar with the numerous books he cited in his own works. He was particularly fond of Johnson's satire, Hazlitt's criticism and Dickens' humor. But it is misleading to think that he lived as an ascetic recluse. He was deeply involved with Iris Barry, Nancy Cunard, Agnes Bedford and Froanna. He lectured in public, published a pamphlet and a book on art, wrote for the leading journals, edited a magazine that expressed his views on art, worked hard on the monumental books that appeared in the late 1920s, and thought out his analysis of and remedy for the radical decay of postwar society. He planned designs for a ballet, brought out a portfolio of drawings, painted a great number of portraits and held several exhibitions. Though he published no books between 1919 and 1926, Lewis appeared quiescent only when compared to his own titanic productivity of 1926 to 1939. Even while "underground," Lewis did more work in a year than most writers did in a decade.

Lewis spent weekends at Garsington and Renishaw, and travelled to Paris, Berlin and Venice. He continued to move restlessly around London and lived in Notting Hill, Fitzrovia, Chelsea, Earl's Court and Paddington before settling, from October 1923 to March 1926, at 61 Palace Gardens Terrace in Kensington, where he paid an annual rent of £250. In the early twenties Lewis also created and projected his notorious public image and became the suspicious, persecuted and manic Enemy. Most significantly, this was the period of friendships (and quarrels) with valuable patrons—Edward Wadsworth, Richard Wyndham, Raymond Drey and Sydney Schiff—and with the leading artistic figures of the time: with Pound and Eliot as well as the Sitwells, William Walton, Ronald Firbank, James Joyce, Ernest Hemingway, Roy Campbell, Katherine Mansfield and T. E. Lawrence.

Lewis had always been very close to his mother and had been deeply upset when recalled from the front in November 1917 during her second attack of pneumonia. A third attack occurred during the great epidemic that immediately followed the War (and killed Guy Baker); and on February 7, 1920, fifteen months after the death of his father, Lewis lost his beloved mother, who had sacrificed so much for his education, his well-being and his career. Her death had a profound emotional and intellectual effect on him. It severed his last family connection and strongest personal bond, and made him more responsive to other women. Because he blamed the War for his mother's death, it also strengthened his desire for peace and influenced his political books of the 1930s.

Lewis, who did not usually reveal his intimate feelings, mentioned his mother's death twice in *Blasting and Bombardiering* and emphasized his bereavement by making her ten years younger than she actually was: "She was as well and truly killed by the military upheaval as if it had been shellfire and not pneumococci that did the trick. . . . [The War] had worn her down and killed her: and I swore a vendetta against these abominations. . . . She was fifty years old and an extremely vigorous woman. And as far as my private feelings about war and all its works were concerned, this death affected me more than anything else."[3] In June he told John Quinn that he had been put out of action for several months because of her death. Though he had lost his patrimony when his father died, he inherited some money from his mother—probably from investments she had made with funds provided by his uncle. This money helped to finance Lewis' prolonged studies during the next few years.

2

Lewis' art books "were written either to defend art as he envisioned it or, by extension, to define the social and political conditions in which art as he envisioned it could flourish."[4] In *The Caliph's Design*, a pamphlet published by the Egoist Press in October 1919, Lewis carried on the art polemics of *Blast*, which he planned to continue but never did. Like most of Lewis' criticism this work was lively, perceptive, but essentially negative: "You spend half your time destroying the cheap, the foolish, the repellent; the other half you spend destroying what is left over after your efforts!" Lewis recognized the significance of Matisse, Derain and Picasso, but attacked the listlessness and dilettantism of their studio art: "*You must get Painting, Sculpture, and Design out of the studio and into life somehow or other*; if you are not going to see this new vitality desiccated in a pocket of inorganic experimentation."[5] On October 22, a week after the pamphlet appeared, Lewis gave a lecture, chaired by Bernard Shaw in the Westminster Conference Hall, on "Modern Tendencies in Art." He was ahead of his time, expressed unfamiliar and unpopular ideas, and was rather out of touch with his audience, who found his talk remote and incoherent. He was also the author of an appreciative and well-illustrated book (which appeared in December 1919) on his old friend Harold Gilman, who once sponsored him for the New English Art Club and had died the previous February.

In April 1921 Lewis brought out his second magazine, *The Tyro: A Review of the Arts of Painting, Sculpture and Design*, which was much less startling and original than *Blast*. It was published—but not sub-

sidized—by Harriet Weaver's Egoist Press and partly supported by £50 from Sydney Schiff. The twelve-page, folio-size *Tyro* expressed Lewis' high seriousness about art and (as he had announced in *Blast 2*) his hope for a creative renaissance after the War. Its object was "To be a rallying spot for those painters, or persons interested in painting, in this country, for whom 'painting' signifies not a lucrative or sentimental calling, but a constant and perpetually renewed effort." The cover was blazoned with one of Lewis' "immense novices [who] brandish their appetites in their faces, lay bare their teeth in a valedictory, inviting, or merely substantial laugh."[6] The second and final number of the *Tyro*, smaller but thicker than the first, was published in March 1922 with the help of £25 from Edward Wadsworth. The *Tyro* published work by Lewis, Eliot, Read, Lipchitz and four former Vorticists. But the poetry and fiction did not match the high standards expounded in the critical essays, which were too abstract to bring in many new readers. The magazine was doomed to an ephemeral existence because Lewis had only enough money to bring out the first two numbers, lacked permanent financial support and was also engaged in more pressing projects.

Lewis began writing what he considered to be his most serious works in the early twenties, while he contributed to the *English Review*, *Athenaeum*, *Art and Letters*, *New Statesman* and began to publish parts of *The Art of Being Ruled* and *The Apes of God* in Rickword's *Calendar* and Eliot's *Criterion*. (The *Wild Body* stories and *Tarr* were completely revised before publication in 1927 and 1928.) He originally conceived the works of this period as one truly gigantic satiric, fantastic, polemic book, entitled *The Man of the World*, which was much longer than *War and Peace*, contained half a million words and had six parts that later appeared under startling and original titles: *The Art of Being Ruled*, *The Lion and the Fox*, *Time and Western Man*, *The Childermass*, *Paleface* and *The Apes of God*. He originally took the "megalo-mastodonic masterwork" to Cassell, who said it was too expensive to print, too heavy to lift and too large to store. So he split it up into six substantial volumes which were published mainly by Chatto & Windus, but also by Grant Richards and by Lewis himself, between 1926 and 1930.

Though Lewis had achieved certain Vorticist effects in the prose of *Enemy of the Stars* and *Tarr*, and illustrated dust-jackets and title-pages of his own books, he felt that writing and painting were parallel but separate activities: "From 1924 onwards writing became so much a major interest that I have tended to work at my painting or drawing in prolonged bursts, rather than fit them into the intervals of the writing or planning of books. Writing and picture-making are not activities, I have found, which mix very well." He did very little painting during 1924–1925 when he was completing his major works.

But Lewis' experiments in literature did have one important influence

on his art: "It became evident to me at once, when I started to write a novel [*Tarr*], that words and syntax were not susceptible of transformation into abstract terms, to which process the visual arts lent themselves quite readily."[7] Though Lewis excised all rhetoric and cut the verbal flesh from his sinewy prose, he was forced to employ the realistic elements of the traditional novel in order to create living characters and make their action significant. He now found that totally abstract art was empty and meaningless, and began to paint in a mixture of abstract and representational styles.

In September 1919 the Sitwells, whom Lewis had met during the War, suggested that he do a set of designs for Diaghilev's Russian Ballet, based on Rowlandson (whom Lewis admired as the quintessential English artist), with music by their young protégé William Walton. But, Walton recalled: "The Rowlandson ballet never even began to get off the ground. It was an idea of Wyndham Lewis to get on the 'Diaghilev wagon.' I hardly composed any music before the idea was scrapped. The only thing I remember of it, was an extremely vivid & wonderful sketch of a head that he had painted on the wall of his studio, then somewhere off Kensington Church Street."[8]

But most of Lewis' art projects came to successful fruition. In December 1919 John Rodker's Ovid Press published a portfolio of Lewis' *Fifteen Drawings* in a small edition of fifty copies. (It is now one of his rarest and most valuable works.) Most of the drawings in the portfolio were done in 1919, including the exciting *Pole Jump*, two fine heads of Iris Barry and an incisive mask-like portrait of Pound. In 1917 Pound described to John Quinn and later showed Oliver Brown, the director of the Leicester Galleries, a collection of erotic cubist drawings by Lewis, entitled *Prick, Arseward, Coitus 1 & 2* and *Ornamental Erection*. These "obscenities" were impossible to exhibit and have disappeared. They may have resembled *Post Jazz* (and *Seraglio*) in the *Fifteen Drawings*, in which a woman with flowing hair stares over her shoulder at a muscular man grasping his huge erection.

Lewis also held two exhibitions in the early twenties. The Group X show, composed of six former Vorticists and four other artists, was held at Heal's Mansard Gallery in March 1920. Lewis organized this group, his last affiliation, exhibited a painting and six drawings—all self-portraits—and wrote the Foreword to the catalogue. He aggressively asserted that Group X opposed the Royal Academy exhibition at Burlington House; the New English Art Club, "a large and costive society . . . choked with successive batches of Slade talent"; and the London Group, a rather swollen and backward institution, dominated by Roger Fry, from which several of his colleagues had recently resigned. But he ended on a more positive note and praised the living achievement of French Cubists and German Expressionists.

Tyros and Portraits, the second one-man show of "Dean Swift with a brush," coincided with the publication of *Tyro 1* and began his fruitful relationship with Oliver Brown of the Leicester Galleries. Despite his admiration of the avant-garde in the *Group X* catalogue, Lewis specifically rejected abstract art in his Foreword to the *Tyros* exhibition. He said that most of his drawings were from nature, and the rest depicted a grotesque and satiric race of beings who synthesized his principal ideas about comedy. Among the most important of the forty-five works in this show, which earned Lewis £600, were portraits of Iris Tree, Sacheverell Sitwell and Ezra Pound, *Praxitella*, the tyronic and sinister *Reading of Ovid* (bought by Osbert Sitwell), and *Wyndham Lewis as a Tyro*: a forbidding figure with a cantilevered black hat, set against a bright mustard background. Lewis seemed determined to live up to his harsh self-portrait; and Oliver Brown gave a lively description of Lewis' hostile *persona*: "He seemed suspicious and did not like my association with other artists with whom he had quarrelled. He used to call at the side or private entrance and ask for me. His first enquiry would be: 'Who is in the Galleries? None of my "old chums" I hope?' When I assured him that the coast was clear he would venture in, but if there was anything of a crowd, he would persuade me to go out for a drink."[9]

Lewis had some money, from his army pay, his exhibitions and his small inheritance, after the War. When it ran out in the early twenties, he put on a boiled shirt and made a breadwinning sortie into the portrait world of Mayfair. He did a large number of drawings of celebrated artists: Pound, Eliot, Joyce, the Sitwells, Virginia Woolf, Ronald Firbank, Robert McAlmon and Arthur Bliss; of patrons: the Wadsworths, the Schiffs and Richard Wyndham; of women: Iris Barry, Nancy Cunard and Froanna; and also many portraits of himself. The great problem, which would face him many times during the next thirty years, was the difficulty of reconciling genuine art and popular taste. When he executed a serious and perhaps unflattering portrait, neither pretty nor photographic, he almost invariably displeased the sitter and, unless he had a firm contract, failed to sell the painting. There was the eternal temptation, which Lewis could not always resist (especially when destitute in Canada), to do hack-work, please the patron and collect the money without risk.

3

One of the principal paradoxes of Lewis' character was that he opposed war and constantly fought for art; that he was usually a gentle private person and a combative public figure. His self-characterization as the Enemy and obsession with the military operations of his real or apparent

adversaries, which led to accusations that he was "paranoid," may have evolved from the experience of trench warfare, for a critic has recently suggested that one of the dominant ideas of the Great War was the persistent fear of "what the other side was up to." Like the soldiers, Lewis came to need and even to love his store of accessible enemies, whose hostile resistance provoked his verbal battles, inspired his polemical campaigns and kept his sword sharp. Perhaps some of his friends became his enemies so that he *could* love them.

The most revealing clue to the character of Lewis, who called genius "the greatest development of conscious personality," is his Nietzschean tract, "The Code of a Herdsman." It was first published in the *Little Review* in July 1917, while he was fighting at the front. Despite the extravagant irony and sardonic tone, Lewis presented in this brief essay a serious and didactic plan of action. He assumed the inherent superiority of the inspired artist, who must avoid the obscenities of vulgar life and consciously strive to maintain a higher existence. The imaging mind of the Herdsman must perpetually mock the Herd personality, "the multitude of unsatisfactory replicas," and always be vigilant to prevent their encroaching contamination. He must always maintain the severe discipline of creative life, methodically root out his own weakness and be savagely truthful with others. He must suppress his dangerous emotions, especially with women and children, which lead to contact and then inevitable submergence with the mass. The self-created artist must become his own isolated caste and dwell alone on imaginary precipices.

This inhuman aesthetic program was difficult, if not impossible, to carry out. For the machine-age Zarathustra, though striding on the mountain peaks, still needed sensual women and stimulating men. But he was unwilling to join any social group. He believed the imagination flourished in a state of opposition, and defined his artistic role by resisting the currents of contemporary thought and maintaining a consistently hostile stance in both art and life. Lewis' exalted view of the creative intellect and contempt for the masses lies at the root of *The Art of Being Ruled*, and is expressed in the hieratic pronouncements of the Bailiff in *The Childermass* and Zagreus in *The Apes of God*.

Lewis, who feared sentimentality and enjoyed secrecy, found that he could hide his emotions and convey a sense of mystery as the Enemy. He protected his privacy at the same time that he courted publicity, for he moved about in a furtive manner, as if in constant expectation of arrest, yet wore conspicuous and flamboyant hats and capes that instantly drew attention to himself. Though he called himself an expert in suspicion, his melodramatic posturing was frequently intended to deceive a known or potential foe. In *Blast 2* Lewis asked: "Why try and give the impression of a consistent and indivisible personality?"

In "The Code of a Herdsman" he also insisted that the artist maintain a succession of masks—a dominant idea in modern art: "Cherish and develop, side by side, your six most constant indications of different personalities. You will then acquire the potentiality of six men. Leave your front door one day as B.: the next march down the street as E. A variety of clothes, hats especially, are of help in this wider dramatisation of yourself. *Never* fall into the vulgarity of being or assuming yourself to be one ego." Lewis seriously carried out this manifesto of dissimulation and disguise, and wore his large black hat even when indoors. He wanted his artistic rivals to believe the legend that he had created—that he was a solitary outlaw: paranoid, insolent, ruthless and destructive—so they would feel uneasy and frightened of him.

Lewis' unpublished letter to Lytton Strachey, for example, was surely ironic and intended to mislead: "It has been a long time since I last saw you. I should very much like to see you soon to discuss two or three literary matters with you. If you are agreeable, I suggest that we should meet for tea or dinner, and that provisionally you should not divulge this arrangement, but that we should meet incognito, or rather unobserved, in an unfrequented part of town—say the Great Eastern Hotel Restaurant, called I believe the Great Eastern Rooms; or if for tea in some obscure tea shop—say near the Law Courts in Covent Garden Market. But I leave the place to you."[10] This strange letter reads more like an elaborate hoax than a paranoid invitation. It is mannered and mandarin, deliberately teasing and vague, freighted with qualifications and alternatives, shrouded in mystery and absurdly convoluted—like the "disguise" that caused people to stare at Lewis. If Strachey accepted this "invitation" he would feel confused and vulnerable; if he decided to "expose" Lewis' incognito—and nothing could be easier to do—he would be fooled by the hoax; if he gossiped to Bloomsbury friends about it, he would merely confirm their suspicions about a dangerous adversary. Though the letter might be considered a trivial waste of time, it obviously appealed to Lewis' sense of humor and strategy. Like the great classicist Richard Bentley, whom he resembled in character and intellect, Lewis had "a tenacious controversial manner, which found no topic too trifling for dispute, combined with a gift for satire and raillery which verged on the cruel."[11]

An incident in the early twenties described by William Walton can also be interpreted as madness, comedy or a mixture of both—rather like Yeats urging his friends to search in the corners of his house for the Irish fairies: "Being suspicious, & suffering from a large inferiority complex combined with, at moments, a superiority complex, made him a difficult person to get on with. He had also a touch of persecution mania. For instance, he one morning asked me to come & see him, why I don't recall, but on arriving at his studio (incredibly muddled, untidy

& dirty by the way) as I sat down somewhere in the middle of the room, he took me by the arm & led me into a corner, & pointing to the ceiling said, quietly, now he's listening so don't raise your voice. Who was supposed to be listening I never discovered, especially as it was a completely isolated room, with no room on top or on the sides. But there it was, he was often like that. Either it was the 'Bloomsburys' or the 'Sitwells' who were his *bêtes noires*, it didn't really seem to matter who it was."[12] It is clear that Walton, and many others, took this aspect of Lewis' behavior seriously. Though it is now impossible to determine Lewis' motives with any certainty, it is possible that Lewis liked to reinforce the public image of a suspicious and persecuted man, and to combine this with a macabre taste of comedy.

At the height of his quarrel with Lewis, the painter Paul Nash wrote an angry letter that emphasized Lewis' Dostoyevskian sensitivity: "I believe you to be a vain, extremely thin-skinned, gentleman 'touched on the raw,' " and described his nature as "calculating, petty, malicious and uncivilised, in short strangely sub-human." Lewis must have seemed inhuman when he attempted to put the code of the herdsman into actual practice. In certain respects he remained "a raw youth" who set himself above the crowd and preserved the adolescent dream of omnipotence. Lewis—more intelligent, learned and thoughtful than other people—was confident in his superiority and arrogant in the expression of his ideas. Though he dedicated himself to the solitary existence of the artist, he still craved his fellow-men's acknowledgment of his artistic achievement. Unlike Pound, who expected and received nothing for his creative work, Lewis demanded that the crowd reward him with wealth and esteem. He became embittered, uneasy and abrasive when he failed to gain significant recognition, and was always tempted to blame his enemies for his own failures. But he possessed an invigorating honesty and was able to dramatize his emotions in a portrait of the volatile Kreisler, the tragi-comic hero of *Tarr*.

Edwin Muir, whom Lewis respected but disliked, was also fascinated by Lewis and emphasized the positive aspect of his negativity: "I find him interesting—there are very few evil, positively evil, figures in our literature at present, and positive evil has an inspiring quality. . . . There is a devastating absence of joy in his work. . . . [He has] an unusually honest and vigorous mind and personality. . . . His candour is on such a large scale that it raises the temper of one's mind." This judgment, once again, condemned the worst side of Lewis' character but surely missed the essential man: the considerable charm, the talent for friendship, the impressive personality, the powerful will, the immense energy, the formidable intellect, the protean imagination—all of which produced a monumental artistic achievement during his long creative life. Lewis could not have led such a carefully organized and intensely productive

existence if he were paranoid and suffered from persecution mania.

Perhaps the most perceptive description of Lewis' elusive character was made by William Rothenstein, who had admired and encouraged the young Lewis at the turn of the century, could see (in 1922) his development in the perspective of two decades, and stressed not only his aggressiveness but also his polemical skill, intellectual independence, courage to sacrifice his reputation for the sake of principle and astounding artistic originality: "I had known Lewis as a handsome youth, adventurous, but uncertain of direction. I now discovered a formidable figure, armed and armoured, like a tank, ready to cross any country, however rough and hostile, to attack without formal declaration of war. . . . Lewis was a master of controversy; with no social or party ties, he was more independent even than Shaw. He was not out against the Philistine, but the literary and artistic gunman, an enemy as well armed as himself. I admired his bold demeanour, and though I remembered the talent he showed when, as a youngster, he sent me his sonnets, I was astonished at his range as a writer. . . . I hold him to be the most forceful and intellectual of English experimenters."[13]

4

There is one permanent factor that has a direct bearing on Lewis' character and must always be kept in mind when attempting to understand his complex personality: his chronic poverty. Though he was extremely industrious and lived modestly, he suffered severe hardship. His intense secretiveness about his address and telephone number, including the notorious use of the Pall Mall Safe Deposit Company in the 1930s, was partly due to his fear of pursuit by numerous creditors. Lewis earned his money from journalism, publishers' advances, exhibitions, and portrait commissions. In the early twenties, for example, he signed a contract with Constable for the *Life of a Tyro* but never wrote the book. They pressed him for the return of the £100 advance in 1929 and eventually settled for £60. Lewis intended to write the book and his failure to do so meant, apart from considerable irritation, that he could not publish with Constable without having the remaining £40 deducted from the royalties of his next book. But he may have felt the trouble was worthwhile since it provided £100 when he was desperate for cash and left him with a credit of £40.

John Quinn, Lewis' most important patron, stopped buying his works in 1921, when he lost interest in English artists and devoted his entire attention and wealth to contemporary French painters. A letter from Lewis to Sydney Schiff gives an accurate view of his financial condition in 1923, soon after he began to support his wife: "Ten years

ago I was forced to take a garden-studio (tin shack) built slap on the earth of a London garden (Adam and Eve Mews) because it was cheap. But even that I could not pay for and had to leave. My next and last attempt to rent a studio was in Holland Street. There within a very short time I had an eviction order against me. In despair at these conditions, I retired into rooms." Lewis clarifies "had to leave" in his autobiography when he described his inability to earn money by painting portraits: "In spite of it all, in the end, I had to do a moonlight flit—flitting with Miss Sitwell's portrait down the Mews at the dead of night, and setting up my easel elsewhere."[14]

Fortunately, some help was forthcoming. In November 1922 Wadsworth's £100 guarantee was called in to pay for Lewis' overdraft; Jessica Dismorr, Olivia Shakespear and Charles Rutherston bought his paintings in the mid-twenties; and from December 1923 until May 1924 a group of Lewis' friends and admirers arranged a fund to provide him with an allowance of £16 a month. The contributors were Edward and Fanny Wadsworth; Raymond Drey, the art critic and his wife, Anne Estelle Rice, the Fauvist painter; and the dilettante artist Dick Wyndham, whom Lewis had met in Venice in October 1922.

Wadsworth's service in the Marine Reserve, where he had camouflaged war ships, had given him a nautical gait, a handsome tan and a fine repertoire of salty limericks. Lewis and Wadsworth had abandoned their artistic connection after the dissolution of *Group X*, and the latter went on to become a Royal Academician. He came from a wealthy family that owned wool factories in Bradford, and inherited a great deal of money when his father died in 1921. "About 1920 I remember Wadsworth taking me in his car on a tour of some of Yorkshire's cities," Lewis wrote in an obituary of 1949. "In due course we arrived on the hill above Halifax. He stopped the car and we gazed down into its blackened labyrinth. I could see he was proud of it. 'It's like Hell, isn't it?' he said enthusiastically."[15] Drey's inherited wealth came from cloth factories in Manchester.

Despite good intentions, this plan to help Lewis was doomed to failure. For even the exceedingly polite Eliot, who was also subjected to his patrons' generosity, called their donations a "precarious and slightly undignified charity." The less tolerant Lewis, who sponged with discrimination but was very touchy about money, quarrelled with his benefactors within six months. Lewis at first praised Dick Wyndham and held him up as a model to Fanny Wadsworth: "Wyndham is a person who has shown the greatest interest in my work, and has given me the most generous help, of whom I am also very fond, and whose work I have in a sense watched over."[16] But he soon began to criticize Wyndham as well as the Wadsworths. Lewis, who nearly always took a taxi, would arrive at the Dreys' house, tell the driver to wait, abuse

Drey roundly and then ask him for the cab fare. In September 1925 they exchanged some extremely acrimonious letters about a disputed £6 payment for some drawings.

When one monthly installment failed to arrive on time Lewis sent Fanny Wadsworth, who doled out the money, a postcard which demanded: "Where's the fucking stipend?" And in May 1924, when Lewis requested payment before it was due on the first of the following month, there was more serious friction with Fanny. The situation was exacerbated because Lewis profoundly resented wealthy people. He felt they remained idle as the money rolled in while he slaved away creating serious works of art for almost nothing. He particularly disliked being dependent upon a rich woman and found it hard to feel gratitude.

Lewis expressed his violent resentment of the Wadsworths in his devastating portrayal of them as the *nouveau-riche*, vulgar and ignorant couple, Richard and Jenny, who patronize Dick Whittingdon in *The Apes of God* (1930). Richard had a "Yorkshire brawn of the voice [that] hammered in the hearty epithets . . . [and] class-war-profiteered factory-wealth but lately-inherited. . . . This awful old bore of a wife of this rich mountebank marine-painter, *would* stick to her stupid opinion and air her views as if anyone wanted to hear them! Small fat half-blind ex-cooks—confused matrimonially with the legatees of rich manufacturers, who were marine-painters, and however much socially a joke, still with palettes upon their thumbs and with powerful Bugattis—should be seen and not heard!" All Lewis' "extraneous economic props" were removed in June 1924; and in March 1925, during the final push on his *magnum opus*, he told Eliot: "I had (and still have) three writs out against me and had weekly to find money somehow to get along."[17]

5

Lewis' friendship and feud with the Sitwells had a significant influence on his creative life, for they led directly to his illustrations for the First Canto of Sacheverell's privately printed poem *Doctor Donne and Gargantua* (1921), to the great portrait of Edith and to his massive satiric onslaught in *The Apes of God*. Lewis met the Sitwells toward the end of the War, perhaps through Herbert Read, who was co-editor with Osbert of *Art and Letters*, to which Lewis contributed in 1918–1920. They were a sophisticated, amusing and well-connected trio who provided (at first) an attractive alternative to Bloomsbury and helped to support Lewis in the early twenties.

Osbert entertained Lewis at his house in Chelsea; Lewis was invited to their family home at Renishaw, outside Sheffield, in September 1922; and he met and drew the two brothers in Venice the following month

when he visited the city with Nancy Cunard. One night in a café an impromptu combat occurred when an Italian painter challenged Lewis to a match of draughtsmanship. Encouraged by the Sitwells Lewis accepted, drew William Walton and easily defeated his rival. Lewis told Geoffrey Grigson, perhaps with some exaggeration, that the Sitwells hired a gondola to take him round the city he had never seen before. He was particularly eager to study the paintings of Tiepolo, but they rushed from palace to palace, gallery to gallery, allowing him only ten exasperating minutes in each place. In October Lewis suggested to Sydney Schiff that he back a "Sitwell review" to rival Eliot's *Criterion*, and offered to be the art editor and contribute stories and essays.[18]

A well-documented dinner-party of January 22, 1920, suggests the tensions inherent in Lewis' hypersensitive relationship with the mandarin and malicious family. In Lewis' account of the occasion Walter Sickert's effusive praise of *Tarr* infuriated Arnold Bennett, who was then writing his influential book column in the *Evening Standard*, and turned him against Lewis: "Not long after the War I was at [Osbert Sitwell's] house for dinner (in Carlyle Square, Chelsea, it was) and Arnold Bennett and Walter Sickert were present. . . . At this dinner-party Sickert began talking about *Tarr*. I could see Bennett didn't like it. I think Sickert saw that too, for he went on talking about it more and more, at every moment in more ecstatic terms. . . . I saw that Bennett was extremely annoyed. . . . *Tarr* had been made to stink in his nostrils. . . . I knew that Sickert had made me an enemy though he had not meant to, for he is the kindest man in the world. . . . For a number of years Arnold Bennett was a kind of book-dictator. . . . He was the Hitler of the book-racket. The book-trade said that he could make a book overnight. . . . The 'author of *Tarr*' under this Dictatorship spent his time in a spiritual concentration camp—of barbed silence."

Osbert's witty and more accurate account, written after *The Apes of God*, in 1947, minimized Sickert's praise of *Tarr* and emphasized Lewis' furious reaction to Sickert's attack on his paintings: "Sickert then lit a cigar and, nipping round the corner of the table, pressed one upon Lewis, with the words, 'I give you this cigar because I so greatly admire your writings.' Lewis switched upon him as dazzling a smile as he had had time to prepare—with him, everything was weighed and premeditated—but . . . Sickert planted the goad by adding, 'If I liked your paintings, I'd give you a bigger one!' . . . Lewis, at this, became very angry, though typically, not with Sickert, but with the rest of the company. He refused, as a punishment, to accompany us to a party at Lady Ottoline Morrell's."[19] Sickert, who had attacked Lewis' *Creation* in the *New Age* of March 1914, later praised Lewis' *Thirty Personalities* exhibition in 1932.

Osbert's version of the dinner was confirmed by two other guests.

The following morning Bennett told Hugh Walpole: "W.L. [was] also there—in grey flannel. He left early—piqued, as some said, by remarks of Sickert." And Frank Swinnerton wrote: "I once sat next to Lewis at dinner at Osbert Sitwell's, and the dinner, in which Lewis was unmercifully teased by Walter Sickert, is described in one of Osbert's books."[20] This incident shows that Lewis, who was quick to seize the offensive and attack others, was (like the outrageous Kreisler) "touched on the raw" when subjected to even mild criticism and pulled down to the level of the Herd.

Lewis' relations with Edith were even more tense and difficult. Unlike her brothers, she was neither wealthy nor elegant. She was six feet tall, pale-faced and lank-haired, with a distinct curvature of the spine and a long curved nose that Strachey compared to an anteater's. Instead of residing in a fashionable Chelsea house, she lived with her former governess in a rented Bayswater flat. When she came to Lewis' Adam and Eve studio in a short fur coat and outlandish hat, and was jeered at by the children in the street, she quickly silenced them by pulling a face and sticking out her tongue.

In 1946 Lewis told Grigson, his old comrade in the campaigns against the Sitwells: Edith "tells her public that 'once she was a golden woman.' Nothing answering to that description was ever visible to *me*, I may say, at the time to which I suppose she refers. She had practically no hair, and such as she possessed was anything but 'golden': it was a dirty lemon. She was so round-shouldered that it almost amounted to a hump. She was hollow chested, with a long frozen nose, down which she looked and sneered to show her father was a baronet." And even Edith, despite her vanity, seemed to agree with Lewis' judgment: "Except for her hands, she insisted that she had no beauty. She disliked the word 'plain'; she thought of herself as ugly."[21]

Edith's physical appearance is significant because she told friends that she had quarrelled with Lewis after firmly rejecting his sexual advances: "When I sat, many years ago, to Mr. Wyndham Lewis, he was, unfortunately, seized with a kind of *schwärmerei* for me. I did not respond. It did not go very far, but was a nuisance as he *would* follow me about, staring in a most trying manner and telling our acquaintances about the *schwärmerei*. So, eventually, I stopped sitting to him (the reason why the portrait has no hands)." Edith's account is not reliable, for when she stated that she had sat to him every day but Sunday for ten months, Eliot replied that Lewis had painted him twice but he had never sat for anything like that length of time. Edith also claimed that the secretive Lewis told their friends about his "passion" and that he wore a black eye-patch while painting.[22]

Yet Lewis' flattering portrait of Edith suggests that she could be seen as attractive and mysterious. Though Lewis found Edith repulsive, he

may have tried to seduce her because of his instinctive impulse to sleep with every woman who sat for him, his desire to conquer her or merely his wish to satisfy his curiosity about what she was like in bed. In any case, Edith remained a Van Eyck virgin whose love affairs were never consummated.

Lewis' portrait of Edith was begun in 1923. Since she refused to sit for him after *The Apes of God*, he repainted and completed it without her in the thirties. The painting shows that Lewis saw and admired some of his own qualities in Edith: her aggressive courage, her daring quest for publicity, her cruel wit, her endurance of poverty and her passion for art. Edith, who wears a helmet-like hat, has an exquisitely modelled face, nose and lips. Her elongated form is compressed by an extensive shelf of Lewis' books that reach half way across the center of the picture, and is reinforced by the severe verticals of the door, chair and two columns of blue background that balance both sides of the work. Her green and gold clothing, which resembles tinfoil, reflects the metallic motif of the chromatic tubes that replace her missing hands and are reflected in the colored scarf that rests on her knees. The hooded eyes and cylindrical neck, and the deliberate substitution of robot-hands for what she felt was her finest feature, reveals a great deal about Lewis' view of Edith's withdrawn and rather inhuman character. Lewis' linear precision followed the tradition of Dürer and Mantegna, and his instinct for design transformed his sitter into a formalized monument. The psychological penetration of the painting makes it one of Lewis' most successful works and perhaps the best-known English portrait of the century.

The Sitwells introduced Lewis to Ronald Firbank, a mannered homosexual and "reincarnation of all the Nineties," whom Lewis clearly disliked. He drew Firbank twice in 1922 and gave an amusing account of his problems with the narcissistic and squeamish sitter: "It was almost impossible to do a portrait of Ronald Firbank, he was so interested in what I was doing. He wanted to look over my shoulder while I was drawing. . . . He fluttered at the thought of so much self-exposure. . . . He writhed about in his chair, clasped and unclasped his hands. . . . I had such relations with him as one might have with a talking gazelle, afflicted with some nervous disorder."

Firbank, in his dubious version of the sittings, claimed that Lewis (who was actually revolted by him) kept praising his appearance and calling him an Adonis. He was also terrified of the scampering mice which easily penetrated the tin-shack studio.[23] Edith claimed that the bold rodents even climbed on Eliot's knee and scrutinized his face (this would have given Firbank a coronary) and that Lewis was at last driven to purchase a large Chinese gong which he banged at the opening of the mouse-hole to drive away the foe.

A surprising acquaintance with E. M. Forster was made on ostensibly hostile territory when the intensely urban Lewis was invited by Lady Ottoline Morrell to Garsington—the rural seat of Bloomsbury—in June 1922 and again in May 1923. On these occasions, Lewis' personality struck the young Lord David Cecil as "powerful, individual, self-conscious and uneasy; at the age of 20 or 21 and unaccustomed to the company of temperamental artists, I did not find conversation with him easy. But he did make a formidable and undisappointing impression on me." Forster thought Lewis "a curious mixture of insolence and nervousness," and Lewis found Forster "a quiet little chap, of whom no one could be jealous." Since Forster did not seem to be a rival or a threat, they got on amicably, went for a walk to escape the other guests and annoyed Ottoline by failing to "perform" at tea.[24]

6

Lewis continued to see, to draw and (after he left London at the end of 1920) to correspond with Pound; and Pound, who Ford said was "frantically loyal" to Lewis and strongly influenced by his ideas, continued to encourage and help Lewis. When Lewis complained about lack of money, Pound (whose wife had a private income) replied with a cheque for £20 and commonsensical advice: "If there aren't 30 or 50 people interested in literature, there is no civilization and we may as well regard our work as a private luxury, having no aims but our own pleasure. You can't expect people to pay you for enjoying yourself." In 1925, shortly after the inauguration of the Guggenheim Foundation, Pound placed Lewis with Joyce and Picasso and (unsuccessfully) recommended him for a Fellowship: "Wyndham Lewis, I consider without exception the best possible 'value' for your endowment, and *the* man most hampered by lack of funds at the moment. Acquaintance with his published work can give you but a very partial idea of why I recommended him. His work in *design* is, I can not say more important than his *capacity* for writing, but the two capacities very nearly of equal importance. His published writings have flaws due to hasty composition between his works as a painter. His mind is far more fecund and original than let us say James Joyce's; he had at the time of publishing *Tarr* or *Enemy of the Stars* a less accomplished technique, BUT he has invented more in modern art than any living man save possibly Picasso." Later that year, Lewis jokingly asked: "Could you get me the Nobel Prize next year? or do you want it for yourself?"[25] Both men were destined to remain virtually excluded from public recognition and honors, while Eliot was awarded the Nobel Prize in 1948.

But in June 1925, as he was completing his six years of continuous

labor and preparing *The Art of Being Ruled* for publication, and after years of accepting Pound's assistance, Pound's well-intentioned interference in Lewis' affairs provoked a burst of wrath that foreshadowed his attack on Pound (and on *This Quarter*) in *Time and Western Man*: "I do not want a 'Lewis number' or anything of that sort in *This Quarter* or *anywhere* else. . . . [You have no] mandate to interfere when you think fit, with or without my consent, with my career. If you launch at me and try and force on me a scheme which I regard as malapropos and which is liable to embarrass me, you will not find me so docile as Eliot. . . . You seem inclined to step in at the last minute and harass the final stages of my work with, I hope sincere, but certainly misplaced, offers of help." Pound, surprised perhaps but unruffled, replied with characteristic candor: "There are some matters in which you really do behave like, and *some* (some not all) lines in this letter of yours in which you really do write like, a God damn fool. Candidly and cordially yours, E.P."²⁶ He was one of the very few people who could say this to Lewis and (almost) get away with it.

Lewis' critical attack, Pound's moves to Paris and to Rapallo, Pound's wartime support of the Fascists, postwar confinement in Washington, and final residence in Venice, inevitably meant that the two friends drifted apart after 1920—though they always remained personally loyal to each other. To some extent Lewis replaced the friendship of the exuberant Pound with that of the cautious and circumspect Eliot, with whom he had more intellectual and less temperamental affinities. Eliot, whom Ottoline Morrell called "The Undertaker," would say at tea: "I daren't take cake, and jam's too much trouble," and showed a puritan distaste for sensual pleasure, which Lewis so eagerly enjoyed. He resented being patronized by Lewis, who had greater vigor and vitality, and in a letter to John Quinn remarked on the temperamental difference between his friends and himself: "I consider that Pound and Lewis are the only writers in London whose work is worth publishing. . . . I know that Pound's lack of tact has done him great harm."²⁷ Tactlessness was also one of Lewis' failings.

Just after he met Lewis, in June 1915, Eliot, in "the awful daring of a moment's surrender," began his disastrous marriage with the daughter of a portrait painter, Vivien Haigh-Wood, who suffered from poor health and "nerves"—and eventually went mad. After two unhappy years as a schoolmaster, he became a bank clerk at Lloyd's in the City and remained there from 1917 until 1925, when he joined Faber & Gwyer and became a prosperous publisher. Eliot found the exuberant, if volatile, Lewis a welcome relief from his domestic and commercial enslavement. Froanna liked Eliot best of all their friends, and Lewis took him to music halls and boxing matches.

Lewis frequently went to Paris to keep up with the latest develop-

ments in modern art and to see the work of Matisse, Picasso and Derain. In the summer of 1920 Lewis, who wanted to get away from the pregnant Iris Barry, and Eliot, who wished to escape from his wife, went on holiday together to Paris (where they had an introduction from Pound to Joyce), to Saumur on the Loire, and then down the river through Angers and Nantes, and north to Quiberon and the Golfe de Vannes in Brittany, which Lewis had visited with his mother in 1908. Outside Saumur Lewis, speeding along at a great pace, had a nasty accident: the handlebars of his hired bicycle snapped off, he was thrown violently on the road and badly injured his knee. He returned to the town furious at the proprietor, who brazenly tried to recover money for damage to the defective machine. The travellers also visited a monastery in Saumur, which Eliot attempted to sketch under the critical eye of Lewis: "The porter told us the hours, and suggested that we fill in the time by visiting the church, a short way up the street. 'Ah you should see that!' he boomed. 'It is very fine.—It is *very old—c'est très ancien!*' Then detecting, as he thought, an expression of disappointment in our faces, he added hurriedly—*C'est très moderne!*"[28] At the end of each day, when they drank their armagnac in the café, Eliot maintained the habits of a bank clerk and scrupulously entered the day's expenses in a small notebook.

Eliot suffered a nervous breakdown at the end of 1921 and spent some time in a sanatorium in Lausanne. During the next three years (also an extremely difficult period for Lewis) he was sick, miserable and acutely depressed: fearful of poverty and overcome by self-pity. In a letter of 1923 that sounds remarkably like Lewis, Eliot told Lewis: "I am ill, harassed, impoverished, and am going to have 5 teeth out. I have managed to avoid seeing anyone for a very long time. I have several enemies."[29]

In 1922 Lewis was present at the first reading of *The Waste Land* in London, when a friend of Mrs. Eliot, with splotches on his face, proudly identified himself as the "young man carbuncular." Eliot published the poem in October 1922 in the first number of the *Criterion*, when he was editing that magazine and encouraging Lewis to contribute to every issue. Despite—or perhaps because of—Eliot's good will and practical assistance, Lewis quarrelled with him in January 1925 when Eliot advertized but did not print a long part of *The Dithyrambic Spectator*. The ever-suspicious Lewis had been publishing two Zagreus sections of *The Apes of God* in the *Criterion* (for which he received £43); and he warned Eliot, who was then friendly with Virginia Woolf and other Bloomsburys: "Should any of these fragments find their way into other hands than yours before they appear in book-form I shall regard it as treachery." Eliot explained that Lewis' 20,000-word essay was too long to print and that illness had prevented him from writing

an explanation, and answered Lewis in a calm and disinterested manner:
"Please do not think that I am pressing upon you . . . a reminder of
supposed services. I consider that anything I do is equalised by any
support you give to THE CRITERION. Furthermore I am not an indivi-
dual but an instrument, and anything I do is in the interest of art and
literature and civilisation, and it is not a matter for personal compensa-
tion. But in the circumstances I cannot help feeling that your letter
expressed an unjustified suspiciousness." But when Lewis continued
his attacks in March—"Since before Christmas you have been guilty
where I am concerned of a series of actions each of which, had I done
the same to you, would have made you very indignant"—Eliot showed
some exasperation and appealed to Lewis' faith in his integrity and
their friendship: "I cannot work with you so long as you consider me
either the tool or the operator of machinations against you. . . . Until
you are convinced by your own senses or by the testimony of others that
I am neither conducting nor supporting (either deliberately or blindly)
any intrigue against you, I do not see that we can get any further."[30]

Lewis, exhausted by work on his huge books, which he hoped would
free him from poverty and obscurity, admitted that he had quarrelled
with almost everyone in order to get the money and time to complete
his work. His furious, intolerant, analytical mind disintegrated many of
his friendships. He had, during this period, sent the same sort of
provocative and even insulting letters to old friends (and enemies):
Paul Nash, Christopher Nevinson, Jacob Epstein, Augustus John,
Frederick Etchells, Edward Wadsworth, Raymond Drey, Richard
Wyndham, Ezra Pound and Robert McAlmon. By antagonizing and
alienating nearly everyone who was in a position to help him, Lewis
certainly diminished the chances of an enthusiastic response to his books.

Lewis' injured tone and fierce impatience with friends, patrons and
publishers once again suggests that he saw himself as a godhead, stand-
ing above the Herd and bearing the sacred flame of art. He refused to
modify his harsh behavior, despite his desperate situation; and success-
fully separated the degrading poverty and squalor of his daily existence
from his exalted intellectual and artistic life.

But Eliot, because of his sobriety and apparent equanimity, was a
difficult man to quarrel with, and remained Lewis' loyal friend and
staunch defender. He believed that Fry and other critics had deliber-
ately hurt Lewis' career, and placed him above Joyce as a prose stylist:
"Lewis was independent, outspoken and difficult. Temperament and
circumstances combined to make him a great satirist. . . . His work was
persistently ignored or depreciated, throughout his life, by persons of
influence in the world of art and letters who did not find him congenial.
. . . [But he was] one of the few men of letters in my generation whom I
should call, without qualification, men of genius. . . . Mr. Lewis is the

greatest prose master of style of my generation—perhaps the only one to have invented a new style."[31]

Lewis and Eliot's first meeting with Joyce, which was engineered by Pound, was brilliantly described in Lewis' autobiography. Though Pound had praised Joyce's work, Lewis had read only a few pages of *A Portrait of the Artist* when it appeared in the *Egoist* and found that it was too mannered, too literary and too sentimental-Irish for his austere taste. But Joyce (also primed by Pound) was familiar with *Tarr* and Lewis' other works, and gave a flattering start of recognition when Eliot introduced them. Both men seemed to be aware of the momentous occasion. Lewis found Joyce an oddity in patent-leather shoes and large powerful spectacles: and his four drawings of Joyce captured the extraordinary face, "hollowed out, with a jutting brow and jaw, like some of the Pacific masks." Joyce played the Irishman in an amusing fashion and Lewis "took a great fancy to him for his wit, for the agreeable humanity of which he possessed such stores, for his unaffected love of alcohol, and all good things to eat and drink." He later called Joyce "a pleasing, delightful fellow, with all his scholarly egotism and Irish nonsense."[32]

The ostensible object of the visit was to deliver a large brown parcel which Pound had entrusted to Eliot. When Joyce received their message and came to their hotel room with his tall son Giorgio, "Eliot rose to his feet. He approached the table, and with one eyebrow drawn up, and a finger pointing, announced to James Joyce that *this* was that parcel to which he had referred in his wire, and which had been given into his care, and he formally delivered it, thus acquitting himself of his commission. . . . James Joyce was by now attempting to untie the crafty housewifely knots of the cunning old Ezra. . . . At last the strings were cut. A little gingerly Joyce unrolled the slovenly swaddlings of damp British brown paper in which the good-hearted American had packed up what he had put inside. Thereupon, along with some nondescript garments for the trunk—there were no trousers I believe—a fairly presentable pair of *old brown shoes*, stood revealed, in the centre of the bourgeois French table."

The shoes and jacket were undoubtedly Pound's response to Joyce's letter of June 5, 1920: "I wear my son's boots (which are two sizes too large) and his castoff suit which is too narrow in the shoulders."[33] Pound meant well by sending the cumbersome gift, but because of the unexpected arrival of a check (which may have paid for his patent-leather shoes), Joyce's circumstances had significantly improved before the literary messengers arrived with the footgear. Pound's unintentional revelation of his penury before (two equally impoverished) *confrères* aroused Joyce's Irish pride. Though he accepted their invitation to dinner, he insisted on paying for several days of lavish drinks, meals, taxis and tips.

Lewis had more spontaneous encounters with Joyce when he returned to Paris in May and June of 1921. He felt freer and happier in Paris, and spent his days visiting collections of Chinese art with the sculptor Frank Dobson and the collector Charles Rutherston (the brother of William Rothenstein), and his nights drinking at the Gypsy Bar, sometimes until dawn, with Joyce and McAlmon. Joyce told friends: I "had several uproarious allnight sittings (and dancings) with Lewis as he will perhaps tell you. I like him. . . . Mr. Lewis was very agreeable, in spite of my deplorable ignorance of his art, even offering to instruct me in the art of the Chinese of which I know as much as the man in the moon. He told me he finds life in London very depressing."[34]

When Joyce told the rather brusque Lewis that he had to learn to deal more adroitly with patrons and should never hint at any imperfections in his work while corresponding with Quinn, Lewis conceded that Joyce had "adequate duplicity." Joyce sang long arias from *Carmen* while sitting with Lewis in a café; when Lewis made some rude observations about French whores, Joyce interrupted and warned: "Remember, you are the author of *The Ideal Giant*." And when Joyce, a great family man, asked Lewis how many children he had, Lewis replied: "Hundreds." Despite the good times, Nora Joyce disapproved of these binges and scolded her husband: "Jim, you've been doin' this for twenty years, and I'm tellin' you it's the end. Do you understand? You've been bringin' your drunken companions to me too long."

In May 1926 Lewis arranged to meet Joyce at his eye clinic. When he arrived the proud Joyce, who had a pad over his eyes and could not see him, asked Nora if a check had come from Harriet Weaver. Nora complained that Joyce was supposed to have many admirers, but none came to visit him when he was ill.[35] Lewis told Joyce that he planned to revive the *Tyro* as a bi-monthly critical and philosophic review which would contain no creative work. When he made an exception for Joyce and asked him to contribute fiction, Joyce agreed with pleasure. But Lewis' *Enemy 1* contained his attack on Joyce and Lewis never published any of his work. Though they still saw each other occasionally in the late 1920s and early 1930s, their friendship inevitably cooled. Lewis' relations with Joyce show that he was more concerned with books than with friends, and had a fierce and ultimately self-destructive need to sacrifice people for ideas.

Robert McAlmon, an American writer and publisher, called on Lewis when he first came to London in 1920 and was with him in Venice two years later. He introduced his new friend to his father-in-law, the shipping magnate Sir John Ellerman, whose taste in painting ran to cow pastures and woodland scenes. But when Lewis arrived late, and became nervous and awkward, he failed to secure a portrait commission. McAlmon's private press, Contact Editions, had brought out Heming-

way's first book and he also planned to publish Lewis. When he failed to do so, Lewis attacked him in *Time and Western Man*. After this book appeared Lewis called McAlmon "a pathetic little figure. When I knew him years ago he was a sad little man, and he is no doubt sadder now . . . with being wiser."[36]

7

Lewis had a dramatic introduction to McAlmon's friend Ernest Hemingway in July 1922 when he pushed open the door to Pound's Paris studio and saw "A splendidly built young man, stripped to the waist, and with a torso of dazzling white, standing not far from me. He was tall, handsome, and serene, and was repelling with his boxing gloves—I thought without undue exertion—a hectic assault of Ezra's. After a final swing at the dazzling solar plexus (parried effortlessly by the trousered statue) Pound fell back upon his settee. The young man was Hemingway." In his bitter, posthumously published *A Moveable Feast*, Hemingway distorted Lewis' motives and asserted: "I wanted us to stop but Lewis insisted we go on, and I could see that, knowing nothing about what was going on, he was waiting, hoping to see Ezra hurt."[37] Like Gertrude Stein, who misinterpreted Lewis' "weighed and premeditated" behavior (Hemingway repeats and exaggerates Stein's anecdote in his book), Hemingway failed to see that Lewis—who was extremely fond of Pound—was absorbed in the energy and design of the fight. Hemingway revealed his own weakness by attributing his aggressive feelings to Lewis.

Hemingway also distorted Lewis' character after meeting him with Archibald MacLeish in December 1927. Hemingway, who had recently published *The Sun Also Rises*, was not confident about the dialogue of the English Lady Brett, but Lewis assured him that he had a good ear for speech and there was no occasion for anxiety. MacLeish recalled: "I took Lewis to lunch in Paris and got Hemingway to come along. Walking back to the West Bank E.H. said: 'Did you notice? He kept his gloves on all through lunch'. . . . Since I hadn't and since he hadn't the question became lurid and memorable. But even as early as that Hemingway had decided not to care for him."[38] Hemingway had undoubtedly heard about Lewis' notorious "paranoia," and decided to contribute his share to the legend that was partly created by Lewis' enemies. In *Across the River and Into the Trees* Hemingway approves of his vigilant hero, Colonel Cantwell, who sits defensively but securely at a table in a Venetian restaurant and "had both his flanks covered and rested solidly against the corner of the room." But when Lewis, who also liked to sit in a corner with his back to the wall, behaved in a similar fashion, Hemingway

criticized him for strange habits. Hemingway, like Lewis, created his own legend and was aggressive, hypersensitive, eager for recognition and intolerant of criticism. The two colossal egos were bound to clash.

The immediate cause of Hemingway's hostility was Lewis' witty and incisive chapter on Hemingway in *Men Without Art* (1934)—a title probably derived from Hemingway's *Men Without Women* (1927). "The Dumb Ox," one of Lewis' best-known essays, was first published in *Life and Letters* in 1934, reprinted in the *American Review*, *Men Without Art*, and three other books, and translated into Polish. Lewis' influential essay criticized the very things Hemingway prided himself on: his originality, sophistication and admirable fictional heroes. It also shot barbs into Hemingway's most vulnerable spots: his embarrassing indebtedness to his literary midwife, Gertrude Stein; his lack of political awareness (a frequent criticism in the thirties, before the appearance of *For Whom the Bell Tolls*); and his passive characters who possess the soul of a dumb ox: "This brilliant Jewish lady has made a *clown* of him by teaching Ernest Hemingway her baby-talk! . . . [She has] strangely hypnotized him with her repeating habits and her *faux-naif* prattle . . . [though] he has never taken it over into a gibbering and baboonish stage as has Miss Stein." Lewis continued his assault by implying that Hemingway's characters reveal his own lack of ideology and intelligence: "It is difficult to imagine a writer whose mind is more entirely closed to politics than Hemingway's. . . . Hemingway invariably invokes a dull-witted, bovine, monosyllabic simpleton, a lethargic and stuttering dummy . . . a super-innocent, queerly-sensitive, village-idiot of a few words and fewer ideas." His characters are "*those to whom things are done*, in contrast to those who have executive will and intelligence." Lewis' criticism enraged Hemingway. He read the essay in the Shakespeare & Co. bookshop and confirmed the charge that he was anti-intellectual by punching a vase of tulips on Sylvia Beach's table and sending the fragments flying across the room.

In his fury, Hemingway failed to notice that Lewis also admired his work. Lewis followed Hemingway's attack on Sherwood Anderson's sentimental primitivism in *The Torrents of Spring* with his own condemnation in *Paleface*. In *Rude Assignment* he said: "I have always had a great respect for Hemingway. . . . He is the greatest writer in America and (odd coincidence) one of the most successful"; and while in Canada he taught and lectured on *For Whom the Bell Tolls*. Hemingway generously gave Lewis an influential and desperately-needed endorsement when he was trying to obtain portrait commissions in St. Louis in 1944. But his vindictive cruelty to Lewis in *A Moveable Feast* (where only Pound escaped whipping) was a pathetic response to Lewis' persuasive criticism: "Wyndham Lewis wore a wide black hat, like a character in the quarter, and was dressed like someone out of *La*

Bohème. He had a face that reminded me of a frog, not a bullfrog but just any frog, and Paris was too big a puddle for him. . . . Lewis did not show evil; he just looked nasty." And he added that Lewis, the triumphant seducer, had the eyes "of an unsuccessful rapist."[39]

Hemingway and Roy Campbell, Lewis' close friend and most notable disciple, had many traits in common; and much of Lewis' criticism of Hemingway—especially of his pugnacious stance and hard-boiled anti-intellectualism—applies with equal force to Campbell. Both Hemingway and Campbell loved and glorified Spain, *machismo*, blood sports, physical violence and war. In 1919, when Campbell first came to London from South Africa, William Walton brought him to Lewis' studio, where he was shown paintings that utterly mystified him. *The Caliph's Design*, Campbell wrote, "put me under the spell of Lewis, and I gradually came more and more under his influence till I started generating ideas of my own."[40]

Lewis attended Campbell's bohemian wedding celebration at the Old Harlequin night-café on Beak Street in 1922. In the middle of the marriage feast, after Campbell and his beautiful young bride had retired to an upstairs room, Jacob Kramer started what promised to be a violent fight with Augustus John. When Campbell was forced to descend in his pajamas to restore order, "A strangled protest and assent at once came from Kramer; and stiffly and slowly, his shoulders drawn up, his head thrust out, in apache bellicosity, Campbell withdrew, all of us completely silent. When the door had closed Kramer got up, came round the table and sat down. He'd put his biceps away."[41]

Lewis admired the virile exploits of Campbell, who inspired three of Lewis' fictional characters and appeared in nine of his books, and was unusually tolerant of his literary faults. Campbell defended Lewis during *The Apes of God* controversy and afterwards, invited him to Martigues in 1932, planned to publish a book about him and continued to see Lewis after World War Two whenever he visited London from Spain and Portugal. In his review of *Time and Western Man*, Campbell emphasized Lewis' satirical and temperamental affinities with romantic writers (like himself): though Lewis "says his outlook is classical and intellectual, his style and his excitability betray him as the emotional romantic." This hidden but important aspect of Lewis' character was also observed by Augustus John, who thought Lewis' romanticism explained his bizarre behavior: "But were these disguises really necessary? I asked myself. Was Lewis a fugitive of some sort? But who on earth was after him? I had never heard that he had ever been (like me) locked up. No, I decided: such behaviour could only be the desperate stratagems of an incurable Romantic *in flight from himself*!"[42] Lewis' criticism of this quality in other writers was partly an attempt to suppress this weakness in himself.

8

Sydney Schiff was Lewis' generous patron during the 1920s and a major victim in *The Apes of God*. A member of the famous continental banking family, he was born in 1868, attended Wellington College, farmed in Canada and worked as a banker in America. After an unhappy marriage he divorced his first wife, rejected a career in finance, married Violet (the sister of Wilde's faithful "Sphinx," Ada Leverson) in 1911 and decided to become an artist. Under the pseudonym of Stephen Hudson he published a novel, *Richard Kurt* (1919) and, after the death of Scott Moncrieff, translated *Le Temps retrouvé* (1931), the final volume of Proust, who was his great friend. Sydney was "bald, thin, alarmingly brisk and slightly deaf, with piercing spectacled eyes and a bristling moustache. . . . Mrs. Schiff was tall and softly graceful, with brown doe-like eyes and slender hands, an unfading Edwardian beauty: 'the angel Violet,' Proust called her, 'retiring, fragrant and miraculous flower.' "[43]

Schiff met Lewis in 1920 and often invited him with Eliot to his luxurious homes in Cambridge Square and Eastbourne, where they admired the Gauguins and Picassos, and were spoiled by their generous host. Schiff was the publisher of Read and Sitwell's *Art and Letters*, backed the *Tyro* and bought a number of Lewis' works in the *Tyros and Portraits* exhibition in 1921. He admired Lewis' work, told him he was "the only definitely creative artist this country possesses," admitted that Lewis had a strong influence on his own books and was eager for his approval. Schiff was ecstatic about Lewis' painting of Violet (1924) —which portrayed his wife with a long column of neck, slightly pursed lips and rigid oriental hair-style—and Lewis delayed completing the much-desired work in order to heighten Schiff's enthusiasm. Schiff paid Lewis the considerable sum of £712 between November 1920 and October 1924 but—as so often happened with Lewis—this led to bitter resentment. When Lewis' demands increased, Schiff refused to give him more money and they quarrelled. In December 1924, when Schiff made a tactless and futile appeal to Eliot to act as a friendly intermediary, Eliot told Lewis: "Schiff produced a paper in which he had typed out . . . each sum of money you have had from him and the date. The object of the interview was to coerce me into mediating between himself and you, and, as far as I gathered, to force or persuade you to behave in a proper manner towards him."[44]

In September 1922, when Lewis and Schiff were still on good terms, Schiff introduced him to Katherine Mansfield. Though the life and work of Lewis and Mansfield seem to be totally different, they were contemporaries and had some surprising similarities. Both were born in British colonies, came from wealthy families but were poor all their

adult lives, lived a bohemian existence in France, had a cosmopolitan rather than an insular outlook, were strongly influenced by Russian writers, and wrote their first, satiric books about Germans. Lewis decorated the Cave of the Golden Calf, where Mansfield performed as a *commère*. Both shared a hostile attitude to Bloomsbury, and wrote for the *New Age*. Both were emotionally involved with Beatrice Hastings, were artistic allies of Gaudier, and friends of the Schiffs and the Dreys. Both were hostile to doctors and unwilling to face the reality of their disease.[45]

Lewis and Mansfield, who had heard about each other from the Schiffs and were familiar with each other's work, formed different attitudes before they met: he was critical and she curious. In his letters to Violet of 1921–1922, Lewis foreshadowed his attack on Lawrence in *Paleface* and expressed irritation at the laudatory reviews of Mansfield's books, that seemed to inflate what he considered to be her minor talent: "Lawrence has brought out another book [*Women in Love*], procurable at enormous expense, from America. It is full of thighs and loins and Midland hecticness. . . . Your neighbor [in France] Miss K.M. continues to reap a monotonous harvest of offensive notices. . . . I have not read her book [*Bliss*]. But the notices are not of the kind that inspire me to procure it. . . . That London, at such a distance, must seem like an equivocal murmur to Miss Mansfield is natural. But I should have thought that the volume of unbridled Press praise [of *The Garden Party*] that reaches her should have dulled the most suspicious spirit."[46]

Mansfield, by contrast, was enthusiastic about Lewis' draughtsmanship and fiction, though she perceived his crucial weakness and saw that his art was limited by his negativism, his inner turmoil, and his lack of what she called a spiritual element. She told Dorothy Brett: "I'm interested in what you say of Wyndham L. I've heard so very very much about him from Anne Rice and Violet Schiff. Yes, I admire his line tremendously. It's beautifully obedient to his wishes. But it's queer I feel that as an artist in spite of his passions and his views and all that he lacks a real *centre*. . . . I feel Wyndham Lewis would be inclined to call the soul tiddley-om-pom." And Violet wrote to Lewis: "We have seen Katherine Mansfield (the [equivocal] murmurs having apparently subsided) & found her charming and looking much better. She expressed great admiration for your essays in the *Tyro* and *English Review* and for 'Bestre.' She remarked that your drawing 'Room 59' was like a work of art from another planet."[47]

In September 1922, four months before her death, when Lewis had the disastrous meeting with Mansfield at the Schiffs' London home, she was suffering from a fatal combination of physical illness and mental anguish, and had lost her gaiety and vitality, her creative inspiration, her faith in her husband and her hope of recovery from tuberculosis.

She was going through a spiritual crisis and had decided to "cure her soul" by entering the Institute of George Gurdjieff.[48]

Though Lewis could not have known very much about her desperate condition and search for a mystical remedy, he felt he had a natural right to lay down the law about art and artists. He was rude, perhaps even brutally cruel, to the dying woman during their heated discussions about the limitations of her stories and her fatal infatuation with the man he accurately described as "the Levantine psychic shark." The embarrassed Schiffs did not defend Mansfield on this occasion,[49] but even Lewis must have realized that he had gone too far. In his subsequent letters to the Schiffs (the closest he ever came to making an apology), he blamed Mansfield's high-strung temperament, revealed his jealousy about her reputation and close friendship with the Schiffs, and tried to minimize the seriousness of the incident:

I was very sorry to hear from Violet that you and she had also been attacked [by me]. I am afraid I must have been too uncouth, or perhaps, who knows, too *sincere*. In considering these serio-comic events, I feel that Miss K.M. has picked a quarrel with me, & it looks as though any pretext was good enough, for I do not believe she normally allows herself the "temperament" of the Prima Donna, nor is in reality so heavily emotional as all that. I ask myself why, of course: and my tortuous nature suggests to me that it may be the result of influences of another sort.—In any case, she seems to have made a fuss, both with you and Violet and me, about nothing in particular.

For me of course she is nothing but a writer of 2 books of short stories, as she puts it, which have been advertised and pushed cynically out of proportion to their merit. I find them, as I have always said, vulgar, dull and unpleasant. . . . K.M.'s note arrived. I don't see how, short of possessing such powers of divination as the Paris Institute would provide you with, you could have foreseen the rather comic dénouement of my meeting with the famous New Zealand mag.-short-story writer, in the grip of the Levantine psychic shark. I am rather glad not to be troubled with her, though I hope she won't be too venomous. . . . I have written K.M. a soothing letter.[50]

9

Despite obvious differences, Lewis and T. E. Lawrence also had certain important characteristics in common. They liked and respected each other, often met when Lawrence came up to London on leave from the R.A.F. in the mid-twenties, and always remained on good terms. Lawrence, who was an archeologist, linguist, soldier, strategist, politician, writer and inventor, was, like Lewis, a man of many talents. Both Lewis and Lawrence had a sporting and gentlemanly father who led a life of impressive idleness, and hid their family background and early life. Both men, who were exceptionally learned and profoundly

influenced by Nietzsche's ideas, had an overreaching ambition. Both possessed a charismatic personality, were idealistic about art and fascinated by political power. Both had been scarred by the War which allowed them to demonstrate their courage under fire. Both were self-declared outsiders who hated emotional displays and surrounded their vulnerable inner core with an envelope of aggression. Both had conflicting desires for obscurity and publicity, and shared a taste for exotic clothing and eccentric extremes of behavior. Both created a mysterious legend as an attractive alternative to reality.

Lawrence must have recognized these affinities, for he asked Lewis to read and collaborate on his masterpiece, a privilege reserved only for the artists he most respected. In October 1922 Lawrence told their mutual friend, William Rothenstein, that he would like Lewis to draw D. G. Hogarth for his lavishly illustrated and privately printed edition of *Seven Pillars of Wisdom*. But Lewis, occupied with his major books, did not complete a set of drawings until they were too late for Lawrence's work. In May 1924 Lawrence asked Lewis—who was writing about the West's infatuation with the primitivism of dark races in *Paleface* and would later describe the Arabs in his Moroccan travel book, *Filibusters in Barbary*—to read his unpublished account of his leadership of the Arab Revolt.

Lewis' description of the character and behavior of "this metaphysical boy-scout," at a time when both men were completing major works, is full of insight. Lawrence would speed into London on his powerful motorcycle, scale the garden wall around Lewis' studio in Holland Park and suddenly appear out of the night. Lewis, always on guard, once mistook him for a dun or tradesman's bully. Lewis had recently wasted years of his life in the artillery and questioned Lawrence about his motives for enlisting and saying farewell to ambition. He remained unconvinced by Lawrence's epigrammatic summary of his social suicide: "I was an Irish nobody. I did something. It was a failure. And I became an Irish nobody again"; and Lewis was depressed by "the spectacle of this stupid waste of so much ability." When he asked Lawrence why he refused the offer to be Governor of Egypt, Lawrence gave a somewhat theatrical reply: "if he had to sit in judgement on another man, he would always feel that he should be where the accused man was." Lewis believed that the political power Lawrence "did not respect got the better of him, and his Arab friends suffered at the same time a disillusion." He praised Lawrence, who "acted very nobly in refusing to participate in a political fraud," and later observed that Lawrence was "far too intelligent ever to imagine that the war would result in the ideal emergence of a powerful and independent Arabian State."[51]

After the publication in 1926 of *The Art of Being Ruled* and *Seven*

Pillars of Wisdom (which Lewis admired), Lewis asked William Rothenstein about Lawrence's response to his attack on Pound, Joyce and Stein in *Enemy 1*: "I was interested to hear what the 'uncrowned King of Arabia' had to say about my essay in the *Enemy*. Like most kings, he is a romantic and historically-minded personage: but I believe there are things in my essay that may have interested him.—As to his wish that I should tick off anyone in sight, that is of course not feasible. But what I [propose] is that my system will enable everyone to do that for themselves, in any instance, once its principles are grasped." In his memoirs Rothenstein quotes Lawrence's admiration for Lewis' intelligence and art, and disapproval of his literary taste and political ideas: "Lewis is a first-rate brain, and a very good artist, surely. His drawings impress me with their power. They are really fine, I fancy. Isn't it odd to like all that a man does, and to dislike, almost vehemently, all that he likes?"[52] Lawrence's paradoxical attitude toward Lewis' art and ideology was shared by many other admirers.

Lewis' six years as an "Underground Man" were an intensely rich period of emotional development, stimulating friendship and artistic creativity. By the end of 1925 *The Art of Being Ruled* was in press and Lewis was ready to launch another powerful assault on the intellectual life of England. There is nothing in modern British literature to equal the sudden cataract of Lewis' profound and monumental books, which came out in startling succession between 1926 and 1930, after his second long period of intellectual preparation.

Man of the World,
1926–1929

Do not expect a work of the classic canon.
Take binoculars to these nests of camouflage—
Spy out what is *half-there*—the-page-under-the page.
Never demand the integral—never completion—
Always what is fragmentary—the promise, the presage.

One-Way Song

Lewis published his most ambitious books in the 1920s and painted his finest pictures in the 1930s. He was fallow, because of exile and the War, in the 1940s; and had an astounding resurgence, while blind, in the 1950s. Lewis released his prodigious energy on a grand scale in March 1926 when the appearance of *The Art of Being Ruled* revived the fame he had first achieved in 1914 with *Blast*. He had been forced, for lack of money, to give up his Holland Street studio; and from 1926 until 1932 he was absorbed in writing and did very little painting. The one splendid exception was *Bagdad* (1927) in which Lewis, playing the role of absolute caliph, transfigured the ruins of the contemporary Mesopotamian city with a visionary and idealistic design.

The emergence of Lewis' books brought him out of obscurity, relieved the intense pressure of work, provided a bit more economic security and gave him greater freedom to travel. In April 1926 he moved to a better flat at 33 Ossington Street, a four-storey house with front balconies and railings, on a narrow tree-lined street off Bayswater Road, and lived there and at number 53 from September 1929 until he left for Morocco in April 1931. He was detained by martial law for three days while travelling in Spain at the time of the unsuccessful artillery revolt against Primo de Rivera in September 1926; and saw Joyce in Paris on his way home. In 1927 he travelled to Ireland, to Gavarnie in the French Pyrenees and to Paris, where he met MacLeish and Hemingway. He began a long, if intermittent, association with the BBC in January 1928 by reading from "A Soldier of Humour." In September he returned to Munich for the first time since the War.

In August 1927 and again in June 1928 he made his first voyages to

America, and remained in New York for several weeks to find publishers and sell paintings. Unfortunately, John Quinn had died in 1924 and was no longer there to assist him. Lewis stayed at the Hotel Brevoort on Fifth Avenue near Washington Square, arranged for the publication of his books by Harper, Harcourt-Brace and Covici-Friede, and lunched at the Algonquin with Edmund Wilson. Lewis' reputation, based on the malign *persona* of his books, had preceded him to New York and people expected him to behave like a monster. But Wilson, who noted Lewis' ignorance of America, assured Allen Tate: "He isn't really peevish, however, but a very agreeable person and quite interesting to talk to when his own personal egoism, though even this is not of a very poisonous kind, doesn't get into the discussion."[1]

I

Lewis was fortunate in having a first-rate editor at Chatto & Windus, which had published his previous book, on Harold Gilman, in 1919. Charles Prentice was also the editor of Norman Douglas and Aldous Huxley, and of Richard Aldington, who eulogized his cultured and charming friend in two memoirs:

Charles was a shy and reserved man, gentle and almost hesitant in manner, often silent, with a very clear complexion and benevolent expression. With his gold-rimmed glasses and bald head and kindliness he had some resemblance to Mr. Pickwick. . . . With Charles the great difficulty was to restrain his lavish hospitality and generosity. His kindness was genuine and disinterested. He was an [Oxford] scholar, particularly devoted to Greek studies, yet enthusiastic for some modern authors. . . . He was unmarried, and in spite of his amiable qualities rather a lonely man, living in lodgings in Earl's Terrace, Kensington, in a chaos of books, boxes of cigars, wines, and pictures by Wyndham Lewis. . . . With sure instinct he chose the profession of publisher, for which he possessed something like genius. He was also a good business man, for he made his firm as prosperous as he raised its literary reputation.[2]

Lewis' close friendship with Prentice, which was based on mutual respect, sustained Lewis during these disappointing years and made his disastrous break with Chatto all the more painful.

This biography provides the background, rather than a thorough analysis, of Lewis' fifty complex books. But it is necessary, for an understanding of the man, to discuss how his works reveal his intellectual development. *The Art of Being Ruled*, despite divisions into sections and chapter-headings that promise orthodox political discussion, was a discursive and associative rather than a reasoned and disciplined critique of politics, art and society: "a rough working system of thought

for the wild time we live in." The epigraphs from *Culture and Anarchy* invited comparison with Arnold and demonstrated Lewis' failure to achieve the urbane style and well-defined scope of his distinguished predecessor. Lewis' Preface, which expressed his deep sense of cultural isolation and struggle to reconcile conflicting purposes, suggested that it would be difficult to follow the maze of apparently disparate subjects. For the massive demanding tract—a strange mixture of theory, invective and prophecy—"must of necessity make its own audience; for it aims at no audience already there with which I am acquainted."[3]

The Art of Being Ruled, like all of Lewis' books of the twenties, had an excellent press. It was admired by Aldington, J. W. N. Sullivan and the still sympathetic and valuable ally, Osbert Sitwell, who praised the force of Lewis' mind in the *New York World*: "The importance of Wyndham Lewis in contemporary England cannot be over-estimated, and his latest book, *The Art of Being Ruled*, is certainly his best book. A writer of extraordinary force and distinction, it is impossible for him to touch on any subject, either in his writings or in his conversation, upon which he does not shed a new and illuminating light." In the most substantial and intelligent review, Edgell Rickword placed Lewis in his cultural tradition and explained his ambitious intentions: "*The Art of Being Ruled* should stand towards our generation in the same relation that *Culture and Anarchy* did to the generation of the 'seventies. It has the same intention, ardently pursued but not hortatory, of arresting the degradation of the values on which our civilization seems to depend . . . and of re-asserting the terms on which the life of the intellect may regain its proper ascendancy over emotional and economic existence."[4] Lewis' contemporaries felt his important ideas about vital cultural problems more than compensated for his lack of exact expression and coherent structure.

The book began by describing the conflict between weak Western liberal democracies, which were in a chaotic condition after the War, and the recently established authoritarian regimes of Russia and Italy. Though Lewis discussed this conflict in relation to the ideas of Proudhon, Marx and Sorel, his argument is neither historical nor dispassionate. He expressed the agony of being an artist in a mass-society where his gifts had little value, and was primarily concerned with the kind of society that would benefit the artist. Ultimately, he was in favor of a powerful authoritarian government in which the "responsible" ruler would permit ordinary people to live the comfortable but controlled life of a democracy, but would also allow the artists and intellectuals to have a leading role and privileged existence. "Instead of a vast organization to exploit the weaknesses of the Many," Lewis asked, "should we not possess one for the exploitation of the intelligence of the Few?"

Lewis associated classicism in literature with conservatism in politics. He was a determined authoritarian who disliked liberal, pacifist democracy, and advocated military efficiency and a stable society that would ensure peace and allow the artist to concentrate on his work. He therefore aligned himself with the source of power that controlled the Herd. He justified his attacks on Marxism and his contempt for the parliamentary system that maintained the illusion of freedom and equality by utilizing Goethe's division of mankind into rare individual "Natures" and mass mechanical "Puppets." (This idea also influenced Lewis' "automaton" theory of comedy.) Goethe "said the majority of people were machines, playing a part. . . . We are *all* slipping back into machinery, because we *all* have tried to be free. And what is absurd about this situation is that so few people even desire to be free in reality."[5] Since Lewis concluded, like Dostoyevsky's Grand Inquisitor, that men were essentially weak and craved authority, not freedom, he inevitably recommended a Fascist form of government: "We should naturally seek the most powerful and stable authority that can be devised. . . . All the humbug of a democratic suffrage, all the imbecility that is so wastefully manufactured, will henceforth be spared. . . . The disciplined *fascist* party in Italy can be taken as representing the new and healthy type of 'freedom'. . . . For anglo-saxon countries as they are constituted to-day some modified form of fascism would probably be best."[6]

Lewis praised Mussolini's Fascist society for its superior order and for its treatment of artists like D'Annunzio, Marinetti and Pirandello. But Gabriele D'Annunzio, the archetypal Italian artist, was a special case of a writer honored by Fascism. He had established a European literary reputation early in the century; and achieved considerable personal power through his heroism in war, and his capture and command of Fiume. He was a serious political rival of Mussolini, and was bought off with a title, a castle, a pension and a sumptuous national edition of his works. Lewis often elaborated his ideas about the artistic advantages of Fascism, but ignored the treatment of writers who opposed the regime. This misconception was largely responsible for his most disastrous political judgments. Lewis was cagey about defining his own political position and in a characteristically ironic statement proclaimed he was "partly communist and partly fascist, with a distinct streak of monarchism in my marxism, but at bottom anarchist, with a healthy passion for order."[7]

Lewis' conclusions now seem reactionary and naive. But his insights into the shortcomings of democracy, which controlled the people by education and propaganda, were vitally important and foreshadowed the effect of mass media on contemporary society. Lewis expressed his passionate anger about standardization and mechanization, various fads

of thought and behavior that were symptomatic of society's wish to evade reality, the fashion for Bergson and the internalizing stream of consciousness technique in literature, the imitation of the child in the art of Klee and Matisse. Lewis loathed the manipulation and oppression of the "Small Man" that he had seen during the War. But he also opposed the rule of the "Small Man," who was hostile to intellectuals and had the power to pervert art and culture.

In 1926 Lewis had no political position more reasoned and coherent than the contradictory and paradoxical *Art of Being Ruled*. His central political dilemma was his inability to reconcile the glaring discrepancy between his endorsement of an authoritarian regime, with its powerful bureaucracy and organized oppression, and his humane commitment to the life of the mind that he expressed at the end of the book: "The intellect is more removed from the crowd than is anything: but it is not a snobbish withdrawal, but a going aside for the purposes of work, of work not without its utility for the crowd. . . . The life of the intelligence is the very incarnation of freedom: where it is dogmatic and harsh it is impure; where it is too political it is impure: its disciplines are less arbitrary and less *political* than those of religion: and it is the most inveterate enemy of unjust despotic power."[8]

In his relatively mild and apologetic *Rude Assignment* (1950), Lewis gave a retrospective account of his polemical, prophylactic books, and revealed the difference between the idealistic ambition to free the mind from intellectual bondage and the negative effect of his authoritarian ideology. Lewis felt passionately about the disintegration of Western culture and wrote *The Art of Being Ruled* as an antidote to this "moronic inferno of insipidity and decay." The book was ostensibly "Ju-Jitsu for the governed," a study of the best method to cope with the ruler. But, he added more accurately, it exhaustively analyzed people's "tendency to herd, and to fly from the rigours of the individual state." Lewis regretfully admitted that he had expressed "a tincture of intolerance here and there regarding the backward, slothful, obstructive majority—'homo stultus.'"[9] It was this unfashionable disdain for ordinary humanity that led him to advocate or sympathize with Fascism until 1938.

2

The year 1927 was Lewis' *annus mirabilis*. He published *The Lion and the Fox*, his Machiavellian interpretation of Shakespeare's tragedies, in January; the first number of the *Enemy*, his third magazine, in February; *Time and Western Man*, his most important non-fictional work, in September; the second number of the *Enemy* in September; and *The Wild Body*, his thoroughly revised comic stories of Brittany, in November.

The first part of *Time and Western Man* discussed the obsessional Time-philosophy in Pound, Joyce, Proust and Stein—he later insisted "Miss Gertrude Stein should get out of english"—and the more popular manifestations of infantile attitudes in *Gentlemen Prefer Blondes*, the Russian Ballet and the films of Charlie Chaplin. The second part analyzed the Time-ideas expounded in the philosophical systems of Bergson, Einstein, Spengler, Alexander, James, Whitehead and Russell. In the opening paragraph Lewis, who preferred the solid and spatial to the nebulous and the fluent, set forth the dominant themes of the book: "This essay is a comprehensive study of the 'time'-notions which have now, in one form or another, gained an undisputed ascendancy in the intellectual world. . . . [It shows] how the 'timelessness' of einsteinian physics, the time-obsessed flux of Bergson, merge in each other; and how they have conspired to produce, upon the innocent plane of popularization, a sort of mystical time-cult." His principal victim was Bergson, whose lectures he had attended during his early years in Paris: "He has been the great organizer of disintegration in the modern world: it is he who has found all the *reasons* . . . for the destruction of the things of the intellect, and the handing over to sensation of the privileges and heirlooms of the mind, and the enslaving of the intelligent to the affective nature."

Lewis took Time as the central unifying symbol for all aspects of contemporary thought that he opposed: romanticism, impressionism, relativism, subjectivity, and the Freudian emphasis on the unconscious. He rejected these tendencies more for aesthetic than for philosophical reasons, and felt these false and sloppy habits of thought were inimical to serious art. This could be created only through classicism, rational thought, pure style, objective presentation and, in the plastic arts, hard line and clear contour. Though Lewis' early paintings had enormous energy, the vortex at the still center of the whirlpool was fixed and motionless. The jagged stabbing quality of Lewis' prose, symbolized by the = sign that separated the sentences in the first edition of *Tarr*, and the lack of a progressive plot in his fiction, were deliberate attempts to produce a series of static moments rather than a fluent narrative sequence. It was no accident that Lewis chose a spatial rather than a temporary art, and was as ignorant of music as Joyce was of painting.

Though the disparity of Lewis' critical targets made *Time and Western Man* characteristically uneven and disorganized, his incisive argument received high praise from nearly all the reviewers. Father D'Arcy called it "one of the most significant books of the age," and Mario Praz justly observed: "how rare in England [is] the phenomenon of a mind combining a habit of scathing analysis with a power of embracing wide vistas of metaphysical concepts."[10]

The most interesting part of the book for present-day readers is the

wrong-headed but fascinating chapters on Pound and Joyce, the first in a long series of patrons, friends, and acquaintances to be lashed by Lewis' pen. As he wrote in May 1927, between the periodical and the book publication of *Time and Western Man*: "The romanticism of Pound was never much to my taste. For Joyce I have great admiration, but I consider him too weak-minded." Lewis began the chapter on Pound on an affectionate note that recalled Pound's financial assistance of April 1922 and anticipated but did not answer the charge of betrayal: "Since the War I have seen little of Pound. Once towards the end of my long period of seclusion and work, hard-pressed, I turned to him for help, and found the same generous and graceful person there that I had always known; for a kinder heart never lurked beneath a portentous exterior than is to be found in Ezra Pound."

Though their names had previously been associated in the mind of the public, Pound now represented what Lewis had already rejected: Bergson, Marinetti, Ford, the Victorian decorations of Edward Fitz-gerald and the facetious, rollicking slap-on-the-back style of Buffalo Bill that belonged to Lewis' childhood. In this revisionist history of the prewar avant-garde, Lewis claimed, moreover, that he had never agreed with Pound's principles, even during the period of *Blast*, when Pound's poetry "was a series of pastiches of old french or old italian poetry, and could lay no claim to participate in the new burst of art in progress. Its novelty consisted largely in the distance it went *back*, not forward." Lewis thought Pound was a genuine *naïf*, a revolutionary simpleton, who advocated advanced principles but practiced traditional poetry. The essence of Lewis' critique, which considered the *Cantos* that Pound had begun to publish as early as 1917, was that Pound was a discriminating parasite who took everything from the past and had no originality of his own. His prose style was stagey and insincere, he was an "intellectual eunuch," a trotter through time, an untrustworthy critic who "has never loved anything as he has loved the dead."[11] Jean Cocteau later echoed Lewis when he called Pound "a rower on the river of the dead."

Lewis felt the time had arrived to repudiate his association with his old comrade in order to avoid compromising his own principles and reputation. He strongly disapproved of Pound's pronouncements about music and industry, and his association with the magazine *This Quarter*, which puffed the trivial work of McAlmon and—like the Apes of God— represented the corrupt "Millionaire Bohemia that has absorbed and is degrading the revolutionary impulse of the West." To gain his freedom and stress his originality Lewis, the self-creating artist defined in "The Code of a Herdsman," had to cast off everyone who had ever influenced him: John, Sickert and Fry in art; Nietzsche, Bergson and Marinetti in philosophy; Ford and now Pound and Joyce in literature. This "mystery

man without a past" had even denied the influence of his father. He wanted to be liberated from all previous associations and restraints, and felt he could forge ahead only after he had dropped the intellectual ballast of the past.

Despite the severity of the attack, which exposed a weakness that had recently worried Pound, he generously accepted Lewis' strictures and forgave him. Pound felt that Lewis, like all large mammals, "should be preserved"; and believed Lewis was a valuable seismograph that detected remote and potentially dangerous intellectual tremors. Henceforth Pound referred to his friend as "Wynd damn" and "Wīnd 'em," to mark Lewis' propensity to condemnation and his obsession with time and clocks. Lewis called his rumbustious friend "Ezroar"; and in *One-Way Song* wondered how the time-restricted Pound had produced his great translations from the Chinese:

> For that matter explain to me how the pages of *Cathay*
> Came out of the time-bound Ezra into the light of common day![12]

3

In his essay on Lewis, Pound contrasted his volcanic exuberance with Joyce's Jesuitical neatness: "Joyce is, by comparison, cold and meticulous, where Lewis is, if uncouth, at any rate brimming with energy, the man with a leaping mind." And Lewis (who had published his drawing of Joyce in *Enemy 2*) began his critique of Joyce, as he had done with Pound, in a personal way. He again emphasized their temperamental differences, remarked on Joyce's humble provincial origins and noted the constant preoccupation of the autobiographical hero of *Ulysses* with his social status: "Joyce is steeped in the sadness and the shabbiness of the pathetic gentility of the upper shopkeeping class, slumbering at the bottom of a neglected province; never far, in its snobbishly circumscribed despair, from the pawn-shop and the 'pub.'" Lewis thought Joyce was still fixed in the provincial Dublin of his youth and spoke of his friend with a kind of patronizing irony as: "This quiet, very positive, self-collected irish schoolmaster, with that well-known air of genteel decorum and *bienséance* of the irish middle-class, with his 'if you pleases' and 'no thank-yous,' his ceremonious Mister-this and Mister-that." Lewis was not eager to make excuses for the behavior of Joyce, who was idolized by his followers, and probably thought his criticism was "objective." But Joyce was astounded and hurt that Lewis would mock his habitual formality and courtly manners, and suggest that he was *arriviste*. Though Lewis mentioned, in connection with Joyce's background, "faded old women in lodging-houses, whose main hold upon life appears to be the belief that they had seen better days,"[13]

he must have been very sensitive about his own origins. For Lewis and his mother had come down in the world after his father had left them and had led just this sort of lodging-house life in the London suburbs, before (and after) he went to the Continent in 1902.

Lewis thought his work was as good as, if not better than, Joyce's and that the "Circe" chapter in *Ulysses* was derived from his own innovative technique in *Enemy of the Stars*. Despite his pretense of objectivity, he was clearly jealous of the critical success, the coterie, the imitators and the patrons that followed the publication of *Ulysses* in 1922. And the fragmentary appearance in *transition* of sections of *Finnegans Wake* seemed to emphasize its eternal flux and flow. Lewis told Pound that the generous Harriet Weaver "was the nearest approach to super-natural experience Jimmie J. ever knew"; and his chapter—which criticized Joyce as trivial, arrogant, romantic, sentimental, derivative and pedantic—was the first significant blow to Joyce's rising reputation.

As with Pound, Lewis felt Joyce's slick craftsmanship disguised his lack of real ideas. He condemned "the extreme conventionality of Joyce's mind and outlook," and remarked that "his technical adventures do not, apparently, stimulate him to think." Lewis very usefully traced the sources of Joyce's style in Rabelais, Nashe, Dickens, Stein—and in his own *Enemy of the Stars*. He claimed that Joyce's characters were merely clichés of poets, Jews and Irishmen; and that his soft, flabby and vague method confined "the reader in a circumscribed psychological space into which several encyclopaedias have been emptied." Lewis thought Joyce's technical virtuosity and literary scholarship produced a torrent of Freudian and Einsteinian flux; and he dismissed *Ulysses* as "a sardonic catafalque of the victorian world . . . eternally cathartic, a monument like a record diarrhoea."[14]

Lewis' hostile criticism of Joyce was ironic in two respects. First critics now praise Joyce for precisely what Lewis condemned: his stream of consciousness technique that reveals the flow of thoughts in Bloom's eclectic mind; his depth of characterization; his elaborate virtuoso prose styles; his profound attachment to Ireland. Second, Lewis' *The Apes of God*, his main attempt to rival and surpass *Ulysses* by "telling-it-from-the-outside" in a longer, funnier and more satirical and fantastic portrayal of the contemporary world, is now condemned for the very faults Lewis attributed to *Ulysses*.[15] By a perverse twist of fate and taste that has exalted Joyce and virtually ignored Lewis, Lewis seems to be criticizing his own book when he writes that Joyce's tech-nique "is very mechanical . . . very dead"; when he says of "the frigid prig," Stephen: "It would be difficult, I think, to find a more lifeless, irritating principal figure than the deplorable hero of the *Portrait of the Artist* and of *Ulysses*"; when the creator of crude anti-Semitic characters (especially in the "Chez Lionel Kein" chapter of *The Apes of God*)

states: Joyce "has certainly contributed nothing to the literature of the Jew, for which task he is in any case quite unsuited"; and when he remarks on the exhausting effect of Joyce's style: "His great appetite for words, their punning potentialities, along with a power of compressing them into pungent arabesques, is admirable enough to have made him more remembered than he is. But certainly some instinct in Posterity turned it away from this *too* physical, too merely high-spirited and muscular, verbal performer. He tired it like a child with his empty energy."[16]

In Lewis' allegorical satire, *The Childermass*, published nine months later in June 1928, the Bergsonian Bailiff, who personifies the doctrine of Time, parodied (for six pages) the "night language" and pretentious learning of *Finnegans Wake*: "For he's a great mixer is Master Joys of Potluck, Joys of Jingles, whom men call Crossword-Joys for his apt circumsolutions but whom the Gods call just Joys or Shimmy, shut and short.—'Sure and oi will bighorror!' sez the dedalan Sham-up-to-date with a most genteelest soft-budding gem of a hipcough. 'Oh solvite me'—bolshing in ers fist most mannerly."[17]

In *The Apes of God*, Lewis' final caricature of Joyce as the Jewish, slum-bred, saurian-skinned, self-torturing, second-rate writer, Jamesjulius Ratner, whose "ambition led him to burgle all the books of Western romance to steal their heroes' expensive outfits for his musty shop," combined Bloom's religion and Joyce's shabby origins. Despite the personal attacks, Joyce, like Pound, tolerated the criticism of his work and continued to see Lewis. In July 1930, a month after Lewis' fourth criticism of Joyce, they dined together at Joyce's request and had a friendly discussion about the career of the Irish tenor John Sullivan, whom Lewis later introduced to his patron Lady Cunard, a close friend of Sir Thomas Beecham. Afterwards, Lewis condescendingly described Joyce in a letter to Aldington, which was particularly ironic in view of Lewis' later blindness: "James Joyce has come to see me, to play Odysseus to my Cyclops—quite forgetting that it is *he* not myself who has half-sight. (Joyce is like an over-mellow hot-house pear, with an attractive musical delivery, but he bored me this time)."[18] In the early thirties Lewis referred even more harshly to Jimmie Joys as an "insinuating ivernian [Hibernian] bastard"; complained that *Finnegans Wake*, "his polygluttonous volume, [was] always 'in progress' —Continuous Present"—never actually completed; and in *One-Way Song* jabbed at his friend for frequently republishing his trivial *Pomes Penyeach*: "and James Joyce / For the third time his thirteen poems deploys."[19]

When Richard Ellmann was writing his biography of Joyce, he interviewed Lewis twice and noted some significant changes in his accounts of their friendship. In 1954 Lewis was more frank and reveal-

ing, and admitted that he had had a good deal of trouble with Joyce after his essay had appeared in the *Enemy*. But in 1956 Lewis appeared more reluctant to assume the guise of Joyce's adversary, emphasized their friendship and said that Joyce had always visited him when he came to London.[20]

Joyce said that Lewis' hostile criticism was by far the best that had been written. But he later became more defensive, conceded that Lewis had scored only a few hits and felt the criticism did not damage the essential elements of his work. As he remarked to a friend: "If all that Lewis says is true, is it more than ten per cent of the truth?" In *Finnegans Wake* (1939), where Lewis is the model for Professor Jones and for the Ondt that is outwitted by the Joycean Gracehoper, Joyce attempted to refute Lewis' criticism of *Ulysses* in *The Art of Being Ruled*, *Time and Western Man*, *The Childermass* and *The Apes of God*. Joyce mimics and parodies Lewis' stylistic mannerisms, includes a number of puns on Lewis' works ("irony of the stars," "cattleman's spring meat," "art of being rude," *Spice and Westend Women*), and wittily satirizes Lewis' preference for Space rather than Time literature:

> Your genus its worldwide, your spacest sublime!
> But, Holy Saltmartin, why can't you beat time?[21]

4

The Wild Body, the last book of 1927, contained ten stories. Eight of them—unified by a single narrator, the showman Ker-Orr—were composed before the War, appeared in little magazines between 1909 and 1917, and were entirely rewritten and given new titles for book publication. The last two stories, one of them published in 1922, were written after the War. The book had been sold before the War to the publisher Max Goschen, along with the *Timon of Athens* portfolio, and should have appeared before *Tarr*. But Goschen was killed, the business collapsed and everything was scattered. The long delay in publishing *The Wild Body* drastically diminished its innovative effect and imaginative force. For the style of the earliest stories, originally published five years before *Dubliners*, was far more experimental than any contemporary prose.

The Wild Body, whose title refers to the uncontrolled physical side of human nature, expressed two of Lewis' dominant themes: the division of the mind and the body, and the conflict between the artist and society. The first idea derived from Descartes, who wrote: "the mind, by which I am what I am, is wholly distinct from the body." Lewis observed that Descartes (who first used the word "vortex") "called animals *machines*: they had not the rational spark. But men use

their rational spark so unequally, and [they are] machines too."[22] In his essay "Inferior Religions," Lewis took up this idea and commented on "The fascinating imbecility of creaking men machines"; and in his war memoir he connected this concept with the military mechanism: "I instantly wheeled with the precision of a well-constructed top; and with the tread of an irresistible automaton I bore down swiftly and steadily upon the adjutant."

In the chapter on "The Meaning of The Wild Body," Lewis explained his theory of comedy, which was related to his political idea that most men are non-thinking puppets. He argued that it was necessary "to assume a dichotomy of mind and body . . . for it is upon that essential separation that the theory of laughter here proposed is based. . . . The root of the Comic is to be sought in the sensations resulting from the observation of a thing behaving like a person. But from that point of view all men are necessarily comic; for they are all things, or physical bodies, behaving as persons."[23] These principles of mechanistic behavior provided the theoretical foundation for Lewis' "automaton" characters in The Childermass, The Apes of God and Snooty Baronet. But in The Wild Body, as in the long novels, the static and insubstantial narrative was unequal to the coruscating style. In a perceptive review Cyril Connolly praised "Mr. Lewis' gift of phrase, his mature and clotted sentences, his prickly and torrid sensibility." But he also noted the disparity between Lewis' ideas and art, and the limitations of his mechanical theory of comedy which failed to bring his characters to life: "The Wild Body is not a humorous book, as much as some extremely technical illustrations of the anatomy of wit . . . an excellent manual for the hard-boiled."[24]

Lewis composed works like The Childermass by roughly sketching the skeleton and then, through infinite elaboration, fleshing out the work and bringing it to life: "The book, of course, is born in the head, not on the paper. But I get down upon the paper, in a rough draught, written at top speed, the action, or the structure of the argument, as the case may be. The detail comes afterwards. But a work of art is a sort of animal—it is not easy for me to tell you just how it is made. It grows all sorts of things on itself—for effect—as it goes along. The brain creates it by a fiat—having pondered upon an entire zoology, for some time. But then the mere craftsmanship takes it over."[25] The Childermass, which alludes to a massacre of the innocents that never occurs in the novel, was an abstract, philosophical phantasmagoria, a tour of the world after death, which took place on a plain outside heaven where the dead were interrogated by the Bailiff before being admitted to the Magnetic City. Difficult to read and to describe (and for this reason ignored in the current fad of fantasy literature), the novel dramatized many of the political ideas of The Art of Being Ruled, contained elabo-

rate discussions of space and time ("Time is the mind of Space—Space is the mere body of Time"), parodied working-class speech and the styles of Joyce and Stein, satirized the public school idiom in the conversations of Pullman and his childish ex-fag Satterthwaite and, in a final dialogue between Alectryon and the Bailiff, discussed the theme of homosexuality that preoccupied Lewis in *The Art of Being Ruled*, *Paleface*, *The Apes of God*, *Hitler*, *The Doom of Youth* and *The Roaring Queen*. H. G. Wells, one of the first to recognize the strengths of the novel, told Lewis: "I find myself more and more deeply impressed by your vivid imagination, your power of evocation and your profound queer humour." And the young Lionel Trilling, reviewing the American edition, observed that Lewis' fierce negativity and lack of constructive alternatives diminished the effect of his art: "In anxious and arrogant prose and with a slashing, savage burlesque, Mr. Lewis pursues modern civilization. . . . He rejects and refuses most of the productions of the modern world. This must immediately give him an eminence and a hearing. . . . But his anger will prevent him from being granted the accord which he must be seeking from the best spirits."[26]

5

Paleface, Lewis' last book of the 1920s, was written in a lively and informal style during his first visit to America in the summer of 1927, and published in May 1929. This polemic once again took up the theme he had portrayed in *Tarr* and *The Wild Body*, and defended the sovereignty of the mind against the onslaught of the emotions. *Paleface* primarily attacked visceral philosophy: " '*The consciousness in the abdomen*,' [which] removes the vital centre into the viscera, and takes the privilege of leadership away from the hated 'mind' or 'intellect,' established up in the head." Lewis argued "I would rather have the least man that *thinks*, than the average man that squats and drums and drums, with 'sightless,' 'soulless' eyes: I would rather have an ounce of human 'consciousness' than a universe full of 'abdominal' afflatus and hot, unconscious, 'soulless,' mystical throbbing." At the time of *Porgie*, *All God's Chillun*, *The Emperor Jones*, *Nigger Heaven*, the cult of jazz (and Nancy Cunard's notorious affair with the Negro musician Henry Crowder), Lewis wittily opposed the spurious and sentimental expropriation of African culture, and rejected the fashionable, arty assumption that the emotional and sensual life of the black race was superior to the white. He illustrated his argument with a striking dust-jacket that placed a foppish but classical Caucasian profile above the "colour line" that separated it from the rather simian side view of an African.

Though Lewis admired the primitive energy of his elemental

European Bretons and Tyros, he concentrated his fire on the exaltation of Negro and Indian primitivism in Sherwood Anderson's *Dark Laughter* (1925) (which had been parodied in Hemingway's *The Torrents of Spring* (1926)) and in Lawrence's minor but representative travel book, *Mornings in Mexico* (1927). When Lewis praised Hemingway's satire, he received an enthusiastic response to his own work: "I am very glad you liked *The Torrents of Spring* and thought you destroyed the Red and Black enthusiasm very finely in *Paleface*. That terrible—— about the nobility of any gent belonging to another race than our own (whatever it is) was worth checking. Lawrence you know was Anderson's God in the old days—and you can trace his effect all through A's stuff. . . . In fact *The Torrents of Spring* was, in fiction form, performing the same purgative function as *Paleface*."[27]

Like Lawrence, whom he resembled in a number of significant ways, Lewis was a dogmatic and didactic crusader against cant and hypocrisy, a volatile and temperamentally intolerant man who felt driven to condemn the evils of the world. And like Lawrence, Lewis could not refrain from attacking and alienating even his closest friends in his attempt to impose his vision and values upon society. After his own books had been suppressed in 1932, Lewis optimistically told his publisher that he too might receive the kind of useful notoriety that had eventually helped Lawrence after the ban of *The Rainbow* and *Lady Chatterley's Lover* (as well as his paintings, which Lewis called "incompetent Gauguin"). He also praised Lawrence's fight against repressive modes of thought: "Half the popular success of D. H. Lawrence it is obvious was due to the constant banning of his books, and the exhilarating spectacle of his battle with antiquated and unreal prejudices of the puritan conscience." Though Lewis admired Lawrence's intellectual courage, he criticized his emphasis on the child, glorification of the feminine principle and Freudian stress on the unconscious. He also grossly distorted and underestimated two of Lawrence's finest novels: "With *Sons and Lovers*, his first [i.e. third] book, he was at once hot-foot upon the fashionable trail of incest: the book is an eloquent wallowing mass of Mother-love and Sex-idolatry. His *Women in Love* is again the same thick, sentimental luscious stew."[28]

Lawrence responded angrily to *Paleface* (first published in the *Enemy* in September 1927) in *Lady Chatterley's Lover* (1928) and in his Introduction to Edward Dahlberg's *Bottom Dogs* (1929). Though David Garnett stated that Duncan Forbes in the novel was based on Duncan Grant, the paintings by the "fellow with straight black hair and a weird Celtic conceit of himself" are far more violent and abstract than Grant's tepid Post-Impressionist pictures, and resemble those of Lewis' Vorticist period: "His art was all tubes and valves and spirals and strange colours, ultra modern, yet with a certain power, even a certain

purity of form and tone: only Mellors thought it cruel and repellent."
The last two adjectives might be applied to Lewis' art, but the *ad
hominem* pronouncement of Mellors, whose strong point is not art
criticism and who advocates a kind of William Morris *ashram* to
rejuvenate mankind, is both arrogant and ill-informed: "I think all
these tubes and corrugated vibrations are stupid enough for anything,
and pretty sentimental. They show a lot of self-pity and an awful lot of
nervous self-opinion, it seems to me." In the Dahlberg Introduction
Lawrence, who was intellectually antithetical to Lewis, violently con-
demned his almost inhuman negativism: "Wyndham Lewis gives a
display of the utterly repulsive effect people have on him, but he retreats
into the intellect to make his display. It is a question of manner and
manners. The effect is the same. It is the same exclamation: They
stink! My God, they stink!"[29]

Lawrence's crude condemnation was a fascinating mixture of moral
judgment, personal bias and self-criticism. He was perceptive about
Lewis' habitual mode of suppressing his emotions, which he mis-
trusted and feared, beneath an intellectual carapace; and he reasonably
chastized Lewis' combative technique and unpleasant tone ("manner
and manners"). Lawrence's condemnation might well have applied to
The Apes of God, but that was not published until four months after his
death in 1930. He was probably thinking of passages in "Inferior
Religions" and in "Cantleman's Spring-Mate," which expressed Lewis'
particular disdain for women and children as well as for the rest of
humanity: "Upward from the surface of existence a lurid and dramatic
scum oozes and accumulates into the characters we see"; "The news-
papers were the things that stank most on earth, and human beings
anywhere were the most ugly and offensive of the brutes because
of the confusion caused by their consciousness."[30]

Lawrence was undoubtedly provoked by *Paleface* and may have
recognized in himself the same faults he condemned in Lewis. For the
autobiographical account, at the end of the "Nightmare" chapter in
Kangaroo (1923), of the medical examination he was forced to endure
while Lewis was fighting in the trenches, closely resembles the extreme
expression of Lewis, with whom he had significant temperamental
affinities: "Because they had handled his private parts, and looked into
them, their eyes should burst and their hands should wither and their
hearts should rot. So he cursed them in his blood, with an unremitting
curse. . . . He was full of a lava fire of rage and hate, at the bottom of
his soul."

Provoked this time by Lawrence, Lewis continued to attack his en-
raged exoticism, "his fetish of promiscuity and hysterical paeans to all
that is 'dark and strange' " in *Hitler* (1931). He mocked and parodied
the super-sexed Zarathustran in the "Sol Invictus—Bull Unsexed"

section of *Snooty Baronet* (1932). And in *The Roaring Queen* (1936), Baby Bucktrout reads Lawrence's notorious novel as an antidote to that Edwardian devil, sexual inversion: "I am compelled to read *Lady Chatterley's Lover*, if you please, and such books as that, in order to prevent myself from falling back into the vices upon which I was nurtured."[31] Both Lewis and Lawrence, who represent two strongly contrasting modes of modern thought, accused each other of sentimentality and could not recognize the merits of their rival's books. For both—goaded by personal attacks—isolated the elements they disliked and ignored the greatness of the work that remained. Lewis was much more emotional, Lawrence far more intellectual, than either of them cared to admit.

In the most intelligent review of *Paleface*, Rebecca West agreed with Lawrence's criticism—though not with his expression. She began by praising Lewis' intellect, style and imagination: "There is no one who has had greater acumen in detecting the trends of contemporary thought that are not candid. . . . There is no one whose dialectic style is more sparkling. There is no one who can more deeply thrill one by a vivid and novel vision." But she concluded that he failed to produce a significant effect on his time because all his books were seriously flawed by exaggeration and distortion.[32] Lewis' extremist views were misunderstood and *Paleface*—the first of his self-destructive books—gave him the undeserved reputation of a racist. But he was, as usual, far ahead of his time in the trenchant exploration of a vital cultural issue: the portrayal of the Negro in white literature.

6

Lewis confidently expected his seven important books would bring him a great reputation, sufficient money to continue his work and a group of disciples. But he was largely disappointed in each of these hopes and could never command acknowledgment of his genius. Though his seminal works were highly praised by the most intelligent writers and critics of the time, he never achieved the fame of Joyce, Eliot, Pound, Lawrence and Virginia Woolf, and had no major influence on English thought and literature. In *One-Way Song* Lewis asked:

> "If so you be the authenticated sage
> Of our epoch, why aren't you all the rage?"

An analysis of his major defects as an artist—his dissipated energy, his lack of form and inconsistent style, his offensive tone, his negativity—helps to explain why he never fully achieved the promise of greatness in *Blast* and *Tarr*.

Lewis was proud of his manifold talents and justly boasted: "I am an artist . . . draughtsman, critic, politician, journalist, essayist, pamphleteer, all rolled into one, like one of those portmanteau-men of the Italian Renaissance." But (as Huxley suggested in *Antic Hay*) his very strengths were also his weaknesses, and his books were too uneven and profuse. Eliot also felt constrained to warn him about scattering rather than focussing his enormous energy: "I have felt very strongly that it would be in your own interest to concentrate on one book at a time and not plan eight or ten books at once. . . . The dispersing in one direction seems to me possibly as unwise as a dispersal in another would be."[33]

A second and more serious difficulty was that Lewis, despite his attachment to the classical tradition, lacked the classic virtues of style and form. His faults were intrinsic with his genius, his brilliant and boring passages inextricable, and his highly-wrought style (as Wilde said of Browning) was too often "chaos illuminated by flashes of lightning." Too many of his imaginative books—like *The Childermass* and *The Apes of God*—had great promise but limited success. They start brilliantly and evoke an exciting visual quality, but gradually disintegrate, go on too long, and finally seem over-written, tiresome and unreadable. The discursive books were not hammered into a solid, coherent shape. He substituted energy for logic, arrogantly cast forth his ideas, never felt that he had to perfect his work and assumed that sheer genius would compensate for deficiencies in craft. As John Holloway observed, they "are scrappy, prolix, tangential to their main arguments or even centrifugal from them, and, above all, written with a kind of smudging, fudging abundance of style which exhausts and bewilders and exasperates." The manifest faults of his over-ambitious books—which were repetitive, undisciplined, digressive and disorganized—made his complex arguments difficult to follow and almost eclipsed his virtues.

Though one gets the impression from reading Lewis' polemical books that they are hasty, careless and slapdash, his manuscripts and correspondence with publishers reveal the minute care he took with them. This paradox is explained by the fact that he was always pressed for money, wrote very rapidly and then took considerable pains in revision and proofs. But Prentice was not strict in his demands for structural improvement, Lewis' tardy attention could never sufficiently remedy the essential defects of style and structure, and his books often lacked form and finish. Though every one of his works contains brilliant passages and bears the impress of his extraordinary mind, they were all seriously flawed. He never achieved sustained greatness in any of his vastly diverse books, and created no *Waste Land* or *Ulysses* that embodied his genius and guaranteed his fame.

In his essay on "Good Bad Books," the immensely readable but relatively superficial Orwell perceptively remarked on the element of emptiness in Lewis' fiction: "Enough talent to set up dozens of ordinary writers has been poured into Wyndham Lewis' so-called novels, such as *Tarr* or *Snooty Baronet*. Yet it would be very heavy labour to read one of these books right through. Some indefinable quality, a sort of literary vitamin . . . is absent from them."[34] Lewis' fierce intensity of vision made many demands on and few concessions to his readers. He had little interest in the traditional elements of fiction and did not attempt to sustain an interesting narrative. His characters were remote, intellectual and fantastic; and in certain novels of the twenties and thirties, which employed a theory of mechanical behavior, he portrayed them entirely from an external point of view. He had an elaborate, contorted prose style, and presented difficult, often unappealing ideas. He lacked human warmth and failed to engage the sympathy of his audience. Lewis' emotions were deliberately suppressed beneath the icy surface of most of his books, but they made a triumphant and redemptive appearance in his two greatest novels: *The Revenge for Love* and *Self Condemned*.

A third difficulty was Lewis' harsh, offensive, truculent and uncompromising tone, and the apparently treacherous way he conducted his polemical warfare. His books were self-indulgent, excessive, extremist and contemptuous; and his intransigent reactionary views were reinforced by a colossal egoism, which fortified at the same time as it detracted from his work. Lewis behaved with equal arrogance to both friends and enemies, who treated him rather like a dangerous and unpredictable animal. Provoked at times by feelings of jealousy and envy, he thought the artist was a public person and that everyone's work was fair game; passionate about ideas and loyal to the highest standards in art, he was honest and open in his criticism of other authors. He exhausted his rancor in polemics, truly thought writers would be honored by the attacks which proved that he took their work seriously, and naively expected everyone to forgive him afterwards. The great writers—Joyce, Eliot, Pound—sustained by a belief in their art, acknowledged the truth of his criticism and remained his friends. Others, like Stein, Hemingway and Read, waited to take their revenge.

The fourth defect was Lewis' querulous and overwhelming negativity: the predisposition of the rogue elephant to break loose and destroy his favorite quarry. This destructive hostility was also related to one of his finest qualities: his courageous and disquieting opposition to the prevailing intellectual fashions of the literary and artistic establishment. In *Tyro 2* he asserted: "The world is in the strictest sense asleep, with rare intervals and spots of awareness. It is almost the sleep of the insect or animal world." His self-appointed commission was to explode this

somnolent complacency by casting hard shafts of light on the intellectual structure of the West. In the end, the only contemporary books that Lewis praised were his own; and few others liked them as much as he did. In *Tarr* he had prophesied with uncanny accuracy his own humiliation when he perceived: "His contempt for everybody else in the end must degrade him: for if nothing in other men was worth honouring, finally his own self-neglect must result."

Like Yeats in "The Second Coming," Pound in "Hugh Selwyn Mauberley," Eliot in *The Waste Land* and Lawrence in *Women in Love*, Lewis recognized that the classical and rational thought of the West had culminated in a War that destroyed traditional society and civilized values. During this War, which had awakened Lewis' political consciousness, many thousands of State-controlled men had been led to pointless slaughter. He felt he had wasted several prime years of his life defending a defunct society and achieving absolutely nothing. The Russian Revolution, the monetary collapse of central Europe and even the General Strike of May 1926 that provided the climax of *The Apes of God* powerfully reinforced his sense of immense disorder, decay and despair between the wars. Lewis' contemporaries looked for more hopeful alternatives in other cultures: Yeats in the Celts of western Ireland, Pound in the ancient Chinese, Eliot in Hindu philosophy, Lawrence in the pre-Columbian Aztecs. Lewis clung to the bankrupt rational tradition, and was reactionary not only in his desire to return to prewar political stability but also in his idealistic reaction against postwar chaos. He felt he had to diagnose and destroy cultural corruption before he could help to create a better society, and his books of the late twenties were a noble but ultimately futile attempt to defend his concept of civilization.

Lewis' contentious books, which were filled with startling ideas, offended the sensibilities and stimulated the minds of his readers. They represented a massive attempt to destroy the cults and fashions of what passed for contemporary thought, and threatened the Classical, Intellectual and Individual Artist: the time process, stream of consciousness, child cult, homosexuality, irrationality, primitivism and neglect of form. "Assuming the existence of a vast conspiracy embracing everything that was happening in the modern world," Hugh Kenner observed, "he dealt seriatim with its manifestations in order of decreasing complexity." Lewis' formidable and convincing attacks pulled all these ideas to pieces, but his central weakness was revealed when he refused to commit himself to a constructive use of his imaginative and intuitive gifts. As Alectryon tells the Bailiff in *The Childermass*: "The trouble is that only your hatred is creative; it is your only way of being creative."[35]

An unsympathetic view of Lewis' books of the twenties—and many people took this view—could ignore his original ideas and energetic style and see the works as a series of near failures. *The Lion and the Fox*

was too thesis-ridden and applied to only a few of Shakespeare's tragedies. *The Art of Being Ruled* had long boring patches and advocated Fascism. *Time and Western Man* suffered from treacherous biassed criticism and the lack of a rigidly-trained philosophical mind. *The Wild Body* was too narrowly limited by a mechanistic theory of comedy. *The Childermass* was too abstract and lacked substantial characters and an interesting plot. *Paleface* seemed racist. The recurrent themes of infantilism and perversion in these works show the connections between the six parts of Lewis' original mammoth work; the radical lack of organization reveals that the parts were imperfectly separated.

Richard Aldington, who shared Lewis' cantankerous personality and satiric skill, gave an interesting, if not entirely convincing, explanation of Lewis' limitations as an artist. In a letter to Herbert Read, written just after Lewis' death, Aldington expressed his admiration for Lewis, attributed his negativity to the fact that he was essentially an outsider, compared his personality and "persecution mania" (closely connected to his lack of recognition) to Pound's, criticized his tendency to attack insignificant targets, and related his formal weakness to his crippling poverty: "I thought highly of him—more than you, not so much as Tom [Eliot]. His negative attitude was probably due, as you hint, to his birth. But I think he was a paranoiac. He and Ezra were much alike in their mania of grandeur and mania of persecution. Both have told me most impressively of the persecution they suffered from 'them.' I have never found out who 'they' were. Of course it was absurd to use this sledge-hammer to crush such tiny little nuts as Alec Waugh and Godfrey Winn [in *The Doom of Youth*]. But surely the *Apes* is a magnificent sortie against what W.L. so rightly called 'champagne bohemia.' His books begin with magnificent energy, and gradually peter out. Poverty and the need to produce?"[36]

7

At the end of 1926 Lewis obtained permission from the lady who owned a typewriting business at 113A Westbourne Grove, Paddington, to use her office; and established the Arthur Press, which published the *Enemy*, *The Apes of God* and *Satire and Fiction* between 1927 and 1930. The first two numbers of the *Enemy*, which printed 1,500 and then an unduly optimistic 5,000 copies, were backed by Lewis' generous friend and patron Sir Nicholas Waterhouse, who lost £450.

Lewis took the epigraph for all three numbers from Plutarch's *Moralia*, which stressed the salutary influence of his galvanic observations: "A man of understanding is to benefit by his enemies. . . . He that knoweth he has an enemy will look circumspectly about him to all

matters, ordering his life and behaviour in better sort." Lewis' first editorial boldly announced: "there is no 'movement' gathered here (thank heaven!), merely a person; a solitary outlaw and not a gang." But after the appearance of the second number, he asked Herbert Read to contribute, stressed the need for propaganda (as he had done with the Vorticists), and said it was essential to give the impression not of a single spy, but of a battalion.

The three numbers of the *Enemy* were Lewis' virtually single-handed attempt to attract attention to his books and enhance his reputation. They had extensive advertisements of his previous works and most of the issues were filled with long sections of his forthcoming books: the first half of *Time and Western Man*, the last three-quarters of *Paleface* and all of *The Diabolical Principle*. In *Enemy 1* Lewis promised the imminent publication of *Time and Western Man* and *The Childermass*; a reprint of *Enemy of the Stars*, which did not appear until 1932; and a collection of political essays, *Creatures of Habit and Creatures of Change* (the title of an essay in the *Calendar* of 1926) which never appeared. And he wittily regretted that: "Circumstances do not allow the editor of *The Enemy* to hope that he can live up to the business-like standards usually expected by the more irascible type of contributor."

Enemy 1 contained a chapter from J. W. N. Sullivan's new centenary book on Beethoven; Wilfred Gibson's essay on De Chirico, whom Lewis admired; Eliot's "Note on Poetry and Belief"; six drawings by Lewis, including a self-portrait; and his amusing essay "What's in a Namesake?" Lewis, who was seriously trying to re-establish his reputation after the War and his "Underground" period, was irritated by the public's constant confusion—which still persists today—between himself and the Catholic journalist and biographer D. B. Wyndham Lewis. The latter, under the name of "Beachcomber," wrote a popular column for Beaverbook's *Daily Express* between 1919 and 1925. "He was one of those humble Press clowns who cut a few humdrum verbal capers every morning," Lewis noted. "Then all of a sudden my name-sake slipped from under his original nom-de-plume, and appeared in the centre of the Rothermere Press, revealed as the 'great English humourist, Wyndham Lewis'."

Lewis claimed that Viscount Rothermere, whom he portrayed in *Thirty Personalities*, deliberately "invented" D. B. Wyndham Lewis after Lewis had quarrelled with Rothermere during one of his elegant dinner-parties.[37] D. B. Wyndham Lewis wrote for the *Daily Mail* under the heading "At the Sign of the Blue Moon" between 1925 and 1930, later edited the popular anthology of bad verse *The Stuffed Owl* (1930), and published what his rival called wishy-washy biographies of Villon (1928) and Ronsard (1944). The ex-bombardier and editor of the *Enemy* who claimed the sole right to demolish hostile belligerents with his

"Lewis gun," genuinely suffered from partial eclipse by the light-weight humorist; this mistaken identity was compounded when the American novelist Sinclair Lewis, the poet C. Day Lewis and the Oxford don C. S. Lewis began their literary careers in the 1920s. Fans of D. B. would sometimes write to Lewis, after reading one of the latter's sardonic books, and lament: "You are not your old dear self." Though a speaker in *One-Way Song* alludes to this confusion and asks: "Is *Snooty Baronet* that dirty book / I once for D. B. Wyndham's jests mistook?," Lewis achieved posthumous revenge. When his nominal rival died in November 1969, *Le Figaro* printed Percy Wyndham Lewis' obituary—and had to run a correction the following day.

8

Lewis, who was forty-seven when *Paleface* was published in 1929 and had spent seven long years writing the ambitious works of the late 1920s, earned pathetically little for his titanic labors. He remained trapped in the poverty which Gissing had described in *New Grub Street* and which he shared with his contemporaries of genius: Pound, Eliot, Joyce, Conrad and Lawrence. All these authors eventually achieved a comfortable income through marriage, business, patrons, popularity or notoriety, but Lewis remained desperately poor throughout his life. His books were published in small editions of 1,000 to 2,500 (except for the second edition of *Tarr* which printed 5,250 copies), his advances for the English and American editions ranged from £50 to £200. He never sold more than 1,000 copies of non-fiction and never earned more than his advance (*Tarr* sold 1,950 copies in the first six months, but Lewis had relinquished all rights to the book for £150). This proud man, who was permanently dependent on patrons, ironically remarked; "I cannot recall a single instance of anyone offering me money and my not accepting it. I can't help saying yes."[38]

Though Lewis' books did not make money, they did bring him a number of important new friends and acquaintances during the late twenties: Sir Nicholas Waterhouse, Anton Zwemmer, A. J. A. Symons, David Garnett, W. H. Auden and W. B. Yeats. Lewis found the ideal patron in the cultured and generous Sir Nicholas Waterhouse, who had no artistic pretensions, paid for the publication of the *Enemy* and *The Apes of God*, and received, in the 1931 edition of the massive satire, Lewis' only formal dedication. Waterhouse's mother was the daughter of a Prussian merchant who had married "a most charming Jewess"; his father Edwin, one of three distinguished brothers of a Quaker family, founded the well-known accounting firm of Price, Waterhouse. Water-house, who was educated at Winchester and New College, Oxford, had

wanted to become a doctor and had served on a government commission on venereal diseases early in the century. He was a thoroughly talented professional man: gentle and charming. He joined the family firm at the age of twenty-two in 1899, was knighted in 1920, and retired as senior partner in 1960. But he was only nominally concerned with running the business, and was content to be something of a figurehead who was free to devote most of his time to his country house, Norwood Farm, near Effingham in Surrey, and to billiards, stamp collecting, fishing and travelling on the Continent in his Rolls-Royce.

Waterhouse was a long thin man, six feet tall, with grey-blue eyes, tortoise-shell spectacles and a gentle, donnish face. In his privately printed memoirs he fondly recalled: "I had known Lewis since the first World War and for the last few years of his life I looked on him as one of my closest friends. . . . His amazing pluck in adversity and never failing sense of humour made him a very lovable friend."[39] Waterhouse expressed his faith in Lewis with consistent financial support. He paid £100 for Lewis' medical bills in January 1933 and for his nursing home in March 1934, and provided a £5 a month allowance when he was ill during these years. He also gave Lewis £375 in 1947, sent him quarterly contributions when he became blind in the 1950s and left Froanna a legacy of £250 after his death in 1964.

Another loyal supporter was Anton Zwemmer, who owned the bookshop that still exists on the corner of Charing Cross Road. He was born in Haarlem, where Lewis had copied Frans Hals, in 1892, first came to England in 1914 and bought the shop in 1921. He always retained his Dutch citizenship, was continental in manner and taste, but had a perfect English accent. He would greet his customers with his "hands in coat pockets, immaculate, rising on his toes, a trifle sardonic, amused, diffident, helpful, knowledgeable."[40]

Zwemmer's shop began to specialize in art books in about 1925, when he first met Lewis, though he continued to import other works from Germany and to sell them under his own imprint. He opened an art gallery on the ground floor of 26 Litchfield Street just after the Crash, in November 1929, and continued it until 1963. He included twelve of Lewis' works, which ranged in price from seven to fifteen guineas, with those of Matisse, Braque, Derain, Dali and Gaudier, in his exhibition of "French and English Contemporary Artists" during December 1934 and January 1935. Lewis also appeared in a mixed exhibition of August 1938 when his painting *Group of Suppliants* (1933), was priced at forty guineas and later reduced to £35 in the Christmas exhibition that year. In May 1957 Zwemmer held a small memorial exhibition of Lewis' work.

Zwemmer was fond of Lewis, who could be a charming and amiable man and often came to the shop to find out about the latest events in

the European art world. Zwemmer faithfully supported Lewis as an artist. He took his work on consignment, advertized and sold the *Enemy*, bought his art and manuscripts (he paid £23 for *Paleface* in 1929) and gave him money. Lewis, who never seemed to have any cash, would appear with a hunted look, and stare up and down the street when leaving. He appreciated Zwemmer's help, saw him as a cultural ally, admired what he was doing for art, and said Zwemmer's and the Mayor Gallery were "the only two places where the most radical form of experiment are consistently encouraged."[41]

Lewis' most surprising and unusual friendship was with A. J. A. Symons, who was three inches taller than the six-foot Lewis, had thick black hair, a large broad nose, thin lips and a strong chin. Symons seemed to be the perfect Ape of God and to represent everything Lewis normally detested. He was a dilettante, a dandy and an aesthete who imitated Disraeli and adored the nineties (which Lewis had nearly finished off in *Tarr*). He carefully concealed his Jewish origins, wore a monocle, dressed in lavender suits, sported a malacca cane, studied books on etiquette, affected an elaborate calligraphy and collected Victorian music boxes. Symons was also a passionate bibliophile and gourmet, devoted to what he called "Home Industries": editing the *Book Collector's Quarterly* and organizing the First Edition Club, the Sette of Odd Volumes, and the Food and Wine Society. On June 27, 1929 he invited Lewis to an eight-course banquet, with fine wines and Napoleonic brandy, in honor of Baron Corvo. Symons read *Snooty Baronet* in manuscript, suggested improvements and even planned to collaborate with Lewis on a book of criticism. He admired and collected Lewis' works and wrote, with typical hyperbole: "It is important that I should live no longer *without* the American first edition of *Tarr*. . . . I sleep-walk to the bookcase and am discovered by the maid (a) nude (b) weeping for *Tarr*."[42]

Despite affectations and preciosity, Symons (like Osbert Sitwell) was a sophisticated, witty, cultured and talented fellow, with a mysterious past. He had a wife and a mistress, wrote the superb *Quest for Corvo* (1934), was a friend of Wadsworth and Dick Wyndham, had many useful connections, and introduced Lewis to Lord Carlow and to his co-editor, Desmond Flower, who published three of Lewis' books. Lewis had a kind of amused appreciation for Symons, considered him an ingenious character and a rare collector's piece, and admired his ability (which Lewis himself so notably lacked) to raise money. Lewis, who was always fascinated by smart operators like Fulton Sheen and smooth phoneys like David Kahma (both of whom he later met in Canada), wrote about such characters in his novels: the Bailiff in *The Childermass*, Zagreus in *The Apes of God*, Humph in *Snooty Baronet*, Hardcaster in *The Revenge for Love* and Penhale in *The Vulgar Streak*.

(The latter contained interesting hints of Symons' character and career.) In a similar fashion, he admired Symons' expertise as a gamesman, gambler and con man who taught him to forge signatures, and enthusiastically told Flower, after Symons had died of a rare brain disease in 1941: "Of course he was a crook, but a good crook!"[43]

Lewis first wrote to David Garnett after he had published an enthusiastic review in America and called the *Enemy* "the most valuable survey of modern thought, of modern philosophy and its influence on literature, that I have ever come across." Garnett thought Lewis was a healthy destructive critic who stirred things up like an electric eel. Lewis was under the impression that Garnett had quarrelled with Roger Fry and had used the favorable review as a weapon against Lewis' old adversary. Lewis also felt he could now win over a member of Bloomsbury and gain a new adherent. Garnett's unsympathetic account of their meeting (which resembles Lewis' proposed encounter with Strachey) appears to be another example of Lewis' deliberate attempt to mystify Bloomsbury. When they met in May 1928 in the basement of a Lyons tea-shop, Lewis wore his Spanish hat, dark spectacles and gloves—to avoid fingerprints on the cups—and sat with his back to the wall. He behaved in a noticeably odd manner, seemed to be a bit mad and acted as if he had a "persecution complex." He said that he was frightened by the enmity of Fry's "gunmen," though Garnett assured him that Fry never thought about him, and insisted that he felt safer in secrecy. Garnett did not attempt to defend Fry or Virginia Woolf when Lewis criticized them, and was unable to satisfy Lewis' curiosity about how Clive Bell had successfully promoted the artistic reputations of Vanessa Bell and Duncan Grant.[44]

But Lewis was primarily concerned about how to promote his own works, especially *The Childermass*, which was about to be published in America. Marie Melony, the editor of the *New York Herald Tribune Sunday Magazine*, had requested an article about Lewis' work. Lewis recommended Garnett, whose successful *Lady into Fox* had recently been published by Chatto, and after their conversation Garnett agreed to write an essay on *The Childermass*. When Garnett received page-proofs, he felt the novel was too strongly influenced by *Ulysses* and did not like it. Nevertheless, he wrote the article, sent it to Lewis and told him he could suppress it if he wished. Lewis evidently thought Garnett's article was better than no article at all, took it with him to New York in June 1928, and sent it to Mrs. Melony along with his negative review (which had been published in *Enemy 2*) of Kathryn Mayo's popular *Mother India*. But Mrs. Melony disliked the review (which reappeared as an appendix to *Paleface*); and Garnett's essay—which terminated his relationship with Lewis and must have fanned Lewis' hostility to Bloomsbury—never appeared.[45]

Lewis kept in touch with developments in Oxford and Cambridge as well as on the Continent. As an undergraduate in the late twenties, Alistair Cooke saw Lewis "when he swept up to Cambridge in the wide black snap brim and laid down ferocious laws for the more rebellious avant-garde. I recall once how I almost shrank against the gateway of Jesus College as he whisked by talking to, almost barking at, William Empson."[46] And when W. H. Auden visited Lewis in Ossington Street in 1928, Lewis found him like a rather "fey" oriental ambassador: "He was very crafty and solemn: I felt I was being interviewed by an emissary of some highly civilized power—perhaps overcivilized—who had considered that something had to be done about me and so one of its most able negotiators had been sent along to sound me."[47]

Auden later expressed grudging admiration for Lewis in two of his poems. In "A Happy New Year" (1933), he praised Lewis for his cathartic provocations:

> The Sitwells were giving a private dance
> But Wyndham Lewis disguised as the maid
> Was putting cascara in the still lemonade.

And four years later, in *Letters from Iceland*, Auden and MacNeice recognized the angry political isolation of Lewis, whose book in praise of Hitler made him one of the loneliest intellectuals of the 1930s. They alluded to his Welsh ancestry, his notorious "persecution complex," his aggressive blond-beast Nietzschean hero, Ker-Orr, of "The Soldier of Humour," and his peculiar combination of keen intelligence and political stupidity.

> There's Wyndham Lewis fuming out of sight,
> That lonely old volcano of the Right. . . .
> We leave the martyr's stake at Abergwilly
> To Wyndham Lewis with a box of soldiers (blonde)
> Regretting one so bright should be so silly.[48]

W. B. Yeats, who had first met Lewis in 1909 and had praised *Tarr*, could have been introduced to his works by Ezra Pound or Sturge Moore. Yeats eagerly read the sections of *Time and Western Man* which appeared in *Enemy 1*, recognized a kindred philosophical spirit, and wrote about it with great enthusiasm to Pound's mother-in-law, Olivia Shakespear: "Lewis has some profound judgments—when he analyses public opinion or some definite work of art—and often a vivid phrase. . . . I am reading *Time and Western Man* with ever growing admiration and envy—what energy!—and I am driven back to my [poetical] reed-pipe. I want you to ask Lewis to meet me—we are in *fundamental* agreement." After a long discussion with Yeats about Lewis' genius, Moore was delighted to convey to Lewis the poet's fervent approval: "Yeats is also reading and rereading *Time and Western Man*. He says

you have revealed to him what he hates, and that he need not in future say any more splenetic things as you have said enough for both. He calls you Absalom on account of your dangerously long hair from a stylistic point of view, but says you can write and have intellectual passion, of which we have been starved for 30 years." Yeats was even more enthusiastic about Lewis' novel, which appeared the following year, noted the affinities with *A Vision* and told him: "I have read 'Childermass' with excitement. . . . It is as powerful as 'Gulliver' and much more exciting to a modern mind. . . . There are moments in the first hundred pages that no writer of romance has surpassed."[49]

Both authors were naturally eager to renew their acquaintance and probably met at the home of Sturge Moore in May 1929. "Have just had tea with Wyndham Lewis," Yeats reported to Olivia Shakespear. "Both of us too cautious, with too much sympathy for one another not to fear we might discover some fundamental difference. We played with all topics and said as little as possible." Lewis liked Yeats and admired his poetry, and they became very friendly for a time. Yeats went round to Ossington Street to see Lewis' art and remarked that the towers in his abstract drawings expressed "just what I felt about life." Lewis, always sceptical about Irish histrionics, told Froanna that when he met Yeats for the last time on Regent Street, he "pushed up that Irish accent as soon as he saw me."[50]

The personal tie cemented the intellectual bond, and when *The Apes of God* appeared in 1930 Yeats paid Lewis a great compliment by comparing him to his idol, Jonathan Swift: "I felt, on first reading *The Apes of God*, that something absent from all literature for a generation was back again, and in a form rare in the literature of all generations, passion ennobled by intensity, by endurance, by wisdom. We had it in one man once. He lies in St Patrick's now under the greatest epitaph in history." Lewis returned the magnanimous compliment in the finest triplet of *One-Way Song*. He praised Yeats for following Pound's austere advice, abandoning romanticism, sharpening the instrument of his poetry and achieving his finest work in the last years of his life:

> . . . the greater Yeats,
> Turning his back on Ossian, relates
> The blasts of more contemporary fates.[51]

Despite the significant approval of Yeats, who endorsed Pound's and Eliot's judgment of Lewis, the contemporary fates had not been kind to Lewis. By the end of the twenties he had revived his prewar reputation, but not his finances. His bitterness about the lack of material success undoubtedly reinforced the satiric intensity of *The Apes of God*, which devastated his favorite *bêtes noires*: patrons, poetasters, homosexuals, Bloomsburys and Sitwells.

CHAPTER TEN

The Apes of God, 1930

But this allows my varying of shapes:
Knaves do grow great by being great men's apes.
Webster, *The White Devil*

Chatto & Windus had published six of the seven books by Lewis that appeared in the late 1920s and had lost money on all of them. After Lewis' poor sales, the firm could not meet what they considered to be his unrealistic expectations and he quarrelled with them about the advance for *The Apes of God*. Lewis felt the small amount they offered was greatly out of proportion to the seven years he had spent on the book, to its great length and importance, and to Prentice's high opinion of the work.

Lewis, who established the Arthur Press to bring out the *Enemy* and had considerable experience in publishing his own work, obtained the necessary financial assistance from Nicholas Waterhouse, sent out a prospectus and subscription list, and bought out the book in a limited edition of 750 signed and numbered copies, at three guineas each, in June 1930. This cubist telephone book of 625 pages weighed five pounds, was three inches thick and illustrated with Lewis' own drawings and designs. During an interview with the London *Star*, Lewis gave an inaccurate, contradictory but diplomatic explanation of why he had decided to follow the practice of Norman Douglas and privately publish the first edition of *The Apes of God*: "People might think I started to publish my own work because I was dissatisfied with my publishers. That is not so. Previously Chatto & Windus had always published for me, and I was always very well pleased with the arrangements. This new book, however, was of the class that always does best when published by a private press instead of a large firm of publishers, so I decided to be the private press myself."[1] He added that in future he intended to publish all his own books at least in the first edition.

I

The Apes of God, based on Lewis' theory and defense of satire, was written in his "external" manner. Beginning with *Tarr* in 1918, he had defined art as the science of the outside of things and said he preferred the hard formal shield of the turtle to the soft amorphous coating of the jellyfish: "Dogmatically, then, I am for the *Great Without*, for the method of *external* approach, for the wisdom of the eye, rather than that of the ear." He also explained that his objective and visual narrative technique was related to the clear, sharp contours of his paintings:

First of all I *see*! The first—and last—thing that I do is to use my eyes. The result is the art of the *visuel*, as Remy de Gourmont called it. . . . In writing, the only thing that interests me is *the shell*. It's the actions and the appearance of people that I am concerned with, not the 'stream of consciousness' of any 'mysterious' invisible Within. I think the normal human attitude is physical, not mental. . . . *The eye* has been the organ in the ascendant here. . . . No book has ever been written that has paid more attention to *the outside* of people. In it their shells, or pelts, or the language of their bodily movements, come first. . . . The ossature is my favourite part of a living animal organism, not its intestines.[2]

Lewis feared sentimentality and mistrusted emotions, which he thought distorted and falsified art. He had the painter's sharp eye for visual detail, preferred a more intellectual and impersonal approach, felt concrete behavior was more revealing than imaginary thought, and believed the external method was more honest, accurate and truthful.

In *Time and Western Man* and *Paleface* Lewis attacked Stein, Proust, Joyce and Lawrence for using the stream of consciousness technique and for presenting things from the "inside." He associated hot feeling, pulsating elasticity and the restless ego with the narcissistic theories of Romanticism. "The method of *Ulysses* imposes a softness, flabbiness and vagueness everywhere in its bergsonian fluidity," Lewis stated. "It is *you* who descend into the flux of *Ulysses*, and it is the author who absorbs you momentarily into himself for that experience. That is all that the 'telling from the inside' amounts to."[3]

At the end of *One-Way Song* Lewis placed himself among the satirists of the Augustan Age and exclaimed, in his finest couplet:

> These times require a tongue that naked goes,
> Without more fuss than Dryden's or Defoe's.

The Apes of God followed this satiric tradition which also included Swift, Smollett, Hogarth and especially Rowlandson, whom Lewis greatly admired and frequently praised, for Lewis believed "true satire must be vicious. . . . The venom of Pope is what is needed." His book is a modern *Dunciad*: a massive, static but sharp-edged catalogue of the

literary evils that arise from contemporary urban chaos. It is a farcical magnification of inanity that employs linguistic virtuosity and the technique of overkill to demolish its helpless victims. It is also a bitter comedy, a deliberately cruel personal attack, and a savage *roman à clef* from which Lewis' enemies begged to be excluded. And Lewis, like Pope, asserted his right and power to pronounce the proper literary standards of his age. Lewis explained that the satire continued his exploration of the collapse of English social life and the pathology of modern culture: "the social decay of the insanitary trough between the two great wars."[4] He once again attacked the confusion of intellect and emotion in a society threatened by revolution, but still immersed in the fantasies of an adult nursery.

The Apes of God attempted to revive English satire which had been dormant, since the death of Byron, for a hundred years. Parts of the book were extremely funny, but the effect was spoiled by excessive elaboration and by the great granite landslides of prose that suffocated rather than stabbed the victims. Lewis conceded that he was worried about the poor quality of his enemies and that the breed left much to be desired. But he justly claimed that his targets were not trivial, for the Bloomsburys and the Sitwells (with their parasitic patronage) were the leading literary coteries of the time. The overwhelming negativity and anger of his satire obliterated the merits of his rivals and reduced them to insignificance. Unlike Pope or Smollett, Lewis was not really interested in his victims and never brought them to life.

Lewis' reliance in *The Apes of God* on external description of character (as in *Tarr*) combined with a mechanical theory of human behavior (as in *The Wild Body*) destroyed the individual qualities of the characters and deliberately reduced them to mindless things. Except for Pierpoint, the Great Absentee who issues pontifical encyclicals to Zagreus but never actually appears in the book, the characters lack both feeling and intelligence, and forfeit the attention and sympathy of the reader. Lewis was unable to surmount the handicap of a self-defeating theory and a rigidly restrictive technique which drastically diminished the effect of his satire. His theory and technique resembled Stein's deadly repetition in *The Making of Americans*, Joyce's poly-lingual puns in *Finnegans Wake* and Pound's dissociated fragments in *The Cantos*. His book was another astonishing example of the limitations of intelligence dominated by abstract theory.

The Apes of God, like *Tarr*, anatomized unsavory aspects of the lower depths of the art world: the worthless imitators of divine creators. The paltry, episodic plot of the energetic but shapeless book concerns a guided tour of this ape-artist world arranged by Horace Zagreus for his moronic Irish protégé, Dan Boleyn. The physique and character of Zagreus, a sentimental, effeminate, pseudo-intellectual practical joker,

with a talent for discovering "genius," was a composite of George Borrow and Horace de Vere Cole (just as Ker-Orr was reminiscent of William Blake and Gene Tunney). Borrow, the Romantic linguist and traveller in Spain (whose followers had been "Blasted"), was a splendid muscular figure, several inches taller than six foot. Cole was a rich and preposterous man who had been a friend of Adrian Stephen at Cambridge and remained on the fringe of Bloomsbury. In February 1910 he and Virginia Stephen (who became Virginia Woolf) disguised themselves as Abyssinian royalty and successfully hoaxed the officers of the British battleship *Dreadnought*.[5]

The satire expresses Lewis' moral and aesthetic values as well as his caustic character, records his friendships and feuds, and gives a lively if biassed account of the literary history of the 1920s. The story of Lewis' personal relations with his victims and the complex reasons for his devastating blast of Bloomsbury, the Sitwells, the Schiffs, Edwin Muir, T. S. Eliot, Dick Wyndham, Stephen Spender and Edgell Rickword are now the most interesting aspects of the book and the key to its meaning. Lewis' Art of Being Rude becomes infinitely more accessible and enjoyable when the sometimes obscure originals of his satiric scourge are identified. Of the three surviving Apes—Spender, Rickword and Sacheverell Sitwell—one is faintly amused, one wearily indifferent and one still furious about his role in the satire.

2

Lewis' relations with Bloomsbury went back to his student days in Paris when he first met Duncan Grant at the Café du Dôme in 1907. Lytton Strachey noticed and sneered at his early stories in the *English Review*, and in 1926 Lewis sent him the strange letter suggesting a secret meeting and perhaps a temporary halt in hostilities. Roger Fry and Clive Bell had praised and bought his Vorticist paintings, but Lewis broke with Fry in 1913. He had spied out the Bloomsbury landscape during visits to Garsington in the early twenties; drawn Virginia Woolf in 1921; launched a few tentative missiles at Bloomsbury in *Tyro 1*; and allied himself with the Sitwells in the 1920s in order to fortify his own position and counter the hostility of the rival coterie. Chatto & Windus also published Strachey and David Garnett, and Lewis enlisted the help of the latter in 1928 to publicize the American edition of *The Childermass*. Lewis held his fire until his books of the late 1920s had re-established his literary reputation that had been obscured by the War and his years "Underground." But the *Blitzkrieg* assault in *The Apes of God* attempted a final Bloomsburial and expressed his slow-fused but explosive response to their destructive conspiracy.

Lewis hated Bloomsbury for five main reasons. He felt they had deliberately hurt his career, he disliked their aesthetic values, their snobbish behavior, their politics and pacifism, and their homosexual ethos. One of Lewis' contsant charges was that Fry maliciously sought revenge for Lewis' bitter exposure of his shady practices during the Omega controversy; and that the rest of Bloomsbury, jealous of Lewis' superior achievement in both art and literature, actively assisted in Fry's caustic but covert campaign. Lewis felt that malefic sect of militant amateurs had infected English culture and society like a strangely-privileged fungus: "Most journalistic channels were blocked, for me, by 'Bloomsburies,' who filled, as they still do, the politico-literary press, where fairly profitable reviewing was to be had. . . . I was a 'highbrow' and a 'difficult' and contentious 'highbrow' at that. . . . I could write a hundred 'Childermasses' and they would be shot to pieces, or still worse ignored." John Rothenstein, who as Director of the Tate Gallery was thoroughly familiar with the English art world, supported Lewis' contention—though he did not provide specific examples: "There was nothing in the way of slander and intrigue to which certain of the 'Bloomsburys' were not willing to descend. I rarely knew hatreds pursued with so much malevolence over so many years; against them neither age nor misfortune offered the slightest protection."[6]

Virginia Woolf's letter of May 1921, a month after *Tyro 1* was published, reveals that Bloomsbury considered Lewis a formidable adversary: "Wyndham Lewis has been abusing everyone I'm told, in his paper, and Roger and Nessa read him in shops, and won't buy him—which, as I say, proves that they fear him." The *Tyro* contained Lewis' essay on "Roger Fry's Rôle as a Continental Mediator," which argued convincingly that Bloomsbury aesthetics were decorative and old-fashioned, and that they used their connections with the Paris art world to puff their own inferior work: "A small group of people which is of almost purely eminent Victorian origin, saturated with William Morris's prettiness and fervour, 'Art for Art's sake,' late Victorianism, the direct descendants of Victorian England—I refer to the Bloomsbury painters—are those who are apt to act most as mediators between people working here and on the Continent, especially Paris. And Paris gets most of its notions on the subject of English painting through this medium. Mr. Roger Fry, the publicist and painter, is their honoured leader; Mr. Duncan Grant their darling star-performer. Mr. Clive Bell, second in command, grows almost *too* articulate with emotion whenever he refers to either of these figures." Ben Nicholson confirmed Lewis' contention when he quoted Picasso, who inquired: "Why, when I ask about modern artists in England, am I always told about Duncan Grant?"[7] One need only compare Lewis' highly original paintings with the derivative work of Fry and Grant to understand his rage at their success and his own failure.

Virginia Woolf, who had heard gossip about Lewis' wretched studio at Adam and Eve Mews, characteristically expressed her loyalty to Fry and criticism of Lewis by ignoring his argument and sneering at his poverty: "Herbert Read, who has been in the Lewis pigsty without wallowing in it, had some amazing stories of the brutes. Lewis now paints in a shed behind a curtain—rites gone through before you enter." The clear insinuation is that Lewis was a brute because he could not afford to rent the kind of elegant studio that Fry's independent income enabled him to have. This is precisely the attitude that Lewis condemned in his splendidly libellous article of 1934 on "The Bloomsburies." Lewis, who liked straightforward manly types, perceptively showed that Bloomsbury equated mannerisms with manners, and used their stammering, halting, blushing affectations to justify their own work and destroy their rivals' art. They employed "the time-honoured technique of social superiority, but put to the uses of *intellectual* superiority: to be socially snobbish about the possession of taste . . . about being a 'genius.' " Katherine Mansfield, who had experienced Bloomsbury's cruelties, also criticized their fundamental hostility to art and their intolerable arrogance: "I confess that at heart I hate them because I feel they are enemies of Art—of real true Art. The snigger is a very awful thing when one is young and the sneer can nearly kill."[8]

Perhaps the most powerful reason for Lewis' hatred of Bloomsbury was their pacifism. He felt this was a cowardly avoidance of the War that had killed Gaudier and Hulme, doomed the hopes of Vorticism and *Blast*, and destroyed the prime years of his artistic life. In this respect Lewis followed Hulme's vitriolic attack on the art snobbery and pacifism of Clive Bell in the "War Notes" he had sent from the front to the *New Age* in 1916: Bell is "enough to sicken any decent man; it makes one want to kick the pompous ass. . . . It is sickening to think that a man like [Gaudier] who showed promise of becoming a considerable artist should be killed, while this wretched artistic pimp [Bell] still survives." By comparison with Hulme's attack, Lewis' accusation that Bloomsbury had used their money to protect themselves and exploit others was relatively mild: "The 'Bloomsburies' were all doing war-work of 'National importance,' down in some downy English county, under the wings of powerful pacifist friends. . . . The 'Bloomsburies' all exempted themselves, in one way or another. Yet they had money and we didn't; ultimately it was to keep them fat and prosperous . . . that other people were to risk their skins."

Lewis had attacked homosexuality in "The Vicious Circle" and "Man and Shaman" sections of *The Art of Being Ruled*, in which he associated inversion with the worst aspects of artistic patronage: intellectual snobbery, the "obligation" of culture, refined speech and millionaire

luxury. Lewis also argued that homosexuality was bad for society as well as for art. The hostility to women was ultimately connected to the disintegration of the family, the sexual immaturity encouraged the cult of youth, the affectations led to doctrinaire dilettantism and the social snobbery was a war on the intellect. Though many twentieth-century writers were homosexuals and a great deal of modern literature deals with homosexual themes, Lewis either ignored or denied their very significant achievement. He associated their literature with romantic emotionalism, criticized Proust and Stein in *Time and Western Man,* and ridiculed Gide, Cocteau, Strachey and Spender in *The Apes of God.*[9]

Lewis, who was strongly influenced by Carlyle, Ruskin and Arnold, disliked Strachey's debunking of Victorian literary heroes and quoted with approval Edmund Wilson's criticism of *Elizabeth and Essex:* "There is something distasteful about it: it marks so definitely the surrender of Elizabethan to Bloomsbury England." But Lewis was fascinated by the physical peculiarity of Strachey: his stiffness of limb, long "false" beard, falsetto voice, outrageous mannerisms and strange sexual entanglements. Certain aspects of the freakish Strachey appear in the arrogant homosexual patron Cedric Furber, in *Self Condemned;* and in the late story, "The Doppelgänger" (1954), Lewis satirized "The hysterical shrieks of laughter of the Old Maid, not less funny because of the long and postiche-looking beard, the come-away-nearer girlish gesticulations of this extremely tall perverse amorist."[10] Strachey had once lost his head and in a rash moment actually proposed marriage to Virginia Stephen—a "mechanical" gesture worthy of inclusion in what Woolf called the "Bloomsbury Black Book."

The Apes of God emphasized the absurd (and eventually tragic) relationship of the long-limbed Strachey and the tiny Dora Carrington. For when Matthew Plunkett goes to a psychiatrist (the Hogarth Press published Freud in England), he is ordered to choose a Lilliputian lady-friend and becomes fixated on Betty Bligh, who "was short and slight, to the point of being the doll-woman . . . the four-foot-ten adult-tot in toto, stunted at the mark of her fifteenth summer." Clive and Vanessa Bell also appear thinly disguised as the Jonathan Bells. Lewis mocked the hearty philistine aspect of Clive that contrasted with his aesthetic Bloomsbury side, and ridiculed Vanessa's posturing as a West End bohemian after the manner of Augustus John: "Oak-timbered 'John' Bell was the 'rudest man in London'—no one was blunter, more straight-from-the-shoulder. . . . Bell's wife was there as a picturesque *plein-air* drudge . . . an indistinct Chelsea gypsy."

Though Lewis' criticism of Bloomsbury was ultimately convincing and valuable, his satire was mistakenly concentrated on their superficial behavior rather than on the more serious limitations of their

morality and art. Nevertheless, his acute summary, which indicts them for social snobbery, Victorian aestheticism, fake bohemianism, confusion of money and taste, lack of originality and mutual glorification, is an essential antidote to the then current indiscriminate adoration of the Bloomsbury sodality: "In Bloomsbury [amateurism] takes the form of a select and snobbish club. Its foundation-members consisted of monied middle-class descendants of victorian literary splendour. Where they approximate to the citizens of this new cosmopolitan Bohemia is in their substitution of money for talent as a qualification for membership. Private-means is the almost inevitable rule. In their discouragement of too much unconservative originality they are very strong. . . . All are 'geniuses,' before whose creations the other members of the Club in an invariable ritual, must swoon with appreciation."[11]

Lewis continued his campaigns against Bloomsbury with attacks on Virginia Woolf in *Men Without Art* (1934), *The Roaring Queen* (1936) and *The Revenge for Love* (1937). Lewis' chapter on Woolf in the first book dissected her well-known essay "Mr. Bennett and Mrs. Brown" (rather than her fiction) in order to determine the role of the feminine principle in her criticism of the realistic novelists: Bennett, Wells, and Galsworthy. His conclusion, which continued the argument of *The Apes of God*, was that Woolf's Impressionistic art falsely claimed to be more delicate, precious, idealistic and spiritual than the robust male novelists, and that the Bloomsbury technique "has been very much to the disadvantage of any vigorous manifestation in the arts; for anything above the *salon* scale is what this sort of person most dislikes and is at some pains to stifle." Lewis, who jabbed at Woolf's feminism and said "I have taken the cow by the horns in this chapter," was criticized by Spender for these "malicious" words and responded with a lively defense of his critical method.[12]

In his more severe novel, *The Roaring Queen*, a literary outrigger of *The Apes of God*, Woolf appears as Rhoda Hyman. She is a precious snobbish literary fraud with that "drooping intellect-ravaged exterior of the lanky and sickly lady in Victorian muslins." Her first name is taken from the depressing heroine of *The Waves*, who suffers from other people's ridicule and scorn and complains: "What I say is perpetually contradicted. . . . I am to be derided all my life." This feeling of self-pity, which Lewis considered characteristically weak and feminine, precisely matches the epigraph from Woolf's essay that he chose for his chapter in *Men Without Art*: "We must reconcile ourselves to a season of failures and fragments." Her second name, of course, rather cruelly suggests the sexual inexperience of Mrs. Woolf.

In *Men Without Art* Lewis showed that Woolf claimed to oppose Joyce's realism, but took her account of the Queen's progress through London in *Mrs. Dalloway* directly from the Viceroy's progress through

Dublin in *Ulysses*. In *The Roaring Queen* the essential accusation against Rhoda Hyman is that she too steals from other writers: "That had indeed been a regal gesture on the part of the Highbrow Queen of Literary London—to 'crown' her *own* work over the heads of all the other works awaiting 'crowns' on the score of bold criminal thefts from other people's books." And Margot Stamp, the soft, dreamy heroine of *The Revenge for Love*, has some of the weaknesses of Woolf's Rhoda, reads *A Room of One's Own* and is criticized for sympathizing with its author: "that great weary queen" who would lead her into a highbrow feminist fairyland.[13]

The hypersensitive Woolf, who mocked Lewis' "ridiculous posing and posturing," acknowledged that he had made "tremendous and delightful fun" of her essay. But she greatly feared for her damaged reputation, took masochistic satisfaction in her martyrdom and confided to her diary that Lewis' criticism had made her ill for several days: "I know by reason and instinct that this is an attack; that I am publicly demolished; nothing is left of me in Oxford and Cambridge and places where the young read Wyndham Lewis. My instinct is not to read it. . . . Then there is the queer disreputable pleasure in being abused—in being a figure, in being a martyr."[14] Though Lewis' criticism of Woolf was both acute and convincing, he later felt he had paid too much attention to Bloomsbury and had suffered more harm than he had been able to inflict. But he could not refrain from attacking Bloomsbury whose malice, manners, and morals, art, literature and politics, dominated the cultural life of the 1920s and provoked him to obsessive, self-destructive rage.

3

Lewis was quite friendly with the Sitwells in the 1920s, as he had been with Bloomsbury before 1914, for both groups were lively and stimulating, admired his work, had useful social contacts, provided patronage and advanced his career. His friendship with the Sitwells seemed at first to be a valuable defensive alliance against Bloomsbury. But as he came to observe them more closely, he saw remarkable similarities between the two tyrannical queens and their asphyxiating coteries: "There is, of course, a very much closer connection than people suppose between the aesthetic movement presided over by Oscar Wilde, and that presided over in the first post-war decade by Mrs. Woolf and Miss Sitwell. . . . For fifteen years I have subsisted in this to me suffocating atmosphere. I have felt very much a fish out of water, very alien to all the standards that I saw being built up around me. I have defended myself as best I could against the influences of what I felt to be a

tyrannical inverted orthodoxy-in-the-making."[15] Many of Lewis' criticisms of Bloomsbury apply with equal force to the Sitwells, for both groups—unlike Lewis—learned to use their social status to help their careers.

Lewis, armed and armored, moved across the literary terrain like a sniper through a battlefield. For Lewis, the individualistic Nietzschean artist, was in conflict with both the bourgeois Bloomsbury intellectuals and the aristocratic Sitwells. He believed he was the only true artist among them and demanded recognition; they took an entirely different view of the impoverished upstart, never really understood the reasons for his rage and thought him "paranoid." Lewis was constantly attempting to mine their base, dislodge them from their secure source of power, and capture their audience and popularity. But their contexts and clients were both repugnant to him; his attacks were futile and he was never able to replace their values with his own.

Lewis felt unmeasured virulence against literary rivals and patrons, and was an especially dangerous friend to the Sitwells, who combined both roles and came to represent nearly everything that Lewis loathed. The last half of *The Apes of God*, "Lord Osmund's Lenten Party," is a vitriolic indictment of the Sitwells posturing at Renishaw that exposes their ancestor worship, pomposity, snobbery, arrogance, bad taste and narcissistic self-admiration. Lewis, who often found it difficult to be civil, let alone ingratiating, felt the Sitwells used fashionable drawing-rooms and the popular press to advertize themselves and achieve their artistic ambitions. He was particularly disgusted by their self-seeking cultivation of the despicable but influential literary establishment: Edmund Gosse, Arnold Bennett and Wilde's old friend Robert Ross. The Sitwells also had their own court favorites and flatterers who periodically rose and fell in their estimation; and their patronizing puffs of young "geniuses," like Brian Howard and William Walton, constituted the "sort of middle-aged *youth-movement*" that Lewis also satirized in *The Doom of Youth* (1932). All these extravagant yet trivial social maneuvers, designed to inflate their minor talents into great reputations, were immensely successful and the Sitwells enjoyed their greatest popularity during the 1920s.

Lewis' most serious charge against the Sitwells was that they were false and frivolous rather than serious and committed artists. He thought they were phoney rebels and condemned their "special brand of rich-man's gilded bolshevism." He referred to them as a trio of clowns and described their mannered games as "a sort of ill-acted Commedia dell'Arte. . . . Their theatre was always with them." *The Apes of God* was the first book to portray the Sitwells as precious poseurs who invented their elaborate performance to amuse their little court. The Sitwells seemed to provide Lewis with ammunition and substantiate his

accusations with their rather arch entries for the *Who's Who* of 1929, which Lewis found less amusing than disgusting:

Edith: *Educ.*: privately; in early youth took an intense dislike to simplicity, morris-dancing, a sense of humour, and every kind of sport excepting reviewer-baiting, and has continued these distastes ever since.
Osbert: *Educ.*: during the holidays from Eton . . . deeply interested in any manifestation of sport . . . played against Yorkshire Cricket Eleven (left-handed) when 7 years old; was put down for M.C.C. on day of birth by W. G. Grace, but has now abandoned all other athletic interests in order to urge the adoption of new sports such as: Pelota, Kif-Kif, and the Pengo (especially the latter); spent the winter of 1927–28 in the Sahara studying same. . . . *Recreations*: Sensitive Dentine, regretting the Bourbons, Repartee, and Tu quoque.
Sacheverell: *Educ.*: Left [Balliol] owing to continued success of Gilbert & Sullivan season at Oxford. . . . *Recreations*: model aeroplanes, plats regionaux, improvisation, the bull-ring.

Though Lewis clearly disliked many of the social and literary characteristics of the Sitwells, who thought of art as an amusing game and lacked his idealism and dedication, he tolerated their artificial world of carefully fostered self-esteem for a decade before breaking their uneasy truce and unleashing *The Apes of God*. Sir Sacheverell Sitwell has recently emphasized that his family had been Lewis' friends and that his sudden and surprising attack seemed completely unmotivated. His fury at Lewis, nearly fifty years after the book was published, is a considerable tribute to the devastating effect of the satire: "In the early 1920's I was a friend and great admirer of Wyndham Lewis. But in [1930] he launched, without warning, *The Apes of God*, a huge time-bomb meant to destroy my brother, my sister and myself. Since then, though still an admirer of this genius *manqué*, I want to hear no more about him. He was a malicious, thwarted and dangerous man. . . . There was no reason except envy and malice for Lewis suddenly writing that time-bomb against us. He was a dangerous, unpleasant man with a touch of genius. . . . We had the impression he was a friend until he tried to deliver this death blow."[16]
The specific provocation for Lewis' attack is rather obscure, but it was motivated by more than mere envy and malice—qualities more readily associated with the Sitwells than with Lewis. The key to the quarrel is undoubtedly the character of Edith, who was bound to come into conflict with Lewis. She herself admitted: "I was born extremely arrogant and vain"; the arrogance was inflicted on other people, the vanity was reflected in her work. Even her admirer John Lehmann was forced to admit: "Often the most venial of lapses, or indeed a purely imaginary slight, a piece of gossip misunderstood or exaggerated, would lead her to substitute . . . condemnation for praise." And during a

newspaper interview, Edith characterized herself with intolerable affectation: "I am as highly stylised as it is possible to be—as stylised as the music of Debussy or Ravel. . . . I have, if I may say so, my own particular elegance."[17] Lewis knew from long experience that Edith had a very nasty temper; when she felt cross, as she frequently did, she found relief in teasing him. As Lewis rather wittily wrote in his memoirs, casting Edith in his own customary role: Edith "is one of my most hoary, tried and reliable enemies. We are two good old enemies, Edith and I, *inseparables* in fact. I do not think I should be exaggerating if I described myself as Miss Edith Sitwell's *favourite enemy*. . . . [But Edith] is a bad loser. When worsted in argument, she throws Queensberry Rules to the winds. She once called me Percy."

We have seen that Lewis first fought with Edith when he was painting her great portrait in 1923. She claimed that he became infatuated with her and that his sexual advances had forced her to break off the sittings; Lewis merely said he found her physically repulsive. According to a letter from Edith to her secretary, Elizabeth Salter, Lewis retaliated for her defection by spreading rumors that Edith—who lived with her former governess—was a lesbian. This displeased her.

In her autobiography, *Taken Care Of*, Edith called the chapter on Lewis "The Missing Collar." She described him as an "involuntary recluse" and emphasized an embarrassing incident that occurred during a visit he made to their country home in September 1922: "Mr. Lewis visited us at Renishaw, but this visit, alas, was not entirely happy, for he mislaid his collar on the morning after his arrival, and could not come down to luncheon until he had found it." Eventually the butler "tracked it down, and it flapped back on to Lewis' neck." Edith rubbed in the fact that Lewis, who was extremely poor at that time and lived in a flat with no proper washing facilities, not only wore a rather worn and distinctly lower-class celluloid collar, but also did not own a spare collar to replace the one he had mislaid. Lewis had come without his wife and was very likely awkward and uneasy during his first visit. He must have been infuriated by his hostess's malicious enjoyment of his discomfort and by her relating this incident to her friends and his enemies before publishing it, after his death, in 1965. Edith also reveals, in the description of Lewis' studio in her novel and memoir, that she found Lewis "dirty"; and there was more than a touch of snobbery in her remark, which alluded to his mysterious origins: "There are men who seem to have been born without relations but with a collar, and Lewis was one of these."[18]

Finally, as Sir William Walton suggests in a recent letter, Lewis may have become irritated, as he often did with his patrons, when the Sitwells failed to provide the necessary financial support: "The only reason I can think of for his hatred of the Sitwells, was their refusal to

buy one of his pictures or drawings. Though I'm probably wrong about that, because one or other of them were always, it seemed to me, to be buying something from him to tide him over some crisis. They & Dick Wyndham were the chief victims. With Edith Sitwell there seemed to be a love-hate situation. She was at times extremely funny about him, not really malicious, & it may have come to his ears & touched off an attack on them."[19]

John Pearson points out that satires on the Sitwells, especially on Osbert who seemed to court condemnation, were a minor genre in the twenties and thirties. In Huxley's story "The Tillotson Banquet" (1922), Osbert appears as Lord Badgery, a rich, repellent, callous, aristocratic ass: "Behind the heavy waxen mask of his face, ambushed behind the Hanoverian nose, the little lustreless pig's eyes, the pale thick lips, there lurked a small devil of happy malice that rocked with laughter." In Noël Coward's play *London Calling* (1923), which parodies the Sitwells' performance in *Façade*, the poetess Hernia recites her verse with her two brothers, Gob and Sago, in a sketch "The Swiss Family Whittlebot." Osbert's weakness and disdain for the lower orders, especially the miners who provided his family fortune, inspired Lawrence's portrait of Sir Clifford in *Lady Chatterley's Lover* (1928): "He was just a little bit frightened of middle and lower class humanity, and of foreigners not of his own class. He was, in some paralysing way, conscious of his own defencelessness, though he had all the defence of privilege." And Robert Nichols' poem *Fisbo* (1934) mocks Osbert's eclectic bad taste and hypocritical character:

> A Regency bed, wax fruit à la Victoria,
> Three chairs constructed from the bones of sauria,
> A poor Picabia, a worse Kandinsky,
> A caricature in waxwork of Nijinsky. . . .
> [You], vowed to register beyond dubiety
> Your attitude toward an effete Society,
> Have, in the fury of your will to grieve it,
> Performed all possible outrage save to leave it.[20]

Despite this onslaught, the Sitwells remained sensitive to satire. When rumors reached Osbert that Lewis was preparing the most ferocious assault of all, Osbert tried to dissuade him in a characteristic letter that combined wit, malice, pleas, threats, snobbery and innuendo with advice about manners and appeals to loyalty: "Don't get onto a frail biographical track in your new book, as it would be extremely tiresome to make us either self-conscious or quarrelsome. . . . In your attack on us as apes, my dear God, you have put yourself in bad company. . . . Also, some of my simian family happen to have written rather good books—a fact you ignore. Perhaps, though, I am developing a 'persecution mania.'"

Lewis later said: "Osbert is a spiteful old woman but he *is* (more or

less) all the things that Waugh would like to be,"[21] and claimed that he had always liked Osbert, in spite of himself. But he did not find Osbert's letter very persuasive. In "Lord Osmund's Lenten Party," an inversion of Proust's magnificent banquets and balls, Lewis tore off the protective masks of Osbert and Edith, and exposed their inner weakness and corruption through precise external delineation: "In colour Lord Osmund was a pale coral, with flaxen hair brushed tightly back, his blond pencilled pap rising straight from his sloping forehead: galb-like wings to his nostrils—the goat-like profile of Edward the Peacemaker. The lips were curved. They were thickly profiled as though belonging to a moslem portrait of a stark-lipped sultan. His eyes, vacillating and easily discomfited, slanted down to the heavy curved nose. Eyes, nose, and lips contributed to one effect, so that they seemed one feature. It was the effect of the jouissant animal—the licking, eating, sniffing, fat-muzzled machine—dedicated to Wine, Womanry, and Free Verse-cum-soda-water."

In contrast to Osmund's static attempt at composure, Harriet Finnian Shaw, who appears suddenly in a destructive, meaningless and comical tempest, tramples and tears the skirt of Lady Truncheon: "a haggard figure appeared as though from nowhere, almost out of the air. In a flying leap this angular female form descended upon the departing train. . . . The train and all the dress from the waist, stayed—torn from her, upon the floor, in her wake. The flying harpy, in her embroidered gold, with a sinister tiara, stood in the middle of this ruin."[22]

Lewis claimed that his satire had a devastating effect on the Sitwells and ironically wrote: "A certain poetess, who supposed herself an 'ape,' had a seizure as she caught sight of Mr. Lewis' advancing sombrero in a Bayswater street, and had to be led into a chemist's shop—where the old-fashioned remedy of Arquebuscade Water was applied with marked success." Edith's first response—after recovering from her "seizure"— was fairly feeble. She retaliated by having Osbert's servant telephone Lewis in the middle of the night and call him "The Ape," and by sending witless but irritating postcards and telegrams: "Percy Wyndham Lewis, 21 Percy Street etc. Achtung. Nicht hinauslehnen. Uniformed commissar man due. Stop. Better wireless help. Last night too late. Love. Ein Freund. Lewis Wyndham. 21 Percy Street."[23]

The Apes of God was merely the first round of Lewis' quarrel with the Sitwells. In 1932 F. R. Leavis, though hostile to Lewis, agreed with his condemnation and published the damaging epigram: "The Sitwells belong to the history of publicity rather than of poetry." Edith responded to Lewis' satire, Leavis' remark and Grigson's severe criticism of her work with attacks on all three in *Aspects of Modern Poetry*. She ridiculed Lewis' recently published *One-Way Song* and mocked his childish sentiment (one of his favorite targets) which she

claimed to see beneath his tough *persona*: "Now Mr. Lewis, in spite of all his boyish playfulness, in spite of that Boy Scout Movement for Elderly Boys called 'The Enemy,' in spite of being, as you might say, a Regular Pickle, has a strong vein of sentimentality underlying all his brusqueness. . . . Mr. Lewis longs for his friends to love him, he longs to be *understood*." In his review of Edith's book Lewis claimed she was "more imperious and impetuous than any Queen in Alice in Wonderland," identified the satiric cause of her animosity, rejected her biassed account of his emotional nature and claimed she presented "Lewis, the famous Ape-tamer, but, oh, very subdued and not at all himself (which is not to be wondered at)—very maudlin, indeed, very moist-eyed, very much the Pagliacci."[24]

Their controversy expanded in a lively way when G. W. Stonier's review in the *New Statesman* revealed that she had not only attacked Leavis and Grigson, but had also shamelessly plagiarized substantial chunks of their criticism of modern poets. Lewis, tasting blood, urged Grigson to "put down" Edith for her barefaced crib, and Grigson added more ammunition to Stonier's attack by showing she had also stolen passages from Read's *Form in Modern Poetry* (1933). In a letter to the *New Statesman* defending his caustic review of Edith's book, Lewis repeated his condemnation of "this rococo palace of blunder, this waxworks divided into 'giants' before whom you abase yourself, and sots or desperadoes at whose effigies you spit and jeer."[25]

Aldous Huxley had shaped the satiric image of Lewis which was later adopted by Osbert and Edith in their double-barrelled fictional attacks that appeared in 1937 and 1938, about fifteen years after *Antic Hay*. The portraits of Lewis in Edith's *I Live Under A Black Sun* and Osbert's *Those Were the Days* were based on their personal relations with him, but they were strongly influenced by Huxley's caricature and embittered by Lewis' public malevolence in *The Apes of God*.

Though John Lehmann adored Edith, he was forced to confess that her "hypertrophied alertness to injury, real or imagined, never left her" and to admit "the violence of her instinct for revenge." Her only novel, *I Live Under A Black Sun*, an inferior by-blow of her book on Pope, retells the story of Swift, Stella and Vanessa, places them in the twentieth century, and concerns the theme of "hatred replaced with love." Yet Henry Debingham, the character based on Lewis, has no real function in the novel and is introduced only to give Edith the opportunity to attack her enemy. For as Edith wrote, in a gratuitous comparison: "Swift was incapable of lying, and his hatred was the reverse side of love. Swift feared nothing and nobody. Lewis enjoyed lying, not only as a defence behind which he could hide, but as an idol."[26]

Debingham, like Lewis, works in a squalid studio, and wears his hat pulled down and his collar turned up as a refuge and protection against

a hostile world. He is extremely fond of role-playing and disguise, and Edith echoed Huxley when she stated that behind his aggressive *je-m'en-fichisme* "he was nothing but a great blundering, blubbering Big Boy, craving for Home and Mother":

There was the Spanish role, for instance, in which he would assume a gay manner, very masculine and gallant, and deeply impressive to a feminine observer. When appearing in this character he would wear a sombrero, would, from time to time, allow the exclamation "Caramba!" to escape him and would build castles in the air (or prisons for the object of his affections). . . . For this remarkable man, who was a sculptor in those moments he could spare from thinking about himself, and from making plans to confute his enemies, had a habit of appearing in various roles, partly as a disguise (for caution was part of his professional equipment), and partly in order to defy his own loneliness.

Though Edith recognized that Debingham's desperate efforts to be impressive are inspired by his profound isolation, she—quite naturally —had no sympathy for him.

John Lehmann's high-minded assertion that "the essence of Osbert Sitwell's satire is his hatred of the insensitive and the philistine"[27] does not apply to the treatment of Lewis, who appears half-way through Osbert's long and rather tedious novel *Those Were the Days* and is the only interesting character in the book. Like Ford's George Heimann in *The Marsden Case*, there is an air of secrecy and mystery surrounding Stanley Esor, whose origins are obscure. Sitwell suggested that Esor is covertly Jewish in order to explain his anti-Semitism—an allusion to Lewis' attacks on Jews during the 1930s. But in all other respects, Esor represents the Lewis of the early 1920s, when most of the novel takes place. Like Heimann and Debingham, Esor wears a swashbuckling black cape and a sombrero, and is fond of Spanish oaths.

Like Huxley's Casimir Lypiatt, Esor attempts to be a poet, musician, painter, philosopher, sculptor and architect; but he lacks genuine talent and his paintings have "a singular quality of wooden stiffness." Esor is Nietzschean in his "*übermensch* pugnacity," his "granite" personality and his desire to shock. But he is also arrogant, bad-tempered and boorish. He sees life "as a perpetual sabre-toothed struggle of man against man, in which the most ferocious, objectionable and un-scrupulous inevitably conquered"; and sees himself as "a strong man, self-willed, a solitary being of unique grandeur, defying the past and saluting the future."

Like Lewis—but in contrast to Lypiatt—Esor "irresistibly attracted" women. He has an affair with a married woman, Joanna Mompesson, who tactlessly brings him a present of new collars. She eventually leaves her husband, Jocelyn, and comes to live in Esor's disgusting Kensington studio: "On the solitary dusty table in the middle of the

room [were] unwashed plates—hiding their glaze under a thin layer of congealed grease—socks and shirts, the green coils of the telephone wire, bits of gnarled, gnawed bread, old empty glasses of beer with only a little stale froth clinging to them." When Myra Viveash comes to Lypiatt's studio at the end of *Antic Hay*, he hears her knock but refuses to answer because he has been deeply wounded by her rejection and her insult about his art. In Sitwell's novel, Esor also hears Joanna's knock, but *he* controls the situation and does not let her in, for fear of compromising his art and being burdened with a domesticated mistress. At the end of the novel Esor becomes friendly with Jocelyn and meets him for tea in A.B.C. shops—which Lewis frequently patronized and blessed in *Blast*.

Sitwell was more concerned with Lewis' life than with his art, and Esor reflects many aspects of Lewis' habits, career, friends and faults. Esor suppressed his Christian name (Lewis disliked "Percy"); he is tall and inclined to corpulence (Osbert later wrote that Lewis' "lean Spanish elegance" had been replaced by a "robust and rather jocose Dutch convexity");[28] and he is the autocratic leader of several artistic movements, who "adopted the pose of a herdsman, a lonely figure far above the flock" (an allusion to Lewis' personal manifesto, "The Code of a Herdsman"). Esor exalts Chaldean and Negro sculpture just as Lewis did when he was influenced by T. E. Hulme's theories; and he does not hesitate to secede and form a new rebel movement of his own, as Lewis did when he attacked Fry and the Futurists (his former allies) and formed the Rebel Art Centre in March 1914.

Like Lewis, Esor is the natural leader of a group of artistic friends and disciples, who also become Sitwell's satiric victims. Dick Grovell, the ferocious and swaggering colonial poet, is clearly Roy Campbell, who was a friend of the Sitwells until their quarrel with Lewis. Esor's other followers are considerably more difficult to identify. But one might guess that Roy Hartle, the knowledgeable musician who loves Elizabethan composers, is based on Cecil Gray; that Joe Bundle, whose "poems were mostly of an obituary character" and who thought all his friends were geniuses, is modelled on their old enemy Geoffrey Grigson; that Wilkins, "the painting disciple, a charming and astonished naive, who copied the personal style of Esor in every detail," is fashioned after Dick Wyndham, Lewis' young patron, whom he also pilloried in *The Apes of God*; and that the music critic, Manfred Moberly, whose "tongue moved with strange, reptilian persistence, flickering in and out of his mouth, making dry, cold sounds," could be Ezra Pound, the author of "Hugh Selwyn Mauberley," who was a music critic for the *New Age* and a contributor to *Blast*.

Despite this loyal "Praetorian Guard," Esor is subject to fits of helpless dejection when he is hypochondriac or ill, an allusion to Lewis'

severe illnesses and operations during 1932–1937. And like Lewis, Esor is extremely suspicious and afraid of being observed, moves about frequently, and often withdraws from circulation and disappears for long periods to write his numerous books. These peculiar characteristics make Esor "that curious combination of fretting neurasthenic and genial cave-man"—a direct echo of Eliot's phrase about Lewis' modern thought and cave-man energy. Though Lewis was satirized in *Those Were the Days*, he remains—in Sitwell as in Huxley—the only vital and fascinating character in their novels.

4

Lewis' portrayal of the Schiffs and Dick Wyndham continued the campaign against patrons that began with his attack on the Sitwells. Lewis, a philosopher-king with a working-class income, never really learned how to deal effectively with the rich. He envied wealthy people at the same time that he despised them, and admired the ability of friends who could tactfully and painlessly extract their money for the benefit of art as well as of themselves. He was fond of quoting Matthew Arnold on the Philistines: "Look at them attentively; observe the literature they read, the things which give them pleasure, the words which come forth out of their minds; would any amount of wealth be worth having with the condition that one was to become just like these people by having it?" And he angrily told Nicholas Waterhouse, with whom he had a unique, untroubled relationship: "I am tired of seeing people lounging around in comfortable bureaucratic jobs while I work my head off, and worry my guts out about money. . . . I am far more sick than I can say of all these time-wasting parasites upon the arts— upon the State!—phoney 'artistics' who use *us* for backstairs social climbing."[29] Like Lawrence with Ottoline Morrell and Bertrand Russell, or Hemingway with Anderson, Stein, Ford and Fitzgerald, Lewis could not help caricaturing people who had tried to help him, and his discarded benefactors served a secondary purpose as satiric victims.

One of the dominant ideas of *The Apes of God* was that the pretentious inhabitants of "Millionaire-Bohemia" not only exploit but also compete with genuine artists. They are "do-it-yourself" patrons who write books instead of buying them, withhold money from real genius, and support second-rate flatterers who praise their inferior work and accept these Apes as Gods: "There are the even more troublesome hordes of monied amateurs, who, because there is no longer any public life worth engaging in, and as riches are best camouflaged in such a revolutionary world, become 'bohemians' and adopt one art or another

—and in so doing quite naturally become competitors in a mild way instead of patrons. . . . They must not be allowed to annex the world of serious art and literature, and attempt to impose upon it their own childishness and unreality. Their influence is profoundly damaging to creative work, if only for the reason that their patronage will always be extended to the second-rate. . . . Their attitude to real genius is invariably that of hatred."[30]

We have seen that Lewis quarrelled with Sydney Schiff about money in 1924 and felt he had not been sufficiently generous as a patron. But there were several other reasons that provoked Lewis' most virulent attack. He thought that Schiff, who was immensely rich but did not have to work for his money, was a spoiled man who led a self-indulgent life. He also felt that Schiff, who had a very slight talent, used his wealth to buy friendship—and assume equality—with genuine artists like Proust, Joyce, Eliot and himself. And Lewis was undoubtedly weary of Schiff's praise of Proust (a Jew and a homosexual whom he had attacked in *Time and Western Man*) and probably jealous of the fact that Schiff had a greater admiration for Proust—and perhaps even for Katherine Mansfield—than he had for Lewis. Finally, Schiff's own work was admittedly influenced by Lewis and he was quite literally one of the Apes of God: *"those prosperous mountebanks who alternately imitate and mock at and traduce those figures they at once admire and hate."*

Lewis, who believed "It is impossible to devise anything sufficiently cruel . . . for the invulnerable conceit of a full stomach and fat purse," portrayed Schiff as a rich Jew who collects erotica and imitates every aspect of Proust but his inversion. In the "Chez Lionel Kein" chapter, Zagreus tells Kein, a dandified, moustachioed, spectacled Dr. Freud, that his concern with other people is purely malicious: "Your interest in a person is in proportion to the power you can exercise over him. It is some combination of your *power-complex* and your appetite for gossip that makes you so pleased with such a writer as Proust."

Lewis is also very severe with Violet Schiff (Isabel Kein) and her sister Ada Leverson (The Sib), who is the reigning pet of Lord Osmund and supplies him with saucy gossip about the figures of the 1890s. Lewis criticizes Violet's obtuse complacency, her pretentious admiration of Sydney and her notable talent for singing German *Lieder* ("Von welcher Judengasse hast du diesen Accent gekriegt, liebe Isabel?"). Lewis' description of Violet's appearance, which emphasizes her sharpness and cunning, balances his flattering painting of her that Sydney so admired: "Her brilliant handsome profile was like a large ornate knife at the head of the table. A certain taint of craft was suggested, in her face, by the massive receding expanse of white forehead, from which the hair was pulled back—by the vivacity of the great,

too conspicuously knowing eyes—the long well-shaped piscine nose, like a metal fish."[31] Lewis' venomous portrait of Violet—a beautiful, kind and talented woman—was more spiteful than satiric. For Lewis, acutely aware of his own poverty and failure, was intensely jealous of her wealth and happiness.

When two other chapters of *The Apes of God* first appeared in the *Criterion* in 1924, the Schiffs gave a much more subtle response than the abusive Sitwells and humbly laid their heads on the executioner's block. Violet took an unusually objective approach and admitted there was a certain justice in Lewis' criticism: "Let me add, though you may not believe it, that I am capable of enjoying, in a sense, an apt & severe criticism of myself, from the right person, & even of benefitting by it." And though Sydney proudly refused to accept Lewis' judgment of himself as an Ape, he had sufficient esteem for Lewis' work to forgive his attack: "I want to make my personal attitude towards you clear. If I am to understand from what you wrote about the pseudo-Proust that my work is included by you in that category of the Apes of God who 'practice a little art themselves . . . but less than the "real thing," ' then my work has failed as far as you are concerned and I regret it. . . . But our personal relations have not been based upon your approval of my work but on my admiration for yours."[32]

The Schiffs' reaction after the book was published was even more extraordinary. For Lewis, who remained angry at them, somehow made that gentle couple feel that *they* had behaved badly and that he was the real victim. Since their Proustian sensitivity made them feel more uneasy about the attack than Lewis did, he managed to project his own guilt on to them. In May 1931 Sydney said he felt a great personal loss because they were no longer on friendly terms; and when Lewis became seriously ill in May 1933 and Sydney sent him £75 for medical expenses, even Lewis was forced to concede that he had behaved extremely handsomely.

Two of the Schiffs' close friends shared their scourge and made a brief appearance in Lionel Kein's salon. Edwin Muir, the Scottish poet and translator of Kafka, who had found Lewis a positively evil figure, was portrayed as Eddie Keith of Ravelstone. He is devoured by Willa, his overpowering caryatid of a wife: "He is as you see, a very earnest, rather melancholy freckled little being—whose dossier is that, come into civilization from amid the gillies and haggises of Goy or Arran, living in poverty, he fell in with that massive, elderly scottish lady next to him—that is his wife. She opened her jaws and swallowed him comfortably." And Lewis also provides a shrewd, ironic vignette of Eliot as the prim, supercilious American, Mr. Horty, who tactfully evades an embarrassing question of Zagreus: " 'You leave me out of it' Horty said, wriggling his lean bottom, and pulling down tightly his mirthless

upper lips as though drily to sip a little tea—'drily' smiling. 'I noticed a good deal, although only a foreigner.' "[33]

Lewis first met Captain Dick Wyndham, the third of the patrons satirized in *The Apes of God*, when he was visiting Venice in October 1922 with Nancy Cunard and the Sitwells. Wyndham was the nephew of the distinguished Victorian dilettante George Wyndham, who had left him "Clouds," a magnificent country house in Wiltshire. Lewis at first liked Wyndham's good looks, refinement and childish candor, and taught the young patron-painter how to sketch Venetian palaces. In *Enemy 1* Lewis mentions that Wyndham drove him across France in his Rolls-Royce, and in the satire Dick Whittingdon has a splendid Bugatti that lies beside him like a large metal lizard. Despite his military background, Wyndham, who had contributed to the short-lived monthly fund for Lewis, had a weak character and was grateful for Lewis' tuition: "Whatever I have done for you cannot wipe out the debt I owe you with regard to my painting and mental development."

Lewis—almost inevitably—quarrelled with Wyndham about money when the patrons' stipend came to an untimely end. After receiving Lewis' harsh, unappreciative letter of May 1924, Wyndham sent a pained reply that accused Lewis of financial exploitation and disloyalty, and suggested that he had deliberately provoked a fight in order to rid himself of a tedious obligation: "I think it a horrible letter, and it hurts me very much. I can now understand the methods you have employed to get rid of so many friends in the past. It also made me realize that our friendship had really been only a one-sided one—you tolerating it for the sake of what you could get out of me. And now that I am hard up [because of his divorce] and of no further use—you write this letter in order to end what was to you always an irksome tie."

When John Quinn's superb collection of paintings was auctioned in New York in February 1927, Wyndham acquired twenty-six of Lewis' largest and finest Vorticist works, including *Kermesse* and *Plan of War*, for $15 each—less than the cost of a case of champagne. This fortunate haul of Lewis' early works, which Lewis thought of as parasitic profiteering, led to the barely disguised portrayal of Wyndham as Dick Whittingdon: nephew of the decrepit Lady Fredigonde, worthless society dabbler and flagellant with an astounding collection of whips. Dick appears in the first chapter as a simple giant, with eager baby eyes, large extremities and loose limbs. As Dick approaches his aunt, with meaningless frenzy, "A lush vociferating optimism, hearty as it was dutiful, was brutally exploded in her direction: a six-foot two, thirty-six-summered, army-and-public school, Winchester and Sand-hurst, firework—marked by 'boyish high spirits'—simply went off."[34]

Wyndham responded to Lewis' satire in an aggressive Sitwellian vein by advertizing, on the first page of *The Times* of September 2, 1930,

two of the enormous paintings he had bought from the Quinn auction. He offered them for sale by the square foot and at an incredibly low price—which was still about seven times more than he had paid for them in 1927: "Percy Wyndham Lewis—Two paintings for sale, 9 ft × 7 ft, and 6 ft ×4 ft, £20 and £15; inspection—Capt. Wyndham, Bedford Gardens." Wyndham renewed his friendship with Lewis in 1937, after a benign description of him appeared in the conciliatory *Blasting and Bombardiering*; and he used to visit Lewis in Notting Hill between 1945, when Lewis returned from Canada, and his own premature death in 1948.

5

Three young poets—Stephen Spender, Edgell Rickword and Roy Campbell—also play significant roles in the satire. Lewis first met Spender, then an Oxford undergraduate, in 1928 when he sent some poems to the *Enemy* and invited Lewis to give a talk to the English Club. Though Lewis refused, he was curious about Oxford, asked Spender to visit him at Ossington Street and read his unpublished novel of university life. Lewis later wrote that he met Spender and Auden at about the same time and that "Spender, who is half a Schuster, and combines great practical ability with great liberal charm, showed me a lot of jolly poems, mostly about Auden—he said modestly, a much better poet than himself."

Lewis, who liked people to be hard and tough, thought Spender was too soft and gentle, and described his fictional prototype, Dan Boleyn, as "a latter-day metropolitan shepherd, fashioned in quick-silver, who melts into shining tears at a touch." In Lewis' book Dan, the picaresque protégé of his Guru, Zagreus, is a beautiful, effeminate, moronic nineteen-year-old would-be poet and potential "genius." His confused and frightened behavior reveals his inability to understand what is happening to him as he rushes from a psychoanalyst and lesbian to a nymphomaniac and flagellant in his exploration of the simian underworld: "The perfectly handsome features of Horace's young client expressed the deepest melancholy; as he stumbled his passionate velvet eyes of the richest black had looked up with burning reproach at his white-maned superior. . . . Dan rushed out haggard and hatless into the street. He panted like a stricken doe. He gazed wild-eyed and dishevelled to the right and left, he started as if pursued, he cast a look of swan-necked alarm over his shoulder. . . . Dan sighed with bated breath, in sympathy, involuntarily. His nose began very gently to bleed. He brushed away a pale crimson smear from his lip."

Spender, who was extremely good-looking and also subject to sudden

nose-bleeds, has confirmed that he was the model for Dan Boleyn, and that friends like Auden and William Plomer had noticed the physical resemblance between himself and that complete imbecile.[35] Spender later wrote an enthusiastic review of *One-Way Song* and sat in 1938 for one of Lewis' most successful portraits. It is a tribute to the force of Lewis' personality and also their magnanimous affection for him that Spender, like the Schiffs and Dick Wyndham, soon forgave Lewis' satire and renewed their friendship.

Edgell Rickword, a good poet and kind man, published Lewis' "The Dithyrambic Spectator" and four other pieces in his *Calendar of Modern Letters* in 1925–1926 and wrote a favorable review of *The Art of Being Ruled*. Lewis carried on an obscurely-motivated one-sided quarrel with him and portrayed him as Hedgepinshot Mandeville Pickwort in *The Apes of God*. Pickwort, with Siegfried Victor (Siegfried Sassoon), "a beautifully carved statue, a little over lifesize but of the finest finish," is compiling an anthology of *Verse of the Under-Thirties* to be published by Jamesjulius Ratner (James Joyce). But in the middle of the negotiations and for no apparent reason, the small, colorless, blond Pickwort "rose with a sluggish stumble, he was dressed in a spotted and baggy undergraduate get-up really, and he crawled out of the Beddington Arms without speaking. Hedgepinshot is rather a rare name and so is Pickwort, but he was a poet and a picker up of words as he went no doubt, and 'pinshot' was a word Pickwort had picked up under a hedge very likely, and Hedgepinshot carried on the 'decadent' tradition upon a tide of pallid very low-volted reactions."

Rickword's riposte to Lewis' labored effort was more effective than Wyndham's advertizement or the Sitwells' fiction. For in 1931 he wrote a severe but perceptive critique of Lewis in the second volume of *Scrutinies*, and wittily mocked Lewis' violent condemnations of inversion by praising him in the ironic *persona* of the homosexual aesthete Twittingpan in "The Encounter." Twittingpan, who had once championed Lewis' *bêtes noires*, Gertrude Stein and the Sitwells, now ironically links Lewis with the sentimental Middleton Murry as "the only moderns likely to survive" and masochistically claims that Lewis has altered his life. He rejects emotion, inversion ("now thrust in front all I had kept behind"), Bergsonian flux and Bloomsbury frivolity:

> Don't you think Wyndham Lewis too divine?
> The brute male strength he shows in every line!
> I swear if he'd flogged me in his last book but one,
> as some kind person informed me he has done,
> I'd have forgiven him for the love of art.
> And you, too, ought to take his works to heart
> as I have done, for torn by inner strife,
> I've made him mentor of my mental life.

You cannot imagine what a change that worked.
I who was all emotion, and always shirked
the cold chaste isolation of male mind,
now thrust in front all I had kept behind.
I'd lived in Time and Motion and Sensation,
then smashed my watch and burnt the Bloomsbury *Nation*.[36]

The Apes of God concluded on an apocalyptic note with the eruption of the General Strike of May 1926, which threatened to destroy the corrupt society he had just condemned: "in the North crowds had sacked the better quarters, in the big factory-towns, mines were flooded, mills were blazing, and the troops were firing with machine-guns upon the populace." Lewis took this catastrophic conception and philosophical justification of the General Strike from the Right-wing political theorist Georges Sorel, who he believed was "the key to all contemporary political thought." Sorel's book, *Réflexions sur la violence* (1908), had been admired and translated by T. E. Hulme, and extensively discussed in *The Art of Being Ruled*. In his general conclusion, Sorel suggested that the destruction of what Lewis called the decayed "insanitary trough" of society—personified by the grotesque Lady Fredigonde, who proposes marriage to Zagreus and then expires in his manly embrace—can lead to the creation of a new and better way of life: "The idea of a general strike, engendered by the practice of many violent strikes, carries the conception of irrevocable ruin. There is in it something frightening—which will appear more and more frightening as the idea of violence occupies a greater place in the mind of the proletariat. But, in undertaking such a grave, fearful and sublime task, the socialists raise themselves above our frivolous society and make themselves worthy of leading the world in a new direction."[37] Lewis, who came out from "Underground" and published *The Art of Being Ruled* in 1926, thought that year was a turning point in personal as well as national history.

6

The Apes of God caused tremors in the literary world, and provoked violent letters, potential libel suits and madcap threats on Lewis' life. He firmly believed his books had to be defended and explained as well as written and published, and wrote pamphlets to protect his works, like destroyers swarming around a battleship. "I became 'a pamphleteer,' to start with, in defence of my work as an artist," Lewis explained. "And I fail to see how an artist who is *outside* the phalansteries, sets, cells or cliques, can to-day exist at all, if he is not prepared to pamphleteer."

Lewis' most active and aggressive ally in his defensive marauding was

Roy Campbell, the South African poet and "pugnacious matador," who had been nicknamed "The Zulu." Campbell appears in the satire as Zulu Blades, whose uninhibited sexual conquests provide an intimidating example for the timid and frustrated Matthew Plunkett (Lytton Strachey): "Blades was the 'black beast,' an evil neighbour: what with his upstart disrespect for his metropolitan betters, since he had brought the hearty habit of the african out-stations into their midst, here. His skill with women was natural, it was true that he roped them in like steers, he must be working off ten years' solitary confinement in the Veldt."[38]

Lewis' high-voltage pamphlet *Satire and Fiction*, was published in October 1930 and inspired by Campbell's review of *The Apes of God*, which had been commissioned and then rejected by the literary editor of the *New Statesman* (the Bloomsbury parish magazine) because it was too favorable. In the first part of the pamphlet, published by the Arthur Press, Lewis printed the rejected review as well as press notices and enthusiastic opinions about the satire that he had received from Augustus John, H. G. Wells, W. B. Yeats and Richard Aldington. The latter assured Lewis that his book was "the most brilliantly witty piece of writing, merely as writing, which I have ever read. You needn't ever doubt that you have added something permanent to European literature."[39] The second part of the pamphlet contained his defense and theory of satire, and his famous "Taxi-Driver" test of fiction, which were reprinted in *Men Without Art*.

Though Lewis had defended himself against the charge that he had conducted a massacre of the insignificants, Eliot felt he was "breaking butterflies upon a wheel": "Mr. Lewis, the most brilliant journalist of my generation (in addition to his other gifts), often squanders his genius for invective upon objects which to every one but himself seem unworthy of his artillery, and arrays howitzers against card houses." Despite Lewis' sharp wit and vigorous style, most modern critics have agreed with the judgment of Eliot and of Lawrence Durrell. The latter modelled aspects of Pursewarden, the hero of *Clea* (1960), on Lewis and wrote a "postface" to the French translation of *Tarr*, which he called Lewis' best novel. Durrell also told Aldington that he shared his enthusiasm for Lewis, but was more critical of his inability to transcend destructive anger: "I never met Lewis alas; but of course he is great. Only with the Ape I felt the personal pleasure of the pejorative made the book good satire but somehow not on the 'universal' plane—don't know how to say it. It sinks under the weight of its own spleen. Will it outlive its subjects? And I felt this immoral because I always felt Lewis to have a greater equipment than Joyce, and he should have spent his time making some art instead of complaining about the lack of it! What a tremendous proser!"[40]

The Apes of God, like *Paleface,* did Lewis more harm than good. Its apparent concern with triviality and failure as a work of art detracted from his stature as a serious writer; its personal attacks created many new enemies, reinforced the idea that he was a malicious and dangerous man, and made him more isolated than ever. His trips to Germany, his sympathy with Fascism and his continued attacks on the Jews stigmatized Lewis in the 1930s and destroyed the reputation he had laboriously reestablished during the previous decade.

Politics, Germany and Hitler,
1930–1931

I

The Apes of God was the first of a long series of tactical errors and
personal disasters that oppressed Lewis during the 1930s. His book in
praise of *Hitler* (1931) damaged his literary career in the same way that
the quarrel with Fry hurt his artistic progress. These ill-advised works
were followed by his break with Chatto & Windus in 1932, the with-
drawal of three of his books between 1932 and 1936, the serious illness
that plagued him from 1932 to 1937, his association with Sir Oswald
Mosley's British Union of Fascists, his two unpopular Right-wing
political tracts in 1936–1937, the rejection of his portrait of Eliot by the
Royal Academy in 1938, and his ill-timed and ill-fated exile to North
America in 1939. Lewis was indeed self-condemned; his greatest enemy
was himself.

It is far more useful to explain than to attack Lewis' reactionary
political views; to understand why he and so many avant-garde writers
were vicariously attracted to power and supported inhuman dictator-
ships. Lewis never took a logically reasoned and carefully balanced view
of political events. He was intensely aware of his artistic individuality,
jealous of his independence and eager to go to extremes. He felt that
democracy would be suffocating if some people did not challenge and
contradict its "emotional excesses" and received ideas; he expressed his
singularity by taking an unpopular political stance and attacking the
ranks of writers on the Left. He thrived on opposition, always sailed
against the prevailing intellectual currents and, like the hero of *Self
Condemned*, "was *un exalté*, a fanatic, a man apt to become possessed
of some irrational idea, which would blind him to everything, as if it
were in a delirium." His bitterness about failure to win recognition as a
painter and writer turned him against democracy, which had ignored his
genius, and toward Fascism, which promised artistic recognition and
rewards. Lewis' political opinions intensified the neglect of his literary
works and made him one of the loneliest figures in the intellectual
history of the thirties.

Lewis was acutely conscious of living and writing between two wars,

and as early as 1933 felt the impending conflict was beginning to over-shadow the previous one. He believed the Great War had been a European civil war; and agreed with Spengler's influential idea that the West was in decline and that liberal democracy was weakened and doomed. He thought that two hostile ideologies—Communism and Fascism—were fighting for the domination of the world, and that Democracy would have to choose between the two authoritarian extremes. He hoped that if the Western powers remained united against the Communists, there would be no new war in Europe.

Lewis had no political ambitions, but he was fascinated by the arm of authority. He was a frustrated man of action who had exercised the "leadership principle" by forming the combative Vorticist group and commanding their art wars; his belligerent strain and theoretical love of power were always roused when he wrote political tracts. His antagonism to Anglo-Saxon democracy was based on a hatred of the common mass and of a civilization that put so many obstacles in the way of the artist, and he greatly underestimated the strength of demo-cracy under the inspired leadership of Churchill and Roosevelt. He held an elitist attitude toward political rule, believed in the aristocracy of art, and agreed with Shelley that "Poets are the unacknowledged legislators of the world." He was therefore powerfully attracted to the idea of a strong savior-leader who could implement his own social and aesthetic ideals:

> If so the man you are, your leaders gone,
> Can you survive into an age of iron? . . .
> Unless, unless, a class of leaders comes,
> To move it from its latter-day doldrums.[1]

In December 1937, a year after the Abyssinian campaign, Lewis told Pound: "I think the Brit. government a lot of warts, and Musso makes rings round them as a politician." We have seen that Lewis preferred Fascism to Communism because he thought this regime would give him more influence and be better for the future of art; and he followed D'Annunzio, Marinetti and Pirandello, who wrote: "There must be a Caesar . . . for there to be a Virgil." These three artists, and others who supported Mussolini and lent prestige to his government, were richly rewarded by the Duce. "Chirico, the 'official' painter of Fascist Italy," Lewis observed, "is a better type of painter than those encouraged in Communist Russia. In return for a pastel of a gladiator, once a month, it is probable that the Blackshirt Emperor would allow you great latitude in your choice of subject."[2] Though Lewis ironically noted that Fascist artists must make obeisance to the power of the State, he ignored not only the fact that Chirico was a better painter because his individual talent was nurtured by the rich pre-Fascist tradition of

Italian art, but also that Russia (at least for a time, until Lenin rejected extreme forms of modernism) had officially encouraged avant-garde painters like Kandinsky, Malevich, Chagall and Gabo.

Unlike the political orthodoxy of the Left, which was founded on the writings of respectable intellectuals like Karl Marx, there was no reputable ideological basis of Fascist thought, which was entirely dependent on the practical effectiveness of a national leader in times of crisis. Nevertheless, "The ambiguity of the ideology allowed those who supported it to read into it what they pleased; they could twist it this way and that, according to their whim. And, for all its malleability, Fascism did constitute a phenomenon which artists found aesthetically satisfactory: it turned anarchy into order."[3] Fascist ideology was designed to attract the lower middle classes who were disillusioned by the postwar world, angered by social disorder, industrial stagnation, chronic unemployment and the collapse of currency, fearful of Communism and hostile to traditional political parties. Though Lewis was educated and elitist, he shared all these political attitudes as well as a lower middle class income, and was anxiously concerned about how he would earn enough to live on.

Because Fascism seemed to offer a stable society governed by a romantic leader who stopped decadence, guaranteed peace by opposing Communism, aestheticized politics and promised respect and rewards for the artist, it attracted an entire generation of modern writers who were radical in their literary technique but drawn to the new totalitarian politics: Yeats in his military songs for O'Duffy's Blueshirts, Pound in *The Cantos* and money pamphlets, Eliot (who also replaced the capitalistic villain of the Left with the Jewish villain of the Right) in "Coriolan," Lawrence in *The Plumed Serpent* and letters to Rolf Gardiner, and Lewis in *The Art of Being Ruled* and his political polemics. Despite their genius, which may have led them to create an imaginative political ideal to replace crude reality, these writers all failed to understand the most significant political issues of their time.

2

On October 9, 1930, after living with Froanna for about ten years, Lewis finally married her in a private ceremony at the Registry Office in Paddington. It is entirely characteristic of Lewis, who loved to camouflage and conceal his private life, to deliberately falsify nearly all the details of the marriage certificate. He spelled his wife's name Hoskins and described himself as Percy Lewis, aged 44 (instead of 48), an architect living at 22 Tavistock Road, Paddington (instead of 53 Ossington Street, Bayswater), the son of an English captain in the

Warwickshire Regiment (instead of a long-retired captain in the Union Army). The main reason for the marriage was their desire to travel together to Germany in November 1930 and to Morocco in the spring of 1931, and their fear of difficulties with passports, hotels and ships if they were not joined in wedlock.[4]

Lewis first became interested in Hitler while working on *The Art of Being Ruled* and reading press reports on Germany. In November 1930, a year after the Depression began, Lady Rhondda, the plump and curly-haired daughter of a Welsh coal magnate and editor of the politically independent *Time and Tide* (which Orwell also wrote for in the thirties), commissioned a series of articles on Hitler and paid Lewis' travel expenses during several weeks in Berlin. He journeyed with Froanna, tried to arrange for the German translation of his books and sold the rights for the Tauchnitz edition of *Tarr* (which came out in 1931) for an advance of £30.

During the final flowering of Weimar culture, Berlin became the cultural center of Europe. More than a thousand newspapers and magazines appeared in the capital, book publishing boomed, the Bauhaus style was born and Post-Expressionism created a powerful influence on the Continent. It was the time of Bertolt Brecht and *The Blue Angel*, of Hindemith and Archipenko, and of Max Beckmann, George Grosz and Otto Dix, who savagely portrayed the horror and fascination of postwar Germany.

Lewis was utterly repelled and absorbed with the grotesque *frisson* of sexual degeneracy in *Berlin im Licht*. In the opening section of *Hitler* he described, in emotional and highly-colored language, the cellars and gutters of the underworld, the succulent ruts and Babylonian excesses, the exotic and peculiar pimps and perverts, tarts and transvestites in the fat and flourishing *Hauptstadt* of Vice. When he reached Berlin (on a later trip) on New Year's Eve in 1933, he was impressed to discover that everyone in the snow-covered city was engaged in an all-night celebration. And he excitedly exclaimed that Berlin's "night-circuses, *Negertanz* palaces, *nakt-balleten*, *flagellation-bars* and sad wells of super-masculine loneliness . . . decidedly convey an air of heavy and louche brilliance, as of a really first-class *mauvais lieu*."

The same perverse spectacle that revolted Lewis, who hated homosexuality and praised Hitler for promising to extinguish vice, attracted the Left-wing Auden, Isherwood and Spender to Berlin, which was a very inexpensive city in the early 1930s. They went there to enjoy the sexual license that Lewis despised, and (as John Lehmann suggested) saw the promise of a renewed Germany in the fag-end of Weimar rather than in the brutal order of the Third Reich: "In [Spender's] view Germany, because of defeat and ruin, had escaped from the mortal sickness of Western civilization, and there youth had started to live

again, free of the shackles of the past, a life without inhibition, inspired by hope, natural humanity and brotherhood."[5]

In *Rude Assignment* Lewis gave a revisionist interpretation of his intentions in writing *Hitler* and insisted that his aim had been "to break the European ostracism of Germany, call in question the wisdom of the Versailles Treaty and get it revised, end the bad behaviour of the French Chauvinists, and attempt to establish healthy relations in Western Europe." Though Lewis' description attempted to make his book seem like Keynes' humane, cogent and convincing *Economic Consequences of the Peace* (1919), *Hitler* does not produce such a positive impression. Lewis claimed to be an unprejudiced observer, but soon abandoned his impartiality and stressed the Nazi point of view. In 1930 German armed might did not exist, and Lewis was moved to sympathy by the sight of the starving beggars and crippled soldiers who symbolized the utterly broken and defenseless country. The defeat, degradation and economic collapse of Germany, which strangely coincided with the cultural renaissance, led inexorably in the direction of Hitler. His Nationalsozialist party had polled $6\frac{1}{2}$ million votes in the election of September 1930 and shot from 12 to 107 seats in the *Reichstag*—a transformation unprecedented in modern German history.

Though Kreisler in *Tarr* embodied the violently self-destructive German character, Lewis failed to recognize this quality in the monstrous political rallies that celebrated this Nazi political victory in the Berlin *Sportpalast*. It was there he first saw Göring and Goebbels, the latter a tiny, nervous figure who screamed out his speech. "The atmosphere was breathless and fierce," Lewis wrote, "the crowd a boxing-match crowd. The police at the entrances had searched it for weapons; the S.A. lads had stood with their hands above their heads while the *Schupos* prodded them carefully for concealed revolvers."[6]

Lewis also witnessed the violent battles and riots of armed bravos and street-gangs, just as he had done with the Fascists in Venice in October 1922. Despite the clear visual evidence, Lewis claimed that the Nazis had issued orders stating that any Hitlerite found carrying firearms would be expelled from the Party, and that most of the wounding and killing was done by the other side. The Communists, who had established a short-lived but influential State in Bavaria in 1919, were the main opponents of the Nazis and the first to be destroyed when Hitler came to power in January 1933. Lewis was correct in asserting that the Nazis, who had the tide of voters behind them, planned—and actually did—set up their dictatorship by "*strictly* legal, beautifully parliamentary, wholly democratic, means." But his biassed attitude and faulty reasoning led to the bizarre conclusion that Hitler actually opposed the Prussian military tradition and was a Man of Peace. Lewis assured his readers that the idea of "Germany being 'a military menace'

can be entirely dismissed from the most apprehensive mind."[7] Lewis' desire for peace made him argue for the necessity of a unified Western culture and oppose war with Germany. He would have been willing to allow the "peaceful" Hitler to realize his irredentist ambitions in Austria, the Sudetenland and Danzig, and to expand eastward into "racially impure" territory in order to secure *Lebensraum*, if Hitler would not interfere with the British Empire. He completely failed to realize that the *Führer* would not be satisfied with the domination of a Continent.

Lewis showed considerable insight in recognizing the importance of Hitler as early as 1930, when most Englishmen thought he had been politically "snuffed out" by his unsuccessful beer-hall *Putsch* and subsequent jail sentence. But Lewis, who grievously misjudged Hitler's character, ideology and ambition, was politically naive and gullible, and never bothered to read *Mein Kampf* (1925–1927) thoroughly until 1938. Though he saw the evils of Stalinism with penetrating acuity, he characterized Hitler as a friend of England, a true democrat and a moralist whose anti-Semitism was essentially propaganda and would soon be replaced by increasing moderation and tolerance of the Jews. Lewis rather vaguely concluded: "I myself am content to regard [Hitler] as the expression of current german manhood—resolved, with that admirable tenacity, hardihood and intellectual acumen of the Teuton, not to take their politics at second-hand, not also to drift, but to seize the big bull of Finance by the horns, and take a chance for the sake of freedom." Though Lewis' book was pro-Hitler, it cannot be said to be pro-Fascist. *Hitler* revealed not that he sympathized with Fascism, but that he grossly misunderstood its true nature.

Though Lewis praised Hitler, he was never an ardent and faithful supporter like Hauptmann, Benn, Hamsun and Henry Williamson; and did not, like Céline, enjoy his own audacity in extolling Hitler's anti-Semitism. There was very little in the actual Hitler to attract Lewis, for neither his obscure origins, personal appearance, artistic taste, intellectual attitude, youth cult, emotional rhetoric, racial theories, military spectacles nor rabid nationalism appealed to him. Lewis' description of Hitler had almost no relation to the real man; he had to invent an imaginary Hitler who would expound Lewis' own political ideas. As Spender observed: "Wyndham Lewis never supposed that he should become the mouthpiece of Hitler and the ideas put forward in *Mein Kampf*. He had in fact a rather supercilious attitude towards Hitler whom he patted (metaphorically) on the back for having expressed rather crudely certain ideas already in the mind of Wyndham Lewis." He saw the Fascist parties as "armies defending the past civilization of which they, the great artists (those whom Wyndham Lewis called 'the party of genius'), were the intellectual leaders."[8]

3

The serialization of the scantily researched and hastily written *Hitler* in *Time and Tide* during January and February 1931 provoked some sharp disagreement with Lewis' political analysis. When the book appeared in March, it received only four reviews—three of them negative. Only *TLS* found it a remarkable work with brilliant chapters and persuasive arguments: "Mr. Wyndham Lewis is a sensitive man and therefore all the better qualified to describe a movement which itself is based rather upon feeling than upon thought." The *Spectator* (like Spender) thought the book was more about Lewis than about Hitler and complained: "Lewis has evidently believed almost everything which his Hitlerite informants told him." The *Saturday Review* agreed that Lewis (who transcribed a chunk of *The Art of Being Ruled* on pages 78–82) "used Hitler principally as a clothes horse whereon to air opinions." And the most severe and accurate review in *Everyman* stated a criticism that was much less obvious in 1930 than in 1939: "Here is a mere 'write-up' of the Nazi case, entirely uncritical, vague and unsubstantial."[9]

Lewis received £50 for the German edition of *Hitler*, the first of his books to be translated; and it was published in Berlin by Reimar Hobbing Verlag in 1932, before the Nazis gained control of the country. In *The Hitler Cult* Lewis claimed the book was sufficiently critical to displease Goebbels, who ordered the translation pulped and burned after the Nazis came to power. The reception in England was equally damaging, for Lewis stopped receiving portrait commissions from wealthy patrons after the book appeared. In *One-Way Song* Lewis lamely lamented:

> All that I know is that my agents write
> 'Your Hitler Book has harmed you'—in a night,
> Somewhat like Byron—only I waken thus
> To find myself not famous but infamous.

And in July 1934 the apolitical Joyce wryly told Harriet Weaver that Hitler "will soon have few admirers in Europe apart from your nieces and my nephews, Masters W. Lewis and E. Pound."

In the *Criterion* of April 1929 Eliot had vaguely admitted that Lewis "inclines in the direction of some kind of fascism." But in his Foreword to the posthumous second edition of *One-Way Song* (1960), Eliot attempted to retract this admission. He justly called Lewis "one of the permanent masters of style in the English language," regretted the eclipse of Lewis' reputation, contradicted his earlier statement in the *Criterion* and claimed: "The more respectable of the [intellectuals], being unable to stomach his work, treat Lewis for the most part to an uneasy silence; the less respectable vociferate the cry of 'fascist'—a

term falsely applied to Lewis."[10] By defending Lewis, Eliot was also attempting to exonerate himself from the stigma of Fascism.

Lewis emphasized his support of Hitler by associating with Sir Oswald Mosley, whose New Party was launched at the Sitwells' home at Renishaw in August 1931. Mosley recalled: "Wyndham Lewis came to see me often in the thirties at my house. Always a rather complicated person with coat collar turned up, etc. He had the impression that association with me made him liable to assassination. We had considerable mental sympathy but I would certainly not claim he agreed with me in all things." In *"Insel und Weltreich,"* a German essay of 1937, Lewis praised Mosley's "great political insight and qualities as a leader"; and in January 1937 (six months after the start of the Spanish Civil War), Lewis appeared with Pound, Roy Campbell and the Norwegian Nazi Vidkun Quisling in the first number of Mosley's *British Union Quarterly.* Though Lewis' essay was more an attack on Communism than an advocacy of Fascism, he did echo Pound's crackpot economic theories and anti-Semitism: "You as a Fascist stand for the small trader against the chain-store; for the peasant against the usurer; for the nation, great or small, against the super-state; for personal business against Big Business; for the crafts-man against the Machine; for the creator against the middleman; for all that prospers by individual effort and creative toil, against all that prospers in the abstract air of High Finance or of the theoretic ballyhoo of Internationalism."[11]

Lewis also did two drawings of Mosley. The first, a three-quarter view portrait in a military tunic, was published in the *London Mercury* of October 1934, opposite Lewis' drawing of Sir Stafford Cripps and under the ironic rubric "Two Dictators." The second, a full-face portrait executed three years later, has a finer, tauter line. It portrays Mosley staring downward, with thick eyebrows and clipped moustache, and reveals his striking good looks and intense manic ferocity.

Though Lewis contributed to Mosley's journal he was too indivi-dualistic to join his political party. He was by no means the only English supporter of Hitler and his followers, nor the only one ignorant of their threat during the 1930s. Just after the extraordinary Nazi electoral landslide, the London *Times* editorial of September 16, 1930, praised the wide emotional appeal of the new nationalistic party: "The Nazis have scored their overwhelming success because they have appealed to something more fundamental and more respectable. Like the Italian Fascists they stand for some national ideal, however nebulous and extravagantly expressed, to which personal and class interests shall be subordinate." Though Isherwood sent Lewis an ardent Nazi post-card ironically congratulating him on *Hitler,* he also rapturously praised the New German Youth Movement in Mosley's *Action* of December

1931: "They are sombre, a trifle ascetic and absolutely sincere. They will live to become brave and worthy citizens of their country." Sartre, who was more politically committed and lived closer to the German threat than Lewis, had "studied Husserl and Heidegger in Berlin when Hitler was already in power, and until the Munich Agreement [1938] was hardly aware of what Nazi rule meant." And even Churchill praised Hitler's personal qualities in the *Strand Magazine*, less than four years before the War broke out: "Those who have met Herr Hitler face to face in public business or on social terms found a highly competent, cool, well-informed functionary with an agreeable manner, a disarming smile, and few have been unaffected by a subtle personal magnetism."[12]

Unlike *The Times*, Isherwood, Sartre and Churchill, Lewis remained unregenerately entrenched in the political attitudes he had first proclaimed in *The Art of Being Ruled* in 1926. He stayed sympathetic to Fascism, ignorant of its true character and true danger, until 1938, and then recanted his extremist beliefs in *The Jews, Are They Human?* and *The Hitler Cult*. But his retraction came too late. He was permanently tainted and condemned by the superficial formulations of his fateful November in Berlin, when he experienced the Nazis' euphoric political promise two years before they secured power and began their destruction of Europe.

Combat and Suppression,
1931–1933

> I took sides *against* myself and *for* anything that
> happened to hurt me and was hard for me.
>
> Nietzsche

During the early 1930s Lewis journeyed to North Africa, America and
the south of France as well as to Berlin in September 1932 and January
1934, and Pont-en-Royans in the Val d'Isère, southwest of Grenoble, in
October 1932. He began to use the cover address of the Pall Mall Safe
Deposit on Carlton Street, off Regent Street, and habitually changed his
residence. He returned to Percy Street, where he had been in 1914,
near Guy Baker and the Tour Eiffel, and lived at number 31 from about
May 1932 until November 1933. He probably had a studio at 27
Ordnance Hill, near Circus Road in St. John's Wood from July to
November 1932; and beginning in December 1933 lived for a year in a
four-storey grey-brick building with a railed balcony at 21 Chilworth
Street, Paddington, across from one of his favorite pubs, the Cleve-
land Arms. Lewis also formed a number of important new friendships
among the younger generation; continued to be plagued by financial
problems and to publish several books a year; and had two of his works
disastrously suppressed. After a long interval he began to paint and
draw again, and in October 1932 held his first exhibition in eleven
years.

I

When Lewis completed a book and had either money or a new com-
mission, he would travel abroad. He was weary of the sedentary habits
of six years of work, decided to avoid the Left-wing writers' beaten
track to Russia and in May 1931 (after signing a contract with Cassell)
went with Froanna to Morocco, which was then a French protectorate.
He had heard about the Rif Wars of 1921–1925 on news broadcasts;
learned about the Arabs from T. E. Lawrence, whose *Seven Pillars of*

Wisdom was published in 1926; read about Morocco in Cunninghame-Graham's classic *Mogreb-el-Acksa*, Gautier's *Les Siècles obscurs du maghreb* and Saint-Exupéry's *Vol de nuit*; and had himself written about primitive culture in *Paleface*.

Lewis stopped for a day in Paris to buy books and maps, left the train at Avignon to enjoy the first sun he had seen for ten months, and took a ship from Marseilles to Alicante and Oran. He next followed the train route southwest from Oran through Tlemcen, near the Algerian-Moroccan border, through the Rif country and the fortified town of Fez, to Casablanca on the Atlantic coast. He then went inland to Marrakech, with its magnificent square, Djemaa el Fna, and down to the southern coast at Agadir, where he settled for six weeks. "I have a whitewashed cell here where I can write," he told Charles Prentice, "and I have started work: in consequence of the propitious scenery and circumstances, at once [on] the *Childermass*. The country is most remarkable and the desert cities, humped antelopes, Berber brothels, etc. abound in suggestions of a sort favourable to the production of the major book."

In Agadir Lewis met Captain LaCroix, a dark, active, intelligent and charming French officer, who gave him permission to travel by car and mule in the desert of the Anti-Atlas. But he was not able to fulfill his ambition of experiencing the "Islamic sensations" of Rio de Oro in the Spanish Sahara. Lewis, who wore heavy clothing in both winter and summer, dressed in London garb in the Moroccan desert. He made several vivid drawings of Berber villages, desert souks, mountain strong-holds and casbahs in the Atlas.

When he returned to Agadir in July he abandoned the continuation of *The Childermass*, which was not destined to be completed until 1955, and excitedly told a friend: "I am here still, upon the edge of the Spanish Sahara, baked by breaths from the Sudan, chilled by winds from the Atlantic luckily, too, and gathering much material for an essay on Barbary. . . . They build the most magnificent castles, upon tops of cyclopean rocks, in the heart of vast mountains. They have to be seen to be believed. And they all poison each other with arsenic whenever they get the chance."[1] He praised the bravery of the Berbers and said they were among the handsomest people in the world. He told her it was just as well they had not met, as they had planned to do, for Morocco was entirely a man's world. Lewis emphasized the last point in *Filibusters in Barbary* (1932) by categorically stating he had travelled unaccompanied and never mentioning that Froanna, who helped him recall important incidents when he was writing the book, had been his constant companion.

A few months later, in November 1931, Lewis travelled alone to New York, Washington and Boston. In the capital he met Alice Roosevelt

Longworth, the daughter of Theodore Roosevelt and a cultivated political hostess, who showed him a serious essay on Lawrence, Lewis, Eliot and Joyce published by her second cousin, Joseph Alsop, in the undergraduate *Harvard Advocate* of October 1931. Lewis, perhaps surprised by the interest in his work at Harvard, wrote to the young Alsop, who invited Lewis to stay with him. Lewis arrived in early December and lived for ten days with Alsop in his two-room flat at 9 Linden Street, Cambridge. Alsop was disappointed and somewhat embarrassed when he met his literary hero in the flesh. He found Lewis a shabby-looking man with some teeth missing and the rest jagged and dirty. Lewis, who did not have enough money to pay his fare back to New York and threatened to become a permanent occupant of the flat, did not seem to mind living off Alsop and consumed a good deal of gin— his favorite drink. But he must have been furious at the contrast between his own degrading circumstances and the affluence of the snobbish young man who had written an essay about him.

Alsop's English tutor was Theodore Spencer, a Shakespeare scholar, poet and friend of Eliot. He had been an undergraduate at Trinity College, Cambridge, was familiar with avant-garde writing, and was one of the very few people at the extremely provincial Harvard of that time who had ever heard of Lewis. Spencer arranged for Lewis to stay at the Continental Hotel, north of Cambridge Common, while he was giving a talk at the university; invited Lewis to do drawings of himself and his wealthy wife; and persuaded Mrs. Alexander, Mrs. Saltonstall, Jean and Emily Lodge Cabot to commission portraits for $100 each. Lewis also drew Alsop when he was asleep, and his host never knew about the portrait until many years later, when he bought it from a sale catalogue.

In order to raise some more cash for Lewis, Spencer and Alsop organized a reading in the library of Edward Pickman's house on Chestnut Street in Beacon Hill. About seventy-five people paid one dollar each to hear Lewis, who was an effective speaker and greatly enhanced the meaning of "Lord Osmund's Lenten Party" in *The Apes of God*. George Homans, then an undergraduate and now a professor at Harvard, attended Lewis' lecture and also listened to him speak more informally: "I heard him give a reading from *The Apes of God* (the episode of 'Mrs. Bosun's Closet') in the Senior Common Room of Eliot House at Harvard. I think the late Professor Theodore Spencer introduced him. I was much entertained and impressed. . . . Alsop and myself took him out to dinner at Locke-Ober's. . . . He insisted on sitting at a table with his back to the wall, as if he were afraid that some enemy might approach him and attack him unseen from behind. . . . [He told a story about] Lady Diana Manners, who at one point used to go around London, naked except for a long fur coat. From time to time she would open her coat, revealing her various charms. . . . He talked about

Irving Babbitt, then Professor of Comparative Literature at Harvard, in whose books, such as *Rousseau and Romanticism*, Lewis was much interested, and of whose views he generally approved."

Lewis evidently had an extensive repertory of lively anecdotes. For the poet Louise Bogan, who met him in New York in November, suggested that he dined out on tales of the London literary world: "We heard some enlightening things concerning Ford from Wyndham Lewis, who was in town for a short time this fall. Quite an odd one. The messianic delusion, I should say. But what a scathing lot of scurrilous stories!" When his publisher, Rupert Grayson, introduced him to a group of Americans as the author of *The Apes of God*, one of the young men enthusiastically extended his hand and said: "then you must be Osbert Sitwell."[2] Lewis visited Harvard as a pauper in 1931 and had to read, draw and amuse in order to pay his way and earn his fare to New York. Under very different circumstances, Eliot was invited as a distinguished guest to give the Charles Eliot Norton lectures in 1932. This was the beginning of the wide divergence in their careers, which led Eliot to the highest honors while Lewis remained in obscurity. Lewis returned to England on the S.S. *Berlin*; a photograph taken during the dreary Christmas party shows him wearing a lounge suit and surrounded by sinister storm-trooper types with monocles and duelling scars.

Lewis' third important trip was a three-day visit to Roy Campbell in Martigues, on the Étang de Berre, west of Marseilles, in March 1932. He came alone and slept next door on a single bed in a stone room. Mary Campbell recalled that "When staying with us in Martigues in Provence he wanted to catch a bus. He mounted an old rusty bicycle on the terrace & went whistling down the rocky path to the main road. I never expected to see him alive again."

In *Snooty Baronet*, published six months later in September 1932, Lewis gave a thinly-disguised account of his stay in Martigues. He praised the solid seafaring sensations of the Marseilles docks: "Harbouring yachts and small steam-fishers, they give you the relaxed joy of canals and crowded backward cities mixed." He thought Martigues was an ideal place for a poet who wanted to fish quietly in the large windy pond, gossip with the rough workers and polish his verse; and he described Campbell's house outside the town, perched on a hill that looked over the lake where his host sailed a boat and jousted with the fishermen. Lewis portrayed Campbell as the barbaric yet up-to-date Rob McPhail, who had prominent cat-like green eyes, wore a white shirt, canvas trousers and espadrilles, and walked with his chest puffed out. During a dull bullfight, Campbell jumped into the ring to take on the animal and was immediately knocked down: "With McPhail you had action-at-a-distance. He lived in a universe as straight as a gun-

barrel—a child world, a Newtonian universe. His fist is upon this landscape. Stamped with his image is all of the small marine industry of the Bouches du Rhône."

Lewis concluded his portrait with rare praise, and showed great warmth and affection for Campbell: "The likeness in our respective ways of feeling (on a number of points) is exceedingly marked. I am astonished at the likeness. It is on account of this I value him so much I think. I feel toward him as I should towards a brother."[3] When Lewis returned to England in April he told Campbell how much he had enjoyed the visit, apologized to his pugnacious friend for killing off "the definitely *pro-bull*" McPhail in the mortuary playground of the bull-ring, and suggested his intense isolation by thanking the one stout companion who had acted as his literary bodyguard when he was threatened by libel suits and violence: "At a point in my career when many people were combining to defeat me (namely upon the publication of the *Apes of God*) you came forward and with the most disinterested nobleness placed yourself at my side, and defended my book in public." Campbell, who took virtually all his ideas from Lewis, said that Porteus' recent book on Lewis did not do justice to his powerful influence. Mary Campbell confirmed that Lewis and Campbell shared the same political beliefs and basic outlook on life, and saw eye to eye about everything that was important. The friendship with Lewis was "one of the biggest events in Campbell's life."

Lewis praised Campbell in *Satire and Fiction, One-Way Song, Men Without Art, Count Your Dead, Rude Assignment* and *Rotting Hill*, and described his uproarious wedding feast in *Blasting and Bombardiering*. He also killed off the Campbell-inspired hero of *The Revenge for Love*, who falls off the edge of a cliff after attempting to smuggle guns into Spain.[4] But Campbell liked Lewis' friendly characterization of him as Zulu Blades, Rob McPhail and Victor Stamp, and thought it would increase his fame.

Campbell's reciprocal admiration for Lewis was expressed in a short but enthusiastic book about him, which was completed by July 1931, announced as a Chatto & Windus "Dolphin Book" and printed in April 1932. But it was withdrawn before publication when Lewis quarrelled with Chatto (who also feared the book might be libellous) in June of that year. As Lewis told W. K. Rose: "Roy Campbell did write a book about me. He was commissioned to do so by Chatto & Windus. The book was set up in type, and the publication about to be proceeded with, when Chatto's became violently angry with me. They informed Campbell that they would not proceed with the book. Roy Campbell, I know, has no copy of it; has several times asked me if I possessed one. I do not." Chatto returned the manuscript and corrected proofs to Campbell in April 1932; and when his publisher, Boriswood, took over the rights

in September, another corrected set of proofs was sent to them. It was also offered to Cape, who published one of Lewis' books and suppressed another in 1936, but it never appeared. After *The Apes of God*, Hitler and the libel suits of the early thirties, no established publisher wanted a book about Lewis.[5]

Though Campbell's finest poems are his lyrics and translations of Baudelaire, San Juan de la Cruz and Lorca, Lewis admired the high-spirited vitality and satiric gift of Campbell, who had contributed a long poem to *Enemy 3*. In *One-Way Song* he alluded to Campbell's book of poems *Flaming Terrapin* (1924):

> And there's Roy Campbell, stiff-chested and slim,
> Posed for veronicas before wild terrapim.

And in *Men Without Art* Lewis claimed: "Roy Campbell in his *Georgiad* has produced a masterpiece of the satiric art, which may be placed beside the eighteenth-century pieces without its suffering by that proximity."[6]

In the knock-out couplets and swaggering stanzas of his neo-Augustan satire on Bloomsbury and sexual inversion, *The Georgiad* (1931), Campbell decried Lewis' lack of recognition, praised him (in his favorite bullfight metaphor) for attacking D. H. Lawrence's primitivism in *Paleface*, and referred to the suppression of his own review of *The Apes of God* by the craven editor of the *New Statesman*:

> For vainly may a Lewis sweat his brains,
> The masterpiece in darkness still remains,
> While any dolt whose industry's behind
> Can win the reputation for a mind. . . .
> Fit game for Lewis' toreadoring skill
> And worthy such a Mithras, if you will
> Who faced him in his towering prime of life
> And gaily dared him to the mortal strife. . . .
> Perhaps some Lewis, winged with laughter soars,
> And in his wake the laughing thunder roars
> To see the fear he scatters as he goes
> And hear the cackle of his dunghill foes.
> How Ellis Roberts to his perch will cling
> And shamming dead, his head beneath his wing,
> Though always full of literary news,
> When Lewis writes, suppresses his reviews.

Though Campbell (a Catholic convert) never actually fought in the Spanish Civil War, he narrowly escaped from his house in Toledo when the revolution broke out and became an ardent apologist for the Nationalists. In *Flowering Rifle* (1939), his long poem about the War, he praises Lewis, with barbarous imagery and characteristic violence,

for his independent opposition to literary fashions and lazy coteries. But his admiration is debased by his doggerel verse and Fascist ideology:

> And few but Wyndham Lewis and myself
> Disdain salaaming for their praise and pelf,
> With cleansing bombs to air the stuffy dens
> Wherein they pick their noses with their pens.

Campbell paid his friend a much finer tribute in his tender and lyrical lines to Lewis in the dedication copy of *Mithraic Emblems* (1936), where he exchanged pure white swans for flying horses in the classical image of Phaeton:

> Wyndham Lewis and Mrs. Lewis
> from Roy Campbell and Mary Campbell

> > —Patience will keep
> > That phantom torch aglow
> > That seems asleep
> > To all but watchful eyes:
> > And live to see it rise
> > Sun-drawn into the skies
> > With swans of snow.
> > R.C.[7]

2

Shortly after *The Apes of God* controversy, which Lewis intensified by publicizing Campbell's rejected review in *Satire and Fiction*, he gave a long and serious interview to the journalist Louise Morgan who published it first in *Everyman* of March 1931 and then in her book *Writers at Work* later that year. Her lively account of Lewis' studio, personal appearance, work habits and public image—corroborated by the extensive testimony of younger friends like Naomi Mitchison, Hugh Porteus and Geoffrey Grigson—provides considerable insight into his life at that time.

Morgan's objective description of Lewis' "office," north of Hyde Park, reveals that his workroom in Ossington Street was much more functional and orderly than the squalid Adam and Eve Mews studio, which was satirically portrayed in the novels of Huxley and the Sitwells: "From the door one walks down a narrow lane made among small chests and piles of books and papers to the fireplace. Canvases large and small are tilted against a wall behind the door. There is an easel, more piles of books on the floor and shelves, and tables with pots of paint and brushes on them. Several old Eastern rugs cover the floor; the curtains are green baize with an orange band, the side of one tacked down its whole length with push pins—evidently to avoid a draught; two Chinese

rubbings hang on the walls. The chairs we sat in were very comfortable; mine was covered in sacking. By the fireplace next Mr. Lewis' chair was a low writing table, with a still lower shelf beneath the top one, neatly equipped with blotting pad and writing paper."

Though the tidy and tasteful room, decorated with oriental art, was clearly subject to the domestic regulation of Froanna, Lewis gave the impression that he lived alone and could afford to rent rooms in four separate houses. He also assumed the mystifying disguises he had advocated in "The Code of a Herdsman": "This is my office. Occasionally I work here, but not very often. I have a room in another house crammed full of books. I call that my library; there I do practically all my writing. Then I have a studio, an enormous shack of a place, in still another house, where I do my big paintings. That's not all! I have another room in a fourth house where I sleep. There's nothing but my bed in it. I live in a series of rooms in different houses." When she wondered if he ever had a barren interval, he wittily confessed: "I feel I ought to entertain a certain shame on the subject of my fertility, like a woman who has had too many children. However, my reply is an uncompromising one—*No*." He later told another friend that he "could easily write two philosophical books, and two novels, and do two hundred drawings or paintings every year," though he never quite achieved this extraordinary productivity. Lewis also explained the important distinction he made between his carefully created fiction and rapidly written polemical books: "The pamphlets are written just as one talks, and nearly as fast as talking. To write they are often a great bore—they are usually quite carelessly written. With my non-polemical writing it is the reverse—that is written with the greatest attention, of course. Into such a book as *The Wild Body* (a book of ten pieces of fiction) I put twelve months' hard labour I dare say: *Paleface* (a squib about the Blacks and Redskins) a sixth of that time."

Morgan described the chain-smoking Lewis as tall, scholarly-looking, calm, thoughtful and sympathetic. Since these qualities seemed to contradict the image of the satiric Enemy who breakfasted on "raw meat, a couple of blood oranges, a stick of ginger, and a shot of Vodka," she asked if he ever felt hate. He said he was above all passion and suggested that art should be ritualized, formal and cool: " 'Hate?' he asked. 'Oh, not that at all. Everything I do is done in cold blood. *Kaltes Blut*, you know.' He smiled. 'The temperament of the duellist.' "[8]

In the late 1930s Lewis became the focus of the most lively and congenial group of artists and intellectuals he had known since the days of the Vorticists: the composers Cecil Gray and Constant Lambert, the art critics William Gaunt, Tommy Earp and R. H. Wilenski.[9] These men noticed the change from Lewis' prewar Hispanic style of dress to the more forbidding figure of the twenties and thirties, conservatively

dressed in funereal black. His friends, who saw the best side of his character rather than the hostile shadow of the Enemy, observed the contrast between the portentous, menacing, somber, disquieting public image and the genial, affable, kindly and courteous private man, whom they sometimes called "Windy." They also admired his ability to draw people out, noted his interest in what they had to say and praised his brilliant conversation at the ten o'clock meetings in Ossington Street.

Cecil Gray (who had been a close friend of D. H. Lawrence during the War) wrote: "Whatever the season of the year, whatever the prevailing climatic conditions, [Lewis] would invariably be enveloped in a large dark overcoat, with the collar turned up, a large black sombrero with the brim turned down, and gloves; so that practically all one saw of his person was a pair of eyes which peered out, with a basilisk glint, through formidable horn-rimmed spectacles." During the evening, "the oracle, like the Bailiff in his *Childermass*, would hold forth without intermission on any and every subject under the sun, moon and stars, to an entranced and highly select audience. . . . I have known many admirable talkers in my time, but I can say without hesitation that Wyndham Lewis was the most brilliant, witty and profound of them all." Lewis' talk, like his work, had a "wealth of invention and imagery, coupled with a complete lack of shape and form." John Rothenstein added: "He talked well: any subject likely to extend his intellect or to add to his stock of information was grist to his mill. . . . As a talker he was largely defensive, expressing his suspicions that this person or that had plotted or was plotting to do him an injury."

William Gaunt, who met Lewis in 1928 after inviting him to contribute to the magazine *Drawing and Design*, also remarked on his defensive posture and constant expectation of attack:

Personally I did not find Lewis a difficult person though when we met he had of course already a long controversial record and a formidable part in what he termed the 'big, bloodless brawl' of the arts c. 1914. By the post-war era he had moved somewhat away from the position of *Blast* and begun to attack the kind of social life and thought that the Sitwells might be said to represent. Outside this arena I found him habitually having a sort of hidalgo courtesy and pleasantly inclined to philosophic entertainment and exchange of ideas. As 'The Enemy,' self-appointed, he did incur hostility in return and this tended to something at least resembling persecution mania. I recall having lunch with him at Frascati's—a restaurant with a dying fin-de-siècle glitter (vanished now) and his insistence on sitting with his back to the wall in a spot that commanded a view of the whole floor. Perhaps his way of caricaturing people he knew in his books, e.g. *The Apes of God* and *Snooty Baronet*, made him apprehend retaliation.[10]

Lewis liked to sip *crème de menthe* in the garishly colored interior of Frascati's—a favorite old-fashioned restaurant on the corner of Oxford

Street and Tottenham Court Road—and to sit in the large, hooded red velvet chairs in the alcoves, where conversation could not be overheard.

In 1930 Lewis met Naomi Mitchison, daughter of the distinguished physiologist J. S. Haldane, after writing to thank her for a review of *The Apes of God* in *Time and Tide*. She had naively failed to recognize the real models of the satire, and Lewis was pleased by her objectivity. He used to come to the big parties that she and her husband, the successful lawyer Dick Mitchison, gave at their home on Hammersmith Mall.

Lewis' friendship with Naomi during the 1930s led to fifteen drawings of herself and her four children (Lewis kept the small ones interested by turning a pudding basin upside down on the floor and telling them that mice were underneath), to a major portrait of her in 1939 and to illustrations for her book *Beyond This Limit*, published by Cape in 1935. Lewis wanted to draw Naomi, a good-looking young woman, almost as soon as they met in his Percy Street studio. She recalled that he talked amusingly while painting her, but she had to remain absolutely silent. Lewis made harsh demands on sitters: they posed for fifty minutes, rested for ten and then repeated the cycle, like professional models. Much later, when a painter asked her how she could immediately return to a pose, she replied: "Anyone who has sat for Wyndham Lewis could do that." Lewis loved her low-cut Turkish dress with red and gold brocade, bought in a bazaar in Sarajevo, which appeared in several drawings. He always beautified her by straightening her nose and said he saw her that way. In 1939, when she was writing *Blood of the Martyrs* (which accounts for the crucifix in the background), Naomi said she could come to his studio only if she could continue to work while sitting for her portrait. Lewis agreed, but when she moved her arm he shouted: "Keep still, don't move!" He painted her with pen in hand, big notebook open on her knee and frustrated frown on her face. She liked the ambience of his untidy (but not squalid) studio, and enjoyed watching him create a work of art with clear and certain draughtsmanship.

Lewis liked to discuss politics with the serious-minded Naomi, whose views were radically opposed to his own. He was curious about the "two dictators," Cripps and Mosley, and admired them without agreeing with them. In controversy he tended to take an extreme position: when others declared Stalin was a wonderful leader, he held the opposite view. But she did not feel he was, in any sense, a Fascist. "He used to glare at me from under his great black hat and sometimes said things which were cruel or violent, presumably to see what I would say, or perhaps to get them out of himself. For he was not cruel or violent inside himself." Like Nancy Cunard, Naomi could not persuade Lewis to adopt a more liberal viewpoint; but she could break through his defensive hostility by appealing directly to his emotions: "I think he

was really a bit mad. Once he opened the door a crack and glared at me with what I now realize was a look of manic suspicion. There had been nothing to quarrel about and I thought the only thing was to be violent; so I gave the door a shove, threw myself onto his chest and cried; in a minute or two he was perfectly all right."

When they worked together on *Beyond This Limit*, Lewis helped her with both style and ideas, and insisted on verbal accuracy. When she did not know how to continue the plot, she would look at his drawings and see what was bound to come next. Many of his illustrations portray Naomi in a kerchief and full skirt, himself in a big black hat. They went to the British Museum to look at the Classical art that she later described in the story, discussed the fictional characters as if they were real, and treated the book as a secret joke that was not really meant for others. He seemed to enjoy her rather simple way of writing and her use of fairy-tale elements. When Lewis spoke of his libel suits and severe problems with publishers, she introduced him to Cape, told them they must deal tactfully with him and helped to arrange their publication of *Left Wings Over Europe* in 1936.[11]

Unlike Naomi Mitchison, who was a well-connected, wealthy and established author, Hugh Gordon Porteus had come from a provincial background, attended art school and worked as a commercial artist. He was twenty-five when he first met Lewis in Zwemmer's bookshop in 1930 and was soon invited to Percy Street, where the walls were padded with seaweed to keep out the noise: "Just inside the door of the studio hung a framed Rowlandson, about a foot square. It depicted a shrewish female face, of life size, the carmined lips neatly sewn together with jagged stitches of black cobbler's thread. This I learned to read as a reminder that no women were allowed to enter here." Porteus soon assumed the role of admirer and disciple, and used to affect Lewis' mannerisms. He had a much more informal relationship than Naomi had with Lewis, and was sometimes treated roughly. Lewis once met Porteus, carrying a pile of review books on Russia, and accused him of being a Communist. Lewis, who suffered from catarrh and had a nervous snuffle (rather like a pug dog) from constantly smoking cigarettes and pipes, was afraid of colds and often accused Porteus of infecting him. When Porteus showed Lewis his art work, he threw it straight into the waste basket and exclaimed: "I don't want to look at that rubbish!"

Porteus had read Lewis' books as they appeared in the twenties, published his first article on Lewis in 1931 and the first serious book about him in 1932. They had the earliest of many quarrels when Porteus refused to let Lewis write the book for him and Lewis complained: "When you began to piss against my leg I should have chased you away." But the book received a number of favorable reviews and "gave Lewis'

career a second innings" after *Paleface*, *The Apes of God* and *Hitler* had seriously undermined his reputation. Lewis was delighted by this welcome change in his fortunes and was usually kind to Porteus. He once said: "Come with me in the Rolls Royce that is taking me to Sir Nicholas Waterhouse." When Lewis got out of the car, he ordered Jebbitt, the chauffeur, to drive Porteus to a friend's house and take them for a ride around London. On another occasion, Porteus was invited to a party in Lewis' flat (which had no chairs) and met Naomi Mitchison, Geoffrey Grigson, R. A. Scott-James (who edited the *London Mercury*) and Stuart Gilbert (who was a friend of Joyce and explicator of *Ulysses*). Froanna, as usual, was invisible.

Lewis was inordinately curious about Porteus' sex life, girl friends and Jewish wife, whom Lewis imagined would be like Anastasya in *Tarr*. When they were introduced he was affable and spoke to her in French with a bit of Russian he had learned from students in Paris. But later, showing his disappointment that she was not a native Russian, he asked: "What do you mean by introducing me to that East End Jewess?" After World War Two, when Porteus was having an affair with another Jewish girl whom Lewis knew, Porteus apologetically quoted *Tarr* and said, "I only go to her to get milked occasionally." Lewis missed the allusion to his own work and thought it referred to an exotic perversion. He then invited Porteus to dinner and after three bottles of wine mischievously said: "Now sit with my wife and show her what you do with Helen." He pretended to leave the room and then tiptoed back to spy on them.[12] Though Porteus was not emboldened to demonstrate with Froanna, this absurd episode may have been a test of his attitude toward her. For Lewis had the mistaken idea that Porteus disliked Froanna and once wrote to him: "You have been offensive whenever you have come to see me since my marriage, and the passage of time seems in no way to change your strange hostility to my wife." (Porteus and Froanna exchanged many friendly letters after Lewis' death.)

Lewis' friendship with Porteus cooled after the War, and in 1949 he rather harshly criticized Porteus for his tendency to gossip: "Hugh Porteus I find faddy and for me personally dangerous, because of his long and silly tongue (more silly and conceited than malicious)." Porteus wrote that after his numerous disagreements with Lewis, their mutual friend Eliot "in his most sepulchral and lugubrious tones warned me that I had initiated 'an irreparable breach.' But in fact, and in due course, all such breaches were mended."[13] Porteus remained fiercely loyal to Lewis, and wrote more than a dozen enthusiastic reviews of his works in the *Criterion* and other influential journals as well as an unsigned profile in the *Observer* of August 5, 1956, that particularly pleased the Master.

The forceful and fiery poet and editor Geoffrey Grigson (a strong

contrast to the gentle and puckish Porteus) met Lewis in 1933, soon after he started his influential *New Verse*. Lewis approved of the journal and promptly summoned Grigson to a meeting. Grigson soon became Lewis' staunchest literary partisan and enthusiastically joined his campaigns against the Sitwells. For Grigson found "the force and scope of his mind and the range of his experience and his reading and his perceptions and the elevation he was capable of were so entirely formidable. . . . [Lewis], disembodied altogether behind an address in the Pall Mall Safe Deposit, stood for less ambiguous energy, for the intellectual passion Yeats admired in him."

In order to get rid of unwanted acquaintances like Reginald Pound, the biographer of Arnold Bennett, Lewis would lead them to the Pall Mall Safe Deposit and exclaim: "This is where I live. Good night!" He once tried this ruse on Rupert Grayson, who replied: "A big man like you must find it rather cramped in there." Though Lewis asked: "What is *SAFER* than the PALL MALL *SAFE* DEPOSIT?" the papers stored there were lost during World War Two.

By the time *New Verse* was firmly launched, Grigson was seeing Lewis frequently, meeting in Lyons tea rooms, lunching at Frascati's (where he first heard Lewis read *One-Way Song*), drinking in Lewis' flat in Chilworth Street. In January 1934 Grigson made a lively note of a visit with Spender to Lewis' primitive number 5 Scarsdale Studios, on Stratford Road, near Kensington High Street: "No electric light inside. No furniture except 3 arm chairs. Candles, whiskey and glasses on a packing case. An easel in the background. W.L. very hard up and harassed. He disliked Spender . . . [later] adding that [Spender] was going to be influential in mod. lit."[14]

In his autobiography, Grigson praised Lewis' way of "imparting a whole sense of the nobility and conscious nature of human achievement in the arts. Here in a London of selling I knew a man not for sale, combative, fearless and independent, but combative in support of a consistent notion of life and art." And in his pioneering pamphlet of 1950, the militant Lewis became for Grigson "the symbol of energy and acuteness, of the controlled expression and the steel edge."[15] Grigson admitted that Lewis had a profound distaste for fools and quarrelled bitterly, and agreed with Pound that Lewis was pursued by the Furies. But, like most people who knew Lewis personally, Grigson insisted that his reputation for being brutal and savage was unjustified. Though Grigson was at first afraid of Lewis, he soon discovered that no one had finer manners. Lewis, a good teacher, was always extremely concerned about his young friend's intellectual life, and frequently suggested books to read and paintings to see. Grigson emphasized Lewis' expression of sardonic amusement, his liveliness and gaiety, his keen enjoyment of good food and wine, women, travel, conversation,

art, literature and ideas: "I never saw Lewis exercising a hostile public persona. . . . Lewis had the best unwavering courtesy I've encountered in any one, equal in that way to Eliot or Thomas Mann. To those he liked he was intellectually generous and concerned." Of all the people Grigson had known in his lifetime, only Auden equalled Lewis in intelligence.[16]

Ruthven Todd, who published his early poems in Grigson's *New Verse*, confirmed his view of Lewis' generosity: "When he first came to London from Edinburgh [c. 1934], Wyndham Lewis had not only presented him with [a signed set of his] books, but when he was broke put him up in the basement of his flat, bringing down the breakfast himself every morning for a week before introducing Todd to his wife, after which they all breakfasted together upstairs. It was not a story which confirmed the popular view of Lewis as everyone's implacable enemy."[17]

One of Grigson's closest Hampstead friends was Henry Moore, whom he introduced to Lewis in the thirties. When Moore first came to London as a raw provincial student in 1921, the Bloomsbury group had a stranglehold on English art. But he was inspired by Lewis, whose work had also been influenced by the primitive sculpture in the British Museum. Lewis provided a crucial link with Gaudier and Epstein; and executed drawings that were important to Moore, who believed all great sculptors were also great draughtsmen. Moore thought Lewis' books provided the stimulating gust of fresh air that liberated him and confirmed his youthful hope that "everything was possible, that there were men in England full of vitality and life."

The meeting with Lewis took place in the Kardomah tea room opposite Burlington House in Piccadilly. Lewis went directly to the point and asked Moore: "How do you carve and with what? Do you go straight for the wood, like an African?" Lewis had immediately raised the crucial question of truth to material, of the dramatic, irrevocable quality of direct carving, which Moore then advocated, as opposed to the more cautious and careful modelling. He also urged Moore to earn money by doing portraits. Though Lewis was mysterious and secretive, and they did not meet very often, Moore got on well with him. He was always generous to Moore and praised several of his exhibitions in the *Listener* in the late 1940s.[18]

The friends and supporters Lewis acquired in the early thirties were gratifying proof that the younger generation recognized his artistic importance. In the Ossington Street circle he found a stimulating group of men who were devoted to conversation, art and ideas; in Naomi Mitchison, an attractive admirer, patron and colleague, with interesting connections in the world of politics; in Hugh Porteus, a lively and loyal disciple who consistently praised his work in his book and reviews; in Geoffrey Grigson, a man who matched his physical presence and fine

intellect, shared his stern standards and fierce intensity; in Henry Moore, an idealistic craftsman and creator. All these artists learned a great deal from Lewis, felt affection and esteem for him, and tried to help him achieve the reputation he deserved.

3

But his reputation was always greater than his earnings. Though he published eight books and an art portfolio between April 1931 and November 1933, and generally received favorable reviews, the early thirties were the most poverty-stricken years of his life. Except for *Snooty Baronet*, for which he received £300, his advances were never more than £150. The printings of 1,000–2,000 were small and the sales even smaller (*Snooty* printed 4,000 and sold 3,000). Only with the first trade edition of *The Apes of God* (1931), a *succès de scandale*, did he go beyond his advance and earn £325. His depressing royalty statement from Chatto & Windus for 1933 showed a debit on all the books published by them since *The Art of Being Ruled* (which still showed a loss of £24 on the final statement of 1957), and a sale of 355 copies for all nine books, ranging from 0 for *The Doom of Youth* to 208 for *Tarr*. In 1931 Knopf paid Lewis $2.75 for the eleven copies of *Tarr* that were sold in America. Lewis' most profitable transaction was surely the £100 of the £250 advance he received from Constable for the unwritten *Life of a Tyro*. He earned about the same amount for his unwritten as for his published works.

Since Lewis was doing virtually no painting, he was forced to sign many book contracts to get the money necessary to live and write. He existed on advances for reprints (*The Diabolical Principle, The Apes of God, Enemy of the Stars*), pot-boilers (*Hitler, The Doom of Youth, The Old Gang and the New Gang*) and minor works (*Filibusters in Barbary, Snooty Baronet* and *One-Way Song*). He had to write these books quickly and carelessly to fulfill his obligations, sustained by the vain hope that they would make money. Unlike the early twenties, when he had sufficient time and funds to complete his major books, he was now unable to finish the sequel to *The Childermass*, which took him much longer to write. It was a terrible and a degrading trap. Lewis wrote more and painted less than he should have done because it was easier to secure contracts for books than commissions for paintings. Publishers had the one merit of paying advances, while patrons often disliked their truthful portraits and refused payment. Lewis told a gallery owner, who had encouraged him to prepare an exhibition, that he was inevitably compelled to suppress the urge in his fingertips to create a picture.

Despite the pride that made him attempt to conceal his difficulties,

all the friends who visited Lewis' bare, unlit studio noticed that he was obviously impoverished. There was a constant stream of demanding bills, dunning letters and eviction notices, and he was deeply in debt. He became increasingly suspicious and secretive, and tried every means to avoid his creditors. He had kept in touch with his friend Sturge Moore by sending inscribed copies of his books; and in November 1932 visited the old poet to borrow £25 and was embarrassed to discover that Moore could not lend him the money.

The fifty-year-old Lewis told Sydney Schiff how miserable it was never to have even a month's relief from financial worry. And he explained to his lawyer why he had not paid his bills: "For months after my illness my wife and myself lived in two rooms and a kitchen: I wrote my articles in a small bedroom, on a writing-pad on my knee, with my papers and books laid out on a bed, and my inkpot by my side on a stool."[19] He continued to write precisely in this way for six years after his blindness.

Though the Depression inevitably reduced Lewis' limited sales and advances, his desperate poverty was also exacerbated by the legal expenses incurred while contesting the withdrawal of two books as well as by the medical expenses during his five years of illness which naturally impeded his phenomenal capacity for work. If it were not for the love, care and sacrifice of his wife, and the emotional and financial support of his friends and patrons during these intensely difficult years, Lewis would not have been able to survive as an artist.

4

In about 1931, when he was still living in Ossington Street, Lewis met the first woman since Nancy Cunard who seemed to arouse his serious interest. Sybil, Lady Cholmondeley, the daughter of a Rothschild and a Sassoon, was a beautiful, wealthy, witty and literate young woman. She was the leading debutante of 1912, married the following year and had three children. She had known Henry James and had been painted by Sargent, Orpen and John. She first met Lewis at John's studio; and soon began to descend from her mansion in Kensington Palace Gardens, cross Notting Hill Gate—carrying sixpences for Lewis' gas meter—and visit him alone in the bare little room in Ossington Street.

Lady Cholmondeley recalled that Lewis, who feared people would pursue him with bills, locked the door the moment she entered the room, wore shabby clothes and had a phobia about being recognized. She found him a strange man who lived in a very different world from her own. He was not interested in talking about classical artists, contemporary painters, recent exhibitions or even the collectors she knew. He

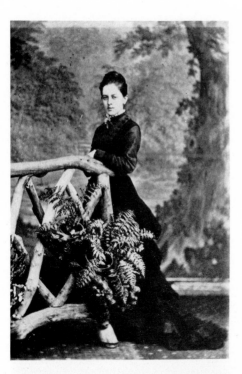

1 Anne Prickett Lewis as a
young woman

2 Charles E. Lewis, 1870

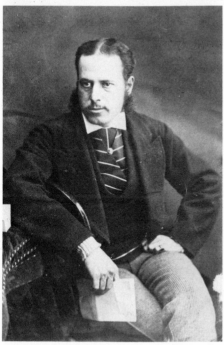

3 Wyndham Lewis, by Augustus
 John, 1905

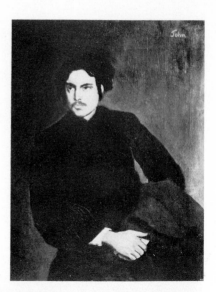

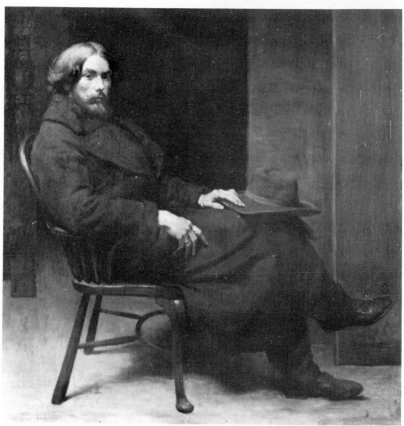

4 Augustus John, by William Orpen, 1900

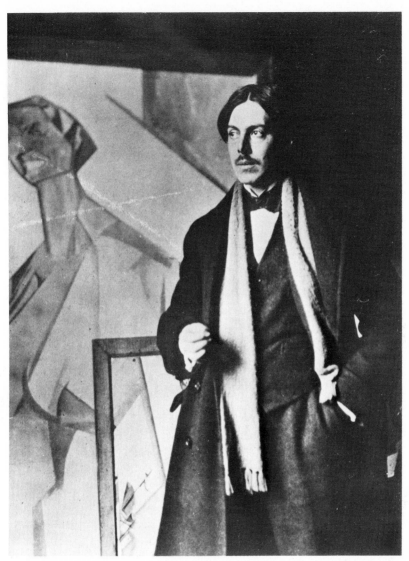

5 Wyndham Lewis and *The Laughing Woman*, c. 1912

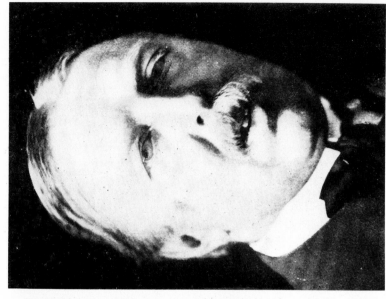

8 Ezra Pound, by Wyndham Lewis, 1938

9 T. E. Hulme, 1914

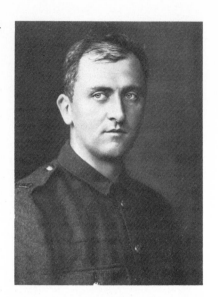

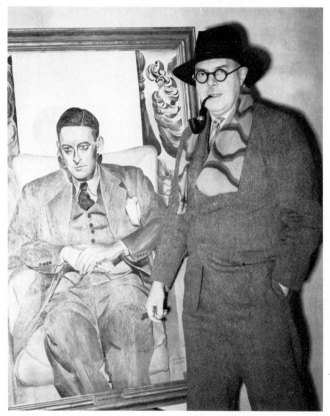

10 Wyndham Lewis and his portrait of T. S. Eliot, 1938

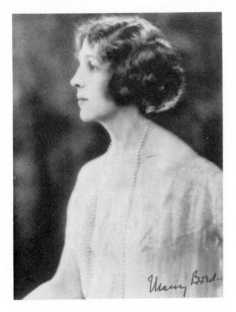

11 Mary Borden, 1920s

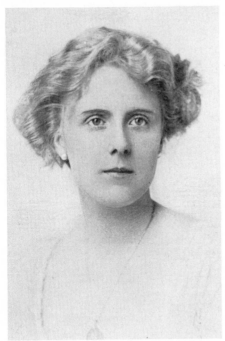

12 Sybil Hart-Davis, c. 1920

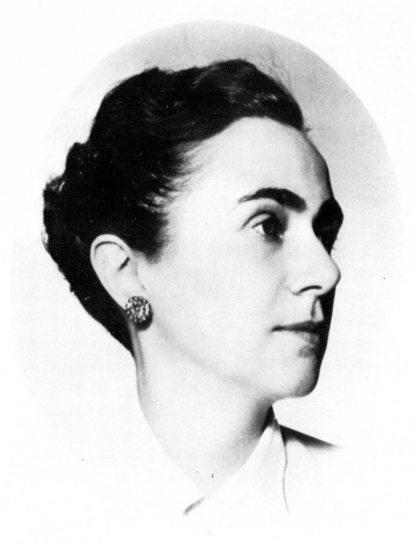

13 Iris Barry, 1925

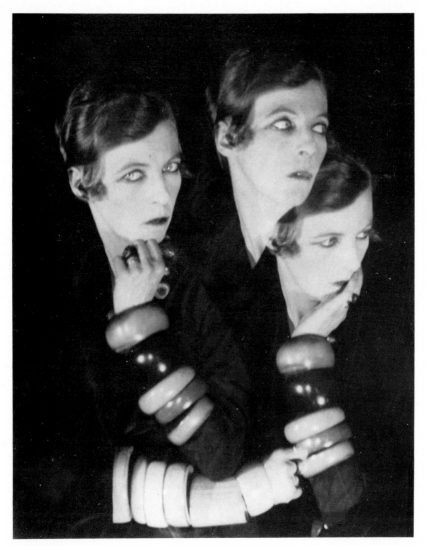

14 Nancy Cunard, 1929

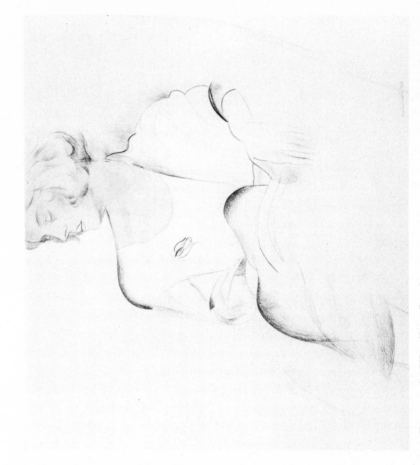

15 Froanna, by Wyndham Lewis, 1924

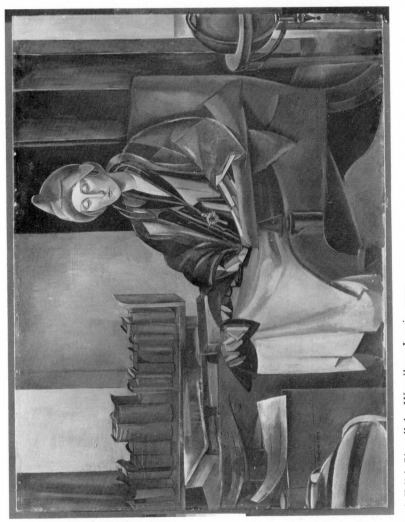

16 Edith Sitwell, by Wyndham Lewis, 1923

17 (*right*) James Joyce, by
Wyndham Lewis, 1921

18 (*below left*) Roy Campbell, 1950s

19 (*below right*) Sydney Schiff, by
Max Beerbohm, 1925

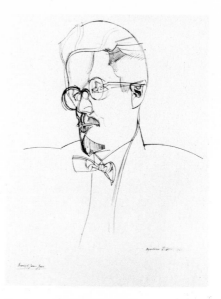

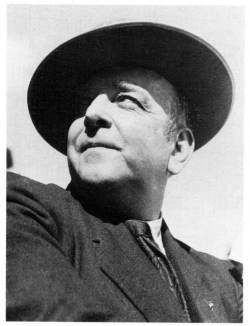

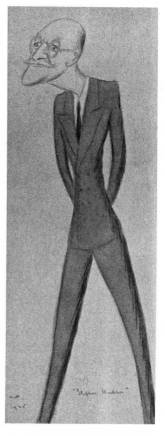

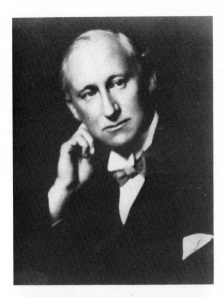

20 Sir Nicholas Waterhouse, c. 1910

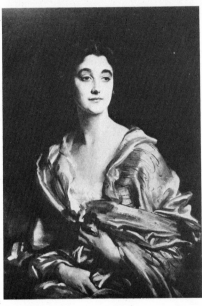

21 Sybil, Marchioness of
Cholmondeley, by John
Singer Sargent, 1913

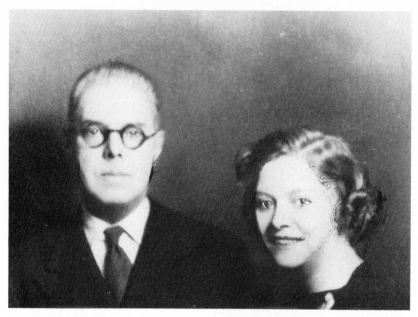

22 Wyndham Lewis and
Froanna, New York, 1940

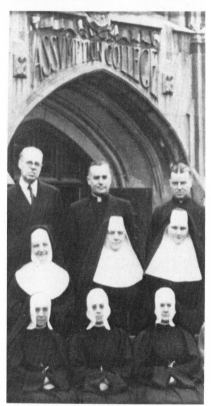

23 Wyndham Lewis, Father
Vincent Donovan, Father J.
Stanley Murphy, Windsor,
Ontario, c. 1944

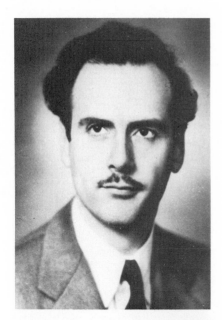

24 Marshall McLuhan, 1940s

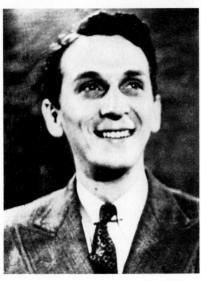

25 Felix Giovanelli, 1940s

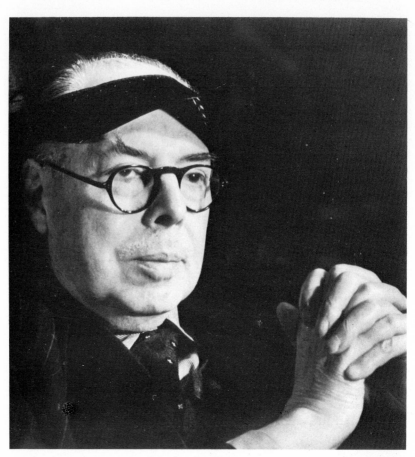

26 Wyndham Lewis, when blind, 1952

mainly discussed his own work and used to read aloud to her, with great effect, from *The Apes of God*, which he presented to her. She was also very friendly with the Sitwells, who had seriously thought of suing Lewis for libel. Osbert was greatly annoyed at her meetings with "her friend Wyndham" and often asked: "What does he say about me?" Though Lewis frequently visited wealthy friends like Sydney Schiff and Nicholas Waterhouse, he refused repeated invitations to Lady Cholmondeley's home, did not want to meet her husband, disliked society people and seemed uncomfortable with servants. She sometimes suspected (despite his refusal to meet prospective patrons) that he saw her only for financial advantage. Though she knew he was poor and ill, she never thought of buying his drawings (except the one of herself) and never offered him money because she felt embarrassed and was afraid of offending him.

Lady Cholmondeley, who thought Lewis "did not like women," was unaware that he had a wife and did not find out about Froanna until many years later. Though she knew nothing of his private life, she assumed he was successful with women because he was unmarried and free to pursue them. He certainly showed no affection toward her and did not express the slightest wish for intimacy. She did not find him attractive, certainly "not to go to bed with." She enormously enjoyed Lewis' company, but did not feel he ever liked her very much and thought their friendship was inevitably transient.

The fifty-eight letters that Lady Cholmondeley wrote to Lewis in the early thirties give a somewhat different impression from her recent account of their relationship. They reveal that she was a powerful and influential woman who was eager to help Lewis with publishers, lawyers and doctors; visited him and paid his medical expenses when he was ill; persuaded Noël Coward and Wing-Commander Orlebar (whom she met through her brother, Sir Philip Sassoon, the Air Minister) to sit for *Thirty Personalities*; and pleaded with Lewis to disclose his address when he disappeared behind the impersonal façade of the Pall Mall Safe Deposit. In July 1932, when he was drawing her during several sittings at Percy Street, she wrote to him that marriage was surely an absurd relationship, that he was always in her thoughts, that she was truly attached to him and loved him very much. Though Lewis was middle-aged and ill, he enjoyed exercising his intellectual power and was still able to captivate a famous society hostess. His friendship with Lady Cholmondeley suggests that if Lewis had less ambition and a more amenable temperament, he could have had—like Orpen and John—a very lucrative career as a society painter.[20]

Lewis had a less successful relationship with Lady Glenapp, who was asked to support the Arthur Press and in 1930 commissioned for £300 Lewis' first oil portrait since *Mrs. Schiff*. Lewis portrayed Lady

Glenapp attractively, standing before a statue in a niche, in the elongated mode of a twenties flapper; her sophisticated pose and style were strongly reminiscent of his drawing of Nancy Cunard. But Lady Glenapp, whom her husband called "a rather hasty-tongued woman," was openly critical and dissatisfied. After her divorce, in November 1932, there was a legal wrangle about the money she claimed Lewis owed her. When she died unexpectedly in February 1933, her estate sued Lewis—perhaps for her advance on another unfinished painting.[21]

The lavishly produced portfolio *Thirty Personalities and a Self Portrait*, which included Lady Cholmondeley, was published by Desmond Harmsworth and coincided with Lewis' exhibition of these drawings at the Lefevre Gallery in October 1932. Half the subjects were Lewis' friends and publishers (Augustus John, A. J. A. Symons, Tommy Earp and Naomi Mitchison), half were well-known public figures in literature, the theater, journalism, medicine and commerce (J. B. Priestley, Edith Evans, Viscount Rothermere, Ivor Back and Ivor Stewart-Liberty). Two of Lewis' finest drawings, of Rebecca West and James Joyce, have already been mentioned. A number of others show Lewis' superb draughtsmanship, great psychological insight and perceptive revelation of character: the nervous intensity of Augustus' son, Henry John (who killed himself in 1935); the intellectual acumen of the Jesuit, Father D'Arcy; the foppish preciosity of Constant Lambert; the elephantine energy of G. K. Chesterton, a "ferocious and foaming Toby-jug"; and, most notably, the impressive courage of the legendary aviator, A. H. Orlebar, who had led the British team in the Schneider Cup racing victory in 1929. His fierce and vital portrait was subtly inspired by Bellini's Doge *Loredano Loredan* in the National Gallery.

Two of the sitters have left accounts of Lewis the artist. The beautiful young Margaret Flower (the wife of Desmond and daughter-in-law of Newman, the director of Cassell) sat for Lewis three or four times in his miserable little flat on Percy Street while he drew furiously for an hour and a half. She found the sittings pleasurable because Lewis was protective and avuncular (she never saw his bitter side), was easy to talk to and entertained her with lively conversation: "He wanted to discover what his subjects were like. We talked about literature to the exclusion of most other things. I was only two years out of Bryn Mawr where I read English, and of course I wanted to make the most of the time I spent with such an eminent writer. He liked this very much and said he was surprised and pleased to find me such a blue stocking. . . . He said he admired Leonardo more than anyone, because he was a man who could do many things well."[22]

Desmond Harmsworth, the painter and publisher who (with his wife) was included in the exhibition, described Lewis' unusual method of lighting his subjects: "The drawing was done at Percy Street, in a room

with shutters. Lewis closed out most of the light, and left one shutter
open, concentrating the light on the sitter. However, the light was
reflected from the white paper into Lewis' spectacles, and as he looked
up this was reflected in turn into the sitter's eyes. 'It was rather painful,'
Harmsworth recalls. 'It was absolutely dazzling, and one's eyes were
streaming after a time. Lewis looked up, then down, drew a little bit,
looked up again. He didn't take long looks, as I would.'" When the
portraits were completed there was an opening at the Lefevre Gallery
at which modernistic blue-dyed cocktails were served to sitters and
guests. The show was favorably reviewed by William Gaunt and
Anthony Blunt, and earned high praise from Walter Sickert who called
Lewis "the greatest portrait painter of this, or any other, time."[23]

5

Lewis' books of 1931–1933 were not his best, though there were lively
passages in *Filibusters in Barbary* and *One-Way Song*. *The Diabolical
Principle* and *The Dithyrambic Spectator* were two separate works,
published together a month after *Hitler*. The second part attacked the
anthropological theories of Jane Harrison and Elliot Smith which
stressed the primitive origins of art. The first part had a more compli-
cated genesis. In *Enemy 1* (February 1927) and *Time and Western Man*
(September 1927), Lewis had lumped together Joyce and Stein—two
writers of very different quality—and attacked both of them as time-
obsessed romantic writers. In "First Aid to the Enemy," an essay that
appeared in *transition* in December 1927, Lewis was counterattacked by
the three obscure editors of that journal, who were the adulators,
imitators, translators and explainers of Joyce and Stein, and had been
publishing their works in progress in the magazine that had become the
house-organ of the Paris-based English avant-garde. In *The Diabolical
Principle*, which had originally appeared in *Enemy 3* (March 1929),
Lewis retaliated with a final attack on *transition*'s nihilistic romanticism
that showed it was derived from the defunct diabolism of the 1890s.
Many of Lewis' books of the thirties were ill-timed as well as ill-
conceived. For *transition* had expired in September 1930 while *The
Diabolical Principle* was in press; and by the time the book appeared in
April 1931, the target—if not the issue—was dead.

When Lewis failed to find financial satisfaction from Chatto—even
before the lawsuit about *The Doom of Youth*—he quietly made arrange-
ments with Grayson & Grayson (who had successfully published the
first trade edition of *The Apes of God* in November 1931) to bring out
Filibusters in Barbary. It had been serialized in *Time and Tide* during
the last four months of 1932 and was Lewis' only travel book.

He also extensively revised his dream-play, *Enemy of the Stars*, originally printed in *Blast 1*, and arranged with Desmond Harmsworth's new firm for its publication in July 1932. According to Hugh Porteus, Harmsworth (the nephew of Northcliffe and Rothermere) was neither an intellectual nor a committed publisher, but a painter who was taught by Lewis and became interested in his work. Harmsworth wrote of Lewis: "He was excellent company, very amusing—even so about the celebrated persecution mania, which was often evident. . . . He was hell for a publisher, at least for me, disregarding publishers' rules about changes in proof, in fact using the printer as a stenographer." Harmsworth also published Porteus' *Wyndham Lewis: A Discursive Exposition* in December[24] and *The Old Gang and the New Gang* in January 1933. The latter was a brief tract that expanded the argument in Part 1, chapter 8 of *The Doom of Youth*, and argued that the new gang of Lenin, Mussolini and Hitler were replacing the old gang of capitalist politicians.

A. J. A. Symons had introduced Lewis to Desmond Flower of Cassell in 1931, when Lewis was having difficulties with Chatto about the sequel to *The Childermass*. In April Lewis signed a contract for three books, "almost as a job lot," which included his finest works of the thirties: *Men Without Art* and *The Revenge for Love*. Flower found Lewis dynamic and impressive, and they got on extremely well. He thought Lewis had a realistic impression of himself as an author; he was rarely critical or difficult and did not complain about the lack of success with Cassell. Flower knew that Lewis was seriously ill in the mid-thirties, though Lewis would never admit it. But Flower did not know his address or what he was doing; he would suddenly appear, then vanish into silence. Lewis was very generous when entertaining friends among the plush chairs, oak-panelled alcoves and chandeliers of the Hyde Park Hotel Grill—the only limit was the money in his pocket:

When he had completed a novel he brought it to me at La Belle Sauvage [Cassell's office] and we sat and talked. He was prompt with his proofs. When the novels did not sell well he never said any more than to express the same sadness that I felt myself. I was not able to offer him another contract because we were in the depths of the slump and one could no longer afford the luxury of supporting an author, however distinguished. When he did his *Thirty Personalities* Lewis invited my father and my American wife Margaret to sit for him.

His persecution mania was never very obtrusive in his conversations with me, although I could sense a feeling that he felt every man's hand was against him. What I recall is the long silences when one did not know if he was away or just retreated into his shell. Then he would suddenly surface, like ringing me at about 7 one evening and saying "are you free for dinner? Meet me in half an hour at the Hyde Park Hotel" and giving me a sumptuous meal featuring an enormous lobster.

When he felt like it he could be brilliant. There was one evening which

made anything I ever heard from the Bloomsbury group sound feeble. Margaret and I asked him, A.J., and John Rothenstein to dinner at home. After coffee they talked until the small hours and, in the days when conversation was still a fine art, Margaret and I eventually went to bed exhausted from concentrating on an unending stream of diamond-cut brilliance. I have never heard anything like it since. . . .

I liked him very much, and he never gave me any cause or reason not to do so.[25]

Lewis' first book with Cassell, *Snooty Baronet*, was an attempt to write popular fiction using the comic "automaton" technique of *The Wild Body*. Hugh Kenner has aptly called it "a peppy and pointless novel." Its hero, Sir Michael Kell-Imrie, the snooty baronet, has a double-barrelled Scottish name, like his predecessor Ker-Orr; he has lost a leg and partially tamed the wild body with a mechanical limb, like Percy Hardcaster in *The Revenge for Love*. The episodic action moves from Rob McPhail's Bouches du Rhône to the "Persian" desert (obviously based on Morocco) where the hero's rich but mean literary agent, Captain Humphrey Cooper Carter, takes Kell-Imrie to investigate Mithraic cults—the subject of his next book. Humph is a caustic characterization of Lewis' current publisher Rupert Grayson, who was also a strong-jawed King's Messenger and author of crime yarns. Snooty's attitude toward him is bluntly expressed: "I hate his face. . . . I disliked it from the start, a long time ago. . . . I stomach the chap with difficulty really!" At the end of the novel he gleefully shoots Humph and remarks: "I don't believe that any shot ever gave me so much pleasure as that second one at old Humph's shammy leathered, gusseted stern, before he rolled off his pony and bit the dust."[26]

Just after Lewis finished writing his next satiric work, *One-Way Song*, he met the high-toned Herbert Read in the Piccadilly tube station and assumed a deceptively casual attitude toward poetic creation. Lewis was "literally dancing with delight. 'I never knew verse-writing was so easy,' " he said to the astonished Read, " 'merely putting one foot after another. I could go on forever.' " By adopting a rather rough, offhand manner Lewis followed the tradition of English satiric poetry he most admired: the line of Butler's "Hudibras," Defoe's "True-Born Englishman," Churchill, Crabbe and Byron. Sturge Moore, who was delighted by the poem, published by Faber in November 1933, told Lewis: "Never since Browning and probably not even by him has the language been used with such swing, verve and gusto."

"Engine Fight-Talk," the first part of the amusing but uneven long poem (which Lewis liked to read aloud), was a satirical rejection of the youthful school of thirties poets who bite "their fingernails behind the breastworks of their cribs," praise machinery and "say it with locomotives." The second section, "The Song of the Militant Romance,"

was a burlesque of the blustering Kipling school of poetry that contained —by contrast—subtle instruction about how to read his own explosive but elusive works. The heart of the poem, "If So the Man You Are," was an *apologia* that achieved poignant significance in the context of his personal troubles during this period of his life. The self-portrait exaggerated his own crudeness and provided ammunition for the Sitwells' fictional retaliations in the late thirties:

> I'm not too careful with a drop of Scotch,
> I'm not particular about a blotch.
> I'm not alert to spy out a blackhead,
> I'm not the man that minds a dirty bed.
> I'm not the man to ban a friend because
> He breasts the brine in lousy bathing-drawers.
> I'm not the guy to balk at a low smell,
> I'm not the man to insist on asphodel.
> This sounds like a He-fellow don't you think?
> It sounds like that. I belch, I bawl, I drink.[27]

Lewis then introduced his hostile shadow, the Enemy, "cloaked, masked, booted, and with gauntlets of astrakan," who speaks in more hostile and violent tones. He addresses himself to the question of why he could never command an acknowledgment of his genius and explains (anticipating the fate of Pound at Pisa) how his three fatal handicaps, as an intellectual, satirist and Right-winger, had inevitably led to his rejection as a writer:

> And still and all, we know the invisible prison
> Where men are jailed off—men of *dangerous* vision—
> In impalpable dark cages of neglect.

After the departure of the Enemy in a frenzy of indignation, Lewis emphasized his own independence, which he found increasingly rare in the world of literature and politics:

> He has been his own bagman, critic, cop, designer,
> Publisher, agent, char-man and shoe-shiner.

Grigson, writing in the *Morning Post*, praised Lewis' compact style and intellectual solidity: "Mr. Lewis has integrated his vigorous imagery and vigorous content, and he has controlled his couplets and fourteeners with a major dramatic artistry. He drives into a single line what a poet of normal ability would leave lying about in a dozen." And in his enthusiastic review of the poem in the *Spectator*, Spender emphasized the strength and unity of the five parts of the book and wrote that the central poem "is a very personal confession, in spite of its violent satire. The subject matter of all these poems is deeply serious.... Mr. Lewis remains inveterately the Enemy: and of enemies, he seems to me the one whom it is most possible to respect."[28]

The main biographical interest in Lewis' books of these years lies in the reasons for the withdrawal of *The Doom of Youth* and *Filibusters in Barbary*, both published in June 1932, which intensified Lewis' bitterness and neglect. Though Lewis assumed a God-like right to criticize and condemn, he liked to pretend that he was a peaceful and strictly defensive sort of chap who was dangerous only when attacked. He admitted that his enemies in their death agony were capable of delivering some nasty kicks, and also claimed: "I have made it my habit never to go to law, but to shoot back when shot at, and frighten them away, once in a while." In fact, the reverse was true. Lewis usually attacked first and his victims went to law to silence him.

The Doom of Youth parodied the title of Alec Waugh's best-selling exposé of public school life, *The Loom of Youth* (1917), and continued the attack in *The Art of Being Ruled* and *Time and Western Man* on the cult of youth and the Time-children: Stein, Anita Loos and Charlie Chaplin. Lewis' book, which reproduced in varied typography a great many contemporary newspaper headlines and stories to illustrate its thesis (and may have influenced McLuhan's *Counterblast*), was one of his shoddiest efforts. Iris Barry wrote a loyal puff in the *New York Herald Tribune*, but another critic more accurately called it "a handful of cuttings waved in the face of the public."

The offensive passages occurred in Part II, chapters 6 and 7, which discussed what Lewis called the *"Youngergenerationconsciousness"* in Godfrey Winn's asinine article "I Wish I Had a Sister" (*Modern*, March 1931), and Alec Waugh's schoolboy novel *Three Score and Ten* (1929). Winn objected to being bluntly called a "hack" and "salaried revolutionary agent." The heterosexual Waugh objected to the accusation that he was effeminate and attracted to young boys: *"motherhood* in its most opulent form was what Mr. Waugh had been destined for by nature, and a cruel fate had in some way interfered, and so unhappily he became a man. . . . [His character, Mr. Cardew] is as crazy about small boys as is Mr. Waugh himself." Chatto's lawyers, Walker & Martineau, agreed with Waugh's contention that these passages were libellous and held him up to ridicule.

In *The Doom of Youth*, even more than *The Apes of God*, the Enemy was guilty of indiscriminately firing his "Lewis gun" at trivial targets. But in a letter to Winn's lawyers, he denied libel and defended his right to criticize writers who wilfully exposed their own fatuity: "Your client appears to me grotesque in the light of such articles [in *Modern*]. If for whatever reason a person writes stuff of that order, it seems to me that he should be prepared, if he is noticed at all, to be noticed in the way I have noticed him. . . . [Winn] regarded it as his mission 'to stop' me from writing books of the type of *The Apes of God* and *The Doom of Youth*."[29] Such a letter was scarcely intended to mollify the plaintiffs.

Winn and Waugh both claimed that the libel threatened their personal and professional reputation, and demanded that Chatto withdraw the book; Waugh applied for an injunction against further sale. On August 16, 1932, Waugh's appeal was dismissed by a judge in Chambers who ruled that the book was not libellous. Waugh wrote that his lawyer, Harold Rubinstein, claimed "that Lewis had accused me of homosexual tendencies. But this he had not actually done and when the summons was heard in High Court [on October 28, 1932], the judge could not accept this contention."[30] Rubinstein then shifted his ground and successfully argued that Lewis had damaged Waugh's reputation as an author.

Lewis, whose counsel was Naomi's husband, Dick Mitchison, felt he had won the case on the issue of libel and that Chatto ought to contest the decision and fight for the life of his book. But Chatto, fearful of incurring damages as well as further legal expenses, agreed to withdraw the work from circulation after only 550 copies had been sold. The booksellers returned 140 copies, and in March 1933 Chatto pulped them and their remaining stock of 750 books. Waugh dropped the action in June 1933 and each party paid his own costs. Lewis' share was £45, nearly one-third of his original advance.

The quarrel about *The Doom of Youth*—Lewis' bitterest and most damaging dispute since the fight with Fry in 1913—brought to the surface his long-repressed antagonism toward Charles Prentice. He felt —and undoubtedly said—that Prentice had deserted and betrayed him, stated that he had been unwise to allow his books to fall into the hands of Bloomsbury's publisher, and suspected that his old adversaries manipulated Chatto to his own disadvantage and kept him "in servitude upon a pittance." After Chatto had (wisely) rejected *The Roaring Queen* for fear of libel, Lewis exclaimed: "And really, Prentice, was I to go on offering your firm forever *Roaring Queens* and *Apes of God*—only to have them turned down on the score that they would be offensive to your Bloomsbury friends, or to be offered advances that would not keep body and soul together." Lewis' animosity was intensified by the fact that he and Prentice had once been close friends and found it more than usually painful to quarrel with each other.

Chatto's small, businesslike advances—soundly based on Lewis' sales rather than on the quality and importance of his books—forced him to seek other publishers in defiance of his exclusive contract with them. He *had* to have a number of different publishers to get the numerous advances he needed to survive. Unlike Chatto, who refused to pay substantial sums for books that consistently failed to sell, a new and more competitive publisher would be willing to pay more to attract an author with considerable prestige.

Lewis' secret arrangements with other publishers inevitably led to

further hostility and acrimony. When the "kindly" Prentice discovered Lewis' *cache* of contracts in June 1932, while fighting the *Doom of Youth* lawsuits, he sent a furious letter to Lewis: "We are amazed to hear this morning that Grayson & Grayson are publishing immediately a book by you on Morocco, and to see the announcement that Desmond Harmsworth is publishing almost at once your 'Enemy of the Stars,' if indeed he has not already published it. I note, too, that Desmond Harmsworth is under agreement to publish several other books by you, and we are also told that you have a contract with a third publisher for a novel [Cassell's *Snooty*]. We not only think you have treated us very badly in holding up 'Doom of Youth' as you did, without a whisper of these other activities of yours, but we are also of the opinion that your action in making contracts with these publishers for these other books is in violation of an agreement you made with us."[31]

However much Lewis felt he was the injured party, Prentice's anger was justified and he was clearly in the right. Lewis had been extremely rash and provocative when attacking Winn and Waugh (though Prentice should have seen this when he read the typescript and the serialization in *Time and Tide* during June and July 1931); and Chatto, who had first option on all Lewis' books, could have obtained an injunction restraining other publishers from issuing his work.

Lewis' relations with Prentice broke down completely in September 1932, when *Snooty Baronet* was published by Cassell, and Prentice again complained about the relatively profitable novel going to a rival firm. He then asked either for the second and third volumes of *The Childermass*, which Lewis had contracted for in 1928 and was supposed to have written instead of *Filibusters in Barbary*, or the return of the £100 advance, which Lewis of course could not pay. Two months later, when Chatto pressed hard for the return of the advance and sued Lewis for breach of contract, his lawyer H. D. Barnes reported: "Chatto & Windus appear to be peculiarly unfriendly towards you and the vindictive feelings shown by Mr. Prentice appear to have been carried to an extreme. I must say that in my only interview with him, I found Mr. Prentice implacable so far as your matters are concerned."[32] There must have been a furious row, with bitter words on both sides, to make Prentice feel such intense hostility toward Lewis.

Prentice failed to back Lewis during the *Doom of Youth* suit partly because he felt the book was indeed libellous and was irritated at Lewis' delay in completing *The Childermass*. But the main reason for his unusually vindictive feelings was that he felt Lewis had been disloyal to him with other publishers. Lewis was angry and embittered by Prentice's compliance with Waugh's demands; and did not publish any more books with the firm that had brought out all his works (except for *The Lion and the Fox* and the privately printed *Apes of God*) between 1919

and 1932. Lewis' break with Chatto led him to drift through a long series of publishers—many of them obscure and inefficient—who did not look after his interests (he never had an agent for English rights) and did not publish his books successfully. He failed to find another permanent publisher until Methuen took him on in 1951 and brought out his last seven works.

The suppression of *Filibusters in Barbary* was a repetition of *The Doom of Youth*. When Lewis was visiting Agadir, he was advised to get local information from Major T. C. MacFie, a retired British officer who lived outside the town in a white Arab house. MacFie had once been a journalist, had heard of Lewis and knew his books; Lewis clearly despised the man and loathed his pretentious swagger. He caustically described the strange plump Cockney-Scot as "a queer middle-aged middle-class Bulldog Drummond of an ex-Temporary Major . . . a pink, fetch-and-carry order of faithful dog-Toby of a man." This was insulting, perhaps, not libellous. But Lewis went on to make more serious accusations against the nameless but easily identified major. Lewis stated that the British consular authorities "have a great deal of trouble with other sorts of Bulldogs, who take advantage of capitulations to defy the French police—engaging in every lawless activity under their noses on the ground that they are Britons," and that MacFie had "threatened, if the French authorities laid so much as a finger upon *his* land . . . that he would put machine-guns on it."[33]

When a copy of *Filibusters in Barbary* finally reached MacFie in Agadir a year and a half after publication, his lawyers complained to the publishers that the book contained false and malicious matter about their client. During the court proceedings of February 1934, MacFie contended that the work "accuses him of defying the French Authorities and of activities such as engaging in contraband traffic and smuggling arms." Lewis refused to apologize, but Grayson & Grayson immediately capitulated, expressed regret, withdrew the book from circulation, and agreed to pay MacFie £305 in damages and costs. They later deducted this money from the royalties of *The Apes of God*, and limited Lewis' earnings on that book to £325. This penalty was particularly galling because he had taken seven years to write *The Apes of God*, privately published and advertized that expensive book, and was mainly responsible for the commercial success of the trade edition that had three impressions and did not go out of print until 1938. *Filibusters in Barbary* was, of course, his last book with Grayson & Grayson.

On January 24, 1934, fifteen months after the publication of *Snooty Baronet*, while Major MacFie was proceeding against Grayson & Grayson, and there was intense hostility between Lewis and his publisher, Rupert Grayson's solicitors wrote to Lewis demanding an apology and payment of adequate (but unspecified) compensation for his

libellous portrait in that novel. Though this matter (like the libel threats against *The Apes of God*) was eventually dropped without cost to Lewis, Grayson remained bitter. His memoirs, which drew attention to the satiric characterization, contained a hostile description of Lewis, with calculating eyes and biting tongue, "the great brim of his black hat pulled well down, browless, unidentifiable, dangerous. . . . He employed his usual weapon, a pen sharpened to dagger point with which he etched my likeness in *Snooty Baronet*, cutting lines jagged and deeper than scars and poisoned with acidic brilliance."[34]

Lewis' serious if reckless attacks on the trivial works of Winn and Waugh, who successfully popularized contemporary ideas, expressed profound resentment toward a public that ignored his own serious works. But his splenetic assaults on MacFie and Grayson merely vented his personal animosity, and were both unjustified and unwise. The suppression of *The Doom of Youth* and *Filibusters in Barbary*—though largely due to Lewis' self-destructive character—wasted an enormous amount of time and effort, caused considerable strain and anxiety, terminated all sales, cost legal fees and damages, hurt his reputation, and made future negotiations with publishers much more difficult.[35] Lewis reached the nadir of his fortunes in October–November 1932 when the High Court judgment in the *Doom of Youth* case went against him and Chatto decided to withdraw the book, when Chatto sued him for breach of contract for *The Childermass*, when Lady Glenapp demanded the money owed her, and when the British government pursued him for unpaid taxes. It is not surprising that Lewis' health broke down at this time, and in December 1932, after giving a lecture at Oxford, he entered a nursing home with an illness that would last for the next five years.

Lonely Old Volcano, 1934–1937

many a good man has unlived,
In conjunction with nephritis.
One-Way Song

I

Lewis had been in good health (apart from a bout of gastric flu in December 1930) since his recovery from influenza and pneumonia just after the War. But illness and four operations dominated his life from the end of 1932 until the end of 1937. Naomi Mitchison and Desmond Flower noticed that he did not look very well, but he was prevented by pride and a sense of privacy from talking about illness to friends (as opposed to patrons who helped him pay medical bills). This protracted period of sickness and hospitals put an end to his many love affairs.

The original cause of Lewis' disease was the gonorrhea, which he had treated himself during 1914–1915, when living next door to the Tour Eiffel Restaurant and completing *Tarr*. He contracted gonorrhea again in the early thirties, boasted to Porteus (as he had done to Aldington in 1913) about having venereal disease and sent a postcard to Desmond Flower stating: "Regret cannot keep dinner engagement. Severe dose of clap." Lewis entered the Porchester Square Nursing Home in Paddington in December 1932 and remained there for three months. On February 12, 1933, he told Violet Schiff that he had to submit to an electrical treatment (probably diathermic cauterization of inflamed tissue), and gave a rather confusing explanation of the etiology of his disease to his New York agent: "I am sorry to say that for 2 months off & on I have [been] ill—I write this from a nursing home. I have had what is called cystitis—inflammation of the bladder. A bug walked from my intestine into my bladder, it seems, & then planted an ulcer in an old venereal scar. Other complications ensued. I left the first nursing home too soon, got flu—and so on." His cystitis, or inflammation of the urinary bladder, was caused by the infection of an old gonorrheal scar in his urinary tube and complicated by the spread of bacteria from his

intestine to his bladder. Lewis left the second nursing home in February 1933, but was unable to work again until May.

Just as his first illness followed immediately after the lawsuits by Alec Waugh, Chatto & Windus and Lady Glenapp, so his second illness—a year later in February 1934—followed the intense pressure that built up during the threats of Rupert Grayson and the libel suit of Major MacFie. On February 25 Lewis had sudden, severe and repeated internal bleeding (probably from the inflamed lining of his bladder), was taken to the York Place Nursing Home at 98 Baker Street at one o'clock in the morning, and had to be operated on to prevent the formation of blood clots. On February 27 he told Nicholas Waterhouse: "Here I am once more in a nursing home—it is an emergency, as on Sunday I began having a bad bleeding. Now tonight the surgeon (Mr. Millin) thinks that it *may* be necessary to slit a little hole in my bladder to pull out a dried clot of blood."[1] Lewis had, in fact, a familiar medical syndrome: gonorrhea, cystitis, hemorrhaging and clot retention.

Lewis' first and most serious operation took place in early March, but was not successful. He felt he had been badly cared for after leaving the nursing home and suffered terribly because of the lack of proper treatment at the crucial time. Froanna recalled that an infected needle was used, which led to septicaemia and left Lewis permanently affected by bouts of delirium and attacks of alternating chills and fever, rather like malaria. They began in December 1940 and lasted for several days at a time. During one attack he referred to his old mistress Ida, and screamed: "Get that German woman away from me!" The accident with the needle led to two additional operations, wasted a year of his working life, left him deeply in debt, and forced him to endure even more anxiety and pain.

In July 1934, when he had recuperated from his first surgery, Lewis explained to Nicholas Waterhouse: "I am not merely recovering from a couple of bad operations, but was ill for a year and a half off and on before that, with long spells in bed and much mental anguish."[2] Richard Aldington, Sydney Schiff and Lady Cholmondeley gave Lewis the money to pay for most of his medical expenses—in the days before the National Health Service—and Waterhouse paid for the nursing home and provided a small monthly allowance from late 1933 until July 1934, when Lewis returned to the French Pyrenees for a restful holiday.

Lewis' illness recurred for the third time two years later, in July 1936, when the same surgeon, Terence Millin, a well-known specialist in bladder operations, wrote to him about the medical procedures he would have to endure: "I wish to have the X-ray examination done under the anaesthetic. I would suggest your coming into All Saints' Hospital (Austral Street, West Square, Southwark) on Tuesday morning [July 7], and I should do the necessary dilatation of the stricture and enlarging of

the opening of the diverticulum that afternoon, combining this with the X-ray. It should only be a question of two or three days in the Hospital." The X-ray had to be under anaesthetic because the introduction of dye under pressure, to visualize the urinary bladder, would be extremely painful. The dilatation of the stricture, which was quite common in the era before penicillin, widened the urethra and stretched the gonorrheal scar in order to allow normal urination. Enlarging the diverticulum—a stagnant sac opening from the bladder, containing urine and prone to infection—would permit the urine to drain normally to the bladder. Though this procedure was technically classified as a minor operation, it was an extensive one.

Hugh Porteus visited Lewis several times in the nursing home and found him "mugging up" on his illness amidst piles of medical books with ghastly-colored illustrations. Lewis mistrusted the doctors, planned to have a local anaesthetic so he could watch the operation and warned: "I won't let the surgeons get away with anything." On another occasion Porteus discovered that Lewis had left the nursing home without permission. When Lewis returned, chirpy and apologetic, they ate caviar on top of raspberry jam, with toast and China tea. (When Lady Cholmondeley brought Lewis a luxurious kind of chicken mousse, he claimed it was made of inner organs and refused to touch it.) Lewis had a third operation in September 1936, and the following month complained to Roy Campbell about the frailty of human flesh: "My machinery still requires some adjustments—would that it derived not from protoplasm but some straightforward *metal*. But my health is pretty good."[3]

One year later, in September 1937, when he was painting Froanna for the Leicester Galleries exhibition, he had another illness: "I was sitting upon an abscess 'the size of a duck's egg' (words of surgeon) which, I was advised by the surgeon, would probably kill me if it burst. It did not burst, but was eventually dealt with by a 'pus operation.' " This procedure was most likely an incision and drainage of a peri-urethral abscess from an infection inside the urethra. It could have killed him because prior to the discovery of antibiotics any serious infection could enter the bloodstream and cause fatal septicaemia. Lewis was so pressed for money that he had this operation in the macabre general ward of a hospital, which he described in *Rude Assignment*: "Some patients would die every twenty-four hours or so where I was: I still can hear the soft thudding rush of the night-nurses, when certain signs apprised them of the approaching end. For some reason it was preferred that death should occur in another ward, reserved for that purpose. The patient would be hurriedly wheeled out to die. Though I saw death often enough as a soldier, that was the only occasion on which I heard the authentic death-rattle."

After this fourth and final operation the surgeon informed Froanna it was remarkable that Lewis had survived these medical ordeals and that he "must have been a very strong man." But the fear of the "blood sacrifice"—of swooning under anaesthesia, having his body cut open and painfully recovering—took a great deal out of Lewis. His physical appearance noticeably deteriorated during this time, when he lost the striking good looks of his early life (possibly from nephritis or pituitary changes) and was transformed into the balding, heavy, puffy, waxen, sallow-skinned, owlish figure of his later years. Lewis' illness of the mid-thirties was the second stage of the disease that had originated in his prewar gonorrhea and concluded in the kidney disease that was the direct cause of his death.

The self-righteous attitude of the healthy doctors toward a "living cadaver" left Lewis with an intense dislike of the medical profession that surpassed all his other aversions and taught him what it really meant to have an Enemy. His hostility was expressed in his stories "The Room without a Telephone" in *Rotting Hill* (1951) and "The Rebellious Patient" (1953), and in Vincent Penhale's violent outburst in *The Vulgar Streak* (1941): "Doesn't it make you *angry* to know there is a place in your district where a staff of trained nurses and doctors are paid by the state to brutalize and kill aged people?"[4]

But Lewis' illness also had one positive effect, and his recovery marked a turning point in his career. In 1937 he abandoned his cold, objective, automaton novels, turned toward naturalism in fiction and realism in art, and began to express more feeling in his first humanistic novel, *The Revenge for Love*, and more tenderness in his moving portraits of Froanna, Eliot and Pound. His new and more sympathetic mode of art was foreshadowed in *The Convalescent* (1933), a gentle painting, done in warm apricot tones, of a visitor giving comfort to an invalid in a shaded sickroom.

2

Despite his sickness, which prevented him from bringing out a book in 1935, Lewis published three of his best works—*Men Without Art, The Revenge for Love* and *Blasting and Bombardiering*—in the mid-thirties, perhaps because he had recovered his intellectual stamina after the exhausting efforts of the late twenties and was again ready to undertake something more ambitious than satire and polemics. Lewis also had a third book, *The Roaring Queen*, suppressed; published his two worst political tracts—*Left Wings Over Europe* and *Count Your Dead: They Are Alive!*—and in January 1937, between the appearance of these books, contributed an essay to Mosley's *British Union Quarterly*. In 1937 he

moved into the flat in Notting Hill Gate where he remained for the rest of his years in England; and became friendly with Julian Symons, who in November brought out a special issue of *Twentieth Century Verse* devoted to Lewis.

Lewis feared the modern age might become the first period in history of "Men Without Art" and wrote his most original and incisive critical work to defend art, especially satire, as he had originally done in *Blast*. This book, published in March 1934, contained (as we have seen) the perceptive essays on Hemingway and Woolf, and his theory of satire and "Taxi-Driver Test for Fiction" which had first appeared in *Satire and Fiction*. The wittiest chapter concerned the intellectual and stylistic limitations of Faulkner's *Sanctuary*; its subtitle, "The Moralist with a Corncob," suggested the perverse propensities of Popeye. Though Lewis satirized Faulkner's melodrama, he was one of the first critics to recognize his importance and treat him seriously. Lewis' chapter appeared eleven years before the appreciative essay of Malcolm Cowley, which led to Faulkner's first serious recognition in America.

Lewis completed *The Roaring Queen* soon after *The Apes of God* (to which it is closely related) and originally offered it to Chatto. They feared a libel action and refused it in June 1930, when Arnold Bennett, the main satiric victim, was still alive. Although Prentice proclaimed it "one of the best things of its kind I have ever read," he considered it "too risky for Chatto's to do. Too many heads are cracked, & the result would be that the wounded would take it out on us, which means not just the partners in Chatto's, but their authors also." The novel was also refused by Desmond Harmsworth because Lewis wanted an advance of £200, before being accepted by Cape early in 1935—four years after Bennett's death. Cape printed proof copies of the book; but they were naturally cautious, after the two libel suits and withdrawals of 1932, and asked for legal advice before binding. When their lawyer pronounced the novel dangerously libellous, Cape refused to proceed with publication; and the book did not appear until 1973.

In *Satire and Fiction* Lewis first announced the theme of the novel: "the immense decay in all our serious critical standards in literature."[5] Bennett, a middle-brow novelist and influential reviewer, seemed to personify this decay. For he was also a complacent and philistine *parvenu*, with a jaunty crest of hair, who had bought a showy yacht with his substantial royalties, and was satirized as Mr. Nixon in Pound's "Hugh Selwyn Mauberley" (1920). Lewis had met Bennett at Osbert Sitwell's dinner-party in January 1920, when Lewis was teased about his painting by Sickert, but claimed Bennett was jealous of Sickert's praise of *Tarr*. Lewis was particularly infuriated by Bennett's review of *Enemy 1* in the *Evening Standard* of April 28, 1927, in which Bennett condescendingly lectured Lewis on technique, adopted the obtuse

attitude of the common reader, and made a few platitudinous hits at Lewis' slapdash methods, flawed books, failure to realize his potential and "paranoia." His final innuendo that Lewis was not "gentlemanly" was an irritating reminder of Clive Bell's admonitions during the dispute with Roger Fry: "As a writer Mr. Wyndham Lewis has considerable gifts, with a slightly amateurish technique. But he is always going and never arriving. The fact seems to be that he lacks the ability to marshal and fully utilise the distinguished faculties which are undoubtedly his. . . . I would like to be able to state what Mr. Wyndham Lewis is mainly 'after,' but I cannot, because I have not been able to find out. One of his minor purposes is to disembowel his enemies, who are numerous. He would be less tiresome if he were more urbane."

Lewis believed Bennett was actively preventing him from getting reviews and selling books. He first counterattacked in "A Tip from the Augean Stable" (*Time and Tide*, March 1932), a two-part article on literary gangs and reviewers' vendettas, which was the basis of a book that was announced by Harmsworth but never published. Lewis replied to a reader's defense of Bennett with the charge that Bennett loved power and had (like Fry) established "a sort of critical dictatorship for the Anglo-Saxon world. . . . He betrayed every standard (intellectual or other) of those splendid [Russian] masters of the mind, in order to boost what was often the completest literary refuse." In *Rude Assignment* he claimed Bennett was primarily responsible for the decline in critical standards: "The era of the puff and blurb in place of criticism . . . started with Mr. Arnold Bennett, when he turned reviewer and star-salesman for the publishers, and was the godfather of as fine a brood of third-rate 'masterpieces' as you could hope to find anywhere."[6] Lewis was justly annoyed that literary hacks who were puffed by Bennett enjoyed great sales and success, while he remained neglected and permanently poor.

The Roaring Queen is a labored satire, in the country house tradition of Huxley and Waugh, which concerns the competition of abysmal authors for the favor of the judges of a literary prize. The main interest of the novel, apart from its suppression, is the elucidation of the *roman à clef*. Lewis, who had criticized Woolf's essay on Bennett in *Men Without Art*, ironically linked Rhoda Hyman (Woolf) with her old literary adversary Samuel Shodbutt (Bennett) and made them both stew in the same literary corruption. The other leading contender for Shodbutt's favor is the eponymous roaring queen, Donald Butterboy, who is based on Brian Howard, the model for Evelyn Waugh's Ambrose Silk in *Put Out More Flags* and Anthony Blanche in *Brideshead Revisited*. Howard epitomized both fashionable homosexuals and what Orwell called "pansy-Left" poets. The cast of characters was rounded out with other actual models. Stella Salt is Rebecca West, Baby

Bucktrout is Nancy Cunard, Geoffrey Bell is the dull fiction critic, Gerald Gould, and Nancy Cozens is the child prodigy and bestselling author of *The Young Visiters*, Daisy Ashford. Jacques Jolat, who "confined himself to employing his pen as a puffing machine, for daily hire," is Eugene Jolas, who had attacked Lewis in *transition*; Mrs. Wellesley-Crook, the pretentious American literary hostess who is supported "with the Chicagoan wealth of the Crooks," is probably based on his former mistress Mary Borden. The painter Richard Dritter is modelled on Walter Richard Sickert, speaks with his "great roguish Ninetyish voice, and with a high-hearted Ninetyish cackle," and laughs "uproariously in his own enormous coarse grey beard as-if-it-had-been-false . . . with weighty German heartiness, which would have pulverized anyone."[7]

The poor response to *The Revenge for Love*, which was inspired by the political events that led to the Spanish Civil War, was determined by its badly-timed publication and its violent attack on Communism. Lewis began to write the book in 1934 and completed it in the autumn of 1935, but because of Cassell's recurrent demand for alterations to prevent libel and to please the Boots reader, it was not published until May 1937. By that time the War had been fought for ten months, the Republicans (supported by the Communists) seemed to be losing the struggle, and the sympathy of the English intellectuals was overwhelmingly for the Left-wing Popular Front.

Nancy Cunard's questionnaire, *Authors Take Sides on the Spanish Civil War* (1937), revealed that virtually the only authors who supported the Right during the Spanish War were Yeats, Pound, Eliot, Waugh and Campbell. The latter had been in Toledo during the siege of the Alcazar and was a fiery Fascist supporter. He felt that England was "kept in ignorance of the true position" of Spanish politics and reinforced Lewis' hatred of the Communists. When Campbell, the model for Victor Stamp, returned to England in August 1936, Lewis planned to paint him and his family on a huge canvas, with a rendering of El Greco's Toledo in the background. Two months later, after Campbell had compared Lewis to Moscardó, the defender of the Alcazar, Lewis proudly replied: "I gloried in the title of *Moscardó*. You may rely on me to behave on all occasions in a manner no way inferior to that of the 'Eagle of Castille.' " He concluded his letters with: "Long Live the New Spain!" When Lewis and Froanna met Campbell, Lewis expressed greater admiration for Campbell than for anyone else he had ever known: "My wife was stupefied with admiration, at your fine appearance. To meet you was a great event for her. She shares my cult for you."[8]

Lewis' satirical exposure of the Communist agitator, Percy Hardcaster, "a tough ordinary little party-man, dialectically primed to do his stuff," was a vivid contrast to the exaltation of Republican heroism—

when Spain was the symbol of hope for all anti-Fascists—in Malraux's
L'Espoir (1937) and Hemingway's *For Whom the Bell Tolls* (1940). But
it had some fascinating similarities with Orwell's unwelcome revelation
in *Homage to Catalonia* (1938) that the Communists were opposing the
revolution and destroying their Socialist allies. "Lewis shows a remark-
ably clear grasp of the consequences of the Communist ideology," wrote
Steven Marcus, "its appeal, the personal motives that press for its
embrace, the pretentious stupidity, neurotic extravagances, and the
ideological viciousness it fosters." It is ironic that *The Revenge for Love*
and *Homage to Catalonia*, both unpopular and neglected when they
were written in the thirties (*Homage* sold only a few hundred copies in
Orwell's lifetime), were first published in America in 1952, at the height
of the Korean War and the McCarthy witch-hunt, when their anti-
Communism was particularly persuasive.[9]

The political context and political ideology led critics to ignore the
other, more interesting aspect of the novel: the emotional relationship of
Margot and Victor Stamp, who are victimized and sacrificed by the
Communists, and die in the Pyrenees (where Lewis had gone to re-
cuperate in July 1934) while attempting to escape from their gun-
running expedition to Spain. The character of Margot, who (we have
seen) was based on Froanna, is a tribute to her devotion to Lewis
during his illness. She is the first sympathetic woman in his fiction, and
is portrayed with extraordinary insight and compassion. Lewis explained
the paradox of his brilliant title by revealing Margot's fearful respon-
sibility for the love that both threatens and sustains her husband: "If
she could have hidden her love away from fate, then fate would have
turned elsewhere, have been kinder to Victor! She was the cause of all
the ill-luck that came his way. It was because *she* was there that no
pleasant thing ever happened. It was *the revenge for love*! . . . Once to
have been loved as she did Victor was enough—it was compromising
to the *n*th degree. He was a marked man!" Margot confirms Tarr's
observation that "People can wound by loving."

Lewis' frustration and failure to achieve success as an artist were
expressed in Victor's struggle to paint, realization that his work had no
economic value and desperate submission to forgery (saleable art).
Victor also considered the theme of love and betrayal, and related them
to the human factor—so rare in Lewis' novels—and to the social
commitment that transcends revolutionary agitation: "Not to let down
another creature, who had brought her life over and cast in her lot with
yours, what sort of a fool's dream was that? . . . A rugged unrevolu-
tionary principle, founded upon sentiment, not intellect. But Victor
Stamp was prone to accept it, because of the simple life that was his
natal background. It was the pact of nature; but with the human factor
it became more. Was it not the poetry of the social compact too?"[10]

The Revenge for Love, for which Lewis received a respectable advance of £400, had only four reviews, two of them by friends—R. A. Scott-James in his *London Mercury* and Hugh Porteus in Eliot's *Criterion*—and sold less than 3,000 copies. In the summer of 1938, when a young painter with Bloomsbury connections visited Lewis, he was greeted with deep suspicion and not admitted to his flat. Though Lewis had been thoroughly stigmatized by his Right-wing politics, the painter was surprised to find him a decent and generous man, more concerned with old literary feuds than with the current war in Spain: "He was one of those men who wanted to walk by himself. He rather faded out in the twenties, and in the thirties I was sent by Naomi Mitchison to collect a picture from him to be auctioned in aid of Republican Spain. I was surprised, because I thought he was a Fascist, but he gave me the picture with a few grumbles about 'Bloomsbury.' "[11]

3

Left Wings Over Europe (June 1936) and *Count Your Dead: They Are Alive!* (April 1937) were written as "peace-pamphlets" between intervals of illness and were read during the violent political events that led up to World War Two: the Abyssinian War (1935–1936), the remilitarization of the Rhineland (March 1936), the Spanish Civil War (1936–1939), the annexation of Austria (March 1938), the Munich pact and occupation of the Sudetenland (September 1938), and the annexation of Bohemia and Moravia (March 1939). The most notable aspect of Lewis' works was his consistent misunderstanding of these political events, which became more embarrassing and appeared more ludicrous as Hitler's power spread over Europe. The main theme of *Left Wings Over Europe*, foreshadowed in *The Art of Being Ruled* and *Hitler*—though Hitler had now been in power for three years—was that England should side with the Fascists in the decisive struggle between Communism and Fascism. Lewis' long, red-covered book was antidemocratic, anti-Communist and anti-Semitic; pro-Mussolini, pro-Hitler and pro-German.

Lewis argued, as in *The Art of Being Ruled*, that democracy was merely mass tyranny: "The Sovereign People can be just as oppressive and tyrannical as a sovereign ruling over the people—indeed the individual may be far less free when at the mercy of *everybody*. . . . Freedom *is not freedom*, anything but, as popularly understood by the average sensual man of a modern democracy." Lewis, who was anti-Communist without being anti-totalitarian, clearly saw that Russia—but not Germany—was "ruled by a permanent terrorist élite." He claimed that Russia was controlled by the Jews and since "the Jews are the reverse

of a military race (militant, but not military) . . . it would be unwise,
probably, for the Western Powers to place too much dependence upon
the purely military effectiveness of Soviet Russia."[12] Like Hitler, Lewis
seriously underestimated the power of the Red Army, and published
his tract just as Stalin began his Great Purge trials and murdered the
Jewish members of the Politburo whom he accused of following Trotsky.

Lewis defended Mussolini's imperialistic invasion of Abyssinia as an
armed insurrection against the unjust Peace of Versailles, though Italy
was on the Allied side in the Great War and had gained part of the
Austrian Empire at the Peace Conference. He called it a war of libera-
tion, "an act of national self-assertion rather than an irresponsible
predatory raid." Lewis defended Germany's right to rearm as a des-
perate gesture of self-defense against the invincible military power of
the Allies and the wealth of all the banks of Europe. He told Hugh
Porteus (one of his very few Right-wing friends): "Of course England
will bomb Germany to pieces. We want war, they don't"; and asked in
his book: "*Why* should the Germans wish to bomb Great Britain? . . .
There is no issue between the Germans and English to-day to prevent
any but the most cordial relations existing between the two countries.
It is only folly, or malice, to think otherwise."

Lewis also maintained that real democracy existed only in Fascist
countries, and once again provided a naive appraisal of Hitler that bore
almost no relation to reality: "This celibate inhabitant of a modest
Alpine chalet—vegetarian, non-smoking and non-drinking, has re-
mained the most unassuming of men . . . who has sacrificed himself,
literally, to a principle; that of national freedom. . . . This man does not
conform to the popular conception of a 'tyrant,' at least. He is more
like one of *the oppressed*!" Lewis concluded with an affirmation of
German friendship and an astonishing prediction that seemed ironic but
was absolutely serious: "I am prepared to prophecy that when all the
rest of the world has turned its back upon [England] . . . the faithful
Adolf will still be there—offering her his strong right arm (if she will
not accept his heart and hand) for her defence against her enemies."[13]

The superfluous *Count Your Dead*, Lewis' worst book, carried on the
argument of *Left Wings Over Europe*. It was another "violent reaction
against Left-wing incitement to War," continued his attacks on Com-
munists, democracy and Jews, and reaffirmed his support of Fascism,
Franco and Hitler. The book featured another moronic *persona*,
Launcelot Nidwit, a political Satterthwaite or Dan Boleyn, who is one
of Lewis' unhappiest creations. The tract was redeemed only by a
brilliant drawing on the dust-jacket (his best since *Paleface*) which
portrayed with Vorticist energy the fierce teeth and swirling capes of an
intertwined Communist and Nazi, fighting each other to the death with
daggers.

Lewis believed England's antagonistic "Hitler-complex" could be explained by Fascism's hostility to the incubus of "loan-capital" (i.e. Jewish financiers) which was "crushing us all down into the gutter." He mocked politicians who expected Hitler "to rush out of Germany, while all decent people were eating their Christmas puddings, and seize Spain, Danzig, Czechoslovakia, and the Ukraine"; and must have felt stupid and humiliated when Hitler helped Franco win Spain and actually did seize Danzig, Czechoslovakia and the Ukraine. He again concluded with an ironic justification of Hitler that revealed the connection between his crude ideas and debased style: "Look what [Hitler's] done. (1) He's muzzled the Press. Monstrous! (2) He sentences Bolshies to death. Barbarous! (3) He prevents Jews from making money. Cruel, I call it! (4) He's apt to seize Danzig, an awfully pretty city on the Baltic. Abominable!" As late as 1937 Lewis submitted a proposal for a (mercifully unwritten) book, *Among the Dictators*, which was "designed to *vulgarise* 'dictatorship' (as the major phenomenon of our time) for the Plain Man. . . . Essentially, it must be an attempt at creating *tolerance* as well as understanding, in Great Britain, for various manifestations in Europe of authoritarian doctrine."[14]

Lewis' anti-Semitism, which was consistent with Eliot's but not so virulent as Pound's, first appeared in *The Apes of God* (especially in the sections on Archie Margolin, Jamesjulius Ratner, and Lionel and Isabel Kein) and in *Hitler*, where he justified racial hatred in America by blaming the Jews: "The anti-Semitism that does exist is sustained solely by the extremely bad manners and barbaric aggressiveness of the eastern slum-Jew immigrant." Lewis thought rich Jews were capitalist exploiters, poor Jews Communist agitators, and found them both a convenient scapegoat. His anti-Semitism continued well after Hitler came to power and implemented the first anti-Semitic legislation in April 1933 and the much harsher Nuremberg Laws, which dispossessed the Jews, in September 1935. In *Count Your Dead* Lewis mistakenly attributed Adler's concept to Freud and stated: "I have often felt compassion for the Jew. (This was before he became so important and began taking his own part so effectively everywhere.) I have thought how bitterly unpleasant it must be to be regarded by everybody as inferior. No wonder it was a Jew, Freud, who coined the phrase 'inferiority complex.' "[15] Lewis' anti-Semitism seemed to be more ideological than personal, for he had many Jewish patrons and friends— William Rothenstein, David Bomberg, R. H. Wilenski, Sydney and Violet Schiff, Raymond Drey, Lady Waterhouse (née Lewin), A. J. A. Symons and Rebecca Citkowitz—and never quarrelled with any of them about their religion and culture. Lady Cholmondeley, for example, was unaware of his Hitler book and did not think he was anti-Semitic.

4

In the middle of 1937, before undergoing his fourth operation and publishing his memoirs, Lewis moved from 121 Gloucester Terrace, Paddington, where he had been for more than a year, to what finally became his permanent address in London: Flat A, 29 Kensington Gardens Studios, Notting Hill Gate, W11, where the rent was £145 a year. Since his return from the War his numerous flats had been mainly in Paddington and Bayswater, and he now confided to Grigson: "I have never found it safe to live more than two or three hundred yards away from Notting Hill Gate."

Though Lewis' most characteristic residence was demolished by a redevelopment scheme in 1957, it can be described with some precision. The long, narrow white-tiled corridor to the flat, on the south side of Notting Hill Gate near the corner of Palace Gardens Terrace, resembled the entrance to a public lavatory. John Rothenstein has described how Lewis' mode of life was like a defensive military operation: "His dwellings were sequestered and fortress-like: at Adam and Eve Mews, off Kensington High Street, where he lived when I first knew him, his rear was protected by a high wall; his room in Percy Street was difficult to find, camouflaged as it were, while 29A Kensington Gardens Studios, where he mostly lived during his last years, was approached by a narrow many-cornered corridor leading eventually to an inner fastness, which might have been constructed with a professional eye to concealment and defence. To the sequestered and fortress-like character of the places where he lived was added an extraordinary secretiveness, as an elaborate security measure."[16] The flat was above a shop, in a large tenement block that had been constructed by the council early in the century, and was reached by a draughty outside staircase at the rear of the building. Children played hop-scotch on the landings and washing hung outside the doors. Lewis had a living-room (decorated with his paintings and with drawings of Froanna), bedroom and kitchen on the second floor, and a studio just above it on the third floor.

Just after moving into the new flat Lewis began to see a good deal of Julian Symons, the younger brother of A. J. A., whom he had first met in 1932 during a sherry party at the First Edition Club. Symons was planning the Lewis issue of *Twentieth Century Verse*, and they would meet every fortnight for lunch or tea to discuss this project. Symons has described his first, somewhat apprehensive approach to Lewis' studio, which was rumored to have a spy hole so that he could observe his visitors and his wife: "I rang the bell and there was Lewis, hatted and piped as before. He gave me a hand, soft, white and large. 'My,' he said, 'you've grown.' I had a sense of confusion. Was he really thinking of somebody else altogether? There was a door straight ahead, but we

did not go through it. We turned sharp left instead, up three or four stairs into a large, dusty studio. There were many paintings around, a lot of books gathering dust: no sign of a peep-hole. Lewis, to my surprise, went over to a corner of the room and thumped upon the floor with a stick. After a few seconds there came an answering thump from below. He went down to the studio door, there was a muttered colloquy, and he returned with tea and bread and butter." Lewis then cooked four hard-boiled eggs and served them with a bottle of whiskey.

Lewis was always helpful and generous to Symons, and in personal (as opposed to literary) relations was a pacific and even a gentle man. Symons noted that he spoke with an aura of Johnsonian authority, was always eager for literary gossip, and was often unfair but not malicious. He had a strong conviction that his talents were not appreciated, always wanted to recover the disciples he had had in the Vorticist days, and was somewhat jealous of his successful rivals, Joyce and Eliot. "His slight paranoia," wrote Symons, "was the result of an attractive innocence blended with a certain natural arrogance of one who knows that he has special gifts." It was at once an illusion of persecution and a protective device which Lewis exaggerated for comic effect, as in the anecdote he told Symons about meeting a parasitic art critic whom he considered an Enemy: "I put out my hand and something got hold of it, something slimy, and I looked down and, Symons, it was a marine growth, a marine growth had got hold of my hand. No, no, I said, no, no, and I tried to pull my hand away but the growth had my hand, Symons, it had my hand and it wouldn't let go. I tell you I was really frightened, I had to pull hard to get my hand away from its suckers and I was very relieved to be able to manage it."[17]

In October, soon after Lewis began to see Symons, he published his autobiography, *Blasting and Bombardiering*. He was provoked into an angry dispute with his fatuous editor at Eyre & Spottiswoode, who insisted on being mentioned in the memoirs and compared Lewis' autobiography with his own; and condemned Douglas Jerrold as "an embittered 'author' turned publisher, who had invented for his own consolation the dogma that 'no good book can sell,' and had pursued his calling with so much languor that in effect his dogma could be guaranteed to justify itself."[18] Lewis' autobiography, which had a gentle tone, was a highly selective account of his life from the outbreak of the War to the General Strike of 1926. It mainly described his lionization as the leader of the Vorticists and editor of *Blast*, his experiences in the Royal Artillery during the War, and his friendships with John, Hulme, Guy Baker, the Sitwells, Campbell, T. E. Lawrence, Joyce, Pound and Eliot. These men were described with warmth and affection in the most genial and readable of Lewis' books, his first attempt to please rather than offend his audience.

At the end of 1937 Lewis had finally recovered from his long years of illness and published his last Right-wing political tract. He had brought out a novel that dealt with human emotions in a convincing way and revealed in his memoirs the more attractive side of his personality. The new studio flat seemed, at last, to be a suitable residence; and *Twentieth Century Verse,* which contained critical tributes from Eliot, A. J. A. Symons, Porteus and numerous other friends and admirers, strengthened his reputation. He painted some of his greatest works in the late thirties, and publicly recanted his sympathy for Fascism in two books of 1939. He was at the height of his powers and still hoped to attract the public recognition that had eluded him for so long. When his paintings were rejected and his recantation ignored, he turned in despair toward the illusory promise of the New World.

CHAPTER FOURTEEN

Rejection and Recantation, 1937–1939

I am never surprised at the unpleasantness of artists.
America, I Presume

I

Lewis had not held an exhibition of paintings since the *Tyros and Portraits* of 1921, and his decision to return to art, during a period of lawsuits, illness and economic austerity, involved considerable financial sacrifice. When he began to paint seriously again in 1932 he did not even have two pounds to buy an easel and executed his canvasses on a chair in the bedroom of his flat. He did not acquire a studio until he moved to Notting Hill Gate in 1937. He later explained that the show was arranged through the encouragement of his dealer: "The Leicester Galleries—and more especially Oliver Brown—were very helpful. For relatively small sums they would buy things as I did them—so enabling me to paint a number of pictures, & do a quantity of drawings: and all told they advanced me about a thousand pounds to help me get together a show. The show was not economically a success, of course, but it repaid the advance to the gallery." Lewis made an ironic allusion to the directors of the gallery in *Self Condemned* when the Hardings name their favorite pigeons Brown and Philips: "But Brown and Philips vanished, in spite of the great reliance these two birds had come to place on the Hardings' bounty."[1]

Because of Lewis' fourth operation in September 1937 he had to work desperately hard to complete the paintings in time for the opening in December, and *Inferno* was still wet when hung. But his financial expectations, after six years of work, were disastrously disappointed. Naomi Mitchison bought the only painting sold during the first week, and when the exhibition closed only four others had been purchased. *Red Scene*, acquired by the Tate Gallery, was the first of his works to enter a museum. Lewis' prices were modest (*Two Beach Babies* was £37, *The Tank in the Clinic* £52, *Inca and the Birds* £63 and *The Surrender of Barcelona* £120), but he did not prosper at a time when English taste

preferred the more palatable and popular art of Augustus John, Duncan Grant and Matthew Smith. After settling his debt to the gallery and paying their thirty-three per cent commission, Lewis earned £220 for his major exhibition of the 1930s.

Lewis had great variations in artistic style, which ranged from the total abstraction of his Vorticist works or the conventional representation of his academic portraits. He still worked outward from the skeleton and based his geometries on his interrogation of nature. He said the source of his inspiration was not an aesthetic but a real emotion—like the feeling he experienced while watching an accident. In his Introduction to the exhibition catalogue, he described the meaning and origin of two of the paintings: "In this composition [*Inferno*] (an inverted T, a vertical red panel, and a horizontal grey panel), a world of shapes locked in eternal conflict is superimposed upon a world of shapes, prone in the relaxations of an uneasy sensuality which is also eternal. On the other hand, the *Departure of a Princess from Chaos* is the outcome of a dream. I dreamed that a Princess [Marina, Duchess of Kent], whose particularly graceful person is often present in the pages of our newspapers, was moving through a misty scene, apparently about to depart from it, and with her were three figures, one of which was releasing a pigeon."

Lewis' finest paintings in this exhibition—and the one that followed at the Beaux Art Gallery in June–July 1938—were his five paintings of Froanna (1936–1938) and *The Surrender of Barcelona* (1936). Though Lewis' intelligence usually led to bitterness rather than sympathy, the portraits of his wife display his tenderness and love. In *La Suerte* ("Fate" or "Luck"), she has a high Spanish hair style, wears a shawl and seems to be divining her future from the pack of cards in front of her outstretched fingers. In *Pensive Woman*, the top half of her body is close to the foreground of the painting as she gazes downwards—rapt, tranquil and lost in contemplation. In *Froanna—Portrait of the Artist's Wife* her features are delineated with force and clarity, and she is robed and seated beside a tea service, poised and dignified. In *The Artist's Wife*, a poignant and lyrical tribute, she wears a kerchief and is seated before the curved ashtray that reappears in the portrait of Pound, and conveys through her clasped hands and dilated pupils a sense of anxiety and grief. And in the *Red Portrait*, the most formal and dramatic work, her bold gleaming brow provides a vivid contrast to the coal fire that is reflected in her high-necked embroidered tunic and glowing hair, and in the burning abstract landscape, heated by a fiery sun. Lewis' artistic study of his wife was a lifelong preoccupation which captured every mood and essence of her character, and revealed as much of himself as it did of Froanna.

Lewis wrote of his masterpiece, *The Surrender of Barcelona* (Tate

Gallery), which is related to *The Armada* of 1937: "I set out to paint a Fourteenth Century scene as I should do it could I be transported there."[2] In the immediate foreground are nine men, shown from the front and back and in profile, who are dressed in helmets and armor, bear flags and swords, and seal off the entrance to the fortified Catalonian city. The center of the painting shows a solitary limp victim, who opposed the surrender and embodies the tragic nature of the painting, hanging on a scaffold beside the bridge that leads into the town. To the right of the hanged man a horseman stands on a green field, bearing a bright yellow standard and followed by four men with lances. Behind the hanged man, Barcelona is dominated by two rectangular towers that flank a circular one which has been captured by the soldiers. One of them can be seen through the embrasure, ascending the stairs; the others look out from the roof and drape down symbolic victory banners. In the narrow passageways between the towers the troops of the army of occupation file into the deserted squares. In the right background stands a round Italianate tower with three levels of windows; and in the left background, behind a high clay-colored wall, the brilliant Spanish light on the harbor filled with sailboats suggests the lost tranquillity of the fallen city.

There are five receding planes in this extremely complex and profound painting: the line of armored men, the hanged man and horseman, the three towers, the Italianate tower and buildings of the deserted town, and the bright blue harbor. The military history of Spain is suggested by the armored men who conquered the Indians of the New World, and the horsemen and lancers who received the Surrender of Breda during the Spanish occupation of the Netherlands—the subject of one of Velázquez' greatest paintings. The theme of the picture is the fall of a peaceful open city, the submission to a brutal military occupation, and the effect of war, siege and surrender on a civilian metropolis. Barcelona was a Republican stronghold that fell to the Fascists in January 1939, doomed the cause of the Loyalist government and led to its final capitulation in March.

2

Lewis also painted major portraits of Eliot, Spender and Pound during 1938. It was highly ironic that his portrait of the eminently respectable Eliot became the center of a stormy public controversy, for the poet had changed a great deal since the "Waste Land" days of 1920, when Lewis had travelled with him to France. Eliot's association with Faber, beginning in 1925, rescued him from economic hardship and led to prosperity; his reception into the Church of England and acquisition of

British citizenship in 1927 provided new strength and security; and his separation from his wife in 1933 finally freed him from the tragic bondage of her mental illness. Eliot had firmly established his literary reputation, and was widely admired as the successor to Yeats and acclaimed as the leading poet of his generation.

Eliot's respectability, religion, success, wealth and fame impeded his friendship with Lewis—who had none of these acquisitions. Lewis emphasized the difference between Eliot and himself when he told Grigson that he once went to visit the poet and found Ottoline Morrell on her knees beseeching him: "Teach me how to pray!" Lewis may have felt residual resentment about his dispute with Eliot concerning the publication of his work in the *Criterion*, but both men remained fond of each other. Lewis spoke teasingly about Eliot, treated him with ironic affection and (mistakenly) thought he himself had a better understanding of the world. He believed he had a superior intellect and never quite understood why he could not make the same artistic impression that Eliot did.

Lewis, who strongly projected his character in his own works, and damaged his reputation with his vehement political tracts, criticized his friend's theory of impersonality (which enhanced Eliot's image) in a chapter of *Men Without Art*. He felt Eliot had made a virtue of becoming an incarnate echo and ought to express rather than repress his personality: "If there is to be an 'insincerity,' I prefer it should occur in the opposite sense—namely that 'the man, the personality' should exaggerate, a little artificially perhaps, his beliefs—rather than leave a meaningless shell behind him, and go to hide in a volatilized hypostasization of his personal feelings." When Eliot first saw a review copy of Lewis' book at Porteus' house, he said: "Oh, I'm very interested in this," borrowed the book and seemed to accept the validity of Lewis' criticism. Eliot found Lewis rather difficult, for he disliked quarrelling as much as Lewis enjoyed it. But he thought Lewis was the liveliest and most original of his contemporaries and always had the highest respect for his genius. Lewis was usually cautious and discreet about Eliot with mutual friends, quietly agreed when the poet was praised, and tempered his criticism with admiration when he wrote about Eliot.

There was a great deal of conversation and laughter when Lewis was working on Eliot's portraits, for his remarks amused and entertained the poet. Lewis expressed his favorable impression of the handsome Eliot both verbally and visually. He described Eliot as "A sleek, tall, attractive transatlantic apparition—with a sort of Gioconda smile . . . a Prufrock to whom the mermaids would decidedly have sung, one would have said, at the tops of their voices. . . . For this was a very attractive young Prufrock indeed, with an alert and dancing eye—*moqueur* to the marrow, bashfully ironic, blushfully *taquineur*. . . . Though not feminine—besides

being physically large his personality visibly moved within the male pale—there *were* dimples in the warm dark skin; undoubtedly he used his eyes a little like a Leonardo."[3]

Lewis actually did two portraits of Eliot in 1938. The first (now in Eliot House, Harvard) is a study for the second and depicts the poet's head and torso against a blank background. The second and much greater painting portrays Eliot, in waistcoat and lounge-suit, slouched in an arm-chair, with crossed hands. He stares slightly downwards and to the left with great intensity, and the planes of his face are more contrasted, his bold features more precisely delineated than in the study. A shadow from his head appears on the pale green panel behind the deeply etched parting of his sleek hair. The abstract designs on both sides of the panel suggest the power of his imagination, while his solemn composure and fixed concentration convincingly convey the strength of his intellect. Eliot greatly admired this portrait, which captured the essence of his mind and art, and told Lewis he was quite willing for posterity to know him by that image (a photograph of 1954, reproduced in Lewis' *Letters*, shows Eliot pointing to the portrait with smiling admiration).

Lewis submitted the portrait to the judges of the Royal Academy exhibition in the spring of 1938. But *Blast* never got inside Burlington House, and the painting was rejected on April 21. The refusal of the portrait caused a furore in the British press, enabled Lewis to strike back at the citadel of artistic orthodoxy, gain some useful publicity, and—ironically—attract for the first time the attention of a wider public. On April 30 Winston Churchill (an amateur painter) defended the rejection at the Academy banquet in a burst of passionate platitudes: "The function of such an institution as the Royal Academy is to hold a middle course between tradition and innovation. . . . Innovation, of course, involves experiment. Experiment may or may not be fruitful. Certainly it is not the function of the Royal Academy to run wildly after novelty."

Augustus John took a radically different view. In a letter to the press on April 26 he publicly followed the example of Walter Sickert and Stanley Spencer (who had resigned the previous year to protest against the censorship of statues by Jacob Epstein) and withdrew from the Academy: "Nothing that Mr. Wyndham Lewis paints is negligible or to be condemned lightly. I strongly disagree with this rejection. I think it is an inept act on the part of the Academy. The rejection of Mr. Wyndham Lewis' portrait by the Academy has determined my decision to resign from that body." John told Lewis: "I resign with gratitude to you for offering me so good a reason"; but later suggested to Laura Knight that his withdrawal was more practical than principled: "I wasn't thinking of doing anybody a kindness and I don't give a damn for that picture." John's biographer later explained that John was

certainly joking, though the joke was in bad taste, when he made that cynical statement. The main reason for John's departure was his intense dislike of the president, Sir William Llewellyn, for he returned to the fold in 1940, after Llewellyn had left, and became what Lewis called a "sleeping-partner" in that undistinguished group.[4] Whatever John's motives, Lewis was grateful for his loyalty during the dispute (as he had been to Campbell during the *Apes of God* row) and praised John's paintings, with rare enthusiasm, in the *Listener* of May 25: "Most of these [works] bear to the full the imprint of his superlative talent for painting and great romantic appetite for life . . . producing image after image of unusual power and beauty."

The two most interesting aspects of this *cause célèbre* are the reasons for the Academy's rejection and for Lewis' submission of this superb portrait. Lewis' lifelong hostility to the Academy predetermined their refusal of his work. Vorticism and *Blast* were opposed to everything the Academy represented, and Lewis' pronouncements on the Academy in his catalogues, magazines and books were consistently abusive. In the *Group X* catalogue (1920) he exclaimed: "The large official *Exhibition at Burlington House* appears to be beyond redemption. It is a large and stagnant mass of indescribable beastliness, that no effort can reform." In his essay on Roger Fry in *Tyro 1* (1921) he stated: "An exhibitor at the Royal Academy . . . is literally, for me, not an artist in any sense at all. The tradition in which he works, the taste and understanding of the large democratic public for which he provides, is beneath contempt." And in *The Art of Being Ruled* he insisted: "The Royal Academy in England is a perfect justification for social revolution. It is the inevitable counterpart of the nineteenth-century industrial slum."

The main reason for the rejection, as he explained during interviews with the *News Chronicle* and *Daily Herald* on April 22, was a kind of "revenge for hate," an aggressive response to the solicitation of their approval by an avant-garde artist who was diametrically opposed to the academic tradition: "The Academy has rejected my picture for the same reason that a very conventional golf club would turn you off the course if you turned up wearing what they considered to be incorrect dress. They say it is not traditional. 'The actual figure is good,' they say, 'but the things on the side are queer and revolutionary.' . . . The Academy has adopted a moral attitude. Because I have produced unconventional work they reject even my straightforward stuff. . . . My name has been buzzing about their ears for so many years that the moment I send in a painting they reject it. I think they have it in for people who make them look silly."

Lewis' motives for sending his painting to a society whose policy he disliked and whose work he despised are more difficult to determine, though he gave several explanations of his behavior. He told the *Daily*

Herald that he submitted the portrait as a test case: "The Royal Academy is a disgusting bazaar in which every sort of filth is accumulated every year. . . . People say about the Royal Academy, 'Your exhibitions are peculiarly dull. Why not get someone new?' Their reply always is, 'They don't send in their work.' So I sent this in to test their sincerity." He also said that he wanted to raise the standards of the Academy by submitting a better painting than they normally exhibited. Though Lewis may have wished to elevate and improve the Academy, he must have been convinced that it was too polluted ever to be reformed. He was too sensitive about his artistic stature to risk refusal deliberately; and was not sufficiently cynical to foresee that the portrait would be considered a provocation. In the end, he gained more attention and earned more money from rejection than he would have done from acceptance.

Lewis' subsequent bitterness and anger suggest that he was surprised and wounded by the rejection. But he immediately took the offensive. He attended the private view at Burlington House and made caustic comments about the accepted paintings to a crowd of delighted eavesdroppers. A contemporary photograph showed him in felt hat, with paunchy face, heavy round glasses, curved pipe, wool suit, sweater and muffler, standing defiantly beside the portrait—which he also defended in a British Pathé newsreel. He continued his relentless onslaught against the Academy in interviews, in *Wyndham Lewis the Artist* and even in *The Hitler Cult* (both 1939). His parting salvo was published in *Vogue* the year before his death when he called the Academy "that enormous trap in the centre of our principal thoroughfare."[5]

The refusal of the Eliot portrait came at the end of a long series of rejections that Lewis experienced in the 1930s. But the controversy aroused interest in the picture (which was refused by the Trustees of the Tate), and in 1939 T. J. Honeyman of the Lefevre Gallery sold it for £250 to the Municipal Art Gallery in Durban, South Africa. This money, and the fees for his other portraits of the late thirties, enabled Lewis to escape from England and travel to North America.

3

In 1938-1939 Lewis also completed portraits of Miss Close, Hedwig Booth, Josephine Plummer, Naomi Mitchison, Lord Carlow, John MacLeod (a bookish friend of Nicholas Waterhouse), Stephen Spender and Ezra Pound. The portrait of Spender was a visual representation of Dan Boleyn—"The tall melting glowing young debutante, fixed in a stock-still confusion, standing suffused with a hot maidenly bloom"— which revealed his "downcast madonna-face, sensitively pained lips,

blushing cheeks," long swan-neck, high wavy hair and the wild-eyed stare of his passionate velvet eyes. Spender thought Lewis, who amused him with lively literary anecdotes, was at his best while painting. When Froanna had a guest for tea and disturbed his conversation, Lewis pounded on the floor to keep them quiet. He was well pleased with the finished portrait (which Spender disliked) and told his sitter: "It's as beautiful as a head by Raphael."

After Pound's mother-in-law, Olivia Shakespear, died in October 1938, he came to London from Rapallo to settle the estate and was painted by Lewis. Unlike the sittings of Eliot and Spender, there was no conversation with the "prickly, aloof, rebel mandarin" whom Lewis had drawn nearly twenty times since his first, impressive painting of 1919. Lewis described how Pound "swaggered in, coat-tails flying, a malacca cane out of the 'nineties aslant beneath his arm, the lion's head from the Scandinavian North-West thrown back. . . . He flung himself at full length into my best chair for that pose, closed his eyes, and was motionless. . . . He did not sleep, but he did not move for two hours by the clock. 'Go to it Wyndham!' he gruffled without opening his eyes, as soon as the mane of as yet entirely ungrizzled hair had adjusted itself to the cushioned chair-top."[6]

In contrast to the rigid, vertical, closed portrait of Edith Sitwell, the portrait of Pound is relaxed, diagonal, open. His posture of aggressive ease resembled extreme exhaustion and provided a strong contrast to his usual bombastic vitality. The portrait captures the hieratic head of the dreaming poet, the thin compressed lips between moustache and goatee, the large impressive nose and staircase of brown hair. The same heavy glass and wavy ashtray in *The Artist's Wife* appears on a round table next to a folded copy of the liberal *Manchester Guardian* (the "nch" is just visible) which Lewis regarded as the "most insidiously wrong" of all the political newspapers in England. In the background, a green sea is painted on a canvas. The portrait, completed less than a year before the outbreak of the War, when Pound was dangerously embroiled with Italian Fascism, suggests (in retrospect) a temporary escape from his terrible destiny. Lewis' painting of Pound, his greatest portrait after *Edith Sitwell*, was purchased by the Tate Gallery for £100 in 1939.

Lewis reproduced *The Inferno, The Surrender of Barcelona* and the *Portrait of T. S. Eliot* in his collection of essays on art, *Wyndham Lewis the Artist: From 'Blast' to Burlington House*, which was published by Laidlaw & Laidlaw, who paid him £100 advance, in June 1939. The revised art essays from *Blast 1 & 2, The Caliph's Design* and the essay on the "Objective of Art in Our Time" (*Tyro 2*) were introduced by two "pamphlets" which surveyed "all that has occurred to painting in England up-to-date—with reference especially to the controversies of

the moment, and with an account of the desperate position in which the painter finds himself, and a hint as to the way out." This book received a surprisingly favorable review-essay in *Scrutiny*, and the critic in the *Listener* (like Pound) concluded that Lewis was unpopular because he was "so often right."

Lewis had been invited to express his views on art and politics on three BBC radio talks in April and June 1935 and June 1938; and on May 23, 1939, he participated in the first televised debate on modern art. William Rothenstein was in the chair, the architect Reginald Blomfield and the painter A. K. Lawrence defended the academic school of painters; and Lewis and Grigson advocated the work of modern artists: Braque, Klee, De Chirico (whom Lewis had met in 1932) and Henry Moore. Grigson recalled that Lewis, who mumbled and was not very effective, refused to alter his formal typescript and make it more colloquial. And Hubert Nicholson satirized Lewis' inarticulate nervousness: "Wyndham Lewis came in looking like a bull spruced for a show. His big face sweated, his thin copper-wire hairs had been brushed back in parallel lines over his blunt head which was going bald. He wore a rough dark-green suit flecked with white, and a blue-and-white tie and horn-rimmed spectacles behind which he blinked furiously. He looked formidable, but he roared like a sucking-dove. He hummed and ha-ed, seemed unable to open his lips freely when speaking and gave me a painful impression of stage-fright."[7]

4

In October 1937, between his last operation and the opening of the Leicester Galleries exhibition, Lewis and Froanna took a recuperative trip to Berlin, where they stayed at a small hotel off the Kurfurstendamm, and to Warsaw, where they put up at the Hotel Bristol. Lewis' seventh visit to Germany and fourth trip of the 1930s finally opened his eyes to the reality of Nazism and led to a radical revision of his political views. They met Hans Rudolf Rieder, Lewis' translator and, Froanna wrote, "As Wyndham knew very little German all the conversations were in English, and occasionally in French. . . . We went there to find out how things were under Hitler. And the result was *The Hitler Cult* and *The Jews, Are They Human?* We left there very quickly because we found it very uncomfortable, or Wyndham did at least." His critical attitude toward German militarism had become very different from the admiration expressed in the first book on Hitler: "I watched, a year or so ago, a party of Black Guards falling in, and marching off down the Wilhelmstrasse. I noted the ascetic, the monkish appearance of their pale faces under the black casques, and the clock-like solemnity of their move-

ments, with the violent kick of the goose-step that leads off the quick march!"

In Warsaw Lewis felt very tired, spent most of his time sitting in the cafés, and was not enthusiastic about Froanna's wish to extend their journey to Cracow. But a visit to the Ghetto (which would be totally destroyed by Hitler in April 1943) seemed to awaken his sympathy for the oppressed and impoverished Jews of eastern Europe: "Last year I spent a week or two in Warsaw: on the last day of my stay I felt I had seen very little of the outlying parts of the city, so I engaged a droshky. We made a tour of churches and palaces, or drew up in front of them, looked and passed on. Then at length the driver, speaking over his shoulder, announced: *'Maintenant, messieurs et m'dames, nous nous approchons du Ghetto'.* . . . The percentage of diseased, deformed, and generally infirm persons is what strikes one most: that and the inexpressible squalor."[8]

The first book Lewis published after this final trip to Germany was the minor and hastily written *The Mysterious Mr. Bull* (November 1938). The book was a study of English society and the English national character, and continued the satiric barbs he had first launched in *Blast*. But it did show, for the first time in his career, two related ideas: sympathy for Left-wing politics and admiration for the intellectual superiority of the Jews: "The majority of the nation is lethargic. That I have called the Big Soft Centre; which will go wherever it is pushed. The Right wing just sits tight, hanging on shortsightedly to its moneybags. All the best brains are on the Left. . . . The average Jew is twice as intelligent as the average Englishman. Indeed, with the Jews, mental endowment seems to be distributed evenly throughout the race to a remarkable degree."[9] Lewis' scorn for the masses, cynicism about democracy and belief that the Communist supporters wanted war had led to a hostile attitude toward the Left. But his observation of a powerful and brutal dictatorship caused him to change his views. He had always valued intelligence above everything but creative genius; and when he saw that the most gifted people were also the most oppressed, he realized that the Nazis were enemies of the mind.

Lewis published six articles in German magazines during 1937–1939 and hoped to be taken up by German publishers to compensate for his neglect in England. In the suppressed Canto XX of "If So the Man," he related how an attractive offer from Kippenberg in Leipzig to bring out a number of his books, beginning with *The Childermass*, was suddenly and suspiciously withdrawn. But Essener Verlag quickly translated *The Mysterious Mr. Bull* in 1939, when Lewis was trying to recant his support for Hitler, and used the German edition as anti-English propaganda. And the dust-jacket of the German edition of *The Revenge for Love* (1938) insisted: "The Germans have good reason to

be concerned with Lewis and his works. The *Europäische Revue* [March 1938] has recently called him the most eloquent and intelligent foreign supporter and admirer of the 'New Germany' and its decisive role in the West today."

Lewis' anti-Semitic statements are still remembered while *The Jews, Are They Human?*, which appeared in March 1939, has been forgotten. This is partly because of the misleading and tactless title (Lewis certainly answered the question in the affirmative), which was awkwardly based on Gustaaf Renier's study of the English character: *The English, Are They Human?* (1931). Lewis' book, which appeared only four months after *Kristallnacht* (November 9, 1938), when 30,000 German Jews were arrested by the Gestapo and sent to concentration camps, neither pleased the anti-Semites nor placated the Jews. It renounced racial prejudice, but still contained some ignorant and apparently hostile statements.

The book provided valuable insights about the origins of Lewis' attitude toward the Jews. His first contact with Jews occurred when he was a child and bears a striking resemblance to Hitler's account of his own exposure to East European Jews in the streets of prewar Vienna: "I once, when I was a schoolboy, went with [an anti-Semite] to the East End of London. He took up his position under a lamppost in the Commercial Road. . . . He gazed at the Jewish passers-by in a kind of rapt and gloating way. . . . He caught his breath when a particular 'beauty' passed—he plucked my sleeve or nudged me and muttered rapturously, 'I say! Look at that one!' " Though Lewis said he was mystified by his friend's behavior, he must have been strongly influenced by this early impression, which he retained for fifty years and which gave him the feeling that Jews were both different and inferior.[10]

Though Lewis' book was essentially sympathetic, he revived the erroneous source of prejudice and claimed Jews were responsible for the Crucifixion. He revealed, on the opening page, his ignorance about the fatal persecution of the Jews: "Germany, Hungary, Italy, Poland, Czecho-slovakia, and other countries, are freezing out their Jewish minorities, by means of what has been described as '*cold* pogroms.' " And, in an invidious comparison of English and German discrimination, he criticized *England* and ignored the fact that the Jews were German citizens: "*We* have our Ghettos, too. Our Ghettos are our *slums*. . . . But in our Ghettos we herd and starve *our own people*. That is the difference."

Lewis also employed a number of racial generalizations that were meant to be sympathetic but were, in fact, crude, condescending and offensive: "The westernized Jew is a highly civilized person—'the human being *par excellence* perhaps' as I said just now. He is pleasure-loving, kind in his private life, and with an even pathetic desire to be friendly." After all these tactless assertions, Lewis' patronizing insis-

tence, "I respect the Jewish intelligence. I have no atavistic residue of dislike whatever for the Jew,"[11] seemed unconvincing and even insincere. His book on the Jews, like many of his political books, did him more harm than good.

Lewis' more thorough recantation, *The Hitler Cult*, was written after the Munich Conference and appeared in December 1939, three months after the outbreak of the War and his departure for North America. He began by indirectly apologizing for his *Hitler* book—the first one in English—and tried to present himself (as he had originally done) as a "neutral" rather than a "partisan." He then renounced his neutrality, which he said was equivalent to being anti-British, regretted his previous attempts at appeasement, and denounced Nazism as a pernicious racket. But Warsaw had already been destroyed; and Lewis' ignorance of Hilter's persecution of the Jews, and ludicrous miscalculation of his military power and ruthless ambition, made his book seem pointless, superficial and inept.

During and after World War Two, Lewis naturally took considerable pains to justify his incriminating political views, which did him great harm in America and Canada. He told his American editor: "I am often today called a *reactionary*. I am not that at all. But I at times have accepted the conservative viewpoint, for conservative action seemed to me all that people were capable of, and that more could be got out of them by indulging their conservatism than by whipping them up into novel efforts." He also confessed that his prewar politics were a fierce yet hopeless attempt to avert wholesale violence; and in *Rude Assignment* frankly admitted that his *Hitler* book and his two "peace pamphlets" could "be written off as futile performances—ill-judged, redundant, harmful of course to me personally, and of no value to anyone else." But even in this memoir, which tried to refute the charge that he had preached the power doctrine, he continued to advocate the authority of a benevolent dictator who could achieve much more than a democratic ruler, and to justify certain aspects of totalitarianism: "Hitler revealed himself as a homicidal lunatic: but even he in the first years of his power effected changes for the better which it is very difficult for a government without such great powers to attempt."[12]

Critics and friends who noticed the change in Lewis' political views in 1938–1939 inevitably wondered about the sincerity of his clumsily expressed recantation. Lewis was always rather out of touch with political reality, was genuinely surprised at the hostility aroused by his *Hitler* book and was shocked by the brutality of *Kristallnacht*. He had violent opinions but was not, like Campbell, a violent man. He felt a personal revulsion for the Right-wing people who tried to take him up after the *Hitler* book, and regretted his hasty conclusions and political errors as much as the harm he had suffered for espousing them. Fascism

involved ideas and people whom he utterly despised—once he recognized them—and since he could not respect the real Hitler, he found it easy to repudiate him when things turned out badly.

There was also a pragmatic side to his recantation, an ineffectual attempt to rehabilitate himself and achieve popularity. But he could not bring himself to the more abject—and therefore more convincing—retractions of Pound, who admitted, at the very end of his life: "I could have avoided so many errors! My aims were good, but I blundered in the method of attaining them. I have been stupid, like a telescope seen through the wrong end. Too late came the understanding. . . . The worst mistake I made was that stupid, suburban prejudice of anti-Semitism. All along, that spoiled everything. . . . I was wrong. Ninety-per-cent wrong. I lost my head in a storm."[13] Pound had gone to far greater extremes of Fascism and anti-Semitism than Lewis and was actually accused of treason, but his torment in the cage at Pisa, his madness and long incarceration in an insane asylum seemed to burn away the guilt.

Apart from his article in Mosley's journal, Lewis never actively supported a Right-wing political party. But he suffered greatly for his politics throughout the 1930s, and *The Hitler Cult* failed to extinguish the hostility he had aroused. In despair and confusion, he turned to the elusive hope of North America. But his choice of Canada and decision to leave England in September 1939 revealed the same misunderstanding of political events and practical realities that had characterized all his polemical books of the thirties. *The Revenge for Love, The Surrender of Barcelona* and the portraits of Froanna, Eliot and Pound represented a creative resurgence that equalled *Tarr* and the Vorticist paintings of the prewar period. But the events of 1914 repeated themselves, and the War that began in 1939 once again eclipsed his reputation and destroyed his career as a writer and artist.

New York, 1939–1940

I feel as if I were in some stony desert, full of shadows,
in human form. I have never imagined the likes of it,
in my worst nightmares.

Lewis on New York

I

Lewis' support of Hitler in 1930 led, indirectly but inexorably, to his
exile in 1939. On September 1 Hitler invaded Poland, on September 2
Lewis and Froanna sailed for Canada, and on September 3 England
declared war on Germany. His inauspicious departure was even more
foolish and disastrous than Conrad's visit to Poland in July 1914, for the
fifty-seven-year-old Lewis remained in exile and *in extremis* for six
long years.

Lewis' reasons for leaving England were complex. His decision was
based essentially on the misconception that he could earn more money
as an artist in America (where he was virtually unknown) than in
England (where he had established a serious reputation). But in 1939,
when he decided to leave, his situation and prospects seemed much
bleaker in England. His exhibitions and books had been economic
failures throughout the thirties (he earned a total of £40 for his book on
anti-Semitism and sold only 975 copies of *The Hitler Cult* in the first
nine months), his bank had stopped his credit in July, and he was
burdened with debts and threatened with bankruptcy. At the same time,
the money from the sale of the Eliot portrait enabled him to book his
transatlantic passage in May, while a lucrative portrait commission of
$500 from Professor Charles Abbott of the University of Buffalo—
whom Lewis met in the summer of 1939—seemed the beginning
(though it was actually the end) of a promising future.

The first section of *Wyndham Lewis the Artist* expressed his lifelong
belief that England was hostile to artists, discussed the difficulties of
maintaining a precarious economic beachhead and helped to explain why
he went to North America. He had failed to sell his work in peacetime

and rightly thought that war would make things much worse. He knew the State would mobilize the arts in time of national crisis and, with his dubious record and suspect loyalty, realized that his prospects for national employment were minimal, and that he might end up selling matches on the street. When Mark Gertler (who now has a dozen works in the Tate) committed suicide in 1939, Lewis wrote that he had been driven to death by financial failure: "The evidence of one of this country's crimes against art is to be found in the most convincing form in this [memorial] exhibition. . . . [Gertler] gassed himself quite simply because no one would buy his pictures, and he had no money."[1]

Though financial considerations were predominant, Lewis was also influenced by a number of other factors: the encouragement of friends, the exhibition of his painting in New York, his Canadian passport, his desire to contact his family, his perpetual restlessness, and his urge to escape the depressing spectacle of another war in Europe. In 1939 Lewis met John Reid, a young Canadian who had sent him the typescript of his unpublished novel. Lewis told Reid there would soon be a war, his career would be finished and he would have to leave London to find peace and save money. He desperately wanted to get away, thought he might as well go to Canada as to the country, and asked Reid about opportunities in North America. Reid had gone to a good public school, Upper Canada College in Toronto, had some close connections with prominent people who were in a position to help Lewis, and encouraged him to come to Toronto. Lewis' *The Surrender of Barcelona* was being shown at the New York World's Fair, which had opened in April 1939, and he thought this excellent publicity would bring in other work.

As Lewis was born in Nova Scotia, he already had a Canadian passport, so there would be no difficulties with immigration. He was eager to see his birthplace, to investigate the history of his American ancestors and to visit the family he had been out of touch with since the death of his mother in 1920. He liked change, was always travelling in Europe and shifting from one flat to another, and believed in D. H. Lawrence's dictum: "When in doubt, move!" A few days before leaving England he told Julian Symons that "he had seen Europe destroy itself in one war and had suffered through it, and that he had no intention of sitting through another."

Lewis was not the only English writer who nourished great expectations about America. Huxley had settled in California in 1937, Auden and Isherwood had moved to New York in January 1939, and all three were publicly criticized for abandoning England in time of war and maintaining their safe refuge across the sea. Lewis belonged to an older generation, had fought in the Great War and (though he claimed to be four years younger than his actual age) was well beyond the call of military service. But he was sometimes associated with these "deserters,"

especially by those who disliked his political views, and was considered disloyal by Canadian patriots. He did in fact feel a certain guilt about leaving England when war broke out, which was exacerbated by the hopeless failure of his expatriation.

Lewis' old friends Ford and Pound had also been in America in 1939 and might have been able to help him if they had been there when he arrived. But Ford, who had been teaching for several years at Olivet College in Michigan, had died in June, and Pound returned to Italy that month. Pound was still as helpful as ever and, while Lewis was sailing up the St. Lawrence River, wrote to President Brewer urging him to offer Ford's vacant position to Lewis: "Wyndham Lewis is at King Edward Hotel, Toronto, Canada. Of course he wouldn't come to Olivet for the meagre fee you can pay. BUT if you modestly put it to him that you don't regard it as pay, but that you can and *would* like to provide him with basic necessities in a way that wd. leave 80% or 90% of his time free to paint and do his writing without preoccupation you have just a chance of getting the MOST ACTIVE of my contemporaries onto *your* campus."[2] Despite Pound's generous efforts, this academic possibility, like innumerable others in the next decade, failed to materialize.

Lewis had originally booked berths on the *Duchess of York*. But when that ship did not sail the passengers were transferred to the *Athenia*, which was torpedoed, with 1,400 people aboard, on September 3. Lewis escaped death only because the superstitious Froanna did not like to sail on a Friday (September 1) and persuaded him to change their booking to the *Empress of Britain*, which left the following day. The ship was loaded with valuable oil paintings that were being sent to the National Gallery in Ottawa for safekeeping. They were only one hundred miles away when the *Athenia* was sunk, and zig-zagged through the mines, icebergs, whales and storms of the North Atlantic.

Lewis travelled first-class, worried about his black and white Sealyham Tut (whom he drew a number of times) being kept in a kennel on deck, and suffered from the intense cold of the voyage that skirted the Arctic Circle to avoid German submarines: "The sea got rougher and rougher, and the temperature colder and colder. We were going north. We were on our way to Greenland. We had cut off our radio and were holding no communication with the outside world. We were just seeking safety among the ice-floes; and now, all our portholes and saloon windows blacked out, and our decks hemmed in with canvas, to make us invisible to an external enemy, we were all by ourselves, in an icy sea, plunging along at top speed in the general direction of the Northwest Passage."

Lewis, who intended his journey to be a short working holiday, had not stored his possessions or rented his flat. But when the intensification of warfare and the lack of money prevented his return and extended his trip from six months to six years, his life, as W. K. Rose observed,

became dominated by several vital concerns: "the wish to be recognized as the notable he was in England, the need to justify his earlier pro-Axis sympathies and his departure from Britain in 1939, the desire for some kind of companionship or ambience to replace his London life, the hope for a more stable existence in England after the war; above all, an almost hysterical pre-occupation with keeping his head above water."[3]

2

Lewis arrived in Toronto on September 12, stayed at the King Edward Hotel, and then crossed the border to Niagara Falls and Buffalo to begin his commissioned portrait. Lewis liked his subject, Chancellor Samuel Capen, a New Englander who had been educated in Europe, and described him as a gentleman, a first-class administrator and a good scholar. Lewis could not find a studio and worked on the painting in a rented room on North Street. He described his stay in Buffalo (which he called Nineveh) in *America, I Presume* (1940), an accurate, tart, satirical book about his first nine months in the United States and Canada. The handsome Charles Abbott, who had invited Lewis to Buffalo, appeared in Lewis' book as Harry Whitaker, "the *sleepiest* looking live-wire I have ever met." He was a Quaker, an Oxford graduate and a Professor of English at the university, and was praised as "a fine chap, a brilliant scholar when he was at school, today, as a university executive, an educational phenomenon of first importance: *and* that rare thing, a man of heart as well as intelligence."

Abbott commissioned drawings of his wife Teresa, his child Neil and himself; after Lewis had lived for a time at the Stuyvesant Hotel on Elmwood Avenue, he invited him to stay in the glassed-in sunparlor at the back of his comfortable house. Breakfasts at the Abbotts' reminded Lewis of banquets in Gogol and the lavish feasts of Old Russia; and the ice-cream sundaes and chocolate cakes were the "child-man's dream of a gastronomic paradise." William Carlos Williams, who met him in Buffalo, recorded: "Wyndham Lewis, his young wife and a little dog were being entertained at the Abbotts' where he had been in residence while painting an official portrait of the president of the college, a commission which Charles had secured for him. He had . . . his apartment on the book-filled enclosure, really the old back porch, where he had been living for a month or more. . . . He told us that he was really an American, that in fact he had been born just over the hill in the Genessee Valley." Soon after Lewis arrived, Abbott took him on a nostalgic visit to Nundā, where Shebuel Lewis had once owned a farm and where Lewis still had relatives he had not seen since boyhood.

Lewis also had several cousins in Buffalo: Alfred George Lewis, Jr.,

who thought Lewis was "a kind of screwball"; and George and Harry Chisholm, the sons of his Aunt Tillie (the ally of his mother after her separation from his father in 1893). The family had lost their considerable wealth and social status, but not their snobbish pretensions; Lewis thought they were "shits"[4] and satirized them as the Grahames. He did not get on with his provincial relations nor with the directors of the Albright Art Gallery, and was openly critical of philistine life in Buffalo. He misjudged the strength of his reputation and expected an enthusiastic reception; they were not quite sure who he was nor how to deal with him. John Rothenstein, who came to Buffalo while his friend was there, found "Lewis had already established himself in Buffalo as 'The Enemy' just as he had in London. . . . One big dinner party was sufficient to show me that it was bad form in Buffalo to talk about anything except Lewis. At this function I tried to smooth the ruffled feelings of a lady who had invited him to dinner and had been asked to produce her guest list. Lewis' family appear to have lived in this city for a time, where he still had connections. On his arrival, he told me, he called on one of these, when the man in question, supposing him to be some obscure failure come to ask a favour, received him coldly. . . . [Lewis] had protested that his presence in Buffalo had not been 'officially recognized' by the Gallery and in consequence declined to allow the portrait of the President of the University to be shown there."[5]

In Buffalo, as in Toronto, the hypersensitive Lewis tried to stand on his dignity; he was rude and offensive, and deliberately ruined his limited opportunities for success. He failed to obtain any other commissions and inevitably found the Buffalo "an animal inaccessible to artistic stimulus." He was forced to borrow $200 in 1939 from Iris Barry, who was married to Charles Abbott's brother (a delicate situation); a £100 guarantee for an overdraft from Naomi Mitchison in 1940; $100 from the Canadian painter Alex Jackson in 1941; $50 from the art critic James Johnson Sweeney in 1942; and $150 from the British High Commissioner, Malcolm MacDonald, to get back to England in 1945. It is ironic that the University of Buffalo and Cornell University, which showed no interest in Lewis when he was living in North America and desperately in need of a job, have spent large sums of money to acquire his letters and manuscripts after his death.

Elliott Baker's fine story "The Portrait of Diana Prochnik" (1974) provides a vivid and convincing account of Lewis' humiliating situation when he was staying at the Stuyvesant Hotel—short of funds and forced to live by his wits and his brush. Baker's story, which resembles Philip Roth's "Goodbye, Columbus," creates a tragi-comic contrast between vulgar Jewish-American materialism and dignified English culture, as embodied in the (anti-Semitic) Lewis. It is the only fictional work in which Lewis appears as himself and is portrayed positively.

Baker begins by refuting Hemingway's biassed view that Lewis had the eyes of an unsuccessful rapist. He portrays Lewis as formal, proud, composed, articulate and highly intelligent; as a dedicated man who "based his entire life on the accuracy and integrity of his vision." Lewis meets the beautiful Diana Prochnik when she is dancing with some other students at the Stuyvesant Hotel. He then brings some of his paintings to her home in order to persuade her father, a wealthy junk dealer, to let him paint her portrait. When the gauche Mr. Prochnik says: "Let's see your samples," Lewis, "with a streak of masochism" but with impressive honesty, shows the ignoramus a work that closely resembles *The Surrender of Barcelona* and gives a brief but impressive lecture on Vorticism: "The first picture he put up didn't have a semblance of a face in it. There were some figures that looked out of Buck Rogers, but most of the painting was of buildings, sort of half skyscraper, half Bavarian castle. There was a horse's rear end in one corner and a moat and some sailboats in the distance. And the colours were muted, a lot of brown."

Though Mr. Prochnik prefers the art of Norman Rockwell, he commissions the hundred-dollar portrait of his daughter with the proviso that "he was to be the sole judge of its satisfaction. If he didn't like it, Lewis would get nothing." When Lewis brings the completed portrait to Prochnik's house he is shown the trashy junkyard paintings of this petty ape of God, condemns them and states his artistic credo: "You know nothing of colour, nothing of composition, nothing of form or texture. . . . You make a few vulgar scrawls that any child could make and want to be praised for it. Men devote their entire lives to art. And no one has the right to cheapen and denigrate what others die for." Though Diana adores the painting, her outraged father rejects it: "Crap! I wouldn't give two cents for it! I wouldn't have it in my house if *he paid me!*"

The most effective aspect of the story is Baker's moving recognition and revelation of Lewis' degrading quest for portrait commissions among the philistine rich. As Lewis wrote from New York, in a letter of December 15, 1939, that dramatized the role of the artist in modern society:

I am here on a painting expedition—I am head-hunting. I desire to *portray*, in oils, chalks, irrespective of looks, age, colour. . . . It is not every day of the week that a painter with any pretensions to being an artist is moving round looking for subjects: for usually the "portrait-painter," whether here or in Europe, is little better than a colour-photographer. . . . If you know any *intelligent*, or *beautiful*, people, that indeed would be marvellous. But I want to paint pictures, and I will take on any mug that offers without insulting it. (No billiard-balls for eyes, *postiche* [false] noses or cauliflower ears! Such a job as Dürer or Bellini would have done, were they alive today.)

Baker's description provides an interesting contrast to the iconoclastic and hostile Lewis who inspired envy and hatred in England during the twenties and thirties. He portrays Lewis in America as somewhat mellowed by age and opposed to a different kind of moneyed philistinism. The story is sympathetic to Lewis and critical of his adversary, but still vividly conveys the aggressive and hypersensitive character who resembles the earlier fictional portraits by Ford, Huxley and the Sitwells.[6]

3

In December 1939 (when *The Hitler Cult* was published in London) Lewis moved from Buffalo to New York City and lived there until the summer of 1940. He stayed at the Winthrop Hotel at Lexington Avenue and 47th Street, and at the Tuscany Hotel at 120 East 39th Street until March; rented a flat at 81 Irving Place, near Gramercy Park, during April and May; and moved out to Long Island in June. He was soon introduced to the leading writers and artists, and even accompanied John Rothenstein to the packed literary salon of Mabel Dodge Luhan, where the main exhibit was her huge, silent and immobile Pueblo husband. Lewis looked up Edmund Wilson, who was the literary editor of the *New Republic*; met the satirist and editor H. L. Mencken; the poet E. E. Cummings, a "jumpy and peppery little creature"; and the writer Louis MacNeice, who was teaching at Cornell in 1940 and gave Lewis financial help. When he asked MacNeice what to do if he could not answer a student's query, the poet said he always replied: "Ah, a very interesting question, that" and talked around it for a minute or two. Lewis also met the novelist Henry Miller, who "had just been shipped back from Greece very much against his will—a new 'region' he had discovered with a rapture that was literally timeless. For he embraced the whole of Hellenic antiquity and the present population in one indiscriminate, burning, accolade. For the remainder of his days, he informed me, he proposed to live in the Orient." Lewis liked Miller but was not very fond of his writing and did not think the novelist would be attracted by his own work. But Miller had read Lewis' books, admired his role as permanent Enemy of the people, praised his paintings in *The Cosmological Eye*, and remembered him as "witty, charming and highly intelligent."

Though Lewis had treated Iris Barry rather badly in the early 1920s, he frequently borrowed $50 or $100 from her (though John Abbott had tuberculosis and she had to support both him and her mother). He asked her to place his work with American publishers, suggested she get him a job at the Museum of Modern Art (she said that would be

impossible), and used her as an intermediary with Alfred Barr, the director of the museum, whom he had first met in London in 1927. Lewis said Barr resembled a "defrocked Spanish Jesuit" and criticized his somewhat mechanical and undiscriminating mind: he was "the perfect man for such a task of mass-education, with his card-index mind and his neutrality as regards all modes of expression; prepared to accept anything on its merits, and tuck it impartially away in one of his mental pigeon-holes."[7] Through Barr, Lewis also met the sculptor Alexander Calder, the architect Philip Johnson and the critic James Sweeney.

Barr had organized at the Museum of Modern Art the enormously successful exhibition of forty years of Picasso's painting, which included *Guernica*, his great anti-Fascist portrayal of the Spanish Civil War. Lewis' essay on this show in the *Kenyon Review* (Spring 1940) criticized Picasso as the leader of the abstract movement in modern art and rather harshly concluded: "Picasso's is altogether too totalitarian a temperament: what he has done, taken in isolation, does not quite justify the space he occupies upon our horizons. He is such a great, luxuriant, voracious, plant: and he is a little too much of the liana—the prolific, tropical creeper—rather than the solid giant of the forest—to which description Daumier, or Cézanne, or Goya answers, but he does not."

Lewis continued his attack on modern art in two articles in the *New Republic*, where he alluded to Cézanne's statement about the structure of modern painting, suggested that America still believed in European fads and proclaimed: "This article is a sort of obituary notice. It is written to announce the death of 'abstract art.' At last the Cube, the Cone and the Cylinder are still forever. . . . Braque's abstract bric-a-brac is fast becoming junk. The most amusing *collage* will fetch nothing in Europe. Brancusi's egg has gone to join the Dodo's."[8] By writing these characteristically cross-grained and intemperate articles, less than a year after he had defended modern art on television, Lewis forfeited his immense prestige as the pioneer of abstract art in England; vainly opposed the current of contemporary American painting—led by Jackson Pollock and the Abstract Expressionists; and proved once again to be an extremely unreliable prophet. Alex Jackson remembered that there was a great row about these articles, which Lewis was forced to defend in the correspondence columns of the *New Republic*. His attacks, which seemed to be inspired by his own bitter failure, roused strong feelings against him in the art and literary circles where he had hoped to earn a living.

Apart from Lewis' own prickly temperament and retrograde aesthetic views, there were a number of other baneful factors operating against a poor, English, Right-wing intellectual. The somewhat shabby and impoverished stranger soon became sensitive to the ferocious American

pride in the possession of money and the pervasive scorn for highly educated people in "low income brackets." He also encountered a good deal of anti-English feeling, a legacy of the Fenian days, which was kept alive by the powerful Irish faction in New York: "Great Britain— to continue in a frank vein—is decidedly suspect all round to Americans. There is no denying that fact. . . . She is a stuck-up old girl who owes a lot of money. . . . She seems to the average American slightly phoney. . . . She has many habits which baffle and put one on one's guard—the curious way she has of speaking with a foreign accent."

Lewis' notorious pro-Fascist political views, despite his recent re-cantation (which had not reached America), did him a great deal of harm. When he first arrived in Toronto, a department store was selling remaindered copies of Gawsworth's compromising book on Lewis, which had the dangerous title: *Apes, Japes and Hitlerism.* The Canadian politician Paul Martin (whose wife Lewis painted in 1945) heard rumors that Churchill had paid Lewis' passage out of England because he was a conscientious objector and would undermine the war effort. Martin did not know that Lewis was born in Canada, had a Canadian passport and had fought in the Great War. The Communist and Left-wing artists and writers were not slow to express their displeasure with the arrogant and suspect exile.

When a favorable review of *The Revenge for Love* by Rebecca Citkowitz, a follower of Trotsky, was rejected by the *New International*, Lewis once again felt victimized by a conspiratorial boycott which recalled Campbell's rejected review of *The Apes of God*. He met the author, who resembled a youthful but unaffected Virginia Woolf, and valued her friendship. The artistic competition in New York was intensified by the influx of anti-Nazi refugees who naturally received more sympathetic treatment than Lewis. He failed to sell any of the books that had appeared in the 1930s, published nothing in American magazines between 1940 and 1945, made no arrangements with any gallery to handle his paintings and received only three invitations to lecture.

When Iris Barry (who had also bought his drawings) failed to place the satirical novel he had finished in America, he vented his spleen on her, made idle threats, and expressed a new vein of self-pity that characterized his pathetically weak position in North America: "You prefer to be as unpleasant as possible, and of course this is a good way of insulting and annoying me, so adding to the general discomfort of my situation. If you don't answer pretty soon I shall write to the Authors Society. . . . Remember, I will show up your bad behaviour. You are kicking an artist when he is down. You are a very bad old girl and a fearful humbug."[9]

4

Lewis' hopeless and depressing existence in New York was broken by three brief but pleasant interludes in Connecticut, Virginia and Massachusetts, which he described in *America, I Presume*. In December 1939 Lewis met the young writer Geoffrey Stone at the house of Philip Johnson, who was curator of architecture at the Museum of Modern Art. Stone, a great admirer of Lewis, had written favorable reviews of *The Apes of God* and *Left Wings Over Europe* as well as two long essays on "The Ideas of Wyndham Lewis" in the conservative *American Review* in 1933. Stone invited Lewis to come to his farm, "Sheepfold," in Bethlehem, Connecticut and do drawings of himself and his wife, Dora, for which he paid $250. Lewis had not mentioned his own wife, and appeared alone after Christmas. He stayed with the Stones for two days, admired the Brueghelesque beauty of the wintry landscape, and then frankly said he had wanted to see their home before bringing his wife. He returned to New York to fetch Froanna, and returned in time for the New Year's Eve party described in chapter 18 of that book.

Dora Stone recalled that Lewis, who was even more guarded and reticent in America, "never spoke about himself; his whole interest was concentrated on those around him and he had a talent for drawing people out. My husband, who was very reserved & quiet, under the probing of Lewis, kept us highly amused and entertained." And Geoffrey Stone, who was Catholic, recorded a conversation with Lewis about religion and an incident that revealed the power of his imagination:

Lewis and I certainly discussed religious questions very infrequently, but one comment of his on these matters stays in memory: he said that the Christian dogma he particularly could not accept—rather oddly, it seemed to me, for someone who preferred "a solid aspect rather than a gaseous"—was the resurrection of the body, and this he asked me, as if he were somehow ashamed of it, not to tell anybody. But I did gain the impression that he was, so far as it is possible to be, nonreligious; he was not actively unsympathetic to religious experience in others; he just had no notion of what it was about. . . .

One fall evening in 1940 when Lewis and I were driving through swirling mists caused by low-lying clouds on the Connecticut hills, he saw a submarine following us, manned by the silent and determined enemies of the Enemy. Perhaps because the drive was in the interval between cocktails and dinner, I am now forlornly vague about the details of that subaqueous chase, reported by Lewis as they occurred, but I do recall that they were as real and unearthly as anything in *The Human Age*.[10]

In about December 1939, the month he met Geoffrey Stone, Lewis was invited to give a lecture at the Foxcroft School in Middleberg, Virginia. He was driven westward from Washington[11] (where he had

renewed his acquaintance with Alice Roosevelt Longworth) to the luxurious school in the Shenandoah Valley that he called Blue Hill in *America, I Presume*: "There were more than one hundred young things at this school and it was said that each had her own horse. . . . The school personnel would have to be almost as numerous as the pupils. What with the riding instructors, gym instructors, the stablehands, the cooks and maids, not to mention the mistresses, it was a busy place. . . . [The] lecture was delivered in a very sizeable hall. Many of the mistresses were there and some of the refugee teachers asked very pertinent questions. . . . After the performance there was much applause, and bands of willowy, trousered young things of from fifteen to nineteen crowded round with autograph books."

After returning to New York in January 1940 from his visits to Connecticut and Virginia, pleased and flattered by the enthusiastic response of the rich and beautiful girls, Lewis, with Aldington and Padraic Colum, attended the dinner of the Poetry Society of America at the Biltmore Hotel. He was also asked to lecture at Columbia University on "Should American Art Differ from European Art?"; and invited by Theodore Spencer to read from *One-Way Song* and speak at Harvard on January 25 about "Satire and Contemporary Poetry." Lewis, who had not visited Harvard since he had stayed with Joseph Alsop in November 1931, found genteel Boston a pleasant change from the cold hostility of New York: "In Beacon Street I felt, almost, that I was home again. Almost! England has moved on a little since the days when it was *quite* like Boston. Bostonians are very charming indeed, in a Quakerish, old-maidish sort of way: hospitable, as everywhere else, in America, and glad to see an Englishman, with whom they feel great kinship."

Professor Harry Levin, whom Lewis later attacked in *Rude Assignment* for his praise of Joyce and criticism of *Time and Western Man*, remembered that Lewis was forceful in maintaining the importance of Marinetti, but was not an effective speaker:

There was no public lecture—only an informal talk in the Junior Common Room of Eliot House, which had been arranged by his host, Theodore Spencer. Emphatically but rather joylessly he read a paper on satire, much of which had found its way into *Men Without Art*. It was punctuated by the thumping asseveration, "Satire is good!" and included some mention of the so-called "taxi-cab driver's test" as applied to *Point Counter Point*. Most of his hearers took it [like his criticism of Picasso] as a rather peevish denunciation of his more successful contemporaries. . . . [When told that Joyce had thrown *Stephen Hero* into the fire and Mrs. Joyce had rescued it,] Lewis said he thought it would be more probable if Mrs. Joyce had thrown it in the fire and Joyce had rescued it. . . .

He spent one evening at my house with Spencer, F. O. Matthiessen and

myself, who were planning a new course on literature and society. I remember asking him a number of questions about Joyce, to which he responded in friendly fashion. He seems to have forgotten this brief acquaintance, when he devoted an unfriendly chapter to me in one of his autobiographical books.[12]

5

Lewis found one more benefactor in New York before he was forced to concede defeat and withdraw to Toronto. The handsome and wealthy John Jermain Slocum had been a Harvard classmate of Pound's publisher, James Laughlin, who thought his friend might be able to help Lewis. Slocum, who was then a literary agent (and later became a career diplomat and bibliographer of Joyce), met Lewis in the spring of 1940 at the Harvard Club in New York. Lewis sat with his back to the wall, insisted "I have enemies," and explained he was having great difficulty surviving in the ruthless city. Slocum was repelled by his rotting teeth and mercenary motives, but admired Lewis' work and attempted to help him. He introduced him to his client Henry Miller, commissioned a portrait, lent him four or five hundred dollars (which Lewis never repaid), and provided a summer residence, the "John Jermain House" on Main Street in Sag Harbor, a lovely beach town at the tip of Long Island. Lewis lived there on thirty dollars a week from about June to October 1940, rented a studio at 86A Isabella Street and completed *The Vulgar Streak*.[13]

Vincent Penhale, the hero of *The Vulgar Streak*, which Lewis started in England, was similar in background, physique, character and behavior to Lewis' fascinating friend A. J. A. Symons, who died four months before the novel was published. Both disguised their impoverished background, constructed a mysterious past history, created a false image of themselves, adopted the dress, mannerisms and speech of the upper class. Both were tall, dark, vital and well-proportioned men. Both were original, talented dilettantes and pseudo-artists who loved to gamble and who passed off counterfeit signatures and money as the real thing. Both were consummate actors who felt a conflict between the dual image of their real and created identity. Both felt their obscure origin and lack of money restricted their freedom and prevented artistic achievement.

The Vulgar Streak is not, as Lewis claimed in a letter, a novel about a man of "power, force and action," for Vincent's only action is acting. He is really a passive character who was "branded on the tongue" by his working-class speech and oppressed by the class system. He confesses twice, is arrested twice, is discovered passing counterfeit money, loses his father and his wife, is virtually blackmailed by Halvorsen, is charged

as an accessory to murder and finally hangs himself. The real Fascist of the novel is Tandish, who exposes Vincent's crime, seeks out Halvorsen and is murdered by him.

The novel opens in Venice, which Lewis visited with Nancy Cunard in October 1922, and is structured by the deaths of four people: Vincent's father; Dougal Tandish; Vincent's wife, April, who dies from a hemorrhage while pregnant; and Vincent, who pins a note on his chest that says: "Whoever finds this body, may do what they like with it. *I* don't want it." These deaths are foreshadowed by the symbolic central image of the novel: a painting, "alive with passion and intrigue," which Vincent sees in a shop window soon after the novel begins and which reveals "A sinisterly darkened lofty apartment, into which a crowd of small masked figures had just poured themselves, gathered in a dark palaver. They had gone inside, into this empty room in some tarnished palace, to set up a dark whisper. Then later, when the maskers had dispersed, probably in a moonlit salizzade or streetlet, a long dagger would flash, a little masked figure would fall, crumpling up like a puppet. Expectant and intent, they crowded their masked faces together."[14]

Lewis' description of Francesco Guardi's *Il Ridotto* (The Parlour), which he had seen in the Museo Correr in Ca' Rezzonico, makes the picture seem much more sinister and foreboding than it actually is. For the painting depicts a large group of elegantly dressed men and women who are flirting and playing music at the Palazzo Dandolo in San Moisè, while two men are gambling at a table (a minor theme in the novel) and a flower girl is being courted by a masked man in a black cape. Though the painting is joyous, Lewis, who was fascinated by disguise and by vengeance, used it to convey the threatening menace beneath the surface gaiety of Venice. Vincent recalls the picture when he is arrested by the Italian police in his hotel.

Though *The Vulgar Streak* has faults—the melodramatic plot, the didactic theme, the one dimensional characters, the undeveloped ideas —it is, nevertheless, a lively and intelligent novel that bears the impress of Lewis' mind and style. It was brought out in London in December 1941 (when the United States entered the War), but American editors thought it was inappropriate to publish an attack on the English class-structure while Britain was fighting the Nazis. Lewis' egoism and desperation prevented him from seeing their point of view; and when Slocum failed to place the novel, he blamed him (as he had blamed Iris Barry), referred to his partner Diarmuid Russell, the son of George Russell ("A.E."), as a "damn afterthought of the Celtic movement," and angrily withdrew the book. He had also failed to place *Snooty Baronet* and *The Revenge for Love*, and did not attempt to publish another novel until 1954.

Lewis found New York a grim and abstract metropolis, a malignant blank wall, and said his exile in America had been the worst part of his life—except for the years of illness. When his one-year American visa, which had been extended for two months, expired in November 1940, he decided not to apply for American citizenship and was forced to retreat to Toronto. He exchanged a "stony desert" for a "sanctimonious ice-box," and his next three years were even more painful and unhappy than his "nightmarish" experiences in New York.

CHAPTER SIXTEEN

Toronto, 1940–1943

I

Lewis met the small group of benefactors who sustained him during his grim years in Toronto through John Reid, soon after he arrived in North America. On November 30, 1939, before moving from Buffalo to New York City, Lewis returned to Toronto to attend a dinner-party at the York Club that was arranged by Terence MacDermott, the headmaster of Upper Canada College, and Douglas Duncan, a patron of the arts and founder of the Picture Loan Society. The guests included Reid, Charles Comfort and Alex Jackson, the Canadian painters, and Stanley McLean, the millionaire owner of Canada Meat Packers. Though some of the guests were depressed about Russia's invasion of Finland, Lewis was in a jovial mood.

On the same momentous day, while these men were gathering to help Lewis, he was also invited by Burgon Bickersteth, the Warden of Hart House—the Men's Union of the University of Toronto—to inspect that ultra-British establishment, a towering Gothic pile of spurious antiquity, where the faculty dined with formality and ritual at High Table in a Great Hall. Lewis disliked the infantile yet pompous enthusiasm of the Warden, whom he satirized as Brandleboyes (like "Dotheboys" in *Nicholas Nickleby*) in the chapter "I Dine with the Warden" in *America, I Presume*. Lewis noted that the Warden used to spend all his summers with the Hitler *Jugend*; and suggested that he took an unnatural, not to say homosexual, interest in the naked athletes who disported themselves under his benign authority.

Hugh Kenner said that though Lewis imputed the homosexual diagnosis rather freely, he depicted the celibate Bickersteth (whose nickname was "Liquorbreath") with remarkable accuracy. But John Reid took the opposite view and wrote: "Bickersteth was not a fool in the *America, I Presume* sense; he was one of those effete Englishmen whose manners resemble some homosexuals; but I have no direct knowledge that he was a homosexual. He didn't in any way resemble the portrait in *America*. Think of a YMCA type who happens to be English and an enthusiast about his own job."

Lewis' satiric portrait, whether accurate or distorted, offended many Canadians at the University of Toronto. Though he later attempted to soften the effect by calling his work "a hymn of praise, couched in burlesque," the university virtually ignored his existence when he returned to Toronto—three months after the book was published. In Toronto, as in Buffalo, Lewis intensified provincial indifference to the arts by tactless provocations which eradicated the initial good will and extinguished his slight chances of success. Despite the hostility he aroused, he did have some contact with the university, for Northrop Frye remembered hearing Lewis tell a tall story (served up for the Canadian audience) about his aboriginal origins: "Lewis was a large man, with an imposing physical presence, which made it easy for him to break out of any conversation that bored him. The only thing I remember discussing with him was his telling me that he was of partly Indian ancestry. I remarked that this threw a different light on *Paleface*, and he said that he didn't know himself about his Indian ancestry when he wrote the book. It is true that Lewis saw very little of the university, and if his career in Canada was a failure, I think it was the result of a rather perverse determination to make it so. I dare say that *Self Condemned* does reflect his attitude toward Canada, but that attitude was almost a caricature of the visiting Englishman in the Colonies."[1]

One year after his visit to Hart House and dinner at the York Club, Lewis was forced back to Toronto and moved into Apartment 11A of the Tudor Hotel at 559 Sherbourne Street, quite near the university. The hotel, a dreary replica of an English manor house, has now been replaced by a high-rise building. Lewis paid $14 a week for one big, shabby, cockroach-infested bed-sitting-room, with kitchen and bath; and lived in that cheap "interim dwelling" for two and a half years. Froanna usually sat on the chintz-covered sofa while Lewis assumed a characteristic posture at the edge of a straight chair, leaning forward, a cigarette stuck to his lower lip, his hands clasped between spread knees. At the beginning of his stay the hotel was a sedate and quiet place, but as the war progressed and it became filled with soldiers, the atmosphere became more tumultuous and violent, with heavy drinking and frequent fist fights in "The Sahara Room." Lewis called his reluctant residence "my Tudor period."

Lewis' grandfather Shebuel had married a French-Canadian, Caroline Romaine; and in 1852 her brother Charles had erected a now blackened pile, plastered with statues, which gave Lewis a sort of sentimental footing in Toronto. When he came to the city he looked up his distant relations, thought his cousin Pierette Romaine was "good value," and went to the funeral when one relative died. Soon after he had settled into the Tudor he told Geoffrey Stone, with appropriate caution and irony: "This seems a 'land of opportunity': though of

course one's problem is to keep calm while this or that opportunity is pruned down and secured to one."

2

Lewis moved from a partial eclipse in New York to a total eclipse in Toronto, where he had no reputation and was almost reduced to non-existence. His appearance in that city resembled his arrival in London in 1908 as the man without a past—for Canadians ignored his thirty years of creative achievement. He was forced to re-create, almost from nothing, Wyndham Lewis the Artist: From *Blast* to Burlington House —if not for his own advantage, then for the cultural benefit of Toronto.

At first there were some promising possibilities, and he began his stay with guarded optimism. On December 12, 1940, he gave the first of three talks on the CBC. Early in 1941 he went unannounced to the office of Dr. Lorne Pierce, the director of the Ryerson Press, and said he wanted to sketch his portrait in crayon. Pierce claimed he had no time to pose, but Lewis persuaded him to do so. This bold approach led to a contract for *Anglosaxony*, a small wartime propaganda book on the British Commonwealth in which Lewis reversed the ideas of *The Art of Being Ruled*, defended the democratic ideal against Left- and Right-wing critics, and rather blandly argued: "Democracy is merely a name for the Anglo-Saxon peoples, and their traditional way of behaving." The book was published in June 1941, fell completely flat, sold only 300 copies in the next three years and may have been pulped—for it is now unobtainable. Three months after the appearance of *Anglosaxony*, B. K. Sandwell, the editor of the leading Canadian weekly, *Saturday Night*, commissioned Lewis to write the first of four articles on the English in war and, knowing he was impoverished, paid him double the normal rates.

Lorne Pierce recalled, in a perceptive letter about Lewis' uneasy attitude toward Canada: "He had come to Toronto with his wife, and was very restless, critical of Toronto, and, I seem to recall, the world, if not indeed the cosmos! He was uprooted, and wanted the friends he had known, and the opponents even, of the Old World. Canada, immersed in the tension and confusion of the War, its cultural life in a sense 'organized for victory,' had little time for the amenities. There were few small groups in which he felt at home, and, badgered constantly over funds, and the business of sitting it out in Canada until Peace, he was not at peace in his turbulent soul. His quarters were not to his liking, the rooms, and their care, likewise the food. He had a low opinion of authors and artists everywhere. They were all hollow men, recreant, two unforgivable sins!"[2]

As Lewis' winter of discontent continued, his situation deteriorated
and his hatred increased. He regarded himself as "tolerant and catholic
almost to a fault" and claimed he was forced to spend his life disarming
and reassuring people who expected the Enemy to explode in their
faces. But if Lewis arrived as the self-created Enemy, his disturbing
influence continued to be felt; and part of his problem was certainly due
to his own rude behavior. He was deprived of the social stimulus of his
friends in London; and found the intense loneliness, boredom and dull-
ness of life in Canada particularly difficult to bear after attracting a
vortex of controversy for twenty-five years. The civilized world seemed
permanently inaccessible, and he began to feel like a trapped animal.
He complained of impotence and wasted hours, and, like an arctic
Blanche Du Bois, was always dependent on the kindness of strangers.
He was quick to express his resentment; and Morley Callaghan, who
had known Lewis in Paris and saw him in Toronto, admitted: "It is
true that Wyndham Lewis was a difficult man to meet. He was so self-
conscious, so worried that his importance would not be recognised, that
he was always ill at ease and without any grace of manner."

Lewis complained that he was practically unknown in Canada and, at
the same time, that his great reputation made the natives sniff at him
suspiciously—as if there were something degrading about his being in
Canada (there was!), instead of in his natural habitat. "Wyndham Lewis
was a highly intelligent, witty, interesting English eccentric," wrote
Edgar Richardson, the assistant director of the Detroit Institute of Arts.
"He had it in his mind that Canada was an arctic country and would
come over from Windsor on a mild winter day . . . wrapped in a great-
coat, sweaters, mufflers, galoshes, as if in the climate of the Klondike.
Nothing could make him believe that life in Canada was not rigorous,
dangerous, unfriendly. . . . The Canadians at that time were resentful
of being thought provincials and thought the English snooty and
patronizing. Lewis came to Canada expecting, I believe, that a person-
ality of the London intellectual world would be received as a great man.
'It seems,' he said with an expression of distaste and disbelief, 'that
there is such a thing as Canadian nationalism.' " D. G. Creighton, a
Professor of History at the University of Toronto, explained why Lewis
was greeted with a certain suspicion and expressed the widespread
resentment about his portrayal of the city in *Self Condemned*: "Lewis
met relatively few people in Toronto, and avenged the hospitalities
which he did receive in a characteristic English fashion, by being rude
to his hosts at the time and by sneering at them after he left Canada."[3]
Lewis was, at least, consistent.

Froanna, by contrast, felt liberated after twenty years of involuntary
seclusion, liked the friendliness of the people she met, enjoyed the more
informal social life, recalled that the years in America were the happiest

period of her married life and said that Toronto was "great fun," despite their lack of funds. In 1942 she applied for work in a sewing factory, but lacked experience with the machines and was not hired. While Lewis was painting, she would sit in a corner reading what he called "penny dreadfuls." In Canada, she could not be forced out of their one-room flat and was glad to have Lewis entirely to herself.

After the first year, when Lewis' prospects were exhausted, his luck turned bad in both Canada and England. In September 1941 he took an expensive but abortive trip to Halifax, Nova Scotia, in quest of a portrait; and in October had serious eye trouble and was threatened with blindness. A. J. A. Symons and Desmond Flower had, in the 1930s, introduced Lewis to Viscount Carlow, who admired his work and began to collect his books and manuscripts. Carlow planned to publish, at his privately owned Corvinus Press in London, Lewis' six drawings and seventeen-page essay, "The Role of Line in Art." The pamphlet, a companion to *Wyndham Lewis the Artist*, argued the historical importance of linear expression, contrasted the controlled line of the Old Masters with the absence of linear content in the Impressionists, deplored the "enfeeblement of the appetite for the linear in the present century," and exalted the tradition of "Dürer, Goya, Mantegna, and Rowlandson [who] were eminently men of line."[4] One hundred and twenty copies of this pamphlet were actually printed and publication was planned for the autumn of 1941, but the building containing the books was destroyed by bombs. When Carlow passed through Toronto on government business in April 1942 and January 1943, he suggested that Lewis illustrate "The Ancient Mariner"; but these plans also came to nothing when Carlow was killed in a plane crash in 1944. Only a small edition of *The Vulgar Streak* was published in England in December 1941, because of the wartime scarcity of paper, and the unsold stock of this book was also destroyed in the Blitz.

In the autumn of 1941, as winter approached and Lewis could find no work as a writer, painter, journalist, lecturer or professor, he began to express his bitter resentment of Toronto. The city reminded him of Archangel and Murmansk, had barren bookstores whose "clients were practically Eskimos," seemed to contain the "dumbest English-speaking population anywhere" in the world, and needed at least two million Jews to bring it to life. He particularly despised the asphyxiating godliness of the Presbyterians and Methodists, who created "a reign of terror for the toper and the whoremaster" and forced him to grovel "before the ugly teetotal Baal set-up in these parts by the most parochial nationette on earth." As he told Alfred Barr: "If New York is brutal and babylonian, in this place it is as if some one were sitting on your chest— having taken care to gag you first—and were croaking out [hymns by] Moody and Sankey from dawn to dayshut." Though Lewis desperately

wanted to go back to England, he could barely earn enough money to pay for food and rent, let alone save the $700 necessary for two ship tickets. It was impossible to transfer money from England because Canada was outside the sterling area; and as the War progressed, new regulations prohibited women from travelling to England. Lewis was forced to remain fossilized in Canada till the end of the War.

In order to convey the sensation of unreality in the appallingly incompatible city, where the subject of war was strangely taboo, Lewis invented a fantasy (similar to the one he had created for Geoffrey Stone about the "submarine chase") in which a military tank suddenly opened fire and destroyed the mute, phlegmatic population: "A tank moved down the street and as it was abreast a group of people, myself among them, waiting to cross the road, it let fly at a range of fifteen feet with a quite sizeable little cannon it had hidden in its flank. Its red flash darted at us, there was a deafening roar, the tank stopped and rocked. —I saw the first tank-attack at the battle of Messines [in November 1917]: but in Bloor Street I was more deeply astonished. The monster rumbled on, firing at us as it went at shoppers. No one took the slightest notice. That was what was so queer. I got the feeling that something unreal was happening: and it was the people who gave it me."[5]

Lewis, who thrived on opposition and could not stand indifference, needed an Enemy to account for his failures and bear his resentment. In 1941, in the blustering streets of Toronto, he suddenly turned on Reid (who was then working for *Saturday Night*), blamed him for all his misfortunes and accused him of spreading malicious stories about his past life in England. They exchanged acrimonious letters, and in July Reid's lawyer demanded the immediate return of the dust-jacket of *The Apes of God* and the book by Porteus that Lewis had borrowed. Like so many of his bitter disputes—including the one with the Sitwells—this quarrel ended in a kind of reconciliation, when Lewis answered the accusations of Reid (who suffered from nosebleeds, like Dan Boleyn) with a defiant counterattack: "I have never had anything against you, by the way, except that you seemed inclined to blame me for your misfortunes. I mean [anything] serious. Just thought you lacked understanding at times and your nose bled too often. So don't regard me as a person who is on bad terms with you."

The state of Lewis' desperation in Toronto was revealed in the strange correspondence that began in mid-1942 with a letter from the enthusiastic young disciple and would-be writer, David Kahma. Kahma, who had abundant epistolary energy but absolutely no literary talent (even Lewis could not teach him how to write), hoped to establish a kind of intellectual center in Vancouver and wanted Lewis to be the star attraction. Though he had no money, he counted on receiving an inheritance. After only a few weeks the entire scheme had shrunk to an invitation for

Lewis and Froanna to live as his guests in Vancouver. But even the train fare for this very modest proposal was not forthcoming, and the correspondence soon lapsed. It was later revived when Kahma began to send food parcels to Lewis to alleviate the austerities of postwar England, and Lewis responded with serious and kind-hearted criticism of Kahma's mountain of manuscripts. W. K. Rose tolerantly called this correspondence (for they never met) "one of the most curious and touching relationships of Lewis' later life."[6] It could be more accurately characterized as a cruel deception practiced by a nonentity upon an intellectual giant, who was reduced to penury, gulled by false hope and unable to ignore any possibility—however remote or pathetic.

The most dramatic event of Lewis' stay in Toronto was the great fire that broke out in the Tudor Hotel while Lewis was having breakfast on the morning of February 15, 1943, and was not extinguished until the end of the day. Lewis received some attention—perhaps for the first time in that city—when he appeared in the headlines of the *Toronto Star* that day:

60 DRIVEN TO ICY STREETS/FIRE SWEEPS TUDOR HOTEL. NOVELIST-ARTIST LOSES VALUABLE PAINTINGS AND UNFINISHED MANUSCRIPTS. FIREMEN AID MANY. Sixty persons, most of them in house slippers and with overcoats thrown over their night clothes, escaped unhurt today when a $200,000 two-alarm fire swept through the Tudor Hotel, Sherbourne Street. Many guests were awakened by ice-coated firemen who helped them to safety down a slippery fire escape ladder at the south of the building, once the home of [the financier and soldier] Sir Henry Pellatt. Other occupants fled down aerial ladders. The fire . . . broke out in the furnace room and mushroomed through two floors with lightning speed. Most of the guests were sleeping in an annex in the rear.

The greatest personal loss was suffered by the English novelist and painter, Wyndham Lewis, who fled with his wife, leaving behind two valuable portraits, two unfinished manuscripts, and hundreds of books.

Lewis probably invented the story of his "personal loss" to gain sympathy and compensation, for Froanna wrote that there was sufficient time for the incredulous guests to leave the building and that "Some lost all their possessions and were left penniless." But neither she nor Lewis ever mentioned what would have been a staggering loss, and she specifically said that his box in the basement of the hotel was saved from the flames.

After the fire, Lewis and Froanna moved across the street to temporary lodgings in the Shelby Hotel, where they received a message that their cheerful and sensitive friend Effie, the manager of the Tudor, had died from the effects of the blaze. Lewis was back in the rear part of the Tudor by March 4; and at the end of the month he gave Eric Kennington a lively account of the conflagration: "The hotel burned

down six weeks ago, all but the annexe. I am living in the ruins. It was
30 degrees below zero at the time of the fire. The cold was so great it
made the firemen's noses bleed, icicles hung from their eyelashes—their
moustaches froze. While the fire was raging over the front furnace, I
and another man went for warmth into the rear furnace room, which
was full of smoke but *warm*."[7]

3

In Toronto, Lewis rented a studio at 22 Grenville Street and survived
mainly by his painting. Though this work also involved considerable
difficulties, he was helped by Alex Jackson, and supported by the only
two indigenous patrons of the arts: Douglas Duncan and Stanley
McLean. Lewis, whose *Canadian Gun Pit* was owned by the National
Gallery in Ottawa, had first met Jackson during the Great War when
they were both working as Canadian War Artists. When Lewis came to
Canada in 1940, he renewed his acquaintance with Jackson and saw him
frequently. Jackson (like Callaghan) admired Lewis' imagination and
wit, and emphasized his extreme self-consciousness and sensitivity. For
he often asked Jackson what people had privately said about his work and
was easily offended: "Lewis had a good sense of humour, but a bitter
pen. He was a gentleman. He was very brilliant—an outstanding artist
and a very fine writer. Yet he was never vain. He was witty, but not
funny. His wit had a biting, critical quality. I liked Wyndham Lewis. I
was always glad to see him. He was an entertaining conversationalist
and he knew many of the celebrities of his time. . . . Lewis had a tooth
missing in the front. One night at a Stanley McLean party at the York
Club, Charles Comfort did a caricature of him and greatly exaggerated
the missing tooth. Lewis was very upset about the caricature. A while
later, he cut Comfort dead on a train coming from Ottawa." Lewis
clearly found Jackson a congenial colleague and companion, and praised
his paintings in the *Listener* of August 29, 1946. "I was accorded a royal
welcome" by Jackson, he wrote appreciatively in his essay "On Canada."
"He received me, coming from a foreign milieu, like a brother. He has
shown me every courtesy, and with the greatest friendliness helped me
on my sometimes perilous way."

Douglas Duncan, the son of the President of Provincial Paper Ltd.,
was born in Michigan in 1902, graduated from the University of
Toronto, and lived in Paris in the late 1920s, where he cultivated his
strain of civilized romanticism and elegant irony. He returned to
Toronto in 1928 and established himself as a custom bookbinder.
Duncan was a rather bizarre looking bachelor, 6 feet 2 inches tall, with
a carbuncular face and enormous restless hands—like Homer Simpson

in West's *Day of the Locust*. He would generously put artists on a
retainer fee or pay them a salary for acting as his assistant; and then,
because of embarrassment about his wealth and their debts, would make
every attempt to avoid them in the street. Reid wrote that "Duncan
came from a wealthy west coast Canadian family and started the Picture
Loan Society: rent a painting by the month and buy if you wish. His
name was given to Lewis by a friend of mine in London. Duncan paid
Lewis a regular monthly stipend and deducted what Lewis owed him
whenever a painting was sold. It took years to sell them all as the art
circles here were left-wing and they couldn't forget *Hitler*. He was
conscientious about supporting Lewis, and that's the important thing."[8]
Though Duncan supported Lewis, he also acquired—for very modest
prices—an enormous collection of his paintings and drawings.

Duncan was a close friend of Stanley McLean who—when Lewis
first came to Toronto—arranged for Lewis to do portraits of himself
(commissioned by the staff of Canada Packers), his daughter and Mrs.
R. J. Sainsbury. But Lewis lost this promising opportunity to display
his ability by executing a commonplace portrait of McLean and making
his daughter into a wooden figure with a grotesque nose. Jackson wrote
that the portrait of McLean "was not a good likeness and the staff were
very disappointed. I think this was the cause of a lot of his difficulties."
Lewis did a "really fine portrait of Mrs. McLean [? Mrs. Sainsbury],
who was a lovely woman. But when he painted McLean's daughter,
Mary, he dwelt on her bad points and the portrait was quite cruel.
Mary didn't like Wyndham Lewis and he didn't like her. All his dislike
showed in the portrait. My impression was that Stanley McLean was
Lewis' chief means of support while he was in Canada. I think McLean
provided him with at least a living allowance. Lewis didn't write while
he was here." After McLean's first commissions, Lewis received no
more requests for oil portraits until 1944, when he painted Pauline
Bondy in Windsor, Ontario.

The personal and financial problems of portrait painting, Lewis'
intense resentment of his dependent position and his barely repressed
antagonism to his rich sitters, were vividly illustrated in a letter of
September 1941 about his trip to Halifax, Nova Scotia: "I went down
to the Maritimes to the sumptuous 'home' of the magnate to paint there
the magnate (if he was well enough) but primarily the manager, who was
visiting him. But the magnate had a doctor in attendance: and the doctor,
after a day or so, said he mustn't sit. The manager hadn't arrived yet.
Then the secretary informed me that the magnate (who had had a
breakdown) was 'trying to run before he could walk' and could not sit
for about a month. . . . So far I have got no elucidation from the bedside
of the ailing magnate back in the Maritimes. *And* I have spent a hell of
a lot of money on making myself respectable—a new suit, and all other

requisites of attire for personal attendance upon the great ones of this bloody earth! (This quite apart from canvases, paints, travelling expenses)."[9]

The difficulties of securing commissions and painting the portraits were more than matched by the problem of pleasing the vanity of the sitters. In New York, the competition had been intense and all the potential sitters had been painted again and again by relays of hungry *émigrés*. In Toronto, Lewis thought, the opulent Methodists felt reasonably comfortable with dead painters but had a deep-rooted suspicion of contemporary artists, particularly himself; and the rival nationalist painters were ruthless in their attempts to eliminate all foreign competition: "If Bellini or Goya came to Toronto they would probably be regarded as 'reds' or 'bums'. . . . A *live* artist terrifies that gentry nearly out of their wits, when they browse comatosely in their offices. . . . You cannot paint many portraits here. If you escape assassination at the hands of the enraged artists after the first, you may paint a couple more, then the *sitters* strike. I have painted four: half the artists won't speak to me, and the sitters all feel I am a smart Englishman who has put something over on them, they don't quite know what. Yet they all flattered their subjects."[10]

Though Lewis eagerly sought commissioned portraits, he disliked doing them. Few of the sitters, who were less stimulating and intelligent than their English counterparts, would tolerate his piercing scrutiny. They refused to recognize that he was a serious artist and asked him to make basic alterations to his work. Most of them wanted shorter noses and stronger chins, and thought they should look like film stars. When one Canadian businessman asked Lewis to act as cosmetic mortician, Lewis became enraged and demanded: "What's your chin? What's it like? Come on, you tell me!" Needless to say, this did not endear him to his employers any more than his caricature of their daughters. Lewis found from his painful experience with Lady Glenapp and numerous other patrons that sitters were apt to be very nice—right up to the final sitting.

He portrayed the bitter conflict between imaginative fidelity and practical reality in *The Revenge for Love*, when Victor Stamp asked Tristram Phipps:

"Have you ever done a portrait of a fashionable woman, or a fashionable man?"

"I did once. A woman." Tristy smiled, "Never again!"

"If you're getting a big sum for it," Stamp said, "it's a hell of a moment when the time comes to tell them that the thing is finished. To watch their faces gives me a pain in the stomach, I always turn my back."

And in *Rude Assignment*, Lewis summarized a lifetime's experience without reconciling the opposition of the artist's vision and the sitter's

demands: "What average persons, in our time, think of as the *truth* about themselves, pictorially (and what goes for the face goes for the spirit too), is, as a minimum, something with all their weak points omitted. . . . What the eye sees is for them a caricature. You are, as an artist, either incompetent, or 'cruel', if you remain upon the objective plane."[11] All these negative factors—the scarcity of commissions, the suspicious attitude toward artists, the hostile Canadian milieu, the unsympathetic subjects as well as his own poverty, depression, sense of alienation, lack of inspiration and deteriorating vision—led to an astonishing decline in Lewis' artistic powers. Within a year, he moved from the penetrating and profound portraits of Eliot, Spender and Pound to the stiff and lifeless figures of Capen and the McLeans.

Lewis' most important commission during his years in Canada came from England, and this too was freighted with frustrations. The artists scheme of the Great War had been revived during World War Two and Sir Kenneth Clark, the director of the National Gallery, was appointed chairman of the War Artists Advisory Committee. When Lewis heard about this plan he asked Henry Moore (whose work he had praised on television in 1939) to approach Clark and arrange for Lewis to join the scheme and portray Canada's industrial war effort. In July 1942 Clark sent Lewis an invitation: "The War Artists Committee are most anxious to employ you; indeed you were one of the first artists we thought of, and if you had been in England there would have been plenty for you to do. I very much admired your pictures in the last war and was spoken to very severely by my drawing master for trying to imitate them."

Despite Clark's friendliness, Lewis may well have been irritated by the painful irony of "if you had been in England" and by the somewhat tactless witticism about the drawing master. Though Lewis thanked Clark for the cordial reception of his proposal, he thought the proffered fee of one hundred guineas was too small (he had received £250 for each of his paintings in the Great War) and that he should be paid in advance. After further deliberations, difficulties and delays, the fee was raised to £300, the rules were stretched and half the money was paid to Lewis in Canada—before he began the painting.

After obtaining the necessary security clearance, Lewis spent six weeks sketching the Anaconda Brass Works outside Toronto. He found it difficult to see because of the smoke and the darkness; the workers, who refused to believe he was an artist, suspected he was a safety inspector. In March 1943 he wrote enthusiastically about the project: "Here I am working all the time in the factories. . . . I am painting a line of furnaces serviced by an infernal personnel (mainly Central European and Russian). Then in another place I am working on a monster having a solitary claw and which goes up to a furnace, thrusts

its claw inside, and draws out a huge jar full of molten glass. . . . A most rugged subject, full of the apparatus of industry, which by screeching and roaring stages becomes in due course the apparatus of war."

Lewis was unable to complete the painting after he had accepted a teaching position at Assumption College in Windsor, and had to prepare for the courses which began in June 1943. But in July he claimed the painting was finished and was paid the last half of the fee. The following year the War Artists Committee began to press him for the finished work. In a long and reasonable letter of February 1944, Clark explained to Lewis' intermediary, Augustus John, that the commission had neither secured the painting nor enabled Lewis to return to England: "A long time ago he wrote me a number of letters describing his dismal condition, and in consequence I persuaded the War Artists Committee to give him a commission. This commission was for one picture, for which we paid him £300 to include expenses for 100 days. We had great difficulty in getting the money paid [because of wartime currency restrictions]. . . . My motives in making this arrangement were partly to secure a painting by Lewis, but I was even more anxious that he should have a sum of money large enough to allow him to return to England, where he could get a post. We have never received the picture, and as I see from your letter Wyndham Lewis seems to be no nearer to coming back to England. This is very sad, as a man of his great intellectual independence would be most valuable here at the present time; but as you will see, it is very doubtful if I can think up another pretext for sending him more money."[12]

In April Lewis confided to Malcolm MacDonald, the British High Commissioner in Canada (these negotiations were conducted at the highest level), that he had not yet completed the painting; and told the War Committee that he was unwilling to send it across the Atlantic during the War. The committee, who were furious about the non-delivery of the highly irregular pre-paid painting, said the work was now their property and they would take the risk. But Lewis clearly enjoyed tormenting the bureaucrats, and would not surrender it to them.

Lewis, who was not entirely satisfied with his painting, which he hoped to make into a first class work, complained to Eliot that the committee was demanding he send it instantly, and abusively blamed Clark for his uncomfortable situation. Clark, who was Fry's literary executor, had replaced Fry as Lewis' enemy. Lewis felt that Clark had succeeded Fry as "art dictator," symbolized the iniquities of the British cultural establishment, and personified all the smooth operators—the patrons, middlemen and bureaucrats of art—who creamed off the power and money at the expense of genuine artists like himself.

On August 17, 1943, overwhelmed with misery and unable to escape, Lewis expressed his unrealistic hopes for an official position and his fear

that his enemies would make things equally difficult for him when he finally managed to get back to England: "I will not ever return to my hand-to-mouth existence in London. I have a great horror of it. I have a natural dislike of being patronised by sleek gentlemen for whom the Fine Arts is a fine lucrative official assignment, and the road up to the social summits for the clever climber." On the same day Lewis also wrote to Augustus John about the possibilities of work in England and took another swipe at Clark, who had a private income from textile mills in Scotland and was then Surveyor of the King's Pictures: "How about 'Keeper of the People's Pictures'? We've got a 'Keeper of the King's'. I think it's absurd that because I don't have a cotton-mill I can't 'keep' something."[13]

Lewis' unpublished letters are filled with libellous references to Clark, who Lewis felt had not helped him sufficiently in the War Artists scheme and had secretly conspired against him. Clark's recollections reveal that he genuinely tried to help Lewis and was irritated when Lewis (who dispelled his anger in writing and was almost never personally hostile) failed to produce the painting: "I hardly knew Wyndham Lewis, but greatly admired his writing. I did not know that he thought of me as an enemy—he was quite friendly when we met. I think he was a man of great intelligence, but not a natural painter. He would not let himself receive sensuous impressions. But because of his intelligence, he was better than most of his English contemporaries. . . . I remember that we made great efforts to get a picture out of Wyndham Lewis during the last war. . . . I remember that he made it very difficult for us, and finally we had to give up hope. I never saw the picture, and did not know that it had ever got as far as a sketch. Certainly nothing was ever sent to us." On November 28, 1944, Clark privately noted on a letter from MacDonald: "I fear that we have simply been swindled."[14]

Though Lewis was mistaken about Clark's attitude toward himself, Clark was wrong about Lewis' fulfillment of his obligations. Lewis did, in fact, complete *A Canadian War Factory*—one of his finest works in North America—and gave good value for the £300. After the War, he took the painting back to England with him, and the War Artists Committee resumed their campaign to gain possession. When curators from the National Gallery came to Notting Hill Gate, Lewis failed to keep the appointment and they found his studio locked. The committee was extremely pleased when they finally saw the painting in 1946; but Lewis took it back to do more work on it and it was not delivered to the Tate Gallery until after his death in 1957.

The background of the impressive painting of the Anaconda brass factory is dominated by the vertical chimneys of three gigantic, hooded furnaces; each one, tended by a laborer, shoots out a great burst of flame. In the left foreground, a Slavic metal-worker, wearing thick

gauntlets and a protective helmet and visor, operates the levers, dangling on thick cords from the ceiling, which hoist, with a heavy chain and sickled hook, the huge metal claw that extracts from the furnace the white cylindrical case of molten glass. The blazing fires in Lewis' portrayal of the creation of war material foreshadow the destruction that will soon be inflicted on the industrial cities of Europe. The intense noise and flame and heat made a deep impression on Lewis' imagination, and influenced his account of the furnace-room fire in *Self Condemned* and the infernal Underworld of *The Human Age*.

Windsor and St. Louis, 1943–1945

I

Lewis thought that he received less material benefits—in proportion to his talent and his effort—than anyone else he knew. He insisted that he had always wasted eighty percent of his time in London trying to earn sufficient money to free him for serious work. In Toronto he spent nearly all his time attempting to raise money and to find employment—in Canada, America and England—as a painter of portraits or war factories, resident artist, art teacher, museum director, author, translator, journalist, propagandist, editor, broadcaster, lecturer, professor or administrator. He even inquired, with uncommon good humor, if someone were needed, during the Blitz, "to accouch the Zebras at the Zoo."

The Carnegie Foundation had organized and paid for an Artist-in-Residence program at American colleges, and Lewis dreamed of getting this assignment for six months or longer. All he had to do was to find a college president who would request his presence on campus, but even this proved impossible. He hoped to go to Reed College in 1941, but when America entered the War the president of Reed left to do government work in Washington and Lewis' prospects collapsed. Lewis then began negotiations with Olivet, where Pound had tried to place him, but discovered they already had a resident artist. He also tried American University, Berkeley, Chicago, Claremont, Colgate, Harvard, Maryland, Mills, St. John's-Annapolis, Sarah Lawrence and Smith, but none of these places wanted Lewis—even if he cost them nothing. He asked Auden's help in 1944, and was still applying to Bard College in 1949. He even thought of teaching and painting in Durban, South Africa, where a spark of light had emerged when the Municipal Gallery bought his portrait of Eliot. Despite his genius, Lewis' reputation was very low at this time, and the only job he ever got came unsolicited. Though Lewis felt, and indeed was, fortunate to get a position at Assumption College—for he was desperately poor and had exhausted his patrons' generosity—his sort of teaching position was held by thousands of mediocre academics all over North America.

Cecil Eustace, the author and director of Dent, who had published *The Hitler Cult* in 1939, suggested to Father Stanley Murphy that he invite Lewis to participate in the Christian Culture series of lectures, which Murphy had founded in 1934 at Assumption College. Eustace recalled: "My impression of Lewis is that of a professional *littérateur*, slightly self-important and at that time rather interested in religion and specifically in the Catholic literary scene"—in writers like Maritain and Gilson. "His attitude towards Canada was that it was a kind of cultural wilderness, I think, and he seemed surprised at the existence of St. Michael's College [in Toronto] and Assumption College in Windsor," for he believed that whatever culture existed in Canada was to be found in Quebec.

Murphy first met Lewis in Toronto in the summer of 1942, invited him to lecture on January 2 and offered a fee of $100. Lewis stayed in the best suite at the college, dined in the old refectory with the faculty and (because Assumption had no suitable auditorium) lectured on Rouault under the heading of "Religious Expression in Contemporary Art" at the Vanity Theatre on Ouellette Street in downtown Windsor. Nearly five hundred people attended the free lecture, drawn more by the fact that there was nothing else to do on a quiet Saturday night than by the fame of the speaker. The talk was a success, Lewis repeated it at Marygrove College in Detroit on about February 8, and was invited to join the faculty of Assumption for ten months, beginning June 1943, at a salary of $200 a month.[1]

Four months after the fire at the Tudor Hotel, Lewis and Froanna came to Windsor, just across the river from the skyscrapers of Detroit, and found a flat by standing on a street corner and asking people if they knew of a place to live. The Royal Apartments at 30 Ellis East, a four-mile bus ride from the college, was a somewhat deceptive address, for Apartment 2 was a dark basement flat in a dingy three-storey red-brick building. They had to leave by October 1, when the owner reclaimed the apartment; and were fortunate to discover a first-floor flat near the college, with large windows facing the Detroit River, at 1805 Sandwich Street West, where they lived for the next five months. Edgar Richardson has described an unusual dinner-party that took place in Lewis' flat: "He was not 'difficult' if he liked you and he seemed to have liked my wife and myself; but he did not mix easily. . . . Although he thought of himself as an urbane man of the world, he was such only in his own eccentric way. We had dinner with the Lewises once in their apartment, some rooms in an old house by the river in Windsor. The first course consisted of beer and Turkish delight. The bedroom where we left our wraps was strewn with the laundry. Mrs. Lewis was a blonde, plump, tranquil woman whom nothing troubled. 'That is Lewis' way,' she would say pleasantly. 'A little mad, isn't he?'"

During June and July Lewis taught a six-week summer school course on "The Philosophical Roots of Modern Art and Literature." The class met daily at 11 o'clock for fifty minutes and consisted mainly of teachers, many of them nuns. Lewis was extremely conscientious about preparing his lectures and worked on them steadily from early afternoon until midnight. He often referred to *The Art of Being Ruled* and taught *War and Peace, For Whom the Bell Tolls* and *Of Mice and Men*. Though he found Cummings' *The Enormous Room* sentimental, he thought its visual descriptiveness "exploded into passages of considerable power."

In the fall semester of 1943, Lewis repeated his philosophy of literature course and also lectured on the "ABC of the Visual Arts." He was also invited to deliver the twelve Heywood Broun Memorial Lectures at Assumption College in November and December on "The Concept of Liberty from the Founding Fathers of the USA Till Now." These talks were the basis of *America and Cosmic Man* (1948). Though Lewis had acquired a public school accent at Rugby, he thought he spoke with rugged American diction; when he heard his *pukka sahib* voice played back on a tape recorder, he was overcome with surprise and laughter. Murphy and Marshall McLuhan, who attended many of Lewis' classes, thought he was a dedicated, stimulating, witty and effective teacher.

On November 30 Lewis crossed the Ambassador Bridge to Detroit and spoke at the Institute of Arts on "Where Are Art's Frontiers?" He had had a good meal, got slightly tight and gave one of his best lectures. Edgar Richardson recalled: "I cannot remember a word that he said but I remember an extremely witty and entertaining performance. It seemed at the beginning that he had no subject, and was merely rambling, introducing one subject after another, until at the end all the various threads were somehow brought together triumphantly into a *dénouement* and you realized you had heard a brilliant performance."[2]

Lewis thought Murphy—who was born near Windsor, educated at Assumption and St. Michael's, and ordained in 1931—was a sympathetic, kind and accommodating man. Lewis found the liberal-minded Basilian Fathers of Windsor infinitely more compatible than the Moody and Sankey puritans in the sanctimonious ice-box of Toronto; and enjoyed, for the first time in Canada, the stimulating discourse of a real intellectual community. Lewis' mother was Catholic, he had been christened in Montreal; and though he was a non-believer, he felt at home in Latin countries, had a sincere interest in Catholicism and called it the only "real religion." Froanna, who became a Catholic after Lewis' death, believed the priests hoped for his conversion.

Lewis had expressed his aesthetic preference for the Roman liturgy as early as July 1916, when he wrote to Pound from his army camp: "I

have adopted the Roman Catholic category in my siege battery. This
will eliminate one of the chief nuisances of life in the army, those
dreadful English churches. I can think of nothing on earth as imbecile
as the music and words of those English hymns. The Mass is a function
I shall not object to." And three years after leaving Windsor he told an
Anglican priest: "I should like to be in a Norwich smelling of incense,
the pleasing rattle of Latin vibrating on the sullen Protestant air. *And*
monks once more shuffling about the streets." Lewis was well-contented
at Windsor and told a Toronto friend: "The priests are very pleasant
and do not mind at all my not being a Catholic. They accept me as a
well-wisher. . . . How good the religious disciplines are for people!"[3]
Lewis, who in *Paleface* ranged himself with the modern scholastic
teachers, said that Jacques Maritain was the priests' supreme con-
temporary authority; he had the pleasure of meeting the French
philosopher (their photograph appears in *Rude Assignment*) when
Maritain lectured at Assumption in October 1943.

Lewis' fortunes had significantly improved since the depths of gloom
in New York and Toronto, and he was much happier in Windsor. But
both Murphy and Pauline Bondy, a sympathetic teacher of French,
noticed that his vision was beginning to fail, and that he was nervous
and suspicious of most people, and felt persecuted. He still behaved in
a secretive and mysterious manner; told Murphy: "I've lost a lot of
money by telling the truth"; frequently asked what people said about
him; and was always afraid of being misinterpreted. His neighbors
thought he was distinctly odd and sometimes bothered him; when one
of them called Lewis a Nazi, he had to send a lawyer's letter. He had a
notorious political reputation, was aware that the hysteria of war
propaganda could put him in serious danger, and became (for the first
time) physically fearful.

The Christmas holidays of 1943 were ruined by the sickness of the
Lewises' dog, Tut, who resembled the furry animal in Carpaccio's *St.
Jerome in His Study*. The childless Froanna was deeply attached to the
little creature and grievously upset when he died of a great tumor in
January 1944: "The death of our hirsute gremlin has left an ugly gap. . . .
This small creature, which stood for all that was benevolent in the
universe, sweetened the bitter medicine for [Froanna]. Like the spirit
of a simpler and saner time, this fragment of primitive life confided his
destiny to her, and went through all the black days beside us. She feels
she has been wanting in some care—for why should this growth in his
side, almost as big as his head, have gone undetected?"[4] Murphy gave
Lewis a rare bottle of scotch whiskey to cheer him up, and the next
time they met Lewis said rather formally: "The liquor has been
consumed."

Lewis also did a number of portraits in Windsor, though these too

were accompanied by the usual difficulties. He did a sketch of Maritain; executed a crayon drawing of Murphy in six one-hour sittings; drew Monsignor Fulton Sheen, whom he called an able man and "pugnacious Irish soul," at the Sheraton Cadillac Hotel in Detroit in the autumn of 1943; and was paid $500 (to augment his salary) for ten flat and lifeless portraits of deceased Basilian Fathers, which were all copied from old photographs. He was still working on the tenth one an hour before the priests came with the college car to take him to the train for St. Louis in 1944.

Lewis' most important commission—and the best portrait of his years in North America—was of Eleanor Martin. Paul Martin, then a young lawyer and M.P. (and now Canadian High Commissioner in London), was introduced to Lewis by Marshall McLuhan's brother during a party at Pauline Bondy's house at the beginning of 1945. Martin gave Lewis legal advice about collecting money that was owed to him for paintings done in America; and noticed that Lewis had financial problems, lacked comforts and did not even own a heavy overcoat for the severe winters. Martin, who expressed a characteristic Canadian suspicion of Lewis, thought he was a peculiar person: he always kept his hat on, wore galoshes indoors, "had a funny mouth" and "was not a Canadian type of personality." "You have a charming wife," Lewis told Martin, "I'd like to do a portrait of her." Martin had never heard of Lewis before; but after Murphy had assured him that Lewis was a great man, Martin commissioned the portrait and agreed to pay $500. He then left for official meetings in England. There he met Kenneth Clark, and was pleased about the commission when Clark told him that Lewis was a superb portrait-painter.

Since Lewis was then living at the Prince Edward Hotel (the best in Windsor), Eleanor Martin had the eight two-hour sittings in her own home. Lewis did a painstaking job and made many preliminary sketches. But he was extremely offensive, courted hostility and repeated the mistakes he had made with Mary McLean. He constantly spoke in a nasty way and made cynical attacks on everything the young lady believed in: patriotism, the royal family, important politicians, military leaders in England, Canada and America. The author of *Paleface* also shocked her by revealing that Nancy Cunard (who had a long affair with Henry Crowder in the early thirties) slept with black men! She loathed the overpowering anarchic Lewis and his Right-wing politics. In wartime, his remarks seemed not only rude, but also disloyal. She remained unconvinced by his arguments, but never said a word; and clasped her hands tightly to control her anger and her revulsion. Lewis seemed to ignore her feelings and kept asking: "Why don't you smile?" His painting of her intense stare, fixed expression and rigidly controlled body revealed her profound dislike of Lewis as well as the dark side of

her character. When her small children saw the finished portrait they said: "*We've* seen that angry expression on your face!"

When Martin returned to Canada and saw the completed painting in Lewis' hotel room, he felt the assurances of Murphy and Clark had been fully justified and exclaimed: "What a magnificent portrait!" But the pleasure evaporated as he noticed the painting was not signed, and Lewis claimed he was entitled to more money and asked for an additional $100. When Martin refused the request, for it was contrary to their agreement and his wife had already given Lewis extra cash, Lewis became annoyed (but not angry) and refused to sign the painting. Martin, who later heard that Lewis had similar quarrels about money with Stanley McLean and Malcolm MacDonald, recalled: "Lewis was not the easiest man to get along with. . . . Lewis had very extreme political views. Some have called them anarchistic. . . . As he painted, my wife Nell, unwise to his philosophy, found him a disturbing and perhaps unlikeable figure. . . . At first she found the painting not fully to her satisfaction. . . . I have since learned that a good painting grows on one. . . . He was perhaps more sophisticated and learned than many of us realized, although I think few would argue that his views were strange."[5]

2

Marshall McLuhan's mother, who had attended Lewis' lecture on Rouault in Windsor, told her son that Lewis had been invited to teach at Assumption. In July 1943, a month after he arrived in Windsor, McLuhan and his close friend Felix Giovanelli, who were then teaching at St. Louis University, came to visit Lewis. They were both ardent and devoted disciples, discussed the possibility of Lewis reviving the *Enemy* and doing "Thirty Personalities of America," and were eager for him to come to St. Louis—the birthplace of T. S. Eliot. When McLuhan returned to St. Louis, he began a lively correspondence, called himself Lewis' "Field Marshal," prepared his campaign with great gusto, adopted the current military metaphor, and said he was preparing to open a second front in America and lead a new offensive for Lewis' books and pictures. Like Abbott in Buffalo, Iris Barry in New York, Reid in Toronto and Murphy in Windsor, McLuhan acted as an effective advance patrol: he established Lewis' reputation, reassured people about him and planned ways to divert the wealth of the city into the pockets of his impecunious idol. When a society lady inquired of McLuhan: "What sort of personal appearance does Lewis make?" he won her over by exclaiming: "Oh, a duke at least"; and advised Lewis: "You can't be too Bond streetish for these people."

Dr. Joseph Erlanger, Professor of Physiology at Washington University in St. Louis, had won the Nobel Prize in 1944 and been given $1,500 to commission his portrait. McLuhan approached Mrs. George Gellhorn, Hemingway's mother-in-law, and suggested that Lewis would be the best artist to paint Erlanger. She immediately called Hemingway in Cuba to confirm Lewis' credentials, and received a generous and enthusiastic endorsement of the painter. Hemingway, who was probably mollified by Lewis' admiring account of him in *Blasting and Bombardiering* (1937), spoke of the author of "The Dumb Ox" in the highest terms and urged Mrs. Gellhorn to do anything she could for him. Lewis received the commission, and portrayed Erlanger holding a sheet of graphs, with his elaborate electronic apparatus in the background.

McLuhan alluded to Hemingway's recent play about Spain, whose heroine was based on his wife, Martha Gellhorn, and said that Mrs. Gellhorn would undermine the defences of the rich and prove to be a Fifth Column in St. Louis. Giovanelli reported that she was browbeating her wealthy friends, like Mrs. Ernest Stix (the wife of a department store magnate), into commissioning portraits. After Lewis had offered to draw his helpful patron for a nominal fee, McLuhan wrote: "Letting Mrs. Gellhorn have it for $40 was a good thing. She knows it was a bargain and wants to consolidate and enhance her bargain by having others pay the full price."

Lewis also painted Margaret Giovanelli, sketched McLuhan and his wife, and in February gave two lectures that his disciples had arranged in St. Louis for $150 each. He spoke at the Wednesday Club on "Famous People I Have Put on Canvas and in Books" and at the City Art Museum on Rouault; he repeated the second lecture at the Art Club of Chicago on February 29. Lewis liked to conclude his talk by saying: "Next time I will explain to you my theory of communication," but he never said anything more about this. Charles Nagel, the director of the St. Louis Museum, recalled: "The lecture was a real disaster. He had I am sure been laboring on his talk, for he had an enormous sheaf of papers which he would read sheet by sheet, but instead of sharing their contents with us he balled most of them up and tossed them aside remarking 'I don't want to say that! . . .' Lewis seemed to me very much on the defensive and presented an impenetrable front as far as I was concerned."

Though Lewis had agreed to teach at Assumption for a year and had already started the second semester when the promising opportunities arose in St. Louis, the college released him from his obligations and Murphy took over his classes. Lewis lived in St. Louis from February to July 1944 at the Park Plaza and Coronada Hotels, and in the flat of the Giovanellis (who moved in with the McLuhans). But he had to go

back to Canada every month to renew his American visa. He taught a three-week summer school course at Assumption on the Visual Arts during July and August 1944; and returned to the Fairmont Hotel in St. Louis during October and November. Though America was at war during Lewis' eight months in St. Louis, he was moderately successful. "I was lured down here by the promise of big money," he told Malcolm MacDonald. "The latter has not been forthcoming, but I have obtained enough portrait work to keep me going."[6] Despite the heat of July, which he found more intense than the Sahara, he was delighted to live in "one of the handsomest cities in the U.S."

McLuhan described Lewis as a large man, corpulent and hefty, who had lost his good looks and was then "fairly bald, with very prominent round eyes and an impressive portly figure with a rather stately stride." He would approach McLuhan's house with Froanna following some thirty feet behind him, her blue cape billowing as she tried to keep pace. Lewis was still very possessive about Froanna, for when she went out alone to sketch in the park, he expressed his disapproval of this activity and kept her at home. He showed no interest in McLuhan's children, but Froanna was very affectionate with them and said she was sorry that she had no children of her own. Lewis seemed to be in good health at the time, with no visual problems, though he sometimes removed his glasses and rubbed his eyes, which were always sensitive.

Corinne McLuhan, who was awed by Lewis, thought him gentle and benevolent, and never saw his harsh and angry side. But McLuhan found Lewis' manner blustery and aggressive. Lewis regarded most people as hostile—with good reason—and thought that art "was a feeble stick with which to beat the world." He felt regretful about—yet threatened by—his book on Hitler, which he believed was compromising and even dangerous; when McLuhan showed Lewis his copy of the work, he seized it, tore it in half and threw it down the incinerator.[7]

McLuhan recalled that Lewis was bitterly resentful of the rich, thought they would be well advised to give him some of their money, was not reluctant to ask for help and liked to repeat: "There's nothing as shy as a million bucks!" Lewis, who sometimes maintained three flats (in London, Windsor and St. Louis) lived mostly on borrowed money and was always in debt. He was slapdash about financial arrangements, never kept accounts and lived in chronic poverty. Though poor, he liked good food and wine, and could be very particular about the menu when invited for a meal. "On one occasion," McLuhan wrote, "he casually called an hour or so in advance and asked what we were having for dinner. When we said we were having ham, and he asked, 'What sort of wine are you having?' I mentioned some popular table wine. He said, 'Well, I'll come another night.'"

Lewis once warned McLuhan: "I'm a strange man. I always seem to come between friends. But I'm grateful whatever happens." He was always a loner, and feared McLuhan and Giovanelli would talk about and conspire against him. He knew that McLuhan had done everything possible to assist him, but resented his help and knew from past experience that he would inevitably turn against his friend. Lewis did, in fact, become angry at the way McLuhan had handled his affairs (always a risky business), imagined that McLuhan had been rude to him and wrote: "I neither care for you nor for the way you behave toward those you are the 'friend' of and 'admire.' I am ashamed to say that you inveigled me down to St. Louis. . . . I do not want or intend to be interfered with. I have not time to write more now: I send you this as a preliminary warning off, and hope you will take it to heart." McLuhan, like Pound, Eliot, Wadsworth and Schiff in the twenties, learned how dangerous it was to help Lewis.

Though Lewis was selfish, ungrateful and irritable, McLuhan felt he was capable of friendship and remained very fond of him. McLuhan, who published a valuable essay on Lewis in 1944, acknowledged that Lewis had profoundly influenced his ideas and wrote a moving tribute to him just after he had left St. Louis in June 1944: "You have been, for years before I met you, a major resource in my life. These past months have been a very great experience indeed. To recruit understanding students for your work will always be part of mine. One day I shall have some influence. Today, when I could be of direct aid to you, I have none." McLuhan, who became the kind of influential academic that Lewis wanted to be, fulfilled his promise and his prophecy. He reaffirmed Lewis' intellectual importance at the height of his own fame in 1969: "My little effort called *Counterblast* was intended merely as an echo for the Canadian scene of his own *Blast* of 1914 and 1915. . . . *Counterblast*, in other words, was not intended as an attack or as a retort to his, but as a development and a reverberation. . . . His analysis of the political, domestic, and social effects of the new technological environments had a great deal to do with directing my attention to these events."[8]

3

Lewis returned to Windsor for the last time in December 1944 to await the end of the War. On March 7 and 9, 1945, he was invited to lecture at the University of Michigan and at Michigan State University on "Hemingway, Tolstoi and War." He compared the failure of courage in Lord Jim and Francis Macomber, and said that Hemingway, who "had the hard-boiled detachment of a crime-reporter . . . is grim after

Tolstoi. If he has not *compassion*, he has a kind of ghastly sympathy for his dying heroes." Lewis' mood, attitude, motivation and sobriety had a great deal to do with his effectiveness and led to an unusual variation in his lectures. His letter to Eliot of March 13 expressed his scorn for the spiritless and sycophantic academic audience: "A group of old hacks teaching English, though they have some difficulty speaking it, supported by a deferential group of young hacks, entertain one to liquorless and beerless six o'clock suppers (I always carry a flask of alcohol, snorts of which I consume in the privacy of my rooms prior to submitting to these routine hospitalities)."

Two of the professors who attended the lecture at Michigan State have provided very thorough descriptions of Lewis' alcoholic preparation and perfunctory performance. According to William McCann:

The lecture dealt with American writers who had written about War: S. Crane, Hemingway, etc. . . . On the whole the paper was poorly presented and not very well received. Lewis, I heard later, had drunk too much gin at a dinner party given earlier by A. J. M. Smith. . . . He had written his lecture on sheets of yellow paper in very large hand-writing and as he finished a page let it drop to the floor. What I could hear was intelligent and interesting, but Lewis mumbled and the acoustics were not good in the auditorium. . . .

Smith told me later that at the dinner party he had hesitated to serve much strong drink because of the presence of the College deans and the possibility that Lewis might drink too much and impair his delivery. When it was time to depart for the lecture hall, Lewis was in the bathroom, the door locked, drinking gin. Smith had a tough time getting him out.

Smith, a Canadian poet, explained the reason for Lewis' thirst and said he was much more effective at the party than on the podium:

He had lectured a couple of nights previously at Ann Arbor and they had given him nothing—or not enough—to drink, so he was taking no chances this time. At dinner he got up and left the table and went to the coat closet and got a bottle of gin out of his overcoat and took a healthy swig—notwithstanding three strong martinis before dinner. He had spent the afternoon 'writing' his paper in an upstairs bedroom—two or three words scrawled in a large hand on each page—because of his near blindness—which resulted in a huge manuscript, very tricky and unwieldy. At one point it escaped from his grasp, and I as chairman had a hard time retrieving the scattered pages and helping Lewis sort them. I'm afraid the lecture can hardly be called a success. . . . Mr. Lewis spoke so softly and in such a heavy English accent that only the first few rows could hear and none I think could understand him.

The party at our house afterwards was a different story—a great success with Wyndham reminiscing, rather maliciously, I imagine, about the literary life as he had known it in England. I'm sorry I cannot remember the funny and somewhat scurrilous stories he told us about the Sitwells.[9]

Lewis' last portrait in America was also a fiasco. Edgar Richardson explained that the Detroit museum was unable to help Lewis and that after the failure with his final painting, he could not even pay his train fare to Ottawa:

The museum had absolutely no money for purchases. We were dependent on gifts. Nothing was more out of fashion than a modern English artist in those days and people thoroughly disliked Lewis' work. At the end of his stay, Dr. Valentiner, the director of the museum, persuaded young Mrs. Henry Ford II to have her portrait done by Lewis in colored chalks, hoping that her example would lead to other commissions. When the portrait was done, the Fords had some friends and the Lewises together for an evening to see the portrait. Lewis came into my office early the next morning in great agitation. 'It was a complete failure. Nothing could be more so. There is nothing to do but get out—go somewhere.' Where? He was penniless. The job at Assumption was over. Could I raise some money to get them to Ottawa? Malcolm MacDonald was governor-general [i.e. High Commissioner] and an old friend, who would see Lewis cared for until he could get home and make a fresh start.

I had a hard time finding enough money to pay the Lewises' trainfare to Ottawa. I know Lewis thought I should have found more but I had to put in all I could afford myself to make up what I gave him. That was the last of Wyndham Lewis in Detroit and in our lives.[10]

Lewis was very eager to get back to England, despite his uncertain future there; but he was afraid of torpedoes (after his close call with the *Athenia*) and did not want to risk returning until the War was over. He stayed at the Lord Elgin Hotel in Ottawa from May to July 1945 and tried to earn enough money by portrait commissions to pay his passage home. Though he had not delivered *A Canadian War Factory*, he suggested that Kenneth Clark pay him in advance for portraits of Canadian war leaders! Lewis was helped by Malcolm MacDonald, borrowed some of the $725 for his fare home, and sailed to England on the *Strathden*, the first passenger ship out of Canada, during the first week of August 1945.

CHAPTER EIGHTEEN

Notting Hill, 1945–1949

I

Lewis' return to the postwar "economic ice-age" after six years of exile was intensely, and perhaps inevitably, disappointing. His long-deserted and now decrepit flat, which he reclaimed after the War, seemed a microcosm of Rotting Hill, a term he adopted from Pound. In August 1942, while living in Toronto, Lewis received notice from his estate agent that his lease would expire the following month, that he owed £390 rent (which he certainly could not pay), and that he was also liable for an additional £50 for damage caused by burst water pipes. His possessions had not been stored and remained in the flat, and removing the long years of dust reminded him of excavating at Pompeii. "When we returned here from our prolonged absence in the States," Lewis wrote, "we found that the glass roof of the studio had been shattered during the air bombardment of London. Although the glass had been replaced, everything was in indescribable confusion. Someone had emptied on the floor cases in which Mss had been stored and a mass of stuff of all sorts had been rained on. The bodies of birds attested to the length of time my studio had only half a roof." The landlord immediately claimed six years' rent and rates; and the telephone company insisted on another £36 for the rental of their instrument, which had been resting quietly on the window sill and which Lewis had neglected to disconnect.

In 1947, during the severest winter of the century, Lewis found his coal inferior and stove inadequate. Dry rot originated in the Christian Science shop beneath his flat and spread rapidly through the building—pursued by a mad carpenter. He had to live in his studio for many weeks and, when allowed to descend, was forced to endure the intolerable noise of the builders above his head. He suffered from frequent bouts of flu, which kept him at home; once when he left the flat he was "sprung at" by a motor bike, which put a hole in his leg. Lunch at the Café Royal was the negation of sustenance, and he managed to survive on food packages from friends in North America. He found himself in "the capital of a dying empire—not crashing down in flames and smoke but expiring in a peculiar muffled way." He was mainly sustained by his

imaginative life: "If Paris could be described as my Paradise, London is my Purgatory.—I have no Hell—no artist has a Hell."[1]

The ruined, squalid and depressing postwar world, vividly portrayed by Lewis in *Rotting Hill* and Orwell in *1984*, made Lewis forget all his previous difficulties and plan another trip to America. There, he seemed to remember, people were kind, travel easy and life comfortable. He applied for various positions as teacher and resident artist; and arranged a visiting professorship at Bard College, near New York, in September 1949. But when the dean wanted him to teach philosophy instead of literature, he felt his deteriorating vision would make the preparation too strenuous and time-consuming, and refused the offer. Lewis was not able to travel abroad until his art exhibition provided extra funds in 1949, when he made a brief visit to Paris in April, and once spent a short time on a small farm outside London in July.

In his later years Lewis dressed as conservatively as a bank manager, though he retained his fondness for his long black overcoat, soft felt hat and inevitable cigarette. G. S. Fraser, who met Lewis at a publisher's office in 1946, recorded: "Thick glasses magnified, and thus disguised the expression of, the striking eyes. The face would have been very handsome if a certain jowlishness had not made it also a little froglike; the flesh, unlined and of a notable clear pallor, was moulded a little puffily on the fine bones. The voice was low, slightly muffled or muted, but oddly lacking, for all its pleasantness, in local or personal coloration. The face seemed not so much a person's face as a mask of calm, abstract intelligence."

Despite his somewhat saurian countenance, Lewis was still concerned with his appearance. In 1949, when he needed some professional photographs, Julian Symons introduced him to John Vickers, who tried to discuss Freud and Jung as he portrayed Lewis and earned the Master's displeasure. When the photographs turned out badly (they reminded Eliot of his anaesthetist), Symons fell into disfavor and Vickers received a caustic evaluation of his efforts: "I hope you will forgive me for speaking plainly: several are unspeakable, and none are otherwise than highly displeasing to me and to everyone else. One or two are what might be described as photographic insults. . . . I have not exaggerated the displeasing impression, and in some cases the horror induced."

Lewis, who was fond of gin, fine brandy and champagne, called postwar England "prohibition without speakeasies." He liked to frequent the cacophonous pub in the Notting Hill tube station and converse there with the local artists. Derek Stanford, who went lion-hunting in that pub, found Lewis wearing the same eyegear that Edith Sitwell had described and was rebuffed by the irascible Enemy: "I discovered him there, seated on a stool at the counter and wearing a black patch over one eye. Having published an essay about him in *The Fortune Anthology*

[in 1942], I shyly approached to make myself known. But when I addressed him with the words: 'Mr. Wyndham Lewis, I believe,' he swung round, denying that this appellation fitted. 'You're mistaken,' he insisted, referring to himself as 'Captain Brown.' "[2] Despite his hostile response to Vickers and Stanford, most people found that the battle-scarred, weary and aging Lewis wanted to make peace with the world. He was gentle in speech, mild in manner. Lewis (reassuring his new publisher) also remarked on the discrepancy between his ferocious reputation and his "easy-going, anything but contentious, self."

Several of Lewis' followers and friends appeared in his collection of stories *Rotting Hill* (1951). Melville Hardiment, who had been a sergeant in the Indian Army and was then studying painting, was the model for Gartsides in "My Disciple." Soon after the War he wrote to Lewis, who sent elaborate instructions to his flat, told him to go past "the only delicatessen in London run by a Negro," walk down the narrow corridor and then up two flights of stone steps. He invited Hardiment to "Come Friday evening and drink pink champagne. We always drink pink champagne on Fridays." The faded flat, filled with Lewis' paintings and books in glass cases, seemed to suggest decayed gentility and was kept shadowy to protect his eyes. Froanna seemed a bit eccentric—a faded blonde, slightly drooping. When she came to life, her eyes seemed to change color. Occasionally she made vehement interruptions and contradictions, but was usually self-effacing and anonymous, while Lewis and Hardiment talked about "the Welfare State, Modern Education, Herbert Read, the Institute of Contemporary Arts, Roland Penrose, Henri Michaux, Claudel, Maritain, British painting, Michael Ayrton, corruption, army life, London social scene (upper crust), Pound, T. E. Hulme, Campbell, Graves, Labour Ministers, the two wars, his books, Edwardian London, Nancy Cunard, Ottoline, modern poets, the galleries, my needs, my desires, my employment."

Lewis seemed to like the rough and independent Hardiment, who knew the seamier side of life and was familiar with the London Underworld. Lewis asked if he needed money, wanted a review in the *Listener* or wished to have an exhibition at the Leicester Galleries, and seemed surprised when Hardiment refused his offers. At the end of "My Disciple," Lewis paid the young artist a friendly tribute: "I rather liked Mr. Gartsides. I even secretly wished him luck. This remarkable sergeant naturally regarded art as an uproarious racket . . . but he retains, to the full, his fine rough artlessness. If only he could learn to paint, he might do for the Army what Rousseau did for the Douane."[3]

Willis Feast, an Anglican priest in Norfolk who wrote to Lewis in mid-1948, was the model for Rymer in "The Bishop's Fool" and for certain aspects of Father Augustine Card in *The Red Priest*. "When I went to the door in answer to Rymer's knock," Lewis wrote, "a large

passionate and weary and frustrated face was thrust up towards mine—a not unhandsome one I thought. . . . [My eye] noted with a relentless acuity what had narrowly escaped being a lantern jaw. . . . It registered the eloquent feminine mouth which pursed itself almost primly and then shot out its lips at right angles. . . . I observed of course the eyes of a somewhat worried but stubbornly amused, big dog. . . . There was no clerical collar on his large weather-beaten neck." Lewis did two drawings of Feast for £20 in 1948; and visited the Rectory at Booten in December 1949, when he was writing the story. Feast thought him surprisingly ignorant about religion, and once instructed Lewis, who listened respectfully, in the catechism. Feast felt that Lewis, who later asked about a Hebrew phrase he wished to use in the revised *Childermass*, suppressed his religious feelings to prevent them from becoming sentimental.[4]

Geoffrey Stone's accounts of his visit to London in August 1949 illuminate Lewis' response to postwar austerity and his hostility to religion. Lewis, grateful for the Stones' hospitality and assistance in America, went to considerable trouble to see that they were comfortable in London: he reserved their room, met them at the airline terminal and took them to their hotel. But during dinner at his home, "Lewis grew increasingly uneasy as the food was consumed, complained about inflation, was about to offer them brandy—and then said, 'But of course you must be going'—and virtually pushed them out the door." Stone recalled: "On our last night in London, we had dinner in the Lewises' flat, then sat talking in the studio on the floor above. Froanna said she thought of joining the Catholic Church (into which I had been received in 1947), and my wife (born a Catholic) said she would be delighted to be Froanna's sponsor, or godmother. The next morning, we called at the flat to say goodbye, and Lewis, obviously in a bad temper, met us at the door and did not ask us in. I assumed he had a hangover and the flat was not yet tidied up." The real reason for Lewis' behavior was his antipathy to religion and irritation at Stone's interference in his personal affairs—for Froanna's conversion would have necessitated a Catholic ceremony if their marriage were to be valid in the eyes of the Church.[5]

In the Envoi to *Rotting Hill*, "The Rot Camp," Lewis paid tribute to four other friends, who appeared without fictional disguise. Lewis admired and praised the work of the homosexual painters, inseparable companions and heavy drinkers, Robert Colquhoun and Robert MacBryde, who shared a studio in Notting Hill and were portrayed in his satirical but affectionate sketch: "Of the Hillworthies who are creative I place [Colquhoun] first. I passed on and saw a kilt. That was MacBryde, wittiest of Hillmen, swinging his kilt along without consciousness of the anomaly. He had an apprehensive eye upon Colquhoun."

Just after Lewis described the two painters, the "lonely old volcano" criticized his old comrade-in-arms for encouraging parasitic hangers-on: "Roy Campbell passed and he raised his large coffee-coloured hat. He walked as if the camp were paved with eggs, treading slowly, putting his feet down with measured care. 'Tis his war wound imposes this gait on him of a legendary hidalgo. He was followed by a nondescript group, some say his audience. I noted a poetaster, a photographer, a rentier, and a B.B.C. actor. He is the best poet for six miles or more around. But he suffers from loneliness I believe. He is like a man who rushes into the street when the lonely fit is on him and invites the first dozen people he meets to come up and have a drink." At the end of the chapter, as if to compensate for his ignominious death in *Snooty Baronet*, Campbell gives a vainglorious description of his exploits in the bullring. When Methuen reissued *Tarr* in 1951 (Lewis' last drawing was a jacket design for this book), Campbell took the opportunity to write a laudatory review of Lewis' works in *Time and Tide*; and Lewis responded with warmth and gratitude, just as he had done when Campbell supported him in *Satire and Fiction*: "It should be a tremendous lot of good and I am deeply grateful. To find you still at my side is a matter of the greatest satisfaction to me: and I hope we shall always remain comrades-in-arms against the forces of philistia. As I learn from you that twenty years ago I was described as an 'old volcano' let me say I shall always be prepared to erupt and pour out a stream of lava upon our foes." Campbell felt less sympathy for Lewis after he "went Cosmic" and a tinge of Utopianism crept into his later works; and in about 1952 Campbell told Russell Kirk: " 'If Wyndham asks you to lend him a hundred quid, don't do it: he'd never forgive you.' Years before, Roy went on, Lewis had told him, 'I never loved anybody—except you, Roy, a little.' "[6]

The last personage to appear in *Rotting Hill* was Lewis' oldest companion, Augustus John. He had sacrificed his serious career for fashionable portraits and social success, and his sad decline was recognized by both Lewis and himself. But John still retained his old lecherous vitality and, Froanna reported, was always fond of making fools of women. When John visited Lewis' flat, Froanna took the precaution of locking herself in the bedroom: "Sure enough, John tried that handle. But there was no nonsense here, no story to tell about Froanna." Lewis portrayed John in his eternal Borrovian quest for gypsies, which he had originally satirized in *Blast*: "I encountered Augustus John, his blue headlights blazing on either side of his bronzed beak. He had heard there were some mumpers encamped not far from the Borough Reading Room. There was an anticipatory glare of fraternity in the old Romany Rye's gaze."[7] Four months later, Lewis praised John's lively, natural style in his review of *Chiaroscuro*, his last piece for the *Listener*. Shortly before Lewis' death, John took his blind friend out to dinner, cut up his

food, deferred to him in conversation, and exerted all his charm and wit to entertain the man he had first seen as a Slade School prodigy.

2

In 1946 Lewis became art critic for the *Listener*, under the inspired regime of Joe Ackerley. He held that influential post, which reinforced his authority and reputation as a theorist and painter, for the next five years and wrote nearly fifty reviews. He also made two BBC broadcasts, in January and March 1947, on "Liberty and the Individual" and on "A Crisis of Thought"—about the early influence of the Russian novelists—which he later published in *Rude Assignment*. Contrary to his ogrish reputation, Lewis was a benign art critic who generously praised the younger painters. He was one of the first to admire the content and technique of Francis Bacon; continued to defend Henry Moore in a protracted controversy with the academic philistines; and gave considerable practical assistance to Denis Williams, a Negro painter from British Guiana, providing an introduction to Alfred Barr in New York, asking Herbert Read to obtain a grant and eventually finding him a job at the Central School of Art in London. In *The Demon of Progress in the Arts*, which expounded his critical principles, Lewis referred to Colquhoun, MacBryde, Bacon, Moore, Edward Burra and Michael Ayrton as "the finest group of painters and sculptors which England has ever known."

During the late forties, the final phase of his artistic career, Lewis' painting seriously deteriorated because of his defective vision. The most important work of his late period was Lewis' second portrait of Eliot, who in 1948 had won the Nobel Prize for Literature. Lewis dined frequently with Eliot, at Scott's on Mount Street or the Hyde Park Hotel Grill, where he ate oysters and dessert—and skipped the main course. Eliot used to send Lewis cases of champagne (he could drink nothing else at the end of his life) and Lewis meticulously noticed that it was not vintage. Still ignored and impoverished, he was inevitably jealous of Eliot's enormous success and resentful about the poet in his letters. He told Pound, who had been charged with treason, declared insane and confined to St. Elizabeth's Hospital in Washington: "You might almost have contrived this climax to your respective careers: yours so Villon-esque and Eliot's super-Tennyson." And he wrote to Giovanelli: "Eliot is a solid mass of inherited slyness. . . . He is no great favourite of mine in later years. Lesser poet than Pound, though not such an exasperating fool of a man. He *has* I agree kicked up a nasty stink around himself of *cult*."[8]

When Lewis painted his second, much more bland and conventional

portrait of Eliot (which lacks the sharp incisive planes of the earlier work) in March and April 1949, he was obliged to scrutinize him very closely. As he wrote in "The Sea-Mists of the Winter": "When I started my second portrait of T. S. Eliot, which now hangs in Magdalene College, Cambridge, in the early summer of 1949, I had to draw up very close to the sitter to see exactly how the hair sprouted out of the forehead, and how the curl of the nostril wound up into the dark interior of the nose. There was no question of my not succeeding, my sight was still adequate. But I had to move too close to the forms I was studying. Some months later, when I started a portrait of Stella Newton, I had to draw still closer and even then I could not quite see. This was the turning-point, the date, December 1949." Another minor problem, as Lewis told a St. Louis friend, was that Eliot (whom he had described as "wriggling his lean bottom" in *The Apes of God*) became drowsy and his bottom "went to sleep" when he was immobilized in one position.

The portrait was completed in time for Lewis' exhibition at the Redfern Gallery in May, when both artist and subject were interviewed by *Time* magazine. Lewis' description recalled his earliest impression of the poet, haggard and apparently at his last gasp: "You will see in his mask, drained of too hearty blood, a gazing strain, a patient contraction: the body slightly tilted . . . in resigned anticipation of the worst." Eliot suggested that Lewis' intensity made him feel somewhat uneasy: "Wearing a look of slightly quizzical inscrutability behind which one suspects his mental muscles may be contracting for some unexpected pounce, he makes one feel that it would be undesirable, though not actually dangerous, to fall asleep in one's chair."[9] When this portrait, like the earlier one of Eliot, was refused by the Tate, Lewis blamed the malign influence of Kenneth Clark. It was eventually acquired by Magdalene College for £300, and hung on the narrow staircase of the dining hall, poorly lighted and difficult to see.

In December 1948 Lewis toured museums and private collections in England and Scotland to select paintings for his retrospective exhibition at the Redfern. The show consisted of one hundred drawings and twenty-five paintings, including *Praxitella* of 1921, *The Convalescent*, *The Mud Clinic*, *The Armada*, *Stations of the Dead* and the major portraits of Froanna, Naomi Mitchison, Lord Carlow, John McLeod, Spender, Mrs. Sainsbury, Eliot and the grave, introspective Julian Symons, which he began in 1939 and completed ten years later. The show had an excellent press, was unexpectedly successful and sold ten thousand dollars' worth of paintings. But very few of them belonged to Lewis, and his prices were still extremely low: *Two Women* (1912) was sold to the Arts Council for £33 in 1949, *Howitzer* (1919) for £15 in 1952, and a major painting, *Inca and the Birds* (1933), for £189 as late as 1959. John Rothenstein, who attended the private view, found Lewis "ex-

pounding to a small group, which included T. S. Eliot, the contrast between the cubists, 'whose art was firmly rooted in the nature they affected to exclude,' with a 'genuine inventor of abstract forms' such as he himself had been before the First World War. . . . [Rothenstein] left the exhibition in the company of Eliot, who spoke with admiration of Lewis, but observed that one of the reasons why certain people so disliked him was that he was a 'pro.' both as writer and painter."

The Redfern show was favorably reviewed in the *Listener* by Eric Newton, whom Lewis helped in 1951 after he had lost his job as art critic on the *Sunday Times* because he scorned the Royal Academy and wanted to write about small shows and young artists. Sir Roland Penrose recalled: "When the *Sunday Times* dismissed their art critic I remember writing to the paper to say that I thought this was a scandal. Following this I received an invitation to lunch with Wyndham Lewis in his favourite restaurant [Frascati's] in Oxford Street where he had a special table half-surrounded by a screen, being very shy as well as ostentatious about appearing in public. I remember the enthusiasm he showed for my attitude and his suggestion that we should organize a march through Trafalgar Square in protest."[10] Newton, whom Lewis considered a useful antidote to Herbert Read, also wrote the introductory essay to *The Art of Wyndham Lewis* by Charles Handley-Read, an art master at Bryanston School at Dorset, where Lewis lectured on "The Artist and Contemporary Society" on August 1, 1948.

3

Despite increasing age, Lewis continued his omnivorous reading and prodigious work. "The Vita of Mr. Wyndham Lewis," written in 1949, provides an amusing comparison with his 1931 interview with Louise Morgan. Lewis wrote that his day begins with tea and a quick scan of seven morning newspapers. He deliberately eliminates distractions and remarks: "Fortunately I have no children, only a wife. . . . I possess no radio. It wastes time and makes a noise"—though he admits he occasionally sees a French film. After breakfast, "I kiss my wife lightly on the forehead, fly upstairs into my draughty workroom (the size of a small church) and drive out the charlady with a stick I keep for that purpose. Mrs. Montgomery shrieks and scuttles down the stairs." He writes with a steel nib in a wooden holder and his right forefinger is always black. "My play is work," Lewis asserted; and in February 1949, when he was sixty-seven, he told Willis Feast that he saw practically no one and labored until after midnight every night.

Lewis had a great deal of trouble with the publication, both in London and New York, of the quite innocuous *America and Cosmic Man* (1948).

This work, the only book he published in the late 1940s, was the fruit of his life in America and lectures in Canada. The Ceylonese publisher and poet Tambimuttu recalled that soon after the War Lewis walked unannounced into the office of Poetry London at 26 Manchester Square, wearing a long overcoat and black hat, and said that Augustus John had written to him in Canada that Tambi was the best London publisher for his books. Tambi had never met Lewis, but knew of *Blast* and his paintings. He took Lewis to lunch at the Gargoyle Club, paid £150 for the completed typescript of *America and Cosmic Man*, and also planned to publish "Château Rex" (the original title of *Self Condemned*) which Lewis summarized in a two-page prospectus, and *The Writer and the Absolute*, which was announced but never published by Tambi.

Maclaren-Ross clarified the controversy (which Tambi was quite vague about) when he stated: "Anything involving Tambi took more time than anyone could possibly have to spare, months, maybe years could go by with nothing done."[11] Lewis became extremely angry at Tambi's delays and in 1947 his solicitors, Clifford & Turner, terminated his contract with Poetry London. Since Tambi had failed to publish the book as stipulated in the contract, Lewis kept the advance. He then signed a second contract with Nicolson & Watson, who paid the more substantial sum of £500 and brought out the book in 1948. After a heated exchange of letters about the negative *TLS* review of *America and Cosmic Man* by Raymond Mortimer (who had written unfavorable notices of *The Childermass* and *The Apes of God*), Lewis attempted to win damages and had to pay an additional £32 in lawyers' fees.

In America, meanwhile, Lewis' chapter, "The Cosmic Uniform of Peace," made an incongruous appearance in the *Sewanee Review* just after the atomic bombs had been dropped on Hiroshima and Nagasaki. (Another offshoot of the book, an essay on De Tocqueville, for which Lewis received $75, was published in *Sewanee* in 1946.) Allen Tate, who was associated with *Sewanee* and literary editor at Henry Holt, expressed serious interest in publishing *America and Cosmic Man* and *Rude Assignment*. But he later rejected both books, and wrote a rather tactless letter about the autobiography which made Lewis furious. The former was eventually sold by Giovanelli to Doubleday, who paid an advance of $750; the latter, published by Hutchinson in November 1950, never appeared in America. Neither sold much more than 1,600 copies.

America and Cosmic Man appeared seven years after Lewis' previous books, *The Vulgar Streak* and *Anglosaxony*, developed some of the "universal" themes of the pamphlet, and reversed many of the political views he had expounded from *The Art of Being Ruled* to *Count Your Dead*. The book discussed the origins of American democracy and expressed Lewis' optimistic belief that the multi-racial structure of America represented a useful prototype of the society of the future: "A

World Government appears to me the only imaginable solution for the chaos reigning at present throughout the world. . . . [America] is a model for all other nations, still battened down within their national frontiers. . . . All that is necessary is *one* government instead of many. . . . The end of state sovereignties would not resolve all the problems of human life. But the difference would be enormous." As Lewis explained to Geoffrey Stone: "The choice to my mind is a black one, between (1) cosmic or universal man: or (2) no man at all. The earth is too small to sustain all the old romantic tribal and national identities." Lewis' untimely Postscript on Harry Truman as a "Rotarian Caesar" had to be omitted from the American edition after he was elected president in 1948.

Rude Assignment, Lewis' second volume of autobiography, described the struggle of an independent mind against those forces of the modern world that prevent creative expression. It discussed Lewis' three "fatal" roles as intellectual, satirist and political pamphleteer, the personal background of his career as an artist, and the pattern of thought in his tracts and novels, from *Tarr* to *The Revenge for Love*. The autobiography also repeated the political recantation of *The Hitler Cult* and *The Jews, Are They Human?*, and attempted to present the genuine change in his political ideas: "Throughout they differ radically from what I believed before the war: you can take it everything I say represents a change of view. . . . Thus, if I am found advocating today a maximum of centralisation, whereas twelve years ago I was all for the doctrine of the sovereign state, these diametrically opposite principles both have been adopted—as *opinion*—with the same end in view"[12]—to avoid war. Ironically enough, though Lewis had changed his opinions, his pacifist warnings of the 1930s—that a war would destroy the British Empire, reduce England to a relatively minor power, and enormously increase the strength and influence of Soviet Communism—came true, despite the Allied victory. Though Lewis supported the Labour Party in 1945 and drastically altered his views in the five political books published between 1939 and 1950, he was never pardoned for the pro-Fascist attitude he had maintained from 1926 until 1938.

4

The change in Lewis' political ideas were also revealed in his quarrel with Orwell and friendship with Pound in the late 1940s. Both Lewis and Orwell, as Julian Symons noted, shared the same cross-grained integrity: "Like Orwell he maintained intellectual independence in a time favourable to one or another sort of conformity; like Orwell had an itch for politics; like Orwell was ignored, because of his ideas, by

some people in important positions; like Orwell was utterly informal, without a trace of literary or social affectation. Yet although he was easy to talk to Lewis was inhuman, in a way that Orwell was not: he was a man devoured by a passion for ideas, which he wished to put to the service of art."

We have already observed important similarities between the ideas, publication and reception of their books on Spain: *The Revenge for Love* and *Homage to Catalonia*. Lewis' *Left Wings Over Europe* (1936), though written from a Right-wing point of view, foreshadowed two important ideas in *1984* (1949). Lewis anticipated Orwell's concept of "Doublethink" when he stated: "I mean *independence* in the real sense —not in the *Alice in Wonderland* sense of contemporary political jargon —where 'Peace' means War, 'Neutrality' means Intervention, and 'Independence' means Economic Servitude." He also foreshadowed Orwell's thematic conflict between freedom and responsibility when (like Big Brother) he asserted: "Ninety per cent of men long at all times for *a leader*. They are on the look-out, whether they know it or not, for someone who will take all responsibility off their shoulders and tell them what to do." In *Self Condemned* (1954), Lewis repeated the main Trotskyite theme of *Animal Farm* (1945)—the "revolution betrayed": "The high aims with which the revolution started cannot co-exist with the wholesale coercion necessary to check the counter-revolution. A rule of iron eventuates in a society no better than the feudal society overthrown."[13] In 1941 when Lewis published *The Vulgar Streak*, an attack on the English class structure that had many themes in common with Orwell's *Keep the Aspidistra Flying* (1936), Lewis asked his editor to send a copy of the book to Orwell, who he thought would be a sympathetic reader.

In his "London Letter" of 1946 to the *Partisan Review* (which later rejected a story by Lewis and said it was too reactionary) Orwell, who was often unreliable in his political judgments, stated, with absolutely no justification: "Wyndham Lewis, I am credibly informed, has become a Communist or at least a strong sympathiser, and is writing a book in praise of Stalin to balance his previous books in favor of Hitler." Lewis, who had staunchly opposed Stalin when nearly all the intellectuals of the thirties had thrown themselves at his feet, was justifiably enraged when Orwell smeared him with Stalinism at the beginning of the Cold War. Orwell's irresponsible and highly improbable assertion, which damaged Lewis' dubious reputation in America (where he was trying to place *America and Cosmic Man*), ignored the radical change in his political beliefs and—what was even worse— stated that Lewis wrote two books in favor of Hitler, when he had actually written a sympathetic book in 1931 and a hostile one in 1939.

Lewis defended himself against the libel of the "emotional public-

schoolboy" in chapter 15 of *Rude Assignment* and mounted a full-scale counterattack in *The Writer and the Absolute* (1952). In that book he contemptuously opposed the commonly accepted view of Orwell's political ideas and argued (though not very convincingly) that Orwell's political development was essentially a subjection to the fashionable convention of Socialism, followed by a final emancipation in anti-Communism. According to Hugh Porteus, the wild rumor that Lewis had become a Communist originated when Lewis said—as a joke—to the gossipy Roy Campbell: "Tell them I've changed my views and am now writing a book on Stalin." Campbell repeated this—in all serious-ness—to Porteus, who unwittingly told Orwell.[14] Orwell, delighted with this fascinating bit of gossip, did not check the source of the story, published it in the *Partisan Review* and damaged Lewis' reputation—as well as his own.

In *The Writer and the Absolute*, which also contained critiques of Sartre, Malraux and Camus, Lewis reaffirmed the main thesis of Julien Benda's *Le Trahison des clercs*—that learned men should confine their attention to purely 'spiritual' values and not yield to political passions—when he asserted (thinking of Pound's career as well as of his own): "Philosophers and poets have always touched politics at their peril." Though Lewis had been out of touch with Pound between 1939 and 1946, he still sympathized with his unfortunate but lovable companion. After the War, Pound resumed his correspondence with "Old Vort" in a series of eccentric letters (which resembled the chaotic typography of *Blast*) written from St. Elizabeth's in his tedious backwoods dialect. William Carlos Williams (who had met Lewis in Buffalo) reported: "Ezra believes Lewis a bit mad but thinks him one of the very few informed people in the world, quite excusably eccentric when you consider the blithering idiots who rule us from high places."[15]

Lewis, who rarely agreed with the "revolutionary simpleton" about anything, called Pound a benevolent but pig-headed dominie and a tiresome idiot. Lewis was particularly antipathetic to Pound's infatua-tion with the past, with the crack-brained economic ideas of Major Douglas, and with Mussolini (whom Pound called "The Boss"); and he strongly disapproved of Pound's still rabid anti-Semitism. The main difficulty in securing Pound's release was the poet's intractable fanaticism, for he refused to accept a pardon (which implied guilt), remained adamant in his self-righteousness, contributed to the self-defeating publications of his racist and anti-Semitic disciples, and continued to make irresponsible public pronouncements on political and economic issues. His poetic reputation continued to increase during his confinement; and some friends felt that since Pound intended to embark on a violent crusade as soon as he was released, it would be better for him to remain in St. Elizabeth's.

But Lewis, who with Hemingway, Eliot, Frost and MacLeish, actively campaigned for Pound's release, took the opposite view. As he wrote to D. D. Paige, Pound's editor: "If E.P. should then, say in a year, obtaining a parole or a pardon, go crusading, in a few months all the ground gained would be lost. . . . It, however, is too cold-blooded a view for me to adopt, that he should remain forever under restraint. If I were in E.P.'s position I should feel rather strongly about the view that for my own good I had better stop in an asylum. So I under all circumstances will do what lies in my power to secure his release." Lewis told Pound he would never take his incarceration for granted, and urged him to adopt a more reasonable attitude, which would make it easier for him to obtain freedom: "It wearies me your remaining where you are. To take up a strategic position in a lunatic asylum is idiotic. . . . Ask your wife to give the signal to your horde of friends to go into battle for you."

Lewis summarized his sympathetic feelings toward Pound in an unpublished letter to Paige, which asserted that Pound deserved forgiveness not because he was innocent, but because he had suffered greatly and had never fully understood the realities of political life: "Pound is one of my oldest friends and one whose welfare I have most at heart. His literary influence has been very great and *very good*; immeasurably outweighing of course any nonsense he may have talked about economics or about politics or any harm he could possibly do in that direction. What has happened to him is terrible, and it does not help to say that it is his own doing. He seems to have understood very little about the Power House of which he was an inmate."

During the late 1940s Lewis gave Paige considerable help in the preparation of his edition of Pound's *Letters*, published in 1950, which Lewis felt would soften the heart of the world toward the very human prisoner. In about 1948 Lewis spoke to the Poetry Society in Portman Square about Pound and affirmed his loyalty and gratitude to the poet. He wrote a sympathetic portrait of Pound (based on the chapter in *Blasting and Bombardiering*) in the *Quarterly Review of Literature* in December 1949 and reprinted the essay in a volume of tributes to the poet in 1950. He favorably reviewed Pound's *Letters* in the *New Statesman* in April 1951 under the rubric of "The Rock Drill," the title of Jacob Epstein's massive mechanical statue of 1913, which Lewis had praised in *Blast 2* and Pound had used as the heading for a section of *The Cantos*.

In 1954 (four years before Pound was released from St. Elizabeth's), Lewis gently satirized Pound's pedagogical urge, submergence in the past and love of arcane languages. Thaddeus Trunk in "The Doppelgänger" "had always the itch to offer advice, to tell others what to do with their lives, to teach them how to Write, to teach them how to Read. . . . He was in love with the Past, being an American and so in any

case would be inclined to apologize for himself as a laggard in the March of Progress, and a snuffly old *passéiste* digging about among musty old manuscripts. . . . Uncle Thad would never take very seriously any young poet who did not know a little Arabic, Tamil, Phoenician, and Early German." Lewis' last word about his gentle but rumbustious friend noted: "He was a timid man, beneath his veneer of toughness, very averse to showdowns of any sort."[16]

Lewis had always believed that Pound would get a "fool's pardon." Though Pound's political views were far more extreme than his own, Pound has (like Eliot) been pardoned by posterity while Lewis—despite the purgatory of blindness and a creative resurgence that produced, like Yeats, his greatest work in his final years—has still not been forgiven.

Blindness, 1950–1954

> Doctors are malignant or benign, like tumours.
> However, their benignity is more terminological
> than real. It does not mean they are not dangerous.
> They are not morally or intellectually responsible
> enough for the powers of life and death they wield.
>
> *Rotting Hill*

I

Though Lewis seemed to have recovered from his urinary disease and his four operations of the 1930s, his health had in fact been radically and permanently damaged: "I was not a whole and well man," he wrote. "It had knocked my teeth about, and one of my eyes." He had injured his left eye when he was about fifteen years old and could never see very well with it; and he first noticed something was seriously wrong with that eye in 1937, the year of his last operation.

In October 1941, when Lewis was living in Toronto, his visual problems recurred: "The other day I had a very unpleasant surprise. For twenty years I had worn the same glasses, and I went to an eye-specialist to get new ones. He informed me that one of my eyes (which had always been weak, as the result of a youthful injury) was practically extinct. My other eye he said would be the same in six months time—if I had what he thought I had: namely glaucoma." Lewis distrusted this Canadian doctor and immediately wired to London for the opinion of Affleck Greeves (who was also Eliot's physician). Greeves replied that there had been no sign of glaucoma when he last examined Lewis in 1939, but that it might have developed since then; and said that pilocarpine, which decreases interocular pressure from built up secretions, was appropriate for the treatment of glaucoma. Lewis' early eye injury made it more difficult to diagnose the new visual defect, especially since he had many of the symptoms of glaucoma.

A second, less prominent doctor in Toronto, assured Lewis that he did *not* have glaucoma, that another cause must be sought and that his

teeth were the most likely source of his difficulties. As Lewis wrote the following June: "an eye-specialist here eight months ago announced that I should be *blind* within six months unless I allowed him to operate on me.—But he it turned out was a crooked doctor and one of my eyes at least is still 100 per cent strong. My long illness all the same left behind it certain physical handicaps." Lewis did not recognize the precise cause of his visual problems for another ten years—and then felt it was too late to do anything about it. But he was profoundly affected by the danger of blindness, which threatened to extinguish his career as a painter and writer: "If my eyes go, I go too. Loathsome as the world is, I do like to *see* it. *That* sort of blackout I could not live in."

Lewis' teeth and eyes, emphasized in his self-portrayal as a grimacing Tyro and philosopher of the visual, both failed him in the end. He had dental problems as early as his student days in Paris in 1905; Alsop and Slocum had noticed the decayed condition of his prominent teeth; and he wrote to a friend in 1941: "When I tell you that I have not been to a dentist since the last war, you will see that my teeth are not unlikely to rank as a septic centre of the first order. . . . Where one's health, or life, is at stake, naturally extortion runs riot.—*Teeth* is the only expense I *could* aspire to."[1] Though Lewis was careless about his health, his condition was certainly aggravated by poverty, which led him to wear the same spectacles for two decades and never visit the dentist—except when he was forced to do so in the Army.

In December 1949, when Lewis' vision began to deteriorate rapidly and he had difficulty in seeing the people he was painting, his eyes were examined and his teeth once again became the prime septic suspect: "There is nothing visibly wrong with my eyes, but it is said that the optic nerve is being injured by some toxin. So *remove the poison* is the cry. I tremble to think what steps may be taken to expel the toxin. But no operation is contemplated, thank heaven. . . . The doctors are urgent: if some toxin is not removed I lose my sight. Monday they start pumping in penicillin. Two days later starts the pulling out of lots of teeth." Lewis entered St. Vincent's Nursing Clinic, a private hospital run by Catholic nuns, which still stands at 12 Ladbroke Terrace; and on January 18, 1950, had all his teeth extracted. Since the 1940s were the great era of septic theory, he was lucky to have retained his gall bladder and appendix.

Lewis described the operation in a bitter story, "The Room without a Telephone," in which the historian-hero, Paul Eldred, foreshadows René Harding in *Self Condemned*. Dr. McLachlan is probably based on Lewis' physician Dr. John Fant: "A beautiful tropical drowsiness immediately began to pour into his brain and invade his limbs, the warmth of a potent obliteration. . . . Eldred was aware of men in white, with white masked faces. One was doubtless the O'Toole, concealing

his forceps behind his back. . . . The needlessly brutal hands of the two
kneeling house-serfs tightened upon his arm, he felt the plunging of a
needle. The world stopped where it was for a second or two, and then
clicked out, like turning off an electric light." After "the show was over,"
McLachlan "warned Eldred he had bled too much as if it were his
fault"; and his patient thinks: "Doctors are always surprised if they have
not seriously injured you." Though the surgeon had done a good job,
"Eldred had had, in his doctor's absence, what almost amounted to
a dangerous haemorrhage." A photograph of the blind and aged Lewis,
taken by Douglas Glass and reproduced in the *Letters*, shows the old
Tyro flashing a new set of dentures. "How absurd to be using false
teeth," he would exclaim, taking them out and holding them up for
show.

Lewis had been practically blind in his left eye for years, but as
darkness continued to encroach on his right eye he realized that the
true source of his troubles had still not been treated, and that he had
endured an operation and lost his teeth for nothing. Certain that his
condition was much worse than glaucoma or cataracts, and tortured by
the knowledge that he was going blind, Lewis was unresigned to his
condition and desperate to find a cure: "I have never at any time, in
my worst dreams, imagined myself deprived of my sight."[2]

When Lewis returned from Canada in 1945 he was warned by an
ophthalmologist that he had a growth in his skull and had ignored this
condition for at least five years.[3] Dr. Greeves had "advised an immediate
operation, told me something was pressing on my optic nerves—I
thought I would wait and see." He was warned again in May 1947 when
his general practitioner, Dr. Ian McPherson, wrote: "As Mr. Greeves
rightly says, the degree of possible recovery of the good eye is dependent
on the speed with which we relieve the optic nerve. If you are not ready
to enter a Nursing Home, at least let us get the X-rays done and put your
name on the waiting list of a hospital."

Lewis finally accepted the diagnosis of a pituitary tumor, after the
extraction of his teeth, in about February 1950. As he told his old friend
Helen Saunders: "Until seven months ago I got along fairly well. Then
[February 1950] I went to another eye-doctor. He informed me, after
x-ray had been taken, that a tumour or cist—inside the skull—was
pressing up against the optic nerves: that an operation would be far
too dangerous to contemplate and that I must rely on x-ray therapy
to reduce the pressure and prevent the worsening of my condition.
In this way I have a good chance of surviving: but the condition of my
eyes will no longer permit me to work as a painter."

Though Lewis suffered from severe headaches (like migraines) as
early as the 1920s and the tumor, which could have been growing for
as long as thirty years, eventually exerted some pressure on the brain,

it did not seem to affect his personality—which remained consistent from early manhood to the end of his life, and did not show marked changes in the 1950s.[4] Lewis' chromophobe adenoma grew upward behind the nose, from the pituitary gland at the base of the brain, gradually pressed on the chiasma, or crossing of the optic nerves, and caused optic atrophy. These nerves had been permanently damaged and could not have re-grown, but Lewis could have retained his impaired vision if the tumor had been removed in the 1940s.

Both Dr. Greeves and Dr. McPherson felt that Lewis' age, and his history of bladder and kidney disease which continued to trouble him in the 1940s, did not preclude an operation; they tried to persuade him to have the tumor removed and felt disappointed when he refused. But Lewis had his own views and could not be persuaded to follow their advice.[5] After his grim experience with bladder operations in the thirties and the mistaken opinion about his eyes in Toronto, Lewis had little faith in either diagnosis or surgery. He hoped that his vision, however defective, would last his lifetime, desperately wanted to complete *Self Condemned* and *The Human Age*, and preferred to risk blindness rather than brain damage and death. "I am informed by the eye doctors," Lewis wrote, "that death, total blindness, paralysis or insanity probably await me as a result of that operation. . . . You can see from all this that I am in for a fairly hot time. But it is after all the kind of thing one has to expect if one allows oneself to be born. Had I been a suitably obstreperous foetus all this could have been avoided."[6] He therefore postponed his decision about an operation, and continued to consult doctors—both British and foreign—who might offer a more hopeful treatment or less radical cure. Lewis almost certainly made the right decision, for he completed six books in the 1950s and lived to the age of seventy-four. Pound referred to his stoical decision to accept darkness in the final and most moving tribute to his friend in Canto 115:

> Wyndham Lewis chose blindness
> rather than have his mind stop.

In June 1950 Lewis and Froanna took two trips abroad to consult specialists in Switzerland and Sweden. The Swiss oculist at the Augenklinik in Zürich made the accurate but futile prediction: "If you do not receive surgical treatment you will go blind." On the way back to London they spent two weeks at the Hôtel Palais Royal in the rue de Valois in Paris and dined at his favorite restaurant, La Pérouse. Eliot lent Lewis £200 (which he repaid from his B.B.C. commission) to go to Stockholm for X-ray diagnosis and therapy with a radiologist who had great success in treating his sort of misfortune. Lewis referred to his sumptuous journey across the North Sea on the opening page of *Rotting Hill*.

In August Lewis had two weeks of radio-therapy in London, which seemed to have a deleterious effect, though it was quite normal to feel ill after radiation treatment, which made the tumor swell and emit a fluid: "The X-ray treatment appears to have set me back—not to have advanced me. My G.P. informs me that in a textbook on the subject it is said that sometimes X-ray treatment produces a liquid (discharge) which temporarily impairs the sight. On the other hand my eye-doctor assures me that in all his experience he has never known X-ray to be responsible for such a reaction. *But* there is no question that between 28 Aug. and 11 Sept. my sight worsened: i.e. the period during which I was treated." In October, his doctors once again considered the possibility of a major operation and Lewis continued to feel uncertain and fearful about precisely what to do about his failing vision. He still did not know—and could not know—whether to have radiation or surgery, whether he would retain some sight or become completely blind, whether the tumor would allow him to live or would kill him. In February 1951 he consulted a third foreign medical expert on the boulevard Malesherbes in Paris. This doctor gave him useless vitamin injections; but Lewis was at least able to indulge his taste for rum-flavored ices and superb champagne at the Écu de France. As late as July 1951, three months after he went blind, he still had doubts about whether the pressure on his optic nerve came from a tumor or from an aneurism.

Lewis once observed that "Plenty of writers go mad but surprisingly few become blind." But he belonged to a tradition that began with Homer and included Milton, who also had a pituitary tumor and whom Lewis alluded to in his essay on blindness and his portrayal of the Underworld in *The Human Age*.[7] Both D'Annunzio (who recorded his experiences in *Notturno*) and Huxley had survived long periods of blindness; and the half-blind Joyce had fought off total darkness with an endless series of excruciating operations.

By April 1951, when Lewis was overtaken by blindness, he seemed to have achieved a bitter acceptance of his condition, for he told Joe Ackerley: "We are all going into some even darker room after all: we none of us ever give a thought to that, so why should I anticipate my more limited black-out?" On May 10 he formally ended his five years as art critic for the *Listener*, informed his readers of the exact nature of his disease (partly to forestall rumors of syphilis),[8] and published "The Sea-Mists of the Winter"—the most brave, most poignant and most perfect work of his entire career.

Lewis described how the appearance of a sea-mist in his eyes indicated "a great acceleration of failure of vision," which affected every aspect of his life. He had difficulty dialling a telephone and once hailed a hearse instead of a taxi:

'You have been going blind for a long time,' said the neuro-surgeon. And I had imagined I should go on going blind for a long time yet: just gradually losing the power of vision. I had never visualised mentally, a sea-mist. . . .

The failure of sight which is already so far advanced, will of course become worse from week to week, until in the end I shall be able to see the external world only through little patches in the midst of a blacked-out tissue. On the other hand, instead of little patches, the last stage may be the absolute black-out. Pushed into an unlighted room, the door banged and locked for ever, I shall then have to light a lamp of aggressive voltage in my mind to keep at bay the night. . . .

As a writer, I merely change from pen to dictaphone. If you ask, 'And as an *artist* what about that?' I should perhaps answer, 'Ah, sir, as to the artist in England! I have often thought that it would solve a great many problems if English painters were born blind.'

And finally, which is the main reason for this unseemly autobiographical outburst, my articles on contemporary art exhibitions necessarily end, for I can no longer see a picture.[9]

As Lewis' tumor, the traitor beneath his brain, continued its inexorable growth and pressure, his vision deteriorated in gradual stages: from sea-mists—to a few remaining islands of dark and light—toward, but never quite reaching, absolute blackness. In August 1951 he explained: "My eyesight is, as you have heard, more than half gone. I no longer have what is called the 'central vision'; that is to say I can no longer see to read or write, and my vision of the world is a very blurred and impressionistic one." In 1953, when Lewis saw Eliot's *The Confidential Clerk*, he could vaguely discern dark and light forms, and roughly see the position of the actors on the stage—though they were surrounded by shadows. And there were still faint glimmerings of light in 1956, when his sight had not yet completely gone.

The pressure of the tumor also affected the hypothalamus and caused drowsiness. Lewis once went to the lavatory to escape the conversation of Froanna and Agnes Bedford—and fell asleep there. He could talk to his friends for only an hour at a time. In April 1955, when he was somewhat forgetful, slow of speech and partially deaf, and had pale waxen skin and puffy features, John Rothenstein "was shocked to find him aged and ill, and obsessed by a painful operation on his hands which he described in detail; his sight was almost gone."[10] He wore a green eyeshade (depicted in Michael Ayrton's drawing) as protection against the light, never learned to walk blind and always feared he would stumble. A young neighbor, who had read about the fiery Vorticist, was surprised to see that Lewis had become a gloomy old man, shuffling along the narrow passageway to his flat. He once saw Lewis fall down and helped him pick up a package that had spilled. Lewis knew he was dying, was far removed from the world and lived only to complete *The Human Age*.[11]

2

When Agnes Bedford, the musician who had been Lewis' mistress in the twenties, heard about his blindness in 1951, she got in touch with him and offered to help with his work. Lewis would dictate his letters and his last books to Agnes, and would sometimes be taken to work at her house at 44 Eaton Mews North, where she lived alone on a small private income. When the Lewises' flat was being redecorated, they moved in with Agnes for a few weeks. Agnes, who was about seven years older than Froanna, was an elderly, unattractive, grey-haired spinster. Though Froanna was more beautiful, Agnes was more intelligent, amiable and placid. She was pleasant to Froanna, always stood up for her, and once told Lewis: "I would have liked Froanna if it weren't for you."

Both women were devoted to Lewis and shared the responsibility of caring for him. But the mood of the small household during the difficult transition to blindness—when Lewis became totally and bitterly dependent—was tense and strained. Lewis' geriatric *ménage à trois*, very different from Augustus John's harmonious and hedonistic harems, resembled the jealous rivalry of Olga Rudge and Dorothy Pound for the loyalty and affection of Ezra. Froanna was grateful for Agnes' assistance, which relieved her overwhelming burden as full-time nurse, companion and scapegoat. But she also resented her presence, sometimes treated her with cattiness and hostility, and told friends she "would rather *not* come to dinner with Miss Bedford." When Froanna became furious with Agnes, who ate a great deal of food, she would spit out the hated name: "Bedford!" And when Froanna lost her temper and threw something at Lewis, he complained: "Not fair. I'm a blind man and can't duck," and told a friend he had left Froanna and was now living with Agnes.

Lewis tried to remain as independent as possible and, like Samson, wished to keep fighting to the end. He liked to answer the telephone himself, but moved across the room very slowly; it took thirty rings before he would pick up the instrument and roar in an intimidating voice: "Bayswater 2089. This is Wyndham Lewis!" He was never an easy person to live with, even at the best of times, could not bear to be tended or touched by anyone but Froanna—and resented even her. Gradually, he came to accept her help, and enjoyed hearing her read to him in the evening from travel books about Africa and Asia. She learned to be more tactful with her help. When mice overran the flat as it was being repaired, Froanna saw a rodent climb on Lewis' shoulder and quietly knocked it off before he noticed anything. During a dinner-party, the lobster dish broke when it was taken out of the oven and fell on the floor. Froanna kept silent, pretended nothing had happened and

crawled on her knees to pick up the pieces. Lewis knew something was wrong and was angry about not being told.

When the tension of blindness and Bedford became too great to bear, Froanna tried to escape. She once went alone to Booten to visit Willis Feast, who felt she was a very forceful character and had to be treated by Lewis with great firmness. In May 1951, the month after he went blind, Froanna travelled to Ireland by herself to get away from Lewis and visit Meyrick Booth on his forty-acre farm in County Cork. But when she quarrelled with Booth's German wife, Hedwig, Lewis (escorted by a companion) came over to rescue her and bring her back. "I was staying in an enormous practically unfurnished house," Lewis told Spender in June. "I was surrounded by violently coughing heads: for my hosts appeared unable to buy fuel. But I consoled myself by sitting in a conservatory beside an Indian tulip tree, and found that the Irish sun through glass is quite respectably hot."

As soon as the Lewises returned from Ireland, they were forced to leave their Notting Hill flat because of problems with plumbing, flooding and dry rot. They moved into a fourth-floor flat, in a grimy red-brick building with stone corridors and a creaking caged elevator, at 18 Ashley Mansions, 254 Vauxhall Bridge Road, near Victoria Station. The flat, which was inconvenient, crammed with furniture and very noisy, forced Lewis to make a new and difficult adjustment. Froanna's health deteriorated as Lewis went blind; and after his death she said she was on the brink of a nervous breakdown. Froanna—no longer sustained by Lewis' energy, vitality and hope that things would improve —became extremely depressed in the miserable flat. She apparently took an overdose of sleeping pills, and her attempt to kill herself was a searing experience for Lewis. When his friends pleaded with the former land-lord to show mercy for the blind old man, they were allowed to return to their old flat until it was ready for demolition; in August they fled from Ashley Mansions back to Notting Hill.[12]

3

In 1951, when Lewis' private life was disintegrating into chaos and tragedy, his professional career suddenly gained new momentum. He acquired two new publishers who were loyal to his work and to his interests, signed a profitable contract with the BBC for the dramatization of *The Human Age* and was the subject of several important works. Without this revival in his fortunes, which enabled him to survive this harrowing time, he might have abandoned all hope of ever writing again. When the literary agent A. P. Watt told J. Alan White, an enthusiastic admirer of Lewis' work, that he was looking for a new publisher, White

persuaded Lewis to sign with Methuen. White had no personal difficul-
ties with Lewis, but there were financial problems because Lewis' books
did not make enough money for him to live on. Though Methuen paid
only £100 advance for the reprint of *Tarr*, £150 for *The Writer and the
Absolute* and £300 for *The Human Age*, Lewis rarely earned his advances.
Despite the lack of substantial sales, Methuen published Lewis' last six
books—from *Rotting Hill* (1951) to *The Red Priest* (1956)—reissued
four others and brought out his *Letters* in 1963. Methuen's interest in
Lewis was matched by Henry Regnery, a Chicago publisher, who
brought out in the early fifties *Rotting Hill*, *Self Condemned* and *The
Demon of Progress in the Arts* as well as the first American edition of
The Revenge for Love. The publication of Handley-Read's book on
Lewis' art in May 1951 coincided with the reissue of *Tarr* and *The
Lion and the Fox*, the appearance of Geoffrey Grigson's lively pamphlet
on Lewis, *A Master of Our Time*, and the BBC dramatization of *The
Childermass*—all in June 1951.

Lewis predicted his fate and sardonically noted the connection
between artistic fame and penury in *Enemy of the Stars* (1914): "When
you hear a famous man has died penniless and diseased, you say, 'Well
served.' Part of life's arrangement is that the few best become these
cheap scarecrows." And in November 1942 he wrote ironically to John
Rothenstein: "I am approaching the age when society usually says to
itself: 'We might as well recognize the existence of that unpleasant
person. He'll be dead soon."[13] Another ten years passed before Lewis
received any official recognition, though Spender had asked the Bollingen
Foundation to help Lewis and in 1951 the Royal Literary Fund gave
him £100 for a dictaphone. After Lewis became blind several friends
(probably Eliot and Naomi Mitchison) helped get him a Civil List
Pension, designed for impoverished men who had distinguished them-
selves in the arts. On February 29, 1952, Lewis received official notifica-
tion which stated: "I am desired by the Prime Minister [Churchill] to
inform you that, on his recommendation, The Queen has been pleased
to award you a Civil List Pension of £250 in recognition of your services
to literature and art." In March 1954 the pension was raised to £400.

Lewis received a second honor in 1952 when Bonamy Dobrée, the
Professor of English at Leeds University whom Lewis had known since
1926, arranged for the award of an honorary doctorate. (Edith Sitwell
had received the same honor from Leeds in 1948 and Eliot had already
collected fourteen doctorates.) Because the Court was in mourning for
George VI, the Princess Royal (aunt of the queen), who was the
chancellor of the university, could not officiate in May and the ceremony
was postponed until November 12. Lewis went up to Leeds to have
dinner with the princess on November 10. Two days later there was a
luncheon for 200 guests at the Queen's Hall, a colorful procession of

academic and civic dignitaries, a ceremony at the Town Hall at 3 o'clock and the Lord Mayor's tea for eighty guests. Arthur Ransome, who had been at Rugby with Lewis, and Margot Fonteyn also received honorary degrees. Lewis had to be led around to the various functions and guided on to the platform for the presentation by Dobrée, which concluded: "In both arts he has exerted an influence, itself a tribute to his genius; thus it is because he is not only a great artist but also a great power, that, Your Royal Highness and Chancellor, I pray you to confer upon Wyndham Lewis the Degree of Doctor of Letters *honoris causa*."

4

Lewis showed amazing resilience and vitality during his final years as the "lamp of aggressive voltage" provided the power to complete the major works of the 1950s. His thought was keener, his heart greater, as his strength diminished. During the severe winter of 1952 he did not leave the house for five months and worked constantly. In September 1956, shortly before his last birthday, as his tumor continued to grow and to press, he replied with iron rigor when a journalist asked if he intended to write more books: "You insult me! I am still alive. I work up to midnight if I feel like it. . . . Life is still rich and fascinating. I am not locked up in a dark room. The mind has many chambers."

Though Lewis said: "Milton had his daughters, I have my dicta-phone," he was unable to use the machine. When blind, he would write thousands of pages in longhand, with painstaking care and infinite courage, on a hard board resting on his lap, which had a wire stretched across it to keep the lines straight. He would carry on until his pen dropped off the right edge of the page, then move the wire down the width of three fingers and begin the next line. He wrote about thirty tiny, widely-spaced words on each page, so they would not run together; and his late manuscripts resemble the holograph of *Finnegans Wake*: a few wavering words scratched across a large sheet. If the pen ran out of ink, Lewis would not know it and would continue to engrave the invisible words on the blank page—until someone realized what was happening. He would drop the pages on the floor in a deep pile, which would be arranged, typed and read back to him by Froanna and Agnes.

When Lewis began to dictate his books to Agnes, after *Self Condemned*, he always knew exactly what he wanted to say, and spoke steadily and without hesitation. The next morning, he corrected the typescript after listening to what he had dictated. As Agnes observed, he had an extra-ordinary recollection of the details and structure of the book: "He remembers all he has written in earlier chapters. His memory is remark-able—as exact as a young man's."[14] When he was nearing the end of a

book with her and finally stopped speaking, she said: "Is that all?" he replied: "That's all"—and the work was completed. But neither Froanna nor Agnes would dare make suggestions about revisions, and the late books inevitably contained some slackness and repetition.

Lewis' last polemical book, *The Demon of Progress in the Arts* (1954), concluded the argument against abstract art he had first developed in his Introduction to the *Tyros and Portraits* exhibition catalogue of 1921. He also unleashed his final onslaught against Eliot's "melancholy ex-lieutenant," Herbert Read, who, Lewis thought, led the dashing but dull rear-guard of abstractists, was besotted with theorizing, neglected the evidence of the eye and never really looked at a picture in his life. If, for Lewis, Fry and Clark were art dictators, Read was an ineffectual impresario and aesthetic buffoon. In 1934 Lewis, who detested Read's Anarchist politics, suspected that he had written a negative review of *Men Without Art* in *TLS*; and in *Wyndham Lewis the Artist* (1939), he charged Read with willingness to provide any art movement with instant respectability and exposed his weaknesses with deadly accuracy: "Mr. Herbert Read has an unenviable knack of providing, at a week's notice, almost any movement, or sub-movement, in the visual arts, with a neatly-cut party-suit—with which it can appear, appropriately caparisoned, at the cocktail-party thrown by the capitalist who has made its birth possible, in celebration of the happy event. No poet laureate, with his ode for every court occasion, could enjoy a more unfailing inspiration than Mr. Read; prefaces and inaugural addresses follow each other in bewildering succession, and with a robust disregard for the slight inconsistencies attendant upon such invariable readiness to oblige."

In 1948 Lewis became angry about Read's choice of the "posterish" *Wyndham Lewis as a Tyro* to represent him at the ICA exhibition and asked him instead to show the *Red Portrait*. Two years later Lewis criticized Read's attempt to discipline the spontaneity of children's art; and in *Rotting Hill* the narrator mocks Read's *Education Through Art* (1943). The intensely independent Lewis (who had an integrated vision in art and literature, and was consistent in his aesthetic theory and practice) believed Read's rather tame and conventional literary work was exactly the opposite of what he daringly professed in the visual arts. Stephen Spender, who said that Read hated Lewis and thought he was evil, explained that Read's conflicting duality was caused by the extinction of his imaginative powers: "The creative side of his talent has gradually been submerged, and the more this has happened the more depressed he feels about the arts in general. He has a line which is to support nearly everything that is experimental and he therefore gives his readers the impression of being in the vanguard, and someone in the vanguard is supposed of course to have burning faith and vitality: qualities which, in reality, H.R. lacks."[15]

In *The Demon of Progress in the Arts*, which drew the reluctant Eliot into the controversy, Lewis repeated his accusations of 1939 and sardonically observed that Read's willingness to trim his sails to the prevailing aesthetic winds had earned him a knighthood in 1953: "In Sir Herbert Read we have a man who has been very recently knighted for being so 'contemporary'; for having been for years ready to plug to the hilt, to trumpet, to expound, any movement in painting or sculpture —sometimes of the most contradictory kind—which was obviously hurrying along a path as opposite as possible from what had appealed to civilized man through the ages."

Lewis' book finally stimulated Read's counterattack, which alluded to the title of Lewis' work and appeared in the *Sewanee Review* of 1955 as "The Lost Leader, or the Psychopathology of Reaction in the Arts." Read relegated Lewis to the ranks of the aesthetic rear-guard and argued: "Reactionaryism is a negative doctrine. It vigorously denounces an existing trend—the historical present—and seeks to establish a contrary trend. It is revolution in reverse." In a note on the first page of his essay, Read mentioned that Lewis had provoked his response and made the unconvincing assertion that his own essay was impersonal: "It may be no accident that these thoughts came to me after reading *The Demon of Progress in the Arts*, an attack on the contemporary movement in art by Wyndham Lewis. It should be obvious, however, for reasons given in the course of my essay, that my observations have no application to Mr. Lewis himself."

When Eliot saw this article he defended Lewis and criticized Read's "psychological" mode of argument. Read, embarrassed at Eliot's censure, became apologetic, maintained that he had always admired Lewis and claimed that Lewis' treacherous attack came as a complete surprise—though Lewis had been condemning Read, with considerable consistency, for thirty years: "The footnote in the *Sewanee* was inserted at the request of the editor, who felt that his American readers would not otherwise see the relevance of my article. . . . I find it difficult to explain why a man for whom I have always had friendly and loyal feelings should turn on me with such bitterness and resentment. . . . Lewis attacked me in a direct and extremely vituperative manner. I was surprised, and I could not reply in kind because I did not feel that way about Lewis—I had hitherto regarded him as a friend. . . . I now regret that I added the footnote—I remember that I added it with reluctance. . . . The harm is that I have shocked you, and there is no one in the world for whose good opinion I have more respect."[16]

Though Read was chagrined by Eliot's displeasure, he continued to attack Lewis after his death in an abusive obituary, a negative review of the *Letters* which appeared under the appalling homiletic title: "A Good Artist But A Bad Friend," and in his memoir of Eliot, published

in 1966. In the memoir Read asserted: "On one of the last occasions that I lunched with [Eliot] alone at the Garrick Club he confessed that in his life there had been few people whom he had found it impossible to like, but Lewis was one of them." It is significant that Read admitted there were no witnesses and did not publish his malicious story until after Eliot's death, for his account contradicted the entire tenor of Eliot's forty-year friendship with Lewis. Lewis' remark of April 1955 provided a convincing refutation of Read and a fitting conclusion to their long standing controversy: "Not long ago Tom expressed to me his misgivings for having, in effect, given Herbert Read his start, encouraging him to contribute to *The Criterion* and publishing some of his books, saying that there was no one whose ideas he considered more pernicious, and I agree with Tom."[17]

5

Lewis' greatest novel, which Eliot called "a book of almost unbearable spiritual agony," was begun in Canada, where he collected local newspaper clippings, lists of Canadian idioms and slang, and extensive material about the individual characters. Lewis wrote the book in the early fifties, after he became blind. In November 1952 he told Henry Regnery that his next work would be a novel called "You are perhaps a fool, my son" (these words, spoken by Harding's mother, became the title of the second chapter), about the strange life of an *émigré* in Canada. And in February 1954, two months before the novel appeared, Marshall McLuhan, who observed that Lewis was the first writer to give serious treatment to any aspect of Canada, reported that Toronto had been alerted and begun to tremble. *Self Condemned*, which became Lewis' most successful book and sold 7,000 copies in the first two years, took Toronto off the map.

Almost all of Lewis' previous novels had been compromised by subjection to a preconceived theory. *Self Condemned*, by contrast, was not jagged and objective like *Tarr*, abstract and fantastic like *The Childermass*, external and mannered like *The Apes of God*, hard and mechanical like *Snooty Baronet*, didactic like *The Vulgar Streak*, ideological like *The Red Priest*. In *Self Condemned*, even more than in *The Revenge for Love*, Lewis abandoned theory and experiment, and returned to a realistic psychological novel that was analogous to his defiant and revealing self-portraits. Unlike *Tarr* and *The Revenge for Love*, where the characters who represent aspects of Lewis are split into Tarr and Kreisler, Stamp and Hardcaster, Lewis' intellect and emotions are concentrated and intensified in René Harding. It is difficult to agree with two of Lewis' best critics who have stated that *Self Condemned*

does not accurately reflect the reality of Lewis' life in Toronto.[18] For Lewis' finest novel remains extraordinarily close to his personal experience, and gains enormous power by the self-lacerating exposure of his most intimate feelings and deepest suffering. Yet Lewis also maintained the requisite aesthetic distance which allowed him to create a novel that transcended the barren and scarifying years in Toronto.

Though Lewis does not mention blindness in *Self Condemned*, the recurrent visual imagery makes it a central metaphor of the novel. For Harding, like Lewis, moves blindly out of England without ever clearly explaining why he left and emigrates to Canada without any realistic sense of what he will find there. Harding's analysis of the transition to the Canadian darkness applies with equal force to the terrible test of blindness which would either destroy or renew Lewis' courage and creative existence: "Either the life he was now to enter was an empty interlude, an apprenticeship to death: or it was a breathing-space, a period of readjustment, preceding the acceptance of a much simpler type of existence for Hester and himself." Harding's life in the hotel, like Lewis' isolation in his Notting Hill flat, "stank of exile, penury and confinement." Canada, with its bursting violent light, "is no land for those with delicate eyes"; and Cedric Furber expresses his authority as well as his insensitivity by forcing Harding to face the glaring daylight till his eyes ache. Harding opposes the symbolic darkness of Canada with the same stoicism that Lewis summoned to face the functional darkness; and while Lewis saw the "sea-mists of winter" overwhelming his vision, Harding exclaims: "I see a fiery mist wherever I direct my eyes. But the fire is not outside me, the fire is in my brain." Lewis also makes poignant allusions to the tumor, "a hot devouring something inside my skull," which caused blindness and led to intense drowsiness. In Toronto "his personality had suffered profoundly. All freedom depended upon consciousness: but now, at times, he felt his brain clouding and blurring. His daily periods of semi-consciousness increased."[19] These passages, like numerous others in the novel, achieve a profounder dimension of pathos and meaning by illuminating both Lewis' life and his art.

The opening section of the novel, an extensive prelude that occupies forty per cent of the work, has been criticized for its slow-moving discursiveness. But like the static overtures to *Remembrance of Things Past* and *Joseph and His Brothers*, the prelude repays patience, admirably fulfills its function and grinds forward "with the inevitability of a glacier." The first part of the novel, which attempts to explain and justify Lewis' as well as Harding's reasons for leaving England in 1939, is emotionally but not intellectually convincing. For Harding, whose rational premises are mistaken, deliberately drives himself to ruin. As Lewis says of Vincent Penhale in *The Vulgar Streak*: "This was a cell

of his own making: full of cold, hard, light, like a symbol of his mind."

Harding's *Secret History of World War Two*, which led *The Times* to call him "fascist-minded," is similar to Lewis' "peace pamphlets" of the mid-thirties—*Left Wings Over Europe* and *Count Your Dead: They Are Alive!*—which anticipated and rather ineptly tried to prevent the coming war, stigmatized him as a Fascist sympathizer, encouraged his exile and made him abandon political writing. Harding's most impressive intellectual quality, like Lewis', is a power of analysis so penetrating that nothing can withstand its intense and ultimately destructive scrutiny: "The process of radical revaluation, the process which was responsible for the revolutionary character of his work, that analysis, turned inwards (upon, for instance, such things as the intimate structure of domestic life), this furious analysis began disintegrating many relationships and attitudes which only an exceptionally creative spirit, under very favourable conditions, can afford to dispense with." Harding, like Lewis, is extremely idealistic but also "carries a sceptic on his back." He has repudiated the intellectual attitudes of his time and feels ostracized by his professional colleagues and rivals. He came to believe that history was not worth recording because it did not reveal man's passion for sanity, decency and morality but was, in fact, "the bloody catalogue of their backslidings." Perhaps the most forceful reason for abandoning his profession is Harding's confession: "Through looking too hard at the material I was working on, I saw the maggots in it, I saw the rottenness, the fatal flaws; had to stop earning my living that way."

The prelude is also a recapitulation of Lewis' prewar life. Harding's French Catholic mother, with whom he shares an extraordinary sense of identity, recalls Lewis' paternal grandmother, Caroline Romaine, his Catholic mother, his own baptism in Montreal and his quest for the origins of his family that influenced the return to the land of his birth. Harding's visit to Rugby recalls Lewis' years at that public school when the young American boy consciously assumed the lifelong role of Outsider and chose the vocation of an artist.

Two of Lewis' friends also appear in the prelude. Harding's brother-in-law, Percy Lamport, who has rimless glasses and a light-brown thatch of hair, and is a wealthy collector of paintings, with a chauffeur and limousine, is based on Lewis' patron and friend Sir Nicholas Waterhouse. Lamport alone recognizes and approves of Harding's self-destructive idealism, and generously offers to lend him £1,000 to sustain him after the resignation. Harding's disciple "Rotter" Parkinson, who has written a long essay on his master's life and work, is modelled on Hugh Gordon Porteus, who wrote a book on Lewis in 1932 and sometimes aroused Lewis' wrath. As Harding leaves Parkinson's flat after listening to him read his article, "His critical frenzy had one of its regular spasms. He tore his best friend to pieces and himself as well; so

much devotion was embarrassing; how could one really feel at ease with a parasite, and with what ridiculous assiduity he had encouraged this man to feed upon his brain. He went round there perhaps once a month to be milked, as it were."[20] The metaphor for their intellectual friendship ironically paraphrases Tarr's sensual relationship with Bertha.

Finally, the relationship of Harding and Hester, clearly based on Lewis' marriage, is solidly established in the prelude before being tested and destroyed in the Canadian crucible. Though Lewis wittily wrote in *The Art of Being Ruled*: "Most people's favourite spot in 'nature' is to be found in the body of another person," Harding (who has an abnormal sexual appetite) has an intellectual suspicion of the Yahooesque panting and grunting between the sheets. He sees Hester as an abstract Woman and live pin-up, and never learns that she is a human being whose desires and needs are independent of his own. When he resists Hester's sensuality, the basis of their marriage, and she can no longer reach him on the physical level, their passionate solidarity begins to crumble and they start to watch each other with the sullen reserve of caged animals.

Like *Anna Karenina*, another novel of an outcast couple whose love cannot withstand the torments of almost universal opposition, the end of *Self Condemned* is foreshadowed in the beginning. The allusion to the suicide of Hyacinth Robinson in James' *The Princess Casamassima*, the moving reference to the anti-Nazi exiles—Ernst Toller and Stefan Zweig—who killed themselves after escaping to New York and Rio, the dangerous leap of Harding's sister from a moving train, Harding's fears that Hester might leave him, and Hester's threat: "I would throw myself out of that window if I knew that my death would result in your returning to England, and that nothing else would do so"—all these dark warnings anticipate Hester's doom with the prophetic force of a classical tragedy.

Once Harding leaves England the novel follows actual events very closely. They refuse to sail on the *Athenia* and later hear that it has been torpedoed only one hundred miles from their own ship. War is announced while they are crossing the Atlantic, and to avoid submarines they zig-zag to the north, bound for Greenland. Though Lewis met Charles Abbott, who invited him to paint the Chancellor of the University of Buffalo, before leaving England, he appears aboard ship as the rather foolish and pompous Dr. Lincoln Abbott, President of the University of Rome, in Arkansas, and a great admirer of Harding's books. (Harding's disagreeable moustachioed London landlady is also called Mrs. Abbott.)

Momaco, devoid of all character and charm, a living death from which no speck of civilized life could ever come, is a variant of Mimico, a suburb southwest of Toronto on Lake Ontario: "The place was the

grave of a great career: the barren spot where you ceased to think, to teach, or to write, and just rotted away." The timorous academics at the university, who were anti-English, "passionately held down their jobs and closed their ranks against the stranger of renown." Harding, like Lewis, is cut off from all money in England, has to buy copies of his own books from second-hand dealers, becomes a columnist on the *Momaco Gazette-Herald* (i.e. *Saturday Night*), writes with a pad on his knee and drops the pages on the floor. He also receives a cascade of registered letters from "someone in Vancouver" (David Kahma), who makes glittering promises of a university position and invites him to stay at his "properties."

The Blundell Hotel was of course the Tudor Hotel, which had an annex and a "Beverage Room" (the Sahara Room) and became for Lewis the violent microcosm of the outside world. In that inhuman void, nothing could be done "except wait for the mail, which always brought discouraging news, or listen to the radio, which droned on in its senseless ritual, or write something which might never see the light."[21] In *Blast 2* Lewis had explained why he could not create in such a deadening atmosphere: "To produce the best pictures or books it is possible to make, a man requires all the peace and continuity that can be obtained in this troubled world." Though Lewis seems to be exaggerating when he writes that a splinter of ice "pierced a boy's eye and blinded him outside the Blundell Hotel," he reported to Nicholas Waterhouse in January 1943: "The other day a man was killed [by an icicle], it shot down and pierced his skull."[22] The cold penetrated the body like radium and temperatures often fell to 30 degrees below zero.

Lewis' Canadian patrons and friends also appear thinly disguised in his novels. In *The Vulgar Streak*, Lewis alludes to the meat magnate Stanley McLean when a letter from Vincent's well-married sister in Vancouver mentions a glamorous social event where she met Bob Brabazon, "President of the Western Canada Canners Co." The wealthy book collector Cedric Furber—whose name is a variant of Cedric Foster, an American news broadcaster whom Lewis particularly disliked—is bearded like Lytton Strachey but based on the tall, affected homosexual Douglas Duncan. Like Duncan, Furber, "a rich lonely bachelor of forty, was very old-maidish and strict." He was also saturnine, taciturn, superior and a barbarous snob. Though Furber generously gives Harding a monthly retainer to keep him from starvation, Harding (like Lewis) finds it difficult to feel gratitude. Duncan, like Sydney Schiff in *The Apes of God*, was pilloried for his callous kindness.[23] One of the few sympathetic Canadian characters, Professor Ian McKenzie, "a smiling Scottish sophist of about forty-five with a faint and pleasing accent . . . a man of his own kind," was probably a composite of Marshall McLuhan, the painter Alex Jackson, and John Burgess, a chemist with strong

philosophical and religious interests who offered Lewis "some financial assistance as well as the pleasure of civilised conversation."

"The Hotel, first and last, is the central feature of the book," Lewis told Michael Ayrton, who illustrated the fire on the dust-jacket of the novel, "and hte death of the hotel gives you flames and ice, smoke, and ruin." The fictional fire (foreshadowed when the continental crowds poured out of the train "like people making a frenzied exit from a building which was on fire" and on to the last boat out of Europe) was based on the conflagration that burned down the Tudor Hotel on February 15, 1943. The *Toronto Star* reported that Lewis had lost many manuscripts and in the novel Harding is unable to reach the furnace room where his papers are stored in a suitcase. In the Tudor fire Effie, the manager of the hotel and friend of Lewis, was asphyxiated by the smoke. In the Blundell fire, Mrs. McAffie is also a sympathetic character: "They developed an affection for this flying wraith, with the faintly rouged cheeks, who dashed, flew and darted everywhere, as though she desired to get rid of every remaining piece of flesh on her bones. She was tall and still enjoyed, in the manner of an afterglow, a vanished grace." But in the novel "Affie" is murdered by Mr. Martin, the owner of the hotel, when she discovers him committing arson. Lewis named this arsonist-murderer, who was responsible for the deaths of fifteen people and was soon apprehended and hanged, after Paul Martin, the Windsor lawyer whom he quarrelled with in 1945 about payment for the portrait of Martin's wife, Eleanor. After the fire, the Lewises moved to the Selby Hotel just as the Hardings moved to the Laurenty.

Lewis' account of the fire, one of the most vivid scenes in the novel, was inspired by Dante's description of fire and ice in the frozen Lake of Cocytus, which holds the souls of traitors in the Tenth Circle of Hell:

> I turned and saw, stretched out before my face
> And 'neath my feet, a lake so bound with ice,
> It did not look like water but like glass. . . .
> Their heads were bowed toward the ice beneath,
> Their eyes attest their grief; their mouths proclaim
> The bitter airs that through the dungeon breathe. . . .
> Their eyes, which were but inly wet till then,
> Gushed at the lids; at once the fierce frost blocked
> The tears between and sealed them shut again.

The apocalyptic extinction of the hotel reinforces Harding's hellish suffering in that cursed place. At the very end of the novel, when he becomes "a glacial shell of a man," he resembles the frozen cave of the burnt-out hotel: "The noise, the glare, the clouds of smoke, the roaring and crackling of the flames, this great traditional spectacle only appealed to him for a moment. But he could not help being amazed at the spectral

monster which had been there for so long, and what it was turning into. It was a flaming spectre, a fiery iceberg. Its sides, where there were no flames, were now a solid mass of ice. The water of the hoses had turned to ice as it ran down the walls, and had created an icy armour many feet in thickness."[24]

Just as "the destruction of the hotel by fire divided their life at Momaco into two dissimilar halves," so Lewis, four months after the fire, began to teach at Assumption College in Windsor. Lewis was invited to join the faculty by Father Murphy just as Harding was by Father Moody, a cordial and rubicund young priest whose eyes blazed with childish benevolence. Assumption (directed by the Order of St. Basil) is the College of the Sacred Heart (directed by the Order of St. Maurice) in *Self Condemned*, a tranquil retreat with a genial atmosphere: "This training-centre for the priesthood was a well-disciplined community, whose life moved hither and thither in response to quiet orders, or to a settled routine. It was an idyllically peaceful place for the victim of dynamic excess to go." The priests hope for Harding's conversion, as they had hoped for Lewis'.

Father O'Shea, the head of the Philosophy Department, is modelled on Father Edwin Garvey. O'Neill, the "handsome, sheepishly devout as well as competent, harmlessly sly" secretary, is based on Father Murphy's assistant, Joseph O'Connor. And the Irish poet Padraic O'Flaherty is Joyce's friend Padraic Colum, whom Lewis met at Windsor in March 1944. Harding gives six extension lectures just as Lewis gave the twelve Heywood Broun lectures in Windsor on "The Concept of Liberty in America." And Harding receives convalescent pay from the University of Momaco while teaching at the College of the Sacred Heart just as Lewis was presumably paid by Assumption when Father Murphy took over his classes, and he moved to St. Louis from February to July 1943 to lecture and paint portraits. Harding resolves this conflict of interest by returning his fee to the registrar of the college; Lewis could not afford this magnanimous gesture, though it is possible that he did not collect his salary for the months he was away.

Though Lewis hated Canada much more than Froanna did, he reversed their attitudes in the novel where Hester "entertains the most vicious feelings" about Canada. Lewis' wartime portraits (*The Artist's Wife*, 1940; *Reading the Newspaper*, 1944; *Portrait*, 1944) make Froanna appear depressed and introspective, and reflect his own gloomy emotions. Hester's breakdown and suicide are based on Froanna's breakdown and attempted suicide, just after Lewis went blind, in the summer of 1951. As Lewis suppressed his intimate feelings and rarely showed affection, so Harding deadens and desensitizes himself and tries to ignore the "Hesteria," ironically induced by the offer of a professorship at the University of Momaco, and her last desperate attempt to

force him to return to England: "Hester, whose face had been convulsing itself in a tragic mask, released, with a sort of howl, a torrent of tears . . . an obstreperous cataract of grief."

Lewis once deleted a moving passage from *Self Condemned* after Froanna had praised it; and when he asked her: "What shall I do with Hester?" she replied: "Bump her off"—and he did.[25] Margot Stamp in *The Revenge for Love*, who was willing to undergo slow destruction at her husband's side, had considered but rejected the suicide that Hester finally chose: "The notion of death always—in spite of the fact that she saw it was quite impracticable for her—brought rest to her mind. For when she had first considered it—before she had realized the catch, from love's standpoint—it had deeply impressed her." Like Vincent Penhale in *The Vulgar Streak*, Harding does not suspect the depth of his love for his wife or recognize the intensity of her suffering, until it is too late to help her. When Harding sees Hester on a slab in the morgue after she has thrown herself under a truck, her head, which had miraculously escaped destruction, seemed strangely detached from her body, as if to symbolize the separation of intellect and emotion in their marriage. Like the "Dumb Ox" heroes of Hemingway, Hester represents the pathetic and "passive little things to whom things are done." Though Hester's death has a profound emotional effect on Harding—who retches, sobs and faints—he coldly condemns her suicide as a form of vengeance, an act of insane coercion, and refuses to be influenced by her sacrifice: "My cold refusal to do what she wanted crazed her egoistic will. She was willing to die in order to force me off the path I had chosen. She probably thought, among other things, that her suicide would oblige me to give up my job at the University. She was acting vindictively."[26]

When Harding resigned his position in England he had an intellectual crisis, saw the gulf between "history" and reality, rejected the comfortable assumptions of society and the compromising restrictions of ordinary existence, and gave in to a wilful impulse to destroy himself. Though cynical about the possibilities of exile, and stricken with sorrow and regret, he never imagined that he would be struck down, humiliated, driven into the wilderness. When Harding recognized that his life in Momaco had become an unbearable self-exile, he tried to integrate himself within society. The hotel fire revived his hopes through its cleansing destruction, and was followed by professorships at Momaco and the Sacred Heart. But he was never able to live entirely by will and intellect, and never reconciled the opposition of the rational and emotional, the icy and fiery aspects of his character and marriage. Harding was more of a Tarr than a Kreisler—a hard, objective man who attempted to isolate himself behind a suitcase and blanket in the hotel room so he would not be distracted by his wife. When Hester killed herself, he

realized that he could never fill the dark and chilling void left by her death because she had supplied his affective life and her suicide had left him emotionally empty. He accepts a job at a pretentious American university and ironically ends, as he began, a successful and disillusioned professor of history: the benefactor and victim of his penetrating power of analysis.

Self Condemned portrays the reality of Lewis' failure and poverty in Toronto as well as the consequences of being a permanent and professional Enemy. His isolation and humiliation led to the characterization of Harding as a tragic, self-destructive figure—intellectual, remote, humorless, egoistic—who denies human feelings in his futile attempt to avoid suffering. The experience of Toronto gave Lewis the deepest insights into his own nature and enabled him to anatomize his emotional limitations. But he does not give Harding this insight and humility, and projects through him the consequences of severing vital connections with other people and maintaining a hostile attitude toward the world. *Self Condemned* is an intensely revealing and self-lacerating novel that penetrates the hard external carapace, exposes through Harding Lewis' own emotional disabilities, and pays tribute to his wife while it atones for his impossibly demanding and potentially destructive relationship with her.

Like *Women in Love, Self Condemned* concerns the devastating psychological effect of war on civilian life. Like Trilling's *The Middle of the Journey* (1947) and Mann's *Doctor Faustus* (1948), it is a tragedy of intellectual defeat. Like Lowry's *Under the Volcano* (1947), it portrays the self-destructive resistance to love, depicted in a harsh landscape that reflects and intensifies a moribund marriage. Though Harding became a glacial shell of a man, indistinguishable from his academic colleagues, Lewis survived the torments of Toronto and, despite his blindness, transfigured the suffering into his most powerful and profound work of art.

CHAPTER TWENTY

The Human Age, 1955–1957

I

Lewis' career concluded, as it had started, with creation and controversy. In his final years he completed the vast *Human Age* trilogy, which began with *The Childermass*, and became involved in a row—provoked by William Roberts—about the Vorticism exhibition at the Tate. He felt bitterly angry about poor health and poverty; was rather irascible, dogmatic and overbearing; and retained his ferocious reputation to the end. In the thirties and forties his combative temperament had often alienated friends, irritated enemies and injured his career. But when overwhelmed by misfortune in the fifties, he showed tremendous courage and independence. His psychological reaction to blindness was totally in character: he refused to accept its limitations, continued his titanic tasks and raged against the dying of the light.

He continued to attract new friends and admirers—Michael Ayrton, Russell Kirk, Walter Michel, Hugh Kenner and D. G. Bridson—who tolerated his sudden changes from courtesy to rudeness. When Bridson, a knowledgeable collector of art, made an observation about watercolors, Lewis sharply retorted: "Bridson knows nothing about painting." But they risked rebuke from the blade of his tongue, which could still slash his friends, because they admired his genius and his guts. Yet Lewis was also generous, receptive and interested in the world beyond the confines of his flat, and depended on friends to keep him informed about everything from politics to physics. Though contentious and egoistic, he did not submit to self-pity; and neither poverty nor illness diminished his intellectual curiosity.

Lewis met Michael Ayrton, the cousin of Israel Zangwill and son of the critic Gerald Gould (whom Lewis satirized as Geoffrey Bell in *The Roaring Queen*), after Ayrton had praised his draughtsmanship in his book *British Drawings* (1946). The two artists soon formed a mutually nourishing and stimulating friendship. Lewis wrote introductions to Ayrton's book and catalogues; praised his work in the *Listener, Nine* and *The Demon of Progress in the Arts*. Ayrton was equally energetic on behalf of Lewis. He did designs, dust-jackets and illustrations for five

books by Lewis, wrote exceptionally fine tributes (in a Lewisian style) in *Golden Sections* and *The Rudiments of Paradise*, and vigorously defended Lewis in his quarrel with Roberts. Ayrton also did a painting of the blind Lewis and several drawings, which were the visual equivalent of his verbal description: "On the summit of Mr. Lewis' black and formal figure was Mr. Lewis' head, wedge-shaped, blade-nosed, with a forehead like a sledge-hammer beneath which the girders of his spectacle-frames seemed to provide a dangerous cakewalk for ideas to cross." Ayrton's conversations with Lewis were mainly about his illustrations and other professional matters, and he often came supplied with Lewis' favorite luxuries: Fuller's walnut cake, Danish caviar and champagne. Ayrton was deeply moved by seeing Lewis' brave attempt to draw when he was going blind, and thought he conveyed a sense of great dignity, power and imagination.

Russell Kirk, the American author and columnist, came with an introduction from Henry Regnery to Lewis, who had read and praised Kirk's book *The Conservative Mind* (1953). When they met in 1954 Lewis was curious about Kirk, questioned him about his background and asked: "what is a conservative city?" (Kirk gave the example of Grand Rapids, Michigan, and described its characteristics.) Kirk disagreed with Allan Nevins' review of *America and Cosmic Man* and thought Lewis was well-acquainted with American history and politics. "I found him talkative, alert and humorous, despite his blindness. He was interested in the practical politics of America, and especially in the character of American conservatives. He certainly seemed to be in severe financial difficulties about 1955. He detested and suspected all publishers, and arranged to have me visit him alone, rather than in company with Henry Regnery. When going out, he would dine only at the Hyde Park Hotel Grill—'It's very expensive,' he declared—as someone's guest."[1]

Walter Michel, a physicist who later completed the standard book on Lewis' art, wrote to Lewis in November 1955 saying that he wanted to buy some drawings and received a prompt invitation to visit the flat. As Michel looked through a stack of drawings, including the magnificent abstract, "Dragon in a Cage" (1914), Froanna described them and Lewis gave the price. When she said: "Oh, Lewis, that's much too high," he replied: "But it may be a masterpiece." Lewis, who seemed to like physicists and was knowledgeable about science in his books and conversation, was not at all intimidating. He was pleased that Michel admired his work and had come to pay homage, and invited him and his wife to return for dinner. Lewis wore a blue dressing gown on that occasion and seemed proud of his new possession. Though Froanna cooked an excellent French meal, served with champagne, Lewis ate very little. He became irritated when she urged him to consume what

he could not see and shouted at her to shut up; but she ignored his command and said it was merely high spirits. As they left, Harriet Michel hugged Lewis and he grumbled: "How do I know she's good-looking?"

Hugh Kenner, who visited Lewis four months before his death, has left a vivid portrait of the final phase: "The flat overlooking Notting Hill Gate had an almost invisible entrance between two shops. One climbed stairs and pursued corridors at oblique angles until utterly disoriented concerning the bearings of the inner fastness, the door to which was answered only after disquieting delay. On his last birthday, 18 November 1956, the festivities were curtailed. He had recently been taken ill. There was champagne, there was pheasant ('Life is too short not to travel first class') but Lewis showed little interest in either. His massive form stooped, his sparse silvery hair curling at the collar, he acquiesced in the ritual shuffling on his wife's arm to the dinner table, but it was only back in the blue armchair that he seemed remotely comfortable. The drawing board and the huge pad of paper he wrote on stood propped beside it. Somewhere nearby dust thickened in the locked studio. It was never alluded to. No one had entered it in the half-decade since Lewis conceded he was blind."[2]

2

Just as Pound had helped Lewis at the beginning of his career, so Eliot sustained him at the end. Though grateful for the poet's assistance, Lewis maintained his ironic attitude as the ecclesiastical Eliot hardened into a national monument: "Tom's always been timid, and afraid of what 'people' will say, 'people' these days for him being 'bishops'. . . . Oh, never mind *him*. [Tom's] like that with everybody. But he doesn't come *in here* disguised as Westminster Abbey." Lewis also continued his rivalry with Eliot. P. H. Newby, who discussed with Lewis the fee for a proposed BBC broadcast, has recorded: " 'I expect you give Tom Eliot much more than me,' Lewis said. 'No,' I replied. 'You would get the same. There are standard fees.' He was not disposed to believe that he would get the same fee as Eliot; I got the impression it was not the amount that mattered but the status it implied. He was frail. I remember his clawlike hand and his wife, who was very caring, gently putting his biscuit into it. . . . People were alarmed by him—but, in my experience, without justification."

Eliot encouraged Regnery to publish American editions of Lewis' books in the early fifties and in 1964 offered to write a preface to the paperback edition of *Self Condemned*, which he called "the best of Lewis' novels."[3] Eliot read the typescript and proofs of *Monstre Gai* and

Malign Fiesta (the last two parts of *The Human Age*), made suggestions about revising the novels, introduced the radio adaptations, and published an essay on *Monstre Gai* in the 1955 volume of *Hudson Review*, which also contained a chapter of the novel. Eliot read the proofs of Lewis' last book, *The Red Priest*, wrote a warm obituary of Lewis in the *Sunday Times* and contributed a Foreword to the second edition of *One-Way Song*, published by Faber in 1960.

The extraordinary circumstances that allowed Lewis to complete *The Human Age* began in April 1951 (the month Lewis went blind) when D. G. Bridson, a producer on the BBC who had written four luke-warm reviews of Lewis' books in the 1930s but was a great admirer of his earlier work, told Lewis that he wished to adapt *The Childermass* for dramatization on the BBC. "He was then living at a flat near Vauxhall Bridge," Bridson wrote, "where I met him for the first time. He agreed to the radio production that I suggested, provided that my adaptation seemed to him adequately to reflect the style and spirit of the work. After it had been read over to him, he declared himself perfectly satisfied on this point. Indeed, as he had not re-read the book for many years, it gave him a lot of pleasure to be reminded of its more amusing passages."

The broadcast of *The Childermass* on June 18, 1951, with Donald Wolfit as the Bailiff, was a great success and diverted Lewis during a harrowing time of his life. As he told Bridson: "*The Childermass* is the book I set most store by, and it is for me an almost miraculous event for it suddenly to spring into concrete life, with live actors bestowing upon it an almost startling physical reality, and a very able and in-genious living composer [Walter Goehr] playing the bailiff's barge across the mournful river and jazzing the appellants into a bacchic dance. Sitting at your rehearsals I could hardly believe my ears. *You* are the magician who has called into life this extraordinary apparition." Bridson then suggested to the controller of the Third Programme that the BBC provide Lewis with financial security for two years by commissioning him to complete the sequel to *The Childermass*, which Chatto had announced as forthcoming in 1928. Though Lewis was then sixty-eight and still working on *Self Condemned*, he received half his £1,000 advance for *The Human Age* in the summer of 1951, and agreed that he would help Bridson with the dramatization when the novels were completed and that they would be broadcast before and after the publication of the book. When *The Human Age* was first commissioned, Lewis planned to write only one more volume to complete *The Childer-mass*. But after finishing volume two he told Bridson that he would write a third volume and asked if he could get more money. Bridson obtained an additional fee, before the BBC had seen the typescript of the second volume.

Bridson has described how he collaborated with Lewis on the dramatizations of *The Human Age* (which lasted for six hours) and of *Tarr* (which was broadcast in July 1956): "These dramatisations were the joint work of Wyndham Lewis and D. G. Bridson. In each case, a first draft was written by Bridson, which indicated the kind of additional narration or dialogue which would be required to bridge the gaps created by necessary cutting and condensation of the original work. For *Monstre Gai, Malign Fiesta* and *Tarr* Lewis wrote a number of new scenes. *The Childermass* was rounded off by a short final scene which he later incorporated in the second edition of that work when it was published as Book 1 of *The Human Age*." Lewis called Bridson—who also collected Lewis' drawings and published *The Filibuster*, a study of his political ideas, in 1972—a "benignant spirit who had suddenly materialised and transformed one's existence"; and he handsomely inscribed a copy of *The Human Age*: "To Geoffrey Bridson—You who did so much to make the completion of this work possible, and who were chiefly responsible for its translation into radio drama—I salute you. Wyndham Lewis."[4]

In June 1951 Methuen paid Chatto £90, the unearned portion of Lewis' original advance of £200, for the rights of *The Childermass*; in April 1953 he quarrelled with Alan White about the amount of the advance and eventually got an additional £100 from Methuen. The twenty-fifth anniversary edition of *The Apes of God*, for which Lewis received an advance of £175, was published by Arco in February 1955. And the dramatizations of the completed novels, *Monstre Gai* and *Malign Fiesta*, which triumphantly fulfilled the BBC's faith in Lewis,[5] were finally broadcast in May 1955, with introductions by Eliot and Graham Hough. (*The Revenge for Love* was broadcast three months after Lewis' death, in June 1957.) At a BBC party to celebrate the broadcasts, Lewis, whose blindness seemed to give his speech and actions greater power, became cantankerous when introduced to the critic V. S. Pritchett. He insisted that Pritchett thought his trilogy was not a serious work, asked why Pritchett (who had written favorable notices of his books) "kept picking on me in his reviews," and stubbornly refused to meet him.

Monstre Gai (whose title comes from Voltaire's phrase "*un monstre gai vaut mieux qu'un sentimental ennuyeux*") and *Malign Fiesta* continued *The Childermass* without recapturing the original impetus of the first hundred pages. Though Lewis worked on *The Human Age* longer than any other book and believed it was his most important work, he made no concessions to his readers in this highly cerebral and static fantasy, which was impenetrably difficult to read. "God," Lewis conceded, "is a big problem"; and I. A. Richards observed: "To an agonizing degree we are not allowed to know what it is all about."

Lewis intended to write a fourth and final volume and in 1955 actually completed a fourteen-page opening chapter of "The Trial of Man," whose theme "was now to be Pullman's slow acclimatization to the Celestial environment." But he postponed this volume to write *The Red Priest*, the elitist's last unsuccessful attempt (*Mrs. Dukes' Million* was the first) to win popular acclaim with a best-selling book; and virtually to complete "Twentieth Century Palette," his unpublished novel about the life of a young artist. As Alan White noted: "By the time he started on Part IV [of *The Human Age*] his physical condition was such that he would dictate a few sentences, drop asleep, wake up a few minutes—or an hour or two later—and continue an unfinished sentence at precisely the point at which he had left off."[6]

3

Ford Madox Ford, in his 1914 review of *Blast*, had wryly imagined the fiery editor loaded with honors at the end of a distinguished career: "Sir Wyndham Lewis, Bart., P.R.A. and Baron Lewis of Burlington House, Poet Laureate and Historiographer Royal." Though Lewis' rewards were not quite so Tennysonian, he ironically conceded: "In England if you only live long enough you become a great painter." In 1955 John Rothenstein and the Trustees of the Tate decided to have an ambiguously titled exhibition, "Wyndham Lewis and Vorticism," which would go well beyond Vorticism, provide a retrospective view of his entire career, and show 155 paintings and drawings—from the Slade studies of 1900 to the portrait of Eliot in 1949. It would also exhibit the paintings of the Vorticist group and demonstrate the effect of his immediate impact on his contemporaries.[7] Lewis was from the outset very unhappy with Rothenstein's plan to include other Vorticists and wanted the exhibition to be devoted entirely to his own work. But he was helpful with the preparation of the show, which ran from July 6 to August 19, 1956, and then toured the provincial galleries in Manchester, Glasgow, Bristol and Leeds. The exhibition was well-received and favorably reviewed by Michael Ayrton, D. G. Bridson, Tommy Earp, Eric Newton, Myfanwy Piper and Denys Sutton.

After leaving for the private view of the exhibition, the heavily-sedated Lewis felt extremely ill and wanted to turn back. Froanna encouraged him to go on, but he could not manage the high steps at the entrance to the gallery and had to be taken up in a freight elevator at the rear of the building. Though old friends and enemies like Kate Lechmere and the Sitwells were present at the opening, the dignified and white-haired Lewis sat silently for several hours between Eliot and Ayrton. Mary Chamot, who helped prepare the show, recalled: "He was able

to attend the private view in a wheeled chair and met many of his friends and admirers. He was already a very sick man at the time, appeared rather stout and bloated, but was mellower than I had expected." And William Gaunt remembered: "I last saw him at the Vorticist Exhibition at the Tate Gallery. Alas! by that time his sight had failed which put an end both to his own productions and the periodical art criticism he had taken to. He greeted me in spite of his physical handicap with all the affability of our past acquaintance though now supported by a younger generation of admirers."[8]

The exhibition, intended as homage to Lewis, provided a belligerent conclusion to his half-century of creative life and revealed that after forty years Vorticism was still a volatile issue. Lewis' rather rash and exaggerated statement in his Introduction to the catalogue: "Vorticism, in fact, was what I, personally, did, and said, at a certain period," provoked a violent reaction from his old ally William Roberts, whose early career had closely followed Lewis'. Roberts had also studied at the Slade, worked briefly under Fry at the Omega Workshops, left to join the Rebel Art Centre, signed the Vorticist manifesto in *Blast 1*, exhibited with the Vorticist group and with Group X, and was a War Artist. Rothenstein described the taciturn and reclusive Roberts as "temperamentally tough, rigid, unsubtle, sardonic, joyless and unresponsive." The young Roberts, whose art was easily mistaken for that of Lewis, had achieved early praise as a Vorticist disciple and lived on that fame for many years. After the Great War, Roberts became a naturalistic painter, clung to a rigidly fixed style and was made a Royal Academician in 1966. His most famous picture, *The Vorticists at the Restaurant de la Tour Eiffel* (1962), portrays Lewis dominating the center of the group and, ironically, belies his own claim to equality with Lewis as an abstract painter. Bomberg, Dobson, Etchells, Hamilton, Kramer and Saunders were alive in 1956 and made no objection to the show. But Roberts refused to accept his minor status as a sprat dominated by a whale, though he had been a precocious and prickly teenage Slade student in 1914. As Henry Moore observed, "there is no doubt that Lewis was the leading light."[9]

Roberts, whose letters to several journals had been rejected by the editors, expressed his views in a lively but puerile series of five privately printed *Vortex Pamphlets*. He angrily objected to Lewis' claim that he had invented, embodied and expounded Vorticism, that he was the sole originator of abstract painting in England, and that the other Vorticists were subservient to him. Roberts argued that the main influence on the Vorticists were Picasso and the French Cubists (it would have been more accurate to say Kandinsky and the Italian Futurists) and insisted: "there was in England a group of Cubists and Abstract artists working and exhibiting independently of Lewis before

the word Vorticism was introduced." Roberts also objected to the way the exhibition was organized and complained: "Vorticism for Lewis is everything he has ever done as an artist. Vorticism for the Tate is anything considered suitable to hang in the wake of Lewis for the purpose of this exhibition." Two years later Roberts concluded his counterattack with a satirical drawing (in the same style as the *Tour Eiffel* painting) of Lewis, dressed in a zoo-attendant's uniform and peaked cap, as Keeper of the Apes. Under Lewis' guidance, the three apes (one of them in his lap) wield tubes, brush and palette, make simian attempts to paint in the Vorticist style, and try to decipher the elusive meaning of *Blast*.

In one of his last letters, Lewis, who had repudiated Vorticism after the Great War and did not consider it the most important phase of his artistic career, clarified his position and asked Ayrton: "Have you seen the booklet written by Roberts entitled Vorticism? I cannot understand how he got it printed. In the main it is abuse of me. He believes that the Tate Show was organised by me, that I am very proud of Vorticism, wish to make use of him, chose the pictures, insisting on his own being very few, etc. etc. etc. He regards you as a bad-man too. This poor little creature apparently did not read my bit in the catalogue, otherwise he would have seen that he attaches more importance to Vorticism than I do. If you have seen his wretched little squib give me your views." Hostilities broke out again when the pamphlets were reviewed in *TLS*, eight months after Lewis' death, in November 1957. The malicious reviewer used Roberts as a stick with which to beat Lewis, implied that Lewis was to blame in his quarrel with Fry (which haunted Lewis beyond the grave) and asserted: "He was a virulent hater, self-contradictory, and, on his own showing, not over scrupulous: always he seems to have been willing to deceive in a good cause—i.e. the cause of Wyndham Lewis." Rothenstein contested Roberts' attacks on himself and Lewis, no longer able to scourge his enemies, was vigorously defended by Ayrton.

Lewis created 100 paintings and 1,000 drawings during fifty years of artistic endeavor and consummately embodied what he called "the English virtues, of the intellect or sensibility, developed by Rowlandson, Hogarth and their contemporaries, and earlier at their flood-tide in the reign of Elizabeth."[10] Lewis is perhaps the greatest English painter, certainly the finest draughtsman and portrait artist, of this century. His works are now owned by major museums in Britain, America, Canada, Australia and South Africa; and a dozen exhibitions of his work have been held since his death. Though Lewis lived and died poor—he left an estate of only £1,045—his 1979 prices have rocketed to £2,200 at auction for a war drawing and £8,000 for *A Reading of Ovid* as his power as an imaginative and influential artist has finally been recognized.

4

The threatened demolition of Lewis' flat coincided, in a terrible way, with the gradual destruction of his body. In September 1956 Lewis told a journalist: "The L.C.C. demolition squads are closing in on me with their picks and hammers to knock this excellent solid room down about my head if I am not out by Christmas. All Notting Hill will be a rubble." And at Christmas-time he was given notice to leave the flat by April 1. Though the building was condemned, Lewis ignored the workmen, made no arrangements to leave during the destruction and wrote fiercely abusive letters to the London County Council.[11] Naomi Mitchison, who used to sit and hold the hand of the silent, dying Lewis, appealed to the local council and—with the help of her husband, a Labour M.P.—managed to delay the demolition of the flat: "One thing my husband did was to get the pulling down of that block of flats near Notting Hill Gate where he and Froanna lived, postponed; he was then already ill and couldn't have managed a move. . . . He did it, probably, through the Borough Council."[12]

Lewis entered hospital in December 1956, but returned home in January and continued to work on "Twentieth Century Palette." In late February he lapsed into a coma and was taken by ambulance to Westminster Hospital, while the workmen were beginning to tear down the building in order to widen the road and build a new tube station. His last, cantankerous words—"Mind your own business!"—were addressed to a nurse who inquired about the state of his bowels. He died while unconscious on March 7, 1957, at the age of seventy-four.

On the day after Lewis' death, a malign fiesta, the wreckers arrived to destroy his flat. They marched through the sitting room and up to the studio, which had been closed since he went blind in 1951, glanced at the drawings and threw them on the floor. When Ayrton arrived to rescue them, he found that one had the mark of a large boot and that a drawing of Pound had half the head torn away (Ayrton later restored this). Since Froanna was desperately poor, Lewis' pictures were sold quickly and for very low prices.

The depressingly flat and uninspiring funeral service—attended by Froanna, Agnes Bedford, Nicholas Waterhouse, Raymond Drey, Hugh Porteus, Lady Cholmondeley, Desmond Harmsworth, Julian Symons, D. G. Bridson, Alan White and a few other friends—was held at St. George's Church, Campden Hill, Kensington, and Lewis was sent to the Magnetic City with "Going Home" played on a Hammond organ. He was cremated at Golders Green cemetery and his ashes were placed in an urn in the wall (no record of them exists); but his brain was preserved in the Pathological Museum of Westminster Hospital—the mortal

remnant of a mighty intellectual life. In his obituary Eliot wrote: "A great intellect is gone, a great modern writer is dead."[13]

5

Lewis passed through a number of distinct physical, temperamental and artistic stages in his life, and his capacity for change and development is one of the most fascinating aspects of his character. In 1888 he left America and became an English schoolboy; in 1902, after his visit to Spain, he became a bohemian; in 1913, when he left the Omega Workshops and founded Vorticism, he became a revolutionary painter and writer; and in 1919, changed by war and by illness, he began to lose his impressive good looks and to acquire a darker view of life. In the 1920s he was predominantly a critic of society, in the 1930s a satirist and political pamphleteer. In 1937, after five years of illness, he aged considerably but became more sympathetic and humane in *The Revenge for Love* and the major portraits of Froanna and Eliot. In 1938, after his last trip to Berlin, he willingly repented and became anti-Nazi. In 1945, after the searing self-exile in North America, he seemed gentler and more generous, praised young artists and helped Pound. In 1951, after the barren years of the 1940s, he lost his sight and his health, but experienced an astonishing creative renaissance.

Lewis' reputation was established in 1914 and destroyed by the Great War; re-created with the major works of the late twenties and negated by *The Apes of God* and *Hitler*; built up again in the late thirties and destroyed by the long and silent years of exile; finally reestablished with *Self Condemned* in the fifties and diminished by the inevitable decline in fame after death. In the 1970s the appearance of Lewis' *Unlucky for Pringle, The Roaring Queen, Enemy Salvoes, Mrs. Dukes' Million*, a reissue of *The Revenge for Love*, two bibliographies, the impressive Vorticist exhibition at the Hayward Gallery and Richard Cork's monumental study of Vorticism have created a strong revival and inspired new interest in Lewis.

Like many geniuses—and Lewis deserves this title—he was a multifarious man who assumed many roles. The disparate aspects of his character cannot readily be focused in a single convincing image, for the Enemy fought bitterly, yet was also a kindly and courtly friend. Though the words "quarrel" and "attack" have frequently appeared as leitmotifs in this book, they do not represent an entirely negative side of Lewis' character. In most of the major disputes—with Fry, Bloomsbury, the Sitwells, Read and Roberts—he was morally and intellectually right. His attacks on friends like Pound, Joyce and Eliot, though personally offensive, contained penetrating and persuasive literary criticism. He

was reckless about libel, but demanded honesty and efficiency from his publishers. His political judgment was seriously defective; but his open and defiant stance on artistic issues was stringent and salutary, and his blasts provided a refreshing change from the mealy-mouthed puffs that usually passed for serious criticism. Though Lewis was ungrateful to his patrons, his attitude was often justified by their arrogant condescension. As Johnson observed in his conclusion to the *Life of Savage*: "The insolence and resentment of which he is accused were not easily to be avoided by a great mind, irritated by perpetual hardships, and constrained hourly to return the spurns of contempt, and repress the insolence of prosperity; and vanity may surely be readily pardoned in him, to whom life afforded no other comforts than barren praises, and the consciousness of deserving them."

If Lewis, who wrote 50 books and 360 essays, had not composed political tracts, but had concentrated on perfecting his major works and devoted more time to painting, his reputation would have been much greater. He was one of the most lively and stimulating forces in modern English literature, and deserves recognition not only as a painter and writer, but also as an independent, courageous artist and a "brilliant and original observer" of contemporary society.[14] As Lewis' centenary approaches, it seems just and proper to include him in the literary mainstream with Joyce, Pound and Eliot—the "Men of 1914"—and as Auden said in his elegy of Yeats, to pardon him for writing well. For Lewis' range of knowledge and intellectual vitality, his gale-force energy and daring honesty, his vigorous experimentation and fighting spirit, his caustic wit and analytic ingenuity, his whip-cracking prose and astonishing invention are unmatched in the twentieth century.

Chronology of Wyndham Lewis

Nov. 18, 1882 born on yacht *Wanda* off Amherst, Nova Scotia, Canada

1882–1888 childhood in Portland, Maine and Chesapeake Bay, Maryland

1888–1893 family lives on Isle of Wight

1893 parents separate. Lives with mother in London suburbs and in Winchester Villas, Portland Ave., Ryde, Isle of Wight

Sept. 1894–Jan. 1895 attends County School, Bedford

Jan. 1895–Dec. 1896 attends Castle School, Ealing

Dec. 1894–Aug. 1897 mother lives at Amherst, Mount Ave., Ealing

Jan. 1897–Dec. 1898 attends Rugby School

1897 injures left eye

Aug. 1897–Mar. 1898 mother lives at Fern Lea, 17 Barnmead Rd., Beckenham, Kent

1898–1901 attends Slade School of Art. Studio on Charlotte St., W1. Meets William Rothenstein

Autumn 1902 Madrid: c/o Mrs. Briggs, 92 Calle Mayor Tercero. Copies Goya in Prado with Spencer Gore

c. 1903 Paris: c/o Mme. Picnot, 41 rue Denfert Rochereau

c. 1904 Paris: 90 rue d'Assas

Oct. 1904 Haarlem: copies Frans Hals for one month

c. 1904 London: 59 Grafton St.

c. 1904 Hamburg

c. 1904 Paris: 19 rue Mouton-Duvernet. Friendship with Augustus John

1905 Paris. Meets Ida

Sept. 1905 Noordwijk, Holland: Villa Cato

Feb.–c. July 1906 Munich: Pension Bellevue, Theresienstrasse 30; studio at Amalienstrasse 85. Studies at Akademie Heymann

1906 Paris: in Kathleen Bruce's studio at 22 rue Delambre

Aug. 1906 Ste. Honorine des Perthes, near Bayeux, Normandy. Visits Ida nearby

1906–1907 Paris: Hôtel de la Haute Loire, blvd. Raspail

1907 Paris: 16 rue de la Grande-Chaumière. Meets Duncan Grant

Summer 1907 Dieppe: Hôtel Rocher

1908 Paris

May–July 1908 Spain: San Sebastian, León, Vigo. Venereal disease

Aug. 1908 Quimperlé, Brittany, with mother

Dec. 1908 breaks with Ida, returns to England

Dec. 1908–March 1909 4 High St., Ealing

Dec. 1908 Ida has their baby
1909 14B Whiteheads Grove, Chelsea, SW3.
 Friendship with Sturge Moore and Laurence Binyon. Meets Ford,
 West, Pound
May–Aug. 1909 stories in *English Review*
Sept.–Oct. 1909 8 Fitzroy St., W1
June–Dec. 1910 stories in *Tramp*
June 1911 1st Camden Town Group exhibition
July–Sept. 1911 Dieppe. Begins *Tarr*
Aug. 1911 4 Percy St., Fitzroy Sq., W1
Sept. 1911 son by Olive Johnson is born
Dec. 1911 34 Arlington Rd., Mornington Crescent, NW. 2nd Camden
 Town Group exhibition
1912 meets Richard Aldington
Spring 1912 decorates Cave of the Golden Calf
June 1912 22 St. George's Sq., Primrose Hill, NW1
July 1912 *Kermesse* at Allied Artists
Sept. 1912 Dunkerque: 24 rue de Neuport
Oct. 1912 *Timon of Athens* at Fry's 2nd Post-Impressionist exhibition
Nov. 1912–Feb. 1913 35 Greek St., Soho
March–Oct. 1913 142 Brecknock Rd., Islington, N7
July 1913 exhibits at 2nd Allied Artists
July 1913 joins Omega Workshops
Aug. 1913 Dieppe, with Etchells
Oct. 1913 in Frank Rutter's Post-Impressionist and Futurist show, Doré
 Galleries
Oct. 1913 breaks with Fry
Nov. 1913 daughter by Olive Johnson is born
Nov. 18, 1913 dinner for Marinetti at Florence Restaurant, Rupert St.
Dec. 1913 "Cubist Room" exhibition, Brighton. *Timon of Athens*
 portfolio
1914 4 Percy St., Fitzroy Sq., W1
Feb. 26, 1914 completes Drogheda panels, 40 Wilton Crescent, SW1
March 1914 in New London Group, Goupil Gallery
March–July 1914 Rebel Art Centre, 38 Great Ormond St., Queen Sq.,
 WC1. Associated with Lechmere, Saunders, Dismorr, Gaudier. Meets
 Hulme
May 6, 1914 Marinetti lectures at Rebel Art Centre
May 16, 1914 Lewis lectures in Leeds on "Cubism and Futurism"
June 12, 1914 fight with Futurists at Doré Galleries
June 20, 1914 *Blast 1*
1914–1915 affairs with Beatrice Hastings, Mary Borden Turner, Alick
 Schepeler
July 15, 1914 *Blast* dinner at Dieudonné Restaurant, Ryder St.
July 1914 visits Mary Borden Turner at Marchmount, Berwickshire
Aug. 1914–spring 1915 venereal disease. Friendship with Guy Baker.
 Completes *Tarr*
Nov. 1914 decorates South Lodge

Jan. 1915–March 1916 18 Fitzroy St., W1
Jan. 1915 meets T. S. Eliot
March 1915 2nd London Group show
June 1915 Vorticist exhibition, Doré Galleries
July 1915 *Blast 2*
Late 1915–Jan. 1916 Vorticist Room in Tour Eiffel Restaurant
Feb. 23, 1916 Vorticist evening at Tour Eiffel
March 1916–May 1917 artillery camps
Late March 1916 Fort Burgoyne, Dover
April–Aug. 1916 Menstham Camp, Weymouth, Dorset
Aug. 1916 Horsham, Sussex
Aug. 1916–Jan. 1917 Lydd, Kent. Acting sergeant in firing course
Late 1916 Artillery Cadet School, Exeter
Jan. 1917 Vorticist exhibition at Penguin Club, New York, arranged by
 John Quinn
May 1917 Cobham, near Portsmouth
May 24, 1917 1st Battery: Bailleul, France
May–Nov. 1917 active service at the front
Late June–early July 1917 Trench fever: Fever Hospital, Étaples, France
Mid July 1917 Lady Michelham's convalescent home, Dieppe
Late July–Sept. 1917 2nd Battery: Nieuwpoort, Belgium
Sept. 28, 1917 Hulme killed in RMA Battery next to Lewis
Oct. 1917 sees William Orpen at Cassel. "Cantleman" suppressed in
 Little Review
Oct.–Nov. 1917 3rd Battery: Ypres Salient, Passchendaele, Belgium
Nov. 1917 *The Ideal Giant*
Nov.–Dec. 1917 Hotel Rembrandt, off Cromwell Rd., London. On leave
 for mother's illness. Sees Konody and Beaverbrook about War
 Artists scheme. Extends leave for 6 weeks. Often with Lady Cunard.
 Meets Sybil Hart-Davis and Herbert Read
Dec. 12, 1917 ordered to report to front
Dec. 31, 1917 reports to Ypres Battery, seconded as war artist
Jan. 1918 Canadian War Records Artist at HQ of Canadian Army,
 Vimy Ridge, France. Sees John
Jan. 26, 1918 returns to London
Feb.–late 1918 war artist in London: work on *A Canadian Gun Pit* and
 A Battery Shelled
June 1918 *Tarr*
1918–1921 with Iris Barry
1918 meets Anne Hoskyns
Aug.–Sept. 1918 1 Hatfield House, Great Titchfield St., W1
Late 1918–Feb. 1919 several months in military hospital with influenza
 followed by double pneumonia: Endsleigh Place Hospital, Endsleigh
 Gardens, NW1. Then one month in seaside convalescent home
Nov. 23, 1918 father dies near Philadelphia
Feb.–May 1919 1A Gloucester Walk, Kensington, W8
Feb. 1919 *Guns* exhibition: 1st one-man show
April 1919 demobilized

June 1919–March 1920 20A Campden Hill Gardens, Notting Hill Gate,
 W8. Meets Roy Campbell
June 1919 son by Iris Barry is born
Aug. 1919 9 Fitzroy St., W1
Oct. 1919 art lecture in Westminster. *Caliph's Design*. Completes *A*
 Battery Shelled
Dec. 1919 *Fifteen Drawings. Harold Gilman*
c. 1920 meets Agnes Bedford
Feb. 9, 1920 mother dies
March 1920 Group X exhibition, Mansard Gallery
June 1920 37 Redcliffe Rd., Fulham Rd., Chelsea, SW10
Summer 1920 trip with Eliot to Paris, Loire and Brittany. Meets and
 draws Joyce
Sept. 1920 daughter by Iris Barry is born
April 1921 *Tyros and Portraits* exhibition, Leicester Galleries. *Tyro 1*
April–May 1921 2 Alma Studios, Stratford Rd., Earl's Court, W8
May–June 1921 Paris. Sees Joyce and McAlmon
Sept. 1921 Berlin
July 1921–Oct. 1923 Lee Studio, Adam and Eve Mews, off Allen St.,
 Kensington High St., W8. Friendship with Sitwells and Schiffs
1921 16A Craven Rd., Paddington, W2
1921–1923 affair with Nancy Cunard
March 1922 *Tyro 2*
June 1922 visits Garsington
July–Aug 1922 Paris. Meets Hemingway
Sept. 1922 meets Katherine Mansfield
Sept. 1922 visits Sitwells at Renishaw, Derbyshire
Oct. 1922 Venice: Casa Maniella, San Barnaba, with Nancy Cunard.
 With Sitwells and Dick Wyndham
May 1923 visits Garsington
Oct. 1923–March 1926 61 Palace Gardens Terrace, Kensington, W8.
 Writing 6 major works of 1920s
Dec. 1923–May 1924 Wadsworth, Wyndham, Drey provide monthly fund
1923 *Edith Sitwell*
1924 *Mrs. Schiff*
Feb.–April 1924 2 chapters of *The Apes of God* in *Criterion*
c. May 1924 meets T. E. Lawrence
April 1925 Paris
April 1926–Aug. 1929 33 Ossington St., Bayswater, W2. Meets Sir
 Nicholas Waterhouse, Anton Zwemmer, A. J. A. Symons, David
 Garnett, W. H. Auden, Stephen Spender
March 1926 *The Art of Being Ruled*
May 1926 Paris
Sept. 1926 Spain
Jan. 1927 *The Lion and the Fox*
Feb. 1927 *Enemy 1*
April 1927 Ireland
Aug. 1927 New York: Hotel Brevoort, 5th Ave. & 8th St.

Sept. 1927 *Time and Western Man. Enemy 2*. Gavarnie, French Pyrenees
Nov. 1927 *The Wild Body*
Dec. 1927 Paris: lunch with Hemingway and MacLeish
1927 *Bagdad*
Jan. 1928 BBC reading: "A Soldier of Humour"
June 1928 *The Childermass*
June–July 1928 New York: Hotel Brevoort
Sept. 1928 Munich
Dec. 1928 2nd edition of *Tarr*
March 1929 *Enemy 3*
May 1929 *Paleface*. Meets Yeats
Sept. 1929–May 1931 53 Ossington St., Bayswater, W2
June 1930 *The Apes of God*
July 1930 Marseilles
Oct. 1930 *Satire and Fiction*
Oct. 9, 1930 marries Gladys Anne Hoskyns
Nov. 1930 Berlin
Dec. 1930 gastric flu
1930 *Lady Glenapp*
Jan.–Feb. 1931 Hitler articles in *Time and Tide*
March 1931 *Hitler*
April 1931 *The Diabolical Principle*
May–July 1931 Morocco. 6 weeks in Agadir
June–July 1931 *The Doom of Youth* articles in *Time and Tide*
Oct. 1931–Jan. 1932 *Filibusters* articles in *Everyman*
Nov. 1931 *The Apes of God* trade edition. New York and Washington
Dec. 1931 Cambridge, Mass.: with Joseph Alsop and at Continental
 Hotel. Returns on S.S. *Berlin*, Christmas 1931
Beg. Feb. 1932 uses Pall Mall Safe Deposit, Carlton St., SW1
March 1932 3-day visit to Campbell in Martigues
May 1932–Nov. 1933 31 Percy St., W1
May 1932 *Enemy of the Stars*
June 1932 *The Doom of Youth. Filibusters in Barbary*
July 1932 Winn and Alec Waugh charge libel in *The Doom of Youth*
Aug. 1932 Waugh's appeal for injunction dismissed
Aug. 1932 John Gawsworth, *Apes, Japes and Hitlerism*—the first book on
 Lewis
July–Nov. 1932 27 Ordnance Hill, Circus Rd., St. John's Wood, NW3
Sept. 1932 *Snooty Baronet*
Sept. 1932 Berlin
1932 German edition of *Hitler*
Sept. 1932 *Thirty Personalities* portfolio
Oct. 1932 *Thirty Personalities* exhibition, Lefevre Gallery
Oct. 1932 Waugh wins libel suit. Chatto withdraws *The Doom of Youth*
Oct. 1932 Pont-en-Royans, Isère, near Grenoble
Nov. 1932 Chatto sues for breach of contract on *The Childermass*
Dec. 1932 Hugh Gordon Porteus, *Wyndham Lewis: A Discursive
 Exposition*

12

Dec. 1932 lecture at Oxford

Dec. 1932–Feb. 1933 Porchester Sq. Nursing Home, Paddington, W2.
Seriously ill until May 1933

Jan. 1933 *The Old Gang and the New Gang*

Nov. 1933 *One-Way Song*

Dec. 1933 MacFie charges libel in *Filibusters*

c. Dec. 1933–Dec. 1934 21 Chilworth St., Paddington, W2. Studio:
5 Scarsdale Studios, Stratford Rd., off Kensington High St.

Jan. 1934 Berlin

Jan. 1934 Rupert Grayson charges libel in *Snooty Baronet*

Feb. 1934 Grayson withdraws *Filibusters* and pays damages

Feb.–April 1934 York Place Nursing Home, 98 Baker St., W1

Early March 1934 1st operation for blood clot in bladder

c. May 1934 lecture at Oxford: "Art in a Machine Age"

July 1934 French Pyrenees

Oct. 1934 *Men Without Art*

April 30, 1935 BBC talk: "Freedom"

June 21, 1935 BBC talk: "Art and Literature"

April 1936–mid-1937 121 Gloucester Terrace, Paddington, W2

June 1936 *Left Wings Over Europe*

July 7, 1936 2nd operation

Sept. 1936 3rd operation

Oct. 1936 *The Roaring Queen* withdrawn

1936 *The Surrender of Barcelona*

Jan. 1937 essay in *British Union Quarterly*

April 1937 *Count Your Dead*

May 1937 *The Revenge for Love*

Mid 1937–Aug. 1939 Flat A, 29 Kensington Gardens Studios, Notting
Hill Gate, W11

Sept. 1937 4th operation for peri-urethral abscess

Oct. 1937 *Blasting and Bombardiering*

Oct. 1937 Berlin and Warsaw

Nov. 1937 *Twentieth Century Verse* issue on Lewis

1937 *Red Portrait, The Artist's Wife*

Dec. 1937 Leicester Galleries exhibition

April 21, 1938 Royal Academy rejects *Eliot* portrait

June 29, 1938 BBC talk: "When John Bull Laughs"

June 1938 *Die Rache für Liebe* (*The Revenge for Love*)

June–July 1938 Beaux Arts Gallery exhibition

Nov. 1938 *The Mysterious Mr. Bull*

1938 *Spender* portrait

Dec. 1938 *Pound* portrait

March 1939 *The Jews, Are They Human?*

May 23, 1939 modern art debate on television

June 1939 *Wyndham Lewis the Artist*

1939 *Der Mysteriöse John Bull*

Sept. 2, 1939 sails to Canada

Sept. 12, 1939 arrives King Edward Hotel, Toronto

Oct.–Nov. 1939 Stuyvesant Hotel, Elmwood Ave., Buffalo and home of Charles Abbott

Dec. 1939 *The Hitler Cult*

Dec. 1939–March 1940 New York City: Winthrop Hotel (Lexington & 47th St.) and Tuscany Hotel (120 E. 39th St.)

c. Dec. 1939 lecture at Foxcroft School, Middleburg, Va.

Late Dec. 1939 Bethlehem, Conn. with Geoffrey Stone

Jan. 1940 Poetry Society of America dinner, with Aldington and Padraic Colum

Jan. 25, 1940 Harvard lecture: "Satire and Contemporary Poetry"

Feb. 14, 1940 Columbia lecture: "Should American Art Differ from European Art?"

April–May 1940 81 Irving Place, N.Y.C.

c. June–Oct. 1940 "John Jermain House", Main St., Sag Harbor, Long Island. Writes *The Vulgar Streak*. Studio: 86A Isabella St., Sag Harbor

Aug. 1940 *America, I Presume*

Nov. 1940–May 1943 Toronto: Apt. 11A, Tudor Hotel, 559 Sherbourne St.

Nov. 1940–April 1941 studio: 22 Grenville St.

May–June 1941 430 Prince Arthur St. West, Montreal

June 1941 *Anglosaxony*

Sept. 1941 trip to Halifax, Nova Scotia

Oct. 1941 severe eye problems

Dec. 1941 *The Vulgar Streak*

Jan. 2, 1943 Assumption College, Christian Culture Series: "Religious Expression in Contemporary Art"

c. Feb. 8, 1943 Marygrove College, Detroit, lecture

Feb. 15, 1943 fire in Tudor Hotel

Mid June–Sept. 1943 Windsor, Ontario: Apt. 2, Royal Apts., 30 Ellis East

June–July 1943 Teaches summer school at Assumption College: "The Philosophical Roots of Modern Art and Literature"

Oct. 1943–Feb. 1944 Windsor: 1805 Sandwich St. West. Teaches Philosophy of Literature course, lectures on the visual arts

Nov. 7–Dec. 19, 1943 Assumption College, 12 Heywood Broun lectures: "The Concept of Liberty in America"

Nov. 30, 1943 Detroit Institute of Arts lecture: "Where Are Art's Frontiers?"

Feb. 1944 Park Plaza Hotel, St. Louis

Feb. 18, 1944 Wednesday Club lecture

Feb. 21, 1944 City Art Museum lecture

Feb. 29, 1944 Art Club of Chicago lecture

May–July 1944 Coronada Hotel, St. Louis

July–Aug. 1944 Windsor. 3 week summer school course in "ABC of the Visual Arts"

Oct.–Nov. 1944 Fairmont Hotel, 4907 Maryland, St. Louis

Nov. 1944 Washington, D.C. Sees MacLeish

Dec. 1944–May 1945 Windsor
1944 Chatham lecture, Chatham, Ontario
Feb.–April 1945 Prince Edward Hotel, Windsor
March 7, 1945 University of Michigan lecture: "Hemingway, Tolstoi
 and War"
March 9, 1945 Michigan State University lecture: "Hemingway, Tolstoi
 and War"
May–July 1945 Lord Elgin Hotel, Ottawa
Early Aug. 1945 sails to England on *Strathden*
Aug. 1945–March 1957 Flat A, 29 Kensington Gardens Studios, Notting
 Hill Gate, W11
Late 1945 warned about tumor
Aug. 1946–May 1951 art critic for *Listener*
Jan. 1947 BBC talk: "Liberty and the Individual"
March 1947 BBC talk: "A Crisis of Thought"
June 1948 *America and Cosmic Man*
Aug. 1, 1948 lecture at Bryanston School, Dorset
Dec. 1948 tours England and Scotland to select paintings for exhibition
March–April 1949 second *Eliot* portrait
c. April 1949 visit to Paris
May 5–28, 1949 Redfern Gallery exhibition
July 1949 stays at small farm outside London
Dec. 1949 visits Willis Feast at Booten, Norfolk
Jan. 18, 1950 St. Vincent's Nursing Clinic, 12 Ladbroke Terrace, W11:
 teeth extracted
Feb. 1950 tumor diagnosed
June 1950 visits Zurich eye specialist, with Froanna
June 1950 2 weeks in Paris: Hôtel Palais Royal, rue de Valois
June 1950 visits Stockholm X-ray specialist, with Froanna
Aug.–Sept. 1950 radiotherapy in London
Nov. 1950 *Rude Assignment*
Jan. 1951 Froanna ill
Feb. 1951 visits Paris eye specialist
April 1951 blindness
May 10, 1951 "The Sea-Mists of the Winter"
May 1951 Charles Handley-Read, *The Art of Wyndham Lewis*
May–June 1951 visits Meyrick Booth in County Cork
June 1951 *Tarr* and *Lion and the Fox* reissued
June 18, 1951 BBC broadcast: *The Childermass*
June 1951 Geoffrey Grigson, *A Master of Our Time*
June–Aug. 1951 18 Ashley Mansions, 254 Vauxhall Bridge Rd., Pimlico,
 SW1. Froanna attempts suicide
Nov. 1951 *Rotting Hill*
Feb. 1952 Civil List Pension, £250
June 1952 *The Writer and the Absolute*
Nov. 12, 1952 Leeds doctorate, with Bonamy Dobrée
Summer 1953 *Shenandoah* issue on Lewis
April 1954 *Self Condemned*

June 1954 Hugh Kenner, *Wyndham Lewis*
Nov. 1954 *The Demon of Progress in the Arts*
May 1955 BBC broadcast: *Monstre Gai* and *Malign Fiesta*
Sept. 1955 E. W. F. Tomlin, *Wyndham Lewis*
Oct. 1955 *Monstre Gai* and *Malign Fiesta*
July 1956 BBC broadcast: *Tarr*
July 6–Aug. 19, 1956 Tate exhibition. Controversy with Roberts
Aug. 1956 *The Red Priest*
Sept. 1956 Norwegian translation of *The Demon of Progress*
Dec. 1956 in hospital
March 7, 1957 death in Westminster Hospital, London

Posthumous Chronology

April 1957 death of Roy Campbell
May 1957 Wagner, *Wyndham Lewis: A Portrait of the Artist as Enemy*
May 1957 Zwemmer Gallery exhibition
June 1957 BBC broadcast: *The Revenge for Love*
June 1957 Japanese translation of *Men Without Art*
Aug.–Sept. 1957 Santa Barbara Museum of Art exhibition
Sept. 1959 Italian translation of *Tarr*
Oct. 1961 death of Augustus John
April 1963 *Letters of Wyndham Lewis*
Nov.–Dec. 1964 York University, Toronto, exhibition
Jan. 1965 death of T. S. Eliot
Oct. 1966 *A Soldier of Humour*
March 1969 *Wyndham Lewis: An Anthology of His Prose*
Nov. 1969 *Wyndham Lewis on Art*
Nov.–Dec. 1969 *Abstract Art in England, 1913–1915*: D'Offay Gallery
 exhibition
Dec. 1969 death of Iris Barry
Autumn–winter 1969 *Agenda* special issue on Lewis
Nov. 1970 French translation of *Tarr*
1971 *Word and Image: Lewis and Ayrton*, National Book League
 exhibition
1971 Michel, *Wyndham Lewis: Paintings and Drawings*
Dec. 1971 *Wyndham Lewis in Canada*
Nov. 1972 death of Ezra Pound
1972 Bridson, *The Filibuster*
May 1973 *Unlucky for Pringle*
July 1973 *The Roaring Queen*
March–June 1974 *Vorticism and Its Allies*: Hayward Gallery exhibition
May–June 1974 Mayor Gallery exhibition
April 1975 Wyndham Lewis Symposium at Tate Gallery
Jan. 1976 *Enemy Salvoes*
Feb. 1976 *The World of Wyndham Lewis*: University of Sussex
 exhibition

Oct.–Nov. 1976 *British Art, 1910–1916*: Norwich Castle Museum
 exhibition
April 1977 *Vorticism*: Davis & Long Gallery, New York, exhibition
Dec. 1977 *Mrs. Dukes' Million*
June–July 1978 Mayor Gallery exhibition, Middlesbrough Art Gallery
April 1979 death of Froanna

Notes

CHAPTER 1: Childhood, Rugby and the Slade

1. "The Vita of Mr. Wyndham Lewis" (1949), p. 10, in the Wyndham Lewis Collection, Department of Rare Books, Cornell University Library, Ithaca, New York; and *The Letters of Wyndham Lewis*, ed. W. K. Rose (Norfolk, Conn., 1963), p. 463 (to Felix Giovanelli, October 18, 1948).
2. Military Service Records, National Archives, Washington, D.C.
3. Sheila Watson, "The Great War, Wyndham Lewis and the Underground Press," *Arts Canada*, 24 (November 1967), 11.
4. Wyndham Lewis, "The Do-Nothing Mode," *Agenda*, 7–8 (1969–1970), 219.
5. Letter from Charles Lewis to Anne Lewis, July 10, 1894, Cornell; and letters from Tillie Chisholm and George Lewis to Anne Lewis, July 6 and December 14, 1894, Cornell.
6. Letter from Charles Lewis to Wyndham Lewis, July 24, 1894, Cornell.
7. Wyndham Lewis, *Tarr* (London, 1951), p. 22.
8. Wyndham Lewis, *America, I Presume* (New York, 1940), pp. 52–53, gives a brief, ironic account of his father's character.
9. Wyndham Lewis, *Self Condemned* (Chicago, 1965), p. 107.
10. J. B. Hope Simpson, *Rugby Since Arnold* (London, 1967), p. 150.
11. Letter from Frank Wiseman, Archivist of Rugby School, to Jeffrey Meyers, May 24, 1977.
12. *Tarr*, p. 28; and Lewis' school report, Cornell.
13. Quoted in Richard Cork, *Vorticism and Abstract Art in the First Machine Age* (London, 1976), p. 1.
14. Wyndham Lewis, *Rude Assignment* (London, 1951), p. 119.
15. Quoted in Cork, p. 3.
16. William Rothenstein, *Men and Memories*, 1900–1922 (London, 1922), p. 27.
17. Wyndham Lewis, "William Rothenstein" (1950), *Wyndham Lewis on Art*, ed. Walter Michel and C. J. Fox (London, 1969), p. 416; and Wyndham Lewis, "Fifty Years of Painting: Sir William Rothenstein's Exhibition" (1938), *Apollo*, 91 (March 1970), 219.

CHAPTER 2: Bohemia and Augustus John

1. *Rude Assignment*, p. 113.
2. Wyndham Lewis, "Frederick Spencer Gore" (1914), *Wyndham Lewis on Art*, p. 54.
3. *Ibid.*, p. 106.
4. *Tarr*, pp. 11, 22; and Rothenstein, *Men and Memories*, p. 36.
5. Quoted in William Wees, *Vorticism and the English Avant-Garde* (Toronto, 1972), p. 149 (c. 1904).
6. *Letters*, p. 34 (c. 1907). W. K. Rose's dating and transcription of French addresses in the early letters are not always correct, the only fault, apart from an excess of letters from David Kahma, in his admirable edition. The address of letter no. 10 is the same as that of no. 7: rue Denfert Rochereau; no. 11 should be spring 1905; no. 15 belongs with no. 34 in 1907; no. 36 should be March 1907; no. 40 should be August 1906; no. 41 should be December 1908; no. 80 should go after no. 74: both are from Dorset; no. 102 "Kalak" should read "Karnak"; no. 264 "blackmail" should read "blackened."
7. Anne Wyndham Lewis, "Correspondence," *Arts Review*, 17 (November 27, 1965), 22. The Bauhaus was not founded until 1919; Lewis must have visited Dessau during his trips to Germany in 1928 and 1930.
8. Letter from Admiral Sir Caspar John to Jeffrey Meyers, May 26, 1978.
9. *Letters*, pp. 31, 35.
10. Quoted in Michael Holroyd, *Augustus John* (London, 1976), pp. 266, 285n (1906).
11. Augustus John, *Chiaroscuro* (London, 1952), p. 73.
12. Letter from Wyndham Lewis to Augustus John, June 1907, owned by Romilly John; and letter from John to Lewis, quoted in Holroyd, pp. 173n–174n (June 1907).
13. *Letters*, p. 36.
14. Interview with Geoffrey Grigson, Broad Town, Wiltshire, October 6, 1978. This incident probably took place in 1921.
15. Letter from Wyndham Lewis to Augustus John, 1909, Tate Gallery Archives; and *Letters*, pp. 45, 70n–71n (c. 1910 and summer 1915).
16. *Tarr*, pp. 24, 40.
17. *Letters*, pp. 18, 37.
18. Interview with Hugh Gordon Porteus, Cheltenham, September 21, 1978.
19. Letter from Anne Lewis to Wyndham Lewis, June 27, 1909, Cornell.
20. Letter from T. Sturge Moore to Wyndham Lewis, c. September 1909, University of London Library.
21. Wyndham Lewis, "A Spanish Household," *Tramp*, 1 (June–July 1910), 359.
22. Letter from Augustus John to Wyndham Lewis, summer 1908, Cornell.
23. *Rude Assignment*, p. 116.
24. *Wyndham Lewis on Art*, p. 295.

25. Wyndham Lewis, "Some Innkeepers and Bestre," *English Review*, 2 (June 1909), 481, 484.
26. *Letters*, p. 40 (c. December 1908).
27. *Ibid.*, p. 564 (to Hugh Kenner, c. March 1956); and Synopsis no. 1 of "Twentieth Century Palette," c. 1956, p. 1, Cornell.

CHAPTER 3: Ford and Pound

1. Letter from Daniel Sturge Moore to Jeffrey Meyers, October 14, 1978; and interview with Riette Sturge Moore, London, September 22, 1978.
2. Quoted in Mary Daniels, *Wyndham Lewis: A Descriptive Catalogue of Manuscripts* (Ithaca, New York, 1972), p. 14.
3. Letter from Sturge Moore to Wyndham Lewis, November 18, 1908, Cornell.
4. *Letters*, p. 293 (July 15, 1941).
5. Douglas Goldring, *South Lodge* (London, 1943), p. 40; and *Rude Assignment*, p. 121. Ford gives the first, more restrained version of his meeting with Lewis in "Mr. Wyndham Lewis and 'Blast,'" *Outlook*, 34 (July 4, 1914), 15.
6. Quoted in *Lewisletter*, 7 (October 1977), 10 (letter from Wyndham Lewis to Sturge Moore, c. September 1909); and in Michael Holroyd, *Lytton Strachey* (London, 1971), II, 74 (letter to Ottoline Morrell, October 1912).
7. Quoted in Cork, p. 270.
8. Ford Madox Ford, *Portraits from Life* (New York, 1937), p. 290. The spaced periods are in the original quotation.
9. Quoted in Cork, p. 158.
10. Ford Madox Ford, *The Marsden Case* (London, 1923), pp. 3–4, 42, 271.
11. Interview with Rebecca West, London, August 25, 1977; and Wyndham Lewis, *The Roaring Queen* (London, 1973), p. 122.
12. Wyndham Lewis, "Ezra Pound," *Ezra Pound: A Collection of Essays*, ed. Peter Russell (London, 1950), pp. 257–258.
13. Douglas Goldring, *Odd Man Out* (London, 1935), p. 100.
14. Ezra Pound, *Letters, 1907–1941*, ed. D. D. Paige (New York, 1950), p. 73 (March 10, 1916).
15. Ezra Pound, "Edward Wadsworth, Vorticist," *Egoist*, 1 (August 15, 1914), 306; and Ezra Pound, *Guide to Kulchur* (Norfolk, Conn., 1938), p. 106.
16. Frank Rutter, *Art in My Time* (London, 1933), p. 145.
17. Letter from Augustus John to Wyndham Lewis [1912], Cornell; and Roger Fry, "The Allied Artists at the Albert Hall," *Nation*, 11 (July 20, 1912), 583.
18. Quoted in Jeffrey Meyers, *Katherine Mansfield: A Biography* (London, 1978), p. 37.
19. Osbert Sitwell, *Great Morning* (London, 1948), p. 208.

20. This painting, not listed in Walter Michel, *Wyndham Lewis: Paintings and Drawings* (London, 1971), has recently been acquired by Anthony D'Offay.

21. Quoted in Frederick Gore, "Spencer Gore: A Memoir by His Son," *Spencer Gore* exhibition catalogue (London: D'Offay Gallery, 1974), p. 12; and quoted (but neither exactly nor entirely) in W. K. Rose, "Ezra Pound and Wyndham Lewis: The Crucial Years," *Southern Review*, 4 (1968), 78. The letter, c. 1912, is at Cornell.

22. Richard Aldington, *Death of a Hero* (London, 1929), pp. 121–122. Aldington, who imitated Lewis' satire, frequently turned against friends like D. H. Lawrence, Norman Douglas and Pino Orioli, and attacked T. E. Lawrence in his notorious biography of 1955. In "Minor Lions," an unpublished story of that year, Lewis portrays Aldington as the mercenary hack-writer, Alwyn Pole:

> Alwyn had settled down upon one deeply respected, recently deceased national hero, and was tearing him to pieces (he called this 'debunking'), showing in how blackguardly a manner the hero had treated women, and how phoney and fictive were most of his military exploits, which had placed him so high in the estimation of his countrymen. This American Colonel Lawrence would stand naked and unlovely in the gaze of the United States. This debunk he expected to earn him twenty-five thousand bucks, with which he proposed to rent a little shack in Florida. ("Minor Lions," p. 5, Cornell)

See Lewis' negative review of Aldington's biography: "Perspectives on Lawrence," *Hudson Review*, 8 (1956), 596–608.

23. Quoted in Cork, p. 82.

CHAPTER 4: Omega Workshops and Rebel Art Centre

1. Gertrude Stein, *The Autobiography of Alice B. Toklas* (New York, 1933), pp. 122–123.
2. Quoted in Wees, p. 145.
3. Interview with William Gaunt, London, September 12, 1978.
4. Kenneth Clark, *Another Part of the Wood* (New York, 1976), p. 111.
5. *Rude Assignment*, p. 124.
6. H. G. Wells, in "The Story of the Last Trump" (1915), memorialized their brief association and wrote of "The beautiful new Lady Chapel done by Roger Fry and Wyndham Lewis and all the latest people in Art."
7. *Letters*, p. 47.
8. Frederick Gore, p. 12; and Interview with Frederick Gore, London, October 5, 1978.
9. *Letters*, p. 48.
10. Quoted in Quentin Bell and Stephen Chaplin, "The Ideal Home Rumpus," *Apollo*, 80 (October 1964), 289.
11. *Letters*, pp. 48–51.
12. Quoted in Bell and Chaplin, p. 290.

13. Quoted in Cork, p. 7. Strachey's letter is quoted in Holroyd, *Lytton Strachey*, II, 74.

14. Roger Fry, *Letters*, ed. Denys Sutton (London, 1972), pp. 376, 379 (to Simon Bussy, December 28, 1913, and to Duncan Grant, March 6, 1914).

15. Quoted in Horace Brodzky, *Henri Gaudier-Brzeska* (London, 1933), p. 172.

16. Quoted in Bell and Chaplin, "Rumpus Revived," *Apollo*, 83 (January 1966), 75.

17. Bell and Chaplin (1964), p. 288.

18. Fry, *Letters*, pp. 351, 486 (to William Rothenstein, September 13, 1911, and to Virginia Woolf, July 27, 1920).

19. Clive Bell, "Roger Fry," *Old Friends* (London, 1956), pp. 68, 89.

20. Leonard Woolf, *Beginning Again* (New York, 1964), p. 95.

21. Quoted in Cork, p. 98.

22. Quoted in Bell and Chaplin (1964), p. 290.

23. Bell and Chaplin (1964), p. 291. Wees and Cork accept this conclusion.

24. *Ibid.*, p. 290.

25. Virginia Woolf, *Roger Fry* (1940), (London, 1976), p. 193.

26. Bell and Chaplin (1964), p. 291.

27. Interview with David Garnett, Montcuq, France, August 17, 1977.

28. Douglas Cooper, "Introduction" to *The Courtauld Collection* catalogue (London, 1954), p. 51; Paul Nash, *Outline* (London, 1949), p. 162; and Grey Gowrie, "The Twentieth Century," *The Genius of British Painting*, ed. David Piper (New York, 1975), p. 301.

29. Interviews with Julian Symons, London, August 26, 1977; with Hugh Kenner, Baltimore, June 24, 1978; and with Anne Wyndham Lewis, Torquay, August 23, 1977.

30. *Letters*, p. 243.

31. Clive Bell, "Contemporary Art in England," *Pot-Boilers* (London, 1918), p. 229. This volume is appropriately named.

32. *Tarr*, pp. 3, 11, 17.

33. Fry, *Letters*, p. 519.

34. John Rothenstein, *Brave Day, Hideous Night* (London, 1966), p. 71; *Time's Thievish Progress* (London, 1970), p. 39; and *Summer's Lease* (London, 1965), p. 129.

35. *Letters*, pp. 57–59.

36. Letter from Wyndham Lewis to Kate Lechmere [December 5, 1912]; and Wyndham Lewis, *Blasting and Bombardiering* (London, 1967), p. 105.

37. In chapter one of Angus Wilson's *Anglo-Saxon Attitudes* (1956) an American graduate student, writing a dissertation on "The Intellectual Climate of England at the Outbreak of the First World War" and concentrating on Lewis and Lawrence, writes to Gerald Middleton about Gilbert Stokesay, who excavated important Anglo-Saxon tombs in 1912 and may have been influenced by the aesthetic theories of Hulme and Lewis.

38. Sam Hynes kindly sent me copies of Kate Lechmere's memoir and Lewis' letter to her.

CHAPTER 5: Vorticism and *Blast*

1. William Roberts, "Wyndham Lewis, the Vorticist," *Listener*, 57 (March 21, 1957), 470.
2. Wyndham Lewis, *The Art of Being Ruled* (London, 1926), pp. 128–129.
3. T. S. Eliot, "Wyndham Lewis," *Hudson Review*, 10 (1957), 169; Anthony Powell, "The Art of 'The Enemy,'" *Apollo*, 94 (September 1971), 242; and Cecil Gray, *Musical Chairs* (London, 1948), pp. 276–277.
4. "The Vorticists" (1956), *Wyndham Lewis on Art*, p. 457.
5. Quoted in Cork, p. 110.
6. Quoted in Wees, p. 147.
7. Interview with Helen Peppin, Oxford, September 30, 1978.
8. Quoted in Cork, p. 419.
9. Letter from A. R. H. Saunders to Wyndham Lewis, June 23, 1920, Cornell.
10. Letters from Wyndham Lewis to Jessica Dismorr, 1914, October 16, 1924, and November 23, 1925; letter from Marjorie Firminger to Wyndham Lewis, quoting Dismorr, September 10, 1930, all in Cornell; and Quentin Stevenson, "Introduction" to *Jessica Dismorr*, exhibition catalogue (London: Mercury Gallery, 1974), n.p.
11. Stulik appears on the first page of *The Ideal Giant*; Soltyk in *Tarr* is a near anagram of his name.
12. Goldring, *South Lodge*, p. 64; and André Gide, *Journals*, trans. Justin O'Brien (New York, 1947), I, 103, 129.
13. Wyndham Lewis, *Anglosaxony: A League That Works* (Toronto, 1941), pp. 41–42.
14. *Blasting and Bombardiering*, p. 33.
15. *Letters*, pp. 62–63.
16. *Blasting and Bombardiering*, pp. 34–35.
17. Wyndham Lewis, *Time and Western Man* (London, 1927), p. 213; and *Anglosaxony*, p. 39.
18. See "Plotinus" in *A Lume Spento* (with tapers quenched) (1908) in *Collected Early Poems of Ezra Pound*, ed. Michael King (New York, 1976), p. 36:

> As one that would draw thru the node of things,
> Back sweeping to the vortex of the cone,
> Cloistered about with memories, alone
> In chaos, while the waiting silence sings.

See also Pound, *Letters*, pp. 28, 72 (to William Carlos Williams, December 19, 1913, and to Kate Buss, March 9, 1916).
19. "Vorticist Exhibition," *Wyndham Lewis on Art*, p. 96.
20. *Tarr* (London, 1918), p. 183.
21. Wyndham Lewis, "The End of Abstract Art," *New Republic*, 102 (April 1, 1940), 438; and Wyndham Lewis, *The Demon of Progress in the Arts* (Chicago, 1954), p. 32.
22. Goldring, *South Lodge*, p. 67.

23. Marshall McLuhan, "Wyndham Lewis," *Atlantic Monthly*, 224 (December 1969), 98.

24. Goldring, *Odd Man Out*, p. 120.

25. "The Vorticists," *Wyndham Lewis on Art*, p. 456.

26. *Letters*, p. 492 (to the editor of the *Partisan Review*, c. April 1949). The lines in my copy of *Blast* are not transparent. Pound's first poem in *Blast*, "Salutation the Third," expressed his obsessive anti-Semitism:

> Let us be done with Jews and Jobbery,
> Let us SPIT upon those who fawn on the JEWS for their money.

27. *Ibid.*, p. 64 (1914).

28. Interview with Henry Moore, Much Hadham, Herts., September 25, 1978.

29. Ford, "Mr. Wyndham Lewis and 'Blast,'" *Outlook*, p. 15; and A. R. Orage, "Readers and Writers," *New Age*, 15 (July 9, 1914), 229. Orage alludes to Blake's 57th "Proverb of Hell": "Damn braces. Bless relaxes."

30. Letter from Wyndham Lewis to Kate Lechmere, Cornell, omitted from *Letters*, p. 69.

31. Ezra Pound, *Pavannes and Divisions* (New York, 1918), pp. 245–246.

32. *Time and Western Man*, p. 55.

33. *Blasting and Bombardiering*, pp. 107–109.

34. Quoted in Ezra Pound, *Henri Gaudier-Brzeska* (1916), (New York, 1970), p. 32.

35. Cork, p. 557.

CHAPTER 6: The Great War

1. Wyndham Lewis, Synopsis no. 2 of "Twentieth Century Palette," c. 1956, p. 2, Cornell.

2. Letter from Wyndham Lewis to Frederick Etchells, [c. 1914], Cornell.

3. This and the postal anecdote were related during an interview with Geoffrey Grigson.

4. David Thatcher, ed., "Richard Aldington's Letters to Herbert Read," *Malahat Review*, 15 (1970), 41–42 (March 12, 1957, just after Lewis' death).

5. Letter from Beatrice Hastings to Wyndham Lewis [c. 1914–1915], Cornell.

6. Ford, *Return to Yesterday* (London, 1931), pp. 433, 436; and letter from Lady Juliette Huxley to Jeffrey Meyers, September 26, 1978.

7. *Letters*, p. 67.

8. This letter is quoted in David Parker, "The Vorticist, 1914: The Artist as Predatory Savage," *Southern Review* (Adelaide), 8 (1975), 19. The other letters from Mary Borden Turner to Wyndham Lewis [1914–1915] are in Cornell.

9. *Letters*, pp. 68–69. The unpublished letters from Alick Schepeler to Wyndham Lewis, September 16, 1915, and September 29, 1930, are in Cornell.

10. Tape recording of William Wees' interview with Helen Rowe, August 8, 1965, kindly sent to me by William Wees; and *Tarr*, p. 20.

11. Letter from Guy Baker to Wyndham Lewis [c. 1917], Cornell.
> There was a young girl of Penzance.
> In a bus she fell down in a trance.
> Ten passengers fucked her
> Likewise the conductor
> And the driver came twice in his pants.

12. *Rude Assignment*, p. 126.

13. T. S. Eliot, "The Importance of Wyndham Lewis," *Sunday Times*, March 10, 1957, p. 10; and T. S. Eliot, " 'Tarr', " *Egoist*, 5 (September 1918), 106.

14. Wyndham Lewis, *One-Way Song* (London, 1933), p. 73; and Wyndham Lewis, "Early London Environment," *T. S. Eliot: A Symposium*, ed. Tambimuttu and Richard March (London, 1965), pp. 26, 29–30.

15. *Letters*, pp. 66–67.

16. D. H. Lawrence, *Kangaroo* (1923), (London, 1974), p. 220.

17. On January 24, 1917, Lewis wrote to John Quinn about oriental painters: "Their steady power of fundamental vision and impeccable taste are a model for us." Cornell.

18. Quoted in B. L. Reid, *The Man From New York: John Quinn and His Friends* (New York, 1968), p. 252.

19. *Letters*, pp. 73–74.

20. Richard Aldington, *Life for Life's Sake* (New York, 1941), p. 170.

21. *Blasting and Bombardiering*, p. 22.

22. Pound, *Letters*, p. 83 (June 24, 1916).

23. Letters from Wyndham Lewis to Ezra Pound, March 29, 1916, April 12, 1916, and July 9, 1917, Beinecke Library, Yale University.

24. "The War Baby," *Blasting and Bombardiering*, pp. 335–336.

25. Peter Quennell, *The Sign of the Fish* (London, 1960), p. 136.

26. Quoted in Holroyd, *Augustus John*, p. 553.

27. Quoted in Daphne Fielding, *The Rainbow Picnic* (London, 1974), pp. 53–54; and letter from Sybil Hart-Davis to Wyndham Lewis, November 1917, Cornell.

28. Herbert Read, *The Contrary Experience* (London, 1953), pp. 136, 139; Herbert Read, "Time and Mr. Wyndham Lewis," *Nation and Athenaeum*, 42 (November 19, 1927), 282, 284; and Herbert Read, "Lone Wolf," *New Statesman and Nation*, 53 (March 16, 1957), 337.

29. The offending passage was probably Cantleman's seduction of Stella:
> The way in which Stella's hips stood out, the solid blood-heated expanse on which his hand lay, had the amplitude and flatness of a mare. Her lips had at once no practical significance, but only the aesthetic blandishments of a bull-like flower. With the gesture of a fabulous Faust he drew her against him, and kissed her with a crafty gentleness. (*Blasting and Bombardiering*, p. 309)

30. Rebecca West, " 'Tarr,' " *Nation*, 107 (August 17, 1918), 176.

31. Ezra Pound, "Wyndham Lewis" (1920), *Literary Essays*, ed. T. S. Eliot (London, 1954), pp. 424, 429.

32. [Anthony Powell], "Satire in the Twenties," *TLS*, September 13, 1947, p. 464.
33. *Rude Assignment*, p. 138.

CHAPTER 7: Women and Marriage

1. Letter from Wyndham Lewis to Augustus John, 1909, Tate Gallery Archives; and Stella Bowen, *Drawn From Life* (London, 1941), p. 51.
2. *Tarr*, pp. 100, 219, 221.
3. Wyndham Lewis, "Doppelgänger" and "Junior," in *Unlucky for Pringle*, ed. C. J. Fox and Robert Chapman (London, 1973), pp. 205, 110.
4. Iris Barry, "The Ezra Pound Period," *Bookman*, 74 (October 1931), 168; and Herbert Read, *The Contrary Experience*, p. 139.
5. Geoffrey Grigson, "Recollections of Wyndham Lewis," *Listener*, 57 (May 16, 1957), 786. Lewis' reticence about his private life encouraged many rumors. In a letter of June 8, 1930, at Cornell, Marjorie Firminger wrote teasingly to Lewis: "I heard a good bit of gossip about you last week—that it was a fact that you had been secretly married recently & had some more children."
6. Letter from Iris Barry to Wyndham Lewis, from Augustus John's house in Dorset, April 14, 1921, Cornell.
7. Peter Quennell's letter to Jeffrey Meyers, March 9, 1978, though unreliable about the details of Iris' life with Lewis, gives a vivid portrait of her marriage to Porter:

 > Iris never spoke of Wyndham Lewis herself; & I knew of their relationship only through hearsay. I am astonished to learn that she had had two children—by her second husband, I suppose. She was certainly childless in my day (about 1922–23), and married to a young poet named Alan Porter, said to be highly talented, though not productive, who seemed to spend most of his time abed, while Iris supported the household as a film-critic. They lived in a run-down 18th-century street, which has now vanished, somewhere off Theobald's Road, and shared a basement-flat. I remember a strong smell of cats in the passage and a Gaudier-Brzeska print on the sitting-room wall.

 Porter edited John Clare's *Poems* with Edmund Blunden, published one book of verse, *The Signature of Pain* (1930), became a Jungian, taught at Vassar and died in the early 1940s.
8. Letter from Iris Barry to Wyndham Lewis, from Montreal (where she had gone to fulfill immigration requirements), November 9, 1931.
9. Information on Iris Barry comes from interviews with: Rebecca West, London, August 25, 1977; Julian Symons, London, August 26, 1977; Pamela Askew, Poughkeepsie, New York, June 26, 1978; Iris' son, London, September 11 and 24, 1978; Yvonne Kapp, London, November 2, 1978; and Pierre Kerroux, Fayence, May 19, 1979; letters from: Margaret Barr, January 4, 1978; Peter Quennell, February 23 and March 9, 1978; Helen Arbuthnot, July 24, 1978;

Alistair Cooke, January 4, 1979; and Ivor Montagu, "Birmingham Sparrow," *Sight and Sound*, 39 (Spring 1970), 106–108; Alistair Cooke, "To Iris Barry," *New York Times*, January 18, 1970.

10. Richard Aldington gives a characteristically sour portrait of the older Nancy in his story "Nobody's Baby," *Soft Answers* (London, 1932), p. 156:

> Hers was not merely the fashionable skeleton silhouette. It was a kind of premature withering, like an apple left too long on a fruit-dish. There was a virginal pathos in her fragility, in the thin hands and wrists, and the legs which seemed too long for so tiny a trunk. . . . Her good looks had vanished helter-skelter. There were little wrinkles round her eyes, a sharp line on either side of her mouth, and she had cut her long dark hair to an Eton crop, which gave her the appearance of a prematurely-aged and nervous schoolboy.

11. Letter from Nancy Cunard to Wyndham Lewis [c. 1921–1922], Cornell.

12. W. K. Rose, "Remembering Nancy," in Hugh Ford, ed., *Nancy Cunard: Brave Poet, Indomitable Rebel* (Philadelphia, 1968), pp. 317–318.

13. Letter from Nancy Cunard to Wyndham Lewis [after October 1922], Cornell.

14. Letter from Nancy Cunard to W. K. Rose, May 3, 1963, Vassar College, Poughkeepsie, New York.

15. Sybille Bedford, *Aldous Huxley: A Biography* (New York, 1974), p. 136.

16. *Letters*, p. 275 (to Leonard Amster, c. August 1940).

17. Aldous Huxley, *Letters*, ed. Grover Smith (New York, 1969), p. 220 (September 10, 1923); and Aldous Huxley, *Antic Hay* (Harmondsworth: Penguin, 1948), p. 40.

18. Lewis, who was easily provoked and intensely pugnacious, continued to snipe at Huxley for the next thirty years. In *Time and Western Man*, p. 75, he says "Arlen and Huxley are baser varieties of Marcel Proust" and in the *Enemy*, 2 (1928), 111, he links Huxley with Arlen, Firbank and Van Vechten—"that fearful 'sophisticated' ninetyish mob, which vulgarly swarms and glitters in any post-war capital." Huxley was probably satirized as Anthony Horncastle in *The Apes of God*. In *Men Without Art* (London, 1934), pp. 301–302, Lewis brilliantly contrasts the opening pages of *Point Counter Point* and James' *The Ivory Tower*, and totally demolishes the "vulgar complicity with the dreariest of suburban library readers" that produced Huxley's "dull and vulgar book." In *The Roaring Queen* (1936) he parodies Huxley's country-house satires; in *America, I Presume* (1940), he refers ironically to *Brave New World*. And on the first page of Lewis' *The Red Priest* (1956), a character blows the dust from the "small precious body" of *Antic Hay* and then puts it back on the shelf with other forgotten novels. Lewis' one positive reference occurs in his conciliatory autobiography, *Rude Assignment*, p. 167n, when he says that *Science, Liberty and Peace* (1947) is worth reading and calls Huxley "a good and sensible man."

19. Interview with D. G. Bridson, London, August 25, 1977.
20. Wyndham Lewis, *The Revenge for Love* (Harmondsworth: Penguin, 1972), p. 71.
21. William Furlong, "Interview with Anne Wyndham Lewis" (London: Audio Arts cassette, 1974). This cassette includes a recording of Lewis reading at Harvard in 1939 from *One-Way Song*.
22. John Beevers, "Reminiscences of Lewis," 1975, typescript at Cornell.
23. In this respect Froanna was similar to Maria Huxley, who also tolerated and admired her husband's affairs.
24. Letter from Hugh Gordon Porteus to Jeffrey Meyers, October 26, 1978.
25. *The Revenge for Love*, pp. 70, 175–176.
26. *Letters*, p. 269 (New York, December 1939). The passage in brackets was omitted from the published version of the letter.
27. The information about Froanna is based mainly on my six-hour interview with her in Torquay, Devon, August 23, 1977; C. J. Fox's taped interview with her in Torquay, June 25, 1977; William Furlong's taped interview with her in 1974; and also on my interviews with Mary Campbell, Naomi Mitchison, Desmond Flower, Julian Symons, Hugh Gordon Porteus and Geoffrey Grigson.

CHAPTER 8: Underground Man

1. *Time and Western Man*, p. 39; and *Blasting and Bombardiering*, pp. 4–5, 231.
2. Interview with Anne Wyndham Lewis; and E. W. F. Tomlin, "Introduction" to *Wyndham Lewis: An Anthology of His Prose* (London, 1969), p. 9.
3. *Blasting and Bombardiering*, pp. 189, 210–211.
4. Walter Allen, "Lonely Old Volcano: The Achievement of Wyndham Lewis," *Encounter*, 21 (September 1963), 66.
5. Wyndham Lewis, "The Caliph's Design" (1919), in *Wyndham Lewis the Artist: From 'Blast' to Burlington House* (London, 1939), pp. 212, 223.
6. Wyndham Lewis, *Tyro 1*, p. 2.
7. *Rude Assignment*, pp. 129–130.
8. Letter from Sir William Walton to Jeffrey Meyers, March 20, 1978.
9. Oliver Brown, *Exhibition* (London, 1968), pp. 75–76.
10. Letter from Wyndham Lewis to Lytton Strachey, July 22, 1926, Strachey Papers, volume 22, British Library.
11. Robert Adams, *The Roman Stamp* (Berkeley, 1974), p. 154.
12. Letter from Sir William Walton to Jeffrey Meyers, March 20, 1978.
13. *Letters*, p. 108 (Paul Nash to Wyndham Lewis, August 21, 1919); Edwin Muir, *Selected Letters*, ed. P. H. Butter (London, 1974), pp. 50, 63 (to Sydney Schiff, May 8, 1925, and April 19, 1927); and William Rothenstein, *Men and Memories*, pp. 378–379.
14. *Letters*, p. 212 (May 21, 1933); and *Blasting and Bombardiering*, p. 216.
15. *Wyndham Lewis on Art*, p. 421.

16. Valerie Eliot, "Introduction" to '*The Waste Land*' : *Facsimile and Transcript* (London, 1971), p. xxv; and letter from Wyndham Lewis to Fanny Wadsworth, c. April 1924, Cornell.

17. Wyndham Lewis, *The Apes of God* (Harmondsworth: Penguin, 1965), pp. 190-191; and *Letters*, p. 153.

18. Interview with Geoffrey Grigson; and letter from Wyndham Lewis to Sydney Schiff, October 3, 1922, British Library 52919.

19. *Blasting and Bombardiering*, pp. 92-94; and Osbert Sitwell, "Introduction" to Walter Sickert's *A Free House* (London, 1947), pp. xlv-xlvi.

20. Arnold Bennett, *Letters*, ed. James Hepburn (New York, 1966), III, 121; and letter from Frank Swinnerton to Jeffrey Meyers, November 10, 1977. The reference to "grey flannel" reveals that Lewis was too poor to buy evening dress.

21. Letter from Wyndham Lewis to Geoffrey Grigson, February 10, 1946, Cornell; and Elizabeth Salter, *The Last Years of a Rebel* (London, 1967), p. 31.

22. Quoted in Salter, p. 61; and T. S. Eliot, letter to the *Observer*, December 18, 1960, in response to Edith Sitwell, "Hazards of Sitting for My Portrait," *Observer*, November 27, 1960, p. 24.

23. *Blasting and Bombardiering*, pp. 225, 227; and Miriam Benkowitz, *Ronald Firbank* (London, 1969), p. 222.

24. Letter from Lord David Cecil to Jeffrey Meyers, January 2, 1979; and P. N. Furbank, *E. M. Forster : A Life* (London, 1978), II, 110.

25. Pound, *Letters*, p. 176 (April 5, 1922); quoted in Noel Stock, *The Life of Ezra Pound* (1970), (London, 1974), pp. 326-327 (to Henry Moe, March 31, 1925); and letter from Lewis to Pound, December 8, 1925, Yale University. Despite Pound's encouragement, Lewis never applied for a Fellowship.

26. *Letters*, pp. 158-160 (June 11, 1925).

27. Quoted in '*The Waste Land*' : *Facsimile and Transcript*, p. xix (January 25, 1920).

28. "Religious Expression in Contemporary Art" (1943), *Wyndham Lewis on Art*, p. 376. Lewis gives an accurate account of this journey in *Blasting and Bombardiering*, pp. 265, 287. In "Wyndham Lewis," *Hudson Review*, 10 (1957), 167-170, Eliot, who admits "my memory is a feeble one," confused the chronology and the itinerary. He stated that the trip took place in 1921 (instead of 1920), did not mention meeting Joyce, and said that they ended up in Paris (instead of beginning there).

29. Quoted in Tom Matthews, *Great Tom* (London, 1974), p. 85.

30. *Letters*, pp. 149, 151-152; and letter from T. S. Eliot to Wyndham Lewis, March 23, 1925, Cornell.

31. Eliot, "Wyndham Lewis," *Hudson Review*, 169; T. S. Eliot, "Homage to Wyndham Lewis," *Spectrum*, 1 (1957), 45; and T. S. Eliot, "A Note on *Monstre Gai*," *Hudson Review*, 7 (1955), 526.

32. *Blasting and Bombardiering*, pp. 12, 267; and letter from Wyndham Lewis to Violet Schiff, April 12, 1922, British Library, 52919.

33. *Blasting and Bombardiering*, p. 269; and James Joyce, *Letters*, ed. Stuart Gilbert and Richard Ellmann (New York, 1957, 1966), II, 468.

34. James Joyce, *Letters*, I, 167 and III, 42 (to Frank Budgen, May 31, 1921 and to Harriet Weaver, June 24, 1921).

35. Richard Ellmann, *James Joyce* (New York, 1959), pp. 530, 570, 581; interview with Richard Ellmann, Oxford, September 29, 1978; and quoted in Robert McAlmon, *Being Geniuses Together* (New York, 1968), p. 129.

36. Letter from Wyndham Lewis to the Paris journalist Pierre Loving, c. 1927, Yale. Bryher, the wife of McAlmon, and H.D., the wife of Aldington, left their husbands to live together.

37. Wyndham Lewis, "Ezra: The Portrait of a Personality," *Quarterly Review of Literature*, 5 (December 1949), 140; and Ernest Hemingway, *A Moveable Feast* (New York, 1967), p. 109.

38. Letter from Archibald MacLeish to Jeffrey Meyers, October 1977; and letter from Archibald MacLeish to W. K. Rose, April 25, 1960, Vassar.

39. *Rude Assignment*, p. 203; and *A Moveable Feast*, pp. 108–109. When Froanna read Hemingway's phrase, "unsuccessful rapist," she exclaimed: "What does that make me?"

40. Roy Campbell, *Light on a Dark Horse* (1952), (London, 1971), p. 231. Campbell said that they first met in the Adam and Eve studio, but Lewis did not move there until July 1921.

41. *Blasting and Bombardiering*, p. 223. Roy Campbell, *Light on a Dark Horse*, p. 253, confirms Lewis' story. During an interview in Sintra, Portugal, August 26, 1978, Mary Campbell also assured me that Lewis' description of her wedding party was accurate, not exaggerated.

42. Roy Campbell, "The Emotional Cyclops," *New Statesman*, 30 (December 3, 1927), p. x; and Augustus John, *Finishing Touches*, ed. Daniel George (London, 1964), pp. 120–121.

43. George Painter, *Proust: The Later Years* (Boston, 1965), p. 339.

44. Letter from Sydney Schiff to Wyndham Lewis, May 15, 1923, Cornell; and letter from T. S. Eliot to Wyndham Lewis, December 12, 1924, Cornell.

45. When Lewis was looking for accommodation in Windsor, Canada, in October 1944, Marion Trowell, the wife of Katherine's first lover, suggested that Lewis rent a room in her house.

46. Letters from Wyndham Lewis to Violet Schiff, February 6, 1921 and March 30, 1922, British Library, 52919.

47. Katherine Mansfield, *Letters*, ed. J. M. Murry (London, 1928), II, 203 (April 4, 1922); and letter from Violet Schiff to Wyndham Lewis, April 11, 1922, Cornell. Lewis' "Credentials of the Painter" was published in the *English Review* of January and April 1922; the rewritten *Wild Body* story, "Bestre," and the eerie, semi-abstract drawing, *Room 59*, appeared in *Tyro 2*.

48. For Mansfield's relations with the Schiffs and with Gurdjieff, see Meyers, *Katherine Mansfield*, pp. 201–203, 238–252.

49. Interview with Mansfield's brother-in-law, Richard Murry, London, December 19, 1976.

50. Letters from Wyndham Lewis to Sydney and to Violet Schiff, September 1922, British Library, 52919.

51. *Blasting and Bombardiering*, pp. 239–241, 244; and Wyndham Lewis, "Perspectives on Lawrence," p. 608. For a discussion of *Seven Pillars* see Jeffrey Meyers, *The Wounded Spirit: A Study of 'Seven Pillars of Wisdom'* (London, 1973).

52. Letter from Wyndham Lewis to William Rothenstein, June 12, 1927, Cornell; and quoted in William Rothenstein, *Since Fifty* (London, 1939), p. 72 (December 8, 1927).

CHAPTER 9: Man of the World

1. Edmund Wilson, *Letters on Literature and Politics* (New York, 1977), p. 371 (July 17, 1928).

2. Richard Aldington, *Pinorman* (London, 1954), pp. 87–88; and Aldington, *Life for Life's Sake*, p. 354.

3. *The Art of Being Ruled*, pp. xii, 415.

4. Osbert Sitwell, "The Importance of Wyndham Lewis," *New York World*, January 9, 1927, p. 11M; and Edgell Rickword, "*The Art of Being Ruled*," *Calendar*, 3 (1926–1927), 247.

5. *The Art of Being Ruled*, pp. 89, 135.

6. *Ibid.*, pp. 147, 369–370.

7. Wyndham Lewis, *The Diabolical Principle* (London, 1931), p. 126. See Jeffrey Meyers, "Gabriele D'Annunzio," *A Fever at the Core* (London, 1976), pp. 89–111.

8. *The Art of Being Ruled*, p. 432.

9. *Rude Assignment*, pp. 168–169, 179, 188. In 1929 the young Day Lewis revealed the contemporary influence of this book, opaquely versified his ideas about individuality and art in the "Skin and Intestine" chapter of *The Art of Being Ruled* and, following the practice of *The Waste Land*, footnoted the source in his "Transitional Poem," *Collected Poems, 1929–1933* (New York, 1935), pp. 42, 56:

 > For the individual truth must lie
 > Within diversity;
 > Under the skin all creatures are one race,
 > Proved integers but by their face.

 > So he, who learns to comprehend
 > The form of things, will find
 > They in his eye that purest star have sown
 > And changed his mind to singular stone.

10. *The Art of Being Ruled*, p. 386; M. C. D'Arcy, "A Critic Among Philosophers," *Month*, 150 (December 1927), 515; and Mario Praz, "Wyndham Lewis," *English Studies*, 10 (1928), 1. In Anthony Powell's *Casanova's Chinese Restaurant* (1960), the fifth novel in his *Dance to the Music of Time* series, the homosexual actor, Norman Chandler, reinforces the passage-of-time theme by reading *Time and Western Man*.

11. Letter from Wyndham Lewis to Pierre Loving, May 9, 1927, Yale; and *Time and Western Man*, pp. 54–55, 58, 87.

12. Interview with Hugh Kenner; and *One-Way Song*, p. 17.

13. Pound, "Wyndham Lewis," *Literary Essays*, p. 425; and *Time and Western Man*, pp. 93, 125.

14. *Letters*, p. 404 (to Ezra Pound, April 9, 1947); and *Time and Western Man*, pp. 107, 109, 112.

15. See, for example, *The Apes of God*, p. 84, for a description of eating that rivals the "Lestrygonians" chapter of *Ulysses*.

16. *Time and Western Man*, pp. 110, 116, 118, 123. Lewis' book influenced later works on the same subject: A. A. Mendilow, *Time and the Novel* (1952) and Hans Meyerhoff, *Time in Literature* (1960).

17. *The Childermass* (London, 1965), pp. 174–175.

18. *The Apes of God*, p. 154; and *Letters*, p. 190 (July 30, 1930).

19. Letter from Wyndham Lewis to Ezra Pound, February 17, 1931, Yale; *The Diabolical Principle*, p. 7; and *One-Way Song*, p. 73. Joyce's poems were actually published five times between 1927 and 1932.

20. Interview with Richard Ellmann.

21. Quoted in Frank Budgen, *Myselves When Young* (London, 1970), p. 207; and James Joyce, *Finnegans Wake* (New York, 1947), p. 419.

22. René Descartes, *Discourse on Method*, trans. John Veitch (New York: Dolphin, n.d.), p. 63; and *Time and Western Man*, p. 323.

23. Wyndham Lewis, *The Wild Body* (New York, 1928), p. 233; and *Blasting and Bombardiering*, p. 22.

24. *The Wild Body*, pp. 244, 247; and Cyril Connolly, "The Wild Body," *New Statesman*, 30 (December 24, 1927), 358.

25. Quoted in Louise Morgan, *Writers at Work* (London, 1931), p. 49.

26. *The Childermass*, p. 229; quoted in Wyndham Lewis, *Satire and Fiction* (London, 1930), p. 28 (January 24, 1928); and Lionel Trilling, "The Childermass," *New York Evening Post* (September 22, 1928), sec. 3, p. 5.

27. Wyndham Lewis, *Paleface* (London, 1929), pp. 177, 196; and quoted in *Rude Assignment*, pp. 203–204 (October 24, 1927).

28. Letter from Wyndham Lewis to Newman Flower, 1932, Cornell; and *Paleface*, p. 180. T. S. Eliot, *After Strange Gods* (New York, 1934), p. 58, attacked Lawrence's lack of humor, snobbery and "incapacity for what we ordinarily call thinking," and cited the "brilliant exposure by Wyndham Lewis in *Paleface* as by far the most conclusive criticism that has been made" of this incapacity.

29. David Garnett, *Flowers of the Forest* (New York, 1956), p. 37; D. H. Lawrence, *Lady Chatterley's Lover* (Harmondsworth: Penguin, 1978), p. 300; and D. H. Lawrence, "Introduction to Edward Dahlberg's *Bottom Dogs*," *Phoenix* (London, 1936), p. 271.

30. *The Wild Body*, p. 239; and *Blasting and Bombardiering*, pp. 305–306.

31. D. H. Lawrence, *Kangaroo*, pp. 261, 267; Wyndham Lewis, *Hitler* (London, 1931), p. 109; and *The Roaring Queen*, p. 71.

32. Rebecca West, "On Making Due Allowance for Distortion," *Time and Tide*, 10 (May 24, 1929), 624.

33. *Blasting and Bombardiering*, p. 3; and *Letters*, p. 151 (January 31, 1925).

34. John Holloway, "Wyndham Lewis: The Massacre and the Innocents," *The Chartered Mirror* (London, 1960), p. 129; and George Orwell, *Collected Essays, Journalism and Letters* (New York, 1968), IV, 21.

35. *Tarr*, p. 256; Hugh Kenner, *Wyndham Lewis* (Norfolk, Conn., 1954), p. 79; and *The Childermass*, p. 315.

36. Thatcher, ed., "Aldington's Letters to Read," pp. 41–42.

37. Interviews with D. G. Bridson and Hugh Gordon Porteus. Disraeli's wife was the widow of yet another Wyndham Lewis.

38. Letter from Wyndham Lewis to Julian Symons, February 11, 1949, Berg Collection, New York Public Library.

39. Sir Nicholas Waterhouse, *Reminiscences* (London: privately printed, 1960), pp. 11–12.

40. Geoffrey Grigson, in *Anton Zwemmer: Tributes from Some of His Friends* (London: privately printed, 1962), p. 7.

41. Interview with Desmond Zwemmer, London, September 20, 1978; and letter from Wyndham Lewis to Anton Zwemmer, January 10, 1935, owned by Desmond Zwemmer.

42. Letter from A. J. A. Symons to Wyndham Lewis, September 1930, Cornell.

43. Interview with Desmond Flower, London, September 18, 1978.

44. Quoted in an advertisement in *Enemy 2*; and interview with David Garnett.

45. See *Letters*, pp. 178–179; and correspondence of Wyndham Lewis and Marie Melony, June 1928, Columbia University Library.

46. Letter from Alistair Cooke to Jeffrey Meyers, January 4, 1979.

47. *Blasting and Bombardiering*, p. 250. See also pp. 4, 249, 340 on Auden.

48. W. H. Auden, "A Happy New Year," *New Country*, ed. Michael Roberts (London, 1933), p. 202; and W. H. Auden and Louis MacNeice, *Letters from Iceland* (London, 1937), pp. 233, 247. Auden's obscure allusion probably refers to the martyrdom of Robert Ferrar, Protestant Bishop of St. David's, who was burned at Market Cross in Carmarthen in 1555 for refusing to adhere to the prevailing doctrines of the Catholic Church during the reign of Queen Mary.

49. W. B. Yeats, *Letters*, ed. Allan Wade (New York, 1955), pp. 724, 733 (March 24 and November 29, 1927); letter from Sturge Moore to Wyndham Lewis, January 18, 1928, Cornell; and Lewis, *Letters*, p. 182 (c. September 1928).

50. Yeats, *Letters*, p. 763 (May 4, 1929); and quoted in Furlong, "Interview with Anne Wyndham Lewis."

51. Yeats, *Letters*, p. 776 (? September 1930). Swift wrote his own Latin epitaph: "The body of Jonathan Swift is buried here, where savage indignation can no longer lacerate his breast." *One-Way Song*, p. 73.

CHAPTER 10: *The Apes of God*

1. "Author As His Own Publisher," *Star*, June 9, 1930, p. 18.
2. *Satire and Fiction*, pp. 46–47, 53; and quoted in Morgan, *Writers at Work*, pp. 46–47. See also *Tarr* (London, 1918), p. 295.
3. *Time and Western Man*, p. 120.
4. *The Apes of God*, p. 470; and *Rude Assignment*, p. 199.
5. Lewis alluded to this childish episode in *America, I Presume*, p. 80.
6. *Rude Assignment*, p. 195; and John Rothenstein, "Wyndham Lewis," *Modern English Painters : Lewis to Moore* (New York, 1956), pp. 14–15.
7. Virginia Woolf, *The Question of Things Happening : Letters, 1912–1922*, ed. Nigel Nicolson and Joanne Trautmann (London, 1976), p. 467 (to Sydney Waterlow); and quoted in Geoffrey Grigson, "Recollections of *New Verse*," *TLS*, April 25, 1968, p. 410.
8. Woolf, p. 573 (to Roger Fry, October 22, 1922); Wyndham Lewis, "The Bloomsburies," c. 1934, Cornell; and Mansfield, *Letters*, I, 235 (to Ottoline Morrell, July 1919).
9. "North Staffs." [T. E. Hulme], "War Notes," *New Age*, 18 (January 13, 1916), 246–247; and *Blasting and Bombardiering*, pp. 184–185. See Jeffrey Meyers, *Homosexuality and Literature, 1890–1930* (London, 1977).
10. "The Doppelgänger," *Unlucky for Pringle*, p. 204.
11. *The Apes of God*, pp. 88, 131–132, 562–563.
12. *Men Without Art*, pp. 168, 170. See Stephen Spender, "One Way Song," *Spectator*, 153 (October 19, 1934), 574, 576; and Lewis' reply, November 2, 1934, p. 675 (reprinted in *Letters*, pp. 222–225).
13. *The Roaring Queen*, pp. 80, 96; and *The Revenge for Love*, p. 235.
14. Quoted in John Lehmann, *Thrown to the Woolves* (London, 1978), p. 31 (c. 1933); and Virginia Woolf, *A Writer's Diary*, ed. Leonard Woolf (New York, 1954), pp. 220–221 (October 11, 1934).
15. *Men Without Art*, p. 170.
16. Letters from Sir Sacheverell Sitwell to Jeffrey Meyers, September 7 and December 5, 1977.
17. Quoted in John Pearson, *Façades : Edith, Osbert and Sacheverell Sitwell* (London, 1978), p. 459 (August 19, 1959); John Lehmann, *A Nest of Tigers* (London, 1968), p. 102; and Edith Sitwell, "Why I Look the Way I Do," *Sunday Graphic*, December 4, 1955.
18. *Blasting and Bombardiering*, pp. 91–92; and Edith Sitwell, "The Missing Collar," *Taken Care Of* (New York, 1965), pp. 111–112.
19. Letter from Sir William Walton to Jeffrey Meyers, March 20, 1978.
20. Aldous Huxley, "The Tillotson Banquet," *Mortal Coils* (London, 1922), pp. 149–150; D. H. Lawrence, *Lady Chatterley's Lover*, p. 10; and Robert Nichols, *Fisbo* (London, 1934), p. 15.
21. Letter from Osbert Sitwell to Wyndham Lewis, c. 1929, Cornell; and letter from Wyndham Lewis to Archibald MacLeish, March 7, 1949, Cornell.
22. *The Apes of God*, pp. 371, 508–509.
23. *Satire and Fiction*, p. 7; and quoted in Pearson, p. 280.

24. F. R. Leavis, *New Bearings in English Poetry* (London, 1963), p. 64; Edith Sitwell, *Aspects of Modern Poetry* (London, 1934), p. 39; and Wyndham Lewis, "Sitwell Circus," *Time and Tide*, 15 (November 10, 1934), 1480.

25. See G. W. Stonier's review, *New Statesman*, 8 (November 24, 1934), 760, 762; Grigson's letters, December 8 and 15, pp. 824–825, 899–900; and Lewis' *Letters*, p. 230 (December 15, 1934).

26. Lehmann, pp. 100, 104; and *Taken Care Of*, p. 111.

27. Edith Sitwell, *I Live Under A Black Sun* (1937), (New York, 1938), p. 184; and Lehmann, p. 139.

28. Osbert Sitwell, *Those Were the Days* (London, 1938), pp. 291, 294, 332; and Osbert Sitwell, *Laughter in the Next Room* (London, 1949), p. 31.

29. Matthew Arnold, *Culture and Anarchy*, quoted in *The Art of Being Ruled*, pp. 377–378; and letter from Wyndham Lewis to Sir Nicholas Waterhouse, August 17, 1943, Cornell.

30. *The Diabolical Principle*, p. 132; and Wyndham Lewis, "Our Sham Society: An Interview with Myrick Booth," *Everyman*, 3 (July 3, 1930), 707.

31. *The Apes of God*, pp. 131, 252, 267–268, 286.

32. Letters from Violet Schiff and Sydney Schiff to Wyndham Lewis, May 24 and May 4, 1924, Cornell.

33. *The Apes of God*, pp. 315, 321.

34. Letters from Richard Wyndham to Wyndham Lewis, May 1924, Cornell (see Lewis, *Letters*, pp. 145–147); and *The Apes of God*, p. 33.

35. *Blasting and Bombardiering*, p. 250; *The Apes of God*, pp. 48, 100, 114; and interview with Stephen Spender, London, September 26, 1978.

36. Interview with Edgell Rickword, London, October 3, 1978; *The Apes of God*, p. 177; and Edgell Rickword, "The Encounter" (1931), *Collected Poems* (London, 1947), p. 60.

 Lewis also includes a nasty but witty portrait of Arthur Waley: "Wildsmith (more meretriciously chinese, the Bloomsbury sinologue *genre* Chu-chin-chow, at every moment) put on a mask of deep offense. Pedants!—what was this they were talking about? Who was a pedant?" (p. 389). Lewis absorbed his hostility from Pound, who disliked Waley because he was both Jewish and an infinitely greater Chinese scholar.

37. *The Apes of God*, p. 643; and Georges Sorel, *Réflexions sur la violence* (Paris, 1908), p. 436.

38. *The Diabolical Principle*, p. vii; and *The Apes of God*, p. 85.

39. Quoted in *Satire and Fiction*, p. 23.

40. T. S. Eliot, "Charles Whibley" (1931), *Selected Essays* (New York, 1932), p. 409; and Lawrence Durrell, *Spirit of Place*, ed. Alan Thomas (New York, 1969), p. 140 (letter to Aldington, 1957).

CHAPTER 11: Politics, Germany and Hitler

1. *Self Condemned*, p. 27; and *One-Way Song*, pp. 80–81.

2. Letter from Wyndham Lewis to Ezra Pound, December 26, 1937;

quoted in Alistair Hamilton, *The Appeal of Fascism* (London, 1971),
p. 45; and *Blasting and Bombardiering*, p. 262.

3. Hamilton, p. xx.
4. Lewis usually gave his marriage date as 1929, and *Who's Who* and the
 Dictionary of National Biography list that year. Froanna was vague
 about the precise date; and when W. K. Rose, who had been unable
 to find this marriage certificate, asked if they had in fact been married,
 she became quite furious. If one did not know that Froanna's father
 was a deceased florist named Joseph, it would be impossible to verify
 their marriage certificate. Another Percy Lewis and Gladys Hoskyns
 were, in fact, married in Bristol in September 1939—a few days after
 Lewis and Froanna had sailed for Canada.
5. *Hitler*, pp. 13–14; and John Lehmann, *The Whispering Gallery*
 (London, 1955), p. 176.
6. *Rude Assignment*, p. 209; and Wyndham Lewis, *The Hitler Cult*
 (London, 1939), p. 5.
7. *Hitler*, pp. 56, 63.
8. *Hitler*, pp. 201–202; and Stephen Spender, *The Thirties* (London,
 1978), pp. 196–197.
9. "Hitler and His Movement," *TLS*, 30 (April 16, 1931), 296; "Mr.
 Lewis Among the Nazis," *Spectator*, 146 (April 18, 1931), 642;
 Reginald Berkeley, "The Dictators," *Saturday Review*, 151 (April 11,
 1931), 535; and Clennell Wilkinson, "Wyndham Lewis on Hitler,"
 Everyman, 5 (April 2, 1931), 303.
10. Joyce, *Letters*, III, 311; and T. S. Eliot, "Foreword" to *One-Way
 Song* (London, 1960), pp. 9–10. Eliot stated that "the text here is
 identical with that of the 1933 edition," but omitted eleven lines
 (from pages 53 and 63) that referred to Hitler and the swastika.
11. Letter from Sir Oswald Mosley to Jeffrey Meyers, October 14, 1977.
 See also Oswald Mosley, *My Life* (London, 1968), p. 225; and
 Wyndham Lewis, " 'Left Wings' and the C3 Mind," *British Union
 Quarterly*, 1 (January 1937), 33. C3 was the lowest form of health
 classification for recruits in the Great War.
12. Quoted in John Fuller, *A Reader's Guide to W. H. Auden* (London,
 1970), p. 71; François Bondy, "Jean-Paul Sartre and Politics,"
 Literature and Politics in the Twentieth Century, ed. Walter Laqueur
 and George Mosse (New York, 1967), p. 28; and Winston Churchill,
 "The Truth About Hitler," *Strand Magazine*, 90 (November 1935), 19.

CHAPTER 12: Combat and Suppression

1. *Letters*, p. 203 (June 25, 1931, and to Naomi Mitchison, July 11, 1931).
2. Interview with Joseph Alsop, Washington, D.C., June 24, 1978;
 letter from George Homans to Jeffrey Meyers, August 1, 1978
 (Homans' letter is almost identical to his earlier account, quoted in
 Michel, pp. 113–114); Louise Bogan, *What the Woman Lived:
 Selected Letters, 1920–1970*, ed. Ruth Limmer (New York, 1973), p. 62

(to the critic Morton Zabel, January 23, 1932); and Rupert Grayson, *Stand Fast, the Holy Ghost* (London, 1973), p. 132. Lady Diana emphatically denies Lewis' story.

3. Letter from Mary Campbell to Jeffrey Meyers, February 10, 1978; interview with Mary Campbell; and Wyndham Lewis, *Snooty Baronet* (London, 1932), pp. 165, 169, 182.

4. *Letters*, p. 206 (April 6, 1932); letter from Roy Campbell to Wyndham Lewis, Martigues, c. 1933, Cornell; and interview with Mary Campbell. Campbell actually met a violent death in April 1957 (a month after Lewis died) when Mary was driving him back to Portugal after spending Holy Week in Seville. The tire of his car blew out, the vehicle crashed into a tree and his neck was broken.

5. Letter from Wyndham Lewis to W. K. Rose, March 16, 1951, Vassar. The book vanished, perhaps when Campbell hurriedly left Toledo in 1936 during the Spanish Civil War. If found, it would be one of the more interesting discoveries in modern literature.

6. *One-Way Song*, p. 73; and *Men Without Art*, p. 160.

7. Roy Campbell, *The Georgiad* and *Flowering Rifle*, in *Collected Poems* (London, 1949, 1957), I, 205, 213, 233; II, 143. The copy of *Mithraic Emblems* is owned by Ellsworth Mason, Boulder, Colorado.

8. Morgan, *Writers at Work*, pp. 44–45, 48–49, 52; and quoted in Julian Symons, "Meeting Wyndham Lewis," *Critical Occasions* (London, 1966), p. 186; and "What It Feels Like To Be An Enemy" (1932), *Wyndham Lewis on Art*, p. 267.

9. Gaunt, a large, tough-looking man and a specialist on British art, did a sketch of Lewis in his Percy Street studio in 1934 which portrayed the barrel-table and gigantic sword that decorated his studio. Earp, who had been president of the Oxford Union and was a critic of contemporary art, had tall furry hair, round staring eyes, thin lips and a high-pitched voice that D. H. Lawrence compared to "a little chicken chirp." R. H. Wilenski, a plump Jewish man with a forceful manner of speech, first met Lewis in 1913, when he attended the dinner for Marinetti; he often invited Lewis to his London house in the late twenties. All five friends wrote about Lewis; Lambert and Earp were portrayed in *Thirty Personalities*.

10. Gray, *Musical Chairs*, pp. 268–271; John Rothenstein, *Summer's Lease*, p. 129; letter from William Gaunt to Jeffrey Meyers, December 1, 1977; and interview with William Gaunt, London, September 12, 1978.

11. Naomi Mitchison, "Sitting for Wyndham Lewis," *Manchester Guardian*, July 9, 1956, p. 5; letter from Naomi Mitchison to W. K. Rose, March 16 [no year], from Cairo, Vassar; and interview with Naomi Mitchison, London, October 11, 1978.

12. Hugh Gordon Porteus, "A Man Apart: A Few Recollections of Wyndham Lewis," *Agenda*, 7–8 (1969–1970), 172; and interviews with Hugh Gordon Porteus.

13. Letter from Wyndham Lewis to Hugh Gordon Porteus, April 20, 1951, Cornell; letter from Wyndham Lewis to Felix Giovanelli, December 11, 1949, Cornell; and Porteus, *Agenda*, p. 177.

14. Geoffrey Grigson, "Recollections of Wyndham Lewis," *Listener*, 57 (May 16, 1957), 785; Geoffrey Grigson, "Recollections of *New Verse*," *TLS*, April 25, 1968, p. 409; and Grigson's note on a letter from Lewis to himself, January 22, 1934, Cornell.

15. Geoffrey Grigson, *The Crest on the Silver* (London, 1950), p. 165; Geoffrey Grigson, *A Master of Our Time* (London, 1951), p. 31.

16. Interview with Geoffrey Grigson; and letter from Geoffrey Grigson to Jeffrey Meyers, November 30, 1977.

17. Quoted in J. Maclaren-Ross, *Memoirs of the Forties* (London, 1965), p. 117.

18. Quoted in Cork, p. 551; and interview with Henry Moore.

19. Letter from Wyndham Lewis to the lawyer Graham Smith, November 4, 1934, Cornell.

20. Interview with Sybil, Lady Cholmondeley, London, September 20, 1978; and letters from Lady Cholmondeley to Wyndham Lewis, July 7, 1932 and [1932], Cornell.

21. Letter from Lord Glenapp to Wyndham Lewis, February 5, 1931; and letter from the lawyer H. D. Barnes, to Wyndham Lewis, November 1, 1932, Cornell.

22. Interview with Margaret Flower, London, September 19, 1978; and letter from Margaret Flower to Jeffrey Meyers, February 12, 1978.

23. Quoted in Alan Munton, "Desmond Harmsworth, Lewis' Publisher," *Lewisletter*, 8 (August 1978), 6; and Walter Sickert, quoted in Charles Handley-Read and Eric Newton, *The Art of Wyndham Lewis* (London, 1951), p. 70.

24. Letter from Desmond Harmsworth to Jeffrey Meyers, April 30, 1978. John Gawsworth's introductory book on Lewis, *Apes, Japes and Hitlerism*, appeared shortly before Porteus' book, in about August 1932.

25. Interview with Desmond Flower, London, September 18, 1978; and letter from Desmond Flower to Jeffrey Meyers, January 19, 1978. There were, in fact, some serious problems with Cassell about their demand for changes in *The Revenge for Love*.

26. *Snooty Baronet*, pp. 57–58, 290. Marjorie Firminger (1899–1976), a rich, silly, gossipy woman, claimed to have been the model for Val in this novel.

27. Quoted in Herbert Read, "Lone Wolf," p. 337; letter from Sturge Moore to Wyndham Lewis, November 23, 1933, Cornell; and *One-Way Song*, p. 34.

28. *One-Way Song*, pp. 61, 75; Geoffrey Grigson, "Three Satirists," *Morning Post*, November 10, 1933, p. 15; and reprinted in Spender, *The Thirties*, pp. 38–39 (December 1, 1933).

29. *Rude Assignment*, p. 52; Wyndham Lewis, *The Doom of Youth* (London, 1932), pp. 105, 113–114; and letter from Wyndham Lewis to Winn's lawyers, Gisbourne & Co., June 26, 1932, Cornell.

30. Alec Waugh, *The Best Wine Last* (London, 1978), p. 13.

31. Letter from Wyndham Lewis to Charles Prentice, July 1, 1932, at Chatto & Windus; and letter from Charles Prentice to Wyndham Lewis, June 21, 1932, at Chatto & Windus.

32. Letter from H. D. Barnes to Wyndham Lewis, November 1, 1932, Cornell.
33. Wyndham Lewis, *Filibusters in Barbary* (New York, 1932), pp. 151–152, 156.
34. Grayson, *Stand Fast*, pp. 129, 133.
35. Lewis lost the reputation he had established in America in the 1920s. After *Filibusters* appeared in New York in 1932 (without any difficulties), not one of Lewis' twelve books of the 1930s (apart from *The Revenge for Love* which Regnery brought out fifteen years later in 1952) was published in the United States during his lifetime.

CHAPTER 13: Lonely Old Volcano

1. Letter from Wyndham Lewis to Coburn Gilman, February 12, 1933, Cornell; *Letters*, p. 217.
2. Interview with Anne Wyndham Lewis; and *Letters*, p. 219.
3. Letter from Terence Millin to Wyndham Lewis, July 3, 1936; interview with Hugh Porteus; and *Letters*, p. 239.
4. Wyndham Lewis, "Record of Life in America," January 1, 1944, p. 3, Cornell; *Rude Assignment*, p. 210; and Wyndham Lewis, *The Vulgar Streak* (New York, 1953), p. 135. I am grateful to Dr. Sheldon Cooperman for expert advice on medical matters.
5. Quoted in Bradford Morrow and Bernard Lafourcade, *A Bibliography of the Writings of Wyndham Lewis* (Santa Barbara, California, 1978), p. 112; and *Satire and Fiction*, p. 55.
6. *Letters*, p. 208 (reprinted from *Time and Tide*, April 16, 1932); and *Rude Assignment*, p. 148.
7. *The Roaring Queen*, pp. 79, 87, 114–115. The models for the characters —apart from Rebecca West, Eugene Jolas and Mary Borden—were first identified by Walter Allen in his excellent introduction to the novel.
8. Wyndham Lewis, *Count Your Dead: They Are Alive!* (London, 1937), p. 22; and *Letters*, p. 239. Campbell exalted Moscardó in his brutal attack on Azaña and the Republican Government in *British Union Quarterly*, 1 (January 1937), 104—in which Lewis' essay also appeared.
9. Steven Marcus, "The Highbrow Know-Nothings," *Commentary*, 15 (February 1953), 189. See Jeffrey Meyers, " 'An Affirming Flame': Homage to Catalonia," *A Reader's Guide to George Orwell* (London, 1975), pp. 113–129 and Jeffrey Meyers, "Homage to Catalonia," *George Orwell: The Critical Heritage* (London, 1975), pp. 119–151.
10. *The Revenge for Love*, pp. 70, 81. This passage may have influenced the theme and title of Graham Greene's novel, *The Human Factor* (1978).

The contrasting sexual relationship between the ruthless capitalist Jack Cruze and the superficial bourgeois Gillian Phipps, described in Lewis' familiar sardonic mode, is similar to the bizarre scene in *Snooty Baronet* where Kell-Imrie has sex with Val, hops naked out of bed on one leg and vomits for fifteen minutes. Compare *Snooty*, pp. 45–46 (in a very different bird metaphor) with *Revenge*, p. 121.

11. Letter from Julian Trevelyan to Professor Robert Gordon, Montclair State College, May 18, 1977. Lewis praised Trevelyan's painting in the *Listener*, March 23, 1950, p. 522.
12. Wyndham Lewis, *Left Wings Over Europe* (London, 1936), pp. 139, 276, 295. Lewis' title echoed the play by Robert Nichols and Maurice Browne, *Wings Over Europe* (1932).
13. *Ibid.*, pp. 128, 165, 280, 330–331.
14. *Count Your Dead*, pp. 167, 276, 339; and typescript in the Lockwood Memorial Library, University of Buffalo.
15. *Hitler*, p. 36; and *Count Your Dead*, p. 41.
16. Quoted in Grigson, "Recollections of Lewis," *Listener*, p. 785; and John Rothenstein, *Summer's Lease*, p. 130.
17. Julian Symons, "Meeting Wyndham Lewis," pp. 184, 187; and interviews with Julian Symons, London, August 26, 1977 and October 1, 1978.
18. *Letters*, p. 248 (December 1937).

CHAPTER 14: Rejection and Recantation

1. Lewis, "Record of Life in America," p. 4; and *Self Condemned*, p. 179.
2. *Rude Assignment*, p. 130.
3. *Men Without Art*, p. 91; *Blasting and Bombardiering*, pp. 282–283; and "Early London Environment," *T. S. Eliot: A Symposium*, p. 25.
4. Winston Churchill, "Tradition and Novelty in Art," *Complete Speeches*, ed. Robert Rhodes James (London, 1974), VI, 5947; Holroyd, *Augustus John*, pp. 597–598; and interview with Michael Holroyd, London, December 12, 1978.
5. *The Art of Being Ruled*, p. 176; *Wyndham Lewis the Artist*, p. 374; and "The Vorticists," *Wyndham Lewis on Art*, p. 457.
6. *The Apes of God*, p. 69; interview with Stephen Spender; and Lewis, "Early London Environment," p. 29.
7. *Wyndham Lewis the Artist*, p. 5; and Hubert Nicholson, *Half My Days and Nights* (London, 1941), p. 225.
8. Letter from Gladys Anne Lewis to Lewis' editor at Methuen, J. Alan White, July 21, 1957, Cornell; *The Hitler Cult*, p. 128; and Wyndham Lewis, *The Jews, Are They Human?* (London, 1939), pp. 42–43.
9. Wyndham Lewis, *The Mysterious Mr. Bull* (London, 1938), pp. 117, 234.
10. *The Jews, Are They Human?*, pp. 31–32. Compare this with Hitler's *Mein Kampf*, quoted in Jeffrey Meyers, "Freud, Hitler and Vienna," *London Magazine*, 14 (August–September 1974), 75; "One day I suddenly encountered an apparition in a black caftan and black hair locks. Is this a Jew?, was my first thought. For, to be sure, they had not looked like that in Linz. I observed the man furtively and cautiously, but the longer I stared at this foreign face, scrutinizing feature for feature, the more my first question assumed a new form: Is this a German?"

11. *The Jews, Are They Human?*, pp. 12, 16, 20. Lewis did not clearly and forcefully express his hostility to anti-Semitism until *Self Condemned* (1954), published much too late to erase the stigma of his prejudice, when he wrote: "The Jews are an alibi for all the double-dealers, plotters and intriguers, fomenters of war, *und so weiter*. A useful tribe, they take the rap for everything" (p. 62).

12. *Letters*, p. 274 (to Leonard Amster, c. August 1940); and *Rude Assignment*, pp. 165, 209.

13. Ezra Pound, interview with *Epoca* (1963), quoted in Donald Davie, *Pound* (London, 1975), pp. 2–3; and interviews with Allen Ginsberg (1967, 1972), quoted in C. David Heymann, *Ezra Pound: The Last Rower* (London, 1976), pp. 298, 312.

CHAPTER 15: New York

1. "Mark Gertler," *Wyndham Lewis on Art*, p. 405.

2. Interview with John Reid, Toronto, May 26, 1978; quoted in Julian Symons, "The Thirties Novels," *Agenda*, 7–8 (1969–1970), 47; and quoted in Maurice Hugiville, "Ezra Pound's Letters to Olivet," *Texas Quarterly*, 16 (1973), 84.

3. *America, I Presume*, p. 45; W. K. Rose, "Exile's Letters," *Canadian Literature*, 35 (1968), 80–81.

4. *America, I Presume*, pp. 77–78; William Carlos Williams, *Autobiography* (New York, 1951), pp. 324–325; and letter from John Reid to Jeffrey Meyers, May 7, 1979.

5. Interview with Katherine Wheat, the sister of Alfred Lewis and granddaughter of the coal magnate George Howard Lewis, Geneva, New York, June 11, 1978; and John Rothenstein, *Brave Day, Hideous Night*, pp. 67–68.

6. Elliott Baker, "The Portrait of Diana Prochnik," *Unrequited Loves* (New York, 1974), pp. 108, 117–118; and letter from Wyndham Lewis to James Laughlin, at New Directions Publishers. Elliott Baker, in a letter of February 24, 1978, to Jeffrey Meyers, has described the genesis of his story: "It was probably a letter or reference by Pound which introduced me to Lewis. I picked up a second hand copy of his collected letters on Charing Cross Road—in the early sixties. There I found the letters he wrote from the Stuyvesant Hotel. Their dates roughly coincided with a time when my high school fraternity held a party dance at that hotel. That was the beginning of the idea of that story. It is a complete fiction. The only exception to that is that I have given Lewis dialogue from his own letters and essays; e.g. his evaluation of Picasso. My reading of his work hasn't extended much beyond these—just pieces of TARR and SELF CONDEMNED. My characterization of him is based on the latter, plus the impression I got of him from his letters. Incidentally, it has amused me that so many English critics have accepted the story as fact. One of them

(Alan Pryce-Jones, I think) said the story slayed a whole society. If so, perhaps W.L. is smiling in his grave."

7. Letter from Henry Miller to Jeffrey Meyers, February 28, 1978; and Wyndham Lewis, *America and Cosmic Man* (London, 1948), pp. 163, 191.

8. "Picasso," *Wyndham Lewis on Art*, p. 357; Lewis, "The End of Abstract Art," *New Republic*, 102 (April 1, 1940), 438; and C. J. Fox's interview with Alex Jackson, 1969.

9. *America, I Presume*, p. 208; interview with Paul Martin, London, November 16, 1978; and letter from Wyndham Lewis to Iris Barry, July 18, 1942, Cornell.

10. Letter from Dora Stone to Jeffrey Meyers, November 20, 1977; Geoffrey Stone's notes on Lewis, 1960, owned by Dora Stone; and Geoffrey Stone, "Wyndham Lewis," *TLS*, April 19, 1963, p. 265.

11. In *Who's Who*, Lewis claimed he was "Advisor to Library of Congress, USA." The Library of Congress, in a letter of May 10, 1979, to Jeffrey Meyers, states: "No references to Wyndham Lewis appear in the indexes or lists of consultants and fellows."

12. *America, I Presume*, pp. 166, 171, 279; and letters from Harry Levin to W. K. Rose, January 12, 1960, Vassar, and to Jeffrey Meyers, July 20, 1978.

13. Interview with John Slocum, Newport, Rhode Island, June 20, 1978; and letter from John Slocum to Jeffrey Meyers, January 31, 1978.

14. *The Vulgar Streak*, pp. 11, 240. For a study of how actual paintings are used in modern novels, see Jeffrey Meyers, *Painting and the Novel* (Manchester, 1975).

CHAPTER 16: Toronto

1. Interview with Hugh Kenner; letter from John Reid to Jeffrey Meyers, June 9, 1978; and letter from Northrop Frye to Jeffrey Meyers, February 2, 1979.

2. *Letters*, p. 278 (November 20, 1940); *Anglosaxony*, p. 20; and letter from Lorne Pierce to W. K. Rose, April 29, 1960, Vassar.

3. Morley Callaghan, "The Way It Was," *Spectator*, 212 (May 22, 1964), 696; letter from Edgar Richardson to Jeffrey Meyers, January 19, 1978; and letter from D. G. Creighton to C. J. Fox, February 10, 1963.

4. Interview with Anne Wyndham Lewis; and Wyndham Lewis, "The Role of Line in Art," *Enemy News*, 10 (May 1979), 2.

5. *Letters*, pp. 283, 308, 331 (to Geoffrey Stone, December 1940, Mrs. Thomas Lamont, November 11, 1941, Louis MacNeice, July 13, 1942); and letter from Wyndham Lewis to Alfred Barr, September 25, 1941, Cornell.

6. Letter from Wyndham Lewis to John Reid, September 16, 1942, Cornell; and *Letters*, p. 335.

7. Anne Wyndham Lewis, "The Hotel," *Wyndham Lewis in Canada*, ed.

George Woodcock (Vancouver, 1971), p. 22; and *Letters*, p. 352 (March 31, 1943).

8. C. J. Fox's interview with Alex Jackson, 1969; Wyndham Lewis, "On Canada," *Wyndham Lewis in Canada*, p. 27; and letter from John Reid to Jeffrey Meyers, June 9, 1978. See also Barbara Moon, "The Man Who Discovered Canadian Painting," *Maclean's Magazine*, January 4, 1964, pp. 16-17, 40-44, which contains a good photograph of Duncan.

9. Letter from Alex Jackson to C. J. Fox, January 2, 1965; Fox's interview with Jackson; and letter from Wyndham Lewis to Geoffrey Stone, September 26, 1941, owned by Dora Stone.

10. *Letters*, pp. 302, 304 (to Archibald MacLeish, October 21, 1941, and to Lorne Pierce, ? October 1941); and letter from Wyndham Lewis to Eric Kennington, June 10, 1942, Cornell.

11. Interview with Julian Symons; *The Revenge for Love*, p. 259; and *Rude Assignment*, p. 48.

12. Letter from Sir Kenneth Clark to Wyndham Lewis, July 27, 1942, Cornell; *Letters*, pp. 350, 353 (to Eric Kennington and Father J. Stanley Murphy, both March 31, 1943); and letter from Sir Kenneth Clark to Augustus John, February 28, 1944, owned by Romilly John.

13. *Letters*, p. 364; and letter from Wyndham Lewis to Augustus John, Cornell.

14. Letters from Sir Kenneth Clark to W. K. Rose, July 28, 1967, Vassar, and to Jeffrey Meyers, December 1977. This letter, and most of the comic correspondence about the painting, is in the Art Archives of the Imperial War Museum, London.

CHAPTER 17: Windsor and St. Louis

1. Letter from Cecil Eustace to Jeffrey Meyers, June 19, 1978; interview with Father J. Stanley Murphy, Windsor, May 24, 1978. See Father Murphy, "Wyndham Lewis at Windsor," *Wyndham Lewis in Canada*, pp. 30-40. Lewis' lecture was published in *Wyndham Lewis on Art*, pp. 367-380.

2. Letter from Edgar Richardson to Jeffrey Meyers, January 19, 1978.

3. Letter from Wyndham Lewis to Ezra Pound, July 16, 1916, Yale; letter from Wyndham Lewis to Rev. Willis Feast, November 12, 1948, Cornell; and *Letters*, pp. 357, 364 (to John Burgess, July 17 and August 17, 1943).

4. Letter from Pauline Bondy to Jeffrey Meyers, June 26, 1978; and *Letters*, pp. 375-376 (to Felix Giovanelli, January 28, 1944).

5. Letter from Paul Martin to C. J. Fox, October 7, 1961; letter from Paul Martin to Jeffrey Meyers, June 20, 1978; interview with Paul Martin, London, November 16, 1978; and interview with Eleanor Martin, London, November 17, 1978.

6. Letters from Marshall McLuhan to Wyndham Lewis, November 27, 1943, and January 17, 1944, Cornell; letter from Charles Nagel to

Jeffrey Meyers, March 16, 1978; and letter from Wyndham Lewis to Malcolm MacDonald, April 11, 1944, Imperial War Museum.

7. After the War Lewis' contemporary, Max Beckmann, the Expressionist painter and German *émigré*, was invited to teach at Washington University, awarded an honorary degree and given a retrospective exhibition at the City Art Museum. In October 1947 Beckmann wrote to a friend: "St. Louis is lovely. A truly fabulous garden city with a hunk of downtown at the Mississippi, many skyscrapers like in New York. People quite agreeable, we are being spoiled a little because they all here have a very exact knowledge of my work. School not too strenuous. Very beautiful studio in which I'm working already energetically." (Quoted in Stephen Lackner, *Max Beckmann* (Coral Gables, Fla., 1969), p. 107.) The difference between Beckmann's enthusiastic and Lewis' lukewarm reception was determined less by their artistic achievement than by their different personalities and political opinions, for Beckmann was anti-Nazi and Lewis was known as pro-Fascist.

8. McLuhan, "Wyndham Lewis," *Atlantic Monthly*, 94, 98; letter from Wyndham Lewis to Marshall McLuhan, February 4, 1945, Cornell; letter from Marshall McLuhan to Wyndham Lewis, June 22, 1944; and interview with Marshall McLuhan, Toronto, May 26, 1978.

9. Wyndham Lewis, "Hemingway, Tolstoi and War," pp. 47, 81, Cornell; *Letters*, p. 380; letter from William McCann to Jeffrey Meyers, October 25, 1977; and letter from Arthur Smith to Jeffrey Meyers, February 21, 1978.

10. Letter from Edgar Richardson to Jeffrey Meyers, January 19, 1978.

CHAPTER 18: Notting Hill

1. Letter from Wyndham Lewis to D. D. Paige, August 17, 1947, Cornell; *Letters*, p. 427 (to Geoffrey Stone, January 15, 1948); and "The Vita of Mr. Wyndham Lewis," p. 14, 1949, Cornell.

2. G. S. Fraser, "Wyndham Lewis: An Energy of Mind," *Twentieth Century*, 161 (April 1957), 386; *Letters*, p. 503 (August 6, 1949); and Derek Stanford, *Inside the Forties* (London, 1977), p. 132.

3. Interview with Melville Hardiment, Harlow, Essex, January 7, 1979; and *Rotting Hill*, p. 224.

4. *Rotting Hill*, pp. 4–5; and interview with Reverend Willis Feast, Norwich, September 15, 1978.

5. Letter from Russell Kirk to Jeffrey Meyers, October 13, 1977; and Geoffrey Stone, "Notes on Wyndham Lewis," 1960, owned by Dora Stone.

6. *Rotting Hill*, pp. 259–260; *Letters*, pp. 542–543 (July 14, 1951); and quoted in Russell Kirk, *Eliot and His Age* (New York, 1971), p. 375. In 1948 Penguin Books planned to reissue *Tarr*, suggested an advance of £100 and then retracted the offer.

7. Interview with Anne Wyndham Lewis; and *Rotting Hill*, p. 264.

8. *The Demon of Progress in the Arts*, p. 4; and letters from Wyndham Lewis to Ezra Pound (May 1, 1948) and to Felix Giovanelli (October 21 and November 1, 1948), Cornell.

9. Wyndham Lewis, "The Sea-Mists of the Winter," *Listener*, 45 (May 10, 1951), 765; and quoted in "White Light," *Time*, May 30, 1949, p. 60.

10. John Rothenstein, *Time's Thievish Progress*, pp. 39–40; and letter from Sir Roland Penrose to Jeffrey Meyers, January 27, 1979.

11. "The Vita of Mr. Wyndham Lewis," pp. 6–7; interview with Tambimuttu, London, January 11, 1979; and J. Maclaren-Ross, *Memoirs of the Forties*, p. 130.

12. *America and Cosmic Man*, pp. 179–180, 220; *Letters*, p. 458 (September 21, 1948); and *Rude Assignment*, pp. 92, 99.

13. Symons, "Meeting Wyndham Lewis," p. 189. Lewis' 1919 drawing of a male nude (Michel, plate 40) bears an uncanny resemblance to Orwell. *Left Wings Over Europe*, pp. 204, 294; and *Self Condemned*, p. 320.

14. George Orwell, "London Letter," *Partisan Review*, 13 (Summer 1946), 323; and interview with Hugh Gordon Porteus.

15. Wyndham Lewis, *The Writer and the Absolute* (London, 1952), p. 29; and Williams, *Autobiography*, p. 337.

16. *Letters*, pp. 468, 548 (October 25, 1948, and September 10, 1952); letter from Wyndham Lewis to D. D. Paige, August 17, 1947, Cornell; "The Doppelgänger," *Unlucky for Pringle*, pp. 207–208, 214–215, 218.

CHAPTER 19: Blindness

1. Lewis, "Record of Life in America," p. 4; and *Letters*, pp. 299–301, 326 (to Frank Morley, October 17, 1941 and Eric Kennington, ? June 26, 1942).

2. *Letters*, pp. 515, 517 (to David Kahma, December 27, 1949, and Nicholas Waterhouse, January 13, 1950); *Rotting Hill*, pp. 125–126; quoted in Julian Symons, "The Blaster," *London Magazine*, 7 (June 1967), 92; and letter from Wyndham Lewis to Michael Ayrton, June 9, 1951, owned by Elizabeth Ayrton.

3. Patrick Trevor-Roper, *The World Through Blunted Sight* (London, 1970), p. 130, stated: "*Before* the Second World War, [Lewis] was told by his London oculist [Affleck Greeves] that he (like Milton) had a pituitary tumour pressing on the optic nerves, which should be removed."

4. Letter from Dr. Ian McPherson to Wyndham Lewis, May 1, 1947, Cornell; and *Letters*, p. 523 (to Helen Saunders, August 4, 1950). There is no conclusive evidence about the effect of the tumor on his brain because Lewis' X-rays, the case notes of his neurologist, Dr. Swithen Meadows, and the records in the hospital where he was treated have all been lost or destroyed.

5. Interview with Dr. Ian McPherson, London, April 25, 1979.

6. *Letters*, p. 526 (to Meyrick Booth, October 7, 1950).

7. *Letters*, p. 524 (to Nicholas Waterhouse, September 1950); and letter from Wyndham Lewis to Hugh Porteus, April 9, 1951, Cornell. See William Riley Parker, *Milton: A Biography* (Oxford, 1968), I, 390: "Milton's forehead and temples seemed to be the seat of chronic mists, which constantly oppressed and weighed down his eyes with a sort of sleepy heaviness, especially during the afternoon. When he stood still, objects seemed to float about to one side or another." See also Lambert Rogers, "John Milton's Blindness: A Suggested Diagnosis," *Journal of the History of Medicine*, 4 (1969), 468–471.

8. Campbell, an intimate friend but not a reliable witness, believed that Lewis' venereal disease of 1914–1915 was syphilis and that this was responsible for his "persecution mania." Campbell told his daughter, Teresa, when she was a child and they visited Lewis in the late 1940s, that she had to wait outside because "Lewis had syph." Campbell also informed Derek Stanford: "Once, years before, they had been dining at some restaurant when Lewis leaned forward and told him they must talk more quietly. 'There's a man at a table behind listening to everything we say.' Campbell had looked around the restaurant on all sides. There was no one within six tables of them. 'He thought he was being persecuted,' he explained. 'The syph he had in 1914, when he tried to cure himself, had touched his brain.' " (Interview with Teresa Campbell Custódio, Sintra, Portugal, August 26, 1978; and Derek Stanford, *Inside the Forties* (London, 1977), p. 132.) Melville Hardiment, a painter who knew Lewis in the late forties, wrote: "Just after Wyndham went completely blind, Nina Hamnett told me, 'Yes. He got the pox from some German whore in Paris years ago.' " (Letter to Jeffrey Meyers, December 29, 1978.) Pound and Aldington also suspected that Lewis' blindness was caused by syphilis, but there is no medical evidence for this and no sign of the disease was found during Lewis' autopsy. (Interview with E. W. F. Tomlin, London, September 28, 1978, about Pound and Lewis; and Thatcher, ed., "Aldington's Letters to Read," pp. 38, 41–42.)

9. *Letters*, p. 537; and "The Sea-Mists of the Winter," p. 765.

10. Letter from Wyndham Lewis to Stuart Gilbert, August 26, 1951, Cornell; interview with Hugh Porteus; and John Rothenstein, *Time's Thievish Progress*, p. 40.

11. Lewis' autopsy at Westminster Hospital revealed that only a parcel of optic nerve fibers had survived the spread of the extraordinary tumor, which was as large as an egg. He was fortunate to have lived for so long with a growth of that great size in his skull, for it frequently caused a fatal disruption of the pituitary function or a massive hemorrhage. The actual cause of Lewis' death was not the pituitary tumor, but the chronic kidney failure (pyelo-nephritis and uremic coma) which was related to the urinary disease that had caused so much pain and trouble in the 1930s. Lewis' death certificate, filled in by the physician on duty, stated that his tumor was a cranio-pharyngioma; the autopsy revealed that it was, in fact, a chromophobe adenoma.

12. *Letters*, p. 539. The account of the relationship of Froanna and Agnes is based on interviews with Anne Wyndham Lewis, Melville Hardiment, Willis Feast, D. G. Bridson, Elizabeth Ayrton, Hugh Kenner and William Cookson. Julian Symons, E. W. F. Tomlin, J. Alan White, Walter Michel and C. J. Fox heard about Froanna's attempted suicide.

13. *Blast 1*, p. 70; and *Letters*, p. 341 (November 17, 1942).

14. Richard Evans, "The Blind Outsider Battles On At 72," *Daily Mail*, September 6, 1956, p. 4. Lewis was nearly seventy-four at that time.

15. *Wyndham Lewis the Artist*, pp. 26–27; interview with Stephen Spender; and Spender, *The Thirties*, p. 174.

16. *The Demon of Progress in the Arts*, p. 53; Herbert Read, "The Lost Leader," *Sewanee Review*, 63 (1955), 551; and letters from Herbert Read to T. S. Eliot, November 12 and 21, 1955, University of Victoria, British Columbia.

17. See Herbert Read, "Lone Wolf," p. 337 and in *Saturday Review*, 47 (April 4, 1964), 29, 43. Herbert Read, "T. S. Eliot—A Memoir," in Allen Tate, ed., *T. S. Eliot: The Man and His Work* (New York, 1966), p. 26; and John Rothenstein, *Time's Thievish Progress*, p. 40.

18. T. S. Eliot, "A Note on *Monstre Gai*," *Hudson Review*, 7 (1955), 524. See W. K. Rose's note in *Letters* (London, 1963), p. 263: The novel evokes "the experience, not as it was but as it felt"; and Hugh Kenner's Introduction to *Self Condemned* (Chicago, 1965), p. xii: "This is expressionist fiction, relieving the author's memory and gratifying his taste for fantasy, at the same time as it delineates René Harding's hell."

19. *Self Condemned*, pp. 162, 211, 397.

20. *The Vulgar Streak*, p. 217; and *Self Condemned*, pp. 105, 138, 401.

21. *The Art of Being Ruled*, p. 35; and *Self Condemned*, pp. 188, 341.

22. *Blast 2*, p. 42; and letter from Wyndham Lewis to Nicholas Waterhouse, January 13, 1943, Cornell.

23. Hugh MacDiarmid, *In Memoriam, James Joyce* (Glasgow, 1955), pp. 135, 141, paid tribute to Lewis by mentioning Furber and quoting from *The Wild Body* (New York, 1928), pp. 234–235:

> Mr. Furber, the Canadian dilettante,
> And all Yahoos and *intellectuels-flics*. . . .
> ('Larvae, hallucinated automata, bobbins,
> Savage robots, appropriate dummies,
> The fascinating imbecility of the creaking men-machines
> Set in a pattern as circumscribed and complete
> As a theory of Euclid—essays in a new human mathematic.')

24. Letter from Wyndham Lewis to Michael Ayrton, January 29, 1954, owned by Elizabeth Ayrton; *Self Condemned*, pp. 203, 290; and Dante, *The Divine Comedy: Inferno*, trans. Dorothy Sayers (Harmondsworth: Penguin, 1949), pp. 271–272. See the Dantean image on p. 185: "Your face would be wet with tears which would freeze upon the face."

25. *Self Condemned*, pp. 360, 379; and C. J. Fox's interview with Anne

Wyndham Lewis, June 25, 1977. The Cornell manuscript contains a variant ending of *Self Condemned* in which the Hardings return to England and Hester, who cannot bear to see René treated so harshly by English society, commits suicide.

26. *The Revenge for Love*, p. 70; and *Self Condemned*, p. 391. The death of Hester is consistent with the violent deaths that conclude all of Lewis' fiction. In *Enemy of the Stars* Hanp stabs Arghol and leaps into a canal; in *Tarr* Kreisler kills Soltyk and hangs himself; in *The Apes of God* the decrepit Lady Fredigonde proposes marriage and then dies in the arms of Zagreus; in *Snooty Baronet* Kell-Imrie shoots Humph while in the Persian desert; in *The Roaring Queen* Donald Butterboy is found dead in bed, with bullet wounds in several parts of his body; in *The Revenge for Love* Victor and Margot fall over a cliff in a storm; in *The Vulgar Streak* Penhale hangs himself; and in *The Red Priest* Father Card accidentally kills his curate with a punch and (in a sardonic allusion to Canada) dies among the eskimos.

CHAPTER 20: *The Human Age*

1. Michael Ayrton, "The Enemy as Friend," *The Rudiments of Paradise* (London, 1971), p. 263; interview with Elizabeth Ayrton, Rockhampton, Glos., August 22, 1977; interview with Russell Kirk; letter from Russell Kirk to Jeffrey Meyers, October 13, 1977.

2. Interview with Walter Michel; letter from Walter Michel to Jeffrey Meyers, October 20, 1977; and Hugh Kenner, *The Pound Era* (Berkeley, California, 1971), p. 549.

3. Quoted in Rothenstein, *Time's Thievish Progress*, p. 40 and Kenner, *The Pound Era*, p. 444; letter from P. H. Newby to Jeffrey Meyers, June 26, 1978; and quoted in Henry Regnery's unpublished "Memoirs," p. 44.

4. D. G. Bridson, "The Making of *The Human Age*," *Agenda*, 7–8 (1969–1970), 164, 170; D. G. Bridson, in Omar Pound and Philip Grover, *Wyndham Lewis: A Descriptive Bibliography* (Folkestone, 1978), pp. 169–170; and *Letters*, p. 540 (June 1951).

5. The only modern analogy to Lewis' novel, begun in the mid-twenties and finished thirty years later, is Mann's *Confessions of Felix Krull*, which he started in 1909 and completed in 1953.

6. I. A. Richards, "A Talk on *The Childermass*," *Agenda*, 7–8 (1969–1970), 16; Hugh Kenner, "The Trial of Man," in Wyndham Lewis, *Malign Fiesta* (London: Calder & Boyars, 1966), p. 239; and letter from Alan White to Geoffrey Grigson, March 31, 1960, Cornell.

7. Ford Madox Ford, "Mr. Wyndham Lewis and 'Blast,'" *Outlook*, p. 15; *Wyndham Lewis on Art*, p. 447; and John Rothenstein, *Wyndham Lewis and Vorticism* (London: Tate Gallery, 1956), p. 5.

8. Letter from Mary Chamot to Jeffrey Meyers, June 25, 1978; and letter from William Gaunt to Jeffrey Meyers, December 1, 1977.

9. Rothenstein, *Modern English Painters : Lewis to Moore*, p. 286; and interview with Henry Moore.

10. William Roberts, *The Vortex Pamphlets* (London, 1958), no. 2, p. 6 and no. 3, p. 8; *Letters*, p. 566 (August 28, 1956); *TLS*, November 22, 1957, p. 700; and "Roger Fry's Role as Continental Mediator" (1921), *Wyndham Lewis on Art*, p. 197.

11. Evans, *Daily Mail*, p. 4. The file of Lewis' letters has been destroyed.

12. Letter from Naomi Mitchison to Jeffrey Meyers, June 25, 1978.

13. T. S. Eliot, "The Importance of Wyndham Lewis," *Sunday Times*, March 10, 1957, p. 10.

14. Saul Bellow, "Cloister Culture," *New York Times Book Review*, July 10, 1966, p. 2. Bellow admiringly quotes a long passage from *The Writer and the Absolute* in *To Jerusalem and Back* (London, 1976), p. 119.

Select Bibliography

Agenda, 7–8 (Autumn–Winter 1969–1970), 1–224. Special issue on Lewis.

AYRTON, MICHAEL. *Golden Sections*. London, 1957. Pp. 146–158.

BRIDSON, D. G. *The Filibuster: A Study of the Political Ideas of Wyndham Lewis*. London, 1972.

CHAPMAN, ROBERT. *Wyndham Lewis: Fictions and Satires*. London, 1973.

CORK, RICHARD. *Vorticism and Abstract Art in the First Machine Age*. London, 1976.

ELIOT, T. S. " 'Tarr,' " *Egoist*, 5 (September 1918), 105–106.

ELIOT, T. S. "Wyndham Lewis," *Hudson Review*, 10 (1957), 167–170.

GAWSWORTH, JOHN. *Apes, Japes and Hitlerism*. London, 1932.

GRIGSON, GEOFFREY. *A Master of Our Time*. London, 1951.

HOLLOWAY, JOHN. *The Chartered Mirror*. London, 1960. Pp. 118–136.

JOHN, AUGUSTUS. *Chiaroscuro*. London, 1952.

JOHN, AUGUSTUS. *Finishing Touches*. London, 1964.

KENNER, HUGH. *Wyndham Lewis*. Norfolk, Conn., 1954.

KENNER, HUGH. *The Pound Era*. Berkeley, California, 1971.

MCLUHAN, MARSHALL. "Wyndham Lewis," *Atlantic Monthly*, 224 (December 1969), 93–98.

MATERER, TIMOTHY. *Wyndham Lewis, the Novelist*. Detroit, 1976.

MEYERS, JEFFREY. "Vortex Lewis," *Southern Review*, 15 (Winter 1979), 257–264.

MEYERS, JEFFREY. "Wyndham Lewis: Portraits of an Artist," *London Magazine*.

MEYERS, JEFFREY. "Wyndham Lewis and His Shadow," *Books and Bookmen*, 24 (June 1979), 32–33.

MEYERS, JEFFREY. "Wyndham Lewis: A Bibliography of Criticism," *Bulletin of Bibliography*.

MEYERS, JEFFREY. ed. *Wyndham Lewis: A Revaluation*. London and Montreal, 1980.

MEYERS, JEFFREY. "Wyndham Lewis and T. S. Eliot: A Friendship," *Virginia Quarterly Review*.

MEYERS, JEFFREY. "The Quest for Wyndham Lewis," *Biography*.

MICHEL, WALTER. *Wyndham Lewis: Paintings and Drawings*. Introduction by Hugh Kenner. London, 1971.

MORGAN, LOUISE. *Writers at Work*. London, 1931. Pp. 43–52.

MORROW, BRADFORD and BERNARD LAFOURCADE. *A Bibliography of the Writings of Wyndham Lewis*. Santa Barbara, California, 1978.

PORTEUS, HUGH GORDON. *Wyndham Lewis: A Discursive Exposition*. London, 1932.

POUND, EZRA. *Letters, 1907–1941*. Ed. D. D. Paige. New York, 1950.

POUND, EZRA. *Literary Essays*. London, 1954.

POUND, OMAR and PHILIP GROVER. *Wyndham Lewis: A Descriptive Bibliography*. Folkestone, 1978.

PRITCHARD, WILLIAM. *Wyndham Lewis*. New York, 1968.

ROSE, W. K. "Ezra Pound and Wyndham Lewis: The Crucial Years," *Southern Review*, 4 (1968), 72–89.

ROTHENSTEIN, JOHN. *Modern English Painters*. New York, 1956. 3 vols.

Shenandoah, 4 (Summer–Autumn 1953), 1–88. Special issue on Lewis.

SYMONS, JULIAN. *Critical Occasions*. London, 1966. Pp. 61–67, 183–189.

TOMLIN, E. W. F. *Wyndham Lewis*. London, 1955.

Twentieth Century Verse, 6–7 (September–December 1937), 104–151. Special issue on Lewis.

WAGNER, GEOFFREY. *Wyndham Lewis: A Portrait of the Artist as Enemy*. London, 1957.

WEES, WILLIAM. *Vorticism and the English Avant-Garde*. Toronto, 1972.

Wyndham Lewis in Canada. Ed. George Woodcock. Vancouver, 1971.

Index